MW00986590

SCREAM OF THE
WHITE BEAR

DAVID CLEMENT-DAVIES

PHOENIX ARK PRESS

ALSO BY DAVID CLEMENT-DAVIES

Fire Bringer

The Sight

Fell

The Telling Pool

The Alchemists of Barbal

For Younger Children

Spirit: Stallion of the Cimarron

Zo-Zo Leaves His Hole

The Terror Time Spies

Scream of the White Bear
By David Clement-Davies
Text copyright © 2019 David Clement-Davies
All rights reserved.

This is a work of fiction. Names, characters, places, and incidents are either the product
of the author's imagination or are used fictitiously, and any resemblance to actual
persons, living or dead, business establishments, events, or locales is entirely
coincidental.

Cover art by Ivan Zann
© 2019 Bookcoversart.com

Phoenix Ark Press
phoenixarkpress.com

The publisher and author are not responsible for any content that are not owned by the
publisher directly.

For Dante and Beatrice

And for Allegra and my father, Stanley, a blazing spirit, wounded by the past and all its love and shadows

ACKNOWLEDGMENTS

I would like to acknowledge Norbert Rosing's wonderful photographic study *The World of the Polar Bear*, published by A&C Black – with gratitude for its inspiration in writing about these extraordinary and very real animals, that I used to watch in awe at London Zoo as a boy. For older readers and lovers of stories, I would also like to recommend a magnificent study on literature and its recurring patterns by Christopher Booker called The Seven Basic Plots, and any of the fables by Robert R. Johnson, in his great, wonderful little books.

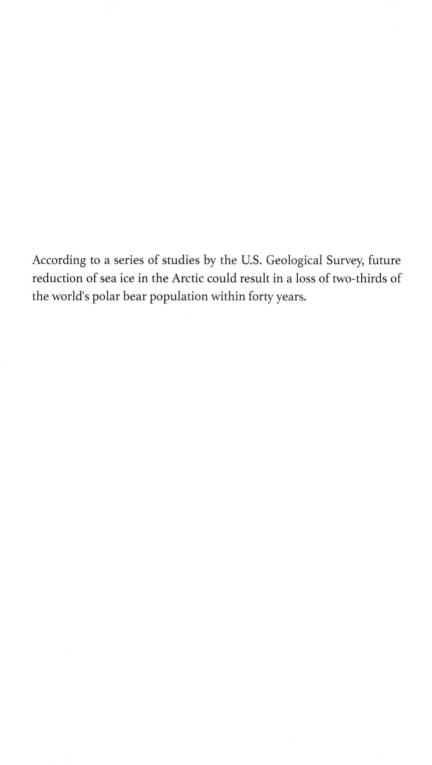

According to a series of studies by the U.S. Geological Survey, future reduction of sea ice in the Arctic could result in a loss of two-thirds of the world's polar bear population within forty years.

"The most beautiful thing we can experience is the mysterious. It is the source of all true art and all science. He to whom this emotion is a stranger, who can no longer pause to wonder and stand rapt in awe, is as good as dead: his eyes are closed."

—*Albert Einstein*

"The modern hero...cannot, indeed must not, wait for his community to caste off that slough of pride, fear, rationalized avarice, and sanctified misunderstanding. 'Live' Nietzsche says, 'as though the day were here.' It is not society that is to guide and save the creative hero, but precisely the reverse. And so, every one of us shares the supreme ordeal - carries the cross of the redeemer - not in the bright moments of his tribe's great victories, but in the silences of his personal despair."

—*Joseph Campbell, The Hero with a Thousand Faces.*

PART I

THE GREAT SOUND

PROLOGUE

L isten cubs, gather round and listen. It was told at a time of great darkness and of fear, told in the Long Night, to warm the heart and calm the hot, beating blood, and so keep many a polar bear cub happy and safe in their frosty birthing dens. But what was it called, this strange, impossible story? It was called the legend of the Ice Lore. No, that's not quite right. It was called the fable of the Ice Cry, or of the Twice Born. Or was it the legend of the Black Paw?

Well, whatever its name, the legend went something like this...

SLAYERS AND STORYTELLERS

"God created man in order to tell stories."
—Hasidic saying

T he scurrying arctic blizzard was done and in the enormous white silences settling like a sigh across the huge expanses of frozen sea ice, up here, high above the Arctic Circle, a savage cry cut the winter night – *"Aooooooow!"*. It was the lonely song of the wild wolf. The searching call seemed to quiver into form on the air, as if the cry itself had suddenly turned into the eerie coloured lights, flickering brilliantly across the great black canvas of moon-clad night.

The glowing astral pathway rose through the winter cold like billowing curls of blue-green smoke, sweeping up off the ice sheets and into the air in a drifting arc around the moon, the single Pole Star, and the great constellation hanging there in the heavens that men in wondering days knew as Arktus, the Greek word for a bear.

The Aurora Borealis the language of science calls these strange astral lights, although the Sioux Indians traditionally believe they are the spirits of unborn children, and some Inuit tribesmen, the ghosts of their dead ancestors: phantoms, swirling in the darkened skies. Closer to their freezing earth world, the Eskimo claim the famous Northern Lights as favourite beasts instead, like caribou, whale, or dancing salmon. But the Lera, the wild animals of the earth, truly

know what they really are, and so they call them The Beqorn – those that bite with their teeth.

If the language of science is to classify them, in truth the magical display of Northern Lights is really caused by the sun's superheated flares, bursting in outer space, sending out the solar winds through the void, that charge unseen particles in our upper atmosphere, making them swirl and flow towards Magnetic North. Yet, as the wolf howl came again, calling out in nature's most primitive tongue, the ice itself seemed alive with a real magic this deep winter night – a Storyteller's magic.

On the darkened flats of sea ice there was no sight of any wolf though. Instead, three huge shapes came lumbering from the blackness, as if shrugging off the bitter winter dark. The great, white creatures had heard the lonely howl, their little ears up on their heads, listening intently, although these beasts were not frightened of mere wolves. For these were Bellarg – Ice Lords – the great white polar bears of the arctic wilds, and, as such, the largest and most dangerous land-living carnivores left on earth.

It was the season of the deepest snows now, in Bellarg lore the season of the King, and in their mythology, this was the region of the King too, the high North. The three wandering bears had long winter fur sleeves at their forearms, and the first was whispering in a voice that rumbled from his white belly like muffled thunder.

"And what story do we tell now, disciples, as we go?" he growled deeply, his keen eyes catching the reflection of the astral lights.

"The Great Story, Illooq Longsleeves," answered the second polar bear immediately, giving a growl, as if even speaking of it made him nervous.

"Of the Coming," added the third eagerly, ice flecks glittering electric blue across his yellow teeth, "at the end of the world itself, Illooq Longsleeves, and everything there is."

"Indeed," growled Illooq gravely, the Bellarg's strong face filling suddenly with light. "At the end, yes, yet the story tells of resurrections too, brother, even the end of Death itself. In such dangerous times though, our great Master forbids us any fighting, brothers. So

we must speak the Great Story instead, as we journey, and only words of true power now. For our Master Sorgan teaches us that the jaw is always mightier than the claw."

Illooq Longsleeves frowned though as he spoke, for these were dark and dangerous times indeed, filled with many unseen threats, as all were whispering of how the very ice world itself seemed to be melting and vanishing completely. How there was a strange hotness in the air too, and how the arctic Lera were dwindling away mysteriously. Illooq shook his head. He was a fighter to his jaws and paws, yet his growling journey forced a different calling on the brave young disciple. One that frustrated courageous Illooq, at times, and made him nervous for all his kind.

Far behind them, the wolf that had indeed howled stood stiff-backed in the darkness, still listening intently, his scrawny tail raised, his keen senses on full alert. A curling white snout sniffed at the bears' paw prints in the snow in front of him, and his yellow-gold eyes glittered with a vicious cunning. The snow wolf had given the cry to make the three polar bears think he was alone, for he well knew they were aware of his presence already. A polar bear's sense of smell is so acute it can scent a seal from more than a mile away, even under the thickest ice, not to mention animals as pungent as wild wolves, and moving above ground too. The wolf turned and saw a red glow of heat and warm blood, for wolves' eyes are perfectly adapted for night vision, and like few they can see in the dark.

The wolf scampered back towards the strange glow, which changed from red to a hazy white as he drew closer, revealing forty more polar bears, all large Bergo as adult males are called, waiting in neat lines on the Ever Frozen Sea, listening closely to the air with their great heads raised to the coloured skies.

These wild bears were watching the numinous Northern lights warily though, for some among them said the Beqorn were really dead Bellarg spirits that, when they leave a polar bear's dying mouth, fly north, calling and whispering to the world eternally, and so lighting the future and giving it warning too. It was said that in the farthest North, the air itself snapped its teeth and told strange tales.

It was an unnatural sight to see so many polar bears together, standing in these regimented rows, especially with no Bergeera around, female polar bears. The males were all magnificent specimens though, huge, powerful and very well fed, for these wild boars took what they wanted, when they wanted and lived by their own savage laws. Serberan – the Ice Slayers – they termed themselves proudly.

At the head stood their leader, Glawnaq, a Bellarg of such massive strength and gigantic bulk he seemed to cast a shadow over all the rest. There was power in his body and courage in his muzzle, although the boar's head was turned away from the approaching wolf and lost in deep shadow. The wolf spy reached the bears and padded up to its master very nervously, lowering his tail in complete submission, for even a young bear could knock him across the ice sheets with a careless paw, and kill him instantly. This waiting Bellarg was famous for his sudden flashes of temper too, a celebrated warrior among the Ice Slayers, who, in the face of the growing threat to all the Bellarg, with snow dens that had begun collapsing on Bergeera and their cubs, and with dwindling food stocks everywhere, planned to make himself Lord of all the Bellarg now. Perhaps over the five thousand polar bears that were said to still survive right across the Arctic Circle. Glawnaq planned to bring them together as one.

The other arctic Lera were asking why, muttering in their dens, nests and snow holes, or coddled for warmth in the most secret places of the earth. For polar bears are famously solitary, independent creatures, wild to their very claw marks, rarely forming anything larger than small family groups. With food growing so scarce too, and the ice so precarious in places, it seemed a strange plan to unite them at all.

"Your report, Varg?" the leader grunted, as the wolf reached him, using the Lera word for a wolf. "Are they Fellagorn or not?"

"Oh yes, great Glawnaq, Fellagorn they are, all right, three fat Warrior Storytellers."

"Warriors!" snorted Glawnaq though. "Priests and holy fools, you mean, Varg, mumbling of souls or mystic spirits and refusing to fight.

Searching the empty wastes of the North for signs of their sainted Great Story instead and branding us all nothing but common Pheline."

The Serberan looked up sharply. The mysterious Order of the Fellagorn had been led for years by their Great Master Sorgan who, with his holy disciples, were keepers of the polar bears' most sacred lores and myths. They were told and retold in their secret gatherings out on the ice – their Telling Moots, they were dubbed – or at their regular Story Jousts, where the ancient sect always met to talk, argue, and hurl stories and legends at one another. For the Order of the Fellagorn were the true guardians of the Ice Lore, the ancient code by which all Bellarg live their savage lives out in the Northern wilds. This fact alone demanded that the Storytellers be honoured, and paid an annual tribute of seal and walrus meat, although many bears resented them for it. Fellagorn did not often come amongst ordinary polar bears, you see, preferring tributes to be left out on the edge of the Ever Frozen Sea. Yet representatives, Tellers they were called, were sent out among the Bellarg, intermittently though, to see if bears were upholding the Ice Lore, or to tell them stories and so renew the stock of their guiding legends.

The sacred order was cloaked in mystery and rumour then, and feared by many, especially the more superstitious among the female Bergeera. Some whispered that great Sorgan himself engaged in terrible rituals, and drank hot walrus blood, up there in the far North. A bear who had reached nearly double the normal life span of any polar bear in the wild, usually around twenty to thirty years. Other nervous Bellarg spoke in baited breaths of some ancient curse that haunted the Fellagorn Order.

There was much speculation too about how a Great Master was chosen. Some said at a Master's death, his soul would leave his body, climbing the skies and then returning to earth, entering a new snow den to fill the spirit of a newly born cub, and so be reborn, when other Fellagorn would set out through the snows to find their new Great Master. Yet the Great Master and his Fellagorn Warriors, just like Illooq Longsleeves and his two companions, were also revered as

fighters, and for their growling voices too, which Bellarg believed had the power to enchant and to affect the course of life itself. For the Fellagorn had a favourite saying: *In the Beginning was the Word*.

Now it was said that Sorgan had summoned all the Order to use their word power to seek out signs and so tell the Great Story again, a tale as old as memory. The story contained all their myths but also told of the coming of a mighty Saviour, at the end of time, a Marked One, only born when the ice itself screamed, groaned and cried out for help.

"But we've their trail now, at least, spy," reflected Glawnaq, with deep satisfaction, swinging his angry head to look at the wolf, who quavered and slunk back immediately. "There can be only one Saviour – Varg. I, Glawnaq One-eye."

The cowed wolf had flinched for a reason, as the Serberan Leader turned his head towards him. Half of Glawnaq's face was gouged and terribly scarred, and his right eye was missing completely. Behind Glawnaq his devoted Ice Slayers began to pound their paws on the sea ice, as a rising wind skittered sharp water crystals against their winter coats, presaging another blizzard.

"My mighty bears shall train their will and their fighting power to meet the new fears, wolf," growled Glawnaq proudly, "like true warriors, not holy frauds. So we'll overturn Fellagorn lies and their feeble, dying Gods forever, and all shall come, when Glawnaq One-eye summons. The Barg shall serve us too," added Glawnaq, with sudden contempt in his face, "and so we Slayers shall not only survive but triumph, as common polar bears at last accept the Truth."

Glawnaq paused as the thumping faded, and looked closely at the wolf spy, for he had no intention of telling a mere servant all his deeply laid plans. His searching left eye had narrowed to almost a pinprick, and there was something terrifying in the look, while the bear's cruel mouth seemed to harden like ice on stone.

"That old charlatan Sorgan believes the Fellagorn can fight what comes with their voices and stories alone, praying to their blessed Atar for salvation, in their snivelling terror."

The Serberan's collective breath came like a scornful wind as they

growled again, as one, this time at Glawnaq's mention of the great moon goddess, Atar. The Fellagorn said that blessed Atar, the Moon, had infused her cold into everything at the dawn of time, to make the good, flat Ice World. She was the moon goddess then who had bestowed on the Bellarg a very rare power too: The Great Gift. It was the ability among all the Putnar, the predators of the world, to understand the myriad tongues of other Lera quite naturally. Only wild Bellarg have it, although being such proud and independent animals, often lofty in their ways, the mighty Ice Lords rarely showed much interest in the common Lera, unless their hunger or anger was aroused.

"So they meet in the far North then," continued Glawnaq thoughtfully, peering at those three fading white shadows moving steadily away into the distance. "And we follow. They make my job almost too easy, wolf. But if there really are any signs, as the Fellagorn claim, then we'll soon remove them all. No lies must hinder bears now. Reason alone must guide, in strength and purity."

"Purity and strength," growled another Bellarg, the largest of a group of eight males set apart in the crowd. His name was Garq, and with claws sharpened daily on huge rocks, and a great fur collar at his throat, this boar led Glawnaq's inner bodyguard, revered even by the other Ice Slayers, and known as The Glawneye. Around Glawnaq and Garq other deep bear eyes glittered savagely, as it started to snow. The blizzard was here once more.

"But go, Varg," snapped Glawnaq, sensing the change. "There's no time to waste. I've sent more of your kind South already, into the regions of the warrior. Search and obey then, Varg, as all your kin shall obey me soon enough. You can take your pay there too."

The wolf nodded, licking his lips at thought of pay, and slunk away as the bitter wind rose again. Glawnaq swung his head toward a lean-looking polar bear standing just to his left, his features and form already beginning to blend back into the growing snowfall, so that his face was completely obscured by a swirling curtain of heavy snowflakes.

"Well then, my best lieutenant, I've had no time to hear your news from the South. What of the so-called free bears there?"

Free bears was the name that any Bellarg not of the Order of Fellagorn gave themselves, until Glawnaq had begun to recruit his new Serberan army.

"Many dark rumours spread among them, Glawnaq," answered a muffled voice, caught and curled on the wind. "There's much fear out there, my lord, of you and for the dying ice world too. Of the Snow Raiders also."

Glawnaq smiled. "Snow Raiders? And we must help protect those weaklings from these Raiders' creeping terror, must we not? Yet what of the Great Sound and that fool Varsaq Wiseheart? A lover of priests and fables, I think."

Glawnaq's lips pursed but his searching eye noticed that his lieutenant's body had stiffened.

"Still leading the Free Council, Glawnaq," the lieutenant answered almost casually, "and talking of wisdom and justice too. They pay the Fellagorn tribute still in the Great Sound and so encourage others to. Yet Varsaq Wiseheart dithers now, and next spring he steps down as Leader of the Free Bears. There'll be an election in the Sound."

"Election?" scoffed Glawnaq. "Because he's nothing but a weak fool. Strength is our natural order, not councils, ice blocks, nor elections. Places for nothing but females' foolish talk. The law of wild nature is our only true law now. Perhaps you should stand, though, and prepare my way."

"Against Toleg Breakback?" whispered the shadowy bear doubtfully. As soon as he said it, Glawnaq threw up his head, growling instinctively and rising on his hindquarters. The polar bear bellowed and opened his arms to spread his claws, and hissed at the very dark.

"The Breakback? You mean that scum's in the Sound again? Toleg settles there now too?"

"I thought you knew, my Lord," whispered his lieutenant almost fearfully. "The Breakback came two seasons hence, and is favoured too by many for his fighting bear hug. And because he..."

Glawnaq's lieutenant paused and Glawnaq snarled at him.

"Because he stole my sight? Is that what you mean? Because Toleg Breakback wounded mighty Glawnaq? The only bear to ever defeat me in battle."

"Yes, lord. Forgive me, but Varsaq Wiseheart tells the Council and the free bears that Toleg's presence alone keeps you from the Great Sound. That you'll not dare fight him again either, in breach of the Ice Lore. To fight to the finish twice."

A look of such hatred gripped Glawnaq's face that his single eye shone like an evil star. The fight had happened four years before, and few had forgotten it. The very world had seemed to shake.

"They think I fear that witless idiot? Slow, dumb, feeble minded Toleg shall know the truth soon enough. He may have taken an eye, but not my ambition, my vision, nor my lust for power and revenge."

Glawnaq's anger seemed to cool with the thought of some vicious retribution and he dropped to the ground once more, as The Glawneye and The Ice Slayers nodded gravely.

"But all in good time. For now, we must not let mere emotions weaken us, nor obscure our greater goal, like foolish Bergeera. All is timing in life, is it not?"

"Yes, great lord. Timing."

"Her though," said Glawnaq suddenly. "*She's* in the Sound too then? Anarga Calmpaw."

Glawnaq seemed hardly able to say her name and something changed in his face. He looked almost handsome again. Glawnaq had loved Toleg Breakback's mate Anarga Calmpaw very dearly once, before he had lost her in his famous Ice duel with Toleg, and his thoughts had turned instead to politics and power.

"Anarga denned there this snowfall, yes, and they'll have cubs. If they survive the winter, that is, and their Coming Out. Many die in birthing now and from collapsing snow dens."

"Cubs?" growled Glawnaq darkly, but then he frowned, "Well, a new family can only weaken my old rival. So go back to the Sound, Lieutenant, but take them our great promise for the future too. Speak of protection then, of new borders and especially of the happiness of

the Barg. Perhaps that will persuade those fools to submit without a fight. I want a tribute, though. Free bears must bend their backs to Glawnaq One-eye, with respect, and have no other leader but me alone."

"Yes, mighty Glawnaq," answered the lieutenant, who had begun to back away but who turned his head into the night. The bear thought he sensed another presence in the snowy darkness nearby. Something was indeed watching them intently, from not too great a distance, but then, with such fear overtaking the whole Ice World, there seemed to be spies everywhere.

"Serve me faithfully then, and that special reward awaits you in our new Kingdom, by the Haunted Island. The hope that you've nursed for so very long, my friend, like a secret claw."

The cunning lieutenant's eyes glistened greedily, but the polar bear said nothing and instead lumbered off into the growing snow storm. He was gone, like a ghostly voice on the wind, although in the bitter air there seemed to be a sudden fluttering of tiny wings.

"And as for you, my loyal Ice Slayers," cried Glawnaq, turning back to his soldiers and Body Guard, "soon you'll have my very deepest wish. The Fellagorn's total destruction, and the end of their lying stories forever."

As Glawnaq spoke the terrible words, something burst in the freezing arctic night, to the blind side of Glawnaq's wounded face, high in the heavens, from the edge of the constellation of Arktus, the Great Bear, also called Pollooq's Claw by the Bellarg. A single shooting star went flashing through the Beqorn, like a human distress signal launched out over a bleak and stormy sea.

THE DYING STAR FELL NOT TO THE NORTH, IN THE REGION OF THE KING, where the mysterious Fellagorn were seeking signs of their Great Story, but southeast, toward the distant land of Canada. Where, just four nights later, another polar bear was walking inland, his paws heavy in the crunching snows, looking with the gravest concern out into the night as he mounted guard. This Bellarg was a Scout and

sentry on the edge of the Great Sound of whom Glawnaq and his mysterious lieutenant had spoken.

He was very unused to the business though, for the Scouts had only recently been formed by the leader of the bears, Varsaq Wiseheart. It was to defend the Sound from the likes of Snow Raiders, especially while Varsaq had appointed his own nephew, a handsome, playful young bear called Eagaq, to lead them all. Eagaq's spirit was as restless as his comrades' though, and he was always wandering off to hunt, forage or gaze up at the beautiful stars and contemplate the astounding world, which he had done once more two weeks before, leaving the Scouts on their own and increasing their nervousness.

The sentry was a powerful polar boar, who had just been thinking of noble, cheerful Eagaq, missing him too, for the Scouts all loved their Leader dearly. Yet thinking less happily of so many enemies now, and rumours everywhere that the very Ice World was dying. His thoughts settled though on this new, creeping threat of Raiders. Around the arctic, rogue bands of hungry Bellarg had been attacking bear families during heavy snow storms, stealing walrus and seal meat, and sometimes killing indiscriminately. They vanished without a trace into the blinding snows though and no one knew where the mysterious Raiders came from, or how to pre-empt their attacks. Some foolish bears rumoured they were ice phantoms come from hell itself, and they were as almost feared as Glawnaq's Ice Slayers. Some other older Bellarg said they were spreading their terror because the free bears had abandoned the Gods, and that the raiders wanted to impose the strictest Ice Lore on the world again.

Now the thick set boar noticed a little arctic tern scooting through the night, with apparent purpose in its dashing flight, but he shook his head and tried to shrug off his darkling thoughts. No raiders had been seen in these parts in a while, and if there was less ice when the spring came again, at least the females' Wander-to-the-Sea would be shorter and less tiring. It was the all-important moment when emerging Bellarg mothers set out across the ice sheets, taking their new born cubs down to the cold water's edge, to play, feed and swim in the sunlight, and fatten them up with their own milk. A true Rite of

Passage was the Wander-to-the-Sea. It was still a long way off though, the sentry realised as he stopped, spotting several other Scouts near the Sound, and shook his head. One was lying in the snow half asleep, and another looked as if he was about to run off into the night. Yet the sentry stiffened and sniffed, groaning as he swung his head to challenge the dark behind him.

"You," he called, seeing a white shadow approaching through the darkness. "Speak the words of passing or stand and fight me freely. Unless you're some filthy spy?"

There was a ringing silence, soft as snowfall, before an answer snapped back.

"Pollooq's Faith," cried a very familiar voice and the sentry relaxed immediately. Such formalities were very important in the large, open Sound, for although polar bears get to know each other well by their looks, manner, and scent, their thick white coats can quickly make their forms deceptive in the heavy snows. Since bears are such natural wanderers, and Canada's Hudson Bay is famous for its rich seal stocks, many strangers moved through too, some settling, others just moving on, which made a word of passing an instant form of trust and recognition.

"Oh, it's you, Sarq," said the challenger, as a rather feminine muzzle appeared out of the darkness, like a light. "I thought you might be a Raider."

The newcomer's bold black eyes, small in his delicate face, glittered eloquently.

"Honour and Vigilance," growled the first sentry now though, giving a formal oath and reply among the Scouts, "but you look worried, Sarq."

"All these rumours, Tortog. With so much fear in the dark, Glawnaq's army swells and I fear War comes to the Bellarg."

"War? Well, at least the Serberan won't know the words of passing, Sarq. And they say that Glawnaq has business in the realms of the King. You think the Storytellers will fight him up there?" he added more hopefully. "War."

Sarq's sensitive eyes looked sad and a little lost at this talk of the Fellagorn.

"The Fellagorn seem too busy searching for signs of the Great Story, Tortog, to fight, even as far North as Pollooq's Paw Print."

Tortog nodded. The Fellagorn had for centuries told the story of how Pollooq was the very first hero; son of the moon goddess, Atar, and the burning yellow sun god, Gog; and a demi-god himself. The Fellagorn believed that Pollooq had walked down the clouds to Earth in the beginning of everything, on to the flat Ice World, the very first Bellarg to step onto the edge of everything. His sacred paw print was still said to lie at the edge of the high arctic, right under the Pole Star, Teela.

"Fellagorn are warriors no longer, Sarq, it's true. For I hear there is even a decree against fighting. So perhaps we should pay their tribute to Glawnaq One-eye instead. He's a fighter, all right, a leader too, and promises if we give him allegiance, in return he'll protect our freedoms, and guard against the Raiders, even with new borders."

Sarq threw up his head.

"Borders? But a Bellarg's very birthright is freedom, and the power to roam at will, as much as fresh seal meat or strong sea ice. There are no borders in the snows for a wild Bergo. Is Glawnaq lost with the Ice Madness?"

His fellow simply shrugged.

"Perhaps, perhaps. Yet many turn to him, in fear of some great calamity. Terror spreads everywhere, and even the smallest of the Lera speak of the end of the world."

"The end of the world? I suppose damned Glawnaq promises to build them an ice ark then, and save their shivering skins."

Tortog grunted slightly in return and smiled. It was a legend as old as Pollooq, when a great flood had come to the bears, in very ancient times, after Atar had quarrelled with Gog again, and her jealous mate had grown so angry and hot, he had roared out his fire to melt the ice, and drown Atar's favourite Lera. Yet Atar, mother of sleep, protector of all polar bears, had visited Pollooq in a moon dream, and told him to

gather together a pair of every arctic animal, male and female, and take them out onto a great ice sheet. So, as the Sun God's fury had burnt and the waters risen, Atar had kept the ice ark whole with her freezing moon breath, so that the multitude of terrified animals had ridden the waves together. Until, after Four Long Days and Nights, a heavenly bird had come to give them all a sign and show that they had reached the top of a great white ice cliff, where Pollooq had led the Lera to safety once more.

"Yet we must face facts, Sarq. Glawnaq talks strength and reason, not beliefs and superstitions, and he says there might even be a place for our bravest Scouts among The Serberan. They feed well, at least, and teach a new Lore too, I hear: Survive, of course, the First Commandment, but fight and take what you want first in life, then pay for it later."

"That's what many here will argue when Varsaq Wiseheart steps down and the election comes," said Sarq thoughtfully, "especially Marg Leantongue. Marg talks so reasonably too, Tortog, with those clever, shifty, nasty little eyes of his, but I don't trust him for a moment."

Tortog scowled, for, like many Scouts, he hated Marg. Marg Leantongue led a special group of spies for the Free Council, formed long before the Scouts and jealous of their position, and there was a furious rivalry between Varsaq's Scouts and Marg's spies. The Scouts, although new, had created a code based on courage, honour and a fair fight. The spies in contrast on stealth, secrecy, and waiting – watching and planning. Marg and his band were somewhere in the North now, but he was always plotting with his faction in the Sound and Eagaq especially despised it.

"I favour Toleg Breakback," said Tortog thoughtfully though. "As our new leader. He'd fight for the honour of the Scouts, all right. Although with Anarga denned, he's reluctant, and thinks only of his coming family. Eagaq talked of standing too though, before he left. That would be a thing. Though he's young."

Sarq looked just as keen, although he looked a little demoralised too at Eagaq's absence. With so many Bergeera denning, everyone was on edge.

"We need a keen eye though, Sarq. For now the free bears' Garn lies sleeping in the snows, like our future."

"Garn," whispered Sarq, as he thought of the energy said to flow through all things. "And Teela's bright tonight," he added, peering up at the lone pole star high in the giant heavens, hardly veiled by the Beqorn. Teela the Pole Star had been named after Pollooq's mythical mate, Teela, and, for boars at least, when the single star shone brightest, it often presaged some grave danger. Tortog's nose was suddenly twitching too, for he had scented someone or something else near them. As both Scouts swung their heads, another bear came running hard towards them and both Scouts set their paws in fighting readiness. But the newcomer did not even slow, and as they saw his face, and recognised that strong, sinuous body, Tortog cried out delightedly.

"Eagaq, why thank Atar you're back again too, Eagaq. The Scouts need you tonight. Everyone's strangely restless."

Eagaq lumbered to a stop, catching his breath in eager gulps, and smiled. His lips were slightly stained with blood. Their Leader, Varsaq's nephew, was a wonderfully sleek young polar bear, a natural fighter and very handsome, with a ready tongue and a generous face.

"Just here to do my duty, Bergo. Honour and Vigilance, eh?"

"Honour and Vigilance, Eagaq," replied both the Scouts at once, as Sarq and Tortog straightened and looked rather more serious than Eagaq did.

"But don't tell uncle I got side-tracked by a walrus again, or I'll have the Ice Lore on my head quicker than a frightened snow hare. You know what uncle's like about the rules."

Tortog grinned, and swung his snout as he scented for walrus, but it was Sarq's expression that had really changed, looking in horror at the ground and cursing himself for not noticing it before.

"Varg. Wolf prints. How could we miss them, Tortog? The Sound's breached already."

All three started to growl furiously, especially Eagaq, for the prints were threading straight past them and back toward the frozen sea. There, in the Great Sound, as the stars twinkled overhead, it seemed

that all nature was dreaming in the snows, while not far from the Ocean, just below ground, a she-bear groaned in the darkness, and woke from her troubled dreams. Anarga Calmpaw was hunched inside the large snow cave the Bergeera had dug two months before – just below four tall pine trees – her secret birthing den. It lay just on the edge of the Great Sound, south west of a gigantic cliff of pure white ice that soared skyward, nearly a hundred and ten feet tall, overshadowing the entire ice-locked bay.

Free polar bears here called it the High Ice Cliff, and it was clouded in a steely dark, as another winter morning dawned around the free Bellarg. What little light that came would not be great, for this was deep in the Long Night still, when the High Arctic is bathed in perpetual darkness. Before the arctic Long Day comes, and the glorious spring and summer arrive, bringing the sun's burning light for nearly six brilliant months – the eternal cycle of the arctic world.

The polar bears here were dreaming, or Scouting for Varsaq, like Sarq, Tortog, and now Eagaq, or sheltered warmly in the snows to protect their Garn, the energy, the life force itself built by feeding and exercise, and there was little more important than conserving it. A Bellarg's survival depended on maintaining Garn in the very harshest colds, or in the arctic summers too, when it grew hot and hard to hunt, and Polar Bears became docile and sluggish. It was why, despite their magnificent white coats perfectly adapted by nature for snow camouflage, wild Bellarg spent so much time sitting about, dreaming, when not hunting or squaring up to fight and box.

A sense of the coming morning made the bears stir on the edge of the frozen bay though. Safe in her snow den, Anarga sensed the change too, for she-bears above all are made of instinct. It is why many Fellagorn believed that Bergeera alone hold the key to any real magic in the world. Anarga and Toleg had consecrated their union in July, but Anarga had denned only recently, since Bellarg underwent something called late implantation, going underground in early November to gestate her cub, or cubs.

Since then, and in a state of semi-hibernation, the she-bear had eaten nothing, and although the birth was very near indeed, Anarga

was hungry and restless. She lifted her fine black snout now to a tiny air-hole just above her head, to taste the jet of cold breeze that ventilated the den. It was no good hoping for food though, for even when her cubs came, Anarga would still have to stay inside, suckling the new born for nearly two long months more, feeding them as many as six times a day.

As they grew, Anarga would draw on the residues of body fat from the walrus and seal meat she had consumed in such large quantities in preparation for the birth. It would have been more if the meagre Still Hunting her mate Toleg and the boars had engaged in before she denned had proved more successful that difficult year. Nothing was normal for the white bears now though, as watchful Anarga knew all too well. Just before she had dug in then, one family had appeared in the Sound and spoken of how they had lost their youngest cub. The tragedy had happened when a little raft had broken from the ice sheets, and carried the defenceless bear cub out to sea, on a voyage that they could only guess had seen the poor cub drown. For Arctus Maritimus, a polar bear death by water was the worst death too, and some said the wild wolf also.

Anarga dipped her head protectively now and licked the skin at her belly, her long blue-black tongue moistening the pinkish white. "And what shall you be?" she growled, "Bergo or Bergeera, or two of each? Four fine, fat little bear cubs perhaps, to play ice slides happily together, all sun long."

Anarga's lovely face shone in the snow cave, as she remembered her own Coming Out. She had loved to play ice slides, although she felt concern too, for cubs can be very rough at play.

"And if a Bergo, will you be a very Pollooq, my little one, and brave and strong as your father, Toleg Breakback?"

Anarga sighed and thought longingly of her mate, as she felt something kick inside her. It was a good pain though, for pain is a part of the world too, although Mother Nature has a way of taking it away at just the right time.

"Or if a little Bergeera, will you be as beautiful as the fabled Teela, Pollooq's great love?"

As she said the name, so unlucky to Bergo, Anarga looked up suddenly. A shadow crept across the sealed den mouth, at the top of the ice passage to her right, like some dark phantom, illuminated by a lunar candle. It had a raised tail, and the shape stretched down the tunnel like a clawed talon. Anarga hissed, quietly, scenting a pungent odour piercing the den: the scent of wild wolf. Then she heard the distinct sound of growling voices outside: hunting growls.

"There's a Bergeera around, all right," said a voice loudly above her. "I can smell her milk."

The hackles rose on Anarga's neck. She wanted to roar and be out in the open, where she could defend herself and her cubs more freely. Bear mothers were notoriously aggressive in defending their cubs, but now was not the time to chuff – the hissing warning a she-bear gave before an attack.

"We should dig then," the ragged, angry voice went on, "with lots of lovely new dens in their Sound, there's plenty of fresh meat around."

Anarga showed her huge teeth.

"And you know Glawnaq's orders," growled a second large wolf, who, from the depth of his voice, was clearly the Dragga, the alpha male of his pack. Anarga swung her head sharply. Glawnaq One-Eye? Something almost guilty came into her face, as she thought how she had walked once with Glawnaq, until Toleg had fought and wounded him. Taken his eye. Toleg had known Glawnaq vaguely too, and they had often squared off and boxed, although they had long been wary of each other's obvious prowess. It was only Anarga that had made their terrible battle inevitable then, when she knew she loved Toleg, although the males naturally disliked each other.

Anarga realised angrily that these filthy Varg were Glawnaq's spies the free bears said were everywhere among the Lera now. The wolves must have slunk past Varsaq's dozy Scouts into their Sound. Anarga tried to hold her breath, as she went on listening closely.

"What are his orders then, boss?" said another wolf outside.

"Causing trouble, of course, but above all putting an end to any signs talked of by the damned Fellagorn and a legend. So when the

dim day dawns tomorrow, we must make sure that the snow is bleed-ing. We mercenaries hunt bear cubs now – fresh new born."

The Dragga snarled happily and despite herself, Anarga let out a stifled growl, but her eyes misted over too, and she knew that her time had come. As Anarga's eyes closed tight, swallowed by darkness, her whole body bracing to meet the pain, dimly the beautiful Bergeera seemed somewhere else though, suddenly above ground, under the stars, gazing at a half circle of seated bears who peered out like Scouts into the night. Beyond these were other Bellarg in a full circle, who seemed to be talking, or arguing with one another. It felt like some strange vision, and vaguely Anarga remembered her father talking of some power called The Sight, but some tale too of a drowning cub. As she looked on, out of the dark more boars were advancing towards the seated watchers, prowling across the flat sea like night hunters, almost shadow shapes, and Anarga had the sense that the seated bears were Fellagorn. She groaned, desperately wanting to give them some warning, yet realising it could only be a dream.

Outside Anarga's den the alpha swung his head toward the sealed snow mound at her growl, yet the wolves were suddenly distracted by the most extraordinary sound that filled the whole arctic bay. It was like a great, thundering boom that shook the frozen ground, and the wolves swung their muzzles towards its source instead, away from the painful birth.

Inside the den the most intense anguish had seized Anarga, half aware of her cramped surroundings, half watching the misty bears out on the dreamy ice in her vision, as her eyes sensed the red of her own pulsing blood. Through the red veil, the Bergo advancing on the Fellagorn were filled with menace, while Anarga knew a warning could do nothing, that she was helpless, sensing somehow that what she was seeing was not in the present either, but the past or future. She wondered why though, as the newcomers moved stealthily through the Scouts towards their victims, the Fellagorn didn't rouse themselves. Instead they sat mesmerised, as if they were letting the attackers in, or were simply asleep. With a roar she could not even

hear, the huge boars fell on the Fellagorn, snarling and raging, rising on their haunches and lashing out murderously.

"The Ice Cliff," snarled the first wolf fearfully outside. "It sounds like it's talking, even crying out. Is it the legend then, Treeg? The curse. Or the coming of a Sav ..."

Anarga's ears were filled with the real sound too, her closed eyes locked on those moaning, struggling forms in her vision, swinging with their claws and opening white hides, that sent dark red blood spattering across the dreaming ice.

"Hush your snout," snapped Treeg outside. "That's lies, Varg. Glawnaq's our true Saviour now. No one else."

"What's happening to me?" moaned Anarga as she heard the cliff boom again, shaking those scenes in her own mind, as Fellagorn began to fall across the windswept ice sea, and pain shook through her whole being. The deafening sounds outside came again, mixed with the distant cries of wild and dying bears, and as Anarga struggled, it seemed as if the whole world were giving birth.

"Look," gasped a third wolf outside in horror, as Glawnaq's Varg mercenaries gazed up at the High Ice Cliff. There was a shattering crack, then another hollow boom, and half of the mighty ice wall broke away and plunged down onto the frozen sea ice below. The block of cliff was so huge it seemed to collapse in slow motion and that terrible fall shattered the very ice, sending up a mighty column of blue saltwater and sea spume, that rose like a giant geyser into the night.

"The end of the world itself," wailed a wolf beside Treeg. "The end of everything there is."

The noise of the dying mountain filled the arctic landscape, waking all the free polar bears. Just above Anarga's birthing den one of the pine trees, damaged earlier in the year by a lightning strike, split in two, splintering from top to bottom and crashing to the ground.

Anarga herself could no longer hear the thunder outside, neither could she see those fading images of dying Bergo either, those halos of blood, for her eyes were open to the warm blue light about her

again, and the terrible sounds outside had been replaced by a steady pounding in her head. The Bergeera's heart was bursting with pride and love too, as the new mother looked down in the icy stillness. For there, in the semi-darkness, on the snowy floor of the ice chamber, lay a tiny new born polar bear cub, no bigger than a tree squirrel, steaming in the chilly darkness. So very vulnerable a thing that a hunting wolf might have lapped it up on its tongue, and swallowed it whole. Instead Anarga craned forwards and licked her new born with the tip of her huge black tongue, nuzzling it tenderly towards her belly. Then the icy ground was shaking again, inside and out, and the wolf mercenaries were fleeing for their lives, as Treeg cried out, "Run fools. There are no signs. This is only nature talking."

Inside the den, the minute polar bear squeaked and rolled over, but Anarga sat back on her haunches in utter astonishment. "But it can't be," Anarga Calmpaw whispered fearfully in the shadows. "It just can't."

2

MARKED OUT

"Such were the joys
When we all girls & boys,
In our youth-time were seen,
On the Echoing Green."
—*William Blake*

I t was more than ten long winter weeks later, in the arctic sound
when the sun god, Gog, glared hot and harsh yellow over the
snow-capped pine trees concealing Anarga's birthing den. The
Long Night was over and the arctic snows revealed in a flash of bril-
liant, flaring white light. Near the still-sealed entrance to the den, a
powerful male polar bear stood like a massive rock. Toleg Breakback
did not have an especially intelligent face, but he was a handsome
and vigorous Bergo, in his prime, with fine reddish fur sleeves
hanging from his thick forearms. Bellarg's coats carried many hues
when you got up close, if you dared do such a thing, and in real
nature polar bears are rarely as pure white as painted in cubs' fables,
except when born.

The Bergo strained his neck forward and growled happily. Toleg
thought he could see the line of the sea, far out toward the Hudson
Bay. Still miles away, yet steadily advancing toward the shore again, as
the spring melt began, and the hungry waters ate at the ice. The east
wind carried a glorious freshness too, while the swelling sunlight had
instilled the free bears with the rising sap of new life and love, for in
bear lore this was the time of love and light, brought on the brisk east
wind.

Toleg sensed that the polar icebergs had begun to shift, and that

the arctic pack ice would soon crack and break up, constantly changing the contours of the open, arctic ocean. In the bear's very bones, the wonderful March day felt as if everything was coming alive again, and starting to move mysteriously beneath the snow and ice, like some stirring God.

Toleg could hear the piercing cries of gulls from above, riding the constantly changing thermals. He felt immune to everything suddenly, quite wonderfully invulnerable, as the bear's heart filled with pride at the thought of his coming cubs. Although, he was concerned that Anarga had taken so long to emerge from the den. Toleg wondered what his cub would be, and how many too, as he glanced across to a small she-bear named Innoo, sitting in the snow nearby, with another beautiful female called Nuuq. Between them sat two bright faced polar bear cubs, playing with a snowball, almost as large as themselves, biting at it and bashing it with their tiny paws. New life had come out into the Sound already.

It was slender, fine Nuuq who had first brought Toleg news that his own mate Anarga had birthed on that dark morning the ice cliff had fallen. Her friend Innoo had timid, heavy eyes, and kept clawing at a strange strip of brown hide around her neck, as she sat back and watched her cubs protectively. Innoo had no recollection of how she had got the thing, but the rumour was that the collar had somehow been placed on her by the only Lera that wild polar bears are truly wary of: the Gurgai – Man.

Innoo's snow den, a mile inland, had collapsed several suns before, but she had dug another next to Anarga's. The Bergeera's wonderful twin cubs playing with the snowball were called Matta and Qilaq, and their fur was as fluffy as new goose down, while their eyes sparked with excitement and natural mischief. A hunting friend of Toleg's called Seegloo was lying in the snow nearby too, his front paws wrapped under him, back haunches rising high, his head pressed flat to snooze. Seegloo kept opening an eye though, to glance rather oddly at Nuuq. The winter before Seegloo had begun to pad with her, but they had quarrelled badly and split apart, although he still had strong feelings for her.

Now little Matta, fed up with her brother's wild paw swings, broke away from the snowball, and ran up to her mother, who bent forward to nuzzle her cub. Matta opened her little mouth and tried to bite her mother's snout and Innoo responded, as they bumped teeth. They were only playing, but it was all vital preparation for a cub to use its teeth in the real world.

Innoo wondered if she should call Qilaq over, for some more lessons, for she had spent all morning trying to teach the cubs some of the many Bellarg words for snow. Naming is almost as important to polar bears as the Gurgai, and there are many. As Toleg watched the cubs and their mother, he felt a sudden frustration at the long wait. His eyes grew a little guilty too, since it was so unusual for a boar to be here at all. Bergo are fiercely defensive of their independence, and males usually play little part in actually rearing cubs.

Matta suddenly glanced for permission at Innoo, then ran back to the snowball, while Toleg noticed Innoo's nose was dry and flaky, with something weary and sickly in her eyes. He frowned, for he knew she had eaten some bad puffin recently, in a place called the Black Bay beyond the Sound. It was where Toleg had fought and defeated Glawnaq One-eye himself.

The Black Bay was a few miles east of the Sound, and the Council had declared it Kassima, strictly off limits. For there, two years back, a great metal belly had broken against the rocks, like a beached whale, and out of its guts had spilled a strange black blood. Many superstitious bears thought it some sign, for the black gloop still covered half the beach, coating itself on the stones and ice, and the backs of unlucky birds, making it impossible for them to fly or feed. Killing them slowly.

"No sign yet, old friend?" growled a voice and Toleg swung around to see a much older bear lolloping toward them up the slope, with gnarled front claws and a yellow, aging coat.

"Nothing yet, Narnooq. Noises and groans below ground, that's all, but I can't make them out very clearly."

Narnooq had a wise, very well-weathered face and Toleg was always pleased to see him. Narnooq of the North, the bear was some-

times called because he claimed to have once journeyed into the High Arctic, all alone, in search of the Fellagorn Storytellers and their secrets.

"Well, it can't be long now, Toleg, so I wouldn't worry."

"I'm not worried, Narnooq," Toleg lied. "I just, er, thought that I'd come and listen for today. I must be hunting soon. But come, friend, embrace me."

"If you don't crush me, Breakback," said Narnooq with a smile. The two adults rose on their hind quarters and tightly clasped one another, growling warmly. Toleg had a temper and could be very moody too, but he was naturally warm and often hugged his friends in the Sound.

"Though we'll need your strength soon enough, Toleg, if you are to stand at Council."

Toleg looked sharply at Narnooq and frowned, not wishing to speak of such things, especially today.

"Enough of that. But you've come to tell the cubs some stories, Narnooq? Of Pollooq or Teela, perhaps."

"Oh, yes please, Narnooq," piped Matta, getting the funny old bear's name wrong. "I so love dearest Pollooq. The Giver of Tales, who brought love back to the whole world."

"Love, Matta?" Qilaq snorted. "Don't be a wet Bergeera. Pollooq was a fearless warrior, just like I'm going to be, especially when he smote the Pheline."

Qilaq had no idea what the strange phrase 'smote the Pheline' meant, but he'd heard it from Seegloo just the other day. In Qilaq's young imagination he already thought of legendary Pollooq as a bear a hundred feet tall though, with a coat that shone like the sun and a roar as loud as a wave. It was told of in the legends too, how Pollooq was especially blessed by Gog and Atar, so that he had fine, flowing fur sleeves, and was so massively strong that he could dangle four bear cubs from each forearm, or lift whole boulders in his grip and throw them at the ice, like mere pebbles, to make giant holes in the surface for seal hunting. How Pollooq had never been defeated, and had once slain a hundred enemies in a single combat, so that his

courage was matchless, and his blows so powerful they could break the great waves themselves. That before the Gods had made him mortal, Pollooq had born up the whole flat world on his very shoulders.

"Well I'd like to hear about the Seeing Caves, Narnooq," called Nuuq, and Seegloo opened an eye again and his right ear twitched. In fable they were ice caves that formed suddenly from Atar's magic breath, but only once every thousand Long Nights, to remind bears of her Eternal power. But there, using their secret knowledge and sacred rites, only the Fellagorn could talk to the Gods directly, if they could find the caves in the wild, and so see visions in an icy Seeing Mirror; visions of the heavens themselves, and of past, present and future.

"But they can't really exist, can they, Narnooq?" added Nuuq.

"Of course they can't, Nuuq," growled Seegloo, wanting to embarrass her. "We're not silly cubs anymore."

"Oh can't they, Seegloo?" grunted Narnooq. "You're always so sceptical, you know, like Glawnaq One-eye. You'll be questioning the very heavens and the Underworld too next, the great commandments, or even the Fellagorn's magic word power."

Seegloo raised an eyebrow, as Qilaq abandoned his snow ball at this talk of magic.

"Just telling the truth, Nuuq," grunted Seegloo, closing his eyes again. "Unlike most stupid Bergeera."

"Well, I want to be a Storyteller too one day," said Matta. "A Flelagorn."

"Fellagorn, dear," corrected Innoo softly, "and don't wish for such dark things, or they might come true. The Storytellers might hear your words and come and find you and snatch you away, Matta, to join their sacred order in the far North."

"Find me how, Mother? My voice is too small, and I never shout like Qilaq."

"No, dear, but some say the Great Masters can read thoughts themselves, and for miles."

"You're quite safe though, Matta," said Narnooq softly. "For the Fellagorn are all Bergo. Fighting males, like Toleg. No Bergeera ever

joined their order, except for fabled Athela, of course, who disguised herself as a Bergo one day, in the story. Athela was Teela's sister."

"But no more stories today, cubs" grunted old Narnooq, "There are real things to worry about now, children, grown-up things, like the coming election, when we'll need a brave new Bellarg on the block, like Toleg."

The twins looked disappointed, while Toleg seemed very unsettled.

"A fool like me, Narnooq? Are you so sure? I can defend my friends or my own, and trap a seal swifter than most Bellarg, but why should I lead us now? You know I hate words and politics."

"Because our Scouts need you, not that slippery Marg Leantongue nor any of his sneaking spies. The Scouts hate them, especially Eagaq, and I hear they're relying on you to win the election for them. Honour and vigilance, Toleg."

"Marg Leantongue thinks Glawnaq can help us, though, Narnooq," said Innoo, looking up, "or at least that we should pay Glawnaq his tribute, for now, even if we don't actually join him."

Toleg frowned heavily.

"And sometimes even Varsaq seems to agree with that filthy Cub Clawer," said Nuuq, shaking her head disapprovingly.

"Cub Clawer?" said Qilaq. "What's that?"

"The Cub Clawer, dear, used to seek out weakness or flaws in a cub" answered his mother gravely, "and sometimes drive it out as a threat to the whole. Even mark it as Kassima, an old Council word for evil, or unclean. Sometimes they were said to eat it themselves."

Qilaq's eyes almost bulged from his head, but Innoo looked guilty as she thought of the dead puffin she had eaten in the Black Bay, a place now Kassima. Many bears thought it some dark magic, while others said the metal belly and the black blood surely came from hell, or even the world of Man. Perhaps Innoo's pains served her right then, but the truth was she had been very hungry after denning so long, and had a bad cold that sun, so she had not been able to smell a thing until she had started to eat a dead bird.

"Marg's from an ancient line of Cub Clawers," said Nuuq, frown-

ing, "although great Sorgan banned the practice many years ago. Marg wants to bring it back, I bet, just like Glawnaq, I hear. He's ruthless enough too. Marg will stand for election, for sure, and still nurses a Seeking Claw, the naturally growing Claw that gave them their power."

Qilaq wanted to know what a Seeking Claw looked like, and wondered what this Marg was all about.

"You'd have me save the whole world, Narnooq, or build an ice ark?" said Toleg rather resentfully. "But I've a family to fight for now."

"Ah yes, Toleg," said Narnooq, almost sadly, as they turned away to talk together in private, "The greatest fight of all."

"Will you tell us a story instead then, Nuuq," said Matta as the Bellarg went off.

"Very well then, twins. Once upon a time, when the world was fresh and the commandments strong, after the Gods carved them in the side of eight ice blocks, the two most powerful groups of white bears in the arctic were the Fellagorn and the Pheline."

"Pheline?" said Qilaq, showing his teeth and nodding." Who mighty Pollooq smote?"

"Who Pollooq certainly fought, Qilaq," answered Nuuq with a smile. "For Pollooq, the first Storyteller, beloved of bears, was half God, and the Fellagorn's mightiest warrior. But the Pheline did not truly believe in their Fellagorn power anymore so conflict began."

"What happened in the end?" said Matta, and Nuuq blinked in surprise.

"End, my dear? But you've only just heard the beginning, silly."

"I know, but when Mother tells us stories I want the end first, so if it's sad, I just won't listen."

"Scaredy," grunted Qilaq, turning to look back at Nuuq. "Go on about Pollooq, though."

"Who loved beautiful Teela, whose spirit twinkles above us as the Pole Star still, high over Pollooq's Paw print. He loved her so deeply, purely and faithfully, that not even death could conquer his love, and at the end of his own story, Pollooq went into the heavens too, but

near Teela, to watch over bears forever, as the Great Bear, also known as Pollooq's Claw. Though lots happened first."

Matta longed to see what the strange stars looked like in the Long Night, for the other cubs were always talking about them, saying that, like Atar, the moon, where if you look long and hard enough you can see the clear shape of a polar bear, and that the stars too peer down kindly on all little bears.

"It was a love so great and legendary, that among the Fellagorn and the ancient free bears, all spoke of it, including the Lera, the wild animals, even the magical narwhals in the sea. The very waves would stop in their breaking and subside, to whisper their sacred names: Pollooq and Teela."

Seegloo was looking at Nuuq rather jealously, but Qilaq raised an eyebrow himself.

"But why did the Fellagorn hate the Pheline?" he insisted irritably, wanting to get his teeth into a real story.

"It was really the other way around, dear," answered Nuuq gently, "for the ancient Fellagorn loved storytelling above all else, except for peace, which is why when Pollooq was journeying alone, Teela, who loved peace too, was sent a special moon dream by Atar, to tell her that she should become a helper of magic stories. Especially a helper of Pollooq though, who had been so alone in the world, and who prayed for a mortal, ordinary life now, to love a mate and raise a family."

Matta grinned.

"When Pollooq and Teela met then, and Teela saw the fire deep in his eyes, their love glowed like flame, for they looked not just with their eyes, but with the inner eye, the very heart and soul. So Teela swore she would do anything for Pollooq."

"Yuck," said Qilaq. "How stupid. What about the Pheline? They sound much tougher."

Nuuq laughed and shook her pretty snout.

"All right, all right, rough little Qilaq. The Pheline were warriors, yes, but young bears, who had travelled far from all across the ice world, and hated the past and the old stories. They loved counting

now and naming things, and wanted a new fortress for themselves, so training in boxing and chuffing, lived out on the ice sheets. As they spoke of a great future, Pheline said everything was just as they saw it, with their eyes, with reason and the waking mind. Many didn't really believe in the Gods then, or in magic stories either, so they hated the old Fellagorn ways."

"Didn't believe in stories?" said Matta in disgust. "How stupid."

"They had stories too, Matta, of course, as they had many lores and rights, but the Pheline upheld reason above all now, and so said there are no Gods, but only strength and power. So they wanted all to adopt their many new lores, and to see the world only as they saw it. They wanted to make everything just like them really. The same."

Qilaq blinked and looked around at the Sound. After they had come out of their den, Innoo had told the twins that every little polar bear cub is as unique as each individual snowflake.

"Just like Glawnaq then, or this Marg Meantongue."

"A bit, Qilaq," answered Nuuq, a little fearfully, "but this is just a story, my dear, from the old times. Anyway, brave Pollooq held the Pheline at bay, and with Teela at his side, the power of the Storyteller truly flourished in him, and his heart glowed gold with the purest love. For Pollooq had found a very heaven."

"Until the demi-god was betrayed," said Innoo, wondering when her mate Gorteq would ever return to the Great Sound. "And so found a very hell. Like so much of the horrid world today."

"Betrayed, Mother?" gulped Matta, wanting to know by whom.

"Er, yes, Matta dear. Poor Pollooq was betrayed indeed," said Nuuq softly.

"Which is why they say that old legend should not even be told, Bergeera," growled Narnooq rather gruffly, who had walked back to them. "You know that, Nuuq. Lest the ancient curse returns with stories of the evil wound."

"Wound?" said Qilaq. "What evil wound?"

"The Wound of the White Bear, Qilaq. Made after Pollooq started to fight again," said Innoo, clawing her collar sadly, "so a Pheline spy was sent to steal the secret of his strength and fighting power, and of

storytelling itself. Then the ancient Pheline conquered mighty Pollooq."

"Conquered Pollooq?" cried Qilaq. "Impossible! I thought he smote them all."

"So there's a wound deep in nature itself," said Innoo with a heavy sigh, "like a great split in a glacier, so deep that nothing can ever heal that ancient curse. We must just hope to keep it out, as best we can."

The cubs felt miserable, and Narnooq looked at Innoo especially disapprovingly, but the bears heard a noise coming from the ground just behind them, and the mounded snow nearby was moving and crumbling away.

"At last," roared Toleg delightedly, swinging round and lumbering back towards them too, "My new born cub."

There was a muffled bellow just near the surface, and the wall of flattened snow below the three pines left standing burst open, showering the cubs in falling ice crystals.

"Ouch," squealed Matta as a lump of hard ice landed on her head, and Qilaq beamed.

"And I bet I can guess who's making all this noise," grunted a voice happily as Anarga's lovely snout suddenly pushed out of the hole. Her eyes were still closed and she looked like a huge white mole, scenting the breeze, her nostrils telling her just as much as her eyes. Her ears twitched as she blinked now and looked around, stung by the blinding sunlight after so long in the dark. Then Anarga was smiling to see such good friends waiting, especially dear Nuuq and Innoo. Anarga groaned with pure pleasure at the sight of Innoo's fine twins too, pulling half her body up, the icy air rushing into her swelling lungs.

"I thought that was you, Toleg, with such a loud, gruff voice, my mate. What are you doing here though, Bergo? Have you turned into a Bergeera, to start a nursery?"

"Hush, Anarga," snapped Toleg, looking embarrassed. "Don't raise my anger so soon."

"I'm teasing, Toleg," said Anarga, with a grin. "We don't want the Bear Rage here, or any wounded Bergo pride. Still strong and hand-

some, though," she added with a smile. Toleg grinned too, delighted to see his mate again, and lumbered closer, but the boar checked himself and stopped in front of her, letting out a low, testing groan and pushing his head forwards. He was waiting for his mate to show him proper respect.

"Don't get too close, dears," whispered Innoo to the twins, who were straining forwards too. They had seen adults fight often, but they stared in wonder at the handsome pair now. Qilaq thinking them Gods indeed, for their own father Gorteq, a Scout too, had not made a single appearance since they had been born. They only knew of him from Innoo's stories and liked to imagine he was still out on the ice, hunting in the wild and free.

"I was just wandering by, Anarga, what's wrong with that?"

Toleg could never lie to Anarga and she felt a sudden deep tenderness for him. She came forwards, scenting him respectfully now before she nuzzled his snout.

"I dreamt of you often in the snow den," she growled fondly, thinking suddenly of those terrible visions at the birth. "Such strange dreams I had in there too, Toleg, of dark and light. But it's high time to bring our little Uteq out."

"Uteq? Not a very heroic name though, Anarga."

"Nonsense, Toleg. It means 'brave one', silly, in the old tongue. An ancient Fellagorn name. Of true power."

"A Warrior Storyteller then," whispered Matta, behind them, with a huge grin. "Uteq."

Toleg looked more approving, and old Narnooq of the North nodded sagely, as they all stared at the tunnel and waited. Something almost apprehensive had come into Anarga's eyes though, as very slowly a little shadow, then a tiny round head emerged in the mouth of the snow passage. A small black bear snout pushed out, and a tiny face looked into the huge, wide world, blinking in the bright sunlight. Uteq had the most charming face, with enormous, inquisitive black eyes. He was so fluffy and white he seemed to shine like a ball of new snow. The nervous bear cub's tongue, pink still, like any Bellarg cub before it turns blue-black, was hanging from his mouth,

but there was something just as nervous in his little look as in Anarga's.

"Hello, Uteq," called Matta, loving the new cub immediately. "Can we be friends please?"

"Hush, dear," snapped Innoo. "Don't frighten him."

Toleg frowned, but Uteq was staring at the twins now, for he had seen his reflection in the wall of the den for weeks, and everything begins with recognition, so he seemed to see himself, doubled. The cub cocked his head and tried to growl, but it came out like a squeal, so the others laughed.

"Welcome to the Great Sound, cub," grunted Seegloo, glancing longingly at lovely Nuuq again. "Poor foolish, little bear. But you'll learn soon enough what it's like up here in the real world."

"Hush, Seegloo," snapped Nuuq, as Uteq noticed a funny bird sailing high through the air and wondered if the extraordinary world was really inside him somehow, since in the den he had often dreamt of flying. It all seemed so strange and new, so mysterious and real.

"See, Qilaq," said Matta. "He's much handsomer than you, and stronger too. Brave Uteq."

Qilaq scowled.

"Greet your father then," said Anarga. "But be careful, little bear. Especially of a Bergo."

"F-f-father?" stammered Uteq, not understanding at all, for all he knew so far in the world was the dark den.

"Of course, little paws," boomed Toleg, so overcome with pride he felt like a King. "Come and bond, and learn the Bellarg saying for any little hero like you: "Bergo never back down.""

The cub hesitated and looked at his mother, then back at his father Toleg in confusion.

"Berg never bark..." muttered Uteq, as bravely as he could. "Bergos never backs...Ber..."

Uteq held back still, and Matta and Qilaq giggled.

"And one day you'll be a mighty Still Hunter, just like me," cried Toleg, "learning patience on the ice, as you build your Garn, to strike and kill fresh Seal. To tear them with your teeth."

"But not too soon, Toleg," said Anarga sharply, as Uteq wondered what Garn was. "He's just a little cub."

"Tush, ignore your mother, Uteq. She's a soft Bergeera. Your father will show you just what's needed in life, for a true Bergo that is. While every little bear must find its true voice."

Toleg rose on his haunches and roared until the twins' ears shook, his famous Summoning Roar, that called allies to a fight, and Uteq was almost blown back down the passage. Instead Uteq climbed out further, bravely indeed, as his father's roar subsided, but he tripped on some chunks of snow and fell forwards.

"Woaaaaaaw," Uteq went tumbling straight down the snow slope, rolling across the ground like a snow ball and hitting Toleg's huge legs with a soft bump, but giving a grin too.

"Er, he's still a bit clumsy," said Anarga apologetically, as Uteq picked himself up, his small legs and paws sunk deep in snow, "but he'll learn with your help, Toleg, if you don't frighten the wits out of him."

"Ice Lords fear nothing, and nor must our Uteq."

Qilaq snorted at the accident, but Matta was transfixed as Uteq shook himself off, in his father's shadow. The cub began sniffing at his father, under his legs, growing more confident with every second and feeling the adult's strength above. He kept looking at his father's gigantic paw and thick black claws, frightened at how large they were, and how large everything seemed out here.

Toleg knew in that moment he would give his life for his cub, but Uteq had come to a stop, shielded by his front right leg, although his head was poking out. With that he thought he heard a strange noise, like a sort of pounding, that seemed to be coming from his father's belly. Uteq blinked in confusion and Anarga's loving expression changed too. But she was peering warily across the Sound now. The twins swung their heads to follow her angry gaze and make out a very lean-looking polar bear, with especially long and feminine fur sleeves, padding through the snows with a swagger, followed by three others, who looked around as haughtily as if they owned the Great Sound itself.

"Marg Leantongue," hissed Anarga, and something especially protective came into her strong eyes. The Council's first spy, with his long, sleek fur sleeves, looked a bit like Eagaq, but Marg had clever, beady eyes and although he didn't look round, the twins felt a sudden chill, for his shadow seemed to be stretching across the snow like a claw towards them.

"Come here, Qilaq," snapped Innoo, "sit safely by me and be quiet."

It was Narnooq whose expression had changed to utter astonishment though, as Uteq wondered why the old bear was suddenly staring not at Marg, but at him, now that Uteq had just stepped out from under Toleg's belly, as Marg and the others drew away again.

"But Anarga," growled Narnooq of the North. "It's impossible."

As the others turned and spotted what Narnooq had just seen, they were amazed at Uteq too, who rushed up to his mother, pushing his snout toward her teats to suckle and hide himself.

"But what can it mean, Qilaq?" said Matta wonderingly. "Look."

"Mean, Matta? Perhaps he's evil. Kassima, like Pollooq became in the story."

"Pollooq? He wasn't evil, he was perfect."

"But Seegloo says he became a killer, Matta, and got the Ice Madness once as well. Some said he was evil then."

Qilaq was smiling but he had dropped his voice, for there is nothing more frightening than madness to polar bears, so the adults heard none of this, as Matta looked at her brother in horror.

"Is it black magic then?"

"He's different," said Qilaq, staring at Uteq's paws. "That's what it means."

"It means nothing, children," growled Anarga, overhearing this part, "It's just discoloured fur, that's all."

Narnooq was still muttering and mumbling though and shaking his old head.

"By Atar. The Great Story, Toleg. And the legend, of a Marked cub, with very special powers, sent down from the very heavens themselves at the end of the world."

"Great story," cried Matta, "Oh, tell us Narnooq, please."

"Bears," growled Toleg though, swinging his head to address the others in his gravest and most commanding voice, "hear me now, for none of you must speak of this, on your very honour. We'll hide this in the snows, and keep it quiet for as long as we can. Especially from the likes of Marg Leantongue. It must be our secret."

Narnooq looked up and a thought struck him like a thunderbolt.

"Yes, Toleg, yes indeed. For if you're to stand for election, this would go against you, for certain, if it ever got out. Perhaps we can ask the Fellagorn if it means anything, when they send the Tellers out again. But they say the mark could only appear when stories themselves are in dan..."

"Peace," grunted Anarga. "No more talk like that. Little cubs need peace to grow and thrive."

With that there was an anguished roar that nearly knocked Uteq over again and made the twins jump out of their skins. All the friends looked around and wondered if they were being attacked, as Toleg rose to defend his little family. Another Bergo had come staggering across the snow towards the den, panting heavily, his chest stained with dried blood.

"What's happened, Rornaq?" cried Narnooq, as the newcomer reached them. "We haven't seen you in suns and now you return covered in blood."

"Betrayal, Narnooq," groaned the Scout, sweating furiously. "A terrible battle in the North."

"Battle, Rornaq?"

"Yes, Narnooq. In the High Arctic, on the edge of the Ever Frozen Sea. I got lost Scouting in a blizzard, but I saw the aftermath. I'm sorry I missed the fight, but I've been travelling for suns to warn you all. I must find Varsaq Wiseheart as quickly as I can. Perhaps the Council will know what to do."

"Tell us though, Rornaq," growled Toleg, dropping down again. "What happened?"

"Back in the Long Night, Breakback, they were all together, the entire sacred order, the Fellagorn, going north to seek the One, I

think. They say a bear betrayed them though, and all were killed, cut down on the Field of the Fellagorn. Murdered. The Warrior Story-tellers are gone forever."

"Murdered," shivered Matta, as if the sun itself had been stolen away. Although he had only heard of it from the Lera, now poor Rornaq began to describe a terrible battle, out there on the Ever Frozen Sea, as Anarga looked at him in astonishment, remembering just what she had seen in her terrible vision. As they listened, the cubs' minds were filled with images of great swirling clouds of arctic snow, and huge, white boars rearing and bellowing, opening their claws to box and slash at each other, giant white shapes in the night that turned blood red.

"So the stories *are* done forever," moaned Narnooq, as Rornaq finished, looking sharply at Uteq's paw again. A groan went up among the adults, and although the cubs hardly understood, they felt sick to their souls. Uteq wanted to rush straight back down the snow passage.

"Was it Raiders though?" growled Toleg. "Did someone betray the Fellagorn to these Snow Raiders?"

"Serberan, by the looks of it. Not the wild slaughter of Snow Raiders, but the careful traps laid by Glawnaq's trained soldiers. Glawnaq hated the Fellagorn with all his heart."

"Then who's left to protect us and the Ice Lore?" groaned Innoo, missing Gorteq even more. "We're all alone now, children. Come here then, come to your poor mother's side and suckle."

Rornaq had swung his head though, and was looking down intently at Uteq. He stared at the cub's front right paw in disbelief.

"But...but what's this?"

"Rornaq," hissed Toleg Breakback. "This must be our secret. Swear it on your life."

Rornaq was as astonished as the others to see something never seen in any Bellarg before. While the tiny claws on Uteq's right paw were white, like human nails, the fur around them was perfectly black; the little snow-white bear cub had a single black paw.

3

THE COUNCIL OF THE ICE LORE

"The secret sits in the centre and knows."
—Robert Frost

Two more shining weeks had passed, and in the growing
Long Day Anarga was lying on her back, cradled in a half
moon in the hot sunlight, as Uteq sat in the curve of his
mother's belly. It was far drier up there than in the softening snows.
Nearby, Innoo was outside her new den, while Matta and Qilaq were
chatting to Nuuq. Old Narnooq was the only boar around now, gazing
out in the direction of the sea, frowning, glancing occasionally back at
Uteq. He was thinking nervously of wolves and of the Fellagorn
seeking signs, while all wondered if Glawnaq One-eye was really
responsible for the destruction of the Warrior Storytellers, and what
move he would make next.

"*Aaarweeeeeeeh!*" came a cry across the bay, where other bear cubs
were at play in a nursery Varsaq Wiseheart and the Council had
formed for their protection. They were being watched over by several
concerned Bergeera, guarding them closely. Matta noticed Qilaq
looking towards a fat little cub sitting on his mother's stomach too,
swinging his paw wildly. A bear cub called Sqalloog.

Anarga looked lean from her time in the den, badly in need of
some fresh fish and seal blubber. The promise of it lay straight over
the ice – with the great Wander-to-the-Sea. Many Bergeera had
delayed it though, for Rornaq's terrible news of the Fellagorn

42

massacre had hit the free bears hard. The Fellagorn had watched over them and the Ice Lores so long that they seemed lost without them. It is why Varsaq had decided to step down even earlier now, to find a fresh successor. The election was at hand this very day.

"Can I join in, Mother?" cried Uteq, looking longingly at the playing cubs, although he knew the answer already.

"No, Uteq, dear, cubs can be a little rough and anyhow, with your..."

Anarga stopped, but Uteq looked at his black paw accusingly.

"I hate being a secret, Mother. It's just not fair."

"I know, dear, I know, but it's for the best for now, really. Until at least after the election and the Wander-to-the-Sea. Don't ever let Marg Leantongue or his lot see it. Promise me. They might use such a thing against your father, or worse, you."

For these last weeks Narnooq had been working on Toleg's conscience again, trying to persuade his friend to stand himself at the election, while Marg had been everywhere canvassing support himself, and the bears in the Sound seemed mightily divided. Many argued some kind of Serberan border round their Sound would at least stop incomers crowding them out and stealing food, and certainly protect against Snow Raiders until the Council decided what to do in the face of so many terrible threats. Uteq though was suddenly looking hard at Anarga's stomach. He had so many questions about the world he thought his head might burst.

"Did I really come from in there?" he asked Anarga, staring down in disbelief. "A Puffin told me I did."

"A Puffin? Don't tell stories now, Uteq, lying's against the Ice Lore."

"I'm not lying," said Uteq indignantly. "It was outside the den yesterday, and it said I came from in there, your belly, just like magic. I like talking to the funny Lera. They make me laugh."

"Oh," said Anarga, thinking Uteq should be asking his father such difficult questions instead. "Well, yes, Uteq dear, although the Fellagorn taught that children really come from Atar and Gog too. From the Heavens."

"And where do they live then, Mother? These Gods?"

"Up in the skies, like the Beqorn, or angels that guard over each and every cub. Perhaps in a starry Snow Den in Heaven, although some Fellagorn taught the Gods are really inside us."

"Inside us?" grunted Uteq, liking the idea of a guardian angel, but feeling a little confused by all these ideas.

"Yes, dear Uteq. When I first loved your father, I thought he looked like a God, although you must never tell him that."

Anarga smiled rather coyly, and Uteq scrunched up his nose trying to understand such an odd idea. But, failing, he suddenly swung a paw at Anarga's head and only just missed her face. Uteq grinned sheepishly, but his mother growled and lifting her whole body. She rolled her cub into the snow, where the bear fell flat on his face. Anarga stood and yawned, looking out longingly towards the sea. It seemed to be calling to her very being.

With that they heard a roar though and, in the distance, they saw a Bergo suddenly rise and bellow at the sky. He was swinging out too, but at the thin air, and at first Anarga braced, ready to defend her cub, but then she relaxed again and shook her head sadly.

"What's he doing, Mother?" cried Uteq. "Has he a sore head, or is he just boxing? He's all alone though and that's silly."

"It's just Mad Mooq, dear. They say Mooq's touched by the Ice Madness, or perhaps that a bad Beeg, a demon spirit, got deep inside him," added Anarga, shaking her head and glancing at Narnooq. "Though he's harmless enough"

"Those whom the gods wish to destroy, they first make mad," muttered Narnooq of the North gravely, overhearing her.

"Though Fellagorn believed the ice madness can bring the power of prophecy too," said Anarga softly.

"Prophecy," gasped Uteq. "Wild, Mother. I wonder if Mooq can do it."

"Some believe so, Uteq," said Narnooq. "for a lunatic is said to be touched with Atar's magic breath. It's where the mad word comes from, in fact, another Fellagorn name for the moon – Lunar. I think poor Mooq's just a little lost though, since his mate Meleqa died. Like

44

Pollooq got so lost, in the story, after he was betrayed and fell down into the Ice Labyrinth."

"Ice Labyrinth? Where's that Narnooq? It sounds horrid."

"And some say the entrance to the Underworld, Uteq, or even Hell itself," said Anarga, "although none know where the fabled entrance lies. Let's hope it's just a place in story. I'm here for you though, my darling, until the great wild calls to you one day, like Toleg's mighty Summoning Call, or I'll have to drive you out myself."

"Drive me out, Mother! Never. I'll always stay with you. And protect you too."

Anarga smiled and nudged Uteq tenderly with her nose, knowing the harder truth of it, and the clumsy cub fell over again in the snow. He got up and started to play around her, circling Anarga and running between her legs, until he grew tired and rather bored. So he sat down again, wondering what to do with the huge day.

"Nuuq," said Matta nearby. "When Pollooq was overthrown by the Pheline, how did they steal the secret of clever Pollooq's fighting power? It's wicked."

"And brought them all disaster, dear," said Nuuq, glancing a little guiltily at Narnooq for having started the unlucky story in the first place those weeks before, "turning them all into slaves. But I shouldn't tell it, dear. Really."

"Well, at least poor Pollooq had Teela to help him," said Matta. "I bet she loved him so."

Nuuq glanced between Anarga and Innoo, and there seemed a secret in the adults' eyes.

"Well, er no, Matta," Nuuq whispered, "perhaps you're too young, but one day Pollooq doubted even beautiful Teela's moon dream, so he backed down from his love of her, and their thoughts of their future together. The two of them just became friends instead, Matta. Best friends though."

Matta did not think this bad at all, but Qilaq looked up sharply.

"What was the secret of storytelling though, and Pollooq's strength?" he asked. "Sqalloog says all Fellagorn were cowards. His

father Gratiq Coldnose says it's good they're dead then, so we should join Glawnaq now. Fight together and be really free and brave."

"Well Sqalloog's just a little bully," grunted Matta. "And his father's in Marg's faction. That's why."

Qilaq frowned, for he had sort of made friends with this Sqalloog just a few suns before.

"While the Fellagorn *chose* not to fight, cubs," said Narnooq of the North, still staring out to sea, "because great Sorgan believed in peace, and holy enlightenment, you see. So following the sacred Garn Path."

The twins blinked and Narnooq sighed wistfully. To Fellagorn bears, Garn meant something a little different than to ordinary Bellarg, who just associate it with storing up food, energy, and warmth. To the Warrior Storytellers though it was something like holy spirit, and so in their daily lives, the mysterious Storytellers had tried to follow the Garn Path; which meant holding back the fighting fury that can descend, the wild Bear Rage – a rage that can drive any Bellarg quite mad, especially in the wildest North, with the feared Ice Madness.

"Then Sorgan's Fellagorn were just like holy Pollooq?" said Matta, sitting up. "When he died for the whole world, and went to join his father Gog in heaven. That must be the Garn Path."

Narnooq looked strangely thoughtful. There were many Fellagorn legends, especially about Pollooq, and some bears said there had been an old tradition of storytelling, but that had gradually changed over time and brought a new Ice Lore to the free Bellarg and a new understanding.

"Perhaps like Goom," Narnooq growled.

"Goom?" giggled Matta, rolling the lovely name around her mouth.

"The wisest, most perfect Fellagorn Great Master ever, Matta, long before Sorgan, who laughed from his belly, and set a flower blooming in his forehead. Though Goom died many centuries ago."

Matta giggled again at such a silly notion, wondering what Goom looked like. He sounded wonderful.

"Though they say many of Sorgan's Fellagorn loved fighting too,

Narnooq," observed Nuuq, "especially his very bravest disciple, Illooq Longsleeves. The brother of Teleq and Beloq, disciples too. Poor bears, though. It's terrible that they've gone forever. Murdered."

"That was a life though," said Matta, with a little sigh. "It's so unfair that Bergeera weren't allowed to join the Order. Except Teela's sister, Athela. I just don't understand why, Nuuq. I love stories above all else and I'm Bergeera."

"Perhaps because Bergo always try to be so important, Matta," grunted Innoo, with a sad smile, "while we Bergeera do the really important things in life. They cause all the problems in the world too, yet still only they are allowed to sit in Council, and tell us all what to do."

Innoo was suddenly furious that her mate Gorteq had not returned to their cubs, but Narnooq frowned, shook his snout and snorted at her for saying this in front of Qilaq.

"Well, really Innoo."

"Hello, graceful Anarga," called a cheerful voice now, and Uteq sunk his black paw into the snow. He turned to see the handsome Scout leader Eagaq approaching them, with Sarq and Tortog walking behind him. The two Scouts both looked wary still and felt guilty about that night the murderous wolves had come. Eagaq was the favourite of all the little cubs in the Sound already though and Matta and Qilaq ran over to greet their hero.

"Eagaq," cried Anarga warmly. "It's always good to see you, young Bergo."

"Hello, Eagaq," cried Uteq, beaming happily.

"Anarga, children," said Eagaq, nodding to Anarga and the other females, "and Narnooq of the North too. I thought you'd be in Council for the election, but you prefer Bergeera's company, I see. Quite right. Dreaming up cub stories, no doubt, to send us all to sleep?"

Innoo and Nuuq smiled and the twins giggled at Eagaq's cheek, but Narnooq liked Eagaq too and smiled also.

"Innoo and the beautiful Nuuq here too," said Eagaq. "We lazy Bergo are truly spoilt today."

Even Innoo tried to grin at Eagaq, but Nuuq gave him her bright-est, prettiest look. She was often talking to him in the Sound, and Seegloo was thoroughly jealous of Varsaq's charming nephew. Seegloo said that Eagaq was just favoured unfairly by his uncle Varsaq, so Seegloo had refused to join the Scouts at all because of it.

"You lot stick together like Walrus though," said Eagaq. "It's as if you're all hiding something..."

Anarga glanced sharply at Narnooq but Rornaq had kept Uteq's secret, she was sure, even among the talkative Scouts.

"But I came to tell you Bergeera to show a Scout's vigilance today, the true price of freedom. We've rumours then about some spy that Glawnaq sent south last winter. A tern reported it to Marg and he told the council."

"Spy?" said Uteq, thinking of the spy in the legend who had betrayed Pollooq.

"Glawnaq's very own lieutenant, it seems, little paws," said Eagaq. "Some brilliant master spy. I think Marg kept it secret until the elec-tion, but perhaps the spy's here right now, or even came from the Sound itself. The tern heard someone talking to Glawnaq, far to the North, the night a star fell. Although apparently it was just too dark to see their face."

Narnooq of the North looked round at this talk of a falling star, just days before the High Ice Cliff had fallen too, when Uteq had been born with his strange mark. His wise old eyes glittered with even greater worry.

"Are you trying to frighten us, Eagaq?" said Innoo reproachfully. "It's hardly the job of the Scouts."

"No, no, Innoo, of course not. And I'm sorry. I just want us all to stay sharp."

"Marg though," said Uteq, nudging the snow with his snout as he thought hard. "I bet Marg's Glawnaq's silly lieutenant and master spy. I mean a Cub Clawer could do both, couldn't he? And Marg was away in the North then."

Uteq's mother was rather startled by the clever thought, yet it made Anarga nervous.

"Poor Marg," grunted Eagaq though. "I think a bad Beeg's got into him, Uteq. Though Marg used to be my best friend."

"Best friend? Don't be mad. I don't believe it. A Cub Clawer."

"Oh, he was friendly once and we used to play together all the time in the Black Bay," said Eagaq with a sigh. "But Marg was always so angry and jealous of me. We argued badly one day, and then his Seeking Claw started growing, and his heart went bad, I think, with stories of the power of the ancient Cub Clawers. It set him apart from the other cubs. Poor old Marg."

Uteq frowned, yet feeling sorry for Eagaq and not Marg at all, and also rather strange. His paw was suddenly tingling and Uteq wondered how a heart could go bad, or if he too was somehow set apart by his paw.

"You filthy cubs," hissed Eagaq suddenly, and as he peered at them his mouth opened, and the handsome Scout's face looked just like Marg's and his voice changed. "You nasty, feeble, worthless little runts. Bow before the judgement of the ancient Cub Clawers, I command it, and die."

Eagaq was only playing, imitating Marg, and he suddenly grinned and it was like the sun coming out again. The cubs shivered, then laughed delightedly.

"Perhaps it's not his fault though," Eagaq went on in his own voice. "Marg's always been feared, you see, coming from a line of Cub Clawers, so he became obsessed with leading the bears himself. With joining Glawnaq, perhaps, although he hates the Gurgai and Snow Raiders too. Or so he says."

"I'll find this horrid spy," said Qilaq. "This secret lieutenant. I'll bite him to death, you'll see."

"Bravo, Qilaq," laughed Eagaq and Qilaq grinned proudly, feeling like a Scout himself.

"Without putting him on trial first, Qilaq?" asked old Narnooq. "Not very just, little bear."

"Trial?" said Qilaq with a frown. "Just? What's that, Narnooq?"

"A place to be judged but justly, little bear, is a trial, but with evidence of guilt and proof of any evil doing. These are bad times, but

we've lores, Qilaq, thank Atar, as we have the Free Council to guide us all. Where we Bergo meet in the circle, to decide, to talk and honour the Ice Lore, as we have for centuries, for only the circle truly sees."

The cubs wondered what on earth Narnooq meant by a circle seeing, but Innoo frowned and shook her head as her cubs glanced at her.

"There you go again," said Eagaq with a grin. "Always laying down the Ice Lores, Narnooq, like some old prophet yourself. Just rise above it, little Qilaq, rise above it. He can't help it."

"Lores?" snorted Qilaq though, scrunching up his nose, "like the stupid Pheline had and they were evil?"

"Perhaps, Qilaq, but they protect us all too," said Narnooq with a smile. "Like pressure ridges protect polar bears in a storm, or a snow den keeps us warm and safe for our birthing. We're just mortal bears, after all."

"But Lores protect even an evil spy then, Narnooq," said Qilaq indignantly, "and the enemy? That's just stupid."

"Quite right, Qilaq," said Eagaq and he winked at Tortog and Sarq.

"Is it stupid though?" growled Narnooq, "and I suppose you know where the lair of Evil One himself really lies then, little Qilaq? In a huge black snow den to the North, perhaps, in the great ice caves that plunge down forever through the giant glaciers, or deep in the belly of the darkest arctic seas?"

Bears often whispered of the Evil One, and an even more terrifying name too – the Ice Lord of the Flies. These words made the cubs frightened, but Narnooq was smiling broadly and Qilaq suddenly felt stupid.

"Er, no," he muttered, "but I'll find him too, Narnooq, Ice Lores or not, wherever he's hiding. Bite off his evil nose."

Eagaq and the Scouts laughed, but something very grave came into Narnooq's wise old face.

"Be careful now though, little bear, for when you've cut down all the lores, brave Qilaq, and knocked down all the snow dens and pressure ridges in the world to get to him, but then the Evil One turns around and looks back at you, Qilaq, why then such an arctic

wind may blow, that even you might not stand up in the terrible blast."

Poor Qilaq looked appalled and he gulped, suddenly wishing he had kept his snout shut.

"Come, come now, Narnooq," said Eagaq softly, "don't frighten the poor cub with talk of some Evil One. We've enough to worry about already."

"The Ice Lore," sighed Innoo suddenly, as if talking to herself, "that whispers on the very winter winds, or glows in the turning colours of a dying leaf, that booms from the arctic ice cliffs themselves, and moans in the endless crashing of the sea."

Innoo's poor face seemed older, as the snow stirred about them.

"But now we go to argue for Toleg and the Scouts," cried Eagaq, shaking his head at Narnooq again, and Innoo too, "with Marg's faction growing, it'll be a close run thing to beat his lot today. I wish you all well then, my friends. Keep up your fighting spirits up, always, and honour and vigilance too, remember. Wish us luck then."

"Honour and vigilance, Eagaq," called the three cubs boldly, and Qilaq felt better again.

"Wait though, Eagaq," grunted Narnooq. "I'll come too. They say the vote's perfectly balanced and Toleg needs any help he can get. We may all need the Ice Lore today then, and our wits about us too."

Narnooq lumbered after them, as Eagaq swung away with his two loyal Scouts, and the cubs watched them admiringly, wishing they could join them. In the quiet, the eager cry of playing cubs came again though, like a call to some holy destiny. "*Awwweeeeeeeeeeeeeeee!*"

It was the cub called Sqalloog crying out happily this time, now thoroughly enjoying bullying the others in the nursery too, as Uteq realised the cubs were Boggeting. They had found a piece of flat drift wood, a bogget, and, after pushing it up a slope with their snouts, were taking turns to sit on it and go sliding gloriously downhill. Uteq jumped up with excitement, then turned beseechingly to his mother.

"Oh, go and play then, Uteq," she said, frowning helplessly. "I want to clean the den anyway."

Uteq's face lit up, until Anarga spoke again.

"But not with the other cubs, Uteq. The ice is good the other way for slides too, toward the High Cliff. I loved that game at your age. Even better than Boggeting, Take Matta and Qilaq too then. Real friends are always what truly matter, dear."

Uteq scowled but was trying to make the best of it, as Anarga looked for permission to Innoo.

"Don't stray then," said Innoo to her twins. "Keep to the straight and narrow always, and the Ice lore too. You heard what Eagaq just said. But the Council convenes beyond the High Ice Cliff, and it's against the Lore for any to listen. So be careful, twins, and if you're bad, I'll cancel the Wander-to-the-Sea."

"Yes, Mother," said Qilaq, wondering how many rules and prohibitions the silly Ice Lore had. The three cubs set off eagerly together in the arctic sunlight then, like three wandering Fellagorn, waddling across the crunching snow, but away from the happy sounds in the nursery, suddenly feeling very independent and grown-up indeed for such very little bears.

"Uteq," said Matta as soon as they were out of earshot of the adults, "have you found out anything about your black paw yet, or this funny legend?"

"No, Matta," answered Uteq with a frown. "Mother won't tell me a thing. She keeps talking about stupid Pollooq instead, just like Nuuq does. Just more stories. Adults never seem to explain anything really important about the real world, or tell us the truth."

"Then we'll find out together," said Qilaq determinedly, "just like brave Scouts. I heard Sqalloog talking about this Marked One though, and he swears that if Glawnaq's looking, he'd help find him."

"Sneak," said Matta. "You better keep your paw hidden from Sqalloog then."

"Well, it can't be me," said Uteq, "the mark this legend talks of. I haven't got any powers, like Narnooq talked about. I'm just normal, like you two idiots, apart from some stupid black fur."

The twins looked thoroughly disappointed, but the three little bear cubs continued intrepidly down the Sound, only distinguishable

against the white because of their black noses and Uteq's strange right paw. They trotted through the snows in silence, wondering about magic powers, as it started to snow lightly. The flakes came falling as softly as silence, like gentle flecks of goose down, widely spaced too, so it felt as if they were suddenly walking together through some magical forest.

"We mustn't go far though," said Matta as they went, "we'll get too close to the Council."

"Great," said Qilaq, the snowflakes fizzing on his hot nose, "and we should sneak up and listen. Maybe the Bergo know about this legend, and I want to know who wins the election. Perhaps they'll all fight."

"Oh, don't be stupid, Qilaq," snapped Matta, "they'd eat us alive, and it's against the Ice Lore."

Qilaq frowned and they went on in silence. The light fall had stopped again, and the cubs were drawing nearer to the High Ice Cliff when Qilaq cried out. "There. There's perfect." Qilaq's little eyes were gleaming as he looked out across the sea ice, below the great cliff, where part of the ice had fallen at Uteq's birth. The sea had frozen again, but here and there it had great shards poking out, that blocked the cubs' view past the looming cliff. It was a strange, alien landscape indeed.

There was no one around at all and the air was perfectly still as the three cubs peered up at the huge ice mountain too. It seemed to reach to the clouds, soaring into the enormous, steely blue, like some frozen giant, with weird shapes like faces in its sides, and sometimes what seemed to be the mouths, the start of little caves. Uteq thought of some icy Labyrinth, or the entrance to hell, and it made them all dizzy and terrified, so the cubs were very glad that the adults were still in earshot.

"You're sure the ice is strong enough though, Qilaq?" Matta gulped, scanning the surface on the ground again nervously.

"Oh, don't be so wet, Matta. We're too light to fall through. Or are you a scaredy bear?"

Matta hadn't told anyone, but ever since Innoo had described a

great white shark to her, she rather feared swimming in the sea. The cub was ashamed, and anxious to hide it.

"No," Matta lied, glaring defiantly at her brother. "Of course not. We'll need to be much braver on the Wander, and I'm Bellarg, Qilaq, and Ice Lords fear nothing."

"And never back down either," said Qilaq, looking at her sceptically and grinning. "Bergo at least. Like the Glawneye."

"Glawneye?" said Uteq.

"Glawnaq's personal bodyguard, Uteq," said Qilaq eagerly, "chosen from among the most powerful and dangerous of the Serberan, and reared on a strict diet of white whale meat. They're old One-eye's crack corps, trained to glissade in to deepest snows, travel huge distances without resting and sent out on very special missions. Some say as assassins."

"Assassins?" said Matta nervously and Qilaq's eyes glittered.

"With teeth like ice daggers, they say, and eyes trained to see in any weather. They're said always to keep coming, and to never, ever give up. I want to be one, one day, with the Fellagorn gone at least. One of the Glawneye."

Qilaq rushed forward now though and started clearing the downy snow off the ice with his tiny paws. It was a great effort, but Qilaq was very strong already and bold too for such a small cub, so he finished at last, and he was already turning to take a run-up for his first slide. He paced at its glassy edge, then threw himself fearlessly at the slide he had made, dropping onto his behind and pulling in his paws. It looked painful, but the bear cub went shooting wildly across the ice, sending up a jet of fresh slush that sprayed in the air, drenching the others.

"Look out, idiot," squealed Matta, shaking herself furiously but grinning. Qilaq laughed, and they wondered how he would ever stop, but he went bashing into a mound of snow the wind had piled up naturally at the far end of the slide. Matta jeered, which made Qilaq furious, but the game looked like so much fun that they all had a go. Uteq slipped constantly, but he got the knack and soon he was sailing along, and after one wonderful slide, lifted up

on his back legs and stood upright. It was even better than Boggeting.

"You look just like a Tulqulqa, Uteq," cried Qilaq approvingly.

"A what?" said Uteq, waving his little paws.

"Tulqulqa. Lera that walk upright sometimes, like otters and ermine. Like Bellarg, too, when we box, and the Gurgai of course. Man. Although Man do it all the time, they say, except as cubs."

"The Gurgai are like us then?" growled Uteq, dropping down and looking guilty and unhappy.

"Well, they're Tulqulqa, yes. Although it's the third Ice Commandment to have nothing to do with Man. Like the second is to know your real friends."

"So mother made us swear to keep away from Man," said Matta, smiling at Uteq. "Always."

"And Seegloo told me he saw Gurgai killing some Bellarg once," said Qilaq, "flying above them in a strange metal container, like this thing they speak of in the Black Bay, but with spinning wings above it, as a bear family crossed the ice. It was spitting out fire and metal hail stones, Uteq, that tore the Bellarg family apart."

Uteq looked horrified, yet rather sceptical too, for it sounded like magic powers indeed. But the cubs regrouped and this time Uteq and Matta hooked their little claws as they threw themselves back into the game, spinning around together delightedly on the ice slide.

"Oh, it's so wonderful," cried Matta as they turned. "You're so wonderful, dear Uteq."

"Me?" said Uteq in surprise, for Uteq found himself awkward and silly. "But why, Matta?"

"You just are," answered Matta sweetly. "Will you love me, Uteq, when we both grow up, just like Pollooq and Teela did in the legend? Before they became just friends anyhow. Will you love me always?"

Uteq felt horribly shy, having never experienced such intensity from Matta before, or any Bergeera, as if she held the whole of him inside her little eyes. But a warm, tingling sensation was flowing through him too, in part coming off Matta's paws, but also as if Garn energy was bubbling out of the very ice. Uteq felt strangely happy.

"Love you? Yes, Matta, I will. I think."

"Promise me," insisted Matta almost crossly, wrinkling up her nose. "And I'll promise to trust you, and love you too. Always. Then one day we'll have cubs of our own, and build the future, just like brave grown-ups."

"All right, Matta," said Uteq, thinking how odd it all sounded. "I promise you. On my life."

Just as he said it, Uteq felt another strange feeling, a vibration, like a tingling again in his black paw. Then the cub could hear a kind of weird moaning that turned into a sort of voice, in his head. It was as deep as Toleg Breakback's, and seemed to be telling Uteq about Matta – a wordless secret, that popped into his mind.

"But what are you staring at, Uteq?" said the little Bergeera, "What's wrong?"

"You, Matta." Uteq answered in a quavering whisper, blinking hard at her. "You shouldn't be frightened though. Father says we Bellarg take naturally to water. It'll be all right then. Swimming on the Wander-to-the-Sea, I mean."

Matta's pretty mouth dropped open, her head jerking back in utter shock at what her friend had just said, although Uteq looked lost in a dream.

"But how did you know that, Uteq? That I'm scared of..."

"I don't know," answered Uteq, coming out of the strange reverie. "Perhaps I heard you talking about—"

"No, you couldn't have. I never have. I never would. Not even Qilaq knows..."

The slide came to an end and as they stopped dead on the ice both the cubs were at an utter loss. Uteq was suddenly very nervous, thinking again of legends and Narnooq's talk of strange powers associated with a Marked One, but he tried to push the horrid thought away. They both got up, and Matta looked at Uteq hard, a deep question in her eyes, but Uteq shrugged and the games resumed. Qilaq had another go first, then Uteq tried to distract Matta from the strange incident by taking a really fast run-up, but he slipped and lost control.

Uteq skated out at first, then fell, so the hapless cub went scooting along, like a bolting snow rabbit.

"Wow!" gasped Qilaq. "Uteq's like a flying cormorant. Wild."

Uteq didn't feel like a bird, but he was pleased to have been brave enough to go so very fast in front of his friends. The tiny bear threw back his head proudly and opened his mouth as wide as he could, sucking in the icy air as the clouds raced above him. It was glorious, and the cub suddenly had no idea where he was at all, as the ice-cold air slapped at his furry cheeks. Above him the giant skies seemed to revolve, and Uteq wondered if he was already in some Fellagorn heaven. It felt so good to be alive. Although somehow Uteq felt his being pulled between the heavens above and some dark Underworld far beneath. But one thing was certain: Uteq had forgotten all about what had just happened with Matta.

Uteq was going faster than he thought though, and he had also misjudged the angle of his run-up to the slide and the snow block at the end. Speaking of birds, a huge, evil looking seagull was sitting on top of the snow block now, and it cawed viciously at Uteq, who ended up sliding straight past it, out onto ice protected from snowfall by the cliff and the wind.

"No, not that way, Uteq," gasped Matta as he went. "The Council. It's forbidden."

"Come on, Matta," gulped Qilaq, running after him. "We've got to stop him."

Uteq had lost all control and the ice was much smoother there, so he picked up momentum and shot straight towards the cliff, as great shadows reared over him, like fighting Bergo, and for a moment the cub felt as if a darkness had just fallen across his very soul. The tiny bear shuddered and put down his black paw to slow himself. As soon as Uteq's right paw touched the ice sheet he felt a violent vibration and his little ears were filled with a great, weary groan. The cub noticed the seagull too, that had taken off, cawing wildly overhead, but the noise in his ears seemed to turn into another voice – a Bergeera's voice, like his mother's, or Innoo's, crying out to Uteq desperately: *"Help Us, Uteq, help the Ice Spirits."* –

Uteq dimly saw the gull sailing off, pulling away his paw in horror, and clamped both paws over his ears, so his desperate slide went on, toward some very thin looking ice with long, angry fissures in it. He clamped his eyes shut too and started to pray to holy Atar, but as Uteq passed the cracks safely he slowed and seemed to brush against something as soft and furry as his mother's belly. The strange moaning voice in his head had stopped, but Uteq's relief was very short-lived, because the cub heard real adults talking all around him as he came to a stop.

"So then, Bergo, the election is at hand," said a deep, grumbling bear. "Marg Leantongue has put forward the case for his leadership, as head of the spies, and for paying tribute to Glawnaq One-eye, to counter the many threats and fears that face us all. Our cleverest mind has been rather convincing, but I at least hope to hear more from our bravest warrior, Toleg Breakback."

Uteq's ears pricked up. Polar bears were grumbling and muttering all around, and Uteq felt desperately sick, but with that the growling stopped and there seemed to be a communal gasp that sucked at the air.

"But it's sacrilege," roared a second Bergo voice, "A cub at a Council meeting. There."

Uteq had slid straight into the middle of the Council and the election. Slowly Uteq opened his eyes, peering up at the adults, horrified to see such gigantic boars in a great white circle; he was sitting in the very middle of a forest of huge bear legs. Uteq saw his father too, though Toleg was looking away, deep in thought, and he suddenly remembered what Narnooq had said of his strange paw being a danger if it was ever known at Council, yet on hard ice he had no way to hide it.

The voice that had spoken first belonged to a huge boar, standing on a rough ice block, like some bear God. He had enormous paws and teeth like small trees. His eyes looked as grave as chasms, as Varsaq Wiseheart peered down at Uteq too. It was Sqalloog's father though, Gratiq Coldnose, who suddenly thrust his head almost into Uteq's

face then looked at his paws. His long, pointed nose was bright blue with cold.

"But his paw," Gratiq gasped, his breath smoking furiously in the cold. "It's as black as the black blood. Look. The cub's marked out, like the legend of the Ice Saviour says. The Twice Born."

Uteq's secret was well and truly out now, and with Gratiq's strange words the Council erupted into deep, questioning murmurs. If Marg Leantongue's shadow had seemed to creep towards the twins outside his den, now fifty fell on Uteq. The cub had heard these words about some Ice Saviour too, and wondered what a Twice Born meant.

"Hello," he gulped though, wanting the heat to melt a hole in the very ice. "I'm Uteq."

Next to Gratiq, Marg Leantongue had craned forward too, among a group of very suspicious looking Bergo indeed, his faction of spies, and his little eyes were like daggers. Marg began to sniff like a weasel, as if he could not control himself at all, and with that he lifted his right paw and flexed it. A single sharp point sprung out, much longer than all his other claws, curving like a black hook.

"The S-s-seeking Claw," Uteq gulped in horror. "A C-c-cub Clawer."

The lofty bear was growling angrily on the ice block though.

"Put that thing away immediately, Marg," snapped Varsaq furiously. "The days of the Clawers are long done with, here at least, especially at Council. Until you're elected perhaps, *if* you are. It's the Lore, for now at least."

"Because the Ice Lore's lost its teeth," snorted another Bellarg, munching on a large fish, "and filthy little cubs have no respect for adults anymore. Soon there'll be no firm ground to stand on at all, Bergo. Mark my words."

Toleg had spotted his own son in the middle of the others and his eyes could have burst from his head. "By holy Atar," he roared, "what are you doing here, Uteq? When your mother Anarga..."

Narnooq was growling in horror too, right beside Toleg, although Seegloo seemed in a kind of trance just behind them both, as ever dreaming of Nuuq.

"So it's yours, Breakback?" growled Varsaq, swinging his head accusingly. "Then why haven't you told us of this before? You know the legend, and the Council must be informed of such strange things. But Marg," added Varsaq. "I said put that damned claw away."

Marg blinked and snapped out of his sudden fury, pulling back his claw like a human switch blade. Uteq was still looking at the hateful Cub Clawer in terror, as Toleg looked shamed faced too.

"Yes, great Wiseheart," said Marg, embarrassed now. "Of course. I'm sorry, I can't help it sometimes, it's in the blood, and I didn't realise he's Anarga's little cub. Nothing wrong with him then, I'm sure, even with that strange black paw."

Marg tried to smile coldly, and Varsaq swung his head back to Toleg instead, as Uteq noticed that a crown of flat snow had settled on Varsaq's head, like some old-world judge's wig.

"Nothing wrong perhaps, Toleg, just as Marg says, for it was the Clawer's role to find out weaknesses, but explain yourself. Explain this thing."

Toleg glanced guiltily at Uteq, then Narnooq and Seegloo too.

"Er, Anarga says it's just discoloured fur," was all that Toleg could say, stumbling, "and, er, that the wolves hunt such marks now, so we thought it best to keep Uteq secret a while."

Uteq noticed Marg glaring at his father with the purest contempt, even hatred. The cub wondered why, and disliked the smelly Cub Clawer even more, but seeing Toleg at such a loss, Narnooq stepped into the circle. Narnooq had noticed Marg's eyes glittering, delighted with Toleg's evident distress.

"Mighty Varsaq," growled Narnooq softly. "And fine brother bears. Illustrious Council members. The Great Story's very ancient, as all know, and filled with different versions too, different interpretations. But it was a friend, wise Mitherakk, who told me once that none really knew what the Saviour's mark would be, not even the Fellagorn, Gog rest them. There are many parts to the story, and it all got confused, over the long centuries of telling. The Fellagorn kept adding to it anyway."

"Wise Mitherakk!" mumbled Varsaq rather irritably, scratching his

snout with a paw on the ice block. "Hmmm, Narnooq? Haven't I heard that name before? My memory isn't what it was. A Fellagorn himself, perhaps?"

"Not exactly, Varsaq," answered Narnooq, looking oddly embarrassed himself. "Just a friend, but talented with legends. I met Mitherakk returning from the North myself. He told me much about the Legend,"

"But if it is that paw, and it's Anarga's cub," growled another bear, with a large wart on the tip of his nose. "The ice cried out and screamed the morning it was born. While just days before, I saw a star fall in the heavens. Sure signs indeed."

Uteq had a vague memory of a terrible sound that had frightened him badly in the dark but he was thinking of the voice in his own head asking for help.

"Can it be the One indeed then, Narnooq? The Ice Saviour himself?" asked Varsaq, looking hard at the little secret in the centre of the circle. The Bergo all began muttering again, each one trying to remember the versions of the Great Story that they had heard themselves as cubs.

"Hundreds of stars fall, Fooq, every single night," grunted Narnooq, "and in the Great Story, there were other impossible signs Mitherakk told me of. A great white wing sent down from heaven, for instance, like a great snow skin, or the breaking of the fabled unicorn's horn."

Narnooq glanced knowingly at Toleg, to reassure him, who growled appreciatively and winked, for they had seen no such signs, although another Bergo with badly crossed eyes suddenly spoke up. He talked in a baleful voice, spittle dribbling from his tongue.

"No hope though, fools, for the world ends anyway," he growled, "with no ice ark to save the Lera this time, since none believe in anything anymore. The ancient curse falls nonetheless, and judgment day comes. The Last Judgement is here. But when they told Mooq the story," wailed Mooq, for it was the mad bear talking, "Mooq heard that the Twice Born will be betrayed by those closest to him. A betrayal to break the world's very heart, before being driven out on a

terrible odyssey, even among the Gurgai. Man. And dreams, such terrible dreams it will bring us all."

The Council were peering in horror at Mooq, and most dropped their eyes, for some believed that even catching Mooq's look could bring the evil eye down on them. Uteq stared at Mad Mooq in terror, wondering what an odd-sea looked like. He shivered, but Uteq noticed the twins nestling under the ice wall now, watching him in awe. His friends had followed him bravely to the Council too and at least their presence reassured him a little.

"And sins," groaned Mooq, "the sins of the whole world, indeed the whole universe, will be heaped on the cub's poor back, so it's hated and reviled everywhere, just like an ancient Blaarq."

Uteq knew the story of the Blaarq – an arctic goat, with little horns and enormous donkey ears, that in the most ancient traditions would be brought to a Bergo Council, once a Winter Solstice. In ancient days the bears would touch it, believing that they were placing their own flaws and crimes on its back, and then drive it out to die, so that they felt clean once again.

"A very scapegoat for the world's terrible evils, it will be," moaned Mooq, more loudly, "a saviour, yes, but one drowning in the very blood of the world, then torn to shreds. So who'll betray the Ice Saviour, who?" Mooq demanded, glaring madly all around him, as the boars tried to look away. No one there seemed to trust anyone at all. Narnooq was eager to put a stop to this somehow though.

"But not Uteq, Mooq," he cried angrily. "Not simply because of his paw. And I've been thinking deeply. The Fellagorn believed they could affect life, didn't they, with their ancient word power alone? But if there aren't any left to even tell the Great Story, so touch fate with their voices and stories, to bring it to pass, the legend just can't happen at all. The Great Story is done with."

Narnooq looked delighted with his own clever logic, and the other Bergo seemed impressed with his reasoning too, especially Toleg.

"Fate," groaned Mooq still though. "Fate and misfortune will haunt the Ice Saviour, or the very vengeance of the Gods themselves.

Like the ancient curse of the wounded white bear, more dangerous than any other alive."

They all growled, as if a terrible enemy had suddenly stepped among them, for all of them knew well enough the danger of a wounded Polar bear in the wild.

"Fate shall haunt us all, perhaps, Mooq," muttered Varsaq though, from the ice block, looking rather worried. "For what are we to do with the Fellagorn gone, the Warrior Storytellers destroyed, and now many say that Glawnaq's sacrilege brings down the heavens' wrath on us all?"

They all knew Varsaq as a naturally superstitious bear and Marg looked up and seemed to spot his opportunity, for something cold and steely sparkled in his eyes. Mooq rose on his haunches though, and seemed to be clawing at the clouds, his eyes bulging.

"Look out," grunted Sarq, next to Tortog and Eagaq, "I think Mooq's going to prophecy."

"I see it now. The wrath of the Gods themselves," wailed Mooq. "Teeth and claws, ice and sea, madness and sorrow, a jealous sister betrays the One, and up in the North, a death and strange vision. The dead, the Field of the Fellagorn Dead, spirits reborn like growlers, and then...poison. All dead. The day itself shall be here then, the Last Judgement. They say then the Evil One himself comes, bears, so if this Uteq is not the One, not The Ice Saviour, is not that unnatural paw enough for a Free Council to declare the cub Kassima? Indeed I do so now. Kassima."

The ancient word went around the circle like a hiss, Kassima, and the twins suddenly thought of their mother and the Black Bay. Making something Kassima was not part of the Eight Command-ments, yet a very old proscription, that carried the deepest sanction, for it made all bears think of the Evil One. But Marg's eyes had just lit up.

"Sent from Hell itself, then, like these ghostly Snow Raiders" hissed an old Bergo. "Is he the Evil One then, Mooq? The Blackpaw?"

Poor Uteq shuddered bitterly. He just wanted to be good, even this silly Saviour if need be, but certainly not the Evil One.

"Come, come now, Mooq," said Varsaq though, "try not to get carried away. Please."

Mad Mooq had stopped, but he swung his head straight towards Uteq.

"I see more," he hissed. "The Sight. *Murder*. It will murder the Ice Lore."

The whole ring swung round to look in amazement at Uteq, as from the circle Uteq noticed Eagaq pushing his own right paw flat onto the snowy ice, as if imitating Uteq that morning and wondered why. Uteq felt something strange in his own paw again, but Varsaq turned his great gaze directly on Uteq and cut Mooq off again, sharply.

"These are grave words. But you little bear. Do you think that paw means anything special? Have you noticed any unusual powers, I mean? Speak up, cub, quickly, and do not lie."

"No, sir, nothing," Uteq lied immediately, feeling sick and utterly desperate, thinking of what had just happened with Matta and that voice. "Nothing at all."

Toleg and Narnooq sighed with evident relief. Uteq sat there wondering if the skies would fall in, but as he looked back at the Council, something even more awful happened. All the great white polar bears in the circle suddenly went black. Uteq blinked, and shivered, but they were white again, as if nothing had happened. Uteq felt horribly guilty though and he knew in his heart that twice now he had transgressed, if hardly meaning to at all.

"Very well then, little bear," growled Varsaq. "Perhaps we must trust Narnooq of the North, for now, and what he learnt from this Mitherakk, for he knows much of the stories. And without those, what upholds the ancient lore anyhow?"

"The Ice Lore," thundered another huge bear, "and the Eight Commandments, Varsaq. They must be obeyed, always. The bear must pay some price then, even for coming to Council."

"But if you go over there, little bear, by your father," added Varsaq gruffly, not unkindly either, "and act responsibly now, almost like an adult, then your forfeit and punishment is to listen, by very

special dispensation. Sit quiet though, Uteq Blackpaw. On your very life."

"Y-y-yes, Sir," gulped Uteq, getting up with relief to have got off so lightly, but nearly slipping under the pressure of all those searching eyes as he waddled towards his father.

"Uteq, I should cuff you mercilessly for being such a little fool," Toleg growled, as Uteq sat down beside him. "And you've only yourself to blame, if anything happens to you here. Or if Marg's lot take over now, perhaps because of you and that paw, Uteq. I wouldn't wonder if your mother even cancels the Wander-to-the-Sea."

Uteq felt utterly desperate, yet it seemed terribly unfair, since the ice itself had taken him here.

"Not so fast, Bergo," growled another bear, another spy in Marg's faction called Gorp. "Mooq has spoken Kassima, and if Glawnaq One-eye seeks signs, a creature like that will hang about our necks like some blighted albatross. We must judge him then, bears, then cast him out. The Gods themselves will it."

"Kassima," cried Mad Mooq again, his eyes lighting up like a wolf. "So feed it to the Varg. Although they say when you're closest to the Evil One, you're closest to the Gods too. Yet only the true Saviour brings atonement for the world."

The word *atonement* dropped into the centre of the circle like a stone and Uteq wondered what it meant. It was Qilaq who shuddered next to Matta though, at this talk of feeding Uteq to the wolves. For he was recalling a deep howl in the Night, that had woken him in the snow den, and made him as terrified of Varg as his sister was of swimming.

"Why bother," snorted Gratiq Coldnose next to Marg. "I could kill the little runt with a single paw swipe, unnatural or not, and be done. That would please Glawnaq. We could send his corpse as part of a tribute, when Marg wins the Election."

Marg's spies were all smiling broadly and Toleg realised that his son was in terrible danger and he had to act. "It's not unnatural, Cold-nose," he roared furiously. "Just look, Bergo."

The Breakback reared and puffed out his huge chest, showing the

council bears a proud fighting scar in its centre where the exposed skin was blacker than Uteq's own black paw. As Toleg crashed down again, Marg was grinning still though and Gratiq shook his head.

"Oh we all know that a Bellarg's skin's quite black, Toleg, like his tongue, but not his fur. But meanwhile and as importantly, a relation of one made Kassima could not lead us at all. That's the Ice Lore too."

Toleg looked rather foolish, and Gratiq's eyes glittered at Marg for the cunning of the thought Marg had had himself too. By the Ice Lore, if Uteq was driven out as Kassima, Toleg could not oppose his master at all in the election, and poor Toleg was nearly at a loss for words.

"You're behind this Marg," he growled, "with your filthy, black tongue. Did you just bribe Mooq to speak thus? So I do oppose you this election day. You talk to us of reason, and of bowing to Glawnaq who speaks as if he were a Gurgai. A human. They love reason above all, Bergo, so would you and your spies bow down to Man too? Would that bring free polar bears to their senses at last?"

Something strange came into Marg's lean, clever face and he could see the effect Toleg's words had had on the Council, for the majority were nodding gravely.

"Man?" he growled, straightening his back. "Never, Toleg. I hate the Gurgai, with all my heart, and watch for them always. They're one of the reasons Glawnaq might protect us. He's not perfect, but he's strong and we must face realities and even think like the best Pheline. I think we should certainly parley with Glawnaq, as I've said, even pay his Serberan tribute, for now. New borders might stop Snow Raiders too, and it's they who speak of truly ancient lores and superstitions, they say, and truly hate us all."

This fear of the Raider's gathering terror was very real and other Bergo were nodding in turn, but Toleg's reluctance to stand in the Sound was changing.

"Is this the Free Council or not, Marg?" he snorted, "Have we abandoned our strongest ideals to speak of filthy borders? Are we wild, brave Bellarg, or Glawnaq's slaves already?"

"While the Lera tell of these Barg," persisted Marg, "the Slayers

bring together to aid Bellarg in their fight. In the old tongue that at least means Blessed. An ancient Fellagorn word, I believe."

Some of the Bergo remembered it came from a Fellagorn story of a large bear tribe, marked out as special, and led to safety by their father Gog, while Uteq liked the term: The Blessed.

"Here we need only honour, vigilance and courage, Marg," said Toleg scornfully, looking towards the listening Scouts and trying to rally them.

"Ah, yes, Toleg," said Marg coldly. "You can fight the whole world then, can you? Well I'm not so blind or arrogant either, for I'm a political animal, I admit it, and at least Glawnaq has a plan, for many, not just for your own. Can *you* say the same Breakback?"

Toleg looked rather confused again. He hated politics and simply had not the words for this. He had no plan himself.

"Perhaps you're right, Marg," said Varsaq from the ice block. "Or perhaps we should be among Glawnaq's blessed ourselves. Many admire the fighting Serberan, the Ice Slayers, it's true and would these borders really be so very—"

"Slick words," snapped Toleg, and Varsaq looked angry to be interrupted, "but would you exile my cub too, because at heart you're still a filthy Cub Clawer, and would bring that ancient shadow back into our midst? Rooting out weakness in the young at every turn, among all our children."

Marg saw the sudden wariness in all their eyes, for many Bergo had new cubs themselves, and several had things wrong with them. The assembled Bergo began to mutter and growl angrily.

"Atar forbid it," cried Marg quickly. "Mooq was wrong. I see it now. Anarga's cub's just an innocent, and though Glawnaq seeks signs, reason and a strong Ice Lore must guide us all, not ancient superstitions. But they say every bear owes a life," he added strangely. "So I offer my own life for the cub, as any may use the Ice Lore to defend those made Kassima. I've been trailed by my Seeking Claw all my life, perhaps like that little black paw itself, so now Marg Leantongue himself shall protect Uteq and every cub in the Sound."

"How dare you," growled Toleg indignantly. "I can defend my own son, without help from a filthy, sneaking, lying—"

"And save us with that hulking hug of yours?" said Marg. "A bear of such very little brains."

"Come now, Marg," interrupted Varsaq, although he was grinning. "A snow den divided against itself cannot stand, and we must all speak plainly now, without fear or favour."

"But act forcefully," said Marg, for he hated Varsaq's easy sayings. "Or at the least decide on something practical and make peace with Glawnaq. Or do you hate Glawnaq so unreasonably, Toleg, simply because of your love of Anarga? Does an old fight wound us all still?"

"And, if we want peace," persisted Toleg, "we can isolate ourselves here, and live free still. Make our Sound a very fortress. Glawnaq One-eye would not dare breach the Ice Lore and attack me twice, Bergo, whatever his true motives. That would be sacrilege indeed."

"You're naïve, Breakback," snorted Marg, "and we can't just hide from the real world, or its dangers either, whatever we do. We're all connected bears, all joined by the Ice Lore, just as the story says, fable or not. It cannot be broken without terrible harm. We must talk with Glawnaq then, at the very least. Reason with him now."

Marg's faction was nodding and even Narnooq looked thoughtful, while Uteq wondered what Marg meant by all being connected, although he liked the idea of living safely in a lovely fortress.

"And perhaps Glawnaq never killed the Fellagorn," said Gratiq Coldnose, "perhaps it was indeed Snow Raiders, even more intent on the old lore than the Fellagorn, but wild with the Ice Madness. Or even Man."

"They're our real enemy," said Marg, smiling at Gratiq, "not Glawnaq One-eye. Man. The Gurgai even murdered Eagaq's father."

Uteq and the twins were amazed, for they did not know this of Eagaq.

"And what of a melting ice world, and failing seal stocks?" said Marg. "What of the black blood? *And* can we trust a bear who lies to the Council about his own son?" added Marg slyly, glaring at Toleg,

"and tries to hide him, against the Lore. The Breakback has broken the Ice Lore himself then, with his lies and bad faith."

This was a master stroke and many glared accusingly at Toleg, as Varsaq tried to take control.

"Well the election's here, I see," he cried, "as great Varsaq's star wanes at last and Toleg has spoken too. We've a clear choice then – Marg's sharp reason or Toleg's great strength – but who else will stand to perhaps show the way?"

Varsaq's eyes were scanning the other Bergo, as were Marg and his faction's but they were mumbling and muttering and most dropped their gaze shamefully. "It's not my problem," observed one. "Far too dangerous," whispered another. "You," said a third, to his neighbour. In that moment Uteq decided that Innoo had been right, and that they could do with many sensible Bergeera at this strange Bergo Council, to tell these stupid males what to do. They seemed to have no idea at all.

"No one?" Varsaq growled with a shrug. "Well you can't blame me then, bears. I've tried."

"Eagaq," cried Tortog and Uteq felt a thrill. The Scouts there had raised their heads excitedly, Tortog, Sarq and Rornaq, as well as a fine bear called Forloq and a huge proud fighter, named Brorq. So Eagaq stepped forwards.

"Well, I will if I must, uncle," he growled humbly, looking rather embarrassed. "Scouts before Spies, at least. Honour and vigilance, before compromise certainly."

Varsaq himself snorted though and almost laughed in his nephew's handsome face.

"My young nephew? Eagaq can hardly control my Scouts, when he's not running off, and we need an experienced bear, Bergo, not broiled young brains chasing dreams on the wind. Who let those wolves in too, after all, but the Scouts?"

"Yes, uncle," Eagaq growled dutifully, looking bitterly at Marg, "Besides, er, Toleg should lead us, and I'll have my paws full, looking for Glawnaq's master spy. This lieutenant. Few are to be trusted now."

Eagaq shot a clearly accusing glance straight at Marg.

"And if he is among us," growled Marg defensively, "I'll find him out, not your feckless Scouts. My Arctic tern brought the news after all, Eagaq, while I set Gorteq on a traitor's trail too in the North, long back."

Uteq looked up at the twins, and they were equally astonished. Their own father, Gorteq, was spying for the Council too, or for Marg. Qilaq was rather thrilled and perhaps it explained why in doing his duty he had not sought out his cubs sooner. Uteq looked at all those strange faces, wondering who it could be for everyone looked rather guilty.

"Let me see into your very thoughts then, Bergo," said Mad Mooq, "as only the Mad and visionary can. I'll find you out, all right. Judge what you truly care about and love."

"But you yourself were away a long time, Marg?" said Eagaq, and their eyes locked. "This spy was seen in the high North the night the star fell, and so needed much time to return."

"Away serving the Council faithfully, Eagaq," said Marg sharply. "As always. I swear it on the Ice Lore. Speaking with the Lera, and watching for Snow Raiders and for Man."

The Bergo looked at each other angrily, but the Scouts were staring as Marg's faction hatefully.

"Good Marg," muttered Varsaq though, still seeming at a complete loss himself. "I'm sure you'll find out who it is in time. We honour your counsel then, always."

"Speaking of time, Varsaq," said Marg sharply, glaring at the leader rudely, "isn't it time that we all voted? The ice world's melting."

"What?" bumbled old Varsaq, the ice block melting under him. "oh, yes, of course. Quite right. The circle knows, Bergo, and so you've a free choice now. Narnooq of the North shall count the votes." There were cries and growls swinging left around the great circle, especially between the spies and the Scouts: "Toleg. Toleg Breakback," they roared, or "Marg. Marg Leantongue." Although half the bears seemed to change their minds mid-way. At last it came to an end, and Narnooq turned to Varsaq and whispered something softly. The result of the great election in the Sound had come.

"Well, this is beyond me," Varsaq said with a shrug, raising his head and looking around helplessly. "It's perfectly matched between Marg and Toleg. Between wits and courage. Though the Ice Lore says in such rare cases I can add my own voice and, having carefully heard your views, much as I admire the Breakback, I'm leaning towards Marg. Toleg has his family on his mind, after all, even that little cub that's caused such trouble."

The Scouts looked horrified and Uteq felt utterly desolate. What had he done?

"There's one voice left though," said Eagaq, looking at Uteq and making him jolt and sit up.

"A cub, Eagaq?" snorted Gorp in disgust, "you'd let a cub..."

"No Gorp. Mooq's vote."

"But he can't," snorted Gratiq. "Mooq's quite mad. You can't let it all turn on *his* word. The fate of all. The Ice Lore does not let a criminal have a say at Council, nor should it let the Mad."

After what had been said Uteq thoroughly agreed, but Varsaq was desperate for this to be done with, and turned to Mooq nonetheless.

"Even you've the right though, Mooq," the Wiseheart growled softly. "It's the Ice Lore still. Tell us then. Your choice for Leader?"

"Eagaq Leantongue," answered Mooq and his eyes looked more crossed than ever and almost seemed to revolve in his head.

"Oh please, Mooq, much depends on your reasoned choice this day. Think clearly then, of the right path ahead, but try to let the Ice Lore guide your grave decision."

Mooq looked as small and nervous as Uteq, as he peered about, but Uteq saw something astonishing. As he stared passed Mooq, at Narnooq, it was as if he could see a glow coming from him, like sunlight streaming out of his old paws into the ice. Uteq sneezed and it was gone.

"Dreams," muttered Mooq bitterly. "Bad Marg spies on my sleep, and torments my dreams."

"What," growled Marg, seemingly in astonishment, "He *is* mad. It's lies. I swear it is."

"Toleg. I like big Toleg," said Mooq. "He's kind and strong as Pollooq and gives me seal blubber. Let it be Toleg Breakback."

"The Breakback wins," cried Varsaq and Marg's face contorted with fury and frustration but as he looked on, Marg seemed to be composing himself and his face cleared.

"Very well then," he whispered through gritted teeth. "I bow to the Ice Lore, of course, and the wisdom of the circle. So I hope that I Marg Leantongue may serve you loyally, Breakback, and your little cub too. The Black Paw has my life promise, as it is."

Uteq felt oddly pleased and was surprised at his father.

"Loyally, Marg?" growled Toleg, eyeing the ice block rather eagerly. "Such a very political animal? I think a Cub Clawer's spent too long among spies, and Eagaq's Scouts shall relieve you of *that* burden. We will hunt down Glawnaq's secret ally, Marg, under our very paws. So be careful."

"Yes, great Toleg," said Eagaq. "You have our word. Honour and vigilance. We'll clip that claw of yours too, Marg, old friend."

The Scouts standing there growled triumphantly and the winning Bergo looked accusingly at Marg, as if Marg was suddenly Kassima, or revealed as Glawnaq's lieutenant, while all his faction seemed to shrink backwards.

"Will no one ever trust me?" hissed Marg bitterly. "It's not my fault where I come from."

Eagaq's eyes glittered at Marg, who half-raised a paw, then thought better of showing his Seeking Claw. Instead he lifted his lean snout higher and turned to Gratiq Coldnose and his faction.

"We're done here. The world's gone as mad as Mooq, and I wash my paws of this folly. Hide from the world if you must, Breakback, and try to build your fortress, but it will return to haunt you, and us all. The Scouts are careless fools and too green to know their paws from their claws."

Marg began to turn away as proudly as he could, but he stopped and swung back again.

"And *you*, cub," he added, glaring dangerously at Uteq, "although you've my promise on the Ice Lore, Marg has his eye on

you too. So keep out of our way, and be careful not to become a misfortune to all of us indeed. If Glawnaq hears of this, and that black paw, he'll descend on us all like thunder, I know that, and take his tribute by force. So I warn you, Bergo. One-eye seeks revenge on your father too, Uteq Blackpaw, for the theft of the lovely Calmpaw."

As the Bergo started grumbling again, and Marg and his faction turned away, Toleg faced his son and pushed his snout angrily into his. "Now get back to Anarga and Bergeera who should nurse cubs and not waste a Bergo's time, you irresponsible little fool. Your mother will know how to punish you, and punish you she must."

Uteq was very hurt, but Toleg dipped his nose, and gave him such a flick the cub went shooting straight back toward the twins, as the Free Council called on Toleg to mount the ice block, and Varsaq stepped down at last. Toleg had overcome his reluctance to lead, and a brave new star had risen on the Council in the Sound.

"You both overheard?" gulped Uteq, as he slid up to the twins again under what was left of the ice cliff.

"Yes, Uteq," answered Qilaq eagerly. "You broke the Ice Lore, but our own father's a spy. Wicked."

"You broke the Lore too, Qilaq" growled Uteq indignantly. "And I didn't mean to, stupid."

"We heard everything though, Uteq," said Matta kindly, looking at him in something very close to awe. "A Twice Born, a Saviour, to be betrayed by someone close. Driven out. The Ice Saviour himself, Uteq. Or the Blaarq, at least, the Scapegoat."

Uteq blinked, for all these stories seemed so mixed up, and how could you know the truth of any of it?

"Betrayed by Marg," added Qilaq, nodding. "Or one of his filthy spies. It must be. And there'll be a murder too, Uteq. A death in the North, and then poison. Mad Mooq prophesied it. While Marg and that lot have their eyes on you now. Before you go on a great *odd-sea,* or over one, and then you're torn to shreds. It's just amazing. Poor you."

"I'm not going anywhere, idiot," snapped Uteq, "you heard what

Narnooq said about impossible signs, and I can't be this Twice Born either. I mean...what does it even mean?"

"Born once in the den," answered Qilaq sharply, "and once coming out. Born twice. That's obvious, stupid. It's all coming true then. The Great Story. But don't worry, at least Marg's lot are finished. The Scouts won the election, so we're safe here for now, though we haven't a chance of going on the Wander-to-the-Sea after all this. What a bore."

"Oh, shut up, idiot," cried Uteq desperately. "Every cub comes out of a den, and Narnooq said no one's telling it anymore, the Great Story I mean, now the Fellagorn are dead, though telling stories is lying anyhow, and wrong. Mother said so. Narnooq talked of real signs too, he heard of from this Mitherakk, not just silly black fur."

Poor Uteq felt as horribly confused as all the Bergo had, and suddenly utterly hopeless.

"But one thing's true," said Matta softly, giving Uteq her sweetest smile, "and not just because your father leads the Council now, and protects us all. Because of what you know suddenly. You're special, Uteq. Just like I said."

"But I don't want to be special, Matta," wailed Uteq miserably. "I just want to be me."

4

A WANDER TO THE SEA

"I stumbled when I saw."
—King Lear

"Oh, do try to keep up, Matta," called Qilaq in the sharp winds stinging their faces now.

The young polar bears were trotting along side by side on the snowy sea ice, just a few suns after the terrifying Council meeting and Toleg's election. Qilaq had been quite wrong though, for another great adventure had already begun for the little bears – the Wander was underway indeed, and the sea was calling them.

Ahead Uteq was riding high on his mother's back, but with Innoo still sick from the bad puffin, Anarga had agreed to take all three children on the Wander-to-the-Sea, and to suckle the twins too. She had punished Uteq only by keeping him in the den an entire day, but there were proud Scouts all across the sea ice now, guarding the Great Sound all the bright Long Day, delighted with their victory over Marg Leantongue's faction.

Under Toleg's guidance, the bears had voted not to present tribute to Glawnaq One-eye at all, and sent word via a small wolf pack the Scouts had surrounded and almost killed. Anarga and the cubs were a good two miles from the den now, trekking beneath the drifting mountains of cloud and punctures of blue sky among the racing clouds. Qilaq had just been trying to keep up with Anarga's huge,

shambling gait, and he looked jealously at Uteq, riding on her back like a little warrior.

Qilaq was feeling as tired and grumpy as Matta, because all morning Uteq had been urging Anarga to go faster. After his great slide toward the election, Uteq seemed to love speed more than anything. As yet, Anarga Calmpaw had not crossed any ice holes though, where she might have Still Hunted seal, so they would have to wait till they reached the sea to eat. For two nights they had made snow dens on the ice in the Long Day, shielding themselves from the cutting arctic winds, where the cubs had complained about the ceaseless bright light as they tried to snatch some sleep. While Anarga had had strange dreams, and Matta too had woken in the night complaining of seeing some horrid monster.

The Bergeera felt her own cub's delicious weight on her shoulders as she strode along, and she suddenly thanked Atar that he was safe after the Bergo Council. She felt sad for Matta and Qilaq though. The bonding on the Wander-to-the-Sea is a vital part of the life journey, and the twins missed Innoo desperately, even if she was always trying to control them and keep them safe.

"Mother," cried Uteq suddenly, "will you tell me about the Gurgai? Everyone seems to fear Man, especially Marg Leantongue. Cowardy cat."

"Bellarg are Ice Lords, Uteq, so we fear nothing really, as your father says. No Lera really challenge us."

"I know, Mother," said the little polar bear proudly, "but Marg thinks they're a danger, and that flying metal cormorant Seegloo spoke of was horrid, like the black blood. While the Puffin said Man isn't a Lera at all."

Anarga wondered just how many animals Uteq had been talking to, as she noticed mothers and their cubs fanned out across the ice, including nasty little Sqalloog whose own mother seemed at times to be finding it hard to find her way. Although they can congregate to sleep, polar bear mothers always like to Wander-to-the-Sea alone with their children.

"But Man *is* an animal, Uteq" growled Anarga gravely, "according

to a story father used to tell me anyway. Of a vision given to all Lera once, long ago, and a strange power called The Sight."

Uteq thought of what Mooq had said when he had suddenly looked at him at the Council. Mooq had talked of this Sight. But Anarga was thoughtful, because she remembered that her father had spoken of it as a power that came in times of great distress, and how it had touched him when he had once saved a little drowning cub from death, but fallen in the water himself and nearly drowned.

"The Sight?"

"The vision showed all the Lera that Man really comes from the animals too," said Anarga "even from the sea itself."

Uteq thought this very odd, even absurd, but he shivered slightly as his mother spoke of a vision. Uteq felt vulnerable, even sitting on top of Anarga's huge back.

"Did the Fellagorn have this funny Sight?" asked Uteq. "Matta says they could see things when they told stories, especially in the Seeing Caves, of past, present, and future. Of the heavens and the Gods."

"I don't know, my darling, but in another story father told us, there's a Lera Guardian of the power, an animal in a great, dark cave, called Pantheos. Some think this spirit was really a bear."

"Like Pollooq?" nodded Uteq excitedly. "He was this guardian. Of all the world."

"Not a white bear, though, a brown one, like our cousins in the South," corrected Anarga, noticing eight cormorants flying in neat formation above, "in the hot lands down there. And black ones too, sometimes, like your paw. They say some white bears tried to make them their slaves, and Glawnaq would do so too now, in his so-called purity."

Uteq's expression showed some doubt about brown and black bears. The little bear wondered how big the flat world was then, and how many strange things were living on it.

"And in the tale, Pantheos gave a black wolf called Fell a very magical word," Anarga went on, "made by Man, and as powerful as all the Fellagorn words put together – *Scientia*. With a kind of prophecy too, about some Gurgai female the Varg Fell loved and protected,

whose descendants would come to save Nature itself. Save the whole world. Isn't that nice, darling?"

Uteq started trying to get this strange word *Scientia* around his little pink tongue, but he could not say it properly. "Man walks on two legs too, doesn't he, Mother?" said Uteq, giving up on the word completely, "Tulqulqa."

"Yes, Uteq, and they're tool users too, just like us. Like the ice daggers a Bellarg sometimes uses to make an air hole in the ice, to fish for seal, or to kill a great walrus in its sleep. But don't think so much, darling."

A light wind was moaning about the travelling polar bears, stirring a delicious cold across their moving flanks, as their paws cut into the white, and a plaintive voice was suddenly riding on the snowy air behind them. It was Matta.

"Please, Anarga, I'm so tired. When will we reach the sea? Can't we stop now, please?"

Matta sat down on the ice and refused to budge and Qilaq looked furious with her.

"Let me down, Mother," cried Uteq with a grin, thinking of his promise to love his friend. "I'll Paw Trail you, with Qilaq and Matta, and keep her spirits up. Maybe I'll tell them about Man."

Anarga felt proud of her kindly son and bent her forelegs, as the clumsy cub fell off her back.

"Then stay firmly in my paw prints, Uteq. The Ice Lore. It's one of…"

"The Eight Commandments, yes I know. Father said so. Though I wish Father wouldn't growl so loudly sometimes. It frightens me."

Uteq got up and waddled back towards Matta, but Qilaq ran at his sister, knocking her over in the snow. As he pressed down, Matta felt a fury inside her and she tried to bite her brother hard. It was the most horrid feeling in the world, like being trapped in a snow den.

"Stop that, Qilaq," growled Anarga, swinging round. "Don't behave like a little Gorg."

"Gorg?" whispered Matta, as she looked up sharply

"The Monster Pollooq fought in the Ice Labyrinth," said Qilaq, getting off Matta. "Everyone knows that, stupid. The Gorg."

"Like in my dream," whispered Matta nervously. "Seegloo talked about the nasty Gorg. But then Seegloo just likes scaring us."

Uteq frowned. He was remembering just what had happened three days before with Seegloo. The friends had wandered up to try and join in on a game of bluffs, where one cub closes his eyes and the others run around him, until the cub catches one of the others and if they can say who they are, they have to take their place. Seegloo had been in the centre, and apart from bullying another cub he called an Offlar, bears that like staying with their own sex, he had caught hold of Uteq. But instantly alerted by the hiss of the others, had pushed Uteq off as Kassima. A pretty cub called Antiqa, with a beautiful, elegant snout, who was desperately fond of Seegloo, had tried to intervene, but Seegloo had laughed at her cruelly. When Uteq had spoken of his father's leadership though and their right to join in, Seegloo had accused Uteq and his father of betraying all the free bears, in not siding with Glawnaq and told him to leave the Sound forever, since he only meant misfortune.

Then Seegloo had run at Uteq and pushed him to the ice, pressing down on him as Qilaq had just done with Matta. "Narlaq", the other cubs had chanted, "Fight...fight...fight" and "Bergo never back down." Uteq had heard in horror too the day before that Seegloo so admired Marg and the Cub Clawers that, though by accident, he had used his own little claw to take out his mother's eye, which was why she was finding the Wander so hard. But as Uteq lay there his paw had touched Seegloo's and he had heard that voice again, had that strange feeling, then he asked why Seegloo was frightened of being alone in the dark and of snow dens. It had shaken Seegloo, for it was perfectly true, and as he had climbed off and walked away, some of the other cubs spoke of magic and witchcraft, staring hatefully at Uteq and calling him Kassima.

"Well Seegloo's horrid then," said Anarga, coming up to the three of them and looking down kindly. "And if anyone scares you, Matta,

just bite them, or tell an adult. Tell me. But yes, Matta, the Gorg was a monster, although yours was just a bad dream."

Matta scowled, for the monster she had seen was just as real and dangerous to her as anything in a story. When she had woken, the cub couldn't stop shaking for ages.

"The Gorg though was made by Atar's mate," said Anarga, "yet imprisoned by the moon goddess in walls of hard cold. Although the Pheline never believed in it, so don't worry, dear."

Qilaq grinned and Matta felt utterly sick, and furious with her horrid brother.

"Who were the Pheline though?" Qilaq asked as he shook himself. "Are any still around?"

"Just part of the legend, Qilaq. Not real, unlike the order of Fellagorn that named itself after the ancient myth. But it is good to think like Pheline, at least sometimes, for in the story the Pheline were strong and ruthless fighters. They had many brilliant bears, who saw many truths, yet upheld power and reason above all, denying the Gods, inside and out. Their first reason was themselves," explained Anarga, "so they saw the world beyond their fortress as quite separate from them, and always to be kept out. Though many of them had come from that world themselves."

Uteq remembered what Marg had said of everyone being connected.

"Many had forgotten the inner lores," said Anarga softly, "of what makes Lera too, the deepest Ice Lore, whispered in the canyons of the North. That all Lera come from the belly and mystery of Mother Nature. So the Pheline reasoned they could make all exactly equal. That Bergo and Bergeera are just the same too."

"But Bergeera *are* equal, Anarga," said Matta indignantly. "Qilaq's no better than me."

"Ah no, Matta." Anarga said, laughing and showing her teeth, but wondering what Toleg was doing, and missing him. "Of course he's no better than you, Matta. Perhaps you're better than he is."

Qilaq scowled and thought he was far better than his stupid, feeble little sister.

"Yet although there was much good in making things equal, for it began the tradition of bear Councils," said Anarga rather seriously, "perhaps Bellarg must know and respect what's different in each other too, to know what being equal really means. Do you want to be a little Bergo, Matta and you a Bergeera, Qilaq?"

"Heavens no," answered Matta in horror, getting up herself in the snow.

"Yuck," snorted Qilaq, looking sharply at Uteq. "They're the enemy, and weaklings."

Anarga frowned softly.

"Well, that will change, I think. But we must know our natures too. Promise me you'll look after one another then, and my Uteq. It's the Second Commandment, knowing who to really trust and befriend. Broken when Teela betrayed Pollooq in the story."

Matta looked at Anarga in utter horror. "Teela betrayed Pollooq? The great star herself. But why? Atar sent Teela her moon dream to help Pollooq tell stories, protect all the world and love him too, even as a friend."

"Didn't you know that?" snorted Qilaq. "Everyone knows that, Matta, even if the story is unlucky to tell. Teela betrayed Pollooq all right."

Anarga looked rather guilty, though not frightened of speaking it, as old Narnooq had seemed to be sometimes. "It's the most famous legend of all, Matta dear," she answered. "After they argued, then made friends, one day war came again with the Pheline and the Fellagorn. So mighty Pollooq, in terrible pain over Teela too, raged and roared, and slew many of the Pheline, out on the ice sheets."

"Smote them," said Qilaq with a grin.

"Why was he in terrible pain?" asked Matta, looking confused. "Teela was his best friend."

"Because secretly he still loved her," said Anarga, wondering if the cubs were too young to hear the strange story, "for he had long been alone telling stories, and trying to help the world, but with Teela he wished he hadn't broken the Lore, and backed down. He was a real Bergo too, after all, and it made him very ashamed."

Matta thought of some of the adults she had heard arguing and roaring that spring, and the cubs who looked so unhappy whenever their parents fought. But Uteq was shocked fabled Pollooq should have broken the Lore himself.

"But when he tried to tell Teela, to explain that something had made him shy of his male power, she would no longer listen," Anarga went on, "or could not hear him. So for six whole Long Days the demi-god cried out across the ice, hoping his love and friend would hear, yet she would not even answer his mighty calls. Then the Bear Rage took poor Pollooq truly, and in fear, the Pheline hurried to their very favourite Bergeera, who they loved too, and asked Teela to help them defeat Pollooq."

"Asked Teela?" gasped Matta in astonishment. "Teela was a Pheline then?"

"Of course she was, dummy," sneered Qilaq. "Don't you know anything?"

Uteq suddenly remembered Mooq talking of a terrible betrayal, to break the world's heart. Could it happen again, in reality?

"But why?" moaned Matta, feeling her little legs go weak. She had loved to think of Teela and Pollooq happy together, perhaps because she was jealous of Anarga and Toleg, and longed deep in her heart to see her father Gorteq. To have a father at all.

"Because despite her moon dream from Atar, and living as a Story-teller for a while, Teela really believed only what she saw on the sparkling surface of things," answered Anarga with a frown, "with her powerful Pheline reason. She became vain too, when Pollooq said he loved her so, and careless. Teela also loved peace, but loved her safety above all, and living in the Pheline's fortress she said poor, raging Pollooq was just mad."

"Mad? Horrid Bergeera," said Qilaq, and Matta scowled and looked confused.

"Then it was a Bergeera," said the she-bear, "a Bergeera who destroyed the Storyteller?"

"Only in the story, dear. It had nothing to do with our Fellagorn, for that's real politics. In the legend Teela went back to Pollooq, to

help her own kind against him. But you don't want a sad story like that, on a beautiful day like this," said Anarga, throwing up her graceful head. "Come on then, it's time we reached the water. We'll march hard now, rest, then make one last push for the sea."

The bears were rather relieved and set off again, the three cubs Paw Trailing Anarga now, and Uteq leading.

"I've been thinking about Marg, Uteq," called Qilaq after a while, at the back of the procession. "Perhaps he isn't Glawnaq's master spy, his lieutenant. I mean, at least he swore to protect you with his life."

"Father says he was trying to impress the Bergo," said Uteq, "for the election. Filthy liar."

"But what did he mean?" said Qilaq. "Everyone owes a life."

Uteq shrugged and realised his pads were warmer in his mother's marks as they Paw Trailed, the Fourth Commandment.

"Perhaps it's a Bergeera," suggested Matta, not wanting to be left out of such important talk. "This lieutenant."

"Oh, don't be so silly," said Qilaq. "Bergeera aren't spies. You just dig dens."

Matta squealed indignantly, determining she would be the cleverest, bravest Bergeera that ever lived, even a spy perhaps, and show her stupid brother one day.

"Though Mooq did say something about a sister," added Qilaq thoughtfully, "and betrayal. Perhaps it's you then, Matta."

Matta looked horrified, but at least they all liked this game of pretending to be vigilant grown-ups. Ahead Anarga was in a blissful world of her own, dreaming of swimming and hunting in the wild sea, yet wondering with all that had happened if there would be any Lera at all for them to eat.

"Eagaq," said Matta, jumping into another big paw mark. "He was away too. Perhaps he's—"

"No way, dummy," said Qilaq. "Eagaq leads the Scouts. Reason it out. Besides he got back the night the tern brought news of a spy far to the north, four nights after the star fell. It's just impossible."

"Oh," said Matta, though looking pleased too, "Coldnose then. Gratiq Coldnose. He's always sniffing about."

83

The three were filled with excitement, for the adult world seemed full of such thrilling secrets and they were trying to solve them. Suddenly though they spotted Tortog coming towards them. It was very unusual to see a Bergo during the Wander, but the hurrying Scout hardly paused as he neared them. He was going very fast.

"Mustn't dawdle, little paws," grunted Tortog, at a distance, "Sarq caught a lone Varg two suns back and questioned him about this master spy. He said one thing only, before Sarq bit half his tail off, and let him go. Glawnaq calls this spy his 'Scourge of Weakness' and 'Secret Cub Clawer'."

"Marg," cried Qilaq. "It *is* Marg Leantongue then. The Cub Clawer."

"Perhaps, so vigilance, and don't talk to strangers either. The Varg said something else. That this lieutenant's trying to work through cubs now."

"Through cubs," gasped Matta, and Uteq thought of Sqalloog.

"Yes. But I must get on. Honour and vigilance, cubs. Always."

The cubs were furiously wary, as Tortog ran on and the children noticed that Anarga, rather far ahead, had stopped to wait and rest. They did not see that they themselves were no longer walking in her Paw Prints. As they went on Qilaq suddenly stepped on Uteq's paw, and Uteq swung his head and looked at him in surprise.

"Wolves," he whispered. "Wolves *are* frightening, Qilaq. You don't like Varg. They scare you more than anything. But there won't be any out here."

Qilaq pulled away, as if he'd just been bitten, looking frightened and rather ashamed and suddenly Uteq felt a pain deep inside him – a kind of strange emptiness too, like loneliness itself.

"What we fear," said Matta, as she saw Anarga rising beyond, turning to call the cubs. Anarga wanted to get on, for the sea was waiting, but the she-bear looked angry seeing them out of her paw marks.

"What do you mean fear, Matta?" gulped Qilaq.

"Somehow Uteq knows what scares us all the most in life, Qilaq," whispered his little sister. "I'm sure of it. Uteq does have strange powers after all."

84

The twins stared at Uteq, who was shivering and shaking his head desperately.

"Just like Mooq," muttered Qilaq, with a nod. "Mooq said he could see into thoughts. But how? Mooq's mad."

Uteq couldn't think of anything to say, though he thought of this visionary power called The Sight. Anarga was calling loudly now, a call that cubs cannot resist, and the three turned and ran towards her as if chased by something. So the Wander-to-the-Sea resumed, the cubs in Indian file again, but as Uteq led once more, Matta and Qilaq were quite silent, too frightened to even speak. After a while though Anarga cried out, *"Agroooar."*

The ice around Anarga's paws was blue with melt-water and slush, and the mist had cleared. The cubs' hearts could have burst with joy, especially Uteq's, sweeping away thoughts of what had just happened. For before them the ice ended abruptly, and ahead stretched a vast expanse of clear, blue, open water, as far as the eye could see. The arctic sea was perfectly flat, apart from floating slabs of broken, drifting sea ice that dotted its surface here and there. In the clear crystal waters, glittering in the sun, huge white shapes reared up out of the silky sea, like small white hills.

As the astonished cubs looked on, they saw brilliant sunlight reflecting off the water, under a wonderful arctic sky, and were startled and confused, wondering whether the ice hills' summits were really in the sea or in the climbing blue heavens above them. The cubs felt as if they had just been turned upside down, and everything seemed doubled, like Matta and Qilaq themselves, and doubly beautiful for it. It was like being inside a world of frosted glass, burnished by wind and sunlight.

"The sea, Matta," gasped Uteq, breathing in the salty air deeply. "At last. But it's so wonderful and free. It's like a fable come true."

Matta was standing in the wind and pressing against it, feeling nothing more wonderful in the whole world, for it seemed to clear her head, yet offer her something bracing and utterly wild. The cubs ran toward Anarga, slithering to a stop in the melt-water around her huge legs and looking out in awe. Uteq was almost jumping up and

down on the ice, hardly understanding why he was so thrilled, or what his Garn was doing inside him. The cub could hardly contain his excitement.

Matta was trembling at the thought of going swimming though, as the wind softened and gently ruffled the ocean waves, while the bears' nostrils were filled with the clean, sharp scent of sea salt. The cubs felt as if they had come to the border of another world, or were about to step through some huge, magical passageway, to heaven knows what wonders lay on the other side.

"What are those funny mountains stuck in the water, Anarga?" cried Qilaq.

"Icebergs, dear, and they're not stuck. Bergs move, like the pack ice moves and groans in spring, although now you can only see a tiny part of them. Most lies hidden beneath the surface."

"They look just like huge polar bears," observed Matta nervously, at her brother's side.

"So we call the small bergs growlers, Matta, like brave little cubs," cried Anarga warmly. "And in the Bellargs' stories, the big ones are giant Fellagorn, though possessed by bad Beeg, brought into being by their own stories. They say things were much bigger in the olden days. Atar breathed on them though to change them into the purest ice imaginable, so save their souls, until Gog forgives them, and they're reborn. As the Great Story spoke of Resurrection. Icebergs are the giant floating Bellarg of myth."

"But that's just stupid," said Qilaq, wondering what Resurrection meant, but deciding stories were silly, and that he was really a clever Pheline, after all. So Teela had done a good thing to help overthrow them and Pollooq the Storyteller. As Uteq looked at them in the sunlight he remembered seeing that strange light from Narnooq at the Council.

"But the Fellagorn have all gone to heaven now," muttered Matta, in confusion, "flown out of their own mouths then, travelling north, to make the lovely spirit lights in the sky. The Beqorn. They light the future, Narnooq says."

"Yes, dear." Anarga smiled. "Good Fellagorn, anyway, finding the

right path. Although no one has ever seen such a thing as spirits flying from living mouths. That's just for legends too, dear."

"Like the Gods that live inside bears," suggested Matta, screwing up her face and trying to understand. "But how's that, Anarga? I mean Atar's the Moon, and Gog, the big yellow sun. I see them all the time. They're real. Outside, not inside anyone."

Anarga smiled warmly again as the children peered out at the huge, intimidating icebergs and the lovely arctic sea. It was all so brilliantly real, it seemed to press itself onto their little minds.

"Yes, Matta dear, and gold's the colour of love," said Anarga softly. "But while we must look well, with the Pheline's skill and clear eyes too, sometimes, with reason, the God and Goddess took many changing shapes. Gog sometimes came as a lightning fork, or as thunder, or even turned into a massive white caribou. Atar sometimes came as delicate ice crystals, forming on a leaf, or changed into an arctic hare. Though they say that the Gods always announce their presence in light. Gog's always chasing Atar too, for he loves her deeply. But so they change shape, just like the Pirik."

"Pirik?" said Qilaq.

"The most mysterious creature of all, Qilaq, that builds its cove at the very centre of the universe, and is said to be so sensitive, that it changes shape to reflect the spirit of everything that lives and dies. No one's ever seen it, though some say it looks like an ermine, others like a blue walrus. The Pirik must never die, because then the universe will die. So the story goes, anyway."

The twins were gawping at Anarga, loving the legend and wanting to see this fabled Pirik.

"Mother," Uteq said though, wanting to talk of practical things instead. "No one could put a border on the sea, could they? Not even Glawnaq One-eye? I mean, it's huge."

"No, Uteq," growled Anarga, sweeping her fearless gaze over the great, mysterious horizon. "Not even Glawnaq One-eye. For this promises a bear's true freedom, Uteq, always."

The cubs nodded, for it seemed utterly limitless, so huge and mighty that it had no end at all.

"Can *we* though, Mother?" whispered Uteq. "Go right to the edge?"

"That's why we're here, Uteq, darling. But don't slip, my clumsy, lovely little bear."

The three cubs waddled on together right to the edge of the sea ice. As Uteq looked down into the deep he remembered a strange dream he had had the night before. He had been looking into a chasm, but somehow had been at the bottom too, looking up at himself. But he hadn't been alone. Uteq had turned to see the shape of a dark Bergeera, watching him. She had looked a bit like Anarga, although Uteq's size, then like Matta, and he had wondered if she could be some guardian angel. Then she was gone and Uteq had been peering through transparent ice into murky waters. Things seemed to be moving there, strange misshapen things, and Uteq had thought of the Underworld of Legend. Perhaps he had dreamt it, thinking so much of the sea, but it was something that Narnooq had said that had made him think the dream important. Narnooq had told the bears to listen to their dreams, for Lera spend half their time asleep, or more, so sleeping must be as important as the time they spend awake.

"Amazing," said Matta, despite herself, awed by the mystery of it all, and the sense of new adventure it seemed to carry in its depths, despite her fears of swimming and of great white sharks.

"I told you, Matta," said Uteq happily. "It's not scary at all."

With that there was a huge splash. Anarga had vanished, but now her great white shape went streaking below the water, and Anarga began pulling herself forward down through the glistening blue, her back pads black above her as she swam. The she-bear was clearly aiming for something as she dived deep. She was under for a good four minutes, then she rose again, like a huge fish, and climbed toward some pack ice, with a living shape struggling in her mouth as she climbed onto an island of free-floating ice. Anarga's coat had changed, quite flat now, streaked grey-black and sopping wet. She had caught a large sea trout in her jaws, which she tossed into the air, then swallowed whole. Anarga felt a Garn strength blooming inside her and the she-bear shook herself, in a halo of sea droplets,

until her heavy coat was fluffy once again, with no danger of cruel ice crystals forming in the sharp wind. It was a deep part of the Ice Lore, the Sixth Commandment, and she was displaying for the cubs too.

"Look, children," cried Anarga, and to the right they saw a flash of grey underwater. "A ring-tailed seal, and female, too. That means pups about. There's good hunting here, all right."

Anarga plunged into the sea again, moving effortlessly through the glassy waters, the huge white bear's head held above the surface, filled with strength and majesty. Polar bears are enormously powerful swimmers, the best of all four-footed creatures and the blue surrounded the graceful Bergeera, and she left an elegant, rippling wake behind her, like a sea-cloak.

"She's so amazing," gasped Matta. "Is she a Goddess, Uteq? I'll never be like her."

"Yes you will," said Uteq. "When you grow up, Matta. Seegloo says everything changes."

"And then you'll love me, Uteq, like we promised? So the very waves sing of it too."

Qilaq made a face, as Anarga came clambering out of the sea again.

"By Atar," she roared. "I feel reborn, and truly clean of the stink of those filthy Varg too, for the first time since the den. But you can only truly know a thing by going among it. So who's first?"

"First?" gulped Matta.

"Some swim on the surface, Matta, others dive deep. If you do, remember to come up for air. Besides, the dipping is a very sacred moment."

"Dipping?" growled Qilaq, wrinkling his nose.

"An old Fellagorn custom. Dipping young bears in water, to remember where some say we all came from, and what truly brings life too. To carve your names in the snow mound of life."

Qilaq had just knocked a piece of heavy snow into the water and Uteq noticed a ripple go out, that made another piece of floating ice bob and tilt and sink, but still the ripple went on. Anarga swung down

89

her head, and Uteq found himself lifted into the air and sailing forward, spinning head-over-paws straight toward the freezing ocean.

"Nooooo!"

"No teacher like experience," Anarga bellowed, with a laugh. "Swim for your life then, brave cub. You were born for it. Besides, that will teach you to Paw Trail when I tell you."

"Uteq," Matta gasped, but before she could say anything to stop Anarga, Matta found herself being knocked forwards, too, with Qilaq as well. "Wooooooooaw!" the twins both cried as they went flying forwards too. Uteq was the first to feel the icy cold engulf him. He felt resentment at his mother for frightening him, and punishing him for breaking the Paw Trail, but he started to paddle instinctively and rose, bobbing up again, gasping for air. Uteq sucked in some water, and coughed and spluttered, as he broke the surface again. "Aahgrooachh."

He blinked, because Uteq had almost let out a roar, far before his time but the cub felt far less clumsy and incapable than before. His confidence was growing. Qilaq had just appeared at his side, looking equally startled and bedraggled. Qilaq grasped a large piece of floating ice, like a bogget, holding on for dear life, but little Matta was nowhere to be seen.

"Matta," Uteq called, remembering her fear, his promise, and that strange, protective voice. "Kick, Matta, as hard as you can. It's just instinct. What's inside you."

There was another splash, and the cubs felt as if the sea had parted, as Anarga streaked under them. Matta was on the surface, lifted on the she-bear's head, and they were all paddling together, as Matta and Uteq swam side by side, feeling much safer, now the adult was in the water with them.

"Let go, Qilaq," growled Anarga, as he clung in horror to his piece of ice. "Your paws might freeze to it, then you'll never get away. Trust yourself above all. Courage, dear. We're Bellarg."

Qilaq moved his paws slightly and was amazed to find the ice seeming to grasp at them, instead of the other way around. He pulled away quickly, and splashed back fully into the sea. The ice had almost hurt him, since the pads of his paws had stuck to it.

"Well done, children," growled Anarga approvingly, "and don't fight too hard. We're made for the sea – not just land. Atar and Gog make everything in its right place, in the end."

The cubs began to relax, and found it easier not to struggle. Anarga swam on ahead, moving through the sea with speed, the cubs following in her wake, again in a little line – the Paw Trailing of the Sea. The seawater was cold and wildly invigorating, while the air had many complex scents to it. All about them swam strange arctic fishes and every now and then, the cubs would hold their breath and dunk their heads. Although the seawater stung their eyes, they found the courage to peer about at the strange depths, but as they went, Matta cried out and lifted her head above the surface again.

"Your paw, Uteq. Look. Under the water."

Uteq looked down to see a trail of shimmering green that seemed to be streaming off his black paw. Especially after what had happened at the game of bluffs, he shuddered. The smoky green seemed to vanish, but Uteq heard the most extraordinary sound, coming from somewhere deep below them. *"Aaaaaooooooh. Aaarrrrwoooooh. Aaaaaooooooh."* The cub was transfixed by the deep melody which seemed to be filling the whole ocean, like a strange song, but it wasn't really frightening and as Uteq listened, it somehow reassured the bear. It was as if the sea itself was making some kind of mysterious promise.

"Phosphorescence," explained Anarga, when Qilaq swam up and asked her about the green stuff, though Anarga cried out again. "Look there, children, walrus."

A furious barking filled the air now, and straight ahead, on another flat growler, lay twenty or thirty huge seal-like shapes, like giant boulders of living blubber, groaning and roaring at the air. Except that these creatures were not grey like a seal, but a dirty brown, and far fatter and heavier, while many had huge white tusks pointing down from their ugly upper lips, and the most enormous whiskers on their funny faces.

"Do they hunt Bellarg, Anarga?" gulped Qilaq, measuring up their vast tusks warily.

"No, Qilaq," answered Anarga with a smile. "They eat clams. They're Peenar, prey, not Putnar, predators. It's all in the eyes. *Eyes to the front – hunt, Eyes to the side – hide*. Seal and walrus have eyes on the side, really. That's how you distinguish Putnar and Peenar, and why we bears must always look ahead. As clear as Phelines, sometimes."

Matta was confused again, for to be a Pheline sometimes seemed a good thing and sometimes a bad one, but the three cubs tried to look ahead boldly.

"What's that red on the ice though?" asked Qilaq suspiciously. "Red's the colour of war."

"They've been fighting for space," answered Anarga, noticing the blood and great, livid scars in many of their sides. "And they've probably been fishing too. All nature fights for space, Qilaq. It's just the Ice Lore, dear, and why we must be tough. But walrus are rather special."

"Special?" said Matta, looking at Uteq, "Why Anarga?"

"Because the females are said to be able to look at you, and tell you just what you're like. They say they're very wise, wise as snow owls, so they know things about you. Fortune-tellers."

Qilaq looked sharply at Uteq.

"But how?" asked Matta, as Qilaq wondered if he dare approach them.

"Female intuition, perhaps. Animals know things sometimes before they even happen, they say, just like the Fellagorn. Though walruses ask an offering of sea cucumbers for their skills. Come on though, let's make for that clear ice island and rest, children."

Anarga turned south and the cubs followed, not wanting to be left near the huge, scarred, fortune-telling walruses.

"What are you so happy about, Uteq?" asked Matta as they swam on.

"What mother said. What I felt and knew too, it isn't a real power at all then. It's just normal, Matta. Like growing up and being free, I suppose."

The island Anarga was headed for was a strange shape, half-iceberg, half-growler, made of flat ice too, where the four polar bears climbed

out, yet rising into a little hill of harder, weather scored ice. It was very windy here, so now the Bergeera hunched her great body around the children, opening her forearms like a cape. The Bergeera polar bear started telling them a story of Pollooq too, though Uteq interrupted her.

"The ice ark," he grunted, looking at the many floating growlers and colonies of walruses all around them, "if the ice world's really going, like everyone whispers, couldn't all the white bears just take an ice ark to safety again like in the legend?"

"Perhaps," said Anarga with a smile, feeling the twins' nipping teeth as they started to suckle. "And it's a lovely story, isn't it, Qilaq? All the artic creatures living together, two by two, until Atar sent an albatross with an ice crystal it its beak, to show them they were near firm ice again. Land."

"An albatross?" said Uteq, though it rather pleased him, because from what a bear had said at the Council he thought they were unlucky.

"The ice ark must have been huge though," said Matta, pausing as she guzzled away. "With so many Lera on it."

"And Gog tried to melt it," said Qilaq, his lips stained with milk too, "angry at Atar again. But if there were Putnar and Peenar together, why didn't the Lera eat each other? They'd have starved otherwise. That stands to reason."

Anarga sighed at such bright questions, yet thought it was true herself and that they would have died of thirst too, for you cannot drink salt water.

"Because Atar frightened the Ocean's sharks," she said quickly, "with her great light, that makes the Oceans move too, thus made sharks hunt the fish so furiously they grew wings and flew out of the waves, to escape. So they landed on the ice ark and fed the Lera. Fish saved all the animals from the Great Flood, without having to eat each other."

"Fish that fly?" cried Qilaq doubtfully. "That's impossible. Birds fly."

"And it's just not fair either," said Matta, thinking of Seegloo's

horrid description of Man's flying metal bird, that had murdered a family of Bellarg. "Why should the poor fish be gobbled up?"

Anarga had to think quickly. An adult finds it especially hard to be wrong with a cub.

"Because they aren't Lera, Matta, but Lerop, as we land animals call them, so they couldn't drown when the flood came. Fish breath water, dear, not air, like us. And there were millions of them anyway, certainly enough to feed the animals. Perhaps that's fairer."

The bear cubs were amazed fish didn't breathe air like Bellarg, and thought them just as strange as any mythical creature, but they seemed content with Anarga's answer for now.

"But let me go on telling you of Pollooq," said Anarga, "this time inside the belly of the great blue whale – the giant Moom. Pollooq was wandering again, and met a group of very wild Bergo, like Snow Raiders. Food ran scarce, and seemed to disappear, and it was as if another curse had fallen on the band of renegade bears..."

The cubs huddled together, for they hated when a curse was mentioned, and Uteq felt unnerved, as he remembered Mooq wailing about doom and the terrible fate of the Ice Saviour.

"Now these wild, cruel Bergo began to look around for a reason for their woes," said Anarga, "as all things do, and their eyes fell on Pollooq. They said he was cursed, unlucky, and so took him to the edge of the waters to sacrifice him to the Gods, like a Blaarq, the goat that carries our sins."

"Blaaaaaaarq," laughed Qilaq, glancing at Uteq.

"Even Pollooq was filled with fear, but remembered that whatever his trials, he must never blame Gog his father, or Atar his mother. So, as the other bears held him at the water's edge, he saw a great blue whale open its giant mouth, and hurled himself straight inside, to escape, but found a great miracle happened."

"Miracle?" said Qilaq sceptically, as the sun sparked everywhere. "Why was there a miracle?"

"Because the big bear was inside the vast chasm of the whale's stomach now, swallowed whole, yet the demi-god was still alive and perfectly unharmed."

The cubs were filled with awe as they imagined the shape of the giant whale's ribs around Pollooq, like a forest of skin and bones, or a strange ice cave, dripping with seawater, and the sound of a deep *plop, plop* echoed all about their little ears. Pollooq had become as small and as real as a cub to them, and they loved him even more.

"Did Pollooq escape again?" asked Uteq eagerly, but with that, they heard growling voices, real voices, coming from the other side of the berg. They were loud Bergo voices, like at the Council.

"Eagaq and the Scouts?" asked Matta, looking up keenly from Anarga's milk. "I want to show them how good I am at swimming after today. Maybe I'll be a Scout too."

"No, thick-ears," hissed Qilaq, "listen. They're whispering. It's spies in the Sound."

Anarga's little ears had come up. Ever protective of the cubs, the she-bear slowly rose and began to listen closely too, showing her teeth, her senses on full alert.

"Marg?" suggested Qilaq. "Holding some secret meeting. That Cub Clawer can't help it."

"I don't know, Qilaq, but stay well behind me, and keep quiet."

Anarga began to pad across the flat ice towards the voices. She came almost to the edge of the growler, where the rising ice dropped and bent north, to reveal another long stretch of flat ice and open sea. There stood three massive Bergo, maybe fifty yards away, staring at the glassy water and waiting.

"Who are they, Mother?" asked Uteq, poking out his head from between her legs. Anarga noticed they all had thickly bristling fur collars around their heavy throats.

"They're not from the Sound, Uteq. They must have drifted here on floating ice boggets. They're strangers."

"Why are they all looking at the water?" asked Qilaq rather loudly. Luckily, the arctic wind striking this part of the growler carried the cub's voice away, but when one of the distant Bergo suddenly spoke, his words sang clearly back at them on the wind.

"Will they come? When we spoke to that one last, he said he'd call Drang himself. We deal with no other, for our plan for the sea."

"Drang?" whispered Anarga.

"They'll be able to see us here," said the bear to his side, the largest of the three males. "Scratch and bang the ice too, like Still Hunting. Then we'll offer him Glawnaq's prize."

"Glawnaq's prize?" growled Anarga in a hiss. "Then they're Serberan, children. Ice Slayers. And almost in the Sound. But what prize?"

The boars started to bang rhythmically on the ice with their great forepaws. *Thump. Thump. Thump.*

"When we've made the pact, we'll soon be gone," said the leader. "I think we're somewhere near that Sound, so we'll swim north, as fast as any Glawneye can, and back to the Haunted Island."

"Glawneye," Qilaq almost cried in disbelief, "wow. They're more than just Ice Slayers, they're Glawnaq's trained assassins. How cool."

"The Sound, Garq?" said the second. "Glawnaq hasn't heard from his Lieutenant there yet?"

"We haven't had word from him all spring, Garq. Though he's said to be so brilliant."

"Him?" whispered Anarga. "Then it's a Bergo, all right."

Anarga looked nervously at the cubs, but now black shapes were racing through the sea towards their little ice island and the Glawneye.

"Look," gasped Uteq, seeing the creatures under the water and remembering his dream too, as if something was rising from Hell. This Garq suddenly called out in a bellowing voice.

"Welcome, the Glawneye greet you, and pay homage to the mighty orca of the deep."

"Orca," said Anarga. "They're summoning seawolves, children."

"Wolves in the sea?" said Qilaq with a shudder, who wondered how far Varg could swim and if like Gods they could change shape, while looking sharply at Uteq and his paw too.

"Killer whales, Qilaq. Seawolves, not real ones. But don't move a muscle."

Now a smooth and brilliantly black body, with white spots at its rounded nose, and a pure white lower jaw, its back topped by a

rounded black fin, rose from the icy ocean like a dream and the sea itself seemed to open. "I'm Drang," cried a booming voice, as if the sea were speaking and to the whole world. "But why do wild Bellarg summon the fearless orca of the deep?" The Killer whale tilted there, to show a huge pink tongue in its open mouth, lined with such an array of vicious, serrated teeth, that it was as if a thousand little ice daggers were contained inside it at once.

"These are strange and dangerous times, Drang," answered the Serberan leader Garq, backing away slightly on the ice, "perhaps the end of the world itself. So Glawnaq would make a secret pact and sends us to parley."

"Pact?" repeated the killer whale, rolling rather scornfully on one side, as six of his compatriots rose and started swimming rapidly around him in a circle. "That's what's rumoured in the deep, Bellarg, against the lore of the ocean. You wish our services as mercenaries to the land?"

"Indeed, Drang," answered Garq, "for Glawnaq would set borders on the very waves. It will ensure his tributes, if any misguided Bellarg resist his leadership. Now Glawnaq forces..." Garq paused. "Now Glawnaq persuades the Five Thousand to join him in his great struggle. Both Serberan and Barg too. His blessed."

As they listened Anarga pulled Qilaq back, who was straining forwards.

"Borders, bear?" snorted the killer whale, seeming confused himself now.

"Indeed, Drang. Then none will disobey Glawnaq," growled Garq proudly. "And all see his true might too, like a very god. Though a real god here on earth, not some lying Fellagorn myth."

"Disobey?" cried the killer whale, slapping the water with his flipper in amusement. "Or not *escape* him, you mean? But my Seawolves, show these fearless Bergo why we're lords of the living oceans." The killer whales turned instantly, breaking left and right, then went streaking straight toward some hapless seal, drowsing on a nearby growler. At the last moment, the speeding seawolves lifted their bodies, and the black whales came barrelling straight out of the

sea and onto the ice. In great jets of lashing foam, they snatched up four startled seals. Two orcas turned their bodies back into the sea, holding their fighting prey, while two more slid right across the growler and back into the water again with their catch.

The whales thrashed the sea into a frenzy that seemed to boil with heat as they consumed their struggling kill, and the cubs looked on in horror, as the sea went blood red. It was as if the very freedom of the oceans, a polar bear's birthright, had been snatched away, or would be if Drang ever took this strange, unnatural pact.

"Wow..." hissed Qilaq, scrunching up his little nose and feeling slightly sick. "Seawolves are wild. Pollooq could never have escaped *them*." Qilaq decided that real life was far more exciting than foolish stories, although now Uteq thought that the sea itself was this lair of the Evil One.

"Behold great Serberan," cried Drang, as the orca finished their feast. "And marvel at the orca. Although loyalty and service to the land comes at a price. A very special price too. So I want Festlar meat for Drang, as discussed."

Uteq thought of the walrus fortune tellers and wondered if everything had a price, but Garq swung his head and barked an order, and a Bergo turned and picked something up and hurled it in the air. Drang burst skyward to catch the Festlar meat and the killer whale swallowed it whole, and slapping his tail on the water, belched loudly.

"You've your pact, Serberan" he sang, clearly delighted with Glawnaq's strange prize. "For such delicious grub I swear loyalty indeed, even to your false Bellarg god Glawnaq One-eye."

"What are they feeding the nasty whale, Mother?" asked Uteq, but Anarga was backing away in utter horror, furious to shield the cubs from the terrible sight and the dreadful truth of it.

"Come away, Uteq, and don't look back. Ever. Just like Pollooq didn't in the Ice Labyrinth."

Matta was still staring at the Serberan who had brought the special prize, as the she-cub started to back off too. The Serberan was holding part of a dead animal in his paws, the white fur tinged with

red. "It's Bellarg," gasped Matta, shaking desperately. "Or one. *We're* the prize then, Anarga. Festlar meat."

Matta was right, for what the Serberan held was part of a lone bear the Glawneye had slain that very day with their clubbing paws, and brought with them to feed the orca, Festlar meat, just as they fed their wolf mercenaries on land. The wind began to whistle and moan over the sweeping, pitiless arctic. Uteq was trembling, for the cub felt as if the Long Night had come again already and as he turned, he slipped and stumbled badly on the ice.

"Come on, children," growled Anarga urgently, as Garq scented something and threw up his head in question. "We must get away, quick. We'll swim straight back to the sea ice, then go back to the Sound to tell Toleg."

"Swim?" gulped Matta. "But the horrid, shape-changing seawolves."

"They're busy now, Matta. Hurry."

All the cubs were petrified of the sea, and what lay under its surface, but as Anarga slipped quietly into the water again, on the other side of the berg, and the three children followed obediently. It was quite a way back to the sea ice stretching to the Sound, and the cubs hardly dared think of what might be behind or below them.

"Are we going home, Anarga?" asked Matta as they climbed out at last, desperately relieved to be out of the water again, and a rising sea mist cloaked the polar bears and made them feel safer.

"Not yet, Matta. I don't think I can make it, if I don't take some seal soon, and you all need my milk for the return. I wasn't expecting to feed three such greedy cubs on the Wander." Anarga led them on quickly through the mist, to get as far away as possible from the Glawneye, but as she walked she kept to the sea edge.

"A secret pact with this Drang," said Matta, "there seem so many horrid secrets, Uteq."

"And I know another," said Qilaq. "How stupid Teela really stole Pollooq's fighting power, after she went back to Pollooq, sent by her Pheline friends to betray him. Pollooq still loved her and said he'd tell

what it was if she could answer a riddle: 'What heals the wound of the white bear'?"

Qilaq was quoting Seegloo, himself too young to really understand the story, or its meaning, and Matta scrunched up her nose, but all the cubs felt wounded by what they had just seen.

"Teela couldn't answer though, so the horrid Pheline spy went to Ineq and asked him instead."

"Ineq?" said Matta, blinking at her twin.

"Pollooq's cowardly half-Fellagorn brother. A thief and liar, and always telling bad stories of Pollooq, even if they were supposed to be friends."

"How could he?" said Matta glumly. "I hope you never tell tales about me, Qilaq."

Uteq was listening intently. The old story brought vivid pictures swimming into his head.

"Anyway, hearing Teela and Ineq talking, Pollooq was hurt even more, and from a dream knew that he would be betrayed, while Ineq told Teela the greatest secret of all. That mighty Pollooq's fighting power would fail, if Teela cut off Pollooq's fur sleeves in the night."

"Fur sleeves," said Matta, and Uteq thought of his father. "Don't be so stupid, Qilaq."

"It's true, Matta. Seegloo swore it. That was the big secret of the Fellagorn. The fur at the bear's forearms, for in it flowed the power of the gods. So Teela went to Pollooq in the night and cut off his fur sleeves with an ice dagger, that melted away in the heat of the morning sun. Yet when Pollooq spoke of it with pain, Teela called him mad, and asked how she could have cut off his sleeves, when there was no tool there at all. Teela said Pollooq must have done it in his sleep with his own teeth. When Atar heard of it, she punished Teela by sending her into the heavens, alone, to be the Pole Star, which means grave misfortune for Bergo."

Qilaq glanced sharply at Uteq and then at his sister too, but grinned.

"That was a punishment?" said Matta. "I thought Teela watched

over us all, just like Pollooq's Claw does, the Great Bear. Are you sure the story's right, brother?"

"Well, don't get so upset, silly. It's only a stupid story."

"An unlucky one, though."

"And were his sleeves the secret of stories too?" asked Uteq, as Matta shivered at knowing some of the Fellagorn's lost secrets she had often wondered about in the snow den.

Qilaq frowned at Uteq's question. "I don't know, Uteq. Seegloo didn't know either."

Matta was distracted though and cried out. "Anarga, what's that?" On the edge of the sea ice, half-protruding from the ocean, was a large white shape, flapping in the brisk easterly wind. The cubs grew nervous again, as Anarga padded over to it. Soon they were sniffing at its odd scent, bumping it with their noses, or prodding it with their paws. Part of it looked like a great broken tree, although much longer, and made of a hard, white substance. Attached to it was a kind of white skin, torn and flapping in the breeze, as it slanted out of the water and snapped at the sea. Anarga led them on again though.

"That way," she cried, swinging her snout inland, and the cubs looked around questioningly in the mist. "The first lesson is how to use all your senses," explained Anarga, hoping to distract them from thoughts of Drang's terrible prize, "and to look for hidden mounds in the snow. Go on."

Anarga was tricking the cubs, who were far too young to see a kill close up, for she had scented her own target, in the opposite direction the cubs ran off in, as she galloped across the ice and reached her quarry quickly. The poor ringed seal pup was without its mother, who had gone to hunt only half an hour before. The pup was asleep, like a beached sea cucumber of pure white fur, covered in cracked snow. There was no malice or guilt in the she-bear's pounce. Anarga finished the snack quickly, and scented another meal not far away, so she took it equally dispassionately. This time though, as the bear fed, a bloodlust overcame her a little, and Anarga found herself swinging her head gloriously, and growling, spattering the ice with bright red specks of blood.

"But it's so cruel," cried a pained voice behind her. "It's terrible, Anarga."

Anarga's eyes cleared to see Matta squatting behind her and shaking badly. The adult she-bear licked her lips clean and frowned.

"No, my dear, it's just natural. But I'm sorry, I didn't mean for you to —"

"And don't be so soft," cried Qilaq brutally, who had just come up beside his twin with Uteq. "You saw that wild seawolf eating some stupid Bellarg. I love the sight of blood. A warrior colour. The colour of war."

"Shut up, Qilaq," hissed Matta angrily. "It's only because you're a Bergo."

"But we can't live on Bellarg milk alone," explained Anarga softly, seeing some of the seal left on the ice, and trying to lighten the mood. "So come and taste your first seal blood. It's delicious, and another Paw Print in the path of the great Ice Lore. For by Atar's will, Bellarg stand higher in the great Paw Prints of eating than seals, although seals are lions in the water, so to be respected too."

The children came up gingerly, but given permission by this, they started to sniff at the ice where Anarga had just eaten. As the rich, bloody scent filled their nostrils, they were suddenly licking at it hungrily. Anarga growled approvingly, as she saw Matta's sudden enthusiasm, her tongue working like an opening clam.

"There, Matta. It's yummy, isn't it? I could do with another snack too."

"Over there, Anarga," cried Qilaq. "I'll be the first though. Let's wake it up."

"Run then, children. And first one there rides on my back all the way home."

The cubs raced off, Qilaq passing Uteq easily and laughing. Uteq caught up and, passing his friend, ran straight up a little snow mound, expecting to surprise a sleeping seal cub, but stopped dead and blinked in astonishment. The cubs looked down with their mouths open, staring at the ice and what was lying there. Anarga bounded up too, worried that they were too timid to do what was natural, but as

she reached the mound, and prepared to pounce, Uteq lifted his black paw to stop her.

"No, Mother, don't." The great she-bear was almost as amazed as the cubs were. In the cradle of heaped snow just below them, lay not a seal pup, but a ball of rough white fur, rising gently up and down in its sleep. It was another polar bear cub, a pretty little Bergeera, lying curled up in a ball, sound asleep, and half covered in fallen snow. Uteq padded down the mound toward her. The sleeping cub was considerably larger than him, yet with something deeply vulnerable about her. As she lay there, she groaned softly, as if having a dreadful nightmare. "No, please. Don't. Stop."

"But where did she come from?" whispered Uteq in wonder. "Is it magic, Mother?"

The ball of fur stirred and rolled over. The cub opened her eyes, looking around and blinking, as Uteq stepped back. Her pretty, gentle eyes were huge and very black, yet as the charming bear caught sight of Anarga, then the others, she looked terrified and seemed to curl back inside herself.

"Don't worry," said Uteq, liking her immediately. "We won't harm you, will we, Mother?"

"No, my dear," said Anarga, growling protectively. "You're a Bellarg, after all. A polar bear and an Ice Lord, just like us."

"Ice Lord? But...where am I?" said the she-cub meekly, as if to be called a bear was some terrible shock.

"*Where* are you?" said Anarga in surprise, "Out on the sea ice, of course. You must have fallen asleep on the Wander-to-the-Sea. Where's your mother though, my dear?"

"M-m-m-mother?" stuttered the drowsy cub. "I...I don't know. I don't think I've got one. I...I can't remember one, anyway."

The stranger looked lost, petrified, and Uteq's heart went out to her. Her eyes reminded him of the stars and he seemed to be drawn into them, as if into some deep pool. Uteq felt the strangest feeling, that he knew this cub already from somewhere else. Had she been the creature in his dream at the bottom of that terrible chasm? But as he

smiled at her so warmly, Qilaq noticed Matta glaring at Uteq and looking hurt and angry.

"You must know, stupid," said Qilaq.

"Your father then," said Uteq kindly, but the she-cub shook her head again.

"No, I don't... I...I'm sorry."

"What's your name then?" insisted Qilaq, thrusting his snout forward, and almost touching her nose. Qilaq thought the bear rather pretty too. At last some glimmer of recognition seemed to come into the little she-bear's huge, beautiful, eyes.

"Seph..." she said, curling up her nose. "Sepharg...Yes. My name's...Sepharga."

"Sepharga? That's a lovely name," cried Anarga, "In the old language, it means 'Bright Star'."

"Bright Star," said Uteq with a smile. Matta scowled and the she-cub seemed completely surprised and wondered what old language this kind Bergeera was talking about.

"And what were you just dreaming about, Sepharga?" asked Uteq softly. Sepharga's lovely face darkened, as if she was trying to remember something she did not want to.

"Dreaming about? I don't know. I...there were...red flowers, I think."

"Flowers?" said Matta in surprise, scowling as Uteq smiled again.

"Look, Anarga. What's that?" snapped Qilaq though, seeing something else on the ice that had distracted him. Just beyond Sepharga was a strange kind of stick twisting into the oddest shape, like the spiral of a seashell.

"Just a narwhal's tusk," muttered Anarga. "Though they're rather rare."

"Please," said Sepharga, looking up at the great Bellarg pitifully, "I'm hungry."

Anarga's heart melted: "Of course, my dear, of course, and especially after that tiring dream. Come here then and suckle too."

The twins watched rather scornfully as Sepharga stepped up to

suckle from Anarga. They thought her far too large, although polar bear cubs can suckle from their mothers for up to two years in the wild. The new cub nestled safely under Anarga though and started to drink gratefully, as Qilaq marched the others off to investigate the strange narwhal's horn. Anarga had decided to adopt poor Sepharga already, and wondered what Toleg would say. She knew her mate's kind heart though and that Toleg was bound to fall in love with Sepharga too.

A way off, the three other cubs were sniffing the long tusk now and rolling it with their paws. They spent a good while investigating it, until Uteq spoke: "Narwhals are the real secret of the deep, Matta," he declared, trying to make up for showing such interest in Sepharga. "Like this Pirik Mother mentioned. No one knows how they travel, but in the dark, their eyes and tusks are so frightening, even orca flee from narwhals."

"I'm frightened sometimes," said a soft voice. The friends turned to see the larger newcomer. Sepharga had finished suckling and wandered over too. Uteq noticed that as well as her huge, deep eyes, Sepharga had a long face and rather large teeth, with prominent gums. It was a strange, unusual face, but full of strength.

"Are you spying?" asked Matta rudely, although this sudden jealousy was a horrid feeling.

"Of course not," answered Sepharga, looking offended.

"Well they're everywhere now," grunted Matta. "Spies. Even if the Scouts did win the election. Not to mention mercenaries too. Wolves and orca. We have to be careful."

Sepharga looked about warily, but Qilaq was peering at her side as she turned.

"Look," he grunted. The other two had spotted a patch of brownish fur where Sepharga's coat looked damaged. "It's you then," said Qilaq. "You're marked."

"Me?" said Sepharga, "What's me?"

"The legend, of course," said Qilaq brightly. "An Ice Saviour, come to sacrifice herself for everything. Torn apart. Don't you know anything, Sepharga? You're the Marked One then."

Sepharga looked at Qilaq in horror, and suddenly wished she had never woken up at all.

"And what are you talking about, Qilaq?" growled Matta, though oddly pleased with Sepharga's reaction. "Just because of her silly fur?"

"And a broken unicorn's horn, stupid," said Qilaq. "Remember what Narnooq said about Mitherakk and signs. And Nuuq told me about it too. How the Fellagorn liked taking real things, but weaving them into their strange legends. It's just a narwhal and its tusk. A unicorn's horn. The old word for them was Narcorn."

"And a white wing too," said Matta rather fearfully now. "Fallen from heaven."

"Right," cried her twin. "Sure signs from the gods, Matta. And think of how we found her, *magically*. Sepharga fell from heaven herself then, like a shooting star, or a Great Master's soul, straight down the Beqorn. She's the Ice Saviour, Uteq, the Marked One, sent from heaven, and not you at all."

Uteq looked at the newcomer sharply, and suddenly felt oddly jealous himself; Qilaq seemed to have warmed to the stranger and was beaming at her.

"Perhaps it *is* you then, Sepharga," he said.

"Stop," said Sepharga, looking utterly horrified. "Please. I didn't fall from heaven, I promise."

"Oh, no?" said Qilaq, with a smile. "Then where did you come from?"

"I told you, I can't remember,"

"Well nothing says this legend and Great Story is about a Bergo," said Qilaq. "Now the Fellagorn are gone, why can't we make it up ourselves? Sepharga's the Ice Saviour then. A Bergeera."

Sepharga looked tiny standing there.

"It's a lie. It isn't really a mark like that weird paw," she said, nodding her head accusingly towards Uteq, "and I'm not a spy. I'm just me."

"Well, Uteq's got powers, it's true," admitted Qilaq, looking proudly at his friend's paw.

"Powers?"

"Her, Uteq," said Matta. "Try it on her, now. Your power. Though I bet she fears everything."

Uteq reached out a paw to touch Sepharga, who gazed at him rather fondly and blinked.

"Heat," said Uteq gently. "That's what you were dreaming about, Sepharga. Red flowers."

"Stop, Uteq," said Sepharga. "You're frightening me."

"Is it true though, stupid?" said Matta irritably, regretting asking Uteq to touch Sepharga.

"Don't call the Saviour stupid, stupid," growled Qilaq loftily.

"Yes, yes it is," answered Sepharga. "I can't really remember my dreams most of the time, but I think I was dreaming of heat. It was so hot, and it hurt me somehow. My fur. But how, Uteq?"

Uteq took his paw away, and felt that strange emptiness in his belly again. A loss.

"I don't know. It's like a trembling, that tells me secrets, like voices, about what the Lera fear most. It happened first spinning with Matta, then I heard the ice cliff scream. It asked me to help."

Sepharga was looking at them all as if she had stepped into a dream indeed, but Matta seemed cross Uteq had not mentioned anything of other sounds or feelings they had shared.

"Then it *is* about you, Uteq," declared Sepharga, "this legend. Not me at all."

"Hush that. If walruses can see things, then why shouldn't I too? Maybe I'm just clever."

"Special," corrected Matta.

Sepharga looked at Matta and something resentful moved between them, for she felt safer now the handsome little bear, funny as his black paw seemed, was taking a lead.

"Don't worry though, Sepharga," said Qilaq, "I'll protect you."

"And we must promise not to say a word," Uteq said gravely. "Promise before the sea itself."

It was a phrase he had heard among the adults, the biggest thing you could promise on, really.

"They might send us both away, like guilty Blaarq" said Uteq,

wanting to tell her about the Council. "So we'll make our own pact, of secrecy. The four of us. If we're going to be friends."

Sepharga had only just been found, and certainly did not want to be sent away anywhere, but Matta was looking furiously at Uteq, and now Qilaq looked rather jealous too.

"But Uteq," Matta growled, "on the spins, you promised me. We made our own..."

"Swear it," said Uteq, just wanting all the stupid myths to go away forever. "We must trust each other now. It's the Second Commandment. *Know who to trust.*"

"I swear, Uteq," said Sepharga. "Before the sea itself."

"Come on then, idiots, form a circle."

"Circle, Uteq?" scowled Matta.

"The circle knows," said Uteq, as he nudged them into a tiny ring and looked at them in as grown-up a way as he could. He was thinking of Marg saying everything is connected too, as the two little males and females stood there in front of the ocean.

"It's a pact between the four of us then," said Uteq, "if we're going to be good, loyal friends, and friends are what really matter. A pact of four, that nothing can ever break."

5

KNOCK, KNOCK, KNOCK

"All the wise world is little else in nature
but parasites and subparasites."
—Ben Jonson, Volpone

The sun god was shining brighter than ever over the Sound, like some huge searching eye, and a mighty roaring from a waterfall tumbling down an icy cliff thundered in Uteq's ears. The rapidly growing bear cubs were changing very fast now, and the air filled with the greedy noises of insects and birdsong.

"It's so strange, Uteq," growled the newcomer Sepharga, as the four new friends marched along together. After the game of bluffs and their great oath in front of the sea itself, the other Bellarg cubs kept well clear of the four of them, and they were never separated now. "So different from winter anyway. Like magic."

High summer had come, and the arctic world had changed too, shorn of its deep winter coat. After the Wander-to-the-Sea, Toleg and Anarga had readily adopted the gentle newcomer, although Eagaq had questioned Sepharga closely, yet kindly. Although she still wondered where she had really come from, Sepharga was happy to have found such good companions. It made her feel safe again, especially after the extraordinary secret about Uteq Blackpaw, safe for the first time in as long as Sepharga could remember, which wasn't long at all. Often in the den though, Uteq had watched her sleeping and dreaming, and muttering in her sleep – "Stop. Stop it." They had had

to widen the den for two growing cubs, and Uteq had wondered what nightmares she was having.

Some had been just that, yet Sepharga had had a similar dream to Uteq's. She had been on a high ledge, then low down on the sea ice where a growling Bergo she half recognised had been near, although he had started to glow like Gog. Yet Sepharga's dreams were dimmer, and she never remembered them properly and would often ask the same question: "Where do dreams come from?"

The snow den had melted away, as had Innoo and the twins' home, and the white bear cubs had grown to the size of large German shepherds, although Sepharga, older and larger, hadn't grown as much as the others, so the three were catching up with her fast. The gull cracked arctic day was filled with a light popping too, from air bubbles bursting in the melt ice and the snow, still left on land. But the landscape had been transformed with Gog's power, into a swathe of green, dotted with the pink-white blooms of arctic wintergreens, and the red, purple blush of orchids and rosebays, as the hot winds stirred from the South, in Fellagorn myth the region of the Warrior.

Today, the four friends had decided to try pretend hunting, without Anarga or Innoo around. Qilaq was always cross with Innoo for being so clinging, although the bear mothers had been overtaken by a deep lethargy with the relative arctic heat, and so were sleeping on the edge of the transformed Sound. The adult Bergo had resorted to jumping for mice at times, with no ice from which to hunt seal, or to gather lichen and algae to eat. It was very unusual for cubs this age not to be with their mothers, as if they had stepped from Paw Trailing early, for they were all very vulnerable and an eagle could take one their size with ease.

The friends were nervous too, for grim news had come to the Sound, just the day before. Varsaq Wiseheart's body had been found in a gravel gully, pecked at by sea birds. The old leader was dead, truly gone then, suddenly and strangely, and it had sent rumours about the Sound again, especially after what Mad Mooq had said of murder. The Council had investigated and no teeth marks had been found on Varsaq at all. But they were especially weary after what Anarga had

told the bears of Drang and the orca and the proof that there was indeed some master spy among them.

"I feel weirdly vulnerable," said Sepharga. "As if everyone can see us now."

"Perhaps they can," said Matta rather coldly, jealous of how much time Sepharga and Uteq had spent in Anarga's den. Qilaq was not immune either, for he liked Sepharga more and more, while all of them seemed to find it hard to cope with strange, new emotions churning inside them. Qilaq was getting bolder by the day, and it was as if their spirits were swelling inside bodies already too small for them. Uteq thought of how exposed they had all felt at the bluffs, when Sqalloog had called him Kassima, but how Sepharga was so quiet, private and contained, naturally peaceful too, and he felt torn. He was deeply fond of Matta, and although he liked Sepharga very much, he had found she was timid and strangely nervous, with her huge eyes, while she kept asking to walk with him in the Sound. It sometimes irritated the growing Bergo.

"When Anarga builds us another den though, Uteq," said Sepharga, "we can talk and dream again, and tell more stories together too, all winter long. Snug, and secret."

Matta grimaced, for being so fascinated by the Fellagorn, Matta rather felt it her right alone to tell stories, but it suddenly sounded a little childish.

"Er, um, yes, Bergeera." Uteq almost coughed and looked away.

"You think Atar made our coats white though to protect us?" asked Sepharga suddenly. "Like Pollooq, when Atar breathed on him, so the great mammoth could find him in the dark."

"So it couldn't find him in the snows," corrected Matta angrily, "for his coat was so white."

"Oh yes, Matta."

Sepharga loved listening to Narnooq's myths, but whenever she tried to tell one of his stories she seemed to get them wrong, or miss the point of it entirely, and they always went on too long.

"Well, Seegloo says Atar didn't make our coats white at all," said Qilaq, nosing up between the females, as ever fond of telling

Sepharga things, "that it really happened over time, just so we don't stand out. Or that Bellarg with whiter coats survived. That's what many Pheline taught too."

"But the Pheline were wrong," said Sepharga, although smiling at him, since she liked Qilaq.

"Not always, mother says," said Matta, "but we're getting too old for that mammoth's fable."

"Too old, Matta?" said Sepharga in surprise. "Why? I thought you liked stories."

"Seegloo says we must all look out with reason and a brave new eye though," growled Qilaq, putting on his bravest face. "Look real life in the face, Sepharga. So maybe Gog and Atar are really just the sun and moon and there are no gods inside Bellarg at all, but only warm blood, or outside either."

"No gods? Just like the Pheline taught," said Sepharga, with a frown, "out on the ice sheets."

Sepharga had picked up the Ice Lore quickly and she seemed hungry to know everything, but Qilaq looked worried, since he so liked her, and did not want anything to come between them.

"Well, everything's changing, Sepharga. All the time. Just like my tongue."

The bear stuck out his tongue, and once a delicate pink, it had turned to a bluish black.

"That'll be as black as Marg's one sun, Qilaq," whispered Matta with a grin, as Qilaq rolled it in his mouth and tried to bite it between his teeth.

"And as for change, maybe the ice is just dying," Qilaq said, looking round again, "just like it says in the Great—"

"Hush, Qilaq," grunted Uteq. "We swore we wouldn't talk about that. The pact."

The friends felt hot and lazy now, and in the Sound, the ice break up had happened – the sea ice having moved and splintered first, groaning in all their ears. Now mighty torrents of meltwater, from land, were making for the sea, as were the bear cubs who had decided to investigate where Toleg had defeated Glawnaq One-eye; in this

Black Bay, just a few miles from their Sound. It would be the furthest they had ever gone alone before.

"You are sure it's all right to go, Uteq?" asked Sepharga. "To this Black Bay. The Council made it Kassima after all."

"As long as we don't touch anything, silly," growled Matta, lifting her head boldly.

"Unlike your mother, to make her ill," said Sepharga sharply, but she dropped her eyes. Sepharga was not unkind and she felt guilty. Uteq swung his head though. His father was striding along, coming towards them from the opposite direction. His great red sleeves hung at his forearms and he was clearly deep in thought. Toleg looked very troubled.

"Father!" Uteq called eagerly, always craving time in his company. Toleg hardly turned his head to his son, as he grunted dismissively instead.

"Not now, Uteq. Can't you see I'm worried? Play with your friends. There's much to do making a fortress of our Sound. Eternal vigilance, remember."

"But Father—"

"Do as you're told. I'm your father, cub. There are serious matters to deal with today too. Varsaq's death is a grave mystery, and there are rumours again on the winds."

"Look, Uteq," whispered Qilaq, as Toleg passed on. About three hundred yards away, Marg was walking along, swaying his own fur sleeves as vainly as ever. The sight made the friends stop dead. He was with some of his faction, including Gratiq Coldnose, and some other bears who had voted for Toleg that day. While Sqalloog, Antiqa and some other cubs brought up the rear. They noticed a little arctic robin riding on Marg's back, which fluttered away and it made them question. There were rumours Marg was speaking with the Lera. As soon as Marg caught sight of them, his beady eyes narrowed, but he just nodded coldly to Uteq and kept on walking, leading the others behind him like a little arctic court. Antiqa lifted her head as she passed, as did Matta, but both seemed to stop short of speaking, for although they had sort of made friends, they couldn't be seen to

fraternise. As Uteq and Sqalloog caught sight of each other, Sqalloog looked away sharply.

"Perhaps Varsaq *was* murdered," growled Qilaq, as thy passed on too, "by Glawnaq's master spy. They say there were no marks, but I'd like to look at his body. Perhaps they missed something."

Knock. Knock. Knock. A strange sound came on the breeze and they all jumped badly.

"What's that, Qilaq?" said Sepharga, especially startled. Qilaq shrugged as Uteq noticed three ground squirrels with sleekly pointed snouts and glistening, red-tinged fur, playing in the dirt by their hole. One was on its back between the two others, and wrestling and kicking its legs furiously.

"Why murder a bear who had stepped down already?" said Matta gloomily. "Varsaq didn't know if he was coming or going. Poor Eagaq though. He'll mourn his uncle terribly."

"I don't trust Eagaq," said Sepharga. "No bear's that nice."

The others looked at her in astonishment and Uteq resented her for saying it.

"Perhaps Varsaq felt unwanted," she added kindly. "Anarga says bears just go when they don't feel useful any more. That their spirit breaks, or vanishes, and just fails in them."

The knocking came again, to startle them once more, though the friends were reassured as they saw Eagaq in the distance, crowning a mound of raised earth, looking out defiantly, scanning the horizon with his bright eyes. The leader of the Scouts seemed hardly to sleep at all, and Eagaq was constantly keeping the Scouts in training. What Varsaq had said about his own nephew seemed to have spurred him on, and Eagaq was always consulting with the Scouts individually and never seemed to wander off carelessly now. The friends wondered if he had heard about his uncle, so often was he out abroad, as the strange knocking came once more. *Knock. Knock. Knock.*

"It's musk oxen, Sepharga," said Qilaq. "They know things others don't, they say, since they stand around so much. The males must be bashing their heads together, to prove their strength. Like Pollooq did for Teela."

"For a bit," said Sepharga rather sceptically. "Until Pollooq backed down, he and Teela made friends but then the Pheline offered Teela white whale meat to betray him."

"That story's unlucky," growled Matta. "The ancient curse. We mustn't even speak it."

Knock. Knock. Knock.

"I know," said Sepharga, jolting again, "So Narnooq won't even tell it to me properly. But at least Teela's sister Athela loved Pollooq much more, so when he turned his eyes longingly toward Teela again, in agony and rage, Athela went broken-hearted onto the ice, and was so brave that she roughened her fur and pretended to be a Bergo."

Matta looked doubtfully at Sepharga, for she did not think her brave.

"Athela told such wonderful tales, that she alone was accepted among the Fellagorn. Athela of the bright eyes, they called her, but Athela was given a Fellagorn name too, Tutsitala – the Storyteller."

"I know," said Matta irritably, "but I want to know the Fellagorn's real secrets. They died though, up there in the North, and now we never shall. Ever."

Matta sighed and as for Uteq, he still looked hurt at his father's casualness.

"They say Marg's still furious," said Qilaq now. "And Eagaq won't let him leave the Sound. Some of the others too, that can't be absolutely trusted, though it's neutralised this spy all right. Marg grumbles about the place being like a prison, and he's always moaning on about Snow Raiders and the Gurgai too."

"More and more agree with Coldnose and the Leantongue," said Matta. "About at least talking with Glawnaq, I mean. They're impressed with his pact with the seawolves too. Coldnose says it proves Glawnaq's absolute right to protect and lead all the white bears, he's so clever. Sqalloog's always going on about it."

"But he feeds his mercenaries Festlar meat," said Sepharga in disgust. "It's terrible."

The friends heard the noisy chattering of birds from a cliff nearby now, and three launched themselves out and went swooping down

the sky toward the sea. The fledglings were trying to make it to the water. Two did, but the third hit the ground hard instead, well short, and lay there helplessly, as they saw a black-brown shape scurry toward it: a hungry little wolverine cub. Uteq was staring at it, strangely fascinated by the little tragedy, which in the great sweep of nature was no tragedy at all, when he saw a big red fox dashing toward the wolverine in turn, which dropped to the ground, as if struck by something. The fox turned away and the wolverine got up and scarpered. It had just been playing dead. Uteq thought of the ice ark, and all the animals wanting to eat each other, no longer believing what Anarga had said of magic fish flying to their rescue, or cosy fables either.

"Yes," said Qilaq, not thinking the pay of Festlar meat especially horrible, "but Coldnose says that bear they fed to Drang must have been a dead Raider, and why shouldn't the Serberan kill those mani-acs? They kill all the time themselves and spread terror. That's just life. Everything fights."

Qilaq puffed out his chest and gave Sepharga his brightest smile. Next to him Uteq was thinking of something else. The strange garter snakes he had seen at the end of the spring, appearing from a cave near the Sound. In winter the arctic can easily reach forty degrees below, but these cold-blooded creatures had somehow survived underground, in secret, where the temperature hardly dropped below zero. It had appalled the bear, seeing their long black, chequered bodies, writhing out of the ground, hundreds of males entangled with each other, as they tried to soak up Gog's living heat. Uteq had wondered too how many secret creatures lived in the white arctic.

Knock. Knock. Knock. Now the eerie sound of fighting musk oxen came a final time.

It was like an unknown threat on the summer air, not from Marg or Glawnaq, Gurgai or Snow Raiders, but somehow from within nature itself. Uteq wondered if the story of Pollooq and Teela could really be unlucky, because Innoo had often sighed, as the summer grew, and talked of a strange curse.

The friends loped on cheerlessly, moving across thick, rough

grass, the ground strange under their paws, but something stranger in their young hearts.

"Should I make up a different story?" Sepharga said as cheerfully as she could. "To take our minds off spies and poor Varsaq. He wasn't very strong, or wise either, but I liked him."

"No," growled Matta. "It'll be winter before you ever finish and you'll only get it wrong."

"That wouldn't be a bad thing," said Qilaq, smiling at Sepharga. "The winter coming again, I mean. I can't wait to go Still Hunting."

"What time of year is it anyway?" said Uteq, wanting snowfall to cover them all again. The bears didn't know, but it was past the twenty-first of June already, the Solstice, when the sun began to sink toward the Long Night, until it reached sunset, around September twenty-fourth, the autumnal equinox. Qilaq had just seen a fallen log to their right though, blackened by lightning, and he almost jumped again, because the log seemed to be moving all on its own.

"Look," he growled in astonishment. "What's going on, Sepharga?"

"A black log," said Matta, "Narnooq said Fellagorn called black the magician's colour."

Matta looked guiltily at Uteq's paw, but Qilaq loped over, drawn by a smell of Lera too, and caught sight of a large, greyish egg lying there on the ground. It was nestled among some stones and moulted feathers, but near it, as he rounded the log, stood an odd little blue-white animal, its bushy tail trapped beneath the log, swiping at the egg hopelessly with a single outstretched claw. The Lera looked desperate and angry, but rather funny and Qilaq showed his teeth and grinned cruelly at it and it hissed, showing some very sharp little teeth itself. Qilaq growled loudly in return, as the others came up behind. Now the little Lera, whose face was black, with a fluffy coat that billowed around it, opened a terrified mouth and spat at Qilaq.

"Ackkkseeeeeeeeeee. Be goink, bad Bellarg."

Qilaq dropped his head now and snarled at the little animal, who desperately wanted to make for one of the numerous holes it had dug in the tundra, since the permafrost had softened so much.

"What are you?" growled Qilaq, "the stupid Pirik? I wonder what you taste like."

"Don't, Qilaq," said Sepharga, suppressing a smile. "We're pretending to hunt seal today, not fox. That's what it is, and Seegloo said arctic fox taste terrible anyhow. Like mice."

It was indeed an arctic fox, different from an ordinary red fox. The little animal was still hissing and Qilaq checked himself and smiled guiltily at Sepharga. Uteq came forward now, lifting his left paw to roll the log back, and the creature dipped her head respectfully as he made to release her. She had small black ears, and black fur around her bright, darting eyes, a pure white line running straight to her black nose.

"Thankink, gracious Ice Lord," whispered the fox sweetly, in a strange, dancing accent. "Prince of the white bears."

"Prince, pretty fox?" Uteq said, making her blush with delight at the compliment. "I think we're all too young to be called Ice Lords yet, or princes either. But thank you."

"Tis not beink true," said the she-fox, "if am knowink things, as am. You're top of Fox Prints of Eatink, big Bellarg, so is why you must be protectink all. Why Lera must be protectink Bellarg."

"Protecting?" said Uteq, thinking uncomfortably of an Ice Saviour again.

"Strong protectink weak, yes."

"Oh she's just being like that because she's scared," said Qilaq scornfully. Uteq put his black paw on top of the log, and as soon as she noticed it the fox's eyes opened in astonishment.

"Paw black," she shivered. "Black as nose on face, and many Lera are speakink of."

The friends looked at each other sharply, thinking of Marg immediately. Had Marg set other spies everywhere, just like Glawnaq and his mercenaries? If so, perhaps the Scouts and Toleg had not won at all at the election that day and unknowing were just working for the other side.

"Because Marked One is comink to save all," cried the fox, "and

meltink ice too, by sacrificink Self for Whole World. Wait till mate is hearink such poetry. Tis like mystic heart of Mother East."

"Mother East?" said Matta, as Uteq hovered over the log.

"Where Ruskova is comink from," explained the fox, dipping her winsome head politely, "and travelink many miles after Bellarg, though are finished in east. There Great Bear is over, done and dead, since tried to live communally, but not workink. Though you are helpink now, Blackpaw."

"I'm not called Blackpaw," growled Uteq angrily, "I'm just Uteq."

"And I, Ruskova," said the artic fox, straightening like a little female soldier. "Ruskova Alopa Lagop is patronymic. But way is way, bear, as heart is heart. Never changink that, in whole wide world. Nothink will, but fear, perhaps. And Ruskova is seeink deep in hearts."

Uteq looked at the fox sharply and thought of female walruses, but his own strange gift also.

"You are, pretty fox? How?"

"With mystic soul of Mother East," answered Ruskova, swinging her head toward Matta. "Poetess fox is Ruskova, so just look at her. She's likink you, plain as stealink bird's eggs. Jealous too though."

Matta was embarrassed at this and showed her teeth but she could hardly deny her feelings, and Uteq remembered something Mooq had said at the Council about a sister's betrayal.

"And her," said Ruskova, turning to look at Sepharga, but frowning softly and shaking her head, "she's beink lost. Then, are not all lost, no? Wanderink souls that Lera are."

"How do you see these things?" insisted Uteq, looking at his friends very significantly.

"Am seeink with eyes first, and Pheline reason sometimes too. But sensink also, before knowink in head. With what best Lera have. Heart and intuition."

Matta and Sepharga glanced at each other and wondered if they had some special power too, for their senses seemed to be expanding with the summer, but Uteq nodded gravely.

"And me?" growled Qilaq, padding closer, dipping his snout and

wondering if the fox would talk of wolves, and his own secret fear of the Varg in the night. He felt rather nervous.

"Bad one, am thinkink. Like demon Beeg. Can't trust tail length."

Uteq looked hard at Qilaq, and a cloud darkened the sun.

"I'm not bad, Fox, and if you see things, it's not as good as Uteq's powers, stupid poet."

"Stop that, Qilaq," snapped Uteq, "nothing's happened since the Wander. I'm free of them, if powers they were at all."

Ruskova looked sharply at Uteq and then Qilaq, who raised an open claw to cuff or kill her.

"Don't, Qilaq," growled Uteq, "Leave her be. She means no harm, and is smaller than you."

"But Uteq, don't be weak, she's just a stupid, evil little scavenger. Ice Lords shouldn't even talk to them. I bet she wants paying in sea cucumbers or something, like the walrus."

Scavenger was no compliment among polar bears, but Ruskova didn't seem to mind a bit, for like her kind, her greatest skill was indeed scavenging, and stealing eggs, or setting off onto the ice in winter, and drifting for days on the ice floes in the Long Night, chasing polar bears in search of the food and scraps they left behind them.

"Scavenger Ruskova is, and scavenger proud," cried the fox. "And what's beink wrong, silly Bellarg? If all Lera had to kill for supper, how long are thinkink World lasts, or Prints of Eating?"

Qilaq hadn't ever really thought of this, but he was still furious for what the strange fox had said about him and looked resentfully at Sepharga.

"Though evil is not word we use in East," said the fox loftily, glaring at Qilaq, "above all poets far to east. Here in west, big bears conquer, and talk good and bad so easy, but far in mystic East they say such words make beinks misunderstand. For world is not black and white, Bellarg."

Qilaq was about to swing at Ruskova when Uteq rolled back the log completely, and the lovely arctic fox sprang free.

"Thankink, Blackpaw," she cried, dipping her head gracefully and

flashing her brilliant eyes, but looking sadly at her enormous, bushy and now very bruised tail, "and now am takink big egg home to eat. Yum. Lazy mate never is huntink for family, as should be. Cubs starve."

"No," said Uteq, though hardly knowing why. "A life for a life seems only fair, pretty fox."

Ruskova blinked at him but Sepharga was smiling at Uteq and the fox's face lit up.

"Not even in pay for future?" she whispered with a grin. "Very well, poet bear. And sense of justice are havink, fine Bellarg. Now Fox must be goink. But warnink too, for nature is not made of easy justice. So be watchink, Ice Lords."

"Watching?" growled Qilaq, looking round sharply, wondering of what nature was made.

"Seeink hard, with full awareness and spirit. Others say bad Glawnaq moves far south this winter, after bringing Barg to help. Mighty Glawnaq is hearink Lera whispering of mark though."

Uteq looked back in horror.

"And listenink starts as ice melts, and whole world dies," said Ruskova gravely. "Deep listenink, Bellarg, in belly of nature. Rumours spread, like black blood in arctic sea, that poison Lera."

"And your father, Uteq," said Matta, "I bet One-eye stills wants revenge on him."

"Yet others say One-eye and Serberan will go elsewhere first, to gather more mercenaries and Barg too, and Glawnaq is not knowink where mark is yet. Still secret."

"The Blessed," whispered Matta, for she had often wondered what they did, "These Barg. But perhaps Glawnaq's heard about Sepharga. She's marked, too, remember."

Sepharga scowled at Matta, but the Arctic Fox darted off into the undergrowth and the bears' gaze followed her. She stopped and looked back. Beside her were six beautiful cubs, their almost perfectly grey fur tinged with white around their throats, muzzles, and little ears. They stood in a quivering line by their mother, gazing in awe at the four polar bear cubs, gigantic compared to them.

"Be seeink Blackpaw well, childlinks," cried the Fox poetess, raising her tail. "He's mystic destiny that one, like Mother East, but terrible burden too. Of whole world, poor, lonely Bellarg."

Ruskova shot down a hole they had not noticed in the undergrowth, and with a strange kind of chirping, her cubs followed their mother back into the safety of their winding, warm-earthed set. The four friends were going to walk on once more, but Sepharga stopped them.

"What about the egg, Uteq?"

Matta looked scornful and Uteq bemused, as he peered down and wondered what a fresh warm egg, boiled by the great sun, tasted like. His stomach rumbled.

"We can't just leave it here, Uteq, exposed, like I was out on the ice sheets. It's not fair."

"But it's just an egg, silly," said Matta. "Step on it, Sepharga."

Uteq bent down and gently rolled the large egg with his nose toward a snowy clump of wild heather, and left it there, resting in the gorse, as the warming sun shone down and made it gleam. So the young friends set off again, not noticing the egg quiver in the gorse and crack, and a little head pop out and look around, spotting Uteq immediately. It seemed rather lost and opened its beak, as the Bellarg walked away and left it all alone there in the tundra, chirruping helplessly.

"What she said," whispered Qilaq, as they wandered on, "I think we should keep an eye on Sqalloog. Remember Tortog said this spy was working through cubs. If Sqalloog knows Glawnaq's lieutenant he may give him away. Sqalloog's always showing off to the others, especially in front of Antiqa."

"Ruskova talked of poison too," said Matta, frowning thoughtfully. "Just like Mooq did. Perhaps then poor Varsaq was..."

Uteq was not listening, glancing up at the sun, as happily as he had after seeing the Walruses. Ruskova's clear proof of foxes' intuition had again persuaded hin he had no real powers at all and could not possibly be this Ice Saviour.

Suddenly the bears came to the edge of a slope, and looked down

at the sweeping sea. Among the small bergs, and bits of ice still floating in the summer waters, the blue arctic was filled with living white shapes. There were thousands of them, streaming into the little bay below, by a scrubby shingle beach, and the Great Sound beyond, like swirling currents themselves, stretching for miles below the glistening blue surface. They were large sea Lera, as white as snow.

"Orca?" gulped Sepharga.

"Mimiq," said Qilaq. "Beluga whales. Sometimes they're called sea canaries."

Qilaq was right, for the entire sea seemed filled with white beluga. Every so often a strange rubbery head, with beady eyes and a happy, youthful face, would breach the surface and send up a great snort of sparkling water into the summer air. It seemed as if the sea itself was breathing.

"They can blow perfect bubbles," grinned Qilaq. "In circles, underwater."

"But it's wonderful," said Sepharga, loving the sight too and smiling warmly. "And if there are so many, it can't be true what they say of the Lera dying, can it? Or our ice world failing."

"I don't know," murmured Uteq, breathing in the salt air deeply. "I hope not."

Sepharga seemed to have a sad thought though.

"White whales, is that what the Pheline offered Teela then to betray Pollooq? White whale meat? Just like some horrid mercenary."

"Stop being so unlucky," snapped Matta, "and this is real life. Don't mix them up."

Matta stopped though and looked guiltily at her friends, then grinned. The sea itself had reminded them of their oath and now she noticed a host of birds by the shore, and it made her smile and feel less cross. They had black bodies and curved orange beaks. They were arctic puffins.

"*One for sadness, two to be,*" growled Matta, quoting an old rhyme that Seegloo had taught her, about what fortune it meant to even see a puffin, "*Three for a she-cub, four a He.*"

Qilaq was looking gravely at the rocks around the puffin though.

The beach was stained with pools of a thick, sticky black substance, like sunless puddles of dark slime.

"The black blood," he growled, sniffing the air now and wincing. "It's still everywhere then. What did Ruskova mean it's spreading like rumours, although it poisoned our mother all right?"

"It came out of that then," said Matta, gazing at a great metal object lying mournfully on its side in the surf, rusting badly away. "That must be the metal belly the Humans made."

As soon as Matta said it, and Uteq thought of the Seventh Commandment, not to eat anything bad, he jolted, because as he looked the lovely white beluga in the sea turned black, just as the bears had done that terrifying day at the Free Council. Uteq said nothing, but as he blinked and breathed out, the whales went white again and the sea was calm and clear once more, filled with moving life.

"Come on," he grunted, eager to see where his father had wounded Glawnaq in their fight by a great boulder, apparently. He led the others to a break in the rocks and a path leading down to the beach. The friends were excited to reach the sea again, and they split up in the sunshine, nosing about or dipping their paws in the edge of the surf. As Uteq stood there, watching the wonderful beluga whales snorting and playing just below the surface, he had the feeling he stood at the edge of the entire world and looked out hopefully across the great horizon. With no icebergs, the flat, blue ocean gave him a sudden deep sense of calm, although now he noticed a small fish caught in a rock pool to his right. He smelt it in his nostrils first, and since the hot sun had evaporated most of the water, it's back was exposed, glistening with brilliant, shining scales. Uteq gave a growl, dropped his head and licked it, tasting the taste of fish and salt on his own wet lips, but startled that the fish's translucent back was already so hot that it burnt him slightly.

Uteq pulled back sharply and had the most extraordinary sensation. He heard the sighing waves and the sea birds calling, and he tasted the complex richness of the fish in his mouth. He felt his paws strong on the shingle and the wind wild in his coat. The sunlight

flashed so brilliantly on the water that everything took on the most amazing brightness and intense reality. Uteq was there, yet not there, part of it all, but utterly separate too, and as the colours around him grew so strong that they seemed to darken, Uteq felt a profound sense both of fear and danger, so that he groaned and swung his snout back, breaking the rock pool open and letting the fish escape.

The intensity was gone, the ordinary, extraordinary day restored and Uteq heard his friends talking again, and with a sigh of relief turned back to them. As he reached them though they could all smell the horrid scent everywhere now, making them growl and wince, as Uteq noticed many dead puffin bodies lying stiffly in the shingle.

"Don't touch anything," said Sepharga, trying to tread as lightly as possible. "It's unclean. Kassima."

"And if it came from the metal belly," growled Qilaq, "where did *that* thing come from?"

Uteq was looking around, wondering where his father's great battle had happened, for he could see no giant boulder, just a small one, then stepped right in a little puddle of the black blood, and as it squelched, he lifted his paw in disgust. The strange dark gloop dripped off his black fur, but Uteq's paw started tingling, more furiously than ever, and his eyes grew glassy and staring.

"The Gurgai," he growled, his paw shaking almost uncontrollably. "Man. The belly and blood do come from the Gurgai then, Qilaq." Uteq paused though. "No, Qilaq. This doesn't."

The vibration came stronger still, and then that whispering – the voice, except there were two voices now, like Anarga's and Toleg's mingled together. Then something else happened, something quite terrifying, that drove away Uteq's reassurance about Ruskova's sensitivity, or animals' instincts, forever.

"But what's happening to me?"

"You can hear something again, can't you, Uteq?" asked Matta softly, wanting to hug him close. Uteq's eyes had opened in astonishment, and he suddenly remembered Anarga and Mooq talking about some power of The Sight, and of an ancient vision of Man too, given to all the animals.

"No, Matta. I can *see* something."

"See?" growled the twins and Sepharga looked nervously at them both.

"Yes. It's like looking out across the Sound. And the black blood isn't from the Gurgai, at all. I mean it is, or they collect it, yes, or I think they do, but the black blood...It's really..."

"Really?" the twins both cried, as Uteq stopped without answering and came out of his sudden trance, sniffing strangely at the black blood, still dripping from his paw as if he had cut himself. The bear looked at it accusingly.

"I don't really know. I...I saw a great forest of trees falling to the ground, and changing, and it's so strange. Like something I can't put my paw on. But I don't think it's blood, or not exactly."

The bears stared at Uteq as if he were as mad as Mad Mooq and gazed at each other. How could trees turn to blood? It was quite crazy. Uteq remembered something Mooq had moaned about the Ice Saviour drowning in the blood of the whole world.

"And it was so odd," said Uteq, "Like...like looking back in time, somehow."

"Back in time?" whispered Sepharga.

"More powers, Uteq Strangenose?" said Qilaq, as he tried to laugh. "Whatever next?"

Sepharga had stiffened in her own paw marks though, and was starting to shake too.

"Oh, not you, as well," growled Matta. "Maybe it *is* both of you then. This Marked One."

"What's wrong, Sepharga?" asked Uteq, thinking she was frightened of the beluga whales. "They're safe in the sea, and they're only Peenar. Prey, not Predators."

"No, Uteq, there."

Sepharga had had no vision but was staring straight out to sea, where, in the distance, the she-bear had spied a tiny white triangular shape, moving steadily across their line of sight on the far horizon. It was real, travelling past the great arctic Sound, on the very shores of their secret world.

"What is it?" whispered Qilaq, squinting hard as he came up beside Sepharga. To the friends it looked just like a broken gull's wing, except that it was held perfectly upright, attached to something large and blue below it, moving smoothly over the surface of the open ocean.

"I remember now," said Sepharga, as her eyes filled with mystery and fear. "That's how I got here. Below a wing, just like that one. Into the Great Sound."

"A wing?" said Uteq in confusion. "Oh what are you talking about?"

"The Gurgai, Uteq. They brought me to the Sound. Man brought me here to you."

"Man?" cried Matta in horror. "Don't be so daft, Sepharga, they couldn't have. They're Kassima, and from another world. Why would they do such a thing?"

"An Odyssey," suggested Qilaq, who had talked about the word and its meaning with old Narnooq, "an Odyssey amongst Man. But not coming back from them," he added with a shrug, and looking confused. Sepharga's eyes were closed though, and her voice sounded mournful and in pain, as she spoke once more. She was shivering terribly.

"They *did* bring me here, I swear it, like the Gurgai who put that collar around your mother's neck, somehow. We all know that. Please believe me then. You're my friends."

Matta and Qilaq's eyes narrowed doubtfully. They often wondered about their mother, and why she had no memory of such a terrible thing as a collar. It seemed impossible. The cubs were staring out at the moving wing still, gliding across the water, but now as if Glawnaq himself had just invaded their world, and brought their fortress down already.

"Perhaps not even Father can keep the world out then," said Uteq.

"And maybe we *should* join Glawnaq," said Matta, remembering Seegloo's description of the awful humans. "And his orca mercenaries can protect us from the Gurgai. A real border, wide as the sea itself,

and forever. They could attack that evil thing, for a start. Sink it in the ocean."

"That's just fear talking, sister," said Qilaq gravely.

"At least we wouldn't have to live with spies, rumours and the passing words all the time."

"Then a raging wind blew in the night," muttered Sepharga though, "and the great gull's wing broke, and we all went into the water, Gurgai and Lera, drowning together. That's how I landed on the sea ice, with that strange skin nearby. Please believe me."

"I believe you," said Uteq kindly, as she opened her eyes and they cleared. "You *did* come from their world. The Gurgai brought you here, in one of those things. But what can it all mean?"

"They're Kassima." shuddered Matta. "That's what it means. Against the Fourth Commandment. So Toleg's fortress is ended. The curse is come indeed, just like Mother says."

As Matta said it, and they stood there motionless, the wind rose and Uteq heard a voice again, all around him, as if from nowhere, singing like some ancient riddle, whispering through the arctic ice caves and the dreams of all the world: "*Show us then Blackpaw. Show us what heals the Wound of the White Bear?*"

6

THE WOUND OF THE WHITE BEAR

"Eyeless in Gaza at the mill with slaves."
—John Milton, "Samson Agonistes"

Pretty, long-faced Sepharga shivered delightedly as the dawn wind threw a handful of snowflakes into her delicate snout, as if cleaning off the stench of the black blood, and the terrible revelation that Man had brought her here to the Great Sound. It was many weeks since their strange visions in the Black Bay, real and imagined, and now the Long Night was returning again, although they were still in the twilight, before the true arctic sunset.

The air though had a wild, eerie quality about it, almost sinister and foreboding. The growing polar bears had marvelled at the black skies in the nights, for they had begun to see the stars, for the first time properly, myriads pricking through the endless black. It made them all think of the gods, or awoke strange thoughts deep in their beings, as they saw Teela twinkling in the North, like some promise fulfilled from stories, or some warning, as they marvelled at the constellation of Pollooq's Claw, the Great Bear. Yet they could see now that where Teela was fixed and static, stars in Pollooq's Claw seemed to roam the black heavens themselves, like hunting Bergo, seeking their mark.

As he stood beside her Uteq smiled at his adopted sister and nodded in the freezing fall day. The young bear was feeling vulnerable though, because nothing could clean away the memories of that

29

extraordinary vision of the black blood, that had brought back Mad Mooq's words. The twins though growled approvingly in the icy winds, equally delighted, as they stood in a line of four, gazing straight out to sea.

"I feel so warm in my new winter coat, Sepharga," said Qilaq, who was more and more impressed with the pretty Bergeera now he knew that she had such a great secret. The Bergo was nearly half an adult's size and often wanted to show his strength to the others, especially Sepharga.

"Good morning, youngsters," called a friendly voice. "And where are you off to?"

Sarq was striding toward them. The rather feminine scout looked shaggier with his own winter coat, but his face was as keen and alert as ever.

"Still Hunting," answered Qilaq. "Our first real hunt, Sarq. And you?"

"Scouting, not mucking about like cubs. I'm off to find Tortog though," added Sarq, looking as though he missed his friend. "Be careful today, strangers were spotted nearby, but two suns back."

"Serberan?" asked Qilaq, for many rumours came from the North now.

"We don't know, Qilaq. They might have been Snow Raiders, that passed on. There was a bad blizzard. Yet they could as easily have been Glawnaq's Serberan. They range far, or so we hear."

The friends looked nervous. Ruskova had said that Glawnaq did not know where this Marked One was, but as winter had approached again, and many Bergeera had prepared to build new snow dens, a strange expectation had descended on all, and a fear of harder, more brutal times. Toleg had almost trebled the Scouts around the free bears, drawing on many newcomers, who had heard of his courage and fighting strength, and his defiance of Glawnaq's ultimatums. It was not just because of Glawnaq though, it was because of Sepharga's sighting of Man, that had troubled the free bears deeply, although in normal times they might not have been so wary of mere Gurgai.

Practically every Bergo there, including Narnooq of the North,

and a very reluctant Seegloo, were in the Scouts now, to make sure that nothing could get into the Sound. Toleg had had bears stationed miles inland, to make sure that word of any advancing Serberan reached them immediately. As they stood there the young bears could see several Scouts ranging over the sea ice now, and all felt suddenly very safe indeed in Toleg's proud arctic fortress.

"But don't worry," growled Sarq. "We'd recognise the One-eye immediately if we saw him."

They all grinned, yet, precisely because Glawnaq had never approached, the Great Sound seemed the only place in the entire region where there were really any free Bellarg left.

"I wonder what he really looks like," said Uteq, trying to look as brave and strong as his father.

"And you'll never have to know, Uteq," said Sarq. "Besides, he's far to the north all right."

"How do you know that?" asked Matta.

"Because Eagaq took out a scouting party a moon back, and travelled day and night to reckie. He's so bold he even climbed a land berg, at the risk of being spotted, and said he saw Glawnaq in the far distance, surrounded by his special bodyguard. The Glawneye. They were moving away too, so we're certainly safe, for a while at least. Good old Eagaq."

It reassured them all.

"And yet there are the Gurgai too now, to worry about," said Matta, glancing at Sepharga.

"Perhaps," said Sarq, "but on the ice you're doubly protected, even from ordinary Serberan."

"Doubly, Sarq?" said Sepharga sceptically.

"Haven't you heard? Uteq's father has ordered different words of passing on land and ice, so no strangers can sneak through at all. It was old Narnooq's idea. I never had such a luxury as a cub."

"Oh really," said Matta, but she looked strangely guilty and glanced away.

"So if any bears were coming from inland, they'd have to know both words of passing, and we don't share both, even among the

Scouts, for added safety. Only Toleg gives them out. But watch it Matta – Marg has been let onto the ice today, since he keeps complaining about a prison in the Sound. You know, I think Eagaq's almost sorry for him."

"Marg hasn't done anything though," growled Uteq, frowning. "He just seems to watch us all."

"And wait, perhaps," said Sarq, raising an eyebrow significantly. "But good hunting all. Eat well, and I'll see you in the Sound. Honour and Vigilance."

Sarq lumbered away, keen to find Tortog, and the four stood waiting in the cold. As Uteq watched Sarq on the ice, it suddenly seemed as if a light was coming from his paws and spilling out onto the ice, just as it had from Narnooq at the Council. It only lasted a second and perhaps it was just a trick of the twilight.

"Mother said she'll meet us here," growled Uteq. "For the Still Hunt."

They all looked out toward the sea. The ice had expanded gloriously, first a thickening slush, as temperatures plunged, then to hard, clean ice. So there was plenty of space to range wild, and hunt, and since they would be looking for ice holes, it would not even take them as far as the sea edge, and so near any dangerous orca mercenaries.

"Can I go with you, Uteq?" asked Sepharga, as Qilaq frowned. "I'll feel safer."

Uteq didn't know what to say. Only the day before he had promised Matta to hunt with her, but Anarga and Toleg were always asking him to look after his adopted sister, so he just shrugged and nodded.

"Oh, Uteq," growled Matta, "don't promises mean anything to you anymore? You and Sepharga spend so much time together I've even thought of making friends of Sqalloog."

Uteq reached out with his black paw to touch Matta kindly, but shuddered, as he heard a Bergo voice again, soft and menacing. *"Alive,"* Uteq grunted, blinking at Matta in surprise. "But how did you know that, Matta?"

"Know what?" asked Sepharga.

"Today's word of passing on the ice," answered Uteq, tilting his head questioningly. "It's *Alive*, isn't it, Matta? You knew."

Qilaq swung his head towards Uteq as he held his paw against his sister.

"That's more than just instinct talking," Qilaq whispered. "Something so very specific, Uteq."

Uteq pulled away, and to his astonishment, Matta swung her head and chuffed at him angrily.

"Don't, Uteq, that hurt."

Uteq blinked, for he had not felt a thing and looked surprised.

"But no one's supposed to know but the Scouts, Matta." said Qilaq accusingly, wondering what had just happened, and they all looked at Matta sharply. Qilaq's sister was trembling.

"No, Qilaq. I...I heard Sarq give it to Tortog." Matta admitted. "I was just listening out for this spy again, and watching Sqalloog, so I found out by mistake. What's wrong with that?"

"Nothing, but you haven't told anyone, I hope," asked Qilaq rather angrily. Matta paused and something strange came into her face.

"No, Qilaq, of course not, brother, why should I?"

She glanced away again and seemed to have something on her mind.

"It doesn't matter," said Uteq, "we're guarded well, all right. Nothing can touch us out here."

They heard a roar and saw Anarga, Nuuq, and Innoo lumbering toward them across the snow, from the North. Innoo looked almost fully herself, for her coat seemed shinier, although her collar seemed to be irritating her. Nuuq, who had spent more time talking to Eagaq, much to Seegloo's dismay, had a springing quality in her step, for she'd heard that Eagaq was out on the ice today.

"Good, my cubs," growled Anarga, as she reached them, "now stay close, and keep away from the sea, when we've crossed the ice. You must be responsible today, and stay alert always."

"The Gurgai are bad enough," said Innoo, "but orca may be around too and they've a taste for Bellarg now, Snow Raiders or not.

How I wish your father would return though, children. It's high time, even for a wandering, feckless Bergo like Gorteq."

The twins realised they had not told Innoo their father had been spying for the Council.

"Come, Sepharga dear," said Anarga. "I want to try the snow later for digging, and show you a Bergeera's true art too, Still Hunting, so stay close, and we'll talk together, my gentle one."

Matta looked rather hurt, for Anarga had grown desperately fond of the quiet she-bear, but Anarga bellowed and lifted her head, turning again and leading them out again across the sea ice.

"But how do we find seal this time, Anarga?" called Qilaq eagerly. "There won't be sleepy little pups anymore, too small to dive to safety into the icy sea."

Only recently Qilaq had learnt that seal pups stay on the ice because they are so small they might freeze in the chilly spring waters.

"Nuuq's nose, of course, Qilaq. It's famous. Just like her instincts."

Nuuq smiled, reared up on her slender haunches and began sniffing furiously at the air, licking it with her blue-black tongue. Innoo looked at her in surprise.

"Surely you can't have caught a seal scent so soon, Nuuq?"

"Don't be so daft, Innoo. It smells like lovely, fresh snow, from the very highest arctic. It'll be a cold winter up there, I can smell it."

In front of the ranging polar bears, the great expanses of sweeping sea ice were completely purple in the twilight after the equinox. Gog's huge face, very low on the arctic horizon, at the end of the great, flat world, hung a sombre orange red, in the hazy purple skies. The sharpest winds were from the west, the region of change and magic to the Fellagorn, and perhaps the greatest mysteries and secrets of all, or so they had told before the Warrior Storytellers had all been slain. So the bears travelled out across the ice for nearly half a day, busy with their own racing thoughts, but very excited as Anarga chatted warmly to Sepharga.

"Anarga," said Sepharga as they went, growing bored of her

constant talk of digging snow dens, "will you tell us what happened after Teela cut Pollooq's fur sleeves? I've always wondered."

"That's very unlucky, Sepharga dear," Innoo scolded as ever, "and you're still too young,"

"Why though?" said Sepharga, a little indignantly, who no longer felt herself so young at all.

"Because the Fellagorn believed that their words, and so their stories, could make things actually happen, dear, good or bad."

"That's what I don't understand," said Sepharga. "How could telling a story alone *do* anything?"

"Well, er, I don't really know. But we mustn't doubt, must we? The gods, or the old ways, I mean. Besides, I think they called it the Word Power, and they say even a Fellagorn voice could somehow mesmerise others. Anyway, it's not a nice tale, for it speaks of the ancient curse."

"We're not too young though," said Qilaq. "We're old enough to hunt and kill."

"And they have to grow up too, Innoo," said Anarga, with a sigh, not really wanting them to, but knowing it was all part of the Ice Lore. "So I'll tell it properly now. Besides, only the Fellagorn's words came true anyway, Innoo, and they're gone forever. Let me see, then. Yes. When the Pheline came to her, Teela was terrified of Pollooq's fury, because she had dreamt of a monster inside herself, but thought it was really Pollooq, whose roars were as loud as the sea itself, as he called and cried out to her in his love and longing. For none had roared as loud as great Pollooq, when the Fellagorn tried to stop time itself."

"Stop time, Anarga?" said Matta.

"Yes, Matta. When he lost Teela and realised he did not wish just friendship from her after all, but life and cubs, Pollooq tried to use the Fellagorn power to stop the stars drifting in the skies, and to freeze the oceans themselves, and so turn the seasons back again, in his terrible grief and pain."

"But could the Fellagorn really do such mighty things with their words alone?" whispered Matta.

"Such love," said Sepharga admiringly, as Qilaq glanced at her fondly, "Poor Pollooq."

"Yes, Sepharga, poor Pollooq. But then the Pheline sent Teela to him, and great Pollooq knew he would be betrayed, through another dream from the Gods. Yet seeing the she-bear he loved so deeply again, his bear rage cooled, and Pollooq hugged Teela once more, and found himself at peace again."

"Peace," said Sepharga wistfully. "I love peace. Like swimming in a calm and lovely sea."

"Yet that Long Night Teela took an ice dagger from Pollooq's brother Ineq," said Anarga gravely, "and when the Long Day came, Pollooq's proud fur sleeves, the secret of his strength, lay dying in the snows, although the ice dagger melted away. So the Pheline fell on Pollooq, and captured all his Fellagorn, lost without their heroic leader, and made them all their slaves."

The growing cubs were listening intently.

"Mighty Pollooq, his arms like ice blocks, with a growl like thunder, tried to fight them off, but with his magic sleeves cut, he only struggled helplessly in the Pheline's paws, telling them of his pain over Teela, and of the betrayal of stories too, of magic and the Gods. But the Pheline laughed and said there is no magic, and that Pollooq could not see with Truth at all, as the Pheline could see, with their clear and reasoning eyes. They called him mad – and a liar, just as Teela had done."

"'I can see nothing, Pheline,' Pollooq moaned bitterly, closing his heavy eyelids, 'for Gog the father is ashamed to look on me, and Atar my mother too, so I must go into the dark, away from the eyes of Heaven and of proud and noble warriors. Down into the very Underworld, perhaps to Hell.'"

Uteq shivered.

"The Pheline though did not believe in Heaven or Hell, and thought Pollooq meant these words literally, for in truth, although many Pheline were clever, they had no metaphors. But still fearing Pollooq, they took him up to a dark ice cave, at the very heart of their fortress world," growled Anarga as the air seemed to darken and a

breeze came up, while she found herself rather enchanted with her own words, "on a great spit of ice pushing out into the sea. There, between two mighty pillars, a stalactite and stalagmite, they stretched out Pollooq's great arms, shorn of their sleeves, and lifted him on his great hind legs, Tulqulqa. Like a Man."

"A human," whispered Matta, shivering and remembering the sail in the bay.

"Yes, Matta. They bound the mighty bear with cords of strangling seaweed, and now from his wondrous arms they hung eight dead Fellagorn cubs, slain in their attack on Pollooq's kind."

"No," gasped Sepharga in horror, though it made her think of the Eight Commandments.

"Only for a while, Sepharga," said Anarga gently, "to remind their slaves of their victory. But then with their Seeking Claws," Anarga added nervously. "They went to pluck out Pollooq's eyes."

"Wow," gasped Qilaq, looking rather delighted, "Then that's the Wound of the White Bear."

"But it's horrible," Sepharga gasped, and she could think of nothing more terrible, while she felt the ice beneath them sharp with hard crystals, that suddenly hurt her pads. The friends felt they were growing up indeed. Matta and Uteq glanced at each other and remembered their promise on the slide. Their eyes flickered warmly, and Uteq felt sad that he had not spent more time with Matta.

"Seeking Claws?" said Qilaq. "Were the Pheline all Cub Clawers, just like Marg?"

"No, Qilaq," answered Anarga, "but they were tough, like you, and hated to look inward, or doubt, for they had sworn to build a bold future, and feared any weakness. Yet some say Cub Clawer families came down from the Pheline, if they were real, although the names long vanished. Which is why Cub Clawers don't understand cubs at all, and are frightened of them too, and sometimes hate them. For to a Cub Clawer, a weakness in something else is a weakness in themselves."

The friends looked rather surprised a Cub Clawer should be frightened of cubs and wondered why, since adults could be so fright-

ening. Uteq thought of Marg and how he had been so horrid to his friend Eagaq as a cub and had somehow tormented poor Mad Mooq's dreams too.

"But now the Fellagorn's mightiest hero opened his eyes and the Pheline were amazed to see them gone already, as if by magic, instead just hollow sockets, edged by gouts of blood, like tears. Teela herself came to look at the wounded bear, once a very king of the ancient white bears, and smiled.

"Smiled," growled Qilaq furiously, looking a little resentfully at Sepharga and Matta now.

"'See, oh mighty Pollooq,' cried the ancient Pheline, 'you asked to be in the dark, to hide your shame, so you've your deepest wish, most powerful of all the Fellagorn, servant of your ancient gods. Although you've stolen your lying eyes for us already – and wounded yourself, Bergo.'

Even Nuuq and Innoo were listening closely. Innoo had a look of anguish on her face though, and she sighed and shook her head, as she thought of the misfortune of even telling it.

"'Fools,' moaned Pollooq though." Anarga went on. "'Do you not know that I was already in the dark when Teela left me and ignored my cries, Pheline? When she judged me and my love so cruelly? But Teela, do you see your Pollooq now?' Who you loved once, then asked to be your friend. Who you gave soft words to, but hard deeds. For you learnt my secret, and deepest trust, yet betrayed me, even through my own lying brother, Ineq. Behold what you have done then, Teela Breakheart...yet talk to me Teela, give me peace."

The air about them was very dark, and the bears could feel a storm on the arctic winds.

"Teela must have talked to him at least," growled Sepharga angrily.

"Not that Bergeera," snorted Qilaq, wanting to kill a seal, as Anarga went on.

"'No, Pollooq,' lied Teela, as she watched in the Pheline's cave. 'You accuse me with talk of melting ice daggers, yet I've done nothing. Face reality then, bear. You're lost with the Ice Madness. You rage and

break the Ice Lores, and think yourself a god in your madness, but look at you now. See yourself at last, mad bear, and despair.'

"'Accuse you, Teela? Do you not know that the real wounds are always unseen? You plunge a dagger into my very soul, and speak of Lores. But I am Fellagorn, while we spoke of the future, like Pheline who always fear the past. Then we made Fellagorn promises in front of the sea together, and talked of the Second Commandment. So do you believe in nothing, Teela Breakheart? Not even your own sweet words, nor mine either? Not even in my love or grief?'

"'Yes,' cried Teela defiantly, feeling the love of the Pheline around her, 'I believe in freedom.'

"'Freedom?' moaned Pollooq, 'My heart beats with love and freedom, and what of me, Teela, bound in your cave? You banish and exile me from your heart, yet chain me here before you still. Are you the cruellest thing alive? You've hung dead cubs on me too, and you kill the spirit of love and innocence itself.' As Teela watched Pollooq raging there, and looked at his hollow eyes, rather than feeling sad, she scorned his wounded bear heart, and for not being a real and mighty Bergo, for having backed down in his own love, and raging so before her kind too. Then Teela called him evil.'

Nuuq and Innoo were shaking their heads and the friends were trying to understand what it all meant, for it touched feelings they had never really known, despite the youthful rivalry between them. Uteq recalled what Ruskova had said of not talking of good and evil in the East and wondered why.

"'Evil,' moaned Pollooq. 'After all you've done? Because I rage, and fight the Pheline, yet love you still? Because my will alone could lift boulders and hurl them at the sea. Do you know nothing of real Bergo, or how true evil is made? It's made by the wounded soul, in itself only beautiful if not harmed, and longing to be pure and love all. You see so coldly with your Pheline reason, the mysterious sun and moon, you feel their beauty, yet you fear real life and call me an evil monster? For does your name in the old tongue not mean fear, Teela, fear of heaven itself?'

"Teela shuddered, remembering the monster in her dreams and

her parents naming her Teela the Fear of Heaven to mark her freedom from old lores, but turned to a fine Pheline warrior, their leader, in the ice cave, and her eyes glittered, as she felt safe and strong at his side, despising wounded Pollooq even more.

"'And you, do you fear nothing, Pollooq?' she hissed, 'Not even your own blessed Ice Lores?'

"Pollooq sniffed at the air as he listened and dropped his head bitterly. 'Give me peace, Teela,' he groaned. 'Kill me then, as you have slain my heart and soul.'

"'I wish you peace, mad Pollooq,' Teela cried scornfully, stroking the Pheline Bergo lovingly, thinking him her hero and her god now. 'But I will not talk to you, ever again, for I do not love you.' Pollooq had become a monster to Teela indeed, and she turned away her eyes in scorn and disgust."

"How horrid," cried Sepharga. "How cowardly and cruel."

"Yes," said Anarga sadly, "for the ancients talked of how there's always a pact between see-er and seen, the judge and judged. That when real love fails, the pact is broken and can make a curse. Which is why the Second Commandment, to know what you really love and trust, is so vital."

The friends looked nervously at each other and thought of their arguments that summer and the pact of four. Something in their eyes seemed to say *they* would never break it.

"Mother," Uteq said though. "What's a soul?"

"A soul? For Pollooq, it was Teela now," answered Anarga. "The deep love he felt inside himself for her, as deep as the sea, though he knew that love is often doomed."

"And loved her even though Teela herself had betrayed him," grunted Qilaq in disgust. "How weak of Pollooq to love that Bergeera still. I'd have hated her."

"Well, you've never really loved yet Qilaq. Pollooq's voice grew weak," said Anarga sadly, "and hoarse and faint, as he cried out to Teela, for even she did not know what a truly wicked thing she had done."

"Destroying a warrior?" said Qilaq. "Pollooq of the Great Heart. Pollooq the Boulder Lord."

"Destroying a mighty Storyteller too," answered Anarga softly, "for Teela had been sent to help stories, remember, yet she had deprived Pollooq of the magic gift of storytelling itself."

"The secret," whispered Matta. "She *had* stolen the secret then. It *was* in his sleeves too."

"Not quite, Matta," growled Anarga. "It was the promise to the gods never to cut them, and so to let the spirit of the world flow through him always, and so not try and cut himself off from it, as the Pheline did. That was the true Fellagorn secret. The Fellagorn needed their courage and fighting power too though, a Bergo's real power, so they could go into the beautiful, dangerous world, and drink it in but speak, of its eternal truths, to all who would listen. Redeem its darkness too."

The friends looked out across the sea ice and Uteq wanted to be a Storyteller himself.

"But when the Fellagorn were alone, to look deep within too, and to speak the truth of a Bellarg's very being – not always happy, but often sad and pained, lost and hurt, full of mystery and longing. To speak of a place also, we cannot know at all, by just looking at the ice sheets alone."

"Place?" asked Uteq, looking round.

"Inside really, darling. That we only touch in dreams, or reverie perhaps. As the Fellagorn had five ways of deep seeing, and outward forms to inspire it too: fire, earth, air, water and ice. A place filled with shadows, ghosts and spirits, where we all go in sleep. Filled with gods and goddesses too, they say, and sometimes monsters."

Once more Uteq thought of his dream, looking down into that chasm and up again at himself, and wondered again about Sepharga's question: "Where do dreams really come from?"

"A place where a true Storyteller must also go to find the truth of the world, without and within, but there, to truly see in the dark, they need the united eye, to fight and keep them safe and whole.

"United eye," said Matta, keen as ever to learn of the Fellagorn. "What's that?"

"Some call it heart," answered Anarga, as the wind bristled her fur, "some thought united with feeling. Some say it lives in the centre of the forehead, where Goom placed a flower, others believe it in the belly. Something made both of a Bergo's will, that fights in the world, and a Bergeera's feeling and love, although each have both inside themselves. But although Teela had been sent as a helper, she had cut away her love, with the speed of a Pheline too, greedy for freedom and the future. It tore out Pollooq's heart, and the united eye also, and his powers completely. Blind Pollooq lost his voice, and the power to make stories at all. It turned him to pure ice."

The wind about them sounded like a dying spirit and Uteq felt sick.

"Oh, Anarga," said Sepharga sadly. "Poor Pollooq. It's so terribly sad."

"I told you," grunted Innoo. "And I hope it's not worse than sad. I mean the telling of it."

"But then the reasoning, unbelieving Pheline did something so cruel," Anarga said, "that even Teela's foolish young soul quavered. The Pheline gave eyeless Pollooq a ghastly challenge."

"Challenge, Mother?" said Uteq immediately and something strange stirred in him.

"They said that they would release mad Pollooq from his shackles of seaweed, and all their Fellagorn slaves from bondage too, the one's left alive at least, if Pollooq could tell them a story, there between the pillars, that would prove magic and the gods to them, by healing the whole world. Healing the whole of creation."

"And to heal the curse in nature too," whispered Innoo hopefully, as she hurried along.

"A story?" gasped Sepharga. "But poor Pollooq couldn't, Anarga, he'd lost the power. Teela didn't love him anymore, and he was alone and bound before them. Shamed as a Bergo, and blind."

"And it's impossible," snorted Qilaq, deciding that he definitely

wasn't a Pheline after all. "A story to heal creation. What could do that, and what does it mean anyway? It's stupid."

"Yes, Qilaq, but truly impossible, because Pollooq felt not only his mind but his guts freezing, and a terrible stillness crowd his raging soul. He was blind, both outside and in. The cruel Pheline laughed and ate seal blubber, and drank from conches brimming with walrus blood, and danced as Fellagorn were said to dance under the Beqorn, for they knew their plan had won and that they had conquered Pollooq completely.

"'Come, wounded Pollooq,' they cried scornfully. 'Stop feeling sorry for yourself. You stand before us like some strange Gurgai. Tulqulqa too. Your bear eyes are gone, so look with Man's eyes now, and so a reason even greater than ours. That's why the Gurgai are higher than even Bellarg in the Paw Prints.' Again, they laughed, seeing Pollooq standing on his hind legs, blind and dying."

"Why dying?" whispered Sepharga, as Uteq wondered what it would be like to see with human eyes, or meet the humans. "He was still alive, even if poor Pollooq was blind."

"He was more than blind, for he had been denied the greatest hope to Lera. The chance of Narlaq or Nollooq, fight or flee. Wanting to hide his pain, but forced to speak, it split Pollooq's soul in two, from top to bottom, like a great pine that began to wither from its very roots."

Uteq thought nervously of the tree outside his birthing den that had split in reality.

"Pollooq's great coat started falling out and his back was bowed, and his darkened soul filled with shame, at the fear of looking inside at all, without love to guide him back, for he knew that journey already. While they saw him now as a ghost of the hero he had been, hurling boulders at the very sea."

On the sea ice the air was sharp, and Matta winced as crystals struck her coat.

"'No, please,' begged Pollooq, swinging about his empty eyes in the Pheline's cave, and scenting Teela with him still, groaning as he tugged at his chains of seaweed. 'I cannot. For the love of Atar, have

pity, Teela. The story will be born misshapen, and the very telling will kill me.'

The hunting bears heard a rumble of thunder in the heavens.

"But no answer came back from frightened Teela," said Anarga. "For she'd forgotten how fine he had been, and why she had loved him. She'd forgotten Atar's dream too. Instead, her Pheline mate cried out angrily. 'There is no soul, Pollooq, just reality and reason, life and death. Hard, brave truths. Winners or losers, wounded, broken bear – like me and you. A winner and loser indeed, for I've won your Teela now. But if you moan so of your blessed soul, pathetic Pollooq, why not tell us a story of that, Fellagorn scum, and go and find it in the dark? Hunt it down like a weasel. Journey to the Underworld, to Hell, to find it, though there's no entrance, fool, except in your lying stories.'

Anarga frowned deeply and then continued.

"Then Pollooq raged and moaned at Teela, and as the Pheline watched him, they heard a sound in the cave from Pollooq's wounded being, his cracked and dying voice, no free Bellarg should ever hear, Bergo or Bergeera. Not the mighty roar of a proud Bellarg, not his purest cry, but his scream. The Scream of the White Bear."

The friends' mouths were hanging open in horror at the ghastliness of it all and Anarga suddenly remembered the sound of the falling ice cliff in the Snow Den and felt guilty at speaking.

"The Scream," whispered Innoo, as the wind carried her words away again. "Bringing the ancient curse, in the terrible, frightening world. So be wary, my little ones and stay close, always."

"But what does it really mean?" whispered Matta.

"Well, I'm glad it's just a story," growled Qilaq, look scornfully at his own mother.

"And a very old one," said Nuuq, "the Fellagorn said would later change."

"Change?" said Uteq, struck forcefully by this.

But Nuuq threw up her head. "Seal. That way, Anarga."

"And thankfully *this* is the real world, children," growled Anarga,

who realised she had been carried away, "and I'm starving. Come on. Let's roar likes free bears now, and eat."

Anarga and Innoo began to lollop fast across the fresh new ice after Nuuq, leaving the terrible, tragic story far behind, or so they hoped. It wasn't long before the adults reached the source of the scent, and started advancing slowly toward a little circle in the ice, where the arctic water lapped and rucked up among the flat, cold landscape. It was an air hole. A water jet shot up, and the bears spotted two grey whiskered snouts pushing out into the frosty day to breathe, a courting couple, before they disappeared. They crept toward the hole, but Anarga stopped and squatted by it, waiting, absolutely motionless. She was Still Hunting.

"Watch her children," whispered Nuuq. "It's a very great skill, and Anarga's the finest at it, next to Toleg. You must contain your Garn, like a Great Master, they say. It takes the true strength of a Bergo, but the deep patience of a Bergeera."

Anarga began to scrape and tap on the ice, much more delicately than the Glawneye had with the orca, trying to attract the seals below with the sound. The bear was fishing. After a few moments, a single grey snout appeared again, topped with long, bristling whiskers, with a much bigger snort of water. Anarga leapt like an enormous white cat, and landed right on the edge of the hole. She reached down into the sea with her right paw, and swept her claw across her chest and upward, with a roar. The male seal was lifted clean out of the water, like a mackerel scooped from a tin, and the sea Lera went sailing helplessly through the air, spinning as it did so, deep claw marks raked red across its blubbery sides, and thumped onto the snowy ice, making it sing.

"Fabulous," cried Qilaq. As the young bears saw that strike, Uteq thought his mother truly immortal, but beside them Nuuq was all intention. Nuuq pounced and killed it, roaring and tearing the seal in two, as the youngsters came in to join them. Yet before she began to eat, Nuuq stopped, tearing the carcass, making sure a little blood spilled onto the ice.

"For the gods," she growled, with a smile, "a libation. To thank life for its great gifts."

Strangely the act made the cubs feel grander as they came forwards, but as they did they jumped back again, for there was a great sigh. Although only Uteq saw it, a shape rose from the dead seal's mouth, like a yellow-gold cloud of light, that went spinning straight toward Uteq, who ducked back in horror and blinked.

"What was that?" whispered Qilaq, who had only felt something, as Uteq saw the shape vanish like ice crystals in the arctic wind. They had all been shaken, but Nuuq called the young bears to eat. It was a big seal, and Bellarg can be messy eaters, so soon the ice was strewn with bits of seal carcass, as gulls flew in overhead to investigate the kill. All nature is opportunistic at such vital moments in the wild.

"Now it's your turn to hunt," said Nuuq to the youngsters, as they finished. "First you must learn to scent the air holes. Try. Your power must be getting stronger all the time."

The friends were soon doing just that, especially Qilaq beside Sepharga, although they felt full already, waving their heads like blind singers and sniffing. Qilaq was the first to catch a scent, a mixture of salt and heavy seal musk. It was another seal and so another air hole.

"That way, Sepharga," he cried, facing north, noticing how bright Teela was in the heavens.

"No," said Uteq, suddenly competitive. "I can smell one that way, Matta."

"Then follow your own instincts," cried Anarga. "Instinct's everything to a Lera, especially Putnar. But use your noses too. It's time you were given your heads. Go then, cubs and kill."

They hovered there, looking a little confused, especially Uteq, who had promised both Matta and Sepharga, although he wanted to go with Matta, especially after hearing the terrible story.

"Take your twin, Qilaq," ordered Anarga though. "And Uteq, go with your sister. Look after Sepharga, but trust a Bergeera's instincts and intuition, young Bergo. We school each other now."

"But Mother..." said Uteq, looking jealously at Qilaq.

"Hurry. They won't hang about. Bellow hard at a catch. Your father's Summoning Call."

So Qilaq and Matta set off in one direction, toward the advancing storm, and Uteq in another, pursued by Sepharga, not wanting to be left behind. The two found themselves moving rapidly east, through a thick, descending mist, but as she caught up with Uteq he stepped on Sepharga's paw and Uteq felt as if he was locked to her fur.

Then, before the polar bears' startled eyes, a strange craft was suddenly pushing through pack ice, in the dark winter Long Night, like the one they had spotted from the Black Bay, though much larger, and Uteq saw little Sepharga curled up in a strange cage of metal. This cub looked terrified, not of the blizzard raging around her, but of something else entirely, of her own imprisonment. Uteq's heart tightened as he saw creatures standing on two legs about the cage, with thin pinkish, hairless skins that he had never seen before.

"What is it Uteq," whispered Sepharga. "What's wrong?"

"Gurgai," grunted Uteq. "Man. On the ship you came on, I can see it. They're here."

The bizarre animals had no natural coats, only flat fur on their heads and chins, yet they seemed to be wearing the furs of other creatures. Then there was a splintering crack, and the ship's metal mast snapped in two and came crashing down on deck, to a furious cry across the boat. "Look out there!" The startled Gurgai were running and shouting, though Uteq couldn't understand their strange, alien growls. As the bear followed their horrified gazes upward though, a gigantic wall of ice reared up before them, and the ship slammed into an iceberg. There was a creature screaming in the water, a narwhal, crushed between the ship and the berg. Its curling horn broke and snapped off. The whole boat began to keel to one side too, hurling Sepharga's cage across the deck, slamming it into the side of the craft and snapping open the door. As the cub rolled out, a wave crashed over her, and she started to paddle in a wild sea, gulping mouthfuls of salt water helplessly.

The vision cleared, and Uteq was back on the ice, before that purple orange sun, staring back at Sepharga in astonishment, and

gasping. Uteq pulled his paw away, as if he'd been bitten by the ice – and he felt that empty feeling again, a kind of awful loneliness.

"Uteq, what's happening. Is it because Anarga told that horrid—"

"No," snapped Uteq. "And come on."

They went on and after a while could sense the edge of the sea itself, feeling a thrill of danger at the prospect of Seawolves, but reassured by the thought of Eagaq's many Scouts, as the first sting of new snow began to fill the air. The blizzard was coming up from behind, fast, but a sharp southwesterly kept it back and cleared the mist as well, to reveal the open ocean.

"Oh, hurry, Sepharga," said Uteq irritably, taking in the still and empty waters, "let's beat Qilaq to a kill, at least. He's always showing off, just to impress you."

Uteq could see the ice hole he had scented, maybe two hundred yards from the sea, and a snort of water went up. As they reached it, Uteq stopped and tried to stay as still as Anarga, as he scratched and tapped the ice. His blood was up, causing him to shake badly, from both excitement and his vision.

"You can take the first one, Sepharga," he grunted.

"Thank you, Uteq, I think."

"Don't think it's cruel," added Uteq, misinterpreting the peaceful look on her face, "although it horrifies a gentle Bergeera, it's just the Ice Lore."

"Yes, Uteq, I know," said Sepharga sharply, her eyes smiling. "And I'm not horrified. But don't worry about me. I'm fine. I just don't want to be any trouble."

The bears waited, watching the air hole and the slowly advancing curtain of falling snow, held back by the fresh sea wind. It was not exactly a hole, more an ice break, with ragged edges, but Uteq also noticed Teela's brightness in the purple heavens, like a warning. But with that, there was another higher spout of water, and Uteq was staring at a handsome face, pointy and pure white, with the most enormous black whiskers - a seal.

The seal, although not a pup, had been born very late and was only a growing creature himself, and seemed rather surprised at the

sight of a young polar bear, especially as Uteq stayed stock-still. Uteq in turn glared at Sepharga who still hadn't sprung. Now though Uteq realised that the clear tension in Sepharga wasn't preparation at all, it was pure terror. Sepharga was looking across the air hole, back into the wall of the storm. Uteq thought he could see shapes emerging through it and hear voices on the wind, and from the anger of their growls they sounded nothing like Scouts.

"Snow Raiders," he hissed. "They strike in blizzards. But how?"

The angry, growling voices grew clearer and turned into ringing words.

"We got through in this blasted storm with their words of passing all right," cried one. "Come on then. That she-cub the growing Bergo told us about spoke the truth. With a little persuasion."

"Shouldn't we have waited for the others though?" asked another deep Bergo voice.

"Not likely. You know there'll be a special reward if we fulfil our mission first. They're coming, though, soon enough. Maybe *he's* here already."

Out of the wall of snow two large Bergo appeared, coming toward them at a furious gallop, but sliding strangely too, as if Boggeting across the ice.

"There," growled one, as he spotted Uteq. "That's the Blackpaw, all right. And now we have him. What a prize this is."

The startled seal disappeared with a plop, and the two glissading assassins stopped on sighting their quarry, then advanced toward Uteq and Sepharga, frozen there like statues. Their snouts were gigantic and massive collars of yellow white fur bristled about their rippling throats.

"Uteq," cried Sepharga, snapping out of her trance. "They've come for you, Uteq. They're Glawneye. But how did they get through and know the words of passing?"

"*Alive*," the other laughed. "But not you, little cubs. You're dead, all right."

"Quick, Sepharga," cried Uteq, springing up too, "the sea. We'll swim to safety, and come back to the Sound later, to tell Father."

They turned and began to run desperately towards the open water, but the confident assassins didn't even quicken their pace, for as they reached the ice edge, Uteq slid to a stop. Twenty great black shapes, with white daubs, were coming straight toward them through the water.

"Seawolves too, Sepharga. Orca. A trap."

"And a long time in the laying," cried a Glawneye behind them, "but then the Father says timing's all."

Uteq's heart plunged but there was a furious chuffing, and out of the blizzard burst a great white shape that head butted one of the assassins in the back and sent the bear spinning painfully across the ice. "Mother!" cried Uteq, as Anarga rose on her hindquarters, opening her arms and chuffing at the next, then with a single calm paw, knocking him in the face. The startled Glawneye was caught off balance and went flying backward too, glissading across the ice at speed, straight past his fallen compatriot, and into the sea. If the orca mercenaries had come to trap Uteq, they knew no real allies in the water, and with a painful bellow the water turned blood red.

"Stay still, children," bellowed Anarga, as the other assassin got up again. Yet if the cubs thought Anarga had saved them, they were badly mistaken. Out of the blizzard they heard a kind of booming laugh, and suddenly four more Serberan appeared from the storm. It was far worse than that, for right in the middle came the most monstrous one-eyed Bellarg the cubs had ever seen; a giant, with a terribly scarred face, whose shadows almost touched them both.

"But it's impossible," gasped Uteq. "It's just a terrible dream."

Yet it was Anarga who had been truly seized by the horror of it.

"Glawnaq," she gasped, her face like a death mask, "Here in the Great Sound. But how?"

7

BROKEN ICE

"Fair is foul, and foul is fair,
Hover through the fog and filthy air."
—William Shakespeare, Macbeth

A s Glawnaq caught sight of his former love, he cried out triumphantly in the eerie purple twilight.

"And it's been too long, lovely Calmpaw, but what's a king without his rightful queen? I've business with Toleg too, as I did when I tried to win you back."

"And you never could, One-eye. Not from a real bear like Toleg."

Glawnaq winced visibly, as his Serberan around him glanced at the cubs in the distance.

"Because of your love and loyalty to a fool?" he hissed, as he glared at Uteq, the incarnation of his own broken dreams. "Which is why I love you still, Anarga. Remember I was handsome once, and good, Bergeera. You said so yourself, when we walked together a while."

Uteq turned his head immediately to look enquiringly at his mother.

"And I can still strengthen the chances of my own bloodline, Anarga, my dear, by removing your filthy cub now, and his feeble, frightened friend. She's a mark too, I hear. So, my long-planned revenge serves more than just one purpose. For I come too to murder a legend. Long I've sought signs, the mark the Lera whisper of now, and it transpires that this famous Blackpaw is none other than son to

Toleg Hateback. Fate is strange indeed, no?" Glawnaq rocked back, growling laughingly. "It's like a legend indeed, though they're lies, of course. Power and survival are all that matter. Reality and reason. That we must teach the Bellarg once again, and how to be Pheline."

"Touch a hair on Uteq's coat," hissed Anarga, "and you die at my own claws, scum."

Glawnaq gave a low chuckle, then the bear tilted his massive head. "A real Bellarg would never do such a thing, Anarga, and besides, we've need of you all now, lovely Bergeera."

"Need, Glawnaq? We'll fight you to the death first. We're all free bears here."

"All?" said Glawnaq, and he smiled again. "I thought Bergeera above all value politics. You'll find the Bellarg cleave hardest to the First Commandment, survive, especially Bergeera." Glawnaq swung his head to his Glawneye. "Take the cubs. Bring them to me, alive or dead. It doesn't matter. We shall raise much finer cubs, with my new Serberana."

Anarga heard the name, while the assassin began to advance as Uteq and Sepharga backed away. They inched east, down a little split of ice protruding out into open water. Anarga hardly knew what to do, but lifted her head and called furiously – Toleg's Summoning Call.

"Roar away, Bergeera," shrugged Glawnaq. "Moan to your dead Storytellers, or your non-existent gods, for your blessed Scouts are nowhere near, I assure you."

Anarga wondered why she had seen no Scouts, as the Glawneye assassins began to move, like hulking giants. But a furious roaring came out of the belly of the storm, and Anarga's eyes flashed.

"Yes, Toleg," she roared back furiously. "Come to us, Bergo, here by the sea. Your little family are trapped and in mortal danger."

From the north Toleg came striding from the snow wall on his hindquarters, claws extended, his great red fur sleeves hanging from his huge arms. He swayed back and forth like a walking tree. Toleg opened his snout to show his huge teeth, and let out such a cry at Glawnaq that it seemed to punch a hole in the day. "No!" The Serberan turned, and two broke away to challenge Toleg, but as they

rose, Toleg swung angrily at the first, and opened the Serberan's cheek, sending his blood spraying wildly across the sea ice. "Anarga," he bellowed. "I heard the call, and always will. Stand firm then, my brave, beautiful Bergeera. We need a mother's strength now, but her courage too."

The second bear lunged, but Toleg swung aside easily and bit into the Serberan's throat, then thrust him backwards, and the Bellarg collapsed dead in the instant. The ice was turning red. A third Serberan broke for Toleg, roaring and showing his teeth. This time Toleg jumped aside, and as he rose on his haunches, he caught the Serberan in his vicious bear hug and began to squeeze. So powerful was his famous embrace the Serberan gave a futile, defeated moan, and all of them heard a ghastly crack. Uteq was astonished as another shape seemed to be squeezed from the Ice Slayer's mouth, a shimmering reddish light that hung over his head, and went screeching past Uteq as he saw another rise from the Serberan lying dying on the ice and both rushed straight out to sea. Startled Toleg felt something without seeing it, but he dropped the Ice Slayer in a heap. Dead.

"Impressive, Breakback," hissed Glawnaq, wondering what strange breeze seemed to have moved through the air. "A worthy opponent still, I see. But you think this can save the Bellarg from all that threatens us in a dying ice world, without the true might and cunning of the white bears?"

Toleg was in the grip of a fighting rage now, and simply roared again.

"And as stupid as ever, I see." said Glawnaq, with a sigh. "Thinking courage alone is enough to master the world, or that you can live in splendid isolation. The Pheline may have been right about many things, but not that, Breakback. Very well then, since Anarga and your son watch us now, is it not time that you fought me again, in single combat? An ice duel to the death, this time."

"Duel?" Toleg grunted, raising his snout in surprise. "But hasn't fear of me kept you from the Sound, Glawnaq One-eye, and the rules of the Ice Lore too? I've defeated you already."

Toleg thought he saw scorn flicker in Glawnaq's eye.

"Then that's what you believe, fool? That I'm a coward, like the Fellagorn? But I'm a fighter to my claws, and have had much work, while I've used your fame, for it's brought many willing bears here, has it not? My new recruits, for our glorious future. We all need a second chance in life."

Toleg snarled at him but again was lost for words.

"You talk of freedom, Toleg, but I, Glawnaq One-eye, make a new Ice Lore for all bears now, Glawnaq's Lore, Glawnaq's Will and Reason, so I have come to battle you again and to conquer. You three," Glawnaq grunted to his Serberan, as his wounded Slayer got up, "get behind me, and watch how your leader fights, and why my kingdom shall triumph for a thousand Long Nights."

"Then perhaps honour's not quite dead," grunted Toleg grudgingly, looking at Glawnaq with something close to admiration. "And bears have not entirely lost their souls."

"Souls," snorted Glawnaq in disgust. "There are no souls, idiot. No gods, no Storyteller power. Only reality, and life and death. Take what you want in life and pay for it later. My kingdom comes. Everywhere."

The Ice Slayers threaded back behind Glawnaq obediently, who rose on his hindquarters and roared himself, then crashed down and thrust is head forwards like a bull. Beyond, Uteq and Sepharga had inched as far as they could down the ice promontory, toward the moon dark sea, and now there was nowhere else to go, so they turned and simply watched helplessly.

Something almost noble seemed to shine again in Glawnaq's wounded features, as Toleg roared too and the two great polar bears rushed at each other, then slid to a halt, swinging their claws forwards, rising up and beginning to box. Both were hugely experienced fighters, and at first, they didn't engage at all. Instead their claws connected momentarily, then the giants backed away, like two opposing armies. The Bergo squared up again, roared once more and lunged again, bellowing and hissing, almost letting their snouts connect as they tried to bite.

Glawnaq was the larger bear, yet his hesitation came from Toleg's clear prowess, and the fact his single eye made his range of awareness

much narrower. But the sheer hatred that the two had for each other meant they couldn't keep apart long. Suddenly they threw themselves at one another like titans, as Arktus and Teela twinkled above in the Heavens. Glawnaq took a chunk out of Toleg's shoulder, and Toleg pulled his claws around Glawnaq's belly, then both caught each other in a bear hug, face to face on their hindquarters, starting to squeeze, staring into each other's angry faces.

The bears both groaned in agony, but neither was winning, and eventually the two had to let go, turning and crashing back down onto the ice, and gasping for breath. They were perfectly matched, like good and evil. The bears were dizzy and breathless too, so it was actually Anarga that saw him first, appearing out of the dying storm, to the Serberan's right. Marg was moving stealthily, like a dark shadow, straight toward Toleg it seemed, and since Toleg was still trying to get his breath, Anarga felt a chill deep in her soul.

"Marg," she hissed. "Then it *was* you who betrayed the word of passing on the ice. *Alive.* You who betrayed us all."

Marg stopped, though, and looked strangely between Anarga, Glawnaq, and Toleg, and the dead bears on the ice too. The spy seemed surprised, almost horrified.

"Me? But Calmpaw, how could you think that I...I who offered my very life for your cub, under the sacred Lore? Even though Toleg won the Bergeera I've admired and loved for so long. The perfect Bergeera. In my very soul."

Anarga looked at him in astonishment and now Uteq realised why Marg hated his father.

"Admired me, Marg?"

"Of course, beautiful Anarga. And did not your father save my life when I nearly drowned as a cub, and we all owe a life."

"You? But Glawnaq's spy in the Sound, Marg. We all thought... Then who?"

"Me, Anarga, I fear," cried another sharp voice, coming out of the snowstorm too, between the Serberan and the assassin. Uteq stood staring in utter disbelief, feeling as if his whole world was dissolving, and everything he had believed in melting away. Toleg began to

bellow furiously, the Bear Rage bursting out of him again, for he hardly understood either, blind with confusion.

"Eagaq," he groaned, "am I going mad?"

"Welcome, Eagaq," growled Glawnaq, ten yards from Toleg. "You've done well, faithful Lieutenant, after we parted in the North, on the trail of those three fools and their holy master. Done well indeed, to conceal yourself so very long in the Sound."

Eagaq stood straight, his handsome head lifted high and beamed.

"And my Scouts are dealt with already, lord, and those that opposed us already under Serberan guard. A few Scouts fought, and we had to deal harshly. Many are dead then, especially from Marg's faction, but a couple of cubs proved most helpful. The trap's well sprung."

"And you've earned your life name, you evil traitor," snarled Anarga. "Eagaq Breakheart."

Eagaq blinked at Anarga but the Scout did not seem to mind at all.

"Breakheart? But don't you know, Anarga?" he whispered with a smile. "They say the Evil One has all the best growls."

As he spoke, two new bears stepped from the storm, like attendants at some ghastly theatre: Nuuq, with Innoo at her side. Nuuq stopped and stood there trembling, as she realised what Eagaq had done: betrayed them all, and opened the Great Sound.

"So that's how One-eye got though," whispered Innoo. "Eagaq's traitors guided him in."

"But Eagaq," snarled Toleg. "Why? All the Bellarg trusted you. Even loved you. I did."

"I'm sorry, Toleg," said Eagaq cheerfully. "But it's been so unfair. After father died, uncle always denying me, opposing my will, going on about the Lore. I met great Glawnaq long ago, wandering, and we talked of a new lore. He told me many strange things, sometimes hard, tough things. We bears must survive though whatever comes, Toleg, and attack's always the best defence."

Glawnaq grinned proudly at Eagaq and he nodded sagely like some Great Master himself.

"I only come to save white bears from lies and weakness," he said

with a laugh, as Toleg swung his head between Glawnaq and Eagaq, wondering who to attack first, or who he hated more. "But a bright, ambitious Bellarg like Eagaq needed very little persuasion."

"But you couldn't have made it from the North in time, Eagaq," hissed Marg, almost pleadingly. "The tern who saw this traitor took four days to get here, and you came in at the same time. The distance is impossible for a bear. Even the Tern had to rest."

"Unless you've trained with the Glawneye, friend, who can move at speed over hundreds of miles, and never stop coming. It was a noble journey, and I ate a whole Walrus as I reached the Sound. Sarq and Tortog thought I was just playing games and being rebellious."

"But you supported me, Eagaq," said Toleg, his eyes clearing a little. "And I trusted you. We all did. Honour and Vigilance, remember. A Scout's sacred oath."

"Words, Toleg, words," chuckled Eagaq. "Like your blessed honour. Aren't actions more powerful? Quite clever to think of Mad Mooq then, to sway it all in your favour. I knew just how finely balanced it was, and had long gone to poor Mooq, while he was sleeping, and whispered things to him. Terrible things. I was always good at imitating Marg's voice."

"But why, Eagaq?"

"Why? Rather than have my old friend Marg use his wits against Glawnaq and I, Toleg. He may be ambitious, but he really wanted to protect you all. He would have resisted Glawnaq himself in time. Pity that he was too obsessed with the Gurgai to see the truth. The real threat in your midst. Me."

"The Gurgai," growled Marg. "I only hate Gurgai because they killed your own father, Eagaq, who was so kind to us when we were cubs."

"Kind? Father was a weak fool, Marg, just like uncle. I wasn't sad at the loss. Why do you think I threw you over as a friend, when you kept going on about it? Besides, by spreading rumours of the spy myself, did I not turn attention away from me? And with one so very slow and trusting leading us in the Sound, I had a free paw to reason

with several Scouts and turn them too. They honour Glawnaq now, as I do."

"But what the wolf told Sarq that day," whispered Toleg, still refusing to believe the evidence of his eyes, "About this secret Cub Clawer. It still doesn't make sense, unless Sarq's one of your..."

"That tern knew of a spy," said Eagaq beyond, "but not his identity, and there was only one bear who saw me, when I left Glawnaq in the North, but I slew him on the Ever Frozen Sea. Gorteq."

Innoo was suddenly chuffing behind them. Eagaq had killed her mate and Qilaq and Matta's father. In that instant Anarga decided, and ran for Eagaq, but as she chuffed and pressed her muzzle forward, the cowardly young bear raked an open claw straight across Anarga's left shoulder. Anarga spun and slipped in a pool of Serberan blood, and slid away from Eagaq toward Marg. Toleg roared, but a kind of madness came over him as he saw his own mate fall, and Toleg's simple, trusting mind tried to cope with what was happening too. Glawnaq snarled as well, not to keep Toleg back alone, but out of jealousy for Anarga.

"Shall I finish her, great lord?" hissed Eagaq delightedly. "Slay the Calmpaw."

"Slay her?" bellowed Glawnaq furiously. "Anarga's mine, you idiot. A Serberana now. As the Bergeera in the Sound shall be the Serberans'. How else will our bloodlines continue?"

Uteq heard it, and it sent a splinter of ice deep into his soul. Toleg bellowed, lashing out at thin air, but Eagaq hadn't heard his master, and the coward was turning on Anarga indeed, to kill her.

"Marg," she cried. "Help us, Marg. Your oath at the Council. A life for Uteq's. Please."

Marg blinked in confusion, and felt a terrible fury and hate inside him for Toleg and the other bears too, especially the stupid Scouts. For how they had doubted him for so long, for the curse of his Seeking Claw and the ancient past his reason and duty to the Lore had wanted to put aside for ever.

"For that spoilt cub, Anarga?" he hissed bitterly. "You expect me..."

Marg's face seemed in terrible pain, as though battling with

opposing forces deep within, but suddenly, as he saw the lovely Anarga lying there and Eagaq passed him, Marg seemed to come to life, animated by something entirely new, and his paw swung up. Marg's seeking claw came out, and went slashing at Eagaq's cheek, opening a vicious wound just below his right eye.

"Live by the claw and die by it, traitor. There's no greater evil, no weakness more terrible than betrayal of your own. It is why real Bergo speak of Teela and Pollooq at all. A warning against the ancient curse. So my Seeking Claw has found your quality at last."

"The curse," groaned Anarga, "of course. It's returned because I spoke that terrible story."

"Which is why I was so jealous of that, dear Marg," Eagaq laughed, glaring at Marg's claw. "When we were cubs. So not to be outdone, Marg, I nursed and grew one myself, in secret."

"Yourself, Eagaq?" muttered Marg. Eagaq lifted his own right paw, and out sprang a Seeking Claw too, as long as, but much straighter, than Marg's. It went straight into Marg's windpipe, and Eagaq pushed, pinning his friend, twisting his claw, as they watched him look deep into his eyes.

"It took me so long to nurture it, Marg, but to conceal it too. The hole in your throat will be tiny, I promise. Just like uncle's. Revenge is best served cold, the best wounds almost undetectable."

"Eagaq murdered Varsaq too, his own blood," gasped Uteq, though he realised he had somehow always known the truth of it, yet tried to deny it too. He thought of old Narnooq saying the circle knows, but in Uteq's mind Mad Mooq's wails of prophecy were riding on the air – MURDER.

"But such a claw shall train many young bears to a new strength and reason," said the foul, handsome, Eagaq, "Obedience, too. For Glawnaq has promised that I'll be his Cub Clawer, in his brave new Kingdom. The true Cub Clawers return, like the brightest Long Day. Yet with no superstitions, nor ancient prohibitions either, nor foolish Councils, to hold us back."

Eagaq retracted his claw, and Marg tottered there, grasping help-lessly at his throat, then crashed onto the ice, quite dead. Even Eagaq

stepped backward in amazement though, as Marg's body gave a shattering groan, and now they all saw it, rather than just sensing something: a great jet of black air, or light, that rose up and glittered gold, as it flew over Anarga's head, then went shooting straight toward Uteq, and passed his snout. As it dissipated, the cub seemed to hear Marg's voice, but in a tone filled with new promise, and a sudden longing to protect, *"I was marked too, little Uteq, But Fly, Ice Saviour, Fly. Talk to the Lera, and redeem us all. Lift the curse forever."*

Back on the main body of ice, Toleg was so blind with the Rage he only just saw Glawnaq turn to attack him. Toleg rose and bellowed, but felt a furious pain in his leg. Eagaq had swung toward Toleg, and come at a gallop. The Scout had dived and sent his claw deep into Toleg's back right paw, pinning it to the ice. The shock and pain made Toleg spread his arms even wider, too wildly, for in it Glawnaq saw his opening and struck. The Serberan giant lunged and swung a forepaw so accurately at his opponent, it took Toleg straight in the throat, and half-opened the white bear's great windpipe.

"No, Father," gasped Uteq, as blood sprayed everywhere. "No."

"Oh, Uteq," growled Sepharga, rising up in despair. "It's so terrible."

"My bears," groaned Toleg, crashing down onto the ice, "Uteq, my cub, I could not protect you, as I swore to in my being that day you came out. Always. Perhaps I've been a fool to lead and play politics, instead of just guarding my family, like a real Bergo. A home should be a fortress."

"No, Father. Don't say it. We all wanted..."

Now Anarga got up on the ice, chuffing in agony, but Glawnaq opened his arms, and let out such a roar of cruel triumph in answer, *"Agrroaarr,"* Anarga's bitter Mourning Call was swallowed whole. Uteq and Sepharga looked on at the blood-spattered ice in near incomprehension, and as they did so the angry sea wind blew stronger, and the snow stopped falling, and they saw them coming across the ice toward them – like an army of ice phantoms in the dim, eerie purple light.

There were maybe a hundred Serberan coming in around them, in a perfect semi-circle, closing in steadily, like some story closing in on itself. Behind them came wolves too, packs of them – Glawnaq's mercenaries – their snarling Varg leaders strong and fat on the dead Bellarg who had already fallen. It was the completion of Glawnaq and Eagaq's terrible trap, capturing the still-loyal Scouts one by one in the blizzard, like murderous Snow Raiders, using the stolen passing words to secure the Sound, and advancing in a perfect pincer movement between land and sea.

"Look, Uteq," gasped Sepharga. "Narnooq and the others. The twins too."

Uteq could not understand why the twins seemed unguarded, as they approached too, but among the lines of advancing Serberan and Varg, Uteq caught sight of Narnooq, clearly wounded, his right ear badly torn. Narnooq of the North was surrounded by several Serberan guards, and being marched along with Seegloo and Rornaq, Tortog and Sarq, Forloq and Brorq, even Mad Mooq, among several other bears Uteq recognised from the Council. Toleg was lying quite still on the ice, and thinking him dead already, and certainly beyond fighting, Glawnaq turned to address them.

"You see the first rule of war, my friends?" he cried. "Never engage the enemy until you've already won." Glawnaq was smiling benevolently though. "But no more enemies. All shall join me now, and be my Barg, my most blessed. Were they not saved by their heavenly father in your stories? Fear not then, children, it will be a grave, shining duty in the North, serving the strength of the Ice Slayers, to protect our own too. Trust me, for I have freed you all from lies forever."

"Delivered us up as Festlar meat for your mercenaries, you mean?" hissed Anarga.

"Nature does not waste, Anarga, and only the lead mercenaries are fed on what succumbs naturally in the wild struggle. My wolf and orca. We are *their* Ice Lords though, and it's no crueller than life, Anarga, and only logical now, my dear. All must eat."

The Serberan and captured bears had stopped to listen intently.

Some were filled with terror, others seemed to be heeding Glawnaq's words. Fear was making them listen, and even admire him.

"But I'll teach you strength and purity, as true white bears again, and so protect you all. Yet first a lying legend must die forever, and the false hope of the Fellagorn, for I'm your saviour now, my children, no one else."

"Pheline," moaned Mad Mooq, from among the throng of overthrown Scouts. "The Pheline return and come down on us all. We're slaves again, bound like Pollooq. The curse returns, but now a terrible evil. The Ice Lord of the Flies is here. The Sight, it shall harm the eye of The Sight itself."

Uteq looked up sharply, but there was something about the tragic grandeur of the scene that had made even the Serberan catch their breath, seeing the spirit and fighting power of legendary Toleg, so fatally wounded, and in a way that had so devastated the Ice Lore, for a polar bear cannot fight twice for a mate. As they stood frozen on the ice, Anarga cried out again though.

"Uteq. Sepharga. You must escape. Dive into the sea and swim for your lives, children. The orca still feed on the assassin. Get to an iceberg and safety. Seek higher ground."

A Serberan growled and cuffed Anarga into silence, but Glawnaq was already chuckling.

"There's no escape for the Blackpaw," he almost yawned, staring at Uteq and glancing at Toleg too, who had groaned faintly on the ice, not quite dead. "Or from his fate. My mercenaries are everywhere – wolves on land, seawolves in the waters – and both my servants very fond of Bellarg meat. Especially meat with the stench of a legend on it. We've seeded the sea well."

The wolves howled and the killer whales rose in the water, with Drang in the very centre, as if paying homage to their new master. Once more a great wind seemed to blow, and it started to snow again, but a new and intense bleakness riding the air, in the coming Long Night. It was as if the entire world knew that the earth was swinging away from the sun and everything was moving back into darkness.

Uteq lifted his black paw helplessly, feeling as if he had killed his

own father, but heard another roar. Toleg had risen, pulling himself up with some supernatural strength and he came staggering toward them, hurling his body down right in front of them, looking desperately at his son. As Toleg's body hit the ice, a great crack went running across it, and Toleg lifted his paw and slammed it down, then tried to pick himself up, as he struck the ice once more and it quivered and sang.

"Yes, Toleg," cried Anarga, realising what her mate was doing, as she came staggering forward too. "Yes, my dearest love. A little ice ark for our son and Sepharga too."

Suddenly Toleg and Anarga were slamming at the ice together, trying to save their cubs, with the last breath of Garn in their wounded bodies. The wind rose and howled even more, and as Glawnaq also realised what they were trying to do too, he reared up and clawed at the air. "No! Quick, fools, take them. Stop them. They're trying to help them escape. Eagaq, do something, you idiot. Earn the name of Cub Clawer, and use that dagger again, or I'll snap it off myself."

The crack in the ice was getting larger, yet still not large enough to separate the promontory from the rest of the arctic ice shelf.

"Oh, dearest Toleg," growled Anarga as they worked together, "it's hopeless."

With that, through the ice sheet, the bears saw a white shape moving below, and a ghostly body under the water was bashing at the ice, too. Uteq thought it was one of the light shadows, but then he realised it had form and strength. With the banging below, the crack suddenly widened.

"Quick," bellowed Glawnaq. "Kill the Blackpaw, and slay his feeble friend too."

The Serberan were almost on them, but Toleg, summoning his last ounce of life and love in defence of his son, picked himself up completely and rose in his bloodied glory before them all.

"You," Toleg cried, "you may have murdered the Storytellers, sent betrayal through the free bears like the ancient curse, but will not pass, nor end the true Lore. Ever. It goes as deep as the world."

Toleg gave a final roar, throwing his body down, straight toward the ice crack. As his body struck, there was an almighty splintering, and the whole stretch of the little promontory broke away from the ice sheet, detaching itself like a little boat, as Toleg disappeared into the sea with a splash.

"No," bellowed Glawnaq, furious to be losing the Blackpaw and the spoils of Toleg's own carcass. Anarga, herself at the water's edge, flailed after Toleg, but it was too late. The rising wind and a strong current caught the cubs' little floating raft of ice though, and Sepharga and Uteq began to drift away faster and faster, out into the great arctic ocean, turning slightly on their little island, as they sat there, huddled side by side.

"Seawolves," snarled Glawnaq, rushing to the water's edge. "Pull them into the water again, and feed. Attack the ice, orca. I order you, Drang."

Drang and his loyal orca were far too busy feeding on Toleg's body though, turning the water an even darker and more savage red. But Anarga saw a grey shadow go shooting underwater, right below Uteq's new ice raft, and on it Uteq thought he heard a cry out of the sea, groaning out of the deep, and in a voice of utter sorrow too. "Avenge me, Uteq. Avenge your father, mighty Bergo."

"Fools," hissed Glawnaq, at the orca and then his Serberan. "Into the water now. I order you. Follow them." With the killer whales lashing the sea to a frenzy, none of his Serberan would obey.

"Take care, my dearest one," cried Anarga, the blood pouring from her wounded shoulder, "come back to me, darling, if I survive this terrible wound. For I've two wounds, in body and soul."

As Uteq looked between his mother and Matta, there on land, he saw two streams of light, like a mist, or bands of thin blue green seaweed, reaching from the centre of his own chest and back towards them both. Yet as the raft swept on and out to sea, the bear felt a terrible tearing inside him, as if he was literally being torn apart.

"No!" he cried, falling backwards beside Sepharga, as the strangling mist that bound him to them broke. Just then, another Bellarg

broke from the group of Serberan and rushed forward to the sea edge. It was Narnooq of the North.

"Uteq," he roared over the waters. "May Atar and Gog guard you always, little bear, and the Great Story too. For this betrayal proves you *are* the One. Trust in its mighty powers then. Tell it always. But find Mitherakk. He wanders far, but often visits the Sqeet, those that live among Man."

"Damn you, you old fool!" bellowed Glawnaq, clubbing the old bear to the ice with a single paw, and killing Narnooq outright, as he turned back to watch Uteq, "Garq and my Glawneye shall follow you wherever you flee, Blackpaw, I swear it. To hell itself, if necessary, if that even existed. You can never escape me. Never."

Glawnaq's vengeful voice bounced across the waves, as the ice raft began to ride the freezing currents properly. Now there was a great sigh from Narnooq's body, and a shimmering purple shadow rose and swooped straight toward Uteq and Sepharga, across the water, as they both heard a kindly, protective voice. "Guard your spirits," the very wind seemed to cry, "The spirit of who you are. Like the Fellagorn did. Keep them whole, and survive. But find Mitherakk and ask of the Pirik too. Go South and find Mithaiiiiir..."

The voice and shadow were gone, and it seemed a pointless command, for whichever way was south, neither Uteq nor Sepharga had any choice about where they were travelling. The young bears were hopelessly adrift, taken by the churning currents toward the splintered pack ice beyond, the growlers and huge, freezing arctic bergs rearing all around them, like vast temples, or mournful giants, as the falling snow grew thicker. The bergs looked like vengeful gods as they reared into the blackened skies, and it seemed as if the polar bears were drifting into an ancient darkness indeed.

Uteq's terrible odyssey had begun.

PART II

JOURNEYS

8

THE LONG MARCH

"And now I know that twenty centuries of stony
sleep were vexed to nightmare by a rocking cradle,
And what rough beast, its hour come round at last,
slouches toward Bethelehem to be born?"
—*W.B. Yeats, "The Second Coming"*

A phalanx of weary polar bears was struggling through a bitter snowstorm, well north of the Great Sound, moving steadily up the eastern shores of Canada in the growing dark, and swinging inland too to escape the flickering settlements of the Gurgai. While the glittering shadows of snow Varg prowled on each side of them, the wolves' tails raised, their night eyes sparking like brilliant fires - Glawnaq's mercenaries. They were not alone in shadowing these once free bears, for in the seas to the east, far out though now beyond the hardening ice sheets, came lines of thrashing black shapes in the ocean too - paid orca.

The guards on land, both wolf and bear, were strangely respectful of their charges though, and would even try to encourage them in what they had dubbed their 'Long March'. They also seemed to be sizing up their catch, male and female, who were kept apart from each other, and from their own cubs too now: 'The Separation', the Ice Slayers called it. Seegloo and Rornaq, Tortog and Sarq then, were together among the Scouts left alive from the Sound, like Forloq and Brorq, the adult males together, but bewildered and battered by the terrible attack, and the sudden deaths of their leader and friends.

Nuuq and Innoo meanwhile marched side by side, among the adult females, although Innoo's eyes looked glazed and lost, for now

she was mourning her lost mate Gorteq terribly – while she kept stopping to paw at her collar, as she wondered how her cubs were faring in the horrible storm. Anarga Calmpaw walked alone in a party of Serberan up ahead.

As they went, two strange rules had been imposed on the captives, although it was put about that none were prisoners at all. First, although the Serberan talked to them and told them hopeful things about Glawnaq's bold new order, supported by his mysterious Barg, it was clear there could be no open complaints at all. Secondly, none of them was allowed to tell stories anymore and the names of Pollooq and Teela were especially forbidden.

Trailing behind, but at the head of the group of younger Bellarg and cubs from the Sound, led by a friendlier Ice Slayer called Keegarq, Matta and Qilaq were still together. Behind them came Sqalloog, and many of the other youngsters who had been in the nursery and on the Wander, including pretty, delicate Antiqa. Antiqa kept glancing at Sqalloog, as all the cubs had grown especially distrustful of one another after a rumour that the passing words had been betrayed, and because of what Tortog had said on the Wander of cubs helping Glawnaq's lieutenant.

Sqalloog himself had grown rather large now and looked very cheerful indeed, despite the hard journey. Often in the dark march north, Sqalloog had picked on the weaker cubs and once or twice they had noticed him talking to Eagaq himself. Up ahead though, the children could vaguely see the shapes of the adult Bergo and Bergeera, and they all missed them bitterly, especially their mothers. But the cubs' world had changed as dramatically as the blistering weather and the plunging arctic cold.

"What are they going to do with us, Qilaq?" asked Matta suddenly as they went. She looked tired and frightened, and still wondered how this had all happened during the confusion of the Still Hunt. They had found themselves at their air hole in the middle of the fray and almost been overlooked, but then had been swept up in the trap, as the air had cleared that day, although not surrounded like the others.

"Taking us to Glawnaq's kingdom," grunted Qilaq in answer, as

the snow swirled about like smoke. "To raise us as Barg, or as Serberan, if we get any choice about it. I was listening to Keegarq just this morning, and he says there are hundreds of polar bears up there already, gathering in Glawnaq's wild new order."

Matta swung her head to look at the Serberan around them. The Ice Slayer called Keegarq was tough, but he wasn't so bad, and good at encouraging stragglers. The twins might have felt far worse about their predicament if they had ever known their own father, but his absence had actually taught both a certain independence too.

"There's a regime of daily fighting and boxing there for Ice Slayers," said Qilaq, rather keenly, as Matta noticed Sqalloog slow and prick up his ears. "Moon Duelling, they call it. I've never seen that before and they say the moon brings out a Bellarg's true fighting spirit. They're making a brave new world for bears, all right."

The snow was heavy now and the wind sharp and it struck both their faces like pebbles, as Matta suddenly remembered the fateful day they had set out for the slide and began pondering how different the snow could be, and one's fortunes too.

"To fill us with the Bear Rage, more like," she grunted. "Or the Ice Madness, Qilaq. Maybe it'll be better among these Barg then. That means 'blessed', at least. The Barg just serve and don't have to fight, I hear. We should try to hope for the best then, brother, and at least the Serberan protect us from the filthy Snow Raiders."

Earlier in the journey, another deep winter blizzard had struck, and after hunting parties had gone down onto the sea ice and the marchers had stopped to eat, twenty strange Bergo had come charging out of the snows, from nowhere, roaring wildly and lashing out at the travellers, yet the Serberan had quickly fought them off. Although they had killed none, it had impressed many from the Sound, and reassured them too. The Ice Slayers seemed to be protecting them all indeed then, just as great Glawnaq had promised.

"Oh, Qilaq," said Matta bitterly though, "I hope dear Uteq's safe. He looked at me so strangely from that ice raft and it hurt my heart. He seemed so angry and lost."

Qilaq glanced rather strangely at his sister, for the rumours of cub

helpers abroad had suddenly reminded him that Matta had known the passing word on the Ice, *Alive*. He suddenly wondered if his own sister could possibly have betrayed them, then felt guilty for the very thought.

"And Sepharga," he whispered sadly. "She looked so vulnerable out there too. But we must never tell the Serberan anything about what we know of Uteq's strange powers, Matta, and at least they've each other now as they journey."

Matta nodded, and Qilaq glanced around and saw Sqalloog still trying to listen. The bully had not heard the last exchange, but his eyes were glittering with both fear and malice, his nose twitching furiously. Well, *Sqalloog knew something of Uteq's power anyway*, thought Qilaq, but little did the twins know that the cub had already planned to tell Eagaq everything, when they got to Glawnaq's new world.

"Oh, I hate walking so much," said a voice nearby, "and can we really trust the Ser..."

"Trust?" snorted Sqalloog, cutting off the youngster, and seeing the deep concern on all the cub's faces, "It's a just new chance, you fools. Great Glawnaq has a clear plan for all our survival now, when his fame and glory finally unite the Five Thousand as one. With Eagaq Breakheart behind him too, Glawnaq One-eye can't fail. That attack, for a start, it was brilliant."

"Unite?" grunted Matta though, glaring at Sqalloog, "but with melting ice and failing food, why bring polar bears together at all, Sqalloog? Won't it just make us all fight like bullies and hate each other all the more?"

"Rubbish, Matta. He'll think of something," answered Sqalloog, "and although the Blessed have the privilege of serving, I'll be a Serberan myself instead, you'll see. If you can't beat the Pheline, then join the Pheline, mother always said. The Ice Slayers broke the so-called honour of our stupid Scouts, all right. 'Vigilance', what a joke."

The twins could hardly contradict Sqalloog, but Matta bridled.

"And your blessed Eagaq murdered our father," she hissed, and Qilaq felt strange as she said it, for although the news had struck him like a blow, he had never even met Gorteq, and so it felt like some-

thing told of in some story rather than something that had actually happened to them.

Qilaq suddenly wondered though if it was Sqalloog who could have helped Glawnaq get into the Sound, but they heard a roaring up ahead. Not far away a Serberan was rearing up and cuffing poor Mad Mooq, who wailed bitterly and cringed back, before another Bergo stepped up and growled at the rearing Ice Slayer. The two polar bears locked eyes, bright and piercing in the darkness, but the Serberan who had challenged Mooq seemed to be consciously restraining himself, and he stepped back and gave a low growl.

The stranger who had just stopped him hurting Mooq was not a Bergo from the Sound at all, but part of a group of stragglers that Glawnaq had caught, as he and the Serberan had swept southwest to spring his trap. The stranger retreated now and seemed to fall away in the growing blizzard, and just for a moment as she watched Matta though she saw him turn and lean down to talk to a small white shape, low on the ground. For a moment it looked like Ruskova, but it couldn't be the Arctic Fox Uteq had saved, for her coat had been black-and-white, not pure white like this creature's, and as they got closer it was gone too.

On the bewildered bears went, marching nearly non-stop now in the growing arctic darkness. They were all becoming more and more anxious, yet when the skies were clear of clouds, all found themselves looking up wonderingly at the gigantic heavens, and the millions of stars in the inky black above, starting to make out shapes among them too that seemed to sail across the very ceiling of the world. When they stopped to sleep, they seemed to share troubled dreams, full of looming shadows, and it made the twins think of Mad Mooq speaking of dreams in his prophesying. A presence was there in all their sleep too, a shape they found familiar, like something dangerous and angry stepping from a dark cave.

It must have been nearly a month into the deepening Long Night when the party suddenly slowed and the twins heard a great roaring, as two Serberan rose nearby. Now the Varg mercenaries lifted their sleek muzzles too and let out a triumphant howl on the arctic wind.

The party had just crested a rise of deep snow, and they were suddenly looking down into another sweeping arctic Sound.

That evening the black winter skies were illuminated by a huge arctic moon, an enormous disc of glowing yellow, and the wash of the Milky Way, with Teela shining brilliantly there in such lonely clarity. The heavens were a lovely sight, yet now the twins spotted carefully sculptured snow mounds below them, and rows of Bergeera, sitting in strict lines, watching the shore intently. They must be Glawnaq One-eye's new Serberana.

Out across the sea ice in front of them, pairs of huge Bergo were roaring, rising up and slashing at each other savagely in the glowing moonlight, sending halos of ice crystals flashing around their swaying white coats, as some of the Serberana seemed to twitch visibly at the sight.

"Moon Duelling," gasped Qilaq. "This must be Moon Duelling then, Matta. It's amazing."

"And watch that one, cubs," said a voice. It was Keegarq, the kindlier Ice Slayer guard and he was watching a particularly savage fighting Bergo admiringly. "He's a famous Southpaw, that one, and I just heard killed four Serberan last month. One was even a Glawneye."

"Killed?" gulped Qilaq in surprise, suddenly wondering whether to admire this or not.

"Of course, cub," said Keegarq. "Moon Duels are to the death. At least it gives us a bit more space in our new home and provides payment for the mercenaries too."

"Wolf Draggas eat the Serberan, Keegarq?" said Matta in horror.

During the Long March some older polar bears had fallen to exhaustion, and at first the twins had been horrified to see the wolves gathering and beginning to feed. But they had not expected Glawnaq's mercenaries to turn on Serberan too, for the wolves were wary enough of Ice Slayers.

"Only sometimes," answered Keegarq, with a shrug. "Perhaps it's their revenge. Orca have the losers too, a quota of bodies pushed into

the sea. Glawnaq finds it more democratic. We're all equal here, you see."

Qilaq thought of the Pheline suddenly, as Teela had demanded that all be equal in the story.

"Equal?" he whispered rather doubtfully. "But the Serberan..."

"Equal in death, cub," said Keegarq sharply. "And not so different then from your great so-called Free Council, I hear. Now Glawnaq's formed a Super Pack of Varg too, there are many hungry mouths to feed. Everything's used here though, cub, and what's a body when the spirit's gone anyhow? No shame in a hero's death, either."

"Heroes, Keegarq?" said Matta doubtfully. "But they look so angry. So brutal."

"Brutal? You'd have us weakened with Bergeera tears, would you?" snorted Keegarq. "As wounded as Pollooq was by Teela, perhaps?"

Qilaq found himself nodding, but Matta was surprised that Keegarq should even mention a myth so openly, and how angrily he spoke of the fabled bear too, while she saw that he was suddenly staring up accusingly at the pole star.

"True Bergo have to fight in the real world," growled Keegarq, "and kill or die, if necessary. As warriors. For they say wisdom is a Bergeera, but loves a warrior, and I promise you that here no betraying Teela will ever steal our honour."

Matta was taken aback, but the fighting bear Keegarq had been talking about lashed out with his left paw in his Moon Duel and struck the other Bergo so hard, that it knocked him to the ice in a shower of blood.

"Loser," grunted Keegarq scornfully.

In normal fights between polar bears, boxing was not an uncommon sight, but as in many cases in nature, it was more for show than anything, for although it seemed savage, nature tested its own strength instinctively, without really trying to wound, for that can quickly be fatal in the wild. It was different then under Glawnaq's brutal new regime. Yet both the twins and the other free bears were mesmerised for in the sinister, silvery moonlight, the sight was almost magnificent, like some terrible beauty uncloaked.

It was the ice itself that caught the twins' attention though, which was rucked everywhere, stretching out into the misty expanses toward the sea like a pitted field, or some glassy hell. Something even stranger caught Qilaq's eyes, for some of the Moon Duellists had long ice spikes clenched in their claws.

"Ice daggers, Matta," he grunted. "Anarga said bears sometimes use for Still Hunting."

"Anarga," said Matta, swinging her head suddenly. "Over there, Qilaq."

Not thirty yards away, Uteq's mother was being guarded by four large Serberan and four sharp-eyed Varg, dribbling hungrily as they watched her. Poor Anarga Calmpaw looked lost, almost broken, and although given the finest seal cuts daily on their March, her wound still hadn't healed properly looking raw and infected.

"It's us, Anarga, the twins," called Matta suddenly, but her young voice mis-carried on the wind, and Anarga never even turned her head. Qilaq had just noticed Eagaq marching up and down, on the edge of the rise, his face scarred from Marg's failed strike. His right eye kept twitching furiously as he surveyed his new kingdom.

"And where will they take Anarga Calmpaw, Keegarq?" asked Matta softly, remembering how she had protected them on the Wander and suckled them too. It pained her heart.

"The Calmpaw stays here and as close to Glawnaq's Ice Cave as possible. He sends her gifts of ringed seal though, and white whale meat too, to win her love."

The twins had followed Keegarq's gaze to the mouth of a huge cave, cut into the side of a low ice wall and inside they saw a shadow moving now, Glawnaq One-eye, like a black cloud, or some land-bound orca.

"From there the Great Father looks out on all," declared Keegarq respectfully. "And teaches his new Ice Lore. The true lore. Fight, triumph, or die with honour. Nothing else."

"Great Father?" said Qilaq, thinking sadly of Gorteq. "That's what Glawnaq called himself on the ice."

Keegarq nodded, but now under that fighting moon they saw the

Bergeera from the Sound, and among them both Nuuq and their mother Innoo. Sqalloog's mother was with them too, although the one-eyed Bergeera had found the journey desperately hard and she looked about to drop.

"Mother," called Matta, but Innoo hardly swung her head either. Her eyes looked as glassy as Anarga Calmpaw's.

With another roar, on the Serberan marched the adult females, and off toward the party of adult Bergo. Among them were Seegloo, Forloq and Brorq, Rornaq who had brought news of the Fellagorn's defeat, and Tortog and Sarq. Seegloo managed to look up and give a little groan as he spotted lovely Nuuq and something seemed to soften in his eyes, though all the Scouts looked bowed and dishonoured, no matter how hatefully they glared at Eagaq Breakheart.

As they watched, the twins heard angry growling, and saw a Serberan snarling at Nuuq, who had just strayed from her group. All the Serberan's mood seemed to be changing dramatically now with their arrival. Fine Nuuq stood her ground though, suddenly chuffing back, even though the snarling Serberan was far bigger, and for a moment it filled the twins with pride again, but as the Slayer rose and swung at Nuuq, another bear rushed forwards and buffeted him hard. He was a large, muscular Bergo, who looked a little like Toleg Breakback, with fine red fur sleeves at his heavy arms.

"Back, idiot," he snarled, showing his teeth and growling.

"Soonaq?" said the Ice Slayer in surprise. "But they're only dumb Barg..."

"Silence," snapped this Soonaq. "And know your place too. She's a Bergeera, idiot, and even ignorant scum like you treat *them* with some respect. She might enter the Serberana one sun, to be protected as a mother of the future. Besides, Eagaq's marked her out for his own special attention."

The Serberan scowled but backed away, much intimidated by Soonaq's obvious strength, and the handsome stranger turned to Nuuq and dipped his head elegantly. Qilaq suddenly felt strangely jealous but utterly helpless too.

"I'm sorry, Bergeera," they heard Soonaq say. "But they'll leave you alone now."

Nuuq's beautiful eyes flickered.

"Thank you, kind Bergo," she growled, liking Soonaq's strong face immediately, but wondering what special orders the foul Eagaq had given in the Sound.

"Soonaq, graceful one," he answered softly, "My name is Soonaq, and not all the Serberan are so hard, you know. But watch yourself Bergeera and stay sharp and alert. Above all, you must know who to trust here. From what I've learnt, it's few from your own Sound, I think, among your Bergo anyway. Still, we get the leaders we deserve, they say."

Nuuq frowned heavily but she nodded, while Qilaq suddenly thought this Soonaq magnificent, a marvellous specimen of a Bergo, though with it, as Nuuq smiled back, came sudden resentment. As Matta heard Soonaq she felt bitter, remembering what Innoo had said of Bergo causing all the problems in the world, but then she noticed her mother, who was swaying her head and scratching at the ground too, like some hungry Varg. Innoo did not seem to know where she was at all.

"What's wrong with mother, Qilaq? Look."

Qilaq watched her for a while but he simply shrugged.

"I don't know, Matta, I don't know."

Down onto the ice went many Serberan now, with some of the Bellarg from the Sound, who had clearly been picked out to accompany them. But as Matta and Qilaq turned to join them too, with Antiqa and several other cubs – for strangely Sqalloog was suddenly nowhere to be seen – a guard growled sharply at the twins.

"Not you two. You go to join the Barg. Eagaq Breakheart marked you out especially. That way then."

Something strange quivered in Matta's heart but they obeyed, wondering what blessings were to come. The Sound before them curved around toward some ice cliffs as they walked, past lines of very tough looking Serberan guards, into another large bay, where they stopped to see maybe three hundred scrawny Bellarg out on the thick

winter ice. Although the moonlight was cheerful enough, there seemed a kind of awful sadness here, for these creatures were not duelling or training vigorously, like Ice Slayers, but lying about in pools of lank moonlight, the Varg and the Serberan watching them closely.

"Behold, cubs," growled Keegarq. "You are home at last, in the Bay of the Blessed. The Bay of the Barg."

Some of the Barg looked up, with eyes as lost as Innoo or Anarga's and on the brutal air, the twins heard an odd tapping coming off the sea, like that strange knocking that fateful summer back in the Great Sound. *Tap. Tap. Tap.*

"The Blessed?" grunted Qilaq. "They look more like slaves to me."

"Silence, cub," snarled a Serberan next to Keegarq. "Any careless talk like that here's punished severely. So watch it."

Out on the ice, Matta had noticed something extraordinary in the eerie moonlight. Just where the odd tapping was coming from were line after line of neat little black circles, perfectly round, and with a small Bellarg cub standing at each, banging rhythmically on the ice with their little paws.

"Tappers," explained Keegarq, with an approving nod, "working at air-holes for Still Hunting. Barg Bergeera cut the holes with ice daggers, just like they dig Serberana dens, and after those cunning little cubs have done their work to draw the seals, your more resourceful Barg Bergo come in to Still Hunt them. All ordered and reasoned out, you see, on Glawnaq's specific orders."

"But why are the Serberan and Varg watching them?" insisted Qilaq. "If we're not prisoners, Keegarq?"

"To prevent accidents, of course," answered the Serberan who had warned Qilaq, quickly, glancing at Keegarq rather guiltily. "And to make sure the work details do their duty. Nothing more. The Varg serve all us Bellarg, and for fair pay too."

Again the eerie ringing sound came from the moonlit ice, but Qilaq suddenly doubted the Serberan completely and it made him think of Anarga making up reasons about the ice ark and the Lerop in her story on the Wander. Everyone seemed to lie somehow.

"You might like it though, cubs," said Keegarq, "when you're not playing together. Just follow the rules here then. With so many Bellarg together, we need as many new laws and rules as the clever Pheline did in your old fables."

Across the new Sound groups of Bergo were trailing back across the sea ice, carrying seal pups or walrus meat in their mouths. Rather than eat naturally though, as polar bears do, the Bergo marched on to a spot on the ice where they dropped it all into a pile, a spot surrounded by Varg and Serberan, who seemed to be counting the catch. The Barg Bergo were like ghostly sleep walkers.

"You there," said the Serberan by Keegarq, seeing the Qilaq's sudden wariness, and looking toward a small party of Bergeera and at one especially weary looking female. The she-Barg looked up obediently, but she smiled thinly and licked her lips.

"You're happy here, aren't you Bergeera?" asked the Ice Slayer. "Truly blessed, my dear."

"Oh yes, Sir," answered the female, as a large snow wolf stepped up and raised its tail. "We're all blessed here, Sir, thanks to the Father."

"And why, good Barg Bergeera? Tell us the Lore."

The Bergeera straightened slightly and pawed the snowy ground.

"Because Bellarg are in mortal peril, Sir," she answered. "Now that our ice world dies, and the end comes."

"That's right, Bergeera," growled the Slayer. "And the verse you all sing at the instructions? Recite it now, for our help and enlightenment."

The Barg dipped her head obediently.

"As ice is clear, the end is near, while Raiders fill the world with fear, yet Glawnaq's brave and truly pure, so teaches Barg we must endure."

The Bergeera was swinging her head strangely, as Matta wondered what these mentioned instructions were, amazed at this talk of an end, for that was part of the Great story Glawnaq himself had banned. Yet the Barg Bergeera faltered as she looked at the twins, as if some memory was pushing into her thoughts.

"Continue, Bergeera," snapped the Serberan.

"Yes, yes, Sir, of course. *And first we serve the Slayer's might, as Barg, whose work is pure delight. For work and duty blessed be, in work our service sets us free.*"

The Serberan smiled approvingly and showed his yellow teeth, and the twins suddenly felt deathly cold.

"Yes, yes," he said, "work makes all you blasted Barg really free, so don't ever forget it. And tell me, what do you learn from the daily instructions is the only true Lera in the whole wide world that works?"

"The Gurgai," answered the Bergeera immediately, "for Man are Tulqulqa too, just like polar bears. Yet only they have mastered true reason and logic, like the reason of the Pheline, so from the Gurgai we find our real path, mere animals no more."

Matta looked at Qilaq in utter horror, remembering what Seegloo had told them of Man and that murdered bear family, and appalled a Bellarg should not want to be an animal anymore.

"Very good, Bergeera, very good," said the Ice Slayer more softly, and Matta wanted to bite his leg. "I'll mark you out for some extra scraps after the next Still Hunt, or even a place on a leave."

The Bergeera seemed delighted, and the other females looked at her rather jealously.

"Leave?" said Matta, but just as she spoke, she saw a group of guarded Barg swinging into the bay; Bergo, Bergeera, and young bears too. They all looked considerably healthier than the others and walked with a spring in their step, and light shining in their eyes. They seemed very well fed indeed.

"That lot, cub," growled Keegarq. "Just back from a leave. Life's hard, but at least you Barg have your rights and so you earn leisure time too. I wish I could say the same for the Serberan sometimes. It's just fighting for us Bergo warriors. But not the Barg. So sometimes we take you off to sleep and rest, and meet up with mates, friends, or cubs. To hunt seal and walrus in the wild, and eat as much as you can. We're not all work and war, you know."

Keegarq grinned and the twins looked startled, wondering if they hadn't been completely wrong about Glawnaq after all, even if he had

killed Toleg Breakback. Now they heard some happy shouts too, and looked over to a group of young Barg nearby.

"Bluffs, Qilaq," said Matta delightedly, "They're playing bluffs. Just like in the Great Sound."

"Hush," snapped a Serberan, "No talk of the past here, only the glorious future."

Again Matta was surprised that the Serberan seemed to be aping the Pheline from the story, but to the twins it suddenly all seemed rather normal and not unhappy at all.

"Wait here though," said Keegarq cheerfully, "and one of the bosses will make sure you fit in, and find your proper place. Ask them anything, or tell them if you have any problems. You've rights, as I said."

"Bosses?" said Qilaq, looking sharply at his sister.

"Of course. Who oversee the work details. The top bosses are Farsarla among the Barg Bergeera, with Gerla second in command, and Darq among the Barg Bergo. Who knows who it will be for you cubs though? But Eagaq will pick one out soon enough."

Now Keegarq and various Serberan turned with the Varg and abandoned the cubs to the strange bay. The twins sat down together, near the cubs from the Sound, while young Barg nearby came up to sniff at them and eye them up, though they seemed frightened of even approaching, or somehow ashamed. As Matta sat there, she suddenly had a strange sensation and swung her head. A tiny little polar bear cub was standing there in the snow, watching her intently. He was very thin indeed, his legs were shaking and, standing there in a pool of moonlight, he was so blue that he looked like a terrified little ghost. Matta tried to smile kindly at him and tilted her head.

"Hello there," she whispered kindly. "And who are you?"

The little tapper looked like a frightened snow rabbit, wanting to bolt at any moment into the warren of the night.

"Pooq," he gulped though, and Matta noticed his right paw was tapping almost involuntarily on the ground, as if he was utterly freezing. "But do you know...the secret?"

"Secret, dear?" said Matta softly.

"Yes, the secret."

There was something so wide-eyed and so utterly vulnerable about little Pooq that Matta wanted to hug him tight, but with that she saw an adult coming toward them and Pooq's tapping got worse, quivering through his whole body, before he suddenly turned and fled.

"How strange," whispered Matta, although coming towards them she recognised the Bergo who had defended poor Mooq from an Ice Slayer. He had somehow left the group of adults, to walk out on his own.

"Well met," he growled as he reached the twins, and Matta noticed his great size and a deep scar running across his forehead. The twins looked at each other in astonishment at his jaunty tone though, and immediately forget ghostly Pooq's strange little question.

"Keep your hearts up, friends," the newcomer went on, his deep voice calm and strong, yet with a strange, lilting note to it that was rather mesmerising. "And your Garn clean and strong too. The real fighting spirit, eh, in two such fine young gods like you."

The twins felt very strange to be suddenly called gods, especially after their miserable journey, but it stirred something deep inside them both.

"We will, sir," said Matta, recalling Narnooq's dying cry to Uteq across the sea, "but we're not supposed to even talk to adults, sir. Just as they've banned stories here. But how did you get..."

"Stories," interrupted the handsome stranger, sitting down right beside them in the dark snow. "Now that's a fine idea. Let me tell you both a story to raise our spirits then. Though first of all, what are your names?"

"Matta and Qilaq," answered Matta, feeling even odder, but also feeling good to be near an adult again. "We're from the Great Sound. We're twins."

The Bergo leant forward and let out a laugh, his deep eyes sparking.

"Oh I can see *that*. And fine reflections of each other too, I hope. For aren't we all seeking our best reflections in the snows of life, to tell us who we really are?"

The twins wondered what the strange Bergo meant, yet dimly words stirred in Qilaq's mind of some pact existing between those who see and those who are seen, and he thought once more of Pollooq and Teela.

"And my name's Janqar, for what it's worth," said the stranger, "though what's in a name? I'm a freeborn bear, and a wanderer, although I think I'll try my fortunes here, a while at least."

This Janqar was talking as if he was perfectly free indeed, and Matta thought something mischievous glittered in his dark eyes, as she noticed his forearms, for where fur sleeves might have hung down, the bear's coat was cut and jagged, and he looked as if he had been in a bad fight fairly recently.

"You must never give up hope," said Janqar warmly. "Ever."

"Hope?" snorted Qilaq. "With Toleg Breakback dead and the Scouts betrayed? The bears here are little better than slaves."

"When great ones fall, young Qilaq, the world trembles," said Janqar with a sigh. "And it looks like that to me too, although there's always the Great Story to guide us still."

"Great Story" growled Qilaq. "It's because of their stupid, unlucky story that we're here at all, and that our poor friend Uteq is..."

"Hush, Qilaq," snapped Matta immediately.

"Uteq?" cried Janqar though, swinging his head sharply. "Then you're friends of Uteq Blackpaw?"

Janqar's eyes seemed to bore into them now.

"We are," answered Qilaq slowly, feeling ashamed to have talked of Uteq at all, as Janqar noticed the anguished look in Matta's eyes.

"And more than just friends, perhaps?" he said. "Very close friends indeed, I think."

"We made a pact, Janqar," said Matta, embarrassed at the heat of her youthful feelings in front of a stranger, "to look out for each other, always. Before the very sea. Just a pact of four loyal friends."

"Then I hope you can keep it, deep in your hearts," said Janqar approvingly. "And when the world conspires to tear love and truth out of you, brave cubs, just look up at the moon, and hold onto her. To Atar's mighty power."

The twins looked up at the distant moon, seeing a circle of light around its shining face and wondered if Atar was really up there. It made them feel better, yet they hardly believed it now, although something in her great light seemed to tug at them strangely too.

"And tell me, did you notice anything special about this friend of yours, twins?" asked Janqar now and Matta looked sharply at Qilaq and was suddenly wary of the stranger and his question.

"Special?" she said lightly. "Er, no, Janqar, not at all. Why?"

"No reason. I'm honoured though, to meet friends of *his*, and so I will stick close, to aid the story, if I can."

"The Great Story?" said Matta sadly. "But no one's telling it, Janqar. We're not allowed to here, and the Fellagorn are all dead and..."

"Perhaps it tells itself then, pretty Bergeera," insisted Janqar softly. "We must have faith."

"And how do you know about Uteq though?" asked Qilaq suspiciously.

"Just rumours," answered Janqar, and Matta thought of that little shape she thought she had seen him talking to in the snow. Matta felt instinctively now that Janqar was hiding something, and she thought of spies too. Who was this mysterious stranger, and what did he really want?

"The Fellagorn though," said Qilaq angrily, "they were supposed to protect us all and the Ice Lores too, Janqar, but now look. They were all just cowards, wasting their time on words and secrets."

"That's bad you think them cowards," Janqar grunted. "It was a furious battle."

Qilaq looked up sharply.

"You saw that?" he gasped. "The Field of the Fellagorn. Rornaq told us what the animals saw, but it was like some strange dream, and we were just cubs then. I'd like to know the real truth now. I'm old enough."

"I see then I've raised the blood of a brave young Bergo," said Janqar proudly. "And yes, I saw it, Qilaq. After the Fellagorn had been summoned, on a kind of Long March too, and three wandering bears,

Teleq, Beloq, and Illooq Longsleeves had found their Great Master again, as they avoided Glawnaq's spies."

Matta and Qilaq sat up straighter and the wind seemed to soften a little as Janqar spoke.

"So the Fellagorn went on," said Janqar, as if suddenly telling them both a story, "but one night the temperature got so cold that hardly anything could move. Then the Fellagorn began a Telling Moot to keep warm, as they posted Scouts, for Illooq Longsleeves had kept his ears open, and warned them all that they were being hunted. The Storytellers began to compete, telling stories rehearsed in the Long Nights, for that's how the sacred order began to pierce the darkness and mystery of the world, with words and stories, like dreaming the very world into being. But it was so bitterly cold, the Scouts froze solid in their very paw marks and so the Serberan, who had rubbed whale blubber on themselves to keep warm and moving, struck and murdered them all."

"It *was* Glawnaq then," hissed Qilaq angrily, although he had no idea that Janqar had just explained why Anarga had thought the Fellagorn asleep in her vision in the den at Uteq's birth. "And some say they were betrayed, Janqar."

"It was Glawnaq, all right," said Janqar, dropping his voice and looking round, "but you'd better keep it secret, you know. After the battle I found the Fellagorn Scouts frozen as solid as ice carvings, or bergs waiting to be released forever and come back to life, with Atar's power."

The thought of a legend of things coming back to life calmed Matta a little, yet it all sounded so unreal too, as if everything that had happened was just some terrible, impossible dream. As if the whole world was.

"You fought there too Janqar?" growled Qilaq admiringly though.

Janqar suddenly looked a little uncomfortable.

"Er, no, young Qilaq, I arrived just after, although I saw much of it from across the flat ice sheets. The moon was bright and pure, that bitter night, when the sacred Fellagorn died."

"Then the secrets of the order died with them." said Matta with a heavy sigh. "And I'll never know them now, Janqar."

"Except that's how I met Illooq Longsleeves myself," whispered Janqar, "the very last of the great Warrior Storytellers."

The twins both raised their heads. Illooq Longsleeves? They both remembered Nuuq talking of this Illooq as a very great fighter indeed, but Matta thought she saw something false and secretive in the stranger's eyes.

"The last of the Fellagorn?" she whispered, for the phrase seemed to have a mythic note.

"The very last, Matta. The Great Master's first and favourite disciple too, who had travelled North so far and faithfully, with his closest brothers. Three wandering bears, seeking a holy path, or a new beginning for the whole world."

"A Holy Path?" said Matta, "To seek the birth of the Ice Saviour you mean?"

Janqar frowned.

"No, Matta, to find the Seeing Caves."

"The Seeing Caves?" said Qilaq in surprise.

"Yes, Qilaq. Sorgan was leading the Serberan away from signs of any birth, you see," explained Janqar, nodding, "and on a wild snow chase, while he sought visions out there in the mythic Seeing Caves. For those caves only form when Atar's power itself is challenged, and she returns to earth. Great Sorgan sought to lift the ancient curse, then, by turning to the power of heaven, not the Hell that Pollooq faced, for at times we must go around to work."

Qilaq blinked and wondered if it was all just a silly story, although this was reported fact, and suddenly he thought himself too grown-up for any of it. But for Matta it was as if Janqar's words were bringing the Fellagorn Storytellers back to life, although as she wondered what the stranger meant about going around to work.

"Illooq was the only one left alive when I arrived," Janqar went on, "yet dying on the ice, lying there right next to his master, and unable to move. Yet he roused his spirit, and so used his last breath to pass on their secrets, and their strange tale too."

187

"But not to fight," grunted Qilaq, disappointed with the story of the mythic battle on the Field of the Fellagorn.

"Fight, Qilaq? They did fight, though there are many paths, and many ways to fight in the world. Even with love. The Fellagorn could not win that night though because the cold had stopped their throats completely, turning their very words to ice, which they always used in warfare too. Their Word Power."

"But why would that stop them fighting?" grunted Qilaq sceptically.

"For as well as claw and paw they used their voices in their battles, to wield great power. But I should tell you from the very beginning."

Even sceptical Qilaq was captivated by this talk of a Word Power, while Janqar's story itself seemed somehow to cocoon them from what was happening around them in the real world, so they both nodded keenly.

"Very well then, I'll go back to before the battle. After much searching, one night the three wanderers led by Illooq Longsleeves, found Great Master Sorgan, with a hundred Fellagorn around him in a circle. Sorgan's mighty winter coat was tinged as orange as fabled Goom's, as he looked around with his half-blind eyes and sniffed the air. There Illooq and the three pressed into the circle, wondering if Sorgan had found the Saviour cub already, for they still thought that their quest, but now Sorgan told them why he had really summoned them into the North, although Illooq Longsleeves was very hot-blooded, and argued strongly for war.

"The Great Master looked up at his disciple sadly though," said Janqar, "asking him what Goom had once said and then reciting his words: 'Better to maim than kill, to strike than to maim, and to turn aside than to strike.' It was a mantra of the Storytellers, the path of restraint, for it was the Fellagorn's first lore never to attack, but only to defend the good.

"'For we are the sacred Storytellers, Illooq Longsleeves,' said Sorgan," Janqar continued, "'who use the Word Power and know that the jaw is always mightier than the claw. So we must contain the whole world within us, and keep our minds still too, and our Garn

spirits clean. The greatest challenge of an enemy is surely that if you fight like them, you may become them. You cannot live well without some clear philosophy either. Yet perhaps all that your Great Master can fight now,' added Sorgan with a heavy sigh, 'is death, and I know who'll win *that* fight. Not I, Longsleeves, and it's close now. Very close indeed. My own death.' Sorgan smiled, but the Bergo around the circle growled and their eyes filled with tears.'

"'The Serberan bring death to everything,' grunted Beloq next to Illooq Longsleeves though. 'We should kill them then, Master. We're warriors, as well as guardians and warriors fight in the real world, so now is the time.'"

"'Beloq, Beloq,' muttered Sorgan softly, 'you must not be so angry, or your Garn may turn against you. Know the true lore then. Just as ice hardens, then melts, so strength turns to weakness, but weakness back to strength, like a wave, for what is mightier than the great sea? Nothing may stop water.'"

The twins remembered their promise before the greatest thing there is, the wild sea and it seemed to rouse their very blood and fill them with hope, although to bring a sadness at thoughts of their own friends lost at sea.

"'And what did Goom love most but laughter?' Sorgan said," Janqar went on, 'Always transcend then, bears. Words become actions, actions character, character destiny. Words that can pierce like a dagger, if used with the true skill and Fellagorn Word Power. Respect them then, and yourselves too, for do we not sense the world, as we listen, then plunge so deep with language, that our very words can crack open the swirling air, and turn a living wing, with a single punching breathe.'

"Even as the Great Master cried it," whispered Janqar in awe, "a gull cawed and seemed to sweep toward them, hitting the sea ice hard."

"Oh I don't believe *that,*" grunted Qilaq and Matta felt just as amazed, wondering how Garn could turn against you, and if words alone really touch the world. She felt as if she was inside a story herself, as Janqar continued:

"'Behold the Word Power,' cried Sorgan, 'And there's a destiny, even in the fall of a gull. So remember Goom's love too. Sink your Garn weight, and breathe, so it does not rise into your head, and bring the Madness. Know words become things too, and always follow the eight great Paw Prints.'"

"Eight Paw Prints?" said Qilaq. "He means the Eight Commandments. The Ice Lore."

"'Not quite Qilaq," said Janqar, "for though Fellagorn respected the old Lore, and helped free bears keep it, they had stepped *far* beyond themselves, so their self-imposed task was to Paw Trail only Goom himself, who brought the Eight Paw Prints into being: right views and intention, right speech and action, right food and effort, right concentration and awareness."

Qilaq frowned. It sounded much harder than the Eight Commandments but he tried to concentrate too.

"Then Teleq noticed the Fellagorn drawing circles in the snow," said Janqar, "with a weaving line through the middle, and a dot in each side. The very symbol of the ancient Fellagorn – the Manda."

"Why circles?" asked Matta, wanting to see this Manda, but Janqar did not answer but simply continued.

"'I follow, Great Master,' said Illooq Longsleeves humbly, although as frustrated as his brothers. 'But can we not end this hatred and fear right now? End Glawnaq's spreading evil forever? Strike hard and swift and deep.'

"Sorgan sighed though. 'You might as well end the world, as end fear or hate, Illooq Longsleeves, and so I wish you always – not too much attachment, nor too much aversion either. Goom taught that you must respect life, and love all, but at a distance and with care. Is not that the true mark of the One that the story speaks of? The Ice Saviour. A cub born to be a very king, and to guide us all back to the light once again.'"

Qilaq stirred at this talk of a king, while Janqar was looking intently at the cubs, and seemed to be trying to tell them something important, and something to protect them too.

"The Fellagorn spent many days talking together in their circle

then, speaking of how for centuries warrior bears had turned to killing, serving misguided alphas, and brutal Lera, but how now they must all find a new path, if the world was ever to be renewed. Fearless in their heart strength."

"Heart strength?" whispered Qilaq longingly and he suddenly felt small and afraid.

"Yes Qilaq. For suddenly Sorgan rose and cried out. 'Good brothers, look into each other's eyes now, with honour and truth, as boars should, and as true Bergo. For fear of each other harms the world and makes liars of real bears.' The Fellagorn boars began doing just that, with a deep love in their eyes, while Illooq Longsleeves, Beloq and Teleq were glad to be with their own once more. Proud Bergo among proud Bergo."

Matta felt rather jealous and Qilaq thought how different it sounded to Varsaq's stupid Council, as Janqar's voice rose, imitating Sorgan's. "'Whom do you serve then, Fellagorn?' 'The lords of life,' answered the Fellagorn. 'And who do you emulate, brother bears?' 'The White Army,' they cried. 'The fabled white army,' whispered Sorgan, nodding, 'that fights only for justice and truth and once protected Goom, when ten thousand demons tried to attack him. It means we must think and act as warriors of light, and not just brutal Bergo killers.'"

Matta's heart was thrilled by the lovely idea of warriors of light, and Qilaq felt jealous. Qilaq had never had a father to show him how to be a real Bergo and now he wanted to get closer to Janqar and learn everything he could.

"Then the boars set off on their quest again," said Janqar, "and Sorgan kept Illooq near him. Beloq and Teleq came too, but one moon, Illooq Longsleeves asked what Sorgan had sought most in his long life and the Great Master stopped, and pressed a paw down and they saw the sharp wind blow the print away again, like crystals of streaming white sand.

"'We're all like that in time,' sighed the Great Master, "and so perhaps I long to go where no bear has ever trod, or know my own self at last. As I ache to hear the sound that echoes from the heart of

all, Illooq Longsleeves, the very first sound, that only Goom knew, that cures ills, heals minds and saves hearts.'"

Matta thought of Innoo once talking of the whispering Ice Lore and longed to hear it too.

"'Yet soon it will be time to choose another Great Master,' said Sorgan, looking between the three friends suddenly, for all were famous Tellers. 'Time for a Story Joust, to choose a rightful successor, as we throw tales at each other, not ice daggers. To see I'll anoint out here, for only a master may continue our secret order.' Something a little jealous seemed to step between the three disciples now," said Janqar, frowning strangely, "for all were ambitious to follow such a great path, and proud of their own word skills too, but only Illooq Longsleeves dropped his eyes. 'Beloq, he's best, Great Master,' he said, 'He tells so wonderfully of Pollooq, and I'm too rash.' Sorgan smiled, for he knew real humility was the greatest gift, but Teleq was frowning. 'Yet if you die out here, great Sorgan," he said, "will we Storytellers not go forth to find your great soul born once more in a snow den? It's the old Fellagorn way.'"

Janqar looked deeply thoughtful now and spoke again.

"Sorgan looked toward the Beqorn in the distance, with his filmy, half blind eyes. 'The old ways? All changes in the real world, Teleq, and what if Glawnaq attacks, and stops all our throats? If I die in this journey though, you must promise to leave me out in the open, for I've another purpose still. It was prophesied that only a Great Master may help the One to truly see, and to know himself at last. If not, the Great Story shall surely fail. It is my sacred duty, for he's too young yet to even understand.'"

Matta looked sharply at Qilaq and they both knew what she was thinking. Sorgan was dead and so he could never help Uteq, if he was the One. The Great Story had failed indeed.

"But Beloq was suddenly staring in amazement at a second paw print Sorgan had just made," said Janqar, "for it looked like a little pool, filled with a shimmering blue-green liquid. 'What is it, Great Master?' asked Illooq in wonder. 'Perhaps the Seeing Caves are close,' answered Sorgan, although something almost mischievous glinted in

his old eyes. 'For they say out here is like a great unconscious sea of dreams and now we are chasing heaven itself. But I think it's pure Garn, disciple. Garn made real.'"

"Garn?" cried Matta, "but that's silly, Janqar, spirit isn't a thing. It's just inside us."

Even as she said it Matta remembered Uteq on the Wander and looked sharply at her brother. Had they not seen the green light under the water streaming from his paw?

"Said to manifest from great feeling, or to appear when a master's close to death, if he's followed the true and holy Garn path." Janqar explained, sounding out Sorgan's words, 'Perhaps I've not been so evil then, disciples, for all have light and dark within and the shadows of the dark world we must carry with us to be whole, for no living Lera may ever out run its own shadow.'"

The twins wondered at this talk of shadows, but suddenly thought of their own dark dreams, especially recently, as Qilaq felt more doubtful of this story, for Anarga had told them the green in the sea was just phosphorescence. Matta though remembered what Ruskova had said of good and evil in the East too, as Janqar spoke once more.

"'Teleq was growling now, for in the paw print the disciples could suddenly see tiny little lights, that formed into a clear picture, a face. It was an aged Gurgai, a blind human, opening his ancient mouth to speak, as if telling a story himself. The blind mouth dissolved though, and they saw strange shapes, like raised snow dens of stone, with flames licking their tops, houses and temples burning, after what seemed some great and terrible battle, lasting for ten long years.'

"'The Gurgai's great wars,' growled Sorgan thoughtfully, 'then they are linked to the bear's own story. I heard tell of one fought over the most beautiful Gurgai face in all their world, for do not the greatest fights happen over love? Perhaps all, in life and death. And I feel like a God myself, disciples, looking down to judge them.' 'A God?' said Illooq Longsleeves, as the old bear reached towards the strange human pictures with his paw. 'Yes, Illooq. For I think Gurgai have two languages, or did once. When their gods looked down

through the clouds, from an ice cliff in the heavens, and played with the fate of Man and of Lera.'"

Matta wondered what Sorgan had meant by two languages, but Janqar was warming to his story.

"'And in their war,' said Teleq now, 'a Bergeera longed for the power of prophecy. So the Gods gave it her, but cursed her too, so although she saw the truth, she would never be believed. 'A terrible fate indeed, Teleq,' nodded Sorgan, 'to see the world, but change nothing at all.' 'And the humans fought,' said Beloq, for the Story Joust had clearly begun, 'and their enemy's cleverest fighter made a giant musk ox of bogget wood, to hide his warriors inside, and gave it them as a gift, pretending to go home. So their army sprung out of the musk ox in the night, where they had been hiding, and slew them all."

Janqar paused again.

"Illooq was silent though, listening," he said, "but now in Sorgan's paw a man stood on a wooden craft, sailing home on a wild sea. He had a shaggy mane at his chin, and his sorrowful eyes were set firmly on the distant horizon. Then he was in a cave with a huge one-eyed giant, a child of the gods, and sailing past whispering female voices, or walking among grunting animals, as if the Gurgai travelling with him were changing into magical, snorting Lera. The tiny scenes brought many trials, until the warrior was on land again, and around him lay a hundred slain Gurgai. Then the most gentle, beautiful female was holding out her hands, lovingly, as Sorgan growled and nodded."

"'A great Odyssey,' whispered Sorgan, 'And they say there are only two types of Gurgai Bergo, the very archetype of all they are. One always sailing out, to find new worlds, and another always trying to come home. A second warrior sailed from that war too then, to meet a beautiful Bergeera who loved him, but would not tarry and sailed away again to found a mighty pack of Gurgai that ruled their world. As heartbroken as Pollooq was for Teela, his love threw herself on a pyre of burning bogget wood and died.' The pictures faded now in Sorgan's paw print and now there was just snow and ice and the wailing wind up there in the North."

"But what can it mean?" whispered Matta, but suddenly the three heard a snarl, which broke their focus completely. Varg were approaching them, with none other than Sqalloog at their head.

"What's the little creep doing?" grunted Qilaq. "I saw him slip off when we arrived. Sneak."

"I'd better get back to the adults," said Janqar hurriedly, raising himself on his paws.

"But the Seeing Caves, Janqar" said Matta, not wanting the handsome stranger to leave at all. "Did they really find them, Janqar, to know why the ice world dies? Did Atar come down from heaven? You must tell us the end."

Janqar smiled.

"Then I'll come and find you again, I promise," he said, pleased his story had gone down so well. "Besides, Matta, you're not the only bears around here who need legends now. They guide us all. Good luck to you both. Have courage, and real heart strength too, but build up the spirit of resistance, above all. Deep inside you. Keep your fire and light alive, always, and stick together."

"Fire?" said Qilaq eagerly, not wanting Janqar to leave either. Janqar had moved away though, and the twins saw a group of patrolling Ice Slayers, and Matta was rather disappointed to see him dip his head humbly to them. Now Sqalloog stopped in front of the youngsters, with the wolf mercenaries around him. He looked very well-fed indeed, with a new arrogance in his darting eyes. It reminded them of Eagaq, although Sqalloog was still hardly weened.

"Wake up, lazy cubs," he grunted. "I'm your Boss now, until you join the adult parties, in time. Eagaq has honoured me especially. He always kept watch in the Sound for the very best among us. Me."

"Our boss?" said Matta with a gasp, and Qilaq bridled too.

"Sure. Until I get a chance to leave you stupid Barg victims completely, and join the Serberan. They train their cubs against ours, but at full moon we can join the Ice Slayers, if we beat them fair and square, though those fights are to the death. Do as you're told though, and I'll favour you with some lighter jobs, perhaps."

"How could you, Sqalloog?" growled Matta, as he grinned at her. "To your own?"

"How could I what? I didn't make the world, did I, Bergeera, or how it really works. All have to adapt, idiot, just like clever Eagaq did, when stupid Wiseheart blocked his ambitions. Not even great Glawnaq made the world."

"Atar," suggested Qilaq, looking up at the moon and wondering how the world really worked, or what truth her light even held.

"Nature, idiot," snorted Sqalloog coldly. "Dearest Mother Nature. And what's crueller, yet more just than she? That's what father said anyway, before he died."

"Died?" said Matta in surprise, remembering Gratiq Coldnose at the Council and his blue snout ranging everywhere.

"Just like all Marg's faction," said Sqalloog, with no emotion. "They tried to fight Glawnaq off, the fools. But it's time to take real sides now and learn the true lore. Survival of the strongest, like the Cub Clawers and Gurgai know, that'll mark us out. And don't think I didn't see you both talking to that adult Bergo. So watch it. My grip's worse than my growl."

Sqalloog laughed and as he turned haughtily the Varg followed him away. The twins were appalled to have been delivered into the paws of such a cruel little philistine.

"Oh, Qilaq," Matta said, as they both rose now. "It's terrible how times can change. And Uteq. How I miss him so…" But Matta noticed Janqar hurrying back past them, watching Sqalloog carefully.

"When there's fear and hate everywhere, Matta," Janqar called warmly, "just breathe, pretty Bergeera and trust. We must have faith and courage, in all things, but hold to our true ideals too."

"But our friends, Janqar, poor Uteq's out there with Sepharga and not even his power…"

Janqar swung his head immediately and his eyes were suddenly glowing.

"Power?" he hissed, as Qilaq looked furiously at his sister. "Then they must keep faith too, and trust each other. Perhaps this sea pact will help him. For if he is the One, Uteq Blackpaw has a journey now

greater and harder than any Lera has ever known. Perhaps an impossible quest. He must survive though, for us all. He must."

"But it's so dark out there, Janqar," said Matta helplessly. "So terribly dark,"

Janqar was nodding as he hurried away, but he growled back through the growing shadows too.

"Then Uteq Blackpaw must keep close to the light."

DEAD VISIONS

"Oh, hear us when we cry to Thee,
For those in peril on the sea."
—William Whiting,
"For Those in Peril on the Sea

W hat then of Uteq and Sepharga's own journey? Even as Janqar left the twins, they sat on their ice raft, lapped by the cruel sea, adrift somewhere on the great arctic ocean, travelling due south, far from their friends. The twilight was dark, yet strangely lighter than it was in the Sound. They were sailing south in parallel with the great Hudson Bay, and far out at sea.

The young polar bears' thickening winter coats were little protection, without snows to burrow into, and they had eaten so little that their Garn was very weak, which made them even more vulnerable to the elements and the endless, searching wet. What meagre food they had had come to them quite by chance – some ragged flying fish, Lerop, that had landed on their ice raft in the darkness.

Food wasn't the polar bears' only problem, of course. They needed to drink too, but the salty sea water made them sick, so Sepharga had come up with the idea of breaking off bits of their raft and sucking ice chunks into their mouths, munching on them to quench their thirst. It was a clever solution, until they realised that if they ate and drank too much, the raft would disappear beneath them altogether and they would drown.

"I'm so c-c-cold, Uteq," shuddered Sepharga now, looking up

miserably in the moonlight. "Will you sit c-c-closer, please? We could sh-sh-share our Garn, just like when Toleg used to hug us."

Although they had huddled together at first, the two had grown strangely distant among the huge bergs in the past few days, and thinking of sitting near her, Uteq remembered his extraordinary vision of Man and the ship when he had touched Sepharga on the Still Hunt. He had no desire to see *that* again. Besides, Uteq wondered again if Sepharga had indeed somehow brought this unlucky legend to the Sound, and if signs were real, why she had been found near a wing and narwhal's tusk. In his secret heart, at times Uteq had begun to blame his adopted sister. Uteq had often wondered about the twins too, and had sometimes dreamt of Matta, yet that had only brought him a terrible, sickly feeling, and Uteq could not understand why.

"I'm so hungry, Uteq," muttered the freezing Bergeera now.

"Well, what can I do about it?" snapped Uteq. "Everyone's always expecting things of me."

"I know, Uteq. Please don't be mad. It frightens me. We must be peaceful."

Uteq looked guilty, but he had woken that morning with a worrying feeling he simply could not fathom. It was like some memory that would not return fully, or some troubled thought in the shadows.

"What is it, Uteq," whispered Sepharga. "What's really wrong?"

"I don't know, Sepharga. That terrible day. I can't get what happened out of my mind."

"I know," shuddered Sepharga, scratching the ice, "I thought we were both dead, for sure."

There was something in the way she said it and Uteq suddenly threw up his head.

"Dead," he groaned, "but that's it, Sepharga. The passing word. *Alive*. The Glawneye talked of a she cub betraying it."

"Yes, Uteq. What of it, though?" said Sepharga with a shiver.

"And Mad Mooq at the Council, Sepharga. Mooq's prophecy *A jealous sister betrays*. That's what he said."

Uteq was shaking, not only with fear, but because of his sudden revelation.

"Matta," said Uteq. "Qilaq's sister alone knew the passing word on the ice, Sepharga. And Matta looked so guilty when Qilaq asked if she'd told anyone, remember? Matta must have told the Glawneye and betrayed us."

"She wouldn't," said Sepharga immediately, but Uteq was certain of it now, especially when he thought again of Teela's betrayal in the terrible story, that had left such an impression on them all, but also of how the twins had been unguarded on the ice that day.

"Matta became so strange after you arrived, Sepharga, and in the summer too," growled Uteq. "So jealous of you. And in the Black Bay she talked about joining Glawnaq to keep everything out."

"No, Uteq, it can't be Matta. I just won't believe it. What of our pact, for a start, before the sea?"

Uteq's eyes filled with confusion and he thought of the Free Council again.

"Pact, Sepharga?" he said rather scornfully. "Well Eagaq betrayed us all, didn't he, even his own Scouts? The finest bear there. Pacts and promises and words mean nothing now, if they ever did, even in front of the sea. What honour had Eagaq Breakheart? None."

"No. But if Matta did," said Sepharga, eyeing the ocean's vastness miserably, "it's just like horrid Eagaq."

"It's far worse. I didn't really know Eagaq, Sepharga. But Matta. It's like…like…Teela herself."

"The story," sighed Sepharga, "and it *was* unlucky, all right. Everything went wrong when Anarga told it."

Uteq frowned but he wondered as he pulled himself up, preferring not to think about it now, as he walked to the edge of the ice raft to look out at the sea. "I suppose I should fish, like a real Bergo," he said nervously, not least because Uteq wanted to clear his head after his terrible discovery about Matta.

"But the orca, Uteq. I saw them again three nights ago. It's s-s-safer up here."

"Safer, Sepharga? They've gone, and we can't just sit here and starve to death. Face reality."

Uteq pointed his nose toward the lapping sea and sniffed. He'd give his claws for a juicy little mouse, although it almost made him a scavenger. Sepharga joined him standing there and the stranded Ice Lords peered out across the steel-grey sea in the darkness, side by side, feeling equally reluctant and miserable.

"Maybe we should wait until it f-f-freezes," suggested Sepharga, wrinkling her snout. "Then walk to safety and food."

"It's not cold enough yet to freeze and we could be drifting for moons. We'll both be dead by then, Sepharga, or maybe we'll just sail off the edge of everything. You know that Seegloo told me that you can fall down into hell itself, below the Beqorn, down a great ice flow on the edge of the very world."

Uteq suddenly remembered Glawnaq swearing that he would follow them to Hell. Was it a real place, or like this Ice Labyrinth of the stories? As the polar bears looked out to the horizon under the moon, Uteq seemed to see light glowing at its edge that always seemed to be dropping away. It was impossible, while all around lay solid bergs and jagged growlers. None was close enough to swim to though, and there was no sign of any sheet ice either and certainly not of land. They were lost, sailing through an endless floating ice forest.

"If we do reach land though, Uteq," whispered Sepharga, "do we find this Mitherakk, near the Sqeet. Seegloo said it means bears who live near man. Like dear old Narnooq's voice t-t-told us..."

"No," snapped Uteq, still wrestling with these impossible events and not wanting to believe them. "We must have dreamt it, Sepharga, or maybe it was just the shock."

A pain suddenly gripped Uteq's gut. His father was dead and his mother badly wounded. Uteq felt the same agony he had when he had imagined those strange weeds of mist binding him to Anarga and Matta. He dropped his head and his thoughts were back in the Sound with his father, suddenly, roaring happily, and his mother teasing

Toleg and the shining beauty of a world just beginning and once so full of hope.

Uteq had often found his thoughts drifting back to the past as they travelled, deep memories of all that had happened, that seemed more real at times than the filmy waters about them, except that it all seemed in slow motion, like some painful dream. Uteq did not know it, but he had touched something, and very young, that always brings the past, something called grief. He was mourning his father and his lovely home.

"But if it *was* real?" he said gloomily. "what did poor Marg mean by *Redeem us all*?"

Uteq glowered at the water and felt utterly lost and helpless as he shook his snout.

"But there are no real Ice Saviours, Sepharga, so maybe Glawnaq's right. Let him save all the stupid bears, not me. He's got some great plan now, and he's welcome to it."

"But, Uteq, the things you heard, and then when you saw those..."

"I'm just sensitive," snapped Uteq, "like walrus and foxes."

Yet Sepharga remembered Uteq's visions in the Black Bay and on the hunt and she was as sure now as Matta had been that Uteq was special, all right.

"The coloured lights though, Uteq. I saw them too, though you did before anyone else."

Uteq had certainly seen the strange lights rising from the dying. Were they ghosts, or demons, and where had they been going? To join the lights in the North? Sepharga had a pleasanter thought now though. "Or maybe this bear Mitherakk could prove that it isn't you, Uteq. That you're not the Saviour. Then Glawnaq wouldn't want to hunt you down at all."

"Glawnaq will always hunt me," growled Uteq bitterly, holding up his black paw. "Because of my parents, and...and because of this."

Uteq young eyes looked wounded. The voices echoing in his mind suddenly were from the Council- Mad Mooq, dribbling like a lunatic, talking of a Blaarq, a Scapegoat, and of bears putting their own sins on a Marked One, to drive him out as Kassima. Uteq didn't under-

stand why everything that had happened seemed to be his fault. He couldn't cope with the awful thoughts, and felt he could hardly breathe either, so he suddenly moaned and plunged over the side of the raft into the icy seas.

"No Uteq," gasped Sepharga, "don't go. Please."

The Bergeera stood there watching and waiting, and as time drifted on with the currents, her heart began to plunge, and she missed Uteq bitterly. Then she started to grow frantic, for no bear could hold his breath that long.

"Uteq. Where are you, Uteq? Please come back. I hate this."

"*Agraaaaaauuucch.*"

Uteq's head burst out of the ocean again, on the other side of their raft, his front paws grasping at the ice island, as he struggled to climb out. He was so cold and tired he could hardly manage, and Sepharga rushed over, reaching down and catching some of his sodden fur in her mouth. She pulled with all her might, and at last Uteq was up and out again.

"I couldn't f-f-find anything," Uteq's teeth chattered as he collapsed. "So d-d-dark and deep. I'm useless, Sepharga. Just a coward, just like Sqalloog said. A hopeless Blaarq."

"Don't say that, Uteq. Just because you didn't like fighting. Sqalloog's a bully, and who says fighting's so special? The real Fellagorn hated it. Goom did. Some say the greatest courage is to walk away."

"Bergo have to f-f-fight though," shivered Uteq, a light snowfall flecking out of the hard skies, as the bears heard a strange sound; a kind of plopping swish, sleek and sinister in the sea.

"It's a shark," gulped Sepharga, swinging her head. "Just by our raft, Uteq. It could have eaten you."

Uteq turned his head, and some twenty feet away, a huge grey fin appeared, slicing up dangerously out of the water. The fin disappeared again, and Uteq slumped onto the ice in utter exhaustion, relieved that it had missed him. His heavy eyes began to close in the bitter cold.

"No, Uteq," growled Sepharga. "Get up. You mustn't fall asleep now."

"Why not?" groaned Uteq faintly, "I can't hunt on this. I can't do anything at all. It's useless."

"Walk around," insisted Sepharga though. "You know what Nuuq told me sharks say? *Move or die.* That's their Ice Lore. They drown if they don't keep moving. You have to keep warm too, or you'll freeze. Act, Uteq. Never go to sleep in the open cold, or you may never wake up again. I should know."

So Uteq pulled himself up wearily and shook out his coat, just as his mother had done when she had fished for them all.

"That's better," smiled Sepharga, as Uteq began to walk around too. His freezing body made Sepharga feel even colder. After a while she noticed Uteq had stopped though, and was shaking again. It was not from cold though, for Uteq was staring at the ocean once more, where he could see a lurid red trail in the moonlight- far out, like a dark crimson slick. It was blood. The friends felt it first, as all creatures sense the presence of others, especially animals. A huge shape was floating toward them in the twilight, like an iceberg, except just below the water line was a monstrous mass of dark blue blubber, as long as five pine trees, drifting steadily toward them.

"A whale," growled Uteq. "It's a blue whale, Sepharga. The largest creatures alive."

"It's dead though," said Sepharga softly.

The bears were awestruck at the immensity of the mythical beat, but sad too that it was dead. Uteq hardly knew what he was doing, but he remembered the hunt, and gently he touched his paw to the ocean and as he felt the wet his whole body went rigid. In his mind's eye, Uteq suddenly saw the whale, but alive and rising from the depths, just as he had seen the ship when he had touched Sepharga, and filled with a mighty Garn. But as the leviathan breached, a huge metal vessel, bore down on the living giant and struck the whale in its side. Uteq cringed back, but to his horror the bear realised that the vessel wasn't a vision at all. A ship was really coming out of the darkness and straight towards them and on the side was written the name, *The Samson and Delilah*.

"Sepharga, look out," cried Uteq. The ice breaker had circled to

investigate whatever it had struck, and it was throwing up a vast wake now, fifty times as big as Anarga had made on the Wander as she swam.

"Uteq," wailed Sepharga, flinging herself at him in terror. "We're lost."

The ship had just struck the whale again, thrusting its carcass to the left like a toy and, as it sank in a swirling pool, Uteq felt their ice raft being sucked toward it. The ship was bearing to the right though and its towering metal sides only just missed them. For a moment, as the polar bears clasped each other, they were right between the vicious giant and the huge whirlpool the sinking whale carcass had made, but the ship just missed the tiny ice raft, and the whirlpool closed too. A foghorn boomed through the night as the Ice Breakers' wake sent them spinning away on their raft, and as it passed on into the darkness beyond, it was if it had never even been.

Uteq and Sepharga blinked into one another's faces, looking startled to be holding onto each other so tightly and let go. They both backed off, tongue tied, embarrassed, although Uteq was feeling bitter that even out here he could not escape his powers. They sat down again, apart once more, gazing miserably at part of the whale's tail, and saw sharks rising and starting to bite at it, pulling off chunks of flesh and blubber and snapping into bone.

"Oh Uteq, is there death everywhere?" groaned Sepharga. "The Gurgai killed the whale. Man."

"And poor Marg Leantongue was right then about those killers, even out here. It's Kassima."

"I know I was born there though," muttered Sepharga suddenly, guiltily too. "In the Gurgai's world, I mean. I've remembered now."

"Born there?" gasped Uteq, as if Sepharga had breached the Third Commandment, although it suddenly made sense, as Sepharga blinked and looked almost ashamed.

"Yes, Uteq. Born among the humans. The memories come back slowly. And they're Putnar too, Predators, just like Bellarg are. No wonder they killed that whale. But why did they just leave it for the sharks?"

"I don't know, Sepharga, but will you tell me more about them? Somehow I feel I was meant to know all along."

Sepharga turned now and her gentle eyes were frightened and confused.

"If you touch me with your paw, Uteq, like you did on the Still Hunt, perhaps you'll see them too. My dreams and memories, I mean."

Uteq felt deeply uncomfortable, remembering how it had so frightened him, and sometimes hurt him too, whenever he pulled away again. He felt coy too with the pretty she-bear, yet he suddenly wanted to know all about the Gurgai. Man.

"All right then, Sepharga. We have to face the real world now. I do. Mad Mooq spoke of the Gurgai."

Snow started to fall thickly in the sombre half-light, as Uteq lifted his black paw and pressed it gently against Sepharga's side. Immediately he heard a voice like Toleg growling at him, then Anarga, and another voice like his own too, only older.

"I was born in a park," Sepharga began, "in the middle of a great..."

Like a flash it came, as Uteq's black paw trembled and her words seemed to blend into images, visions, transporting both bears far away from their ocean raft, to another world entirely.

"I was born in a strange, man-made pool."

Uteq felt as if he was swimming through a pool himself, and now he could see two full grown Bellarg, a Bergo and Bergeera, lounging in a great tank of greenish, mossy water, halfway submerged, moving in slow motion, and behind them was a kind of berg of white ice, that didn't look quite real.

"My parents, Uteq. My mother and father. Farq and Selar. Are they still alive then?"

Uteq knew these were only her memories, and far in the past, yet it was not in slow motion, like his own grieving thoughts, and now he could see Gurgai too, like the ones he'd first seen on Sepharga's ship, watching her parents through a glassy wall. Their human young

seemed to be laughing and pointing at the trapped polar bears in their strange prison.

"But your parents' Garn looks as if it wants to burst out of them," growled Uteq angrily. "It's horrible, Sepharga. So cruel. To trap great creatures like that. And where in the world is it?"

"Far away, to the south, I think," she sighed, "yet not so far for the Gurgai, for now they can travel almost as they please. Even through the air, like that magic metal bird you told me of."

Uteq remembered it had spat fire like magic and the voice got louder in his ears. Suddenly they were inside a square metal den though, moving fast over the ground, and they could see through some kind of slit, out into a strange human world. What Uteq saw there terrified him, even more than the looming ice breaker. The bears were in the middle of a human city, but made of great canyons of metal and glass, as high as the High Ice Cliff, that glowed with brilliant lights, bright as the Beqorn. Uteq could feel they were moving at great speed, and as he looked behind them through the darkness, he saw eyes of red and orange and green, glaring and flashing, then objects of yellow gold, coming straight at them fast over the ground, filled with Gurgai.

"They're human dens, Sepharga," he said. "Everywhere. And spirit lights too, in the dark."

The place seemed enchanted, or bewitched. The air was filled with the most extraordinary noises too, like the caw of a thousand metallic gulls, and in the distance was a huge human Bergeera, not alive, but made of a green metal. The giant stood on top of a rock out to sea and rose more than a hundred feet tall. She seemed to carry a mighty flame in her hand, and on her head was placed a star.

The view changed though, and now they were looking back at the crowded dens again, as they sped along, hard, and hot, blazing with glittering lights, as if a thousand burning suns had been captured and placed inside the dens at once. A word suddenly popped into Uteq's mind, which he'd heard once before: *Scientia.*

"But how many Gurgai live there, Sepharga? They're like plankton in the sea."

Uteq fell back into the vision. They had stopped now and through the slit Sepharga had been peering through, Uteq could see one of the humans climb down from their vehicle and walk over to a metal object his own size. He pulled something out of its side that looked like a narwhal's tusk, except that it was metal, hollowed out, curved at the top, and attached to a black tube that seemed to be made of rubbery walrus skin. Something dripped out of the end of it too. It was a dark liquid, that Uteq recognised immediately.

"The black blood," he whispered, "There, in their strange world too."

"But what's it for, Uteq? Do they eat it?"

"I don't know, Sepharga, but when I touched it, I saw trees, and then I knew that it somehow held..."

"What, Uteq? You never told us that day."

"Garn, Sepharga. Somehow the black blood's like Garn."

Sepharga blinked in astonishment.

"Yet there's something else. The past, it seems to contain that too, like memories, or stories. I knew then the Gurgai don't make it, but only collect it and use it for something else. I don't know what."

As if in answer another Gurgai appeared now with a little white stick in his mouth that gave off smoke, and light. He stumbled though, and the fire stick fell to the ground and there was a flash and a great blaze of heat and light leaped up from the black blood on the ground. Sepharga was suddenly cowering back on their raft, as if she was being attacked.

"The red flowers," she groaned, slashing a paw at the air. "The heat. Stop it, Uteq, please stop. Its burns."

"No, Sepharga, it's not really here," whispered Uteq gently, as the snow fell thicker, understanding now just what red flowers really meant to her. "Just a bad memory. But it's how you were marked, not by Atar at all, or some silly legend either. And why your greatest fear is fire. But you're safe out here with me now."

Sepharga blinked in confusion and looked around. The red flowers were gone. Uteq pulled his paw away, but this time Sepharga bared her teeth, snarling, just as Matta had done before the Still

Hunt.

"Sepharga!"

"I'm sorry, Uteq," growled the she-bear, "but that hurt. When you pulled away so quickly."

Uteq felt that emptiness again too, as if part of him had been torn out, and remembered that strange mist between Matta and his mother. He suddenly resented Matta intensely, as they peered about, and their freezing spirits plunged, for it was snowing very heavily now and the cold getting even worse.

"The Gurgai," grunted Uteq. "No wonder Marg feared them even more than Snow Raiders. But what do they want of the world?"

"To kill everything, no doubt," sang a ghostly voice suddenly, seemingly all around them in the dark.

"Who's that?" jumped Uteq, as if he'd heard old Narnooq on the wind again.

"A shark," answered the watery song, as loud among the waves now as Drang's voice had been. It seemed to emanate from a fin that had just appeared right next to their ice raft. The sea was talking again.

"Sguguq's the name," said the shark, as vicious, jagged teeth glistened at the bears from the water. "The Gurgai kill us sharks, all right. We had enough trouble just to avoid that damned ship, as we followed you."

"Followed us?" growled Uteq. "You serve Drang then? Another of Glawnaq's filthy mercenaries."

In answer the shark lashed the water with its tail, and rolled on its side and glared up at them both.

"*Impertinenssssss*, Bellarg," it spat. "Sguguq serves none but Sguguq, and my hungry shark pups. And served myself well, when I ate my own twin, in my mother's belly, before she even dropped us in the cruel sea, in a pool of her own sweet blood."

"How terrible," growled Sepharga, backing away in disgust and flicking her snout at the shark.

"Just fighting nature, Bergeera," laughed Sguguq. "Life. Every-

thing fights, even in families. That's the Lore. One day I hope to take a
fearful Gurgai though, and avenge all the murder they do."

Sguguq's fin turned, and the bears noticed snow had settled on his
back.

"Avenge?" growled Uteq, feeling a strange hotness in his blood
and thinking of Toleg's cry for vengeance from beneath the waters.
The anger seemed to animate his body, but Uteq did not know what
to do with it at all. "But why do they fear or kill you, shark?"

"Into every life, a little snow must fall. But because we've taken
some of theirs, bear, ten or fifteen a year, though in return Men
murder a million of us, each Long Day and Night, yet call *us* evil."

"But that's not fair," said Sepharga, looking indignantly at Uteq
and thinking of Pollooq too.

"What's fair about life? And do they fear us, or just wild nature? A
cousin told me they like our fins, but it's not *that* we really have to
fear."

"Really have to fear?" whispered Uteq.

"The seas grow warmer. The coral reefs wither and die, like the
Lerop. Plankton no longer feed krill and clams, which feed the fish,
that feed sharks, the truest Putnar of the Oceans, so disrupting the
great Shark Teeth of Eating. All's upside down."

Uteq and Sepharga remembered the flying fish, rather fondly, and
the legend that Atar had made shark chase fish onto the ice ark but
now it all felt like a foolish cubhood dream.

"Then the humans are really evil, Sguguq," Uteq growled angrily,
"and not sharks at all."

Somewhere in his mind Uteq could hear the bleating of an arctic
goat though and thought of himself at the Council being called evil
and Kassima.

"The whole world goes mad, all right, bear, and because of the
Gurgai, sharks have long heard the most wicked sound of all then, out
on the ice."

"What sound?" whispered Sepharga nervously.

"From seal pups, when Gurgai hunters pour salt down that makes

their tongues stick to the ice. Then humans run out and club them and tear them away, so they scream."

The bears could suddenly see Pollooq, bound with seaweed in the cave, crying out in agony. The Scream of the White Bear.

"Sguguq," said Sepharga quietly though, "what's the most beautiful sound in the world?"

"Beautiful, Bergeera? What shark knows that, or what stupid Lera either? But I've no time to idly discuss life or death, beauty or ugliness. I'm hungry, so come swimming with me, bears."

"Not likely," Uteq grunted. "Glawnaq's hunting us, as it is, and as for you, shark, you shouldn't stop, you'll drown."

"That's a myth," spat the shark, "just a silly ocean myth. But why does One-eye hunt you?"

"Because of my black paw," answered Uteq, in surprise at this talk of an ocean myth.

"The Blackpaw," cried the shark immediately, his tail lashing furiously in the icy water. "Then I'll not stay here another moment, Bellarg. For you're cursed, like the albatross, or the luscious, bleating Blaarq. Marked out. Doomed."

With a flick of its great tail, the shark fin was gone again in the blackness, leaving Uteq feeling even sicker than before, and Sepharga trembling terribly.

"Not doomed, just special," she whispered though, touching Uteq gently and feeling a little better. Uteq thought of Matta, and Teela in the story, and shook her off, as a strong wind rose, and soon the bears were being bounced up and down on the angry waters. The waves grew higher, like those great metal canyons in that human city, as they sat in the dark, lashed with water and freezing spume, wanting to go to each for warmth and comfort, but too embarrassed to do so. The storm raged and roared, like some terrible angry god, and they thought of Pollooq again, hurling boulders at the very sea to break the waves, but they knew the mighty Pollooq of the story was cast down forever.

Until the roaring wind caught a curl of water off the waves, and tipped it over them both. The bears flung themselves at each other

now, drenched and freezing and holding on for dear life, their teeth chattering furiously. It was as if the death of the whale had awoken the very fury of the deep, like a terrible curse.

"At least I've my friend here, Uteq," cried Sepharga warmly, "but let's pray to Gog and Atar together. They'll help us."

"Oh, stop that," moaned Uteq, staring up at the brooding, swirling sea. "Gods and stories are just lies."

As Uteq sat there he did secretly try to pray though; pray that the wind would bare him home, to Anarga and to Toleg and the past, before Glawnaq's triumph, yet with all that had happened, especially his revelation about Matta, Uteq found he couldn't even pray. The bitterness was getting worse. The two grew wearier and wearier, thinking of land, of water and of food, wondering when a wave would drown them both, or sweep them away, until at last they closed their eyes, wishing Anarga was there with a story, as Uteq wondered why he felt so horribly resentful towards his friend.

Yet Sepharga dozed beside him and her head rested against his shoulder, and at first Uteq flinched, wondering if the visions would come again, then he felt her breathing growing calm and steady, and in that feeling of trust, that peace that descended on him in her trusting to his own strength, although he was as weak as a kitten, Uteq suddenly felt like a little king.

10

GIFTS

"I looked upon the rotting sea,
And drew my eyes away;
I looked upon the rotting deck,
And there the dead man lay."
—Samuel Taylor Coleridge,
"The Rime of the Ancient Mariner"

"Arrrrrrggggh!" Uteq grunted as he woke again, all alone though, feeling he had been falling, shivering from another terrible nightmare. "Matta," he groaned in a whisper, feeling the pain of that tearing mist again, as the real nightmare went on.

The Long Night had come properly now, and Sepharga was sitting a little way away, dozing fitfully on the ice raft. The poor she-bear looked thinner and weaker than ever. The pair hadn't eaten at all, except small chunks of their raft to drink, and were truly starving. All around them lay nothing but icy open water.

The sea still had not frozen though and there was no land, nothing but darkness, lit by a mournful quarter moon. The poor polar bears could hardly move, and now they felt the very last droplets of Garn ebbing away, each wishing some miracle might come, but something very dark was in Uteq's heart. The icy sea seemed to have lost all its vigour too, to have taken on a slimy hue, as if it was congealing, yet somehow refused to.

Uteq felt he was still half asleep, as he saw bits of jetsam floating in the water, and tiny creatures nibbling at it to feed, then a mouth opened on them, but another fish swallowed it in turn. Uteq was

mesmerised, horrified, remembering the garter snakes, but as he sat there he had another vision.

Uteq suddenly saw strange insects, as ugly as any monster, crawling, creeping things in the dark, as if he was in the ground itself, buried in the earth. Then, under a burning hot sun, a huge, leathery backed dragon, like a giant lizard, with teeth and poison in its spit, was snapping at the leg of a struggling four-footed beast. Everything seemed to be writhing, fighting, struggling for life and power. It was all so utterly cruel.

Then Uteq was in the sea itself, beneath the water, and saw white alien shapes flapping towards him, and the giant squids' skins flared red, the colour of the warrior. The magic of it made Uteq's head swim. But suddenly he was looking at thick vegetation instead, far thicker than the arctic tundra, and swarming with millions of tiny insects, ants, but they seemed on the march, like soldiers, and in that sight, it seemed that nothing in nature was equal and that everything was really organised for war. Then Uteq saw a huge mouth, opening and closing, as if eating everything, yet speaking some wordless secret of the whole world too. In that sickly twilight it was like a dream he could never shake off.

"Evil," he moaned. "There's evil everywhere. And fear and hate."

The visions were gone again and Uteq thought of reason and the eyes of the Pheline watching Pollooq in the Legend, but what reason made this terrible world? He felt a longing to know, but he had come to a decision in the night and Uteq suddenly struggled up. As he stood in the moonlight he saw a jellyfish floating by, a mass of slime, and knew it was alive, yet wondered if it had feelings or thoughts, for it seemed to peer up out of the sea at him, like some horrible accusing eye.

Uteq felt that some bad Beeg was trying to get inside him, and words from the hunt and that nervous gathering of males at the failed council too were ringing in his ears, but all jumbled together. *"Kassima cub, you've yourself to blame. An Ice Saviour torn to shreds. Take responsibility, Blaarq. Grow up and redeem us all."*

Uteq looked at Sepharga, asleep and moaning softly in her own

dream. He was no stupid Saviour to redeem anything, but at least he could try to save his friend, and so keep his promise before the sea, some honour too that the foul Eagaq had stolen from them all; by going fishing for her, even if he died in the attempt. Uteq felt almost delirious now.

"Uteq," said Sepharga faintly, suddenly opening her eyes, "Where are you—"

"Nowhere, Sepharga. Just going for a short swim. But I may be a while."

Uteq braced, hardly knowing what he was doing, but thinking that if he drowned and more flying fish came, at least Sepharga would eat alone and so survive a little longer. The young bear stared straight into the water and gritted his teeth. *Poor Sepharga*, he thought and blessed her in his heart, and just then he felt a sharp breath of lovely wind. Uteq also noticed several shark fins not far away, slicing ominously through the water once more and hunting. The poor bear sighed and readied himself. It was all over.

"Stop, Uteq," cried Sepharga. "Look."

"The Shark," Uteq whispered dreamily, still in a daze, as the wind bristled his fur. "I know, Sepharga. Sguguq asked me to go swimming. And why not? There's no hope for us here, anyway."

"No, Uteq. Look. On our ice raft. A bird."

Slowly Uteq turned to see the most extraordinary sight of all his born days. On the corner of the little ice raft, snapping a huge beak and staring straight back at the drifting polar bears in the moonlight, stood the most enormous brown-feathered bird. It had webbed feet and crazy eyes, a bizarre expression on its long, angular face. But as soon as Uteq turned fully, it cried out to him in a weird, strangulated caw, like a belch: "*Murther.*"

"Murder?" whispered Uteq, stepping back and thinking of Mooq and his prophecy at the Council.

"Murther," repeated the sudden visitor, hopping up and down now on the bobbing raft. Then the bird did something extraordinary. Again it opened its beak, but now a mixture of squawking bird noises

and a sort of grumble came out. It sounded as if it was actually trying to growl, just like a polar bear.

"Is it a good Beeg, Uteq?" whispered Sepharga. "A good spirit sent by Atar herself? Or an albatross, that brought hope to the ice ark at last, and not misfortune."

"That's just a story," said Uteq. "But I think it's a goose, Sepharga. An emperor goose."

The emperor goose – for that's exactly what it was – waddled closer and for a moment Uteq thought he should pounce, but the bear had no strength left. His Garn was exhausted.

"Go away, stupid bird," he grunted instead and at his command the goose opened its huge wings and lifted into the dark air without argument. It was gone again. Uteq shook his head and turned back to face the sea with a new resolution.

"There's no magic," he growled angrily. "No miracles, for Pollooq to prove or not. No Atar. Nor Gog. And the Pheline were right in the end, in their great fortress isolation. Stories are just..."

Suddenly something flashed in front of Uteq's face, and there, at his paws, was a huge fish, wiggling on its side on the ice, as if it had been dropped from the very heavens.

"A flying Lerop?" muttered Uteq in confusion, but instinct is strong in wild animals, and he had just enough strength to slap his black paw flat on the Lerop. But it wasn't a flying fish, at all, for it had no wings, it was an ordinary fish, and Uteq looked up to see the strange goose circling just above, but it landed again and nodded its beak furiously. Its brown feathers were shining with seawater, yet dry because of their oil, and its little eyes proudly aglow. The emperor goose made a gobbling deep in its craw now, and regurgitated another lovely fish on the raft, right in front of Sepharga this time, then swung back to Uteq, and repeated the strange word proudly: "Murther."

Uteq blinked, but the bird rose in the air again, and this time they saw it fishing fearlessly near the circling sharks, as the bears started to eat their living gifts. Five times the bold goose brought them fish, and by the end of its thrilling sea dives, so much Garn strength and hope was coursing through them again, that they wanted to run around

their little ice raft and growl for joy and hug each other. The lovely wind carried them faster and faster too, as the Emperor Goose landed again, making them feel as if they could fly off the ocean itself, straight into the darkened skies, like huge white fish with magic wings.

"He saved us, Uteq," cried Sepharga delightedly. "A good Beeg bird saved us."

"Yes, Sepharga. It's amazing. Thank you, goose. But who are you?"

"*Murther,*" squarked the bird again.

"Please stop talking about murder," snapped Uteq, bits of fish flecking from his lips. "It's bad enough out here. There are sharks and orca everywhere."

"*Murther,*" repeated the stubborn bird though, nodding its beak at Uteq's paw.

"That's it, Uteq," cried Sepharga, jumping up. "*Mother*. That's what it's really trying to say, Uteq, and not murder at all. It thinks *you're* its mother, so I know exactly who it is, and why it's helping us too."

"Who?" asked Uteq in bewilderment.

"Egg," declared Sepharga.

"*Ehhhhgggggggg!*" cried the bird, nodding at the she-bear furiously and looking as if it wanted to explode with joy at being recognised at last.

"Oh, what are you talking about, Sepharga?" moaned Uteq.

"Don't you remember, silly? The egg that you saved from Ruskova in the summer. That's who it is. It must have been an emperor goose's egg we rescued."

"Oh!" cried Uteq, in amazement. "Egg!"

The goose nodded its beak frantically again, squawking delightedly too and trying to growl as well.

"It must have hatched as we left," said Sepharga thoughtfully, "and the first thing it saw was you, and your black paw. And it must have been very lonely without you, Uteq. Poor little Egg."

"Right," said Uteq, sitting down on the ice with a bump. "But what do I do with it?"

Uteq did not do anything with it, for it was Egg that truly took care

217

of the polar bears now, and saved both their lives, like a careful mother. Each dark morning and evening, Egg would go fishing for them, bringing them a delicious array of marine life, so the friends feasted like kings and thought it a true miracle.

As it did so Uteq realised too that with Egg's eyes and wings, they could scout for dry land, and if the wind brought them in sight of landfall, they might have a chance of swimming for it. Nor was Egg quite so monosyllabic as he had at first appeared. For since Egg had spent time among his own, learning his own bird talk, he had something of a story to tell, if a little story, and not a great one. Egg had indeed seen Uteq, just after he had rolled his home into the gorse. Being too small to fly though, he had flapped around helplessly, with virtually no chance of survival at all, until the little emperor goose had stumbled on another nest nearby, a snow goose's nest.

The kindly mother bird had taken Egg in and raised him as her own, quite by mistake, for snow geese really aren't very bright, and much to the irritation of Egg's fellow chicks too, not least because Egg had kept insisting that he wasn't a goose at all, but a brave Bellarg and a magic, flying polar bear. As Egg had grown, his new so-called brothers and sisters had become utterly exasperated with his strange attempts to growl though, so at last, they had driven Egg out into the savage, beautiful arctic, feeling lost and bitterly isolated. Until, heading south quite naturally, Egg had seen a dash of black against a circle of white below, in the Long Night, and his heart had done somersaults over the sea.

"You really must stop calling me Mother though, Egg," said Uteq, one dark arctic morning, as he suddenly thought of Anarga telling him that she would have to drive him out one day. They were sitting under a myriad of twinkling stars, that had given them the same wondrous thoughts as the twins. "For one thing, Egg, I'm Bergo and for another I'm a Bellarg, and you're a goose, stupid."

Poor Egg looked most distraught and snapped his beak unhappily.

"An emperor goose, mind," added Uteq more kindly.

Uteq's eyes were bright again and his heart had swelled in the

days that had passed, and sometimes he had felt so much love for life, that Uteq could hardly bear it. Somehow the strangeness of it all, of Egg's arrival, had opened him to the world again, with a warmth coursing through his whole being, yet it somehow hurt him too, especially now Uteq thought of all he had seen.

"You sure, Murther?" said Egg miserably. "I bird, not bear? Not big strong Bellarg?"

The emperor goose looked utterly crestfallen, even rather guilty.

"Face facts, Egg. That's why you can fly, silly, which Bellarg certainly can't. And why you've feathers and webbed feet and a beak. Just look."

Egg opened his wings and looked under them both, then at his strange webbed feet too, and back at the bears again. He ruffled his feathers uncomfortably and lifted his right leg and flapped it down on the ice.

"I'm sorry, Egg," said Uteq softly, "but we just have to see the truth. To tell it too."

"I fish now, Pheline," said Egg gloomily, but then the bird perked up again. "Bellarg fly high."

"Oh, if you like," sighed Uteq in exasperation, thinking he'd never drum it into the daft goose at all. "Thank you, good Egg."

"Pleased, *Murther*," cried the friendly goose "Feathery Bellarg bring fish, for furry snow geese."

Uteq shook his head heavily as Egg flew off once more, and Sepharga smiled.

"I feel like a fish," she whispered.

"Yes, Sepharga. But they'll be coming soon. It's all there is out here to eat."

"No, Uteq, I mean I really feel like a fish. Smell like a fish. And I bet I taste like a fish too."

Now Uteq grinned. "I know, Sepharga. I wish there was some delicious walrus blubber, or some fresh seal to eat instead."

The poor bears both sat there, imagining how lovely it would be feast on anything but more fish. But they were content too, daydreaming under the glistening moon, although as they floated

there Uteq had the strangest sensation. It was as if he could suddenly see Matta, sitting quietly in the snows, talking kindly to a shivering, scrawny little cub, except that Uteq could not really see her at all. It was as if he sensed her instead and somehow knew what she was doing. Uteq felt resentment again, if she had indeed betrayed the word of passing, yet he was glad if it meant that Matta was still alive too. What of her brother Qilaq though? It was strange too, for this sense not been just about fear, and it had not come with touching anything at all with his black paw.

"Poor Egg," said Sepharga suddenly, "he must be so confused thinking he's a bear."

"He doesn't really," said Uteq softly. "He really fears being a coward. I think he felt so frightened and alone when he hatched, he determined to be brave all his life. He thinks polar bears are brave. The bravest things alive."

"*Rrruuuurk. Grrrrrr.* Laaaaaaaaand o'er there," came a sudden cry from high overhead.

"Land?" roared Uteq.

The bears both looked up now to see the emperor goose circling high, and looked in the direction of his pointing beak. Their hearts nearly burst from their chests. Before them was the dim outline of the arctic coast and Uteq and Sepharga had never seen anything more wonderful, yet their hearts sank too when they realised just how far it would be to swim.

A strong coastal current had caught them, though, and toward evening, when a full, ochre moon seemed to fill the very heavens, they found they had come much closer to the shore. But they could sense the current swinging out again, threatening to carry them right back out to sea, so Uteq made a bold decision.

"We've got to try for it, Sepharga. Right now. It's our only hope."

"Yes, Uteq. I know. I'm ready."

"Sepharga," said Uteq suddenly, thinking of the pact that Matta had broken, wherever she and Qilaq were now, "we're real friends aren't we, Sepharga? Like the Second Commandment says we must..."

"Of course, Uteq. Or I hope we are. I trusted you as soon as I saw you."

"Then follow me, my friend, and keep kicking and paddling hard. Never give up."

"No," said Sepharga softly, lifting her eyes firmly toward land. "Never back down."

With that, they plunged in together. Uteq was amazed that Sepharga was the better swimmer, for her skills had been learnt and tested when the Gurgai ship she had been travelling on had gone down. The weather was changing though, and the moon retreated behind heavy clouds, making the freezing waters even colder. As the bears got closer to the land, they found pack ice forming too, although not firm enough to stand on yet, and making it harder and harder to swim. It was Sepharga's instincts that sensed the real threat first though, perhaps as a ripple in the current, or a subtle change in water temperature, or just the reverberation of billions of years of arctic evolution. Uteq though saw the smooth, shiny black back first, suddenly rising above the waves.

"Orca, Sepharga, seawolves," he cried. "Swim, swim for our very lives."

Both polar bears were suddenly lashing out with all they had for dry land. The hungry orca came barrelling straight for them, pushing the congealing ice aside, its vicious mouth open wide, but on the first pass dear Egg saved them again. Just as the seawolf was about to strike, the plucky emperor goose plunged, turning in the air, and swept its webbed feet straight between the orca's teeth. The seawolf's instincts could not resist Egg's movement, nor the smell of fresh goose either, so instead of closing on Sepharga's back paws, it turned its body up at Egg instead, rising in the sea and snapped – but it missed both.

"Thank you, Egg," cried Sepharga. "Thank you, dear friend."

"*Quaaaaaaark. Grrrrrr. Gobble.*"

Killer whales are some of the most powerful, skilful, and graceful marine creatures on the planet, but once they have missed their kill, it is not always so easy for them to find their bearings again in the

murky seas, especially in the dark, so the Orca circled for a good while, quite lost.

"Hurry, Sepharga," ordered Uteq, paddling furiously again. "It's not far now. Don't give up."

Sepharga, who had made more headway anyway and no intention of giving up, was already clambering out onto land though and she turned and shouted back, "That's it, Uteq. Keep going. I'm here, dear Uteq."

Uteq felt embarrassed she had beaten him to land, but now Sepharga noticed a thick fog bank rolling in, and gasped in horror as she saw the seawolf turning. Her heart plunged too as she saw a second orca, hugging the shoreline now, and coming straight for Uteq. Sepharga was almost too terrified to look.

"No," she wailed. "Oh, Uteq. Hurry. And don't look back."

Uteq's paws were scrabbling at the hard ice edge, but as he saw the second killer whale, he panicked and slipped backward into the sea with a splash. Sepharga saw the first orca pick up speed, as the bear plunged helplessly back into the water.

"No, Uteq," she groaned.

"Murther."

Right on the edge of the fog bank, fearless, intrepid Egg dipped on the air, then dived, but this time the sea Putnar wasn't to be tricked, and its whole body rose, as it snapped its mouth shut on the fragile goose, right on the edge of the thick fog bank. "*Arcccccccck.*"

"Egg!" wailed Sepharga, as the air was filled with fluttering brown feathers, that blended with the foggy air like black snowflakes. Poor Egg was gone, swallowed up like some angelic Beeg. The very future they had allowed by helping the egg that summer, was already ended in life's ruthless fight, but now the second orca was just five yards away from Uteq.

"I'm done for," groaned Uteq, but with that, a white shape shot right between him and the second Orca, lashing the water with a powerful flick of its tail. The killer whale was distracted, turning on it, and missing Uteq, who pushed hard, with the last of his strength, and managed to struggle up onto the ice next to Sepharga. He rose, bewil-

dered, and turned to see a white shape appear above the surface, making a strange barking in the moonlight, and clapping with its slender flippers.

"A seal," gasped Sepharga. "It's a white seal, Uteq."

"But not just any seal," whispered Uteq. "It's the seal we hunted at the air-hole before the Ice Slayers sprung their trap. What's going on?"

"You saved my life, bear," cried the seal cheerfully from the water. "That's what's going on. And as my great, great, great, great grandfather always said to me, 'one good arctic turn deserves another.'"

"Saved you, seal? But I didn't save your stupid life on the Still Hunt, I was waiting for Sepharga to—"

"Hush, Uteq," said Sepharga wisely. "Maybe now's not the time."

The white seal wasn't really listening anyway, delighted with what it had just done. It had been taught to always repay a favour, and now it started to swim up and down on the edge of the land, showing off its graceful prowess in the sea. It flipped on its back and slapped happily on the arctic waves.

"Your special paw, bear," it cried. "Even the krill talk of it now, Bellarg, and the Great Story too. I may be seal, and you Bellarg, but we've all got problems now."

"Problems?" said Uteq rather miserably.

"You worry about polar bears, with so few seals about, but how do you think we feel? There are fewer of us because of plankton, and so fewer fish. The Great Flipper Flaps of Feeding are in danger, so maybe it's time to help each other out, like real friends?"

"Help?" said Uteq doubtfully. "But I'm Putnar, seal, wild and free, and made to hunt your kind."

"Well, I'm Putnar too," snorted the seal, "to a stupid halibut anyway. And do you always stick to the rules? Look at the Gurgai, they don't and they usually win. Very dangerous Lera, indeed, is Man."

Uteq thought of the Ice Lore and wondered what Lores the Gurgai lived by, but the brave seal turned gracefully in the water. "And talking of Gurgai," he cried, "be careful, for lots live around these strange parts. Go south, and you'll strike a big

human settlement. I swim in their port sometimes, where the great ships come in. I like their anchors, they're covered in food."

The polar bears both growled hungrily and looked around nervously in the darkness too, thinking of the terrible foghorn and the mighty blue whale that the evil humans had mown down so pointlessly in their metal craft.

"My name's Flep," cried the seal now. "It really means, well, flappy, or flipper."

Uteq and Sepharga blinked but smiled at the funny name and the seal winced.

"I know, I know. Mother wasn't very original, silly seal. But at least she always taught me how to hold my breath, and I had to longer than I'd ever had, to break your raft."

"It *was* you then, Flappy," cried Uteq. "I mean Flep. When my parents struck at the ice?"

"Of course, it was, and my great, great, great...Anyway, wise old Rurl was especially good at it. Holding his breath, I mean. But always remember to breath too, when you come up for air."

"Rurl?" said Sepharga, liking the name immediately, as Flep's eyes seemed to revolve in his head.

"*When the lore is bruised and broken,*" he suddenly sang, like the Barg Bergeera in the Bay of the Blessed, but with hope in his voice, "*shattered like a blasted tree, then shall Herne be justly woken, born to set the Herla free.*"

"Herne?" said Sepharga. "Who's that?"

"And does he mean the Ice Lore?" said Uteq. "Broken by Glawnaq. And what are Herla?"

"It's just some silly rhyme mother taught me as a pup," said the seal. "I think it came down from the great Rurl himself. He loved freedom all right, and always went on about the god Herne and some Pantheos too. Still, we must always listen to the ancients too, as we seek the new. Like not ignoring the gods."

The young bears wondered why Flep kept talking about Rurl at all. Had he been some seal god, as well as his great, great, great grand-

father? But Uteq remembered his mother talking of this Pantheos and it strangely reassured him.

"And I wish I could come too," said the seal suddenly. "But it's not my fault I'm made for the sea. Still, I can have some fun with those dinosaurs. You know Orca are cousins to dolphins, but nowhere near as bright. But even Dolphins only use one fifth of their brain power. Just think if we all started to use the lot?"

Now they saw the mercenaries that Flep was insulting returning from east and west, hungry for seal meat and revenge too. Flep just hung there though, until the murderous seawolves were almost on him. Then, with a graceful backflip, the balletic white seal danced away, making the whales collide with a painful crack.

"Wallop," cried Flep delightedly, reappearing and twitching his whiskers. "And good-bye, Uteq Blackpaw and lovely Bergeera. I'll see you again though, if the Great Story has anything to do with it. I feel it in my very whiskers."

The orca's collision had sent up a wave that the seal breasted, seeming to perch on the top for a second, before flipping over and plunging back into the water, and as Flep surfaced for a final time he cried out in the distance.

"And always remember this, Uteq Blackpaw, the wave and the ocean, they're really one."

"Wait though, Flep," said Uteq, feeling a sudden anguish to lose this new ally and wanting to know so much, "but how did you find..."

Flep had dived now though, to hunt delicious Lerop, and the astounded polar bears were left safely on the snowy shore. They felt a sharp wind come up, that forced the rolling fog bank across them in the dark and obscured the sea once more.

"Did I just dream that?" Uteq growled softly, trying to look out to sea through the fog.

"No, Uteq," she whispered. "And Egg. I'll miss him so. He was lovely too."

"Dear, old Egg. It's strange though, Sepharga. I saw no spirit light."

Sepharga blinked hopefully but Uteq felt his spirits plunge at the memory of their young, featherbrained friend, because he wondered

suddenly if he was doomed to lose everyone he cared about in his life and if so, why?

"But what do we do now, Uteq? We're somewhere to the south and remember what old Narnooq's spirit whispered about the Sqeet, those that live near man. Do you think we should try to find..."

Uteq lifted his black paw helplessly, as they heard the angry wind rise and realised a blizzard was coming up again. Uteq was already mourning Egg deeply inside, but he wondered if he could ever escape this blasted story, or, if the Lera were so keen to help him out, if he even should. Then Uteq heard Mad Mooq's voice speaking of the wrath of gods, and a prophecy of what lay ahead. "*Teeth and claws, ice and sea, madness and sorrow, a jealous sister betrays the One, and up in the North, a death and a strange vision. The dead, the Field of the Fellagorn Dead, spirits reborn like Growlers, and then...poison. All dead. The day itself shall be here, the Last Judgement. The Evil One comes at last.*"

Uteq shuddered terribly, as he remembered something else Mooq had cried out too, perhaps stranger than all the rest, even than his talk of poison and murder. "*The curse returns, but now a terrible evil. The Ice Lord of the Flies. The Sight, it shall harm the eye of The Sight itself.*"

"Yes, Sepharga, I know," he sighed, wondering what on earth it all meant. "Try to find Mitherakk, and ask him for the answers to a legend."

11

THE BEAR CAPITAL OF THE WORLD

*"I could be bounded in a nutshell and
count myself a king of infinite space,
were it not that I have bad dreams."*
—William Shakespeare, Hamlet

"I t's so strange," said Uteq in the swollen darkness, as the friends
walked side by side through the arctic Long Night. "Are they
these Sqeet then, Sepharga? It's as if the bears around here are
all enchanted."

The friends had been walking for days and days through a wild
coastal region, but just a night back they had started to see other
Bellarg. They lay around in the snows now, giving dismissive, disinter-
ested growls to the cubs' enquiries after Mitherakk, while the friends
had noticed how odd and unnatural their eyes seemed.

"Or cursed," said Sepharga, sensing they were drawing closer to
the world of their shared visions. Man's world. Uteq stopped as he
thought of the Third Commandment, not to go near Man. Everything
they've been doing seemed to breach the Ice Lore. As he did so, they
both felt they were being watched and Uteq swung his head towards a
great, curling snow mound, that had been swirled up in the wind to
nearly twice their height, like a static wave that could never break. On
the top he saw a small ball of brown fur in the shape of a pear, with
tiny, gleaming eyes, shivering in the wind and watching them closely.

"What's that?" Uteq whispered.

"A lemming," growled Sepharga, with a smile. "Qilaq showed me

one once. Yet it shouldn't be out at this time of year, but safe underground. Poor, dear little thing."

"*Pif, pif, piffle*," squeaked the lemming, "we's not even safe even in our own burrows, so we's keeping watch all the time now. Everything in the arctic eats lemmings. *Pif, pif.*"

Uteq glanced at Sepharga and wondered why it was making its strange piffing sounds.

"Qilaq told me lemmings are a bit, well...soft in the head, Uteq," said Sepharga, "since they've a habit of suddenly throwing themselves off sea cliffs, in their thousands."

"What," said Uteq, "but why?"

"Apparently they're very romantic and that can be an agony. They're always falling in love."

"*Piffle*," cried the Lemming indignantly, lurching forwards, and to the bears' astonishment it walked straight off the edge of the snow mound, and came tumbling down its face in a ball, then bounced off a lip of hard snow and landed like a falling apple. Two more fury shapes appeared at the top of the wave and with similar squeaks, then did the same, so there were suddenly three lemmings before the polar bears in the snow.

"Do you think we's mad?" said the first, picking himself up and shuddering. "Or that we's stupid? Do you think we's fond of suicides? That's just a lie about falling off cliffs. We lemmmings just like to bounce."

The other two were nodding their heads most indignantly, offended by this talk of being romantic, or committing suicide.

"And as for romantic, or love, what's love but the vanity for two? Far more important things in the world. Besides, you's the stupid suicides, Bellarg," the lemgot went on, suddenly glaring at Uteq's black paw, "from where I hear you's going anyhow, bear, *piff, piff*. Because from *there*, there's no return."

"What do you mean where I'm going?" asked Uteq nervously. "You mean to find this bear Mitherakk?"

"The Blaarq. *Pif. Piffle*," spat the lemming. "Going to Hell, and no return. Inevitable. Madder than a mad lemming. No way out, though

none have found the way in. No Narlaq or Nollooq neither, no fight nor flight, just stuck in the middle."

"No way out," piped the other two lemmings irritatingly, but there was an awful fear in their eyes.

"You're going to Hell, Blackpaw, and no mistake" piped the first lemming, "and there's no way back from there. Maybe's suicide's better then, stupid bear. Just jumping off an ice cliff. But I wouldn't stays near here either."

"Though he has the world on his shoulders now, *pif*," said the lemming to his right, more sympathetically.

"The world," snorted the one on the other side, "you means everything. Everthing theres is."

Uteq was trembling and feeling sick too. He growled and stepped forward but the lemmings broke right and left and disappeared around the sides of the strange snow wave in fright.

"And you won't eat us either, *pif, pif*," said a little face, poking back round the wall, "cos we's not stupids, and we's hates suicides. Don't stand at the top of the cliff though, Bellarg, and stare too long into the drop, *pif, pif*, or you may find the abyss looks straight back into yous. Yuck."

The lemmings were gone again, and Uteq remembered his strange dream on the Wander-to-the-Sea.

"Lemmings," he growled, "they fear madness more than anything, Sepharga, even more than polar bears."

Even as he said it and his black paw touched the snow Uteq felt strange, for he could sense something beneath them, and that moaning voice came to his ears. A grave fear stole over him too, and through the winds he could see a shape, a huge brown body, with enormous tusks coming towards him. He wondered if he was suddenly mad, yet when he blinked, it vanished.

Uteq did not understand he was standing ten or twenty feet over the frozen body of a woolly mammoth, almost perfectly preserved in the ice. The creature was long extinct from the earth, though not as long as many, some 4000 years, but it had tried to survive here, even long after the great dinosaurs. It had been migrating to its summer

hunting grounds to give birth, then had gotten lost in a blizzard, and damaged its leg in a fall. Unable to feed, it had succumbed to an icy death, but was preserved still, far below them in the snow and ice.

Now a furious roaring filled the darkness though, and a real shape reared out of the night, huge and white, twice the size of any Bellarg, yet metal, like one of the things in which they had travelled in memory through the great human city, with eyes that seemed to shine like the sun. Inside the moving beast the polar bears saw spindly creatures, peering out eagerly into the night through sheets of glass.

"Gurgai," cried Sepharga, starting to shake too. "They're here, Uteq, now. Humans. It's all real."

"Get back, Sepharga, or they'll kill us both."

The strange metal creature was spewing black steam from its behind, and the friends huddled back, near the snow wave, trying to make themselves invisible in their winter coats. The truck passed them by, but it swung across the ground to where two other adult Bellarg were sitting, half asleep in the deep snows.

"Why don't they run, Uteq? Or fight," whispered Sepharga. "Nollooq or Narlaq."

The Gurgai's strange machine drew right up to the polar bears and now flashing lights came through the glass, but if they expected the bears to be torn apart, like Seegloo's description of the flying metal bird, nothing happened but the flashing. The truck's strange growls receded too, as it moved on again, and as Uteq stared at the smoke that the machine made, his eyes took on the intensity of vision.

Suddenly there was more growling though and right behind them. The friends turned, as a thin faced Bellarg came lumbering at them, with an enormous belly, although strangely spindly forearms and back legs. Uteq tried to rear up, but the new arrival didn't seem to want to attack them, and instead he stopped, and peered at them with nervous eyes, looking almost upset. They were like the eyes of the bears they had met already, vaguely lost, a slightly different colour, yet with some precise intensity, that peered deeply into them.

"Ho there," the stranger mumbled, scenting the air cautiously. "Got any grub then, Bergo?"

"No," growled Uteq in surprise, angry he had startled them so, "and we're both starving."

"Well, I'm Tuq, Bergo, and don't just hang there. Come on then. We must hurry."

"But why?" said Uteq. "The Gurgai only seem to be looking at us. It's so strange."

"Don't you believe it, Bergo. Most just come to look, but it's also the time of the Dart."

"The Dart?" said Uteq.

Tuq's eye's sparkled strangely and with that, another vehicle came bouncing through the night, but a small one this time and poking out of a window at the side was a shiny hollow metal stick. There was a sharp crack and one of the other two Bellarg roared and fell flat, with a little red arrow poking from its neck.

"Is he dead, Tuq?" gulped Sepharga, though seeing no blood in the white snows.

"Gone to sleep, sister," answered the newcomer. "A magic dart. They'll tag him now too."

Suddenly Tuq jumped and swung round with a growl, turning in circles until he stopped again and looked rather embarrassed, staring down at his own shadow in the moonlight. Something had frightened him.

"Let's hurry," grunted the nervous bear. "Bears can out run Gurgai easy, but not their moving dens and not those nasty little darts either. They're everywhere."

The strange polar bear swung around and ran off, as the growling cubs raced after him.

"Do you know a Bellarg called Mitherakk, Tuq?" cried Sepharga after him, as they tried to keep up.

"Can't say I do, Bergeera, but it'll be good to have some real company, while you visit."

"Visit?" said Uteq in surprise and Tuq looked back scornfully.

."Nothing worse than a spineless Sqeet, Bergo. That's why Tuq's the only bear Bergo round here who'll never be tame. *Tuq the Freeborn*, that's me. I keep to myself and do as I please."

The friends thought proudly of their own birthright as polar bears; to live, wild and free.

"Why are their eyes like that though, Tuq?" whispered Sepharga.

"Like what, sister?" said Tuq and Uteq noticed his belly was not fat, but hollow and distended.

"And where's here, Tuq?" asked Uteq. "Will you tell us about this place?"

"What's to know, Bergo? Except humans come here from all over now, in their shiny metal birds and floating metal bergs. They hang out in dens, and go to watch humpback and bowhead whales. But they come to watch us Bellarg too, from their moving dens."

Uteq shook his head, for the more he heard of the Gurgai, the stranger Man seemed, but he growled as he thought of those eyes at the bluffs watching them, and then of Sqalloog and his mother.

"Well if they get anywhere near me," Uteq snorted, "I'll take out their stupid eyes, all right."

Sepharga turned her gentle head and looked rather shocked at Uteq.

"And they've humans dressed in green," shrugged Tuq, unfazed by Uteq's anger, "who go around and mark out where land starts and finishes. They monitor the borders round here."

Uteq immediately thought of Glawnaq and his mercenaries. Where did the borders of his world stop now then? Tuq had slowed though and Uteq and Sepharga gasped. Across the deep snows the northern wilderness came to an end, the Long Night too, for blazing brilliantly with flaring white lights, lay lines and lines of wooden dens in the winter dark. The polar bears had come to the western edge of a famous town in eastern Canada known as Churchill, having drifted very far south on their ice raft, beyond Repulse Bay and Whale Inlet, and now a huge human settlement stretched before them, houses twinkling in the freezing arctic night.

"Come on, grubs," cried Tuq, "We're going hunting."

"Hunting?" said Sepharga. "For what? The sea's the other way, Tuq."

"It's the wildest sport in the whole, wide world, Bergeera. Wait and see, sister."

"Can we trust him though?" said Sepharga, as Tuq went on. "His eyes are so odd too."

"Do we have a choice?" answered Uteq, but as they set off again they were unaware of three more shapes that came loping out of the darkness, not far behind them – three more Bellarg, but not Sqeet at all, but also strangers to the famous town of Churchill. One lifted a huge paw and exposed the most vicious set of sharp black claws, as he scratched the giant collar of fur at his rippling throat. It was Garq, the Glawneye from the Sound who had summoned Drang and who was hunting Uteq to the death.

Up ahead, Uteq and Sepharga wondered what they could be hunting themselves, here, so far away from the sea, as the friends suddenly heard a loud, angry barking in the night. Two large dogs, Doberman Pinschers, a male and female, were held by long chains just up ahead, half starved, and they had caught a scent too, as Uteq noticed tracks in the snow like wolves, but lighter.

"Damned guard dogs," snorted Tuq. "The Gurgai train them to guard their grub."

But as he spoke another Bellarg suddenly came lumbering straight toward them, and the chained dogs started snarling at it viciously. This Bellarg was huge, with a very mean look in his eyes and the first Doberman seemed to think better of its fury, for her tail came down in submission and she whined instead. As the enraged bear got closer, although it opened its mighty arms, it suddenly stopped, and bent down – then the animals embraced each other, and the female Doberman licked the Bellarg's face delightedly.

"Oh, how lovely," whispered Sepharga, and Uteq frowned at her, although it was a surprise to see Lera acting like this in the wild. Perhaps everything was affected by these humans then, and not just the Sqeet.

"I've seen that stupid Sqeet before," growled Tuq. "He's been a prisoner round here."

"Prisoner?" said Uteq, thinking of the Commandments and the Council.

"The Gurgai have many prisons, brother – big metal dens, for the time of the Dart, when they study us all. That Sqeet should be ashamed of himself though. Chilling with dogs like that."

Uteq had suddenly noticed a kind of collar around Tuq's back left paw though, if much smaller than Innoo's, with a little light blinking from it. It made him and Sepharga both more nervous, but they left the dogs and the lone bear to it, and found themselves wandering down an icy street, straight into Churchill itself. Their coats were soon bathed in the glow from the overhead lights, like Beqorn, and Uteq noticed three wooded contraptions, piled high with long sticks of black metal, that had odd strings attached.

They had come so close to the human dens Uteq could see into one, although the windows were filmy with crystallised ice. Inside red firelight danced on a wall, and the glow of a strange metal and glass box, where Uteq was surprised to see images, just like he had by touching Sepharga, as muffled voices drifted outside.

"Glad to be back in the bear capital of the world, Bill?" said a tall Gurgai, standing inside the den, half watching the light box. "Too many damn tourists for my liking now, though. You're lucky you go north next season, with those yanks, to do some real work. Bet the pay's good too."

This human was a ranger and thinking of visiting an old settlement nearby they had unearthed just recently, which must have been made a thousand years before. But Bill was staring out of the window, and as he did so the Canadian ranger nearly spilled his coffee, as his mouth dropped open in amazement.

"Well, I'll be damned," he mumbled, as the TV flickered on. "A polar bear with a black paw."

The strange voices receded behind them as Tuq led them off into town, but soon Tuq pulled up sharply, while Uteq bumped into him and felt his paw quiver immediately.

"Mmmmm," Tuq growled, swinging his head. "Just smell that, grubs. Luscious."

The most putrid stink was coming from a huge green container just up ahead. Tuq's eyes were on stalks and he was dribbling greedily, but Sepharga wanted to be out on the clean ice again, hunting fresh seal, not in this filthy place.

"This is where the stupid Gurgai dump all their lovely rubbish," said Tuq. "For Bin Hunting."

"Bin Hunting?" said Sepharga in astonishment. "What's that, Tuq?"

Tuq smiled and crept ahead, stealthy as a cat, and Uteq started to wonder if he was quite mad, for he approached the stationary object just like an ice hole, positioned himself next to it, then sat motionless as a Still Hunter, staring at the bin. They noticed that his whole body was quivering, as if Tuq could not control himself, like Mad Mooq, or he was very cold indeed, despite his heavy coat. Nothing moved, until suddenly Tuq leapt at the container and knocked the lid off. The polar bear bellowed, clambering right inside, tearing at the things he found there, as if ripping apart a living walrus. Tuq roared triumphantly, as a stream of human garbage filled the arctic night, like snow.

"I thought you didn't want the Gurgai to hear us, Tuq," called Sepharga warily.

"Bergo mustn't ever be Sqeet though," snorted Tuq, surfacing from the stinking pile, with a jagged metal container in one paw, and rotten garbage on his head, grinning wildly. Tuq had something pink stuck to his nose. But Uteq suddenly noticed Sepharga had cut her paw on a rusty tin can, like the one Tuq was holding, as a gout of her blood plashed in the snow. He reached out and touched her, winced, and was suddenly back in that human city. Yet this seemed long ago, and Uteq was surprised to see the Gurgai were smaller than any he had seen. Then there was a flash, and he was in a modern city again and Gurgai were walking there with bellies almost as big as Tuq's, stuffing their mouths with food. They looked like walruses and Uteq pulled his paw away in disgust. He remembered something then about things being bigger in the past, and Uteq realised it was no truer than a shark always moving, but was

just another myth. The stories of Pollooq and the gods suddenly seemed much smaller too.

"No worse fate than being tame," cried Tuq, trying to blow the bubble gum from his nose. "And Bergo never back down. Mmmm-mmm, rotten kippers."

"But if they hear you, Tuq, won't they put you in prison?" said Sepharga.

"Back in prison, you mean, sister. Quite an old lag is Tuq, if you want the truth. Although most every bear's been inside round here."

Tuq was slobbering, his eyes glazed, and there was a strange intensity in the way he ate the rotten kippers, almost a desperation.

"That thing on your back paw though, Tuq," said Uteq, "did the humans give it to you then?"

Tuq nodded, munching happily on a bone now and belching loudly.

"Yup. That's how they bring us back, if we wander to the bound-aries. I think it gives off a sound."

"Innoo," said Sepharga. "Maybe that's why poor, dear Innoo can't remember where her collar came from. A Gurgai dart must have put her to sleep too, long ago."

It startled the friends and made them wonder fearfully if the humans got everywhere, and how many times they had been among the Bellarg too, or what they really wanted of Polar Bears.

"But for you this whole place is a prison then, Tuq?" added Sepharga rather sadly.

"Hey, don't dump your garbage on me," said Tuq indignantly, but he gave a heavy sigh too. "Yet the whole damned world's a prison now, Bergeera, with so little space left. Yet I could be free, free as the wind itself, if my dreams weren't so dark. All the Sqeet are having bad dreams now though, some say all the Lera."

Uteq looked sharply at Sepharga and thought of his own vision and dreams. Then it wasn't them alone.

"And when I lost my mate, three Long Nights we had been friends, I got the madness, and they first darted me," said Tuq. "So I met that other mad lag – always talking about his struggle. How he'd take

revenge on the whole world too." Tuq grinned and ate some rotten cabbage. "Mad as a herring, that one. Kept studying the Gurgai, moaning on about some blasted female he'd lost too, snarling with that horribly scarred face."

"Glawnaq," cried Uteq. "It was Glawnaq and he was talking about Mother. He was here."

"That's it. Glawnaq One-eye, I dubbed him. But you, grubs, you hungry or not?"

The bears were utterly shocked with the revelation, that Glawnaq had been a prisoner among the humans, yet they were too hungry to resist now, even if it meant going through Gurgai rubbish. At least what Ruskova had said of scavengers made them less ashamed. As Tuq went on making an exhibition of himself though, inside the bin, they chose some morsels strewn across the snows, that did not breach the Seventh Commandment, although bears have far stronger stomach's than humans. They felt considerably better as they finished too, and followed Tuq after another catch.

It was at a crossroads in town though that they caught their first sight of their murderous pursuers. The three Glawneye assassins came from different directions, growled on by Garq, his eyes flashing blood red and filled with will and hate. The Glawneye stopped at the sight of such easy prey and snarled delightedly as one.

"Freeze, Blackpaw," cried Garq, his coat changing colour to amber in the street lights. "You don't escape me twice. Don't you know when you're beaten, little bear? Don't you know when to give in?"

"Uteq, they've come for you even here..." Sepharga hissed, wondering where to run to.

"Then we fight. You'll help us, won't you, Tuq?"

Uteq was still far too small to fight though and Tuq was already lumbering off down a little alley, his belly swaying like an old sack.

"Any sad Bergo can fight," he cried. "But Tuq must be free. Besides, I need another shot, grubs."

"Shot?" called Uteq angrily.

"A Dart," said Tuq, looking suddenly smaller than he had, and quite as haunted as poor Pooq, "they bring such wild dreams, bears,

better than our ordinary ones now. Only way to escape the world round here, or anywhere maybe. Into wild dreams. But good luck to you, grubs. Good luck."

There was a terrifying roar, as Garq reared up and sprang at Uteq and Sepharga. Uteq jumped aside and the friends went running toward the crossroads, as the other Glawneye converged like orca, but just missed them. As the assassins collided too, lights came on all around them, as they turned and swung after their quarry. Uteq and Sepharga were in full flight through the middle of the polar bear capital of the world, Churchill, although with her cut Sepharga was slower, and looked in real pain, though she tried to hide it bravely.

"Come on, Sepharga. Just keep going. Try. Run as hard as Tuq."

"Coward," snorted Sepharga, wondering what he dreamt about, "just like Ineq in the story."

"That's what I saw when I touched him," cried Uteq. "Tuq's scared of everything, even his own shadow. But the Sqeet, that's why they look so strange and docile. They've all been darted, or in prison, Sepharga. But what did he mean everyone's having dark dreams now?"

Sepharga was trying hard to run as fast as she could but the Glawneye came on relentlessly. At last the friends swung onto a narrow alley where they stopped dead and saw Garq glaring at them smilingly, not fifty yards away. He had circled and come another way. As the huge murderer came lumbering forwards, they backed away towards some tall broken fencing at the side of the alley.

"Look, Uteq. We can make it through there," Sepharga cried, pointing her snout towards a large hole in the fence, as Uteq knocked over something metal and a dark liquid spilled out into the snow, spreading out across the ice.

"The black blood," growled Sepharga, catching the acrid fumes too. "It's here as well, Uteq."

Garq was almost on them though, but now they heard a loud crack and something whizzed past their ears. A Gurgai was pointing a stick from an open window, and in the darkness a single human eye was looking straight at Uteq too, through a little metal tube. Inside, a

crossbar was moving up and down, trying to centre the polar bear and as the human fired, the petrol can that Uteq had overturned blasted through the air. The ranger fired again, but the live round missed Uteq once more, and instead spat up the snow just near the fence. Suddenly flames were licking up behind the polar bears; and hot red flowers, like in their visionary memories, were blooming everywhere.

"The black blood," cried Uteq, "is it magic? It is the flowers, somehow, Sepharga, like it is the past too."

The two other Glawneye assassins stopped dead at the end of the street, in the face of the flames, but from a different direction there was a dull *phut*, and a startled look came into Garq's vicious eyes. The assassin froze, spun and crashed to the ground, as two Gurgai in green, both carrying metal sticks, came striding down the street with Sepharga and Uteq in their sights.

Sepharga swung towards the fence and the hole, but now she looked on in horror. It was on fire and the flames were rising even higher and terror danced in her face as she seemed to be wrestling with herself. But Sepharga suddenly dived through the burning hole, breaking the wood away in great flaming splinters, as her fur caught, and rolling around in the snow beyond. When she rose, Sepharga looked around in wonder. She was quite unharmed and the flowers were gone.

"Come on, Uteq, jump and roll in the snow – somehow the cold kills the red flowers."

Uteq dived through as well, fire singeing his fur, but as the bear rolled too, the horrible burning was extinguished immediately. He picked himself up, smut and soot smeared across his face.

"Bless you, Sepharga, you saved our lives. Let's leave this Hell, though, and the evil Gurgai too."

Yet something came into Sepharga's dark eyes and she stopped him.

"No, don't say evil, Uteq. Didn't the Fellagorn teach we must be careful of words, and Ruskova too, from the east? The memories have been getting stronger ever since we came ashore, and it's so strange,

Uteq, but I suddenly know why the Gurgai brought me to the Sound. They were trying to free me."

"Free you?" gasped Uteq, looking at her sceptically.

"Yes, Uteq. Free me into the wild again. I was unhappy in their world, and a human Bergeera wanted to bring me back, before their craft sank and we started to drown. Before she drowned."

Sepharga looked very sad and lost again and Uteq thought of her parents in that tiny tank.

"But why, Sepharga? If the humans hate the Bellarg, and the Lera too? Kill us all the time?"

"Not all of them do, I think, especially not this one, Uteq. She'd feed me milk, and loved me too. Touch me with your paw, Uteq, and I'll try to show you."

As the flames flickered on, Uteq put out his black paw and touched her and he could suddenly see a struggling little bear cub. It was Sepharga herself, not in the pool like her parents, but in a den filled with bright, hard light. The little cub was wrapped in a green skin, and a human hand held something thin and shiny in her hand, moving toward her fur.

"Stop," growled Uteq, as a needle pushed into Sepharga's skin. "Their drugs Tuq uses. They're torturing you."

"No, Uteq, it was something she did to make me well again."

"Well again?"

Quickly the vision changed, and now the little cub was lying on her back, her furry throat moving greedily, as she guzzled on a glass bottle, filled with fresh, delicious milk. Then Uteq was looking at a beautiful female Gurgai, with hair flowing about her, as red as the fur sleeves on Toleg Breakback's arms. The gentle human was suckling Sepharga by hand and her eyes glowed with pure love. Uteq was astonished. This human Bergeera did not look evil at all.

Uteq thought of something Nuuq had said once too, that if you really love something you must help it to be free. He looked around the den in the vision, filled with strange objects and other humans as well, as a Gurgai boar opened a white box and mist came spilling out like fog floating over ice and snow.

"They've captured the cold too, Sepharga," he hissed. "But how? Do they want to put it in prison like us?"

As he spoke, they were back in the park where her parents lived, in the very middle of their great city, New York City, but now Sepharga was out in the open, wearing a collar just like Innoo's, but a lead too, and being led into a strangely shaped wood-and-stone den, filled with Gurgai, sitting in rows on benches and clapping their strange hands together. The red-haired female walked with the waddling cub down to the front of the den, and was suddenly talking, pointing proudly to Sepharga, gesturing at what looked like the white wing on the Wander. Then the light in the den was turning dark, and another light blazed, as the polar bears saw pictures; moving on the wall behind. Uteq was confused, for since he was seeing them now, he could not tell if these creatures were inside him or outside. They could hear noises now, and as the Gurgai watched, Uteq was as astonished as the Fellagorn had been looking into Sorgan's paw print and seeing that voyaging warrior on a stormy sea.

"Look, Sepharga," he gasped. "It's our own ice world."

There were indeed moving pictures of the great arctic being thrown across the wall in the film. It was suddenly as if the bears were flying through their own beautiful habitat, soaring over huge blue cliffs and great snow-capped tors, over open tundra, great glacial plains and humping pressure ridges. It was both wonderful and thrilling, like escaping this horrid town, but as the polar bears watched, the images began to change.

Great stone towers appeared, billowing out smoke and fire, like the fence. Then they saw successions of huge, sprawling cities. Next, they were in their homeland again, looking at a gigantic cliff of blue ice and down it crashed before their startled eyes. Then one ice face after another was falling and went plunging into the ocean, in slow motion, just like Uteq's grief-filled memories, then hundreds were falling, throwing up columns of water like steam.

"The end of the world," gasped Uteq, as the flames from the fence rose into the freezing air. "Humans know about the Great Story too then, Sepharga, and the curse. The Gurgai tell it themselves."

Now though the bears saw huge black-and-silver metal arms that seemed to be moving of their own accord. Their solid arms reached down into the earth and as the bears watched, a viscous liquid suddenly gushed out of the ground and stained the pristine ice jet black. It was a river of black blood.

"That's where it's from then," growled Uteq. "Inside the earth. Gurgai take the black blood from the earth. Is the very earth wounded and bleeding? Is this the blood of their world?"

Other pictures came too, of little black rocks being dug from the earth and piled high in huge mounds of coal and slag, that climbed into great black mountains of coal.

"But why, Uteq?" shuddered Sepharga. "What do they really want?"

The fence flared though and the images in the pictures had altered, and now they were looking not on fresh snow flakes, but on vast swaths of arid desert, parched and burnt by Gog's heat and stretching for hundreds of miles. Then the bears could see mighty stretches of forest and jungle, just like Uteq had seen when he had touched the black blood itself, that seemed to go on forever. But in the middle, terrible fires burnt, and for thousands of miles trees had been cut down, strewn like discarded matchsticks before them. Instead of miles of rainforest now, they saw thousands of acres of palm bushes, and Uteq saw another gushing river, but of yellow oil now, and then strange, orange animals like humans, dying in their tens of thousands; a primate genocide, as their habitat was stripped away.

Then through the fallen trees walked half naked men, with painted faces and feathers in their hair, but elsewhere came Gurgai in green-black clothes with metal sticks, and in flashes of fire the feathered men were falling to the ground, their bodies torn and broken, bleeding on the ground. Then there was parched earth again and men were attacking each other with metal hatchets. They saw soldiers, armies on the march, and everywhere all that Man seemed able to do was fight and kill. Then they saw encampments, made for peoples on the move, and then among their cities, vast seething slums

of human life. If this was the 'reason' the Gurgai used above all, it seemed as terrible as the Pheline's, or mad as Mooq.

Now they were suddenly back in the city Sepharga had been reared in and two metal birds were flying towards two great towers that burst into flame as they struck, and then came more visions of Gurgai fighting. It seemed unstoppable. The very earth was at war.

"Human Bergo," hissed Sepharga. "Putnar, Uteq. Do they hate each other, as well as the Lera?"

Sepharga pulled away sharply, and this time Uteq turned and snarled at her.

"Stop, Uteq." She growled, "Please."

"But that hurt *me,*" growled Uteq. "And they're monstrous, Sepharga. A real curse. No wonder Tuq has bad dreams and wants to escape it all, with their darts and drugs."

The friends could feel the heat again, but on the other side of the fence the Glawneye backed away from the flames, and the Gurgai too, for humans seemed just as vulnerable to it as bears.

"Failed," growled one of the Glawneye, looking scornfully at Garq on the ground. "He'll be mad, all right, when he wakes. But there'll be another chance, and we've orders too now. *Special* orders."

"Special?" said the other, wondering why Garq was moaning so strangely.

"For the Father's great solution. To persuade the Gurgai to help us all out."

"Help us out? But here they seem to care for the Bellarg. Protect them."

"Times always change, especially if we wake up Man's fear and so his hate."

Beyond the blazing fence, Sepharga turned and saw a great open expanse of snow sweeping beyond Churchill. In the brooding skies above, heavy Chooka flakes had started to fall again, making the flames spit and crackle furiously, but Uteq seemed transfixed, as he gazed into the great fire.

"Uteq, what's wrong?" Sepharga cried. "Another vision?"

"No, Sepharga. Something very real this time," he said, and it was

as if a light was coming on in Uteq's mind. "Man and the black blood, Sepharga, and the lights and heat and red flowers. Man's found a way of capturing Garn, of changing it, and using it to feed his great machines. That's how those things move through the snows, and among the Gurgai dens where you were born. It makes them live."

"Using spirit?" whispered Sepharga in amazement, as Uteq blinked in the dancing lights, still trying to understand.

"Spirit? I don't know, Sepharga. But the black blood, yes. It brings their metal creatures to life, just like magic. So their metal dens move on their own and feed on the black blood somehow."

Sepharga thought the idea so strange, for to her the machines seemed to be dead and monstrous things.

"But as he uses that Garn, Man always makes something else too, like rubbish, that can blacken the rivers, or kill and poison the Lera, like the puffin that Innoo ate. As he burns up the past."

Uteq looked up into the snowy air, at the cinders mingling with the beautiful snowflakes and they seemed to be carrying his dark thoughts skyward and the bear felt as dizzy as a cub under an ice cliff.

"And all Man does gives off heat into the world, and air. That's what's really melting the ice, Sepharga, and not Glawnaq's sacrilege at all. Everything's getting warmer. The whole world's changing."

The fence flared angrily and spat at them.

"Then Glawnaq isn't to blame for the melting world?" Sepharga whispered. "He isn't evil at all. He's just protecting us."

"Glawnaq saw it too, and he may be evil or not, but it's Man that's really killing the world, Sepharga. Man's the real wound of the White Bear and of all the living Lera too. They're our true enemy now."

The polar bears were paralyzed by the enormity of Uteq's sudden revelation, but at last Sepharga stirred.

"Then it's all true, Uteq. The Great Story, I mean," she said. "So if you know this about the Gurgai, you can be a Saviour, after all, Uteq Blackpaw, and stop the ice melting too. You can save the whole world."

The wind rose and the snow heaped down, dousing the angry flames, and Uteq felt as if the sins of the whole world were settling on

his back indeed, like cinders, or that he was drowning in a sea of black blood, simply because of what he had seen and learnt. It felt horrible to even look.

"One Bellarg against all that Man is?" he whispered miserably. "There are millions of them, Sepharga, billions perhaps. Like sea plankton indeed, before plankton started to vanish too. Am I responsible for everything?"

"Two Bellarg against Man," said Sepharga firmly though, as she turned to the fence. "And the flames are going now, Uteq. So we've got to get away, or they'll follow with their darts and bring us back again."

"But Mitherakk. If he's back there among those Sqeet..."

It seemed pointless finding this Mitherakk anyway though, so the polar bears, numb from what they had discovered, turned and hurried off into the storm. They felt the snow's protective cloak enfold them this time, like Anarga's arms, hiding them from the assassins, and the terrible, evil humans

For five nights the two friends fled through that blizzard, and when it cleared for two more weeks, they hardly stopped or slept, desperate to get away from Sqeet-ridden Churchill. They felt as if everything was chasing them now, not only Glawnaq, but the whole world, and it was only when another storm rose and died again, and a huge arctic moon climbed high in the heavens, that they felt safer, as they walked onto a little frozen pond and found themselves suddenly slipping forwards.

The polar bears both reared up, clutching onto one another for balance, skating across sheet ice, and spinning around together. The bears held each other up and let the wonderful momentum take them, arm in arm, in the blue moonlight, gazing deeply into each other's eyes. The wind had died and Atar cast a beautiful, gentle glow across them both, so that their shadows literally blended together and waltzed beside them.

The air was magical, muffled and soft, and Uteq could have leant forward and licked and kissed Sepharga's lovely snout. Until Uteq thought of the lemming and what it had said about 'love and vanity for two' and so suddenly grew embarrassed again, remembering his

promise to Matta guiltily. The very thought made them wobble and slip, then crash down again, on the other side of the little pond, near a single moonlit tree, on the edge of a shallow slope.

Just ahead the bears spotted the most extraordinary shapes, standing motionless in the pristine arctic. Before them in a loose circle stood several enormous brown Lera, like walruses, but each with four spindly legs and heavy fur. Their heads were half-heaped with cakes of snow, and their eyes tight shut, while their dark winter coats seemed to drip off them. The animals had horns too, curling like brute bones in the windy dark, and the male's were huge and sharp. It was a herd of musk oxen.

The friends both remembered that strange knocking last summer, but also what Qilaq said about oxen knowing things others did not. Perhaps they would know of Mitherakk then and how to find him.

"Look," said Sepharga, as something stirred inside the circle. "In the middle, Uteq. Calves. They're protecting their calves. How lovely."

There were indeed Musk ox calves, but now the bears heard a savage howl as several dark shapes came rushing at the oxen through the night, at least ten Varg, arctic wolves swirling around them, snarling and snapping at them hungrily.

"Uteq, can't we help them?" gasped Sepharga. "The little ones, I mean."

"Help them? But why, Sepharga? It's only nature's way. The Ice Lore."

Uteq thought of Flep though and of Egg. Of himself as a little cub too, in the centre of that circle of foolish Bergo at the Council, and how terrifying it had all been to the tiny, guiltless bear.

"Oh, come on then, Sepharga. We're Ice Lords too and Guardians, at least in the stories. So let's show those filthy Varg."

Suddenly though Uteq had a strange sense of Qilaq, just as he had done of Matta, who he saw now in his mind's eye turning and snarling fearlessly, but Uteq blinked and the sense of it was gone again. For a moment Uteq did not know where he was.

"How though, Uteq? There're only two of us, and we aren't exactly full-grown bears yet."

Uteq shook his head but he looked at the tree looming into the world, and almost wanted to hug it, as it cast a huge shadow before it in the moonlight, down across the snows towards the oxen. Then he thought of Tuq and their own shadows dancing together on the pond.

"Shadows, Sepharga," cried Uteq. "We'll use moonlight to make us both look bigger and to trick the brutes."

Uteq felt a strange clarity, as strong as his revelation about Man, and he suddenly ran into the open moonlight and rose up, roaring furiously, as Sepharga joined him. Some of the wolves turned, as half the Musk oxen opened their eyes. The polar bears seemed truly gigantic now, the wind magnifying their bellows and the musk oxen's courage rallied and one gave a wolf a glancing blow with its hoof, while another head-butted a second Varg. As the wolf pack's purpose broke and they all bolted, three, including the big Dragga, realised that the bears weren't quite as large as they'd imagined. Infuriated by the clever trick they turned to attack, but now, chance stepped in. For near the tree was a great drift of deep snow, and the wolves disappeared straight into it. Two startled Varg emerged and scrambled out again, fleeing the scene, but the Dragga's head was hardly visible above the surface as he fought the white, his scuffling paws appearing and vanishing again.

"Shouldn't we help him, Uteq?" growled Sepharga, as the two polar bears passed a large branch that had broken from the tree.

"So it can just attack us, Sepharga? Why let it live, especially if it's one of Glawnaq's mercenaries?"

"I'm no filthy mercenary, bear," snarled the Varg, struggling fruitlessly. "To sell my soul for Bellarg meat, like so many of those greedy Gurgai. I'm a proud, freeborn arctic Varg, and wild. And nothing so Kassima as two cursed Bellarg either, in the moonlight, helping musk ox against the very Ice Lore itself."

"Kassima?" snorted Uteq. "The Ice Lore fails, Varg, now the whole world's gone mad, and all ends."

As Uteq thought of his terrible visions of the black blood, remembering Mooq's words about the Saviour drowning in a sea of blood, a strange pity gripped him.

"Would you say it's against the laws of nature though if two Bellarg help you now, Varg," he whispered.

"Help?" squealed the wolf, spitting out gouts of wet snow. "How, bear? Blaaaaach."

"That log," growled Uteq, glancing round. "We could roll it toward you. If you keep my paw secret from Glawnaq One-eye, or that you've seen us here at all. They're hunting for us."

"You?" cried the wolf. "Then you're the child of the Calmpaw? The great Bergeera they say's so ill, and refusing to cub. Glawnaq's filled with rage, and my cousins say he's a terrible secret too, about the Barg."

Sepharga looked sharply at Uteq, but thinking of Anarga, Uteq stepped forward.

"What do you know of my mother?"

"Only what I heard my cousins saying on the wind, young Bergo. Varg who serve Glawnaq One-eye, in the far north. They say this Calmpaw was badly wounded in some fight."

"Yes, on the sea ice, defending us."

"And the wound goes deep," said the wolf, "but because she refuses to eat properly, the sickness stays in her blood, so now, although she will not die, Anarga Calmpaw is in terrible pain."

The pain went deep into Uteq's own heart. The wolf was sinking again though, its Garn almost spent.

"Promise, Varg, on whatever gods you hold dear to you, to keep this meeting secret."

"And you mustn't touch the calves either," said Sepharga suddenly.

"Then how am I to feed myself and my young, Bergeera?" snarled the wolf. "Their coats should shine, and their hearts run free, to fulfil the beautiful, terrible lore. All must eat in the world. To survive. All."

Sepharga looked back at the little calves, her eyes filled with moonlight, and she did not think it beautiful at all. She hardly understood the Ice Lore, or its Commandments either: *Survive; Know what to trust; Don't go near Man; Paw Trail; Bergo never back down; Shake your coat of ice; Don't eat anything rotten.* Suddenly Sepharga realised that

she did not even know the eighth. Everything they had learnt on their terrible journey though seemed part of some wider and stranger Lore. What was the real truth of anything?

"All right, Varg," she growled, "but not for three moons at least. Promise us."

The wolf snarled angrily again, treading snow to keep his snout out of the white, but he nodded.

"Very well. I promise on the great wolf gods Tor and Fenris then, but hurry Bellarg. I'm drowning alive."

The polar bears turned and rolled the log to the drift, and the Dragga pulled his weary body up and out with his claws.

"My thanks, Blackpaw," he gasped, as he stood again, lifting his fine tail proudly. "My name's Karn, and you've my life debt now and we all owe one, they say. But I go, to live free and wild, and never again to be touched by such strangeness. It's Kassima, and not real, savage nature at all."

Uteq frowned, for he had remembered Marg saying we all owe a life, but he nodded too as the Dragga let out a piercing cry, a howl half in gratitude, half in anger, and then Karn stopped to listen, his fine ears cocked high in the bristling arctic winds. The air was growing savage again.

"What are you doing, Karn?" asked Sepharga nervously.

"Wind talking, kind Bergeera. Some Lera think our cries have just one note, but they carry the first language, bear, the very oldest tongue, before the word, and say different things, from the depths of our very beings. All animals speak of the world, bear. Perhaps all life."

The polar bears heard answering howls, that flew towards them on the arctic wind – rich and complex notes, called out of the deepest darkness, for Karn's pack were answering him.

"I go," growled Karn, "and fear not, bears, I won't tell my kind any of this. There's usually hell to pay when a Dragga misses his kill. Might take months to sort it out, or even years, if at all, and I'll have to do some hard fighting as it is. But my grip's stronger than my growl."

Proud Karn turned tail, and for a while they stood staring at the muscular circle of oxen, for to their amazement the musk oxen had

hunkered down again, unmoving, and seemed to have gone back to sleep.

"Well, that's gratitude for you," snorted Uteq, but the polar bears drew closer and the musk oxen stirred, though all with their eyes tight shut. They had the most absurdly long faces, very grave indeed, ending in enormous black nostrils that smoked with icy steam in the moonlight.

"Excuse me," grunted Uteq, stepping up in front of them. "We're looking for a Bellarg called Mitherakk. Can you help? You know many strange things, the Lera say."

There was silence from the nervous musk oxen, as the wind began to rise and moan.

"Please," growled Sepharga rather indignantly. "Uteq needs your help."

At this, one of the cows standing next to the largest ox, answered, although she kept her eyes closed. "Hush, bears. We're trying to sleep and save our Garn. Many are hungry in these parts."

"Because everything that lives is hunted," growled Uteq bitterly. "Like us. And there's no gratitude either. That's the real world. Fight for yourself and survive. Nothing else."

With that, there was a kind of rumble, and the huge musk ox facing them opened just one eye, twice the size of Glawnaq's, and looked hard at the strangers.

"Real world!" he lowed, in a deep and rather contemptuous voice. "What do you say there?"

"Everything's hunted, ox. It's why life's so sad and unfair. And no one believes in anything anymore, especially not the mad Gurgai. Not in ideals, not in life, not in anything at all."

"And what do you hunt, bear, to live and be?"

"Seal, I suppose, so scarce now, but I've even scavenged Gurgai garbage. But now I'm hunting some stupid bear, some Mitherakk, to ask him about a silly story. Though we're all doomed in the end anyway. To die."

The musk ox opened both eyes now. They had a distant look, as he chewed on his huge lips.

"And why call the Great Story silly, bear? You could anger the gods themselves."

"Because gods and legends and stories just aren't real, are they? Pollooq never proved any magic or miracles, and Atar and Gog don't exist, while there's really only one real Ice lore. Survive."

The great musk ox suddenly yawned in Uteq's face.

"And the law of coincidence, perhaps," he said. "But there's no greater poison than bitterness, Bellarg."

"Coincidence?" said Sepharga.

"That you should seek out a creature you believe a wise white Bellarg, my dear, then bump straight into me in the middle of nowhere. Extraordinary, don't you think? Like some strange story."

"You're Mitherakk," gasped Uteq, and the weary polar bear nearly fell over.

GERLA

*"The Mirror crack'd from side to side.
'The Curse is come upon me,' cried
The Lady of Shallot."*
—Alfred, Lord Tennyson,
"The Lady of Shalott"

I n the land where Glawnaq ruled with his Serberan, nearly a
thousand polar bears from right across the arctic circle had
gathered under a marvellous wash of stars, driven by fear of
Snow Raiders and Man, the failing ice, the hope of service, or the
ambition to fight. Odd dreams touched them all in the nights and
days though, as Tuq had said near the Gurgai; dark and filled with
strange shadows.

A pair of Bergeera stood together, braced against a high arctic
wind, above the ugly, crowded bay of the Barg. One of them was
digging feverishly in the snows, Innoo, and beside her Nuuq flinched
as she caught sight of two more Bergeera marching straight toward
them under the crescent moon. High above glittered Pollooq's Claw,
the Great Bear, and lone Teela too, as brilliant but as cold as ever.

"Look out, Innoo," hissed Nuuq. "It's two of the bosses."

Innoo seemed confused, but she stopped and turned as the others
reached them, although she kept pawing at the snows like a dog,
wanting to turn back again to her work as if she had no choice about
it at all.

"You," growled one of the approaching she-bears, who had a fat
little frame, if such a thing was possible here, and heavy forearms too,
with the most pugnacious snout. "Why are you lounging around,

Barg, when there's work to be done? You should be with the other Bergeera in a work detail."

"My friend, boss," whispered Nuuq politely, "she's not so well. Something she ate, I think."

"She shouldn't eat at all," snapped the pugnacious Bergeera at Nuuq's lie, for the bad puffin that had once made Innoo ill had been in the Great Sound long ago. "No work, no food. Right? A fact of life that Glawnaq learnt from the Gurgai."

"Not so rough, Gerla," said the bear next to her though. Her face was much gentler and finer than Gerla's, her eyes strong and kind, if tired and hollow looking.

"Yes, Farsarla," said Gerla, blushing and addressing the boss of all the Barg she-bears respectfully. "But the Serberan pick on us bosses, if they don't work hard enough. That's the new Ice Lore, right?"

"Right, Gerla, but we mustn't turn into them," said Farsarla softly, as the she-bear turned and spoke kindly to the friends. "It's Nuuq, isn't it? And Innoo – the mother of those twins? They work hard, I hear, among the Barg cubs, and they're popular with the Tappers too. They're kind to them."

"And that Qilaq's a brave one," said Gerla, though rather grudgingly. "That's why the Serberan picked him from among the Barg, to fight their own cubs, regularly too. Special bluffs."

"Qilaq fights?" gasped Innoo, throwing up her muzzle and looking almost aware for the first time in ages. "But Qilaq's far too young. Oh the world's a terrible, savage place."

Innoo had not seen the twins since she had arrived, except at a distance and every day she mourned them like a death. The Separation was especially cruel for poor Innoo, with Gorteq's loss.

"Don't be a dumb puffin, Bergeera," snapped Gerla. "If Qilaq fights, he gets to avoid some of the harder duties among the Barg, and earns extra rations. Though no Barg's proud of avoiding their duties, I hope. *For work and duty blessed be, in work our service sets us free.*"

Gerla looked proudly at Farsarla for approval as she recited the mantra, but Farsarla said nothing.

"And of course they're only testing him to see if he's strong enough

to progress. If they give him a place in a Moon Duel, when Atar's full," said Gerla, looking guilty mentioning Atar at all though – "so he could even fight his way right into the Serberan. Become a great leader of bears, we all serve. Think of that, Bergeera. Great Glawnaq himself may even notice Qilaq, and give him advancement."

Gerla seemed to have something almost like love in her eyes as she spoke of Glawnaq, but she had just decided that she would be kinder to Qilaq in future, as Nuuq looked at Gerla in horror.

"Qilaq join the Serberan? But he can't."

"What prouder thing could there be in the whole world than to be an Ice Slayer," said Gerla with rather misty eyes. "Or a Serberana. Served fresh seal, and open clams, and tended to by the loyal Barg."

Gerla was almost dribbling at the thought of it, although only a Barg herself.

"They need my milk," was all Innoo could mutter. The twin's mother looked so thin, she hardly seemed capable of producing any milk, let alone giving it to them in a snow den.

"Milk?" hissed Gerla, looking behind Innoo at the start of a snow passage. "That's what you're doing then. I knew it, Farsarla. She is digging a snow den. Is she mad? It's that Gurgai collar."

Only Barg Bergeera specifically granted permission by Eagaq or Glawnaq themselves could dig dens in the Bay of the Blessed, or mate either, and then only to bring forth new Tappers for the work details at the ice holes. Farsarla knew Innoo could be punished very seriously indeed for this, if the Serberan or wolves ever discovered it.

"Of course, she's not," said Nuuq. "Er, Innoo's just honing her sculpting skills, to work in the Sound, for the Serberana, and dig loyally. She's very proud of the thought, and just practicing."

"Well, she looks moon drunk," growled Gerla suspiciously. "Or like a Sqeet. Like that Mad Mooq. Though many seem touched now, so quite useless to us all. Perhaps she needs to be selected for a Leave."

Nuuq looked sharply at Gerla and there seemed a strange fear in her eyes suddenly. A secret had started to spread about the Leaves, and the selections they made for them, whispered on the sharp arctic

wind, that some of the Barg just disappeared. Perhaps the journeys were too harsh for the tired workers and the wolves were bolder now, and always very hungry too.

"Just tired perhaps, Gerla," said Farsarla kindlier. "We all get tired here. Even you, Gerla, though you've the strength of a musk ox, and a will like ice."

Gerla looked delighted at this talk of Musk Oxen, for she had heard they were very wise indeed, but with that, they heard a great roaring, booming through the icy air, and swung their heads.

"A summons," said Farsarla, as they saw some Serberan, including Keegarq, standing in the moonlight, lifting their powerful boar heads. "Time to hear the Instructions then. For all our good."

Farsarla looked doubtful, but already the separated groups of Bergo and Bergeera had started to abandon their work duties and move obediently toward the Ice Slayers. The Summons was almost a daily event, for giving Marching Orders, hearing Barg recite instructional sayings and phrases, and telling the wearier ones when the Leaves were going out, and who was lucky enough to join one.

"They're as loud as poor Pollooq," whispered Nuuq sadly.

"Hush," snapped Gerla, looking round sharply "It's not allowed and you know it. Besides, I don't know why bears went on about Pollooq's terrible pain. What did Teela do anyway to his silly sleeves? It's not as if he couldn't eat seal, or tell his stupid stories. He had a tongue, didn't he? Always complaining, just like the Barg Bergo. I loved two furry mice as a cub, but they died. I was heartbroken, but I don't go on about it."

Nuuq blinked and looked back at pugnacious Gerla, wondering if she was quite real.

"But that's not the same as really loving another bear, Gerla," she said. "That's what the story's about."

"Besides," shrugged Gerla nonetheless, "the Pheline were right, there are no gods. Except great Glawnaq. Pollooq lost, just like our Fellagorn, and your lot did, to Glawnaq. So what? We have to go on."

Innoo looked blankly at Nuuq and her face was suddenly filled with pain and misery.

"Aren't you two coming?" growled Gerla, looking angrily at them both.

"They can miss this one, Gerla," said Farsarla softly, as the Serberan's roars came again. "Come on, look sharp. They especially don't like it if we bosses are late."

Nuuq stood watching the two in the darkness as they left and shook her head. "She's a good one, that Farsarla. Thank heavens she leads the Bergeera, and keeps bosses like that fat bully Gerla in check. They say the Bergo have it harder under Darq. Farsarla's always snatching extra food for the younger bears too, and looking out for us all. She's like a mother..."

Innoo was only half listening, but at this talk of a mother she turned and started scratching in the snow again and Nuuq sighed bitterly. "Please don't hurt yourself, Innoo. The twins are fine, and they're both strong and too large to den anyhow. You'd have had to drive them into the wild one sun, and Qilaq can handle himself now. Besides, you shouldn't want to have anything to do with denning, not from what I hear of Eagaq's plans for Barg cubs next spring."

"Tappers have fun," said Innoo unconvincingly, as she scraped away. "The only ones who do."

"Not Tappers, Innoo," said Nuuq doubtfully, "I meant Eagaq's Knowing."

Innoo growled dully. Her paws were almost numb with cold since she was so hungry and weak.

"Knowing?"

"It's awful, Innoo, but they say that for the newborn that come next year, for some reason Eagaq plans a little test. The filthy Cub Clawer's calling it his Knowing."

Nuuq wondered if Innoo was even listening as she dug on more and more desperately.

"That filth's grown obsessed with learning cubs' deepest fears, Innoo. He keeps talking about Uteq, and I think he's been talking to Sqalloog too. Something's got into him, all right."

Neither Bergeera knew anything of Uteq's power to know things of others and their fears, but that's where Eagaq had gotten the very

idea, for once Sqalloog had told him of it. Nuuq shivered as she thought of Eagaq. Power and freedom were swelling in the Scout with his own betrayal, and everywhere the Cub Clawer went that single vicious Seeking Claw was out now, fully revealed, ready to expose any weakness, not only in the younger bears, but to the Barg adults too. But it was to Nuuq herself that Eagaq was showing an entirely different kind of attention to, and Nuuq hated it. Many times, Eagaq had followed her on the Still Hunts, offering her help and protection, and humiliating her in front of the other Barg. She was relieved another bear had also shown an interest then, Soonaq the Serberan.

Whenever Soonaq came to visit, Eagaq was never to be seen, and the other Barg seemed to like him, for the Ice Slayers were less brutal when Soonaq followed the work parties, and he had a clear contempt for the wolves. The Varg feared Soonaq's paws and teeth, and he often lost his temper with them and knocked them across the snows.

"Bad Qilaq mustn't fight though," said Innoo miserably, throwing up large lumps of snow. "It's just not right in such a terrible world. He's just too young and sensitive."

"I'd like to fight," growled Nuuq suddenly, frowning at her, "or at least see the Bergo from the Sound stand up for themselves for a change. Seegloo's useless, and what honour have the Scouts anymore? They're broken."

DOWN IN THE BAY OF THE BLESSED, MATTA WAS SITTING ON THE EDGE of the sea ice in the deep darkness, near a group of young bears from the Sound who had just come in off the ice from another heavy work detail. They moved like ghosts now, thin, drawn and listless. She was looking at those regimented rows of seal holes, and watching the eerie Tappers, tiny silhouettes on the ice, when she heard a Bergeera roar, and suddenly plunge through one of the ice holes and vanish. Matta was horrified, yet she was almost too tired to care. She had seen it before, many times. Suicide.

Matta looked around at the Barg, the adult males and females in their groups, and the cubs in their own and noticed how many were

resting alone, pawing at the ice, or staring helplessly into the middle distance. Their daily lives, the banning of stories and the awful things they sometimes had to endure, had driven many of them deep inside themselves, as if they were searching for some place kinder than this one. Now Matta noticed Qilaq walking toward her, her twin nursing a bad wound on his right foreleg.

"Qilaq. They made you fight again then, brother?" she whispered, as he sat down beside her in the snows and licked his foreleg roughly. "In one of their charming little duels?"

"Yes, Matta," grunted Qilaq. "I nearly lost it today too. The Serberan always pick bigger bears for us to fight, but at least they're not allowed to do serious harm, yet. I hate most of those Serberan cubs, Matta. They're such arrogant little bullies. Like that Ogguq. He's even worse than Sqalloog."

"Their parents never do anything except bully us either," said Matta angrily. "And the Varg make no pretence of waiting until the weak fall now, and not only their leaders feed. It's so terrible."

"It's hard, sister," growled Qilaq, but he looked strangely guilty too. "But as for the fights, they're preparing some of us to be chosen next spring, I think, to see if we can enter the Serberan."

Qilaq's eyes suddenly looked rather strong and eager but Matta growled at him.

"Don't ever say that, Qilaq. We're free Bellarg, not filthy slaves. That's all Sqalloog wants now too. He loves being a boss, but he wants to be an Ice Slayer even more."

"Not filthy slaves?" snorted Qilaq, "Just look at the Barg, Matta. Look."

He fell quiet though and the twins sat there, side by side, staring up at the stars and the sweeping path of the Milky Way glittering above them.

"I caught sight of Mother again yesterday," said Matta softly, "although Sqalloog wouldn't let me leave the work detail. She's building a snow den for us, I'm sure of it. Poor Mother, you should try to get to see her and talk to her. Stop her."

"So she can just tell me how awful life is?" grunted Qilaq, suddenly looking resentful.

"Qilaq," growled Matta sharply. "She's our mother."

"I know that, Matta," said Qilaq guiltily, "yet what did Pollooq say in another of the stories, Matta? *Get thee behind me, mother.* Perhaps if she hadn't been so frightened all the time, I'd be..."

"Hush, Qilaq. Never blame your parents," said his sister gravely. "Mother feels a lot, that's all. But it's made me so sad. Our Bergo are no good, and I'm just a weak Bergeera. Useless."

"Useless?" growled a voice, and the twins turned in surprise to see Janqar standing there one again. They had hardly seen the stranger since they'd arrived, except moving among the adults, or talking like a conspirator with some of the boars, at times it seemed even the Serberan.

"Never say anything's useless, Bergeera," said Janqar cheerily, swaying his scared forehead. "You can never lose true freedom, if it's really inside you. And what have you learnt of this place, twins?"

"That I don't believe half of what I see," answered Matta angrily, as the Bergo sat down. "There are dark rumours about what happens on the Leaves. That some are just not coming back."

"Perhaps they escape," said Qilaq hopefully. "Into the wild arctic again."

"Rumours among the younger bears too then?" said Janqar thoughtfully. "Things aren't as they seem at all, Matta. Not even with the glorious games of bluffs are quite real then?"

"Bluffs! You know how they really play it here? But maybe my dear brother should tell you, Janqar. Now Qilaq's grown so very fond of fighting, like a *real* Bergo."

"I don't like it," said Qilaq defensively, "but if you're caught, you're almost scratched to death, Janqar. One cub, Ogguq, far their best fighter, likes to take out eyes, always joking about Pollooq too."

Janqar growled and nodded sadly. "Then we'd better all grow up, and not play games, eh cubs? But don't you want to hear the rest of the story? I mean what really happened out there."

"Really happened?" said Qilaq.

"The real story of the Fellagorn?" said Matta. "Oh yes, Janqar. But we'd better watch it. If Sqalloog spots you, he'll be bound to report you. He's always spying on us now, just like Eagaq."

"Then I'll cuff the little runt," whispered Janqar and the twins grinned. Janqar growled but went on with the strange tale that he had begun when they had first arrived in the Bay of the Blessed.

"Where was I, now? Ah, yes. Onward the Warrior Storytellers fought their way, after seeing the voyaging warrior in Sorgan's paw print, through the arctic cold, and it was near midnight on the twelfth night, when Sorgan sensed something in the gusting blizzard, and stopped dead.

"'Illooq, what do you see ahead, my best disciple?' he whispered. 'Only a wall of snow,' answered Illooq Longsleeves in confusion. 'Whiteness everywhere.' The Great Master growled irritably. 'No, Illooq, no, you're a sacred Storyteller, aren't you? Look even harder then and truly see. Use the magic sight of the Fellagorn and tell me. Use the united eye.'

"With that, the very wind seemed to die around the warrior bears, and a hole opened magically in the storm. The Fellagorn saw the moon and the Beqorn blazing a deep blue in the enormous skies again. Right ahead of the Fellagorn was a great shape though, like a small hill, illuminated by the heavenly dance above, on the flat sea. It had a giant mouth of black – caves of ice. 'The Seeing Caves. They have formed again,' cried Illooq Longsleeves in the biting winds. 'Once in a thousand Long Nights. Our quest's done then. The heavens await us now and holy Atar herself.'

"'Our quest within as well just begins then,' said Sorgan though, and rather fearfully. 'So come brother bears, and let the Tellers enter Atar's holy den beside me. We go to ask the gods why polar bears die, and the ice fails, with no ice ark to save us now.'"

So Janqar told of how the Fellagorn Tellers, leaders of the Telling Moots, had stepped forward. "Fifteen Warrior Storytellers, with Illooq and his brothers, were filled with awe, and something close to holy dread, as they stepped through that black mouth. Great walls of hard blue-reared around them, twisting into strange and beautiful shapes,

frosted with freezing shawls of glistening beauty. The ground crunched underfoot, and their skins began to tighten with the furious cold. It was cold even for a Bellarg, up there out on the Ever Frozen Sea, in the coldest winter the Fellagorn had ever known. The passage-ways were filled with a mournful wailing too as they went, like Beqorn spirits crying out to them. They felt they might be turned ice, by Atar's awesome power and wondered if the moon goddess herself was really waiting within."

Qilaq shook his head, for he reasoned that since the Fellagorn were dead, there was little point in even hearing about what they had seen now, if they had ever seen anything real at all. He was looking at Janqar suspiciously too, for he had often seen him talking to Serberan himself and even sharing food, that some of the Barg claimed he had stolen from the hunts, during the Barg work details. Matta though felt as if she were dreaming suddenly, utterly mesmerised by Janqar's powerful voice.

"The place was like a giant snow den, where the deepest mysteries are birthed. Further in the searching bears went, and deep beneath the ice was the sea. Suddenly the passage ended though, and the Tellers growled in fear and wonder. A huge chamber had opened before them now, ribbed with huge ice stalactites and clusters of heavy snow crystals of a myriad shapes and colours. It was like the cave Pollooq himself had been bound in in Legend."

"Except for one wall ahead," said Janqar, "flat and plain, where the wind had smoothed it out, so that there the polar bears saw their own searching faces, looking back at themselves in the ice. Only half blind Sorgan, who had spent so long looking both within and without, could also see what they could not though, shimmering shapes at the side of each, reflected in the Ice Mirror. Bergeera stood there now, beside the male Tellers, looking like their twins.

Matta looked sharply at Qilaq.

"Bergeera, there, with the Fellagorn," she said, "who were they though? Is it magic?"

"'The Seeing Mirror,' Sorgan growled to them softly,' said Janqar in answer, as the shapes vanished. 'Here, just as mighty Pollooq spoke

with the creatures of the dark, we may speak with the heavens instead, and summon down the spirits of Gog, the sun, and Atar, the moon, calling them from within and without. So let the magic mirror show, Fellagorn. Close your eyes, but then behold, Bergo, a very river of fable.'

"The Storytellers closed their eyes, summoning their storytelling power, but groaned in absolute astonishment as they opened them again. The mirror had misted and a circle had appeared, cut with a waving line – the Manda. But this time one half was white, one black as night, with a dash of black and white in each opposing side. Something even more astonishing happened though. It was as if spirits were entering the Seeing Cave now. Eerie lights of red and blue, green and yellow, came creeping steadily across the ground like a sacred mist, toward the great Ice Mirror, and the lights themselves seemed to be whispering, like heavenly voices.

"The Beqorn," said Matta. "The lights in the skies. Then they are spirits from heaven."

"Or hell," snorted Qilaq, "but I don't believe it, Matta. There must have been a hole in the roof and they were just shining down."

Janqar went on though.

"'The god and the goddess have come among us,' growled Sorgan gravely, 'The gods are here indeed, Fellagorn and bring the souls of the dead to tell us all the truth.' The Tellers started to groan in front of the mysterious mirror now as the lights coalesced in the middle, and swirled in a circle. The wall seemed to shimmer too, as if it contained a power pulsing deep inside it.

"'Ice mirror on the wall,' said Sorgan humbly. 'Tell us then. My own death is near, but the Fellagorn shall not go forth this time to seek a Great Master's soul. Instead I'll choose a successor, but with your wisdom, for though we've jousted already, none yet has triumphed. Which disciple is true and worthy then?' Beloq, Teleq and Illooq looked at each other, but, nothing happened in the mirror."

"'Strange,' muttered Sorgan with concern, 'Perhaps none shall succeed. Then tell us first of the past, and what has harmed the ice. Is it Glawnaq's sacrilege that melts our world?'

"Still nothing happened and Sorgan spoke again. 'The present then,' he said softly and with that the very ice before them just melted away, and now they stepped back as they saw Gog himself, huge and burning yellow in the very centre of the mirror, like a terrible eye, and the vision seemed to drip and melt the mirror itself.

"'Heat,' cried Sorgan, 'Bellarg feel it, spirits. But do the gods punish the white bears with the ancient curse? What shall the future bring then, or how shall Fellagorn speak to heal the wound?'

"The image seemed to flicker, and they could see Serberan fighting now, like the battle that Rornaq had described to Toleg and the others. But the vision before them changed again, and there was the Ever Frozen Sea, flat and still as a sigh, yet black shapes were suddenly looming out of it, slicing open huge water leads in the ocean.

"'Man,' cried Illooq Longsleeves, 'Man's metal bellies, Sorgan, that carry the Gurgai through the oceans. But what do they want here? Are they hunting us like seal?' The Fellagorn Tellers were given their answer, for that symbol appeared again, the Manda, but suddenly the black side of the circle was spreading across the surface, then bubbling out of the Mirror itself, like an ugly spring. Black blood gushed from the wall, filling the polar bear's nostrils with a terrible scent, as it swamped the chamber floor in the magical Seeing Caves."

"The black blood," cried Matta. "That's what the Fellagorn saw, Qilaq. But why? It poisoned mother and that puffin in the Bay all right, and we saw Man when Uteq touched it."

"And it doesn't make sense," snorted Qilaq. "They bring it to our world, Matta. Though the bay was Kassima and Mad Mooq spoke of blood. The Saviour drowning in the blood of the world."

"Sorgan saw that," said Janqar, "and that it will happen soon too, in the present, if nothing stops the Gurgai. Some Great Masters called it the human's Garn."

Again though Janqar went on with the tale.

"The Tellers were murmuring fearfully now, for the black blood, which was only a vision, seemed to evaporate, but now they felt the ground and the walls of the Seeing Cave shudder, and a great crack

went straight across the fading visions before them. The sacred mirror split, from side to side. As the Fellagorn looked they saw themselves again in the reflection, but not with Bergeera at their sides, as Sorgan had seen them, but as if they themselves had been split in two.

"'The curse goes deep indeed,' cried Sorgan, 'The wound. The Ever Frozen Sea's shifting too, bears. Do the heavens themselves fail now? Quickly, back into the open air, Bergo. Run, run for your lives.' The Tellers swung round, especially Teleq and Beloq, and hurried back down the passage, but old Sorgan stayed just where he was, staring at himself in the cracked ice and shaking his head bitterly.

"'Great Master,' cried Illooq Longsleeves, who alone had waited behind, 'you must hurry.' Huge shards and splinters of sharp ice began to fall, but Sorgan shook his head still. 'No, my true disciple. My time has come at last. If the Gurgai come to plunder the black blood, wherever it lies, perhaps I should make a stand here then, and simply growl and snarl at them.'

"Illooq Longsleeves looked at his master in horror, because Sorgan seemed to have given up hope too.

"'But you must come, Sorgan. You can't leave us leaderless, and if your soul does not to return to the world, you must anoint a winner of the Story Joust, at least. Fight, Sorgan, please. Or we'll all be lost.'

"'Fight, Illooq?' whispered Sorgan wearily. 'And what warrior have I been? I feel I'm dead already, my Garn grows so faint, and even my spirit retreats. Perhaps I've just been arrogant then to tell stories so long. To behave like some God, and make up beings, acting with the power of life or death. For you know the tale of Fostog?'

"'Fostog, Great Master?' growled Illooq nervously, as the walls shook again.

"'A Great Master too, a brilliant mind, who saw the pettiness of the world, its cruelty, stupidity and injustice, and so set himself apart, and studied all. He looked into an Ice Mirror, long and deep, but a cunning voice came to him and tricked him, promising him the greatest love in all the world, and the wealth of the seas, the knowledge of time, and power over all. Fostog looked deep in the glass and saw those wonderful things there, and thought himself a king and

god. Until, one sun, he woke and saw only his own reflection in the mirror and that the images had been phantasms and now he was as old as dust. My power fails too, Illooq, like his, as all must fail in the end. I feel cut in half. Empty as a snow den.'

"Illooq shivered, but it set some new determination in him and he growled passionately. 'No, Sorgan, is it not hard to go inside oneself sometimes, for that is the danger and the true curse of a Fellagorn. Yet that power you speak of is worse when real, in the paws of a Glawnaq. We follow the Path, yes, but must fight again for freedom, fight in the real world too, and if you die here, alone, how will we ever lay you out beneath the Beqorn, for your spirit to escape in space and time?'

"A sudden fear shone in the Great Master's failing, half blind eyes.'

"'Escape to the heavenly dance? But am I mad? My promise, Illooq. I must go to help the One, and so I can't be sealed beneath the endless seas. Lead me then, Illooq, quickly, the pupil becomes the Master.'"

"Thank Atar," gasped Matta. "Illooq Longsleeves sounds so wonderful and true. I wish I'd met him, Janqar. He should have been made the..."

Matta dropped her eyes though, for she already knew the end of this story. They had all died up there in the snows on the Field of the Fellagorn.

"Illooq led the Great Master safely out," said Janqar though, "knocking away the falling ice with his head, although a piece struck Illooq hard, and almost knocked him down. He shook away the blood fiercely though, and soon they were out again, and saw just what had shifted the magical caves. Not far away, a crack had appeared, and a wide lead of moving water was opening in the arctic ocean itself.

"'Even here, in the High Arctic?' groaned Illooq as he saw it. 'Then the Ever Frozen Sea shall lose its name indeed.' 'All is change, Illooq,' growled Sorgan sadly, 'so be careful of the world, disciple. Find your place, and learn who and what to trust, and how to grow. Yet perhaps the wound's too deep. The curse.'

"Illooq noticed the pole star now, piercingly bright in the heavens, and to echo Sorgan's words, the break fissured across the ice,

straight toward the caves, and the ice itself concertinaed. The magical Seeing Caves were swallowed by the water, blue-black and hungry, as the ground slammed shut again. The Seeing Caves had vanished forever.'

"'Our world,' moaned Sorgan. 'The white bear's world vanishes like a dream. The fabled realms of the Ice Lords, the lands bathed in colours of the king. We're all forsaken then, Illooq, if the Ice Whisperer does not come.'

Janqar had stopped his wild story, his tale of the past, and Matta and Qilaq stared at him hard, especially Matta.

"Ice Whisperer, Janqar?" she said, blinking at him. "Whatever did the Great Master mean?"

"I don't know, Matta. That's all Illooq told me. It was the last thing he said, before he died too on the ice, next to the Great Master: '*If the Ice Whisperer does not come.*'"

"Well, it doesn't matter," grunted Qilaq. "They all died, so they couldn't really see anything true. That's why we're here, and our future's so dark. The Great Story's led us all into the dark. I want to fight everyone, unlike our stupid Scouts, and tear out the Serberan's filthy, lying black tongues..."

"Qilaq," snapped Janqar, "hold your peace, young bear, and your own tongue too."

"Peace, Janqar? I'm a Bergo, and I'll do and say what I—"

"The greatest strength of a true Bergo," Janqar interrupted sharply, "is to contain their words and feelings, Qilaq. Like love. To hold their power and peace. For anger is just Garn that must be used. Be careful what you let out into the world in words then, bear, for it may come true, and how will you ever take them back? Fellagorn taught words become things, so remember the Eight Paw Prints, and Goom's love too."

Qilaq looked crestfallen, yet he shot a resentful look at the mysterious stranger. Janqar stole and he spoke with the Serberan as well. How was that following any stupid Paw Prints?

"But no Great Master can ever come to help the One now," he said miserably, "so the prophecy must surely fail. The Storytellers can

never come again, with no one to anoint them, or any other bear either."

Matta looked hard at her brother and felt utterly alone, as Janqar growled.

"Unless something happens, Qilaq. For like lives, or the sea ice, stories themselves can change."

Not so far away, and very much in the real world, a huge Bellarg stood in his own ice cave, staring at his reflection, as Glawnaq perused his own bitterly scarred face with his hungry, searching eye.

"You want us to bring in more Barg, Glawnaq?" said a voice behind him. "Don't we have enough workers now to serve us? Their bay gets very crowded."

Glawnaq turned to face Eagaq, and the Cub Clawer's own eye twitched from Marg's wound.

"Of course I want more Barg. Besides, we need Bergeera, and so greater choice for the Serberana – and the chance to breed more little workers too. Their old grow weak and feeble."

Eagaq lifted his paw and his vicious Seeking Claw came out. "But resources are hard pressed, Glawnaq. We feed them instructive words for their minds, and scraps for their bellies, yet it puts a pressure on all, and is hard to stop them stealing. The bosses have to punish them more and more."

Glawnaq's eye narrowed immediately, like a snake's. "Then work more of the older ones to death, little Eagaq, and free up some more space. My loyal mercenaries need pay. And true loyalty and trust is only ever bought, in the real world. Like the Gurgai, with their black blood and their strange bits of metal. It buys everything. And someone always pays, Eagaq, that's just life. There's always something to owe."

Eagaq suddenly wondered how Glawnaq knew so much of the humans, but Glawnaq had grown irritated with his Cub Clawer's presence, and was thinking of Anarga Calmpaw nearby. He was deeply concerned that she would not eat and now he wanted to see her again. Glawnaq had visited Anarga many times, but she hardly spoke these days, always staring fixedly out to sea.

"But with growing numbers," said Eagaq, "the details function less efficiently."

"Then have the Serberan select more leaves, fool," snapped Glawnaq. "And I've other plans for finding resources, Eagaq. There are many logical solutions for the Bellarg's problems. You must have faith in my mind, and in pure logic and reason, and think like the best Pheline too. I'm a father to you all now, to show the way."

Eagaq dipped his head respectfully and a cloud covered the moon, as Glawnaq turned even darker in the ice wall. Eagaq suddenly remembered a story his father had told, of an ancient philosopher bear, who spoke of Bellarg who lived in a cave, speaking of Lera in the world, yet confusing them with their own shadows he saw on the wall.

"And I watch for you, father," said Eagaq, "though even I cannot have eyes everywhere."

"Eyes?" grunted Glawnaq, with a broad smile. "Do you really think I rose so high by trusting to only one, Eagaq, like you? Knowledge is power, fool, so I've other, secret eyes, and at work among them even now. And a keen, skilled and loyal ally too."

Eagaq stepped backwards and looked truly mortified.

"Another ally, Father? But why?"

"To root out any dissent and to learn of Uteq Blackpaw. Yet there's an irritating problem with the wild white bears out there still. Independence, Eagaq. I think the free bears are beginning to grow less afraid of all those horrid Snow Raiders, and they hear rumours that the Barg might not be so blessed after all." Glawnaq swung his head and smiled again. "So I've decided to use another force, to aid our plans. Even as my Glawneye hunt that evil cub. Garq has his scent, but they have my plan to persuade others to help too."

"Others, Glawnaq?" said Eagaq and Glawnaq turned his back on the cave mouth.

"My own gods, if you like, Eagaq. Gurgai. The humans themselves. Man. So Garq will make them a little sacrifice."

13

MITHRIL

"There are more things in heaven and earth, Horatio, than are dreamt of in your philosophy."
—William Shakespeare, Hamlet

F ar to the south, Uteq and Sepharga stood in front of the huge musk oxen still, amazed they had stumbled on the Lera they were seeking quite by chance, although he was not a bear at all.

"It's Mitherakk," corrected the Musk Ox irritably, "and of course I'm him. I'm famous here."

Uteq caught the scent of the creature now, strong and musky in his nostrils, and it made him hungry, then oddly ashamed. He had been searching so long, Uteq could hardly eat the creature.

"Narnooq's voice told us about you," he whispered. "So we thought you were a Bellarg."

The huge ox lowed approvingly and suddenly looked rather fond.

"Narnooq of the North? The kindest Bellarg ever, who dug me out of a snow drift as a calf, on his way to find the Fellagorn. I owe him my life, and we all owe one of those."

The other oxen stirred, and a murmur of assent went up around the little herd, especially from the female beside Mitherakk, the ox's oldest and favourite mate called Mooqar.

"Narnooq did that?" said Uteq, realizing that the story about Narnooq going North had been true then. "But it's against the Lore, Mitherakk. It just doesn't happen in real life."

"And who are you to presume to know all the laws of nature?" snorted Mitherakk. "or what really happens in life? There are many mysterious things in the Universe, bear. The Gurgai know that now. The ones fully awake, at least, or waking up. It's their greatest power, and freedom too. *Scientia*."

The strange word rang in Uteq's mind again and he wondered what he meant by being fully awake. What lores really guided the Gurgai, for they certainly had prisons?

"For months, old Narnooq virtually reared me as his own. Not a bear at all but an ox. Bovidae, actually. Like, um, sheep, goats, er, well, certainly ruminants. A lot of that. Ruminating. Cloven hoofed.

But you said *his* voice, bear? What do you mean?"

"Narnooq's dead, Mitherakk," growled Sepharga sadly, feeling an awful emptiness inside. "But his spirit light rushed out of his mouth, and straight for Uteq. Uteq saw them first, then we all did."

Mitherakk looked at Uteq more carefully now, noticing his black paw for the first time.

"Then spirits are appearing, just like the story says. Perhaps the North is calling us all."

"Why should Narnooq tell us to find you though," asked Uteq, "when you were just a calf when he knew you?"

"Just? Don't be a dumb caribou. What did wise Goom always say? '*Suffer the little cubs to come to me.*' Can one enter heaven unless like a cub? Besides, Narnooq of the North sensed I had The Sight."

Uteq stepped forward, feeling very far indeed from his own cubhood now.

"The Sight?" he said. "A way of seeing among the southern Varg, that gave all the Lera a vision that Man's really Lera too, just like us. I think Mad Mooq had it. He talked of it too, and of something harming it."

"Correct, bear. But not just the Varg. Some say it's the same power that allowed the Fellagorn to see visions from the very heavens on the Ever Frozen Sea. To speak, and tell the Great Story at all. The Sight."

The bears looked sharply at each other.

"A power written into the fabric of being, common in Putnar,

predators, especially Man, who's way of seeing is changing. Some believe that Gurgai can read thoughts and see distant realities too. Even affect things with their minds. Yet when The Sight appears in Peenar, prey, it can be strong also. Like me."

The huge musk ox lowed, letting some snow fall off his massive head. As it plopped to the ground and exploded with a thump, Sepharga noticed one of the calves looking back at her in the most peculiar way, her left eye opened wide, her little head tilted sideways. She was adorable, about a quarter of the size of any adult, with big ears and a glistening little nose, a snow bonnet sitting on her small head.

"Hello," said Sepharga softly, "is anything wrong, dear? Why are you looking at me like…"

Sepharga stopped, as she realised the calf couldn't open her other eye at all, because she only had one.

"Oh my poor little one," she growled kindly, thinking of Glawnaq himself, "did the bad wolves steal…"

"Hush," said Mooqar, next to Mitherakk, "don't talk about Mithril like that, or stealing either. And little one, come and stand under your mother now, for warmth."

Sepharga noticed the calf had started to shiver, and Uteq that some of the other calves in the great circle had begun to nestle under the adults' great bellies and hanging fur coats.

"She's only in the middle because of those stupid Varg," said Mooqar. "Come here, Mithril."

"I'll look after her, Mooqar," lowed another she-ox, looking jealously back across the circle.

"No, let me," said a large ox nearby and Mithril swung her head at the sounds, and for a moment didn't know which way to go. Just for a second, she looked as if she was about to fall over.

"Mama?" she said, swinging back to Mooqar and Mitherakk.

"Oh she's so lovely," said Sepharga tenderly. "Dear little thing."

"And any one of us will give our lives to protect her," said Mitherakk, as Mithril made up her mind and trotted towards her mother, ducking under Mooqar's coat, her head poking up from behind her

haunches. Mithril was sniffing, tilting her head, as though trying to see them with her ears rather than eyes.

"Poor Mithril," said Uteq kindly. "I'm sorry."

"Stop that," snapped Mooqar. "Mithril's the most loved calf in any herd across the great arctic and has powers to heal too. She certainly doesn't need any feeble pity from a blundering Bellarg."

The adult oxen nodded sternly, but some of the other calves looked out jealously from under their parents' flanks at Mithril, who seemed to be smiling and a light was twinkling in her little eye.

"But how did you..." Sepharga began softly.

"I was born without one," piped Mithril. "I didn't mean it."

"No, my darling," said Mooqar, "it's in there somewhere. It just didn't grow as big. Maybe you'll decide to grow it one sun." Mithril tilted her head, as if asking her closed eyelid a question.

"Decide?" said Uteq, in astonishment. "But we don't decide anything really. We're just born."

"Don't you know anything?" said Mitherakk disapprovingly. "Brains make eyes, and decide, so why shouldn't she decide to grow another? I mean she's still young, and we've all free will, don't we?"

Uteq thought he had decided nothing about his own story in this world, but Mithril was still scrutinising them closely.

"They say Morthorg over there decided to grow enormous horns, when he was still inside his own mother," said Mitherakk and now Mithril seemed rather embarrassed, but Uteq was shaking his head.

"But her eye, Mitherakk. Why didn't Mithril's—"

"Glawnaq," said a voice gravely, and another male raised its head. "Glawnaq's anger and hate stole away Mithril's eye, I believe, just like the Pheline took Pollooq's. Who'd want to see the world he makes?"

"But my father," gasped Uteq suddenly, "he took Glawnaq's right eye in their duel."

Uteq blinked. The coincidence was strange, unnerving, not just with Mithril, but with Glawnaq and Pollooq's blinding too in the Legend. It was as though his very story had some horrible power deep inside it, or the Fellagorn Word Power had turned bad. He wondered what it all meant, but then he remembered talking to Tuq in

Churchill about being seen by the humans and talking their eyes. Uteq suddenly felt utterly terrible. Had his own words and his own anger somehow affected the little ox and harmed her? He wondered when Mithril had been born and if it had been at the same time.

"Don't be soft, Moolop," said a she-ox. "Mithril was born with warrior fire in her, so touched by the musk ox god of war. In legends he's only got one eye too. Modin the magnificent."

"Well it's war that Glawnaq's bringing to the arctic, all right," said a third Ox. "And death too."

"Perhaps it was that suffering Pollooq of yours," grunted a fourth ox, "and his terrible fury from long ago. The curse itself. His eyes were stolen, weren't they? Blind inside too? Perhaps it affects everything still."

"In the snow den of the blind, the one-eyed ox will rule," said Mitherakk gravely, "but it suggests all's connected in the world, bears, yes, so nothing can escape their own responsibility, for that's the ice lore too. Perhaps all that's happened in the arctic frightened Mithril and stopped her growing one."

Again, Uteq remembered Marg speaking at the Council of connections.

"I'm not frightened," Mithril said loudly though, pushing out her head even more to listen.

"Of course you're not, Mithril," said Mooqar, "and you've got better ears than any, to tell us of stupid wolves. And can taste things few musk oxen can, and feel more too, because you've such a big heart. And you're special, Mithril," added her mother firmly, as Uteq's heart suddenly ached with sadness.

"But I don't want to be special, mother, I just want to be—"

"Then listen to the stories, darling," said Mitherakk, "And I'll make one for you, myself, a story, to help you heal and grow. But, where was I now, bears?"

"The Sight," answered Uteq, remembering all the terrible things he has seen in the humans' pictures and the strange visions he had had himself. Not only visions, but a sudden sense of the twins Matta and Qilaq.

"Ah yes, The Sight. When Narnooq was digging me out, I had a vision of the Fellagorn's Story, as they once saw it in an Ice Mirror. Far too introspective, mother always said."

"But what did you see? Can you tell me if I'm—"

"I can't remember," lowed Mitherakk flatly, chewing his great lips. "The power fades if not used. Which is good, since it's dangerous. The Sight hurts. Especially if you see in the wrong way."

Uteq and Sepharga both wondered how anything could see in the wrong way.

"And my kind don't have very good memories. All asleep, most of the time, unless hunting or running. Besides, we Lera much prefer dreams, although we've all started to have very bad ones now. Dark dreams."

They thought of Tuq and the calves looked miserable and were nodding under their parents, all except Mithril who had a huge grin on her face. She loved dreaming and was rather good at it too.

"Dreams," said Sepharga, "where do they come from, Mitherakk? I've always wondered."

Mitherakk looked at her sharply.

"Who knows, she-bear? The Heavens, or the Underworld? Where does The Sight really come from? Some say animals though, while dreaming of their own lives, can share a dream, or a nightmare."

Uteq had a bizarre thought. He wondered if thinking and dreams themselves were Garn, that somehow travelled into the head, whether awake, or asleep. Apart from the basic feelings of anger, hunger, fear, love and hate though, where does thought itself come from? Perception itself come from?

"Though haven't you ever felt you've dreamt everything that's happening to you before?" added Mitherakk, yawning again, and clearly wanting to close his eyes and have a dream right now.

"Happened before?" said Sepharga, thinking of her visions with Uteq on the raft and in town and thinking perhaps that she had indeed felt it.

"Karmara the Fellagorn called it," said Mitherakk's mate, "like

fate, or the past. Some have bad Karmara, some good. I mean, how is it some calves seem to know things naturally that others just don't?"

"Though some say one can become so aware," said Mitherakk, looking at Uteq hard, "that they can change their Karmara even as they live. Remake their destiny. Perhaps affect the past too. Especially the One. Unless everything is already marked out, in the great snow den of life. Everything that is to come, I mean."

"But if you've forgotten, Mitherakk, we'll never find out about the legend," said Uteq desperately.

"What's that to do with me, bear?" said Mitherakk though. "Everything fights for itself alone. To survive."

The wind moaned and threw Uteq's harsh words back in his own face, as Mitherakk quoted Uteq himself.

"Very well though, bear. We ox do have hidden depths, and besides, you helped your fellow creatures, quite unasked. Goom did that a lot too. Very good for Karmara, I think. I may have forgotten my vision, but you clearly have The Sight too. Once a very great power, Bellarg. To see visions in water, and through the eyes of birds, to see into minds, and even control thoughts and wills."

"I do?" gasped Uteq, thinking of those images flying through the ice world in the human's pictures. It had been like looking through the eyes of a soaring bird, looking down on everything.

"Or The Sound," said Mitherakk. "Perhaps your mother or father had it too, for each cub is usually linked more to one or the other. The legend always said that in the One though, The Sight would become more powerful than ever before, so they would hear the beating of the very polar heart, and know the sound that starts everything."

Uteq felt a strange ache in his heart and all his senses seemed more alive suddenly. *The sound that starts everything.*

"That they would go on a journey beyond all Lera too, to see the greatest sight of all, as only Man can see, and feel the most wonderful feeling on earth. That they would see and know, too, in the end, what life itself fears above all else. But they must keep their senses open and clear."

"What life fears above all else?" said Sepharga. "Uteq knows the animals' fears. He can see them. Or feel them."

The herd looked back warily now, and some looked almost angry and suddenly rather aggressive.

"A very dangerous gift then," said Mitherakk. "For remember, we're all filled with shadows and throw them on others too, even as we look, so can judge and hate wrongly, because of what we really fear in ourselves. And did not the brave Fellagorn fight for the truth, for light and life, before they froze to death, up there on the Field of the Fellagorn? But you want to know if you are indeed the Ice Whisperer, Uteq Blackpaw?"

"Ice Whisperer?" said Uteq, blinking at him in the bitter cold.

"A very king, born in the lands of the king, a healer, though a great warrior too. A true Saviour, who could tell a story more powerful than any other, like Pollooq made real again. For stories are living things, bear, like Lera and the Gurgai, and perhaps some with power can change the world."

"Change the world?" said Uteq, remembering Qilaq talking of stepping from the paw trails and breaking free.

"Perhaps, yes, if their words get close enough to the ice face of reality, bear, and touch all."

"Why the Ice Whisperer though?" asked Sepharga, wondering if Uteq was born to be a king, yet realising he could not have been, because Uteq had not been born up in the North at all.

"Because Atar and Gog also made four helpers to aid a true hero's journey, my dear. A Sea Summoner, with mastery over the waves. A Wind Talker, who spoke with the clarity of the arctic air. A Fire Bringer, who purified through flame, and an Earth Eater, who could make enemies simply disappear."

Mitherakk's eyes glittered and Sepharga blinked and suddenly thought of Karn and his pack, although it all sounded impossible.

"The true hero though, the One to save all the world, would be the Ice Whisperer," said Mitherakk. "It might be you, Bergo. Said to be able to speak with the ice itself, and heal it, perhaps."

"Heal the ice?" cried Uteq. "But that's impossible. I just sense things, like walrus, or a poetess fox."

"And feel them, Uteq" growled Sepharga softly. "More than any bear I've ever known."

Uteq remembered the slide to the Council and that voice too: "*Help us Uteq. Help the Ice Spirits.*"

"Perhaps, bear," said Mitherakk with a smile. "But you've changed since a cub, as all is change, so the power may come still. Maybe you can look into the centre then, and see the real light. Like the Pureem."

"Pureem?" said Sepharga, blinking at the huge oxen.

"Ideal animals, my dear, glowing with pure celestial fire, embodied in four beasts, for the four very greatest ideals. Freedom, given shape in the narwhal. Truth, seen in the huge wise eyes of the giant snow owl. Beauty, living ever in the loveliness of the sacred ermine, and the mightiest Pureem of them all, bringing the immortal power of—"

"Hush, dear," said Mooqar, "stop filling their heads with nonsense. They're here for a reason."

"Nonsense, Mooqar? You'll be saying the Greatest Blessing's nonsense next, that holy Atar sends only in the darkest hour. The gift of—"

"Mitherakk," snapped Mooqar, as Uteq wondered what the fourth Pureem was. "We've guests."

"Or the Pirik," said stubborn Mitherakk though, "even older than the Pureem, no ideal at all, but very real, taking the shape of the world's spirit, in its den beyond the Underworld. Though none have ever seen it."

Uteq looked at Sepharga sharply, remembering Narnooq had told them to ask of the Pirik.

"The centre, Mitherakk?" he said though. "The centre of what?"

"The circle knows," Mitherakk shrugged, "Perhaps where Pollooq was forced to journey, when he took the Pheline's challenge and journeyed deep into the darkness of the world and himself."

"The story," gasped Sepharga as she heard it, remembering the

image of pitiful, eyeless Pollooq bound in his cave. "The demi-god accepted the challenge then. A story to heal creation itself?"

"Yes. And to see with the Gurgai's reason, so to know the true journey of Man. Their real truth."

"That unlucky story," growled Uteq. "What's it really about, Mitherakk?"

"Love, bear. And the pain of it, that must not turn to anger or hate. For some say Atar and Gog sent Pollooq on a quest for love and meaning, the truth of all, and even knowing the bear would be betrayed, some say to take the very sins of Lera away. Though others say Pollooq really came with a claw."

"It's like the Blaarq though," snorted Uteq, "Just some stupid scapegoat then, there to put our own guilt on to. If the Gods so loved Pollooq, why would they sacrifice their own son? It's terrible."

"Yes," answered Mitherakk softly, "and perhaps it came from an old lore. Yet perhaps it was told to change stories too, bear, and so bring the power again to turn darkness into light. But don't you let anything ever make you just a Blaarq, bear, or steal your light."

"Change stories?" said Uteq, and he felt as if he were changing inside himself.

"As the Fellagorn fought in their Telling Moots, so their stories fought too and changed. While the Blaarq bleated of old, vengeful paternal gods, Pollooq, even in the paw trails of the past, tried to make a better story, and so free them from the ancient past forever. To make all really see."

"Poor Pollooq couldn't go into the dark place though," growled Sepharga, looking fearfully at Uteq. "He'd lost the power, and Teela's love too. The united eye. So even telling it was killing him."

"Yes, and he was blind now," nodded Mitherakk. "Yet perhaps love could guide him still. But that was a story, my dear, and this is real life. If the true hero fails now, they say even the Pirik may die, and with it the whole universe fails."

Uteq and Sepharga looked at each other in utter astonishment. Seeing all Man was doing to the world had been bad enough, but were they on some quest to save the very universe?

"But what do you think you must do, Bergo?" asked the old musk ox gravely.

"I don't know," answered Uteq bitterly. "The world seemed so pure once, so beautiful. But now it's all so dark. When Father died, he called on me to avenge him, like the sea. I hear it in my dreams sometimes. And a real Bellarg should be fierce and brave and fight in life. Wild and strong."

Uteq was trying to convince himself, but his words sounded false and hollow.

"As Bergo never back down?" said Mitherakk with a smile. "To hate's a terrible thing though, bear. Not the sacred Garn path at all. Beware the Bear Rage then and vengeance too. What else troubles your heart though?"

"Mother," sighed Uteq. "A sickness is in her blood. Shouldn't I try to heal her?"

As he thought of his dead father, his strength and fury, then Anarga Calmpaw, and how as a little cub he had promised to protect her, Uteq felt even more confused and torn. He felt helpless, in fact.

"Healer, heal thyself," said the ox suddenly. "But are you just a mother's Bergo, or a real hero, and a true warrior? This journey is far more important than any one family, Uteq, or any one Bellarg either. It talks of all creation."

Uteq looked taken aback and glanced at Sepharga.

"A hero, I hope," he answered. "I certainly want to know if the Great Story's true, Mitherakk. Nothing we were told seems quite right though."

"Good bear. And I may have lost The Sight, but we can still knock heads together, can't we?"

"Knock heads together?"

Mitherakk swung his head to the others, who looked frightened, and closed their eyes, not wanting to be noticed, as the polar bears wondered what Mitherakk was talking about now.

"You, Musknog," he said. "You'll do. Come here immediately."

A young ox sighed and walked obediently toward his leader and the good father of the herd. Musknog faced Mitherakk, just on the

edge of the circle and simply waited. The old ox gave a violent jerk and head-butted Musknog in the temple – *Knock!* Mithril laughed and Mooqar looked at Sepharga with a sigh. "Males, dear."

This headbutting went on though, before Mitherakk faced the bears again.

"I've remembered now. And thank you, Musknog, you may go."

The poor bruised ox limped off with a head as sore as any angry Bellarg's, lowing bitterly, but now an extraordinary look had come into Mitherakk's huge, wise eyes, and one a little like Mad Mooq's at the Council.

"Yes. I see it all now. To know if they are the One, the Ice Whisperer must go on a terrible journey, into the black, and into the dark. They can only know who they really are if they find the entrance that none ever have found then, the fabled entrance to the Underworld. Some call it the Lair of the Evil One, or Hell itself."

Uteq and Sepharga had frozen in their paw marks. This was utterly terrifying.

"There they must learn of the past, and speak with the dead too. There they must look with the eyes of Man, although that sight alone may strike any Lera stone dead. Perhaps they must really die, to talk with the dead, and so may never return. But although none living have ever found the fabled entrance, they say it lies across the sacred Garn River, that flows by Pollooq's Paw Print, right beneath Teela and the Beqorn. Far to the arctic North, where the Lera's eternal dead sing and wail, spirits crowd the entrance like bats."

The lemming's little voice was talking to the bears again of no return and no way out. Of suicide in fact.

"The hero must be strong and fearless, braver than any other, to make such an impossible journey and to complete their quest, and so they must help blind Pollooq too."

"Help blind Pollooq," said Uteq in astonishment. "How could anyone help a fable, far in the past? A story."

"I don't know, bear, but some believed The Sight could change the past too, and so the present and future. Perhaps by learning blind Pollooq's secret, bear, and his greatest sin too. Healing the wound."

"Pollooq sinned?" whispered Sepharga in surprise. "But it was faithless Teela who..."

"They say even Pollooq sinned, Bergeera, although only the dead know why. The truth of it and the past lies in the other world then, where the dead look back at life and judge their own sins. But on the way don't be beguiled by siren voices that never made it north and which will try to draw you from your path. Though some say the sacred river itself has the power to cleanse sin," added the ox sadly, "and so restore all. If you don't drown in it, bears, that is, for the Garn River has strong currents too, like the ancient past, very dark and deep ones indeed."

Uteq wondered if this Garn River could possibly exist, and looked miserable, feeling he was to blame for all that had happened already, and now what was happening in the world too, to the Lera and to the air and the trees. He suddenly felt as small as a little arctic goat, with ridiculous ears.

"Be careful too then, Uteq," said the ox sharply, noticing his look, "of taking on great burdens too soon. For nature's nature, and to Fellagorn, in the old tongue to sin just meant to miss the mark, or to be without."

"Without what?" growled Uteq helplessly, looking at Sepharga.

Mitherakk smiled but he did not answer.

"Just as the word holy in the language of the Fellagorn, like holy Goom of the purple flowers, is from a word for light," said Mitherakk instead. "For Helios, the ancient name for Gog, the sun. So know goodness, bear, but don't ever forget that all things contain the same darkness too, perhaps. Though beware of becoming a slave to the Evil One. The Ice Lord of the Flies."

Uteq growled angrily, suddenly thinking of Tuq's collar and Innoo's too and of slaves.

"But if Gog and Atar don't really exist," he said, "then the Pheline were right and there isn't any hell, Mitherakk, or any heaven either? Let alone any sacred Garn River. That's really why none ever found this entrance?"

"Perhaps not," said Mitherakk thoughtfully. "Perhaps there's no

way to the heavens either, said to lie through the fabled Seeing Caves. Yet have you not seen the gods without and within already? Mithril sees them all the time. They announce their coming with light, though some say we only see them when in love, bear, or in extremis. In terrible hurt, or in grave danger. Perhaps when we despair."

Another oxen spoke up now and he looked decidedly cross.

"Ancient gods, Mitherakk?" he grunted. "Silly myths. There's only one God. The Father of all, where our true atonement lies. The giant sky ox, with horns like ancient trees and..."

Half the herd were nodding and Mitherakk looked a little cross, as Uteq thought of Mooq using the strange word – atonement – and remembered his father Toleg and his call for revenge.

"Hush," said another Ox, "we can't speak of God like us, for really God's a Gurgai word for what still exists beyond our understanding, and which always changes too. The best Fellagorn knew that."

"And perhaps there are no spirits," sighed Mitherakk, "no Garn River either. Just lights in the skies. But are you strong enough to journey where none ever have gone, and slay the Monster?"

"Monster?" gulped Uteq, "In the lair of the Evil One, or the Gorg in the Ice Labyrinth that..."

"A Fellagorn myth," snapped Mitherakk. "Wake up, bear. If you've to see like Man, speak like a Pheline too, perhaps, and look around you hard. The dead will tell you though. Tell all."

"Glawnaq's the monster then," said Uteq. "Except, is he? After all I've seen of wild nature, and of Man too. The real world isn't black and white, Mitherakk, though there seems such hurt everywhere."

"Indeed, little bear, so the ox say the poor Pirik is in terrible suffering now. But you've a dark shadow on you, Uteq Blackpaw. Shrug it off, bear, or keep it before you somehow, for we all need our shadows too, like day and night, or teeth and claws. Like dreams. If you gaze too long at the dark though, you may find it gets inside you. Look to the light, bear, and never hide it. It's always darkest before dawn."

Uteq remembered how he had been so scared of Sqalloog and

others at the bluffs, but he thought of those images in the human zoo as well, like strange shadows on a wall, cast by light.

"Man's destroying the world too, Mitherakk," he growled angrily, "so perhaps Man's the monster. Everything grows hotter now and melts the ice world."

"How lovely," said little Mithril though, shivering in the bitter cold.

"Perhaps to the Gurgai then Nature's become the monster," said the ox thoughtfully, "But in the darkest times, remember to give yourself a blessing too. Maybe the White Army will appear to aid you. Ghosts of the past, enslaved by betrayal, that rise again to fight for truth and light once more."

The wind ruffled their coats, as it had on the ice raft, but a white army sounded a fine thing indeed.

"The Underworld though?" said Uteq miserably now, "I...I don't want to die, or sacrifice myself either. That's just the Truth."

The old ox nodded sagely. "And there are many stories of sacrifice, for the Lera say even Man tells of a Gurgai, who died on a tree and taught that the kingdom is really within; though hated and reviled for telling stories. The perfect man. Or perhaps just an impossible ideal, certainly for Lera, a human Pureem, although wild wolves also talk of a white Varg called Larka who saved her brother Fell."

The bears looked back at him and wondered what this Larka had been like.

"If the hero cannot find the entrance none have though, then the journey must fail, and everything fail too. Your path's dangerous and dark, yet we're Lera, and even a cat has nine lives. How many have you, Uteq Blackpaw? We'll see if you can take hold then, even of yourself, like a true king of wild bears, or just stay a cub."

They wondered if they were cubs still, but Uteq felt nothing like a king and he thought of Qilaq and wished his brave friend was here. It was all so strange, with Mithril's presence too, and now Uteq felt a quite impossible burden, as if the sky itself was pressing him down, as Mitherakk seemed to read his mind.

"Perhaps you'll learn nothing can run away from its own truth,

bear," he said softly, "and that one sun you may have to turn boldly, and face it with a growl, before you die. That there's nowhere in life left to hide."

Now Uteq thought of the end of the world and some terrible Last Judgment too.

"But winter's advanced, Mitherakk," he groaned, "and going north will take us through Glawnaq's kingdom."

"Then you must wait through the spring and summer, learning a Bergeera's patience, perhaps the greatest strength, and building your fighting Garn too, the Bergo's power, that pushes out into the world. Then set out like a hero to find your own destiny, Uteq Blackpaw, and the story you really tell."

"Story I really tell?" said Uteq. "I don't understand anything. An Ice Cry that was really a falling cliff. A Twice Born, from a snow den. A bear Saviour, or just a stupid Blaarq. The legend of this and that."

"The Legend of the Unbelieven," whispered Mitherakk with a nod.

"Oh, not another one," sighed Uteq.

"The story says that the Ice Whisperer will learn terrible, extraordinary things, yet not be believed, so may never be able to heal the wound at all. Stand your ground then, but speak only what you think right and true, and follow your dreams too, dark or light, for they are your Garn path too."

"Garn," said Sepharga. "Is it a thing, like the black blood, Mitherakk? Uteq says that's spirit too."

"The greatest Fellagorn taught of two clear yet invisible states of Garn, my dear, one felt more clearly in Bergo, one in Bergeera. So they drew a symbol of it, that Goom had given them all – the Manda. For male and female Garn, without which nothing can be. They exist together in each Lera, and must never be split, as they were when Pollooq began to die. Perhaps that was his own sin against the Ice Lore."

"The Ice Lore," growled Uteq. "Everything we've done seems to have broken it, Mitherakk. Are we being punished?

The ox looked at Uteq very closely.

"Punished? The Fellagorn stepped from the paw trails of cubhood, bear, perhaps from the Lore, to know the truth, as Goom sought the nature of evil in his deep love of the world. I do know this though. If you *are* this hero, you must conquer betrayal and find your Faith again too. So keep the faith."

Mooqar opened an eye now and looked sharply at Sepharga.

"Perhaps it's that one, dear," she lowed, nuzzling Mithril to her again. "His faith."

Sepharga blinked, for Mooqar was talking about faith as if it was just an animal, a real Bergeera. Her.

"Matta," said Uteq suddenly though, and poor Sepharga looked suddenly wounded.

"Yet perhaps betrayal's a word for cubs, not adults," said Mitherakk with a sigh, "for each seeks its way. Is it not better to 'betray', to stand out than to live in the chains of duty, or old lores? Yet if we do break oaths or duties, we should do with a brave, swift paw, not a Bellarg Kiss."

"Bellarg Kiss?" said Sepharga.

"One story says the Pheline didn't know what Pollooq looked like when they sought him, so Teela agreed to point him out, by planting a kiss on his snout. And you will travel with him, as his true friend and ally, Bergeera? They say a hero needs many on his journey. The story's not only about him, perhaps not about him at all."

"Not about me?" said Uteq, yet oddly he thought of the Pirik, as Sepharga thought of Teela's betrayal though, and in that moment, she realised the horrible story had made her almost guilty to be a Bergeera. She was terrified of this hellish entrance too, yet she nodded firmly, and Uteq's heart glowed.

"Good bear," said Mitherakk. "So ask what a Bergeera must do when a Bergo's lost and rages and what her true power is then and her greatest strength too."

"My mother though," growled Uteq, "Her sickness. Shouldn't I..."

Mitherakk snorted, yet there was something in his eyes, as mischievous as Sorgan's. "Perhaps you want to climb back inside her belly," he lowed. "But that can never be, bear, for you can only be

remade through water and the sea. Yet some Storytellers told that by the Garn River bloom black healing berries, under a little blue snow flower, the most fragile flower in all the world. Like the flowers Goom made bloom in his own forehead and in his mind too. Find them if you can. They can heal many things."

Uteq and Sepharga both felt a strange warmth and all the female oxen had opened their eyes.

"And if you do," said Mooqar, glancing at Mithril. "Would you? Well, you know..."

"Yes," said Uteq. "Of course. Yet this terrible entrance, Mitherakk, how will we possibly find it if none ever have?"

"Are you wild Lera, or half-sighted Gurgai," snorted Mitherakk, "cut off from their own nature and instinct by reason? How do the wild snow geese know their way, or beluga to spawn in the ocean? And just use your eyes too, bears, for Teela and the Beqorn will guide you north. The Great Bear also, Pollooq's Claw. There are many guides, if you understand and trust. Trust yourselves."

Uteq and Sepharga thought of the pole star now, and how strange it was that even Pollooq's betrayer of the story should help them on such a terrible quest to find the Underworld.

"But I almost forgot," said Mitherakk, "I must show you the shell."

Mitherakk eyed a female ox now who came forward, and to the bears' astonishment she opened her mouth and out dropped a shell, the size of Uteq's paw. It was beige, curling like the Narwhal's horn and looked as if it was made of stone, though covered in spittle, and Mitherakk gazed at it lovingly.

"I found it in my snow hole," he said. "Some say that where we stand even now was covered in water once, the first flood, long ago, but if you listen, you can hear the sea inside it. As some can see the stars in a speck of sand."

Uteq blinked, for the flood was a story too, but Mitherakk's eyes were closing.

"It holds some great secret I think," he yawned, "although there's only truly one thing Mitherakk wants to know. If a soul exists beyond ourselves, or if we are only what the Pheline saw with their eyes.

Perhaps Pollooq failed then. It may be your fate too, Blackpaw, for a Great Master will have to help the One."

Uteq sighed bitterly next to Sepharga for Sorgan and the Fellagorn were all dead. Their quest was futile. Impossible.

"And remember, bear," said Mitherakk drowsily, "there's both a light and a dark side to The Sight. So be careful how you look, just as you must be careful of the story you tell of yourself, for it may come true. It can do great harm to look deep into the dark, even where there's great love. But go."

"But Mitherakk," growled Uteq, "what Mad Mooq saw too. He spoke of a death in the North."

They both thought of the lemmings again and since the journey seemed quite impossible, thought of suicide too, but the old ox's eye had closed, and he looked as if he had frozen solid. All the others had closed their eyes too, and only little Mithril was looking on at the strange polar bears.

"Mitherakk," said Uteq desperately, "tell us more about the Gurgai too. They're the real enemy, I'm sure of it now. The monster. Theirs is the Lair of the Evil One."

Mitherakk was as motionless as Mooqar.

"Mitherakk, please."

It was no use, for all the oxen had fallen sound asleep again, even Mithril, and Uteq could get nothing more out of old Narnooq's strange friend. So Uteq and Sepharga set off in the freezing cold. The friends would have to wait until the light came, and then the darkness again, then set out for real and if they ever made it to the terrible realms of the arctic dead, or found this entrance to this Underworld, that none ever had, ask them the truth of Pollooq's Sin, and see with the eyes of Man.

PART III

THE DARK

14

ATHELA

"In the midway of my life's journey,
I came to a dark wood."
—Dante, The Divine Comedy

More time had passed than Mitherakk had spoken of, for the arctic spring had come and gone, then another summer and a Long Night, and a second spring too. As the Long Day dawned again, bathing the world in a rich gold, glowing across the white, in the snows around the Sound of the Serberan, the sun shone on a series of carefully made snow mounds sculpted by the Barg: birthing dens for Serberana.

To bear fathers there should have been a great joy associated with the light, carried on the breath of the east wind, and those glistening mounds of white, but even here there was worry and fear. It was worse for those Barg Bergeera who had been allowed to den to create new Tappers for the regimented hunts. Now, as a mother's claw opened a hole in the snow wall in the Bay of the Blessed, and a nervous little cub pushed his face through to look at the sun, Eagaq Breakheart's twitching face was glaring straight down at him.

"Welcome," the Cub Clawer hissed, with a cruel smile, "it's time to confess, cub filth, confess all your fears, and you'll be judged worthy to live, or a weakling and a burden, in the Cub Clawer's Knowing."

The cub looked out and saw other Barg Tappers, already marked with scars on their little cheeks.

"F-f-fear?" it gulped though, just as it's mother had told him to, "I'm not frightened of any..."

"Liar," snarled Eagaq Breakheart, "all cubs fear, it's only a question of finding out your secret heart."

The cub looked helplessly to some of the Barg adults standing nearby, but they seemed distracted, looking strangely at their forearms. Eagaq's Seeking Claw had not only been at work on the cubs then, for now Glawnaq had decided that each Barg worker should be marked too, with a little scratch on their black skin, just below their fur, to tell their number in the bay, and identify them forever. It set them apart too.

The summer came now and was almost over, as the spinning earth took them all inevitably back toward another Long Night. Anarga Calmpaw sat on a scree of exposed tundra, gazing out mournfully to sea above the Sound of the Serberan. She looked older and still very ill, just as Karn had told Uteq and Sepharga, and her coat was ragged and patchy. The arctic sun beat down, although a sun Anarga no longer cared to call Gog.

The Bergeera was surrounded by four Serberan guards and four bored Varg, who lay nearby, powerful and hugely well fed, waving their arrogant tails, licking their paws and watching the Calmpaw closely, as she had been watched since she arrived – a prisoner for nearly two long years.

One swung his head though and growled nervously. Glawnaq was coming toward them with his private bodyguard, but as he approached, a Barg came galloping from the direction of the Bay of the Blessed. His name was Darq, the lead boss of the Bergo there, a thin although once handsome bear, with a weak and tormented face.

"What is it, scum?" growled Glawnaq irritably as Darq reached him, for Glawnaq did not like to see Barg here in the Sound and was keen to talk to the Bergeera who had obsessed him for so long.

"In the southern ice gully, Dark Father," panted Darq, "beyond the bay. A great metal belly broke offshore, coming out of the east and spilled black blood everywhere. They spirited the Gurgai away in

metal wings, but fish and many puffins are dying. An Ice Slayer let me come to tell you myself."

Darq very much wanted to please his lord, although terrified of his power, and his body squirmed before Glawnaq.

"The humans, Darq?" Glawnaq whispered. "They keep coming to our world then. Some of my spies have seen a huge metal craft too, waiting beyond the Haunted Island for something. But no matter."

"But my best Bergo workers though," Darq managed to mutter, "they may wander down to the water, and so poison…"

Glawnaq threw back his head immediately and snarled in Darq's exhausted face. "Good, Barg. Feed any dead to the mercenaries then, to help us clear the ice of your detritus. But warn them if you want, Darq, though I hear you're cruel enough. Now get back to work, slave, unless you want you privileges revoked."

The Barg boss backed away, and thought bitterly of Farsarla suddenly, for Darq had known her as a cub and loved her in his heart, but now, although he tried to impress her as a boss, he knew she did not approve of how hard he sometimes had to be, though with the Separation, he never got near her.

Glawnaq loped on and reached Anarga, as his bear bodyguard hung back behind.

"My dear, you're well?" said Glawnaq. "The sun's golden again today, Anarga. You like that,"

The proud Bergeera was silent, simply gazing out still, sick in both body and soul. Glawnaq had come to her many times the year before, although the work of securing his new kingdom and order had distracted him.

"Will you not come into my cave though, Anarga? You'll be warm when the snows return. And love me too, in time."

The Bergeera turned slowly to face Glawnaq, and though weak, her proud eyes still blazed at him. "Love you, Glawnaq? Have you the Ice Madness? You murdered my beloved Toleg, killer."

Glawnaq's eye flickered and he seemed confused, as his scarred face looked back at her.

"But it was a great battle, Anarga, and all's fair in love and war. Does the Ice Lore judge war murder too, now?"

"What Lore, liar?" she spat. "The lore of power alone. You hunted my cub too. To his death, I know it now."

"You can have others, Anarga. We can. Forget the past, at last and live again."

"I'll never forget what you did, and are trying to do. I'd rather die than have your cubs."

"Which can be arranged," hissed Glawnaq immediately. "But I just serve Mother Nature, Anarga, cruel as she is, and I'm a father to you all now. Father's must lead, and take on the heavy burdens of the world. Or would you make me a scapegoat for the real world, and what all must do to conquer and survive, like some Blaarq?"

"Mother Nature?" snorted Anarga, feeling a fury rising in her heart. "You bring darkness to everything, Glawnaq, nothing more. Fear and death. That's your true secret, not Nature's."

Glawnaq's eye glinted at talk of some secret, but he smiled. "Will is what triumphs though, Anarga, pure will, through courage and reason. If Eagaq breaks their spirits, it's only because they're weak and unworthy."

"Reason without love is the most terrible thing of all," Anarga said simply. "The animals know that. And love cannot be imprisoned. It moves like the wind. That's the Ice Lore. The lore of the heart."

Glawnaq wasn't listening. He was thinking about himself and his great fight in prison, as a breeze moved the clouds and the golden sun seemed hotter on his heavy coat. He was suddenly sweating.

"I've suffered too," he growled, and he seemed to find it hard to say it. "Even I need friends, Anarga Calmpaw. But what you did to me? What ideals had I left after that? The Pureem died indeed in me."

Anarga's eyes were suddenly almost guilty as she thought of how she had known Glawnaq before and loved him.

"Did to you? I said I loved you once, yes," she whispered. "But it cooled in us both and does not love bring many falsehoods too? Then Toleg came. My true mate, and the father of my cub."

"Cooled in you?" snarled Glawnaq bitterly. "Yes, Anarga. But it's

not just love, or you, or Toleg. When I saw my mother and father, my brother and sister die before my very eyes, I was little more than a cub myself, inside the den, looking through the snow passage, when the Gurgai hunters came. Then I saw real life all right, Anarga Hardpaw, and real death too."

Anarga looked at Glawnaq in astonishment, for Glawnaq had never told her this. Perhaps there were always reasons for the way the Lera were then, even the worst of them. Anarga was tempted to pity Glawnaq, as she looked at his scarred face, and remembered him of old, how handsome he had been, but something stopped her. She thought of life and scapegoats. A scapegoat is what is made when others avoid responsibility for what they are involved in too. That was different to judgement before the Ice Lore, and Glawnaq had broken all those lores. She wondered if life would punish him now, but she doubted it, for Glawnaq made the only lore here.

"Yet would it help to change your mind, Anarga," asked Glawnaq softly, "to know that your Uteq has survived."

Anarga gasped. "You're lying," she cried bitterly. "You're just saying it to trick me. I gave up hope for my Uteq long ago. It's better to know the truth than live with strangled hopes and lies."

"It is the truth, Anarga. I swear it," insisted Glawnaq. "Garq and my Glawneye assassins saw him near the Sqeet, and his little friend too, the winter before last. But there've been other sightings too, among the Lera. His black paw stands out like a berg."

"Sepharga?" said Anarga, and her heart ached even more. "Then at least she's at his side."

"Yes, Anarga, though we're hunting them still," added Glawnaq with a cold smile. "But try to think kindlier of me now, and I'll call my dogs off their scent entirely. The cub would still have to remain in exile, of course. Kassima."

Anarga's beautiful face darkened. It was a terrible bargain.

"If I love you, you mean," she whispered, "and bend to your will?"

"And remember me as I was, perhaps. I'd let you see your friends in the bay too," added Glawnaq, his heart beating strangely, "although the Separation forbids it. Innoo and her friend, and some of those

stupid Scouts too and that Antiqa. I'll even bring you all together again. You would like that wouldn't you, my lovely Anarga?"

Anarga didn't answer, but her heart pained her deeply, as she thought of the adults and of Matta and Qilaq too, and her eyes assented. Anarga wanted only to protect her friends now. It was her birthright.

"I ask only that you think about it, and look at me with a more... equal heart," said Glawnaq as reasonably as he could. "Then I'll call off my guards too. But you must promise me to eat and to heal this summer, and you must grow strong and be well again. A prize indeed. My rightful Queen of the Serberana."

Anarga Calmpaw felt as if her very soul was in danger and now she wanted only to be equal in death. "Nuuq," she said though. "Nuuq must be allowed to choose her own mate this season."

Glawnaq's sniffed the air and growled. "Nuuq? Who Eagaq has his eye on, although she dared resist him last Spring? He came to me a moon ago, and I gave him permission to den her this year."

"Then change your mind. Or his. I hear Nuuq likes a Serberan called Soonaq."

Glawnaq seemed vaguely troubled. "Hmmmm. My lieutenant's been a godsend, yet the Cub Clawer gets above himself, and has even asked to command my Glawneye. Eagaq's ambition swells and swells."

Glawnaq let out a low chuckle.

"Very well then, Anarga. Nothing shall stop the Father's bloodline, so Eagaq shall be ordered off Nuuq and it'll teach him his place again. We've our bargain then?"

Anarga sighed, for it was a devil's pact indeed, but she had no doubt that poor Nuuq hated Eagaq, and Glawnaq was offering her Uteq's life too, exile or not. At least in her suffering she could help others.

"We've a bargain then, Glawnaq," she whispered bitterly, knowing her duty now was to live.

· · ·

ON THE EDGE OF THE BAY OF THE BLESSED, RAGGED AND EMACIATED polar bears were trying to clear the scant ice of droppings, or hunt in the scrubby gravel by the sea for scraps, or for mice. There was something desperate in their jumps as they found them, for although polar bears eat lichens and hunt mice in the summer, normally they have built up great residues of fat in the winter hunts. Not so these Barg.

Others were trying to rest and to preserve their meagre Garn, desperate for the cold to return, although it lay weeks away, for at least in regimented hunts they could steal food under the Serberan's noses. Some were thinking longingly of a Leave, and earning a place on one, while some were even dreaming of escape, looking across the ice out to sea. The polar bears knew that the sea too had become a prison. For no great pods of beluga or narwhals visited these shores now, to raise their mythic horns, but only circling orca, and there were many more Barg too, recruited or just captured by the ranks of Serberan, who, lazy as they naturally felt with the summer, marched out almost daily to fight Snow Raiders, they said, or bring in more Barg to serve. It seemed strange there should be a threat of raiders even in the arctic summer.

Matta sat looking out cheerlessly too. She had changed, grown into a three-year-old, and now her face had a sad beauty in it, lean and delicate. But Matta heard a frightened voice nearby.

"Please Matta, I'm so hungry."

She looked down to see that ragged little cub, as thin as a snow weasel, Pooq, shivering furiously. The cub who had spoken of a secret, nearly a year and a half before, although poor Pooq had not grown at all. His life and his body too had been stunted by fear and malnutrition.

"Hello Pooq," Matta whispered kindly.

Pooq had little purpose in the bay, until the ice came again and he could start tapping once more. He had a scar on his cheek, for whining last year that his mother had gone on a Leave but had never come back with the others. His father had fallen on the ice too, of exhaustion, and been fed to the orca. The orphan's eyes were sunken, and he looked even more like a little ghost, although the sun was

shining on him. Matta's heart ached and she thought of Uteq spinning with her in her paws, so long ago now.

"Oh, Pooq. I just don't have anything to give you. I'm sorry, Pooq. I can't fight the Serberan for food. I'm just a Bergeera and weak with hunger too."

The little bear was shivering still, and his right paw started moving up and down on the tundra, uncontrollably again, tapping even now. His eyes looked like Tuq's.

"I'd fight the Serberan, Matta," Pooq whispered though. "I saw them snarling at you. I'll bash them all."

"Thank you brave, Pooq. I'm proud of you. And if you come back later, I'll ask my brother if he can steal you a nice clam or two. Qilaq's a fighter, all right."

Matta said it with great sadness though and Pooq tried to smile, but he seemed to want to speak.

"What is it, dearest Pooq?"

"Me...Matta. I'm," Pooq stopped and looked down, "nothing, Matta...it's a secret."

"Tell me, Pooq. You can trust me. Just be brave now."

Pooq was shivering still, but something set in his ghostly eyes.

"Nobody loves me, Matta," he whispered, "and I'm very frightened."

Matta's heart could have broken, furious that the cruelty of the Serberan, and the want of the Barg, should seemed to have coalesced in the sufferings of this one poor creature. It was like the fabled Pirik. Pooq slunk away to join some other Tappers nearby, who seemed to be congregating together and all had scarred cheeks.

Beyond, Matta suddenly saw Qilaq. The twins had both grown considerably, and their adolescence had almost ended. Both the three-year-olds were docile with the fading summer, and lack of food, although Qilaq had been faring better, for those young bears among the Barg picked as potential Serberan, like Qilaq himself, were fed real seal rations. It had kept them both going the winter before though, for Qilaq always shared it with his sister. He walked up to her slowly and growled.

"You fight again, brother?" she asked coldly. "A game of so-called bluffs?"

"Yes. In three nights' time, Matta. In the Sound of the Serberan."

"Three nights?" gasped Matta, jerking up her head. "But that's a full moon, Qilaq. Then it means..."

"Yes. It's a Moon Duel to the death, Matta, or a new life, perhaps."

The Bergo stared down almost defiantly at his sister now. Matta noticed Qilaq had something in his right paw, a jagged stone, and as he squeezed it she saw a tiny drop of blood, that plashed red into the snow, like a tear drop. Matta shivered, as she remembered Qilaq on the Wander, telling them how he loved the sight of blood, and thought of how the Barg adults were marked now.

"Refuse then, Qilaq. Please. Not even Barg have to accept a Moon..."

"No, Matta," said Qilaq firmly, sitting down beside her. "I'll fight, sister. I must."

"Must? You want to be a Serberan then? An Ice Slayer?"

Qilaq's face set hard. He was excited how his growl had deepened that spring, and how he had found a trick for landing boxing blows, and developed such a strong bear hug too, modelled on Toleg's. Qilaq was just starting to grow fur at his throat and sleeves on his arms and knew he was old enough to mate, though normally no three-year-old would have put on enough body weight to take on larger males.

"Rather than be a Barg," he said coldly, clutching the rock. "Yes. Why shouldn't I live, like great Toleg, and perhaps win a beautiful mate? A Serberana. If I survive the Moon Duel."

"Hush," whispered Matta. A group of huge Varg guards were coming by, their tails lifted high. There were fewer wolves in the bay than last year, for many had been sent north to create borders for Glawnaq's kingdom, but their presence always made Matta angry, and Qilaq very nervous indeed. The wolves were far smaller than him, yet when Qilaq saw them they seemed to loom in his mind and imagination into huge and invincible beings.

"We could escape together, Qilaq," said Matta, when they had passed. "When we were near the adults the other sun I overheard

some talking about it. Rornaq hasn't lost heart. Sarq and Tortog too. Forloq and Brorq. The Spirit of the Scouts lives on somewhere, Qilaq, even here."

"The Scouts?" snorted Qilaq. "They were broken, Matta. Dishonoured. And escape to where?"

"Into the High Arctic, maybe. I don't know. I wonder where Uteq's gone."

"If Uteq's even alive. It's been so long, Matta. Nearly two whole years."

"Of course he's alive," said Matta indignantly. "Have faith. And he'd never be a filthy Serberan. They're monstrous."

Qilaq swung his head and showed his teeth now. They had grown too.

"Listen, sister, we have to live in the real world, like it or not. Not all the Serberan are the same. Soonaq's kind enough, and I think he likes Nuuq very much."

Qilaq frowned and it seemed to stir some deep emotion in him. Matta wondered if he was jealous.

"Keegarq's not bad either. Not like that filthy Darq, and those bought Bergo bosses, who even hate their own. Snivelling cowards who you can't trust for a moment. Who's more monstrous then, Matta?"

Qilaq was filled with a deep anger suddenly and again he wished he had met his father Gorteq, or really been among the circle of the Fellagorn, honouring each other in the North, but they were a myth now too.

"And maybe I can talk to them," he said, "have some kind of influence on them. I'd like to go and fight Snow Raiders, or even follow the Leaves, and make sure more come back safe and sound, not collapse, or disappear, as many seem to. I'll protect the Barg from the filthy wolves here too."

Qilaq gulped, for that seemed the hardest thing for him to do. His very greatest fear.

"Or just turn into one of them, Qilaq," growled Matta. "You heard

what the Great Master said about fighting and becoming your enemy, becoming Evil. Haven't you any ideals left?"

The three-year-old glared at his twin and wondered how different they really were.

"Evil?" he snorted. "Ideals? Yes, I've ideals. To live and fight and win. You talk of evil, but isn't there a new Ice Lore? At least they're fighters, or do you want me to be a victim all my life? Just like..."

"Me, perhaps?" said Matta, as he paused. "You heard what Janqar said about the future, and resisting inside, not stunting our spirits. Have they broken you too then, brother?"

Matta felt something warm in her heart. She had seen little of Janqar after he had finished the strange tale of the Seeing Caves, except at a distance. Though he had seemed to keep an eye on them both, and she liked him very much. Yet Matta had not seen him that spring and summer at all, and now she wondered if the wanderer had escaped. It made her sad but, if so, at least dear Janqar would survive.

"I heard a story, Matta, that's all," said Qilaq. "And how did Janqar know that Illooq Longsleeves was even telling the truth? Fellagorn made up stories, remember, and he was dying, so he could have been delirious. What does it prove or mean anyway though? All that talk about the black blood and Man."

"That there's a greater power in the world," answered Matta. "And that the Great Story—"

"Great Stories," Qilaq snorted. "We're not cubs anymore, we're real animals. The Fellagorn are dead, so no one's even telling it. There's no ice ark, and even if it were true no Great Master to help the One either. It's finished. Done."

"The Ice Whisperer," said Matta though. "Oh, where's poor Uteq now? I promised—"

"Oh, you're so damned stubborn, sister."

Matta swung her head and growled at her brother.

"And you try to be so strong, Qilaq, so cold and grown up. It is not strong not to love, brother. Not to feel and to care, like a Pheline. Do you make your own paw trails in life, or just adapt to it to survive? To this lot."

Something seemed to catch in Qilaq's face and he looked confused.

"I'm just being realistic," he muttered. "Not like some innocent cub, following its parents paw prints blindly. And you talk of Janqar, but there was something not right about him too. There are rumours about him."

"You've seen Janqar then?" said Matta, rather too warmly.

"Not recently, no, but last year he avoided all the really hard work, yet always seemed better fed than most. Janqar was always hanging around the edge of Sound, and he stole too. I saw him myself."

Matta looked shocked but as she stared at her brother she told herself that Qilaq did not want to believe in Janqar either anymore, because he did not want to listen to the old stories.

"He was kind," she insisted, "and if he likes the Serberan, you should like him too, shouldn't you, dear brother?"

"Why do you hate the Serberan, Matta? They love their cubs too, don't they? And their Serberana also."

"Yes," growled Matta coldly, "and that's what I just can't understand. They live their lives, do things all bears do, yet the neighbouring bay can preside over such horrors. Can't they see?"

"It's not a question of liking or hating, it's..." Qilaq guilt paused guiltily though. "It's about having a choice at least, Matta. Choosing my own way and being free."

"Choice? Even if that way is death and murder, Qilaq?"

Qilaq looked startled, for the choice had not presented itself to him like this before.

"At least I'll be free of this prison, and you can hardly admire the Barg for being so weak. But Matta, I'll have to fight hard, and for real. I'm not some lemming, or planning to die. So will you..."

Qilaq wanted to ask his sister for a blessing, but he was too proud and Matta looked harshly at her twin.

"You want me to come, I suppose, and roar you on?" Matta snorted. "And honour a Bergo and a killer."

Matta suddenly realised she sounded like her mother, and with Innoo so lost, she felt strange.

"You can't," grunted Qilaq angrily though, "we fight on shore, Matta, when our Serberan opponents are picked, and only Eagaq and the Ice Slayers watch the bouts, and at close quarters only the Tok spurs us on, to kill."

"The Tok?" said Matta, for in truth the world of the cub fights was one of which she knew little.

"The Toks judge the bouts and keep us at it," said Qilaq. "Set the rules. Besides, an ordinary Barg could never get past the guards into their Sound. Especially not a Barg Bergeera."

"A feeble, frightened Bergeera, you mean?" hissed Matta resentfully. "Loving only peace, like stupid Teela, or wanting to know the end of stories first, in case they're too frightening to even listen to?"

Qilaq looked sharply at Matta and he suddenly thought of the dishonour of the Scouts.

"Perhaps, Matta. Yes. You're always so righteous, after all, talking of being pure, or resisting. Yet you were jealous of Sepharga, because you wanted to be happy with Uteq yourself. In all this time then, I've never asked you what happened during that Still Hunt. The truth of that terrible day that they broke us all."

Matta's eyes were suddenly filled with a strange and guilty light, and she glanced away.

"Well," growled Qilaq angrily, "was it you then that really so hurt your beloved Uteq, by telling them the word of passing? You knew it all right, sister. *Alive.* Uteq saw that too."

"Qilaq!" Matta growled.

Her indignation might have put off a cub, but something set harder in Qilaq instead.

"Stop playing the innocent and answer then, sister. Did you tell them? If you give me your word that you didn't, I'll never mention it again."

Something seemed to be wrestling inside Matta, as it had in Sepharga, facing the flames in Churchill and desperate to escape, but she dropped her eyes and shut her mouth tight.

"You did," hissed Qilaq. "You did. Mad Mooq was right then. He really saw. A jealous sister betrays the One."

Qilaq was beside himself now but with that there was a loud growl, and a Bergeera boss came marching up. It was fat little Gerla, except even Gerla seemed to have lost some of her bulk, in the days of work and instruction.

"You two," she grunted, "always nattering and avoiding real work. I know you fight soon to join the Serberan, Qilaq, but even if you stay in the Barg, it's time you're both parted, right? The Separation."

Gerla looked delighted, for her hard, cruel little eyes were ever hungry and watchful, and she knew how close the twins had been the year before. It had made Gerla strangely jealous. Unnaturally.

"Parted?" groaned Matta though, her heart beating and feeling an awful pain inside her.

"Right. Then given your number markings and counted with Pheline precision. You're both old enough to leave the younger bears, for adult work details. So we're separating you. It's time you twins grew up."

Matta suddenly felt utterly lost, but Qilaq looked bitterly at his sister.

"Good Gerla," he snorted, "we've already grown apart, and we've nothing in common at all anymore."

Qilaq turned, but he felt something tugging at him too and he swung back furiously.

"Don't you get it yet, sister? Can't you see? There are no happy endings for the Barg."

Her brother turned away and as Matta watched Qilaq go, she felt a terrible guilt, and wondered if her brother's story would have a happy end, in just three suns' time. Matta had not even wished her brother luck, and she thought of little Pooq and his courage in telling her his sad secret. She was tired and frightened too, and though she wanted to be there for Qilaq somehow, how could Matta ever get past the guards into the Serberan's brutal Sound?

"Oh, foolish Bergeera," whispered Matta miserably, "you weak and feeble bear."

Gerla shook her head, glaring hard but she turned too and marched away. As Qilaq went, her twin was furious with Matta,

feeling hurt that she had not cared more. But Qilaq was really appalled that Matta had not denied that she had revealed the passing word, for whatever reason, and confused about the Serberan too, proud of the prowess he had developed in fights last year, sharpening his bear claws on stones and rocks, just like the Ice Slayers.

Yet at Full Moon in three days' time Qilaq would have to face the young Serberan for real. Their cubs were far stronger than the Barg, even him, often allowed into the bay to goad working adults, while most Slayers saw the fights as nothing more than easy training for their children. There were real killers among them too, like Keegarq's cub, Starg, or that vicious bully at the bluffs, Ogguq. Qilaq thought of Sqalloog too, for he was fighting for his place as well, abandoning the role as a cub boss he had so gloried in last year.

As Qilaq worried about what would happen, he spotted Seegloo sitting by a rock, looking as if he was spying on someone. Seegloo seemed just as dopey as he had in the Sound and Qilaq followed his line of sight to see Nuuq walking with a Serberan – Soonaq – through the scrubby tundra. It was unusual enough, but Nuuq suddenly turned and nuzzled the handsome Serberan's snout and Seegloo winced.

"Seegloo, it's me. Qilaq."

The Bergo swung around. "Qilaq," he grunted. "You've grown. Have they let—"

"Yes, Seegloo, except I fight in three suns to join the Serberan. A Moon Duel to the death."

Qilaq expected some response, but Seegloo seemed disinterested and just sighed bitterly.

"Oh, what are you doing, Seegloo?" hissed Qilaq.

"Just thinking, Qilaq. The Serberan hardly give us any time to think, with all the work. I got some time away. I must get back soon though or they'll punish me."

"And spying on Nuuq," snorted Qilaq in disgust. "Pining still then, even after so long. You're worse than Pollooq."

Seegloo winced and Qilaq felt a fury now, thinking of the difference between the stupid Council, and those legendary Storytellers.

Seegloo could never teach him anything, and the Fellagorn were dead. Seegloo had noticed a large group of Barg though, heading off on a Leave and the Bergo raised himself lazily.

"Another selection, Qilaq," he muttered. "They say the Serberan have made a huge, lovely new sound especially for the Barg Leaves. Maybe I'll earn one soon then, Qilaq and forget about Nuuq, for a while at least."

Qilaq had heard the darker rumours about the Leaves though and he wanted to tell the stupid Bergo to wake up, but Seegloo cocked his head. "That's odd, Qilaq. Look how many older Barg are in that group going on a Leave."

"Why odd?" grunted Qilaq. "The older Barg need the Leaves more than the rest of us."

"And those crippled bears, injured at air holes on the work details, or collecting ice daggers. So many too. And those five are Offlar, and the Serberan hate Offlar."

Qilaq thought of the term that meant Bergo who prefer the company of other male bears.

"And Tappers too," said Qilaq though, watching the detail still, "especially those stunted cubs, that never grew last year."

"And look at those bears at the back, Qilaq."

Now Qilaq saw that the group bringing up the rear were moving very listlessly indeed, and swinging their heads strangely. Some were twitching, as the Varg snapped at their heels, with little pretence of any restraint at all. One at the back looked vaguely in their direction, spit dribbling from his open mouth.

"Mooq," whispered Qilaq. "It's Mad Mooq, Seegloo."

Seegloo and Qilaq looked sharply at each other, and Qilaq felt the shadow of fear claw across his very soul. If a Selection and Leave was the reward for hard work, why was this party made up of the very weakest and maddest Barg? He heard Mad Mooq wail now and cry out too.

"But don't they see the truth of visionaries?" he cried. "Have the gods cursed me, to have my prophecies not believed? Our Last Judgement comes. The End"

In Qilaq's mind Mooq was indeed prophesying again, but if Mad Mooq had prophesied that day at the Council, the proof now of his sister's guilt meant there was truly some strange power in the world after all. Yet now Qilaq's growing mind wanted some deeper proof of it all, just as he had long asked for proof of the gods he had never seen.

"Silence Mooq," hissed a Serberan though, "or what do you want for your mad lies – sea cucumbers?"

It was three nights later, and a great full moon had risen over the Sound of the Serberan, giving off little light though in the Long Day. Instead the moon was a huge, flat grey-blue disc in the bright sky. The air was warm and everywhere came chattering birds, flown in from the south, who knew that after the spring brings the gold of love to their hearts, the comparative heat of summer always brings danger again and fear too, and the sight of red blood.

A hundred pairs of young Bellarg were waiting down by the sea now, including Qilaq and Sqalloog, as Eagaq Breakheart patrolled slowly up and down. Half were well fed Ice Slayer children, and half were emaciated Barg. Eagaq's elegant fur sleeves were as long as Marg's had been now, but scarred Eagaq looked far less handsome than he had, as he rose and extended his Seeking Claw.

"Bears," he cried, his right eye twitching, although his scar had long healed. Eagaq's smile was charming, but cold as ice. "Brave young Bergo. Today, beneath the full moon, that liars and fools once called Atar, you're gathered here, with the mighty sea as your witness, to prove your true worth as real Bergo."

There was anger in Eagaq's eyes, for only yesterday he been told by Glawnaq to keep away from Nuuq, and now he wanted to see blood. The Barg and Serberan cubs, mostly three-year-olds, saw orca circling in the waters, whose path looked odd, their natural migrations ruined by Glawnaq's strange pact, and their even stranger pay.

"So then, fighters, begin."

Almost as one, the young Serberan cubs rose up on their

hindquarters, showing their own claws, grown harder by the day, and growled and bellowed to the Cub Clawer, yet acknowledging their true leader.

"Glawnaq," they cried. "Father of bears. We who are about to die salute him."

Eagaq sneered slightly, for Glawnaq wasn't even here, but each Toq was announcing the names of Serberan opponents too, as Qilaq wondered who he would have to fight, and suddenly felt desperately alone. His own sister had broken the pact of four, made before the sea, and although Qilaq was far now from his old feelings for Sepharga, and his friendship with Uteq too, he had often wondered what had happened to them both and wondered again now.

Qilaq noticed a shape beyond though, on the shore where some Serberan were nosing about, with younger cubs from that spring's Coming Out. They were walking between two curving arches, that rose out of the shingle, like the bending branches of a great tree, and dripping with strange pink leaves.

Qilaq blinked, as some polar bears started to growl and snap at each other, while gulls cawed overhead, for he realised it was the dead carcass of a beached bowhead whale. As the Bellarg snuffled for food between its ribs and hanging skin, Qilaq realised now that the ancient stories, the stories of his innocence and his own cubhood, had been stripped of their flesh indeed, to reveal a very hard reality. Well then, Qilaq thought, if Sepharga and Uteq were dead, if Matta was estranged, he would face life bravely alone, and make his own Ice Lore too.

"Ogguq," announced his Toq, a rather bored looking polar bear, suddenly choosing Qilaq's opponent from a little group of smiling Serberan. Qilaq's heart sank, as the biggest and most brutal of all the Serberan cubs stepped towards him. Ogguq was huge, and as Qilaq saw those claws that had scratched so many little faces, despite his new resolve, he wished bitterly that he had said goodbye to his sister. Qilaq was half in a dream, trying to stare back defiantly, his spirit wanting to shrink inside him and hide, as he heard an angry Serberan voice up the bay, growling at another bear, with the scruffiest of coats,

who was running furiously towards them, from the direction of the dead whale.

"Hey you there, where are you going?" cried the adult Ice Slayer.

"I'm a Toq, sir," came an answering growl on the wind, "but I'm late. So sorry sir. I was foraging."

"Then get a move on, idiot. They're starting. Then we'll have to clear the shore too, Bergo."

For some reason Qilaq thought of Janqar, as he turned resolutely and Ogguq began to square up to him, as their own Toq dipped his head to start the killing bout.

"Now I want the dirtiest fight possible," the Toq snorted, "and no backing down neither. Survive's the only rule today, and kill, of course. Drink hot blood then and glory in your coming Serberan power and freedom."

Qilaq was waiting for the Toq to tell them to begin, but Oqqug swung immediately. Qilaq pulled back just in time, as a clutch of vicious claws flew right past his nose and he felt his stomach churn as he tried to roar, but little came out. Qilaq suddenly found his throat choked with fear and hated his own weakness.

"So you want to be a hero, Barg coward?" laughed Ogguq. "Well, I'll teach you to get ideas above yourself, or try to be a real Bergo, and win a life name. I hear you like the sight of blood, Qilaq, so I'll show you some now. Your own. But don't worry, you'll be my equal soon. In death."

The watching Toq looked thoroughly bored, half gazing out to sea, but Qilaq felt that Ogguq was right about trying to be a real Bergo. Ogguq lunged though, catching a roll of Qilaq's skin in his teeth and biting hard. The pain raised anger, and Qilaq buffeted him, knocking him back. So both bears rose and began to box, as Qilaq half noticed another young Bergo come up to the Toq, who had been challenged by The Serberan, the Toq who had been late.

"Hey, you look tired," the newcomer grunted to the first Toq. "And I'll do this one. Eagaq gave the order."

Qilaq felt his fear deepen, for Eagaq had often looked at him threateningly among the Barg cubs, as the first Toq seemed disinter-

ested, shrugged and wandered away. Ogguq lunged again though, bashing Qilaq's chest brutally with his paws and knocking him over. As Qilaq tumbled, Ogguq raked his claws deeply across Qilaq's back. The pain seared through Qilaq and he rolled, but horrid Ogguq was looming over him now. His eyes looked like flames and his muzzle was open wide.

"Lie still, scum," hissed Ogguq, "it'll be less painful if you don't fight, they tell me. What have you to live for anyway, little slave, among those worthless Barg? So just accept my judgement and at least die like a Bergo."

Qilaq remembered what he had said to his sister about freedom and was ashamed, humiliated, so he hardly moved. So much had happened, so many had died last year, and Qilaq hardly understood why. He had tried to be a Bergo, all right, but had had no one to guide him, and now Qilaq just wanted it all to end. Qilaq suddenly longed to see Matta again, just to say goodbye. To tell her that he was sorry, even frightened, and that he forgave her for what she had done at the Still Hunt as a cub.

"Kill me then, Ogguq," he almost begged, but Qilaq heard a growling voice sing out around them.

"Remember your spirit, Qilaq, and the gods too. Fight, but with love and truth, and then survive, like the fine, true Bergo you really are. They'll never steal that from you. Who you truly are."

Qilaq wondered if he was dreaming, or if the voice had come from heaven, this gentle Bergo voice. He thought of Janqar again, and his mind cleared, for it was as if something was filling him up, a force beyond himself. Who is Qilaq really, he asked, and as he saw Ogguq's hate-filled eyes, a rage gripped him indeed.

"You just need to stand up to bullies, Ogguq," Qilaq roared, "because the truth is, they're really cowards, bullies, preying on weakness in their own hate and fear."

"Weakness?" hissed Ogguq. "Don't you see it's your weakness that makes us hate you, Barg?"

Qilaq sprung and it really began, arms swaying, claws raking, as the young polar bears all fought before the summer sea, in their

Moon Duels to join the Serberan, and be wild warriors. Their own training encouraged them never to back down, and soon many fell, their blood staining the ground. The adult Ice Slayers smiled as they looked on, for most casualties were Barg that bright night, as if Gog had swallowed Atar.

Although both fought bravely too, between them now Ogguq was just too strong, and Qilaq was beginning to flag. Both had disengaged, but Ogguq, growing embarrassed that a Barg was proving such a worthy opponent in front of the adults, attacked again as Qilaq turned, and once more Ogguq raked his back. Qilaq bellowed bitterly, feeling the blood gushing through his fur, but he dipped down, and Ogguq saw his opening. Poor Qilaq's neck was suddenly exposed and Ogguq bared his teeth, already in his mind tasting Qilaq's blood. Ogguq was poised there, when he heard a gruff voice, that had something strange in it too.

"*Why so cruel, killer?*" it hissed. "*Why so much hate? Don't you know that my spirit will haunt you forever, if you strike me down? I'll only rise up all the stronger then, for you cannot conquer Spirit.*"

It wasn't just the voice that checked Ogguq, for to his amazement, just to the right of his intended victim, Ogguq saw Qilaq, or another Qilaq, as if he was looking into an ice mirror, although his face seemed smaller and rougher, staring back scornfully at them both, as if the Qilaq on the ground was already a ghost. Ogguq wailed in terror and the real Qilaq swung to the side, as Ogguq lunged and missed. Qilaq's heart rallied and he turned and caught Ogguq in his bear hug. There was something fuelling Qilaq's rage now, his thoughts of the bears selected for the Leaves and the fear of it, but it was as if that voice had blessed him too.

Ogguq struggled furiously, wondering where the ghost had come from, gripped so hard by this real bear, but Qilaq held on with all his might and will, and as he did so, partly to his triumph, and partly to his utter horror, Qilaq heard a ghastly snap. Ogguq slumped in his grasp, as Qilaq noticed the scrawny coated Toq backing away fast, and turning up the slope. The fight was done, Ogguq's back broken, he was dead, but the glory Qilaq had expected to feel as an Ice Slayer, the

freedom and triumph at a kill, did not come at all, as he placed Ogguq on the ground, glad at least no more eyes would be sacrificed in the bluffs.

Yet as the bear stood there he heard other words in his mind now.

"*Bad one, am thinking, like demon Beeg. Can't trust tail length.*"

Ruskova's words were confused with thoughts of Matta too, and Qilaq felt a helplessness in the face of life, like a queasiness deep in his own soul.

"What have I done?" he trembled, as a shadow fell right across him. "What am I now?"

"Well, well, Qilaq," said Eagaq Breakheart coming up now, as the sea swelled in Qilaq's ears, "this is a great surprise indeed. To have killed one as tough and cruel as Ogguq. It'll earn you your place among the Serberan, all right, Qilaq Snapback, as a new champion of our true Ice Lore. Just like your little friend Sqalloog over there."

In his mind Qilaq heard Mooq speaking of murder again and he felt he had just broken the Ice Lore, but across the bay he heard a triumphant roar and saw Sqalloog standing over his own dead opponent, his mouth filled with blood. Dead on the shore in front of him was Starg, and his father Keegarq was groaning and keening in the snow nearby. Sqalloog was smiling at Qilaq though, who felt his confusion deepen, for now these two were brothers.

Up from the shore, the strange Toq was hurrying away across the Sound, when another Bergo came lumbering rapidly after him and stopped him with his deep voice.

"Hey you there, wait up, why are you running away? Can't you stomach the sight of real blood? It's just life."

The Toq froze, trembling, and answered in a voice far too deep for a young Bergo.

"Er, I've been told to gather some Barg, sir, and help clear the dead."

"And tell them some fine ghost stories too, perhaps?"

"Ghost stories, sir? Of course not. We're not allowed to tell—"

"I know we are not allowed to, Matta, but what's that to do with it, my clever Athela?"

Matta swung round sharply to reveal her nervous face, and the coat she had spent all afternoon roughing among the tundra, to make herself look like a boar, especially her throat. It had scratched her everywhere, and Matta had only just managed to get past the Varg and Serberan guards, in disguise into the Sound. She wanted to get back to the others as quickly as possible now.

"I'm so proud of you, Matta," said the Bergo. "To use a Fellagorn story like that."

"Janqar," cried Matta, recognising her friend now. "You're here too then, Janqar. I thought you might have escaped this year."

"And left you to the mercies of the Ice Slayers, Tutsitala? Of course not."

Matta's eyes narrowed though and she wondered about what Qilaq had said of him. If Janqar was here in the Sound, had he spent the spring and summer among the Serberan, and if so why?

"How did you get through though, Janqar? You seem to wander where you please."

Janqar smiled. "Not disguised as a Serberan Bergo, that's for sure, Matta. I just bribe the guards with stolen food, for I need to wander and think...But you're badly upset, I see."

Janqar's strong voice calmed Matta, as she looked at the scar on his forehead tenderly, yet Matta did not quite believe bribery had done it alone. There was something very strange indeed about this wandering Bergo.

"The Moon Duel, Janqar," she said. "Qilaq's killed another Bellarg."

"I saw it, Matta, and how you helped him too. But we must keep faith," said Janqar softly. "Resist. Qilaq's not really one of theirs, and never will be. I know that. How could a bear who's shared the story of Illooq Longsleeves and the Seeing Caves ever be? Or one who has been helped by a very goddess, my pretty Athela."

To be called pretty, after living so miserably, almost brought tears to poor Matta's eyes.

"He doesn't believe it anymore, Janqar. I'm not sure what he believes in now. What I do either anymore. I know mother was

wrong, though, Janqar, and it isn't Bergo that are to blame for the world."

"And why do you say that, Bergeera?" smiled the Bergo.

Matta felt very strange. Disguised, to break into the Sound, she had felt something she never had before. She had moved among Bergo, not interested in admiring or protecting her, moved as one of them, and felt the aggression and rivalry that came out of their beings, especially the Serberan's. As she had deepened her voice, walking with a tread filled with purpose and direction, it was as if she had had to press her spirit and will to the edge of herself, and it had frightened her, and almost made her feel sorry for Bergo. What a hard thing to have to stand and fight in the world like that. How lonely.

"Mother said Bergo are to blame, Janqar, but perhaps it's just how hard life can be. How it's really made."

Matta suddenly felt an anguish for the father she had never known, and an impossible sense of the mystery of Gorteq too, the spy, doubled by the fact she had only heard him spoken of in stories, before Eagaq had murdered him. Janqar smiled softly though.

"Except some Bergo," he grunted, "for are we not made as individual as each snow flake? There are some very mad Bergo out there, Matta, yes. Bergeera too. At least Qilaq has his eyes and wits about him now though, and he's found his fighting power too, with your help, Athela. Brave, kind, and true Bergeera."

Matta looked suddenly confused.

"Fighting power?" she said. "Somehow I've always felt so sad about what Teela did, and I want to fight this lot, Janqar, to tip their filth into the sea before the winter comes, and drown them all."

"Patience, patience, Matta," said Janqar softly, "and courage. Isn't that the Bergeera's gift? Why you're so contained, unlike us poor Bergo, sometimes, roaring and raging all the time. Why you're such a mystery and wonder to us all. But things take time to come out, Matta."

Matta had not really meant it, because she could not see anyone opposing the Serberan now, but she wondered what Bergo were really

like, or if she could ever know. Perhaps everything is really alone, she wondered.

"Well, brother," said Janqar with a wink, "shall we walk back to the Barg, and fight off any who try and stop us, together?"

Matta almost blushed, but thought of all those Fellagorn in their circle, and for a moment knew something, standing beside Janqar, that few Bergeera ever know – brotherhood.

"Are we just made different, Janqar?" she said. "By our natures. Or does life make us that?"

Janqar looked thoughtful for a while, then growled.

"You know the story of when they tried to hide Pollooq as a Bergeera cub, Matta?" he answered. "Because of a prophecy that he would one day cause a terrible war, but die fighting in it too? How they found out he was really the bravest Bergo hero alive and the finest warrior too?"

Matta shook her head and smiled back at him.

"They offered the supposed Bergeera cub a present, of either an artic flower, or an ice dagger. The strong little cub grabbed the ice dagger immediately, so they found Pollooq out. We must be true to our natures, yet know our spirits too. But may I honour Athela by telling her of Pollooq again, who survived all? The story of the Ice Labyrinth, for a start."

On the shore Varg were biting savagely at the coats of the dead, snarling as they dragged them away.

"Pollooq in the Labyrinth?" said Matta. "I've never heard that story, Janqar. It sounds so dark, but what could be more frightening than this terrible place? At least stories aren't quite real, in the way life is."

Janqar suddenly wanted to protect Matta from all the dangers of the world, for even with her coat as rough as a Bergo's, she was kind and gentle and her lovely being had not been made for this brutal place.

"Maybe I should tell of Athela instead then," he said. "There's deep love in that story. A love and courage you've shown today.

Though even love can weaken us in dark times. It's why the Fellagorn never took mates, Janna."

"Janna?" growled Matta.

"An old Fellagorn word for Sister, Matta. Janna."

"No, Janqar," said Matta, her voice dropping again to a Bergo's growl, "I've shared something of you Bergo today, so tell me of the Labyrinth indeed. Was it before Pollooq fell to the Pheline?"

"Not before, Matta. For the legend of the Labyrinth was part of the story Pollooq himself told, as he stood in chains of seaweed in the Pheline's cave, blind and dying, inside and out. A story inside a story."

Matta looked up sharply. "Pollooq took up the challenge then? How brave."

"Or foolish, Matta, for it spoke of seeing as Man sees, using their reason too, and it was a living agony to the blind Bergo, knowing it was a journey to Hell itself, after the heaven he had once touched at his beloved Teela's side and with none to guide him back. Yet Pollooq had no choice but to speak it now, and for all to hear. A story to heal creation."

Matta wondered what choice the Barg had, or Bergo either, thinking of what Qilaq said.

"Why no choice?" she whispered.

"His heart was broken, Matta, his body withering and dying. But as the first and bravest Fellagorn, he was a Storyteller to his very paws. While now he knew that if he resisted the Pheline, the bears of reason without love, of white whale meat and power alone, it would kill him. Yet if he did not speak now, of love and belief and defiance too, and did not tell the greatest story that he had ever told, it would kill something far more precious than his body: It would kill his very spirit, Matta. His very soul."

Matta stirred and wondered what a soul really is, or if gods are real. She so wanted to believe.

"Go on then, Janqar," she growled. "Tell me of the terrible Ice Labyrinth."

"Very well, pretty Athela," said Janqar as they walked. "For Teela's sister Athela was listening too in the cave, disguised as a Bergo just

like you, to help Pollooq, who she loved in secret. But now the broken bear, bound with cords of strangling seaweed, urchins stuck to his bleeding brow, kept his head bowed, as he began to speak.

"'Pheline,' Pollooq said faintly, 'I see that mercenaries are truly in the temple. So I will tell you a story, to see and heal the wounded world. Blind as I am, I'll look with the Gurgai's eyes, and with human reason too.' The Pheline all around him smiled coldly and nodded approvingly. 'Yet since first I must heal myself, and make the story true, I will tell a real tale of love, and an ordinary Bergo and Bergeera. So listen, cubs, gather round and listen. Pheline adults too, who forget how to truly listen. Forget the love and idealism always born in brilliant young cubs. Yet all must listen now, for in telling only cubs' tales, do we not simply stay cubs forever?'"

Matta shivered, remembering the happy, carefree days in the Great Sound, days that seemed so very far away. She wasn't sure she liked pretending to be a Bergo at all, and wanted to be somewhere else, laying her head on Janqar's strong chest in the gentle snows, and listening.

"So now Pollooq spoke of himself and of Teela," said Janqar, "of his treacherous, lying brother Ineq, of shorn fur sleeves, lost love and friendship, and of a dying bear. But although his voice was faint, and in his hurt mind Pollooq was stumbling through the shadows, searching left and right, his words from deep within the cave of himself still had the Fellagorn Word Power in them. For Pollooq was a magician."

Strangely Matta thought of that great purple sun that had burnt in the skies on the Still Hunt, for purple is said to be the real colour of magic and of change. The magic of change in all things.

"So each Pheline listening thought that he was not speaking of Pollooq and Teela at all," said Janqar with a smile, "but of themselves, and of their own feelings, fears and journeys in the great, mysterious world. For great stories have the power to become us. They heard their own names spoken too then, not Pollooq's and Teela's and Ineq's at all, as if we are all just shadows of each other."

Matta felt something stirring in her. She was thinking of Qilaq

again, and Uteq too, yet as she looked into Janqar's strong, clever eyes, she suddenly wanted to be with him all the time, safe and happy. Yet poor Matta felt guilty about the pact, which she had refused to deny to Qilaq she had already broken.

"Pollooq told them then of a very great love, that each long for in our souls, like coming home, and a great ideal too. But of doubt, and a Bergo and Bergeera's fear. Of how in backing down, and not speaking of his true heart at the right time, a Bergo had found he had done the most terrible thing of all, for it had robbed him of his own power and meaning. A Bergo's true heart strength."

Matta looked down at her own roughened coat, and thought of her love for her brother and she was glad she had done what she had for Qilaq. But she thought too that Pollooq was wrong to think he had done a terrible thing, for what had Teela done in her coldness and reason to the wounded hero she had said she loved?

"Pollooq told of how Teela now spoke to him like a scorned cub, and a stranger. Of how the Bergo staggered out into the snows with the Ice Madness, and coming to a dark hole in a windswept glacier, he slipped on the ice and fell down it, into the fabled Ice Labyrinth. A place where all abandon hope."

"Down into its endless chambers and winding passages Pollooq plunged, like a falling star, quite alone, unable to claw onto the icy sides and utterly lost. And being the very first Storyteller, Pollooq knew something terrible waited for him far below. For Atar had made the Labyrinth with her icy breath, to imprison the creature that Gog had created at the very beginning of time, and which must never be released into the mortal world: the monstrous Gorg. A bear animated with fire and anger, and power from the very sun, yet only half of him was bear, for the other half was Gurgai."

"Gurgai! The Gorg was half man?" gasped Matta.

"Most dangerous of all, Matta. Part Lera, part Man, part red demon, capable of destroying all. Many handsome young Bergo and Bergeera had been sent to him by Gog to appease his hunger. And as the listeners looked at the Gorg, he seemed to have only one eye in his face, searching like a ray of angry sunlight, but burning with red fury,

and it seemed to be trying to look into them all, like a light of blame. For its father had never told it how it was made, or why it lived alone, down in the dark, and was so feared and hated by all the living world, in its hate and rage. Pollooq knew he had to face the Gorg now, yet Teela would not be there at all to growl to him, as another legend had spoken of a guide back to heaven and the light, and the happiness of her love and peace."

Matta shivered.

"Pollooq was lost entirely, perfectly alone, and in the Labyrinth's ice walls, although the Bergo had been blinded, he used his very soul to look now. He saw visions there of terrible, evil things, great screes of rock, dark wintery forests, wild snarling wolves, eagles with hunting eyes and vicious beaks, and his soul quavered, as he remembered as a cub that he had to stick to the narrow paw trails of the Ice Lore, and walked alone in his solitude and exile. For the loss of love is always exile.

"He could not tell if these things were in the world outside though, or inside himself, for above all he saw himself, as if in a thousand Ice Mirrors, his wounded features staring back, his coat mad and mangy, accusing and mocking himself: 'Coward, Pollooq. Wicked, unloving thing,' he wailed. 'A Bergo who backed down.'

"Teela's real voice was there too though, in the story that Pollooq told the mesmerised Pheline now, yet not calling to guide him with love or friendship, but laughing at him instead. 'Evil Bellarg.' 'Mad Bear.' 'Nothing.'"

Janqar growled softly and went on.

"Alone in the Labyrinth, Pollooq knew there was no way out at all, for a hero needed a guide to call them back to the light again. But Teela was gone, so Pollooq was lost forever, as a great shadow fell on Pollooq now, large as a cliff, from the creature so foul and grotesque that even the Fellagorn feared to speak it. The Evil One. Ice Lord of the Flies. It turned and roared at the hero, and snarled with bitter, primal grunts – *AGorrr, Gorg, Gord*. It seemed to be trying to form a single word, as if sculpted at the beginning of its being, or of time itself."

Janqar stopped though. A sharp sea wind was ruffling the bears' coats now and the friends had just reached the Bay of the Barg. The terrible mythic battle with the Gorg would have to wait, even though Matta knew that blind Pollooq was lost in the darkness forever, without a guide at all, or any friend to help him.

EVEN AS THEY STOPPED THOUGH, OTHERS HAD STOPPED TOO, FAR FROM the Serberan's Sound and the Bay of the Barg, after a hard, three day's march on their Leave. They saw before them now a great ice depression, although pierced with the summer tundra, and surrounded by huge Glawneye and since it was so far from the sea, they wondered where they were to be allowed to hunt and rest. This place seemed to offer no shelter from wind and sun either, though the tired Barg looked nervous as they noticed thin, deep channels carved in the ice and tundra.

At the back of the group of marked Tappers little Pooq was starting to shake frantically again. It was something in the Glawneye's eyes, the burning fire there, and the smiles on their cruel faces too, that had filled the little Tapper with terror. Snow wolves were snarling now and suddenly the Glawneye began to herd the bears into the centre of the depression and nearby Mad Mooq began to wail and moan.

"The End. The End is here."

"Please," said a weary Bergeera to a Glawneye, "I'm hungry, sir. It's been such a hard journey and we're on leave now. It's wonderful."

"Hungry, Barg filth?" snorted the Glawneye. "Like all bears, with resources failing everywhere. So thank your lying gods that the Father brings real Bellarg his great solution."

Pooq looked on in horror as the assassin opened his mouth and with a roar, bit down straight into the Bergeera's neck. The Varg began howling triumphantly and suddenly the Glawneye were falling on the weakened Barg, tearing at them, biting into their fur and flesh and those carved rivulets were gushing with Barg blood. The Glawneye were eating them alive.

15

HUSKIES AND GURGAI

"We are such stuff as dreams are made on, and our little life is rounded by a sleep."
—William Shakespeare, The Tempest

Sepharga and Uteq had told stories too, in the year and more that had passed since they had met Mitherakk. The friends had found a place to wait until the ice froze again, so they could continue their terrible, fatal quest, to find the entrance to the Underworld and speak with the dead. It was a cave not so far from Churchill though, near Whale Inlet, where the friends had learnt to swim, and dive, and hunt, far more effectively than they had as cubs.

Sepharga had admired Uteq's skills in the water, and he her quiet patience and gentle, serious nature. In early spring her cut had become infected though, and Uteq had watched over her, as the illness had moved through her body like some bad Beeg, or a terrible dream. But she had woken again, to find Uteq had brought her food and it had deepened their friendship. Yet the growing bears were strangely wary of each other too. The power of Uteq's black paw, or The Sight, was something that had affected them both, and they feared the visions of Man that sometimes came, and a dying ice world.

The bears' coats began coming fully too, and from the mouth of the cave, side by side, they had watched the turn of the seasons together. In the lovely east wind, they had felt the sun glow in their coats, and with the summer ice melt, the bears had fished together, as

polar bears will, in a great arctic salmon river near their cave. They splashed and sploshed in the wonderful fresh waters, and plucked the living Lera from the currents with their paws and teeth, to build their Garn strength.

But as the winter had come again, and the great freeze tightened, something had delayed the friends in their journey – life itself, and the fact they were still really only cubs. They had found themselves playing carefree in the early snows instead, knocking snowballs at each other, laughing together, or even Boggeting. It was as if the friends were desperately holding on to their own youth, like Qilaq had clutched at the ice on the Wander, or because the fear of what they had to confront in the North was simply too much for them.

So the winter and the dark had deepened again and Sepharga had made a kind of snow den outside the cave, not to cub, of course, but to keep warm. Uteq had found himself sitting outside, like Toleg himself, for the visions worried him, and it was too confined for him to be inside all the time. There he had grown introspective, thinking either of the North, or of his friend sleeping inside her den, having the sensation that in the swirling white he could see Matta, or Qilaq, fighting on some distant shore.

So the spring had come again, and the ice packs cracked and groaned and broken up, and the polar bears had found their coats even fuller, the two three-year-olds. It was that swelling summer though that, in the lethargy it brought, Uteq had had another strange vision, yet not because of his black paw at all.

He had been walking back alone, leaving Sepharga fishing happily among the arctic midges, and nearing their cave, he had heard a strange, disembodied sound from inside, like a moan. Uteq had wondered if some dangerous arctic animal had made it its home there during his absence, and the bear had advanced warily. Through a curtain of swirling insects, hanging at its mouth, destined to live and die for but a single day in their seemingly pointless struggle, Uteq had seen another Bellarg standing at the back of the dark cave.

He was not much older than Uteq, although quite a bit larger, with once hugely powerful forearms, and a fine, intelligent snout. He

was pacing back and forth, like a caged tiger, but now he stopped, looking at the ground, shaking his head. As Uteq watched, the poor bear seemed to wince, as if some pain had gripped his belly, and something like a strangled sob came from his throat.

"But don't you see?" he groaned. "I'm just a Bergo asking a Bergeera to understand and feel. Why can't you hear me? Why do you judge me so, and poison my heart? Love does not end, friendship does not end. They're as constant as the stars themselves, as true as ideals. The Pureem."

Uteq wanted to ask the stranger who he was, but he found himself growling softly, kindly, and the bear swung his head to look back at him. He was looking straight at Uteq now with huge, feeling eyes, and yet as he did so, it was if he was looking straight through Uteq too, or could not see anything at all. It was as if he was blind. But then he spoke, choking back a cry, and when he did so Uteq might have turned to stone.

"Teela," the stranger muttered, half raising a paw, "is it really you, Teela? You've come then. You understood at last, and I waited so long. I'm sorry Teela, for the rage. Sorry I scared you, but you said I felt more than any bear you ever knew."

Uteq growled and shook his head, for he felt The Sight must be gripping him, or he was dreaming, but it seemed perfectly real.

"But why your terrible silence, Teela? Six bitter Long Days. Don't you know silence the wickedest weapon of all, and that Bellarg can suffer anything but not knowing. I was fighting for you Teela, not against you. Isn't love forgiveness too? I thought you really believed in stories, Teela. In the gods. In me."

Uteq's mouth had dropped open with a mixture of astonishment and utter fear.

"Pollooq?" he whispered incredulously.

He thought of the Council, that had seemed like some Court of the Ice Lore, but this bear suddenly looked so wretched and lost, his body thin and his coat mangy. Uteq felt a kind of pity, and yet a strange contempt too. He realised something then of adult fights, and knew that losing love can hurt so much, because it is like being

judged. He knew in that moment too, that real love is not a Court of the Lore.

"Oh Teela," said this vision of Pollooq. "What can I say, Teela? I spoke, some many words, when I only should have acted. For true love is only doing and living. Perhaps it was father's rage," added Pollooq, and he looked as if he was feeding on pain or memory, his eyes like Tuq's. "Father talked of his parents too, for his father told him his mate was the rock his life was built on. Isn't love what redeems everything, Teela?"

Uteq wondered himself and heard Marg in his mind too but now Pollooq bellowed and threw up his head, as if trying to throw off some awful weight, and his features became a mask of animal savagery.

"Evil?" he hissed. "Yet you dared call me evil and mad, you thoughtless, cruel cub, or tell me that life's unfair? I who've felt a suffering so deep, and known a loneliness so great, that even the wind itself fears it. For I am Fellagorn, and speak with the gods, in the caves of the Ice Lore. Yet know this, cruel, vain Bergeera, something must always flow in a teller's veins as cold as ice too. So since you speak evil then, believing you are good or true, then look on the face of what you really speak, and know terror and despair."

The bear snarled furiously, his face contorted with such mad anger that the cave seemed to shake.

"Pollooq," whispered Uteq again, staring in astonishment at this real, suffering polar bear, and wanting to help him with all he was. A breeze caught the moving air though, and the sun burnt so hot that it seemed to catch the insects in its blinding light, and burn them up, like little lice popping in a human candle, and the cave mouth was completely clear of the curtain, but Pollooq was gone. All that remained was the cave's stone doorway, hewn from the moving earth, and the ancient work of water and erosion, wind and rain; the pitiless work of time, and death and loss. The living tragedy of the world.

Uteq looked at the hard, real ground, and as he saw the cold dirt, scattered with pebbles beneath his paws, heard the distant rush of meltwater, and felt the hazy strangeness of the arctic warmth, he shivered and wondered if Innoo had been right; that there was some cruel

wound in Nature itself, perhaps some ancient curse indeed, that framed the unbearable beauty and sadness of all life and death. Yet Uteq realised something else now. The legends; the flood, the great stories, even Pollooq and Teela themselves, they had all been based on real events in the life of the world, or in the minds and perceptions of living beings, and in the language of Storytellers had been raised to the power of Myth.

Uteq did not mention the vision of this real, tangible Pollooq to Sepharga, but still they talked and dreamt and slept in the cave, side by side, and talked on. Until the hard, clear cold had returned, and the ice had formed once more, spreading out like a white cloak from the land before them. So it was that the friends had come to a decision at last, to set out on their dark quest, however reluctantly, for they knew they were moving from life toward darkness and death. The legendary entrance to the Underworld awaited them, if they could ever find it, although in their hearts all they wanted was life. It lay somewhere in the high North, and the mysterious regions of the King.

The darkness had begun to return too, as the west wind filled the arctic air with bruising colours, until at last Uteq had taken the lead and decided to follow the birds and the Lera, travelling due east now, out onto the frozen Hudson Bay. Then they swung up in a wide arc to avoid the borders of Glawnaq's kingdom, sweeping far up into the Arctic Circle, and out onto the Ever Frozen Sea.

There the two polar bears walked now, in the heavy arctic twilight, Sepharga limping slightly from her old hurt in Churchill. In their travels, they had seen lines of wild Polar bears in the distance, moving west across the new ice sheets toward the Haunted Island – and Glawnaq's kingdom. The 'True Fortress' some called it now, for Bellarg were going to serve Glawnaq in their fear, and out of what they called at least their own free will.

"What's that, Uteq?" said Sepharga suddenly, as they crunched along, and the air moaned.

"Just the wind, Sepharga," said Uteq. His voice was deeper and Sepharga had a new confidence in hers.

"Strange, Uteq. I keep thinking someone's following us. I'm almost sure of it now."

"Garq and the Glawneye, you mean?" said Uteq, though he thought of Tuq and then of Pollooq too in the cave. "No, Sepharga. But now there are no birds, nor Lera, and no lights in the North either, with these thick clouds, to guide us. I think we're lost. Which way?"

The two polar bears stopped and peered into the vast formless expanses before them. The high arctic lay ahead, perhaps the lair of the Evil One himself. It was not only the feeling of exposure that was so cruel, but that they had not eaten in suns and both were hungry now.

"Our instincts, Uteq," Sepharga answered firmly, trying to look as brave as possible. "Mitherakk said we should feel the way. Look within perhaps, like the Fellagorn."

The white arctic skies were flat and dull too, with no sign of any magical lights, and Uteq was discouraged already. Suddenly, there was a ringing crack, and the bears felt the sea ice shudder.

"Quick, Uteq. Another fissure's opening, like that one we nearly fell into half a moon back."

The friends started to run, almost gallop, bounding over the ice away from it, and behind the polar bears was a terrible groaning that seemed to chase them across the frozen sea.

"Is all the ice failing now, Sepharga? How could we get to the edge of everything then?"

"I've been thinking too, Uteq. How could we ever be there if the Frozen Sea really moves. Because then Pollooq's Paw Print must move as well. That just stands to reason."

It was still only early winter, and they had only just come to the edge the Ever Frozen Sea, but the friends had already sensed the vast mournfulness of the place.

"And you think a Garn River, or these healing flowers really exist, Uteq? Sometimes I think Mitherakk was mad too. Or all the Lera are."

Uteq growled doubtfully. Their time together had given them a taste of many wonderful, beautiful days as free bears, living a real life,

wild and happy, but now they seemed to be drawing further away from the world the bears were born for. Uteq had had strange dreams of Matta too, all alone and freezing in an ice storm. They seemed to tug at him, just as the wind did, and guilt about his parents too, as if his very thoughts made him part of some wider reality for which he was responsible.

"And nothing seems to grow out here, Sepharga. I'm glad we took that scrawny seal last moon."

"It was two full moons back," Sepharga growled, feeling even hungrier with the memory.

The friends huddled that night in the deepening cold on the ice, shivering inside a half mound of snow Sepharga and Uteq had dug together. Uteq woke early, thinking of Matta resentfully again, yet missing his cubhood too and saw Sepharga gazing up at the myriad stars through a hole in the thick clouds.

"What are you thinking about, Sepharga?" he asked her softly, hardly wanting to disturb her thoughts at all.

"Just stories, Uteq," she answered, without turning her head. "The stars reminded me of Pollooq and the golden eagle, whose wings he stole to look into the face of Gog, before Gog's fire melted their oil, and he plunged into the arctic sea."

"I liked that one, Sepharga. It always made me dream."

"Narnooq said it means the way of real animals is not the way of the gods, of Heaven nor the Underworld, but in between. Though we must try, I think. Do you remember the tales?"

Sepharga was not telling the whole truth about what she had been thinking about though. In the night, as Uteq had slept, she had opened her eyes to see a strange, shimmering shape, a Bergo, glistening with an intense golden light, that turned his head as she did, then vanished into thin air. Yet it was not as strange as something Sepharga had seen that summer too, though now she could not tell if it had been a dream either. She had seen a she-bear who, if she had known it, looked strangely like Pollooq had to Uteq in their cave, standing near a rock where she had been fishing alone, listening to the air as a terrible roar came across the water, and the stranger flinched awfully. The Bergeera

had been quite frozen there, as the anguished bellow came again and seemed to cut through her like a knife. "Stop it," she had whispered, "you're frightening me. You're not a god, not a hero, just a weak, selfish Bergo. Mad and deluded, always talking of your freedom anyway. Don't I have a choice, to love where I please? You're not the One for me, Pollooq. I don't judge you, I just don't love..."

This real Teela had stopped though, at saying the word 'love', and vanished in the haze again, leaving only the sound of rushing water. Sepharga looked up now at Uteq and wondered if it had been real at all. With The Sight, she had seen things with Uteq of the real world, far more clearly than dreams or memories.

"Remember tales of Pollooq in the whale's belly?" growled Sepharga.

"No, not that well, Sepharga, and it's best I don't."

"Why best, Uteq?"

A wind got up and clouds were gathering quickly, obscuring the wash of stars again.

"We have to fight real monsters now," answered Uteq, gritting his teeth as it started to snow. "So we have to know what Man's really like, don't we? Mitherakk spoke of knowing their true journey and seeing as they do, especially if Man is this monster."

"A sight that might strike us dead. If we even find the entrance to this Underworld."

"We all die, Sepharga," Uteq said simply, as the snow worsened. "But Mitherakk said they've changed too, as the stories changed. So they think differently than us now, I'm sure of it. See more."

"See more? How, Uteq? If they're just Lera too. Is it The Sight?"

"That's what we have to find out too. Maybe it's something mother mentioned, *Scientia*. But look how they spread, and fill the skies with heat. Look how they kill each other too, the trees and ice. So much hate and anger in their world."

"And fear. While even the weather changes, and our ice world melts. It's so sad, Uteq."

Sepharga lifted her head sharply though. "But the Humans, they

seem so powerful too, so I wonder if they could..." She stopped, as if she was about to say something embarrassing.

"What?" growled Uteq.

"Use this special way of seeing ourselves, Uteq, if it's this Scientia, to help us all somehow, or stop the ice world melting. Like magic, or the power of the Gog and Atar. The Gurgai themselves make me think of gods."

Uteq smiled at her innocence, but he liked the kindness of her thought and wondered what this Scientia was, remembering it was a word perhaps more powerful than all the Fellagorn's.

"Change the weather itself, Sepharga? They seem to use their reason to eat up all the Lera instead, but that would be a story indeed. That I'd have to see to believe though."

Sepharga looked very dejected now and she growled softly.

"What's wrong?"

"What you told me of Mooq. When he saw a death, Uteq. That means one of us is going to—"

"Hush," said Uteq though, looking around suddenly. "Sit still."

Sepharga heard the noises out of the blizzard too, and now they saw eight white forms in the storm, bears. The friends stayed as still as they could as the prowling figures drew closer.

"Perfect attack weather," one was saying. "Ideal for a cunning Snow Raider."

Uteq looked sharply at Sepharga.

"Yes," growled another. "A brilliant ruse to dream up the Raiders, and send out his Glawneye, to strike like ice phantoms, and spread terror everywhere, bellowing of one true Ice Lore."

"Every great leader needs an enemy," said another Glawneye, "especially ones who talk of ancient gods and absolute lores. We're telling now of our evil raider leader living in a cave. How else really control the animals, and what better nightmare too than old gods, or the end of the world itself?"

The brutish Glawneye laughed as his troupe passed close, but they didn't see the two young Bellarg in the blizzard, nor scent them

either, and they vanished again, leaving the friends looking blankly at each other.

"Glawnaq, Uteq. That filth's behind the Snow Raiders too then. He *is* against the bears. But what's his real purpose? Is this secret just to make Barg slaves to serve the Serberan?"

Again, the questing friends struggled on in the Long Night, and the twilight ended at last and the full darkness descended. Their hunger grew, and it seemed they were moving into perpetual night, as an emptiness gnawed at their bellies. Another dark day had dawned, and the wind died too, when Uteq pulled to a stop. Even in this open wilderness, he could see tracks stretching straight ahead of them across the sea ice.

"Varg?" growled Sepharga but Uteq shook his head.

"No, Sepharga. They look like prints from that dog that strange Sqeet hugged."

On each side of the paw marks were a set of strange parallel lines in the ice.

"And can you smell it, Uteq? Gurgai again. Man."

"Yes. Even out here. But the scent's different. Dogs and Man together. What's going on?"

As if in answer, the polar bears heard loud barking coming across the sea ice, dogs indeed, and then in the darkness, a human voice was shouting, and repeating just one word: "Mush!" A great shower of melt snow went spraying up, and the bears caught sight of shapes coming fast over the ice in the darkness: two lines of dogs with shining silver-white fur. Each was bound with something like Innoo's collar, and they pulled a sled behind them, on top of which stood a Gurgai, wrapped in a thick white coat. "Mush!"

The face peering from his hood was dark brown, and his eyes were keen and slightly slanting, and there seemed to be something ancient in his face. As he caught sight of the polar bears though, he called other strange words, urgent and frantic now, and swerved away.

"Look," said Sepharga in horror. "On its back, Uteq. Bellarg fur. They're wearing us as coats."

"Kassima," hissed Uteq.

There were more cries and another four sleds came rushing toward them. Only two had dogs at their front, this time, for the others were moving on their own, spewing thick smoke across the pristine ice; it was more of the humans' magic, motorised machines, filled with the black blood.

"Keep still, Uteq. They can't see us against the white."

The friends kept as still as Still Hunters, but one of the dogless sleds swerved in their direction. They saw two Gurgai balancing on the back and one seemed to be steering, but the other had just stood up and was pointing one of those metal sticks straight at them.

"No," groaned Uteq, but it was too late, for with a *phut*, Sepharga saw something red speck against Uteq's side. He growled, and a look came into his eyes like Tuq's, as he swayed and fell.

"Uteq..." gasped Sepharga.

There was another crack, and a dart thwacked into her belly too. It didn't hurt, but it was as if all the blood was suddenly rushing to her head, and her beautiful eyes began to cloud, as she crashed down onto the ice too. Drugged. The friends were suddenly lost in a world of dreams and shadows, ones that haunted Tuq in Churchill, but these were dim and glassy, like watching a screen, and Uteq suddenly felt as if he was floating down a great river. Somewhere voices were calling to him, like lost souls. *"Help us, Uteq Save, us all. Heal the wounded bear, and lift the curse forever."*

"No," Uteq growled bitterly. "They're just stupid stories. I don't want to be special. I'm no Saviour at all. No Ice Whisperer. Go away."

Other voices were speaking though, cunning voices. *"Yes, Uteq, they're just dreams and lies. The Pheline speak the truth, with reason, and the true Ice Lore is to survive. Legends and gods are for fools, Blackpaw. Avenge your father then, just as Glawnaq kills, wild and strong and free. Be a real Bergo at last."*

Uteq woke with a jolt under a swarm of stars twinkling in the cold, to find himself lying on his back. As soon as he moved though, he heard a strange clanking sound and rolled, feeling something tugging at his back leg. He saw Sepharga on the ice next to him, still drugged and sleeping deeply and she looked so vulnerable that his heart

ached. Now he noticed a metal ring around her back paw, attached to a chain running to a metal pole, sunk deep into the ice.

"Prisoners," snarled Uteq, feeling the horrid, powerful fizziness in his blood. The drug. There were two chains running from the pole, and one ran straight back to Uteq too. He was still drowsy himself, but Uteq realised that he and Sepharga had somehow been moved. Uteq pulled himself up, and began to yank angrily at the chain, growling and tugging hard on the ice. "*Grooooar!*"

"Hush, bear, or you'll wake them. Keep the peace."

At the voice Uteq swung around to see two lines of dogs lying in the snow. The team of huskies were fast asleep, except the lead dog, lying with his head flat on his paws, and watching Uteq intently. He had a noble face and strong, clear eyes. Around the huskies, Uteq noticed bits of half-chewed meat, and behind that a sled was piled with those black metal posts that they had seen in Churchill. Beyond were the oddest series of little dens on the ice, with light glowing through them. They were not made of wood but of the same thing as the white wing. Uteq sensed there were humans inside the canvas tents, and next to the makeshift den, set apart, was the strangest den he had ever seen. It was rounded like a Bergeera den, except on top of the ground, made out of square blocks of ice, glowing yellow in the starry dark. By the igloo was another pole, with a fluttering cloth patterned with lines and what looked like stars, red and blue and white. Uteq heard a voice in his mind whispering strange words – "*The Great Satan*" – and the flag was burning, but he blinked and the vision was gone.

"Who are you, dog?" Uteq growled angrily, looking back at the husky. He felt exposed and deeply irritated it had been watching him so hard.

"Egigingwah," answered the husky, curling up its pink tongue, then running it around his lips with a huge yawn, "but don't growl so loudly, stupid Bergo. My pack's sleeping, and we've been working this route for months and months, so we need our rest."

Uteq yanked at his bonds even harder, and moaned in frustration as he felt a burning anger swelling in him.

"Pulling along the evil humans and their killing sticks, you mean," he said, "like filthy slaves?"

"Oh, what are you growling on about? I'll have you know, although our kind used to run with wolves, we've been working with the Gurgai for thousands of years, and proudly. It's changed us over time."

"Proudly?" said Uteq, surprised at the husky's stout response, and yet realising this dog looked rather like a wolf, yet seemed much finer, its coat shining with something of the ice itself.

"Of course, bear. With the great Inuit tribes that made the snows here their home. And there's no shame in that, bear. Though they all seem interested in your kind now."

"My kind, dog? Why?"

"You lot were invisible once, but now everyone seems to be taking an interest in you. The humans anyway. Beats me, why. I mean, why would anything want to take rubbery seal with their bare teeth, when you can work with the clever Gurgai instead, and live in peace?"

"Be tame, you mean, Sqeet?" said Uteq scornfully, thinking of Man's own visions of the Great Story.

"Domesticated," corrected the dog. "Not all Gurgai are good, and some beat us and starve us to make us work too. But I think those ones are scared, or fear and hate something in themselves, for they say you can always tell the true heart of a Gurgai, by how the Lera feel in their presence."

Uteq thought of Mitherakk's words of casting our shadows on things and of the monster being nature itself now. He looked at the paw marks and the straight sled lines, and two worlds seemed to merge into one.

"Although some Lera think all the humans care about now is their black blood, like Varg mercenaries." said the dog. "It makes them act in the strangest way. Like the metal and paper they give each other, and fight over all the time. There's so much now, that they say they've lost control of it all."

Uteq blinked and wondered what this metal and paper was.

"Yet Lera are interested in you too, BlackPaw," said the dog. "I hear

my wolf cousins seek you, especially Treeg, who leads Glawnaq's super pack. To offer you a bargain, bear. If you remain in exile, Glawnaq will turn a blind eye now, and leave you be forever, Kassima cub."

"Like a scapegoat?" grunted Uteq. "Perhaps he fears the Great Story might really unseat him one sun, Egigingwah, and his hate. The story of the Ice Saviour."

The husky yawned. "Oh, I doubt it. I hear Glawnaq can no longer spare his Varg or seawolves, to hunt you. That's just politics. Even your Pollooq said that you should give to the world what's the world's, and to the gods, their due. Our cousins tell a story of a true Saviour though, called Sita, reviled and killed but who rose again. A Varg called Larka tried to follow her, and paid a terrible price. Very fanciful, wolves."

Sepharga stirred next to Uteq and seemed to be dreaming deeply now.

"And there's a story about a black wolf too, gone bad, but restored by Larka's love, although what happened to Fell none know. But I think they're just myths, so perhaps your Dark Father's right."

"Dark Father?" grunted Uteq angrily, thinking bitterly of Toleg and missing him.

"Glawnaq calls himself the Dark Father, now, bear, in his True Fortress. He says in times of darkness, Lera must draw on what's darkest in our very natures, though I'll stick with the clever Gurgai."

Uteq suddenly wondered what future any of the polar bears faced now, or the arctic Lera either.

"I hear many wild rumours on my cousins' voices," said the husky, "about the Barg and the fearlessness of Glawnaq's most ruthless Serberan too. Eagaq and Soonaq, Sqalloog or Qilaq."

Uteq threw up his head. Sqalloog's name was bad enough, but the last cut into Uteq's heart like an ice dagger.

"Qilaq?" he groaned, tugging at the chain again.

"Hush, bear. Though do you know of this Qilaq? One of the braver Glawneye, I hear."

"Qilaq's become a Glawneye!" Uteq cried in horror.

"I said quiet," snapped the dog, looking back at the makeshift dens. "Be careful, Bellarg, for I heard them growling too, when my masters were arguing with the white Gurgai, with the flag. It's they who've being making us drag these blasted metal sticks everywhere. They're mighty heavy."

"For what?" said Uteq. "Are they digging here too for the black blood?"

"Of course not. This is just a staging post, one of their many Scientia stations. We go north still. They're doing something with them up there. Did all last season too. Beats me what."

Egigagwah dipped his head though and nudged something on the ground that Uteq hadn't noticed before. It was round and made of silver metal and glass.

"What's that, dog?"

"Not sure, Bellarg. One of them dropped it, but they all carry them. And watch," said the husky, pushing it with his snout. "The little red claw always points toward your fabled Paw Print."

"Always? But how? Is it alive? Can it think?"

"Stranger things in the world, bear. How does the moon draw out your Bear Rage, or make the seas rise and fall? Other dogs here even whisper that the moon can affect human Bergeera's blood." The husky sighed heavily though. "Oh, my fine and lovely mate. I've hardly known which way to turn, since she died. She was my north and south, my east and west. My very star."

The husky looked up at the myriad stars and Uteq suddenly wondered why all creatures seem to make so much of one word, love. The night sky was tinged with dim colours, low on the horizon, but they could see unlucky Teela there, above Uteq's final destination at Pollooq's Paw Print. It made him think of what Sepharga had said of Mad Mooq and what he feared deep inside himself now, that one of them was destined to die out here. Then he saw it, in the heavens, at the pole, live a river of darkness flowing down towards the ground.

"You know, bear, some huskies say the stars aren't even there, or some of them. Like ghosts," said the dog with another yawn.

"Not there? But I can see Teela right now."

"Yes, bear, but some whisper their light's so far away, perhaps a billion whales' lengths, that by the time it gets to our eyes, sometimes the thing it's from is gone, or changed or dead. So that what we see isn't real anymore."

Egigingwah had caught the scent of meat though, and he sniffed and licked it on the ice. He saw Uteq looking at him rather scornfully, as if he was just some sad Scavenger, but shrugged.

"Well, we're all in the slush, bear, but at least some of us gaze up at the stars."

Uteq felt a strange longing, but Egigingwah shook himself and looked at Sepharga.

"Anyway, I think one of my masters wants to eat that one, all right."

"Eat my friend?" growled Uteq, feeling the sharpest pain in his heart.

"Face facts, bear. The Inuit have been doing it for thousands of years, using you for food, for clothes, even your oil as light, and why shouldn't they survive too? Bellarg meat's the only Lera that really tastes like Man, they say, and you are what you eat, eh?"

Uteq was appalled, yet he could hardly argue that the human animals had a right to survive too, and wondered how feeble these human creatures really were. Perhaps it was their very vulnerability that made them so dangerous then, and made them think so very hard about how they could survive and fight and destroy. Yet perhaps the husky meant something else too, Uteq thought, *that we are not only what we physically eat, but what we consume in every way, and so therefore what we see too, what gets into our eyes, and also deep into our beings.* Uteq had already seen enough, both in fact and his visions, to know that surely that could make one's being very dark indeed.

"One group up here used to take as many as seventy of you a year," said the husky, "though they say the Inuit are only allowed three or four Bellarg now. Though Gurgai are breaking the ration too, after what happened."

"Happened, Egigingwah? What ration?"

"Two years back, bear, near the Sqeet, some bears started it by attacking a human den, and killing some Gurgai. They ate a cub."

"Ate a human child?" gasped Uteq, thinking of Garq and the Glawneye in Churchill and wondering if it had been them.

"Yes, bear. Tore it to shreds, like some sacrifice. There've been other attacks too. So some angry humans have been out attacking Bellarg in revenge, and breaking the ration. An eye for an eye, eh? And from the word of a Doberman, there's some bear plan too, to get humans all worked up. The Col, or something."

"Col?" said Uteq, looking at the straps on the dogs and thinking of Innoo again. "The Collar, perhaps?"

Now there was a banging though, and the doors to one of the square dens suddenly opened and out stepped a human. He carried one of the metal sticks and the air was filled with that strange music – human words.

"What's all this noise?" he grunted loudly, though neither Lera understood him. "Growling and yapping all the time. Maybe one of the damned bear's awake."

Now an Inuit emerged from the glowing igloo, and two more followed him out to stretch their legs. Uteq had slumped back immediately, playing dead. The memory of that wolverine in the summer had saved him.

"The drugs won't wear off till morning," said a second voice. "Then we'll pump them up again, to keep 'me docile. It's why I darted 'em, to stop them blundering into camp, while we go north."

"Maybe we should set them on those damned Ruskies, Bill. Their Russian Scientific Polar Survey."

"Scientific Survey, my eye. Wake up, son," said Bill. "The Russians have got enough manned drifting stations up there, and they say there's a nuclear sub around here somewhere too, patrolling for oil contours."

"Hey, stop nattering," said a third male voice though. "We've got to up sticks, guys. So I say we do it painlessly. The Inuit want the skins – especially that one with the strange black paw, the one you saw in

Churchill, Bill. They say he's sacred, like the bowhead whale. One of the fingers of their great god Arnaknagsak."

"Stop that, Hank," said a soft female voice now though. "They're both healthy adolescents, three-year-olds, and could breed soon, and we didn't come north to start killing a flagship species like polar bears. Sure it's really all about protecting biospheres, but these are my speciality, and I've got a strange feeling about this female too. Somehow I think I..."

But the woman stopped and looked confused.

"Hey, Christina," said Bill, "and what do you think animals dream about. I mean they dream, right?"

Uteq felt a shadow fall across him, but it moved on, and he could sense that the human Bergeera was crouching over Sepharga. Slowly he opened one eye and he saw a gentle hand stroking Sepharga's muzzle – but to his astonishment, it was a human hand that he recognised. Uteq moved his head. It was like a dream, a sense of another world, but that gentle face, that long red hair. It was the human who had hand-reared Sepharga herself in his visions, and her memories, though Sepharga had said she had drowned, but with that there was a shout.

"Hey. Look out. The big male's awake," cried a terrified voice, as Uteq heard that crack, and felt another dart strike him.

"Goodbye, bear," he heard Egigingwah whisper. "Good luck to you out here."

Once more Uteq was drifting on a sea of strange images, floating across his mind's eye, that made his very soul feel queasy. He saw great seawolves and shark too in a slimy ocean, as black blood leached everywhere.

"Uteq, wake up now, Uteq."

Uteq felt a delicious warm, wet feeling on his face as he opened his eyes to see Sepharga standing over him, licking his nose, her huge eyes smiling down at him warmly.

"Stop that," he growled though, feeling suddenly vulnerable and rather foolish.

"I'm sorry, Uteq," whispered Sepharga. "But I didn't think you

should sleep any longer. The dreams were horrid. But we should get moving soon too."

"Sleep?" said Uteq, scenting a delicious smell as he noticed a strange glow flickering all around them, as green as that trail from his paw in the sea. "But where are the Gurgai, Sepharga, and the dogs too? Egingwah."

All traces of a chain had vanished. The bears were free again, all alone on the empty, desolate ice.

"The humans must have darted us, and just rushed on, Uteq," answered Sepharga. "No wonder Tuq was so strange. My head's like a snow den with their horrid drugs. The dreams were awful. Far worse than normal."

"Just rushed on?" said Uteq in surprise. "No, Sepharga. The camp, and chains, the black poles, and her. I saw them all."

Uteq looked around. There was no sign of a camp, no flag, no glowing ice den, just great expanses of ice again in the vast, open darkness, tinged with a green glow, like the algae in that pool in New York City. Uteq wondered if it had indeed all been another dream, a drugged vision, except lying nearby was a whole seal carcass.

"Nightmares, Uteq," said Sepharga kindly. "I had one last night too. Perhaps it was The Sight."

"No, Sepharga, the human Drappa who reared you was here. She's not dead. I swear it."

Sepharga smiled indulgently.

"That was from *my* story, Uteq, not ours. You're just sleepy still."

"No. They *were* here, I'm sure of it. Their husky Egingwah told me Glawnaq's attacking the humans, because of some plan about collars. Perhaps that's the secret, and there were black sticks too."

"Stop it, Uteq, please. You know you can go mad out here. Come on now. I told you they weren't all bad. They left us this seal, at least, or maybe it fell off their sled. Anyway, I'm starving, but I waited for you."

Sepharga was standing over the seal carcass licking her lips, and she suddenly growled and was going to bite down hard when she

stopped and tore a little flesh away instead, then began to nudge it to one side.

"What are you doing, Sepharga?"

"A libation, Uteq, to the gods," she growled, as a tiny drop of blood fell onto the ice, "to thank them for the food and for the gift of life. Though it's body is starting to freeze."

"The gods?" said Uteq coldly, "shouldn't we be thanking the humans now instead?"

Sepharga bit down hard though, gulping up the delicious meat, and Uteq felt his stomach churn.

"Now I'm even more lost," he said miserably. "Where are we really, Sepharga, and which way's north?"

The wind rose though and suddenly slapped something in his face, blinding Uteq's vision for a moment. It was a piece of paper, off one of the sleds, but the wind caught it again, curled it up and blew it away again, like tumbleweed across the ice sea.

"We'll never find our way," groaned Uteq, swiping his paw after it, and growling as he saw Sepharga eating the seal happily, although she answered with her mouth full, lolling her blue tongue at him.

"But I can tell you which way, dear Uteq," she said. "And for certain."

"A Bergeera's instinct? What guides all Lera in the end."

"Not at all, silly. Just look."

Sepharga swung her head, and when he turned too, Uteq saw the most beautiful, mysterious thing he had ever seen before. There, in the huge arctic night, rising like columns of flame off the ice sheets themselves, flowing upwards and coloured extraordinary shades of blues and greens, curling towards the yellow moon, the heavens were literally dancing with brilliant lights.

"The Beqorn," cried Uteq, his heart pounding. "Those that bite with their teeth."

"The Spirits," said Sepharga, her voice dropping in fear. "Of the Dead. Above the very entrance to the Underworld itself."

16

SLEEP WALKERS

*"Bright star, would I were steadfast as
thou art."*
—John Keats

S o the friends pressed on toward the High Arctic, led by the
Beqorn themselves now, and as they marched, both somehow
marked by their strange journey, each began to wonder which
one of them was walking towards their own death, or if they could
ever escape a vision. They thought of the lemming's words and there
being no return, and they wondered if they were mad indeed to
pursue this impossible course, as they grew hungrier, colder and
lonelier.

A huge, yellow full moon had risen one night, so close off the edge
of the world that it was as if the great ice sheets had somehow spread
out across the end of the flat earth itself, and it seemed that the polar
bears could walk straight across them, and onto the great moon itself
and see if Atar was real, or if a bear did look down on all. They could
sense they had come very far north indeed now, and their apprehen-
sion began to wear on their spirits, while Sepharga was praying that
they might find some birds out here they could eat.

They suddenly stopped dead. Straight ahead were strange shapes
rising up out of the windswept ice, like little pointed boulders. They
looked like the snow carvings that Uteq had once seen in the walls of
the Ice Cliff, ice crystals streaking off them in the punishing wind, and

as the two drew closer they seemed to be shaped into the forms of seated polar bears.

"Uteq, could the winds have done this?" whispered Sepharga. "Atar's breath, just like the Seeing Caves in the story? It's so strange. Are they growlers, Uteq, frozen to save their souls?"

As the friends drew nearer to the shapes, like sleep walkers themselves, they suddenly grew afraid. These weren't ice carvings at all, but real Bellarg, dead polar bears, frozen and covered with snowfall, out here on the Ever Frozen Sea. Twenty of them were sitting in a wide half ring, facing out towards the world. As they drew closer beneath their snow shawls, Uteq and Sepharga began to make out brittle, frozen hides, and as they passed among them too, seated there like some forbidden Bergo Council, all had fur sleeves that hung down like ice sheets. They looked like Still Hunters, their coats standing sharply on end, their grave faces locked in the deepest concentration, as if some arctic enchanter had put them all to sleep. Some of their mouths were frozen open too, as if they had been just about to say something, while others looked as if a half thought was caught in time, in the seizure of their changing expressions. In the moaning wind, it felt as if the very air was haunted, and the two polar bears suddenly wondered about those lost souls Mitherakk had warned them of, tricking them in their journey.

"Are we there then, Uteq?" gulped Sepharga, beginning to tremble badly, but trying to keep her voice down. "The fabled entrance. Will they speak to us? The Dead. There's no river here though, of water or Garn, just flat sea ice."

"Fellagorn," gasped Uteq suddenly. "The Scouts that froze that terrible night. It's the Field of the Fellagorn Dead, Sepharga."

Now they saw too, beyond the ring of frozen Storytellers, the remains of the other murdered Storyteller Scouts, who had fought in that fatal battle, though deprived of their real Word Power. There were Fellagorn bones and bodies everywhere, a field of frozen corpses, cut down like arctic flowers, while the ice was blackened with their frozen blood. It was a bitter sight, not least since what Uteq and

Sepharga had experienced only as a story, had suddenly taken on a ghastly reality, like staring their own deaths in the face.

"Mooq," said Uteq. "He *could* prophecy then. Mad Mooq talked of coming here too."

The memory only made Uteq think of Matta though, and Mooq's words of a betraying sister, and then wonder why Mooq had wailed in terror at some other vision?

"Three whole years," said Uteq sadly. "They've been out here three whole years."

They had been frozen here as long as Uteq had been alive then, but Uteq was suddenly shaking, heard a thundering in his ears and looked terrified.

"What is it Uteq?"

"When I was born, Sepharga, my mother saw this, and heard the cliff fall too. It terrified her and me too, I think. I think that turned my paw black. I wonder if I am more linked to Anarga than my father."

The eerie moon shone down on the seized dead and a grave fear was settling on them both. They padded on, subdued by the utter loneliness of it, wondering if the Storytellers' vengeful spirits would suddenly rise around them indeed, or Gog breathe down his heat to release their captive souls. Sepharga, in her biting hunger, had a dark thought too, as she looked at these dead creatures, but she pushed it off. Then she saw two bears lying there who had once been Beloq and Teleq, while Uteq walked up to one older than all the rest, lying on his back, his aged arms open wide as if trying to embrace the stars themselves.

The ancient Bergo's filmy white eyes were wide open, looking up at the heavens, although the ice around him was still dark with his icy blood. The Great Master lay alone, a strange look of peace, even of triumph, on his aged face, gazing up with his filmy dead eyes. Uteq wondered why he seemed so at peace, somehow so satisfied, and he reached out to touch him, but then he recoiled at what life always finds impossible to understand and must speak of only in stories, perhaps, death.

"You think their souls have really gone north, Uteq?" asked Sepharga. "To crowd the entrance like bats, Mitherakk said."

Uteq thought of what he had said about growlers restored and touched the brittle body now. Only the wind moaned around Sorgan though, and if Uteq had expected to hear or see anything at the touch, he felt nothing at all. Uteq was touching death, such a natural part of reality but not of life.

"Gone," he sighed, pulling his black paw away again. "So long I've wondered what a twice born means, Sepharga, but now I know that when you're dead, you're dead. The body doesn't come back at all. And if it's you, Sorgan," he added, looking down, "there's no Great Master to protect anyone anymore, or to help the One either. No warriors left, except the Serberan."

An anger was rising in Uteq and Sepharga wanted to reach out to him in his loneliness, in front of this proof that his whole journey was failing. She could see the emotions working deep inside the polar bear, as if Uteq wanted to defend himself from everything but could not control the confusion, and his mounting desire to lash out. Yet what was Uteq fighting now, but ghosts and shadows?

"Why do you look so smug though?" he suddenly growled bitterly at the dead Fellagorn Master. "Why didn't you fight and turn on the Ice Slayers like real warriors? All your stupid, powerless words and stories. What good were you at all as real Bergo? You betrayed us all."

Suddenly, in the darkness, the ice sang, and there was a boom under the sea.

"What's that, Uteq?" cried Sepharga. "A waking god? The monster? The Gorg?"

Uteq pressed forward on his haunches and snarled at the sound. With that the Frozen Sea itself cracked open, and a huge black metal shape reared up among the corpses, smashing through their frozen vigil, hurling empty bodies left and right. Some bounced likes Boggets, and others fell into the suddenly appearing water with a splash.

"The Evil One himself, Uteq?" cried Sepharga. "The Ice Lord of the Flies has come."

The polar bears looked back in horror, dawfed by a strange metal tower, poking straight up out of the sea ice, piled with great ice shards around its hard, black sides. Uteq remembered the story of the bergs, not myths, but huge and plunging down into the sea, and wondered how much lay beneath life's surfaces.

"The Gurgai, Uteq, they're here too. Inside that thing now. I know they are. Man."

As he nodded, Uteq suddenly felt a furious desire to be freed of this journey, but to know the truth too, to know what was reality and even the lore. As his black paw touched the ground his whole body went rigid, locked to the ice itself. Uteq's vision was suddenly travelling down through the water below the Frozen Sea, to the deepest seabed, where a Russian explorer had planted a flag so recently, as if claiming ownership of the whole world and Uteq could hear a terrible pounding, like this father's heart, or was it his own?

"Uteq, what's wrong?"

Uteq could not hear Sepharga, yet he remembered something about hearing the very polar heartbeat itself. Then his vision was travelling on, down into the earth, burrowing like some enormous garter snake, into another great, dark sea, a sticky black soup, held inside the rocks themselves. The black blood was here too then, far below them. Was that all the Gurgai sought, he wondered, out here in the wild arctic?

Somehow Uteq knew that this blood was not made from trees though, as before, but the crushed bodies of dead Lerop. But how, he thought, and how did it somehow contain the past? Down his vision went, through miles of black blood, into earth again, until it burst into a sea of red, like real blood. Except it wasn't blood, but fire, flame and molten lava; the red flowers, flaring in a fiery inferno, a very Hell itself, for a polar bear. Uteq pulled away in horror and fell back, wondering if he had found the terrible entrance, or was dreaming, or it was just The Sight. He clutched at the cold ice, trying to gather it into him to cool himself, but somehow his vision had affected his mind and the freezing ice seemed to burn him instead, and he sprung up again. Uteq was

345

staring furiously at the dark tower now and the dead Storytellers too.

"Hell," he snarled, "they see it too then. The monster is inside that thing."

The fury that Uteq had just felt, and a memory of being chained up in the camp, was filling him with an unbearable rage.

"Sacrilege. Don't you care who they were? The Fellagorn. Don't you care about anything, Gurgai scum?"

Uteq roared and rushed at the monstrous shape, growling and snarling pointlessly at the huge metal vessel, rearing up and banging and bashing on its sides impotently.

"Don't, Uteq," pleaded Sepharga, "you'll only hurt yourself."

Uteq's claws slipped anyway and the polar bear tumbled back onto the broken ice, as clumsy as a helpless cub. He lay there, as if defeated by Sqalloog, furious and humiliated, then he pulled himself up once more, snarling at the human monster again, but suddenly turned, with an awful wail, and ran straight past Sepharga to get away forever.

"Wait, Uteq. Come back."

"No, Sepharga. Just leave me alone. Please."

"Alone? But, Uteq, please, I promised Mitherakk, and I'm your friend."

"Friend? Like Teela asked for Pollooq's friendship?" snarled Uteq, as she began to run after him. "What do promises matter? They're lies, like everything in the world. Stories and dreams. Myths. We're born alone, and we die alone, can't you see that? That's the wounded bear."

Uteq was almost galloping, and Sepharga finding it hard to keep up as he began to growl even more furiously. His eyes were dark with a terrible anger and he could hardly breathe, or see straight either.

"Stop, Uteq, please. The Ice Madness." Sepharga's voice was really frightened now and Uteq did stop, but he turned savagely too, opening his mouth, and baring his teeth at her.

"Stop? Is that all you can ever say? Those monsters are here, now, and killing the whole world. That's no bad dream, she-bear. While the

pact's destroyed, and Glawnaq masters the Barg. The Fellagorn were liars too, cowards, like the bears at the Council, and now they're all dead. Glawnaq triumphs, just like the Pheline did. We've all become his slaves, whatever his real secret."

Sepharga looked at him helplessly but gentle Sepharga didn't know what to say.

"And what good are you, Sepharga? Always so scared, always saying be careful, and peaceful."

There was a sudden tightness about Uteq's body, or his mind, as if seaweed was binding his arms like Pollooq.

"Why shouldn't a real Bellarg feel a rage though, as great as the dying, unbelieving world's? As great as Glawnaq's, or Pollooq's, blind, chained, telling his stupid fables, to save his non-existent soul? Why shouldn't Bellarg think like the cunning Pheline and build a fortress by conquering all? The only true fortress now."

Sepharga backed away as Uteq began to advance on her threateningly across the sea ice.

"And the Gurgai, Sepharga. Maybe *you* brought them here. I only started seeing their world when you saw their ship, and then when I touched you. Did you summon them then, like Teela led the Pheline down on poor Pollooq, betraying him with a Bellarg's kiss, you little traitor?"

"Uteq, how could—"

"Mooq said it, sister, so perhaps you betrayed the passing word that sun. Betrayed me."

"No, Uteq, that's lies. I was with you all the time. That's the truth. End of story."

"What is truth?" Uteq snarled. "What is the blasted Ice Lore? Stories or lies. Can't I ever be free? Father's dead. Murdered. Mother may be dead too, but no one ever showed me how to fight in the real world, that's the truth, and I'm lost in a story I don't even understand."

Sepharga's huge eyes were filled with a sudden tenderness.

"Oh Uteq, I know, Uteq, I'm sorry, but we must—"

"Sorry? Don't you feel or care about anything but your blessed peace? Can't you stand up for anything? Even a Bergeera will kill for

her cubs. You feel no anger though, no ideals, no courage – always wanting to be invisible, and not be any trouble. Such a political animal. I hate you, Sepharga."

For Uteq, it was suddenly like looking through a dark tunnel with a single, searching eye, or through the passage of a snow den, or a human's telescopic sight. His mind was hunting for answers and he suddenly felt a terrible will inside him too, that seemed to set him apart from the whole world.

"Stop, Uteq, please. You're—"

"Frightening you, Sepharga?" he snarled. "I'm glad, stupid Bergeera. Why don't you just leave me out here then, alone, and abandon me like the rest of them. Like the whole world."

Sepharga felt some strange resistance at the bear's self-pity, but she kept her voice calm and strong. She had remembered what Mitherakk had asked that a Bergeera might do in the face of a Bergo's helplessness and rage and suddenly Sepharga knew.

"I won't ever abandon you, Uteq. I swear it on my life. On the sea. Oh, Uteq, I..."

Sepharga did not say what was so deep in her soul, just what mythic Teela had denied in the story, but Uteq raged on still.

"And even if the damned Gurgai are destroying the world," he cried, "we're all going to die one sun ourselves. So why does anything matter? I lied at the Council and I'm just going north because I'm a coward. Not any hero at all. Besides, what stupid hero alone could ever stop what's happening to the world now? I've always feared duelling Glawnaq too, if you want the truth, Sepharga, even to avenge my own father. I'm a coward."

"No, Uteq. The journey. Keep the—"

"Faith? In what? Ideals? In blinded, broken Pollooq? In lovely, lying Teela, perhaps? In the Ice Lore, or man's black blood and murderous *Scientia*? Or in a law of nature so cruel at times, in beggar's belief? How could any One change that? There are no heroes, Sepharga, no gods, and if Pollooq suddenly did appear again, what do you think would happen anyway? He'd just be blinded once more and killed, because no one would even believe him."

Poor Uteq knew that he was ranting now, and it was all too much.

"Is there nothing in the world but fighting or killing, and a curse in nature none escape? Something always pays the price for life."

Sepharga raised her head though and lifted her paw gently.

"Oh, dearest Uteq. What can I—"

"Help me," moaned Uteq, "because I don't know how to help anybody at all."

Uteq dropped his head bitterly and almost sobbed.

"I'm sorry, Sepharga. I'm so, so sorry."

"Oh dearest Uteq, but there's peace too. And love. Where life really grows."

"Love?" wailed Uteq. "But don't you see? Love only opens you to the pain of it all. The Sight. Sometimes it swamps me, like the sea. All the feelings. The thoughts. I feel the pain in nature everywhere."

"Yes," said Sepharga softly, though she thought of Innoo. "Is love itself the real wound then?"

Uteq blinked, his feelings so deep that he felt they would drown him, but it was one thing alone that Uteq thought of as she asked of the wound, and not of Pollooq, nor his parents, not Glawnaq either, or even Mithril's wounded eye. Strangely it was the taste of that hot fish in his mouth, by the sea that sun when he had first touched the black blood in the bay. Yet Uteq seemed to calm a little at Sepharga's steady voice and his vision cleared and the terrifying tunnel was gone.

"I'm sorry, Sepharga, I don't know what's wrong with me. It's like some bad Beeg's got inside me. Please don't tell anyone."

Sepharga was surprised that Uteq was worried she might tell anyone, especially out here.

"I won't, Uteq, and nothing's wrong with you. You're just angry and frightened, that's all."

"I felt so strange though, so dark. It was horrible. I must sleep, Sepharga, sleep."

"Over there," growled Sepharga, looking toward a small pressure ridge, rucked up by wind and snow and the sudden changes in atmosphere out here. Sepharga thought it might give them shelter

from the growling gale and Uteq nodded wearily. He walked over and lay down in its lee, as the polar bear closed his eyes thankfully.

"Thank you, Sepharga, for not breaking your word, and staying true to our pact. It's kept me sane, I think."

"Maybe it's just hunger, Uteq. I wish I could give you some of my own Garn. I miss the way Toleg used to hug us all. That felt like it gave me Garn. But let's think good things. Shall I tell you a story?"

"A Bellarg legend?" whispered Uteq faintly, as the she-bear sat down beside him in the wind.

"Why not a musk ox one instead? Remember that lone ox we met in the spring? He told it me. The story Mitherakk promised to make for dear little Mithril, to help her heal and grow."

The wind was moaning louder and Uteq's voice growing fainter as he laid his head on the ice.

"About the she ox with only one—"

"Yes, Uteq, one eye, but how she grew into the cleverest she-ox in all the world, and spent so much time thinking, that she grew cleverer than anyone else, and so a princess of all the musk ox herds."

Uteq had not really listened the first time and now he was drifting between sleep and waking.

"Many young oxen admired her, but when they tried to come close, she would always turn away. But one day a brave young ox came wandering by and fell in love, although he could only see one side of her. 'What are you staring at?' she lowed, as she sensed him. 'You,' he answered. 'You're so beautiful. I love you. Will you love me too and walk with me forever?'

Sepharga looked down at Uteq's coat, and with no reflected light suddenly realised the hairs were not white at all, but transparent. It was as if she could see the hollow filaments that made them up now, which makes them so perfect for absorbing sunlight or warming the black skin beneath, reflecting the snow.

"'No,' said the proud ox princess, staring towards the horizon,' she went on though, 'You're a liar. And you can't love me; you haven't even seen at me properly.' The princess swung her head then and stared

him in the face. 'See,' she lowed, irritably, seeing his surprise, 'I told you.'

"'I still love you,' lowed the fine young ox though. 'Why? Don't you think I'm handsome?' 'You're not bad,' sniffed the she-ox, thinking him very handsome indeed, 'But I still can't love you, because if you think me beautiful, then you must be blind, and a fool.' Now the she-ox thought this was very clever, but the male ox held his ground. 'I still love you, unconditionally. Even if you think I am stupid.' The young ox looked rather hurt none the less. 'I do think you're stupid, and I know stupid. Like all those horrid calves who teased me when I was growing up. But I showed them.'

"'Please love me,' said the male ox, 'I'll do anything for you.' Something woke in the she-ox now, for in her heart she was very kind, yet extraordinarily determined too. 'All right then,' she said, 'though you're clearly mad, go through the entrance into the dark world, and find my right eye again.'

"The entrance to the Underworld?" growled Uteq dreamily, as he listened, "up here in the frozen North?"

"The dark world in the story, Uteq," said Sepharga, a little irritated Uteq had interrupted her, "But anyway, the young ox looked astonished. 'Where's that?' he asked. 'Well I don't know *that*,' answered the she-ox, although she loved fairy stories. 'Brave, male musk ox are supposed to know *that*. But deep in there, and among all the dangers of the world, bats with big teeth, snakes with giant heads, lies a cave, where my eye sits on a rock, guarded by three blind enchantress oxen, tossing it from horn to horn, because each uses it see with, and tell the future. They've a servant too, a terrible one-eyed giant, although his eye is in his forehead. If you can find the entrance, fight all the animals and find my eye, I will love you. Though you'll be even more stupid to try, because none has tricked the enchantresses, or been strong enough to battle the giant, let alone find the entrance.'

"Now the ox was filled with fear, and his heart quavered but he nodded nonetheless, and set off. He travelled everywhere, and fought many creatures, but he couldn't find the entrance anywhere, and one day grew so weary, and missed the she-ox so much too, that he lay

down, laid his head to the left, and simply fell asleep. But when he woke he was smiling and mooed and ran straight back to where he had started, and walked right up to the princess.

"'Well? Did you find the way in?' she asked loftily. 'Yes, and fought the creatures, found the cave and met the three enchantresses too.' 'Oh,' she said, since she thought it a story, 'and how did you trick them?' 'I didn't. They'd never stop cackling, so I just told them to shut up, or I'd bash them with my horns. And though I've fought many battles, the giant was fast asleep, and snoring like a lord.' Now the princess was looking at him sceptically with her one, clever eye. 'And my other eye?' she said, 'did you find it? Give it to me, and I'll love you, I promise.'

"'No, answered the young ox, wanting to kiss her lips, 'it wasn't there.' 'Then you've failed," she lowed, 'so face reality, and go away.' 'No,' said the ox. 'I love you. And you were wrong, your eye wasn't in the cave at all, it's here, in the sunshine.' 'Oh what are you talking about, idiot,' said the princess, a little nervously. 'Where?'

"'There,' said the ox, looking at the right side of her face, 'where it was all along. Now look into my eyes.' The princess had often been nervous, because she sometimes saw Lera's nervousness there, or thought herself ugly, but she peered deep into his eyes. 'Deeper,' insisted the ox. The princess felt as if she were swimming, but as she looked, she felt her heart melting and saw herself in his eyes, blinking with two huge eyes too, and knew how beautiful she really was, and that she loved him too.

The wind whistled and Sepharga looked down longingly at Uteq.

"'Don't you see,' said the ox," she whispered longingly. "'I can't see you haven't an eye. And even if I can, it doesn't matter, because real beauty is within and I love you. And if you're stupid enough to look for some clever clogs who could love you more, then you're more stupid than me. And I am quite stupid, sometimes.' 'Right,' whispered the princess humbly. 'So we're off,' said the ox, 'And when you're not sure what's coming from the right, I'll tell you. And when you feel unsafe, I'll love you. And when—' 'Shut up,' said Mithril then, 'I love

you too.' So they lived happily ever after, and died together happily, though they built a fine herd."

Sepharga stopped her story and she was looking back at Uteq very strangely, wondering to herself what stories are for, if they are not real, but she felt Uteq's breathing change, and knew he was asleep. The gentle, brave Bergeera looked down at her friend, marked out by his black paw, thinking of how he had been hunted savagely when Uteq just wanted to be an ordinary bear. Then kind Sepharga growled, and with infinite care, she lay down to shield him from the biting wind with her own slender body.

"I won't leave you, ever, dearest Uteq, but don't ever scare me like that again."

Uteq was suddenly murmuring to himself though. "Why, Matta? You promised we'd have beautiful, happy cubs. You were my faith. How could you? Like Teela tortured Pollooq. It hurts so badly."

Poor Sepharga looked desperately sad now as she lay beside him. "Oh, dear Uteq. To travel with you so far, without you once even realizing how much I..."

The wind caught her words as she closed her eyes and fell asleep too, exhausted, the rhythms of her heart beating in tune with Uteq's own. Uteq was dreaming very deeply now and he saw Matta and shapes of the past, or shadows of the future, up there, so close to the Realms of the Dead, and seemed somehow to struggle to know if it was real, or a nightmare. Then he seemed to be in a snow den and there was Nuuq, denned like a mother. Then he was outside it in the snow, and there stood a Bergo, guarding her proudly, who looked a little like Seegloo. But in the eerie moonlight another Bergo was creeping towards Seegloo, stealthily, and as he turned, there stood none other than Qilaq, with a huge fur collar at his throat. Uteq remembered the Glawneye saying he had a taste for blood and suddenly he lifted his paw and Uteq was horrified to see an Ice Dagger in his paw that Qilaq plunged into Seegloo's chest and a word was crying on the arctic air – '*Murder*'.

Uteq opened his eyes with a jolt and turned his head. His vision was cloudy still, dreamy, and as the wind moaned, he felt a terrible

loneliness, for Sepharga was gone. Even she had abandoned him then, he thought scornfully, and had broken her promise to stay with him on this terrible, futile journey. In that moment he thought of Pollooq again, and this strange vision he had just had of Qilaq murdering Seegloo, and he heard Pollooq wailing of a dagger plunged into his heart by Teela. His vision had returned to that dark tunnel again and he felt an awful loneliness, and the moaning arctic was a terrible place indeed. Uteq wanted to turn and run home, to Anarga, to his cubhood, and be safe again, but in that howling snowstorm of darkness, he blinked and saw a shimmering shape instead, glittering and glowing brilliantly on the ice. It was a Bergeera.

"What's happened to you, Sepharga?" he whispered wonderingly, blinking hard and getting up.

It was a she-bear all right, yet as Uteq looked now it was somehow Sepharga, but Matta too, and his mother also, and as he moved, it moved with him, like his own shadow. Uteq remembered something Mitherakk had said, about seeing things only in love, or in extremis.

"A goddess?" he whispered. "Are you holy Atar herself?"

Uteq remembered that the gods were within though, and felt a terrible longing. He was all alone and the Bergeera was so radiant, so brilliant, that it felt like looking into the face of Gog. Uteq growled, and with a desperate, impossible will, as if he wanted to break through the ice walls of reality itself, he ran frantically toward her and flung his arms around the glowing light and tried to hold on to her, as if he could draw her inside himself and heal.

In that exact instant the air was filled with a terrifying scream though, far louder than Pollooq's in the cave, and Uteq remembered Matta's fury fighting Qilaq, or anything being trapped. He was hurled backwards, onto the ice, and the shape was gone. It was a waking dream though, for Uteq was on the ground still and felt he was still asleep, and to confirm it Uteq saw three shapes in the far distance, a narcorn, turning into a narwhal, a snow owl, yet small and silly, and not wise at all, and a golden ermine, except just a dull yellow. They vanished too and Uteq laid down his head sadly on the ice again. The Pureem were lies too.

Uteq closed his eyes again and slept on. In truth he was lying next to Sepharga still, and the Beqorn flickered and flowed at the edge of the world, but if a wild animal had been looking on, it was as if an igloo of light had suddenly settled over the Bergo and Bergeera, to protect them from the deepening shadows. When Uteq really woke again to see the clouds like an ice sheet above, he felt clearer, and rolled to see Sepharga close by too, though set apart.

Uteq felt a furious relief that she was here still and knew he could not have woken in the night at all. Yet that strange glowing spectre had been so real, and a warning voice was telling Uteq that the murder he had seen, Qilaq's terrible crime outside Nuuq's snow den, had been very real too. He knew it was The Sight, yet had the crime just happened, or was it still to come?

The friends were distant that day, Uteq unable to tell Sepharga about his dream, or that glowing shape on the ice either, and Sepharga too was strangely tongue tied. As they went on though, their fear seemed to crowd in on them again and Sepharga started to speak of what lay ahead.

"I thought that human craft might be the Evil One, Uteq, but is his lair really up here?"

"We have to face him if it is, Sepharga. But the dead will show us the truth. Of Man and of Lera too."

Uteq looked very mournful indeed but with that they heard a savage cry, a cry they both knew all too well. "*Aoooooow!*"

"Varg, Uteq," cried Sepharga, "wolves, I knew something was following us, but I thought..."

Now six huge wolves came racing across the flat sea ice, led by a huge Dragga and Uteq set his haunches square, remembering how he had turned on Sepharga himself, and opened his mouth and bellowed. But now his anger was controlled and directed, with the purpose of protecting his friend. He surprised himself, as Sepharga looked at him admiringly, to see suddenly how he had grown, and how small he had seemed the night before.

"Get back, Varg scum," Uteq bellowed furiously, "if you know what's good for you."

Sepharga was starting to chuff proudly at his side too, and the wolves suddenly looked frightened, for at a distance they had thought the bears were just cubs, not grown Bellarg. Though the Dragga threw back his head and howled. It was different from the cry that had just alerted them, or had followed the Fellagorn, or indeed from Karn's wind talking, full of such warning and anger, that it seemed to cut into the Bellargs' very souls. It carried a word deep inside it too, a sound both of loneliness and warning, and a cry that wolves know above all – 'exile' – like a clear marker on the arctic air.

"I know that voice," Uteq grunted suddenly. "I heard it outside our den, Sepharga, in my little dreams after I was born. Is this Treeg then? Then he's always been hunting me. A Dragga spy and mercenary."

Uteq reared, surprising even Sepharga with how strong and huge he suddenly looked.

"Filth," he cried. "You dare challenge a wild Ice Lord? Is nature itself turned upside down?"

Uteq roared as loudly as he could, and the Dragga shook as his wolf comrades cringed back. The friends looked magnificent, and Uteq felt a wonderful, wild anger flowing through him.

"You, BlackPaw," trembled Treeg. "It is you then. So I bring you a bargain. Glawnaq's exile in the north forever. Quite a lair, up here, for the Ice Lord of Lies."

As Treeg snarled another *crack* rocked the sea. The wolves saw the bears standing side by side, but one wolf squealed, for a fracture the size of his tail went shooting between his legs, straight towards them both. The crack got wider, revealing the cold, wild waters, and it moved so fast the polar bears had no time to react at all. It cut right between the two, and as the ice opened, Sepharga fell sideways straight into the ocean. Uteq seemed to totter too, gripped with fear, but his brow knitted with resolve and he threw himself after her. *Splash.*

The wolves watched in amazement as the polar bears' heads bobbed there in the wild sea, while the crack was closing as quickly as it had opened, as the bear's heads ducked and the sea slammed shut again. The Ever Frozen Sea had swallowed them both completely.

Treeg and the wolves just stood there, gawping, astounded, as if a legend haunting them all for so long had just been gobbled up forever by life's remorseless chances, but wolves see well in the dark. The snow heaped up on the wolves' backs, but their fur was true, and the adrenaline was pumping powerfully through their veins, so none of them were cold. Time seemed to stand still, frozen itself like the Fellagorn, although one of the wolves thought he felt a faint pounding beneath them, but the frozen sea did not open again. At last, a strange hush fell over the startled Varg, as the wind moaned wildly around their heads.

"They're gone," Treeg grunted at last. "Down to the Underworld, even before they took the bargain. Some mad bear spoke of a death in the north, but it's two, it seems. Death's their true exile then, and the Great Story dies with them. Is not life strange and brutal, Varg? Come then. We've much to tell our Master."

"Ooooot – eq!" Sepharga cried as she fell and the ice-cold water engulfed her, filling her mouth and nostrils and making her choke and spit, and all her senses revolt. "Then it's both of us, Uteq, Mooq's prophecy. We're lost."

"Suck in the air," growled Uteq "Remember Flep and Rurl. Sepharga. Hold your breath and turn."

The polar bears gulped in as much air as they could, and down they went, as the solid ice closed above them. Under the water and the ice too now, Uteq span, and in the furious, freezing arctic, Sepharga felt his movement and copied him. Uteq had his paws locked on the ice, literally clawing through the blinding sea in the dark and wet. His movement made it easier for Sepharga, who was slip streaming him now. Sepharga felt a terrible fear enfold her though, yet she knew there was nothing to do but hope and struggle and fight. The sea was desperately cold, their coats soaked through, and they felt a pain growing in their great chests, as the air failed in their lungs. They also sensed the depth and vastness of the ocean below them.

There was a swift current though, and they were swept a long way, but hope was dwindling fast, as Uteq began swinging and bashing at the ice above, trying to break through. It was of little use though, for the ice was thick and the water killed his blows and not only the bears' strength but their breath was dying. It was useless. The Ever Frozen Sea had turned into their tomb.

Suddenly Uteq found himself wondering if this was the Underworld indeed, and he could talk to the dead, but now Sepharga blinked as the water stung her eyes, because before her she suddenly sensed a glowing green trail, like Green blood, but it vanished. They were drowning indeed, doomed, but then Uteq heard a noise, like a faint memory, of something from his own cubhood – a promise from somewhere very deep indeed. "*Aaaaaoooooooh.*" "*Aaarrrrwoooooh.*" "*Aaaaaooooooh.*"

The distant moaning was really filling the water, not Uteq's mind at all, and a sharp hope gripped his heart. The bears felt it against their bodies too, the pressure of something quite enormous moving upwards fast. Suddenly a vast grey shape rose in the pitch-black water nearby, and its huge back struck the ice roof. The Frozen Sea broke open immediately, splintering great ice blocks into white shards in the heavens. Although the Bowhead whale was suddenly descending again, the polar bears were sucked out from under the ice, and out into open water. They gasped and thrust their heads above the sea again, to draw in the wonderful life-giving air.

"Oh Uteq, that lovely creature saved us," gasped Sepharga, in disbelief. "We're not dead at all."

"Then perhaps things can change their own Karmara," growled Uteq with a smile, although Uteq knew there was no time to delay. He bit at Sepharga's fur and pulled her toward the edge of the ice, just as she had done to him on the raft, and clawed his way out of the ocean, as she clambered after him. The two collapsed side by side, Sepharga gulping in air at first, but closing her eyes in exhaustion and the snow fell, as the wind brushed them and something in Uteq knew that if they just lay there, it would all be finished. With a growl, he staggered up again.

"No, Sepharga, don't sleep, breathe, breathe deep, and remember the shark and The Ice Commandment too. Our coats, we must get the ice crystals out. And keep moving out here."

The Bergeera had heard him, and pulled herself up as well, if half reluctantly. Brilliant, deadly ice crystals were already forming in their coats and the friends stood opposite, shivering terribly and their teeth chattering mercilessly.

"I know, S-s-s-sepharga," said Uteq, "we'll pretend we're shaking our coats in a Moon Duel."

"Not like S-s-serberan though," Sepharga shivered, her dark eyes glistening defiantly, "but like F-f-fellagorn, Uteq, throwing stories and w-w-words at each other, at a brave Telling Moot."

"Yes, Sepharga, yes, a Telling Moot."

They both shook their backs now, sending sharp, glittering icicles flashing out into the dark and freezing air.

"The whale, and your G-g-g-garn, Uteq, the Lera really are drawn to it then. Before the bowhead came I saw that green glow."

Uteq did not want to think of it now, yet it was an extraordinary thought.

"At least those Varg will think we're dead, Sepharga. If we ever return from Hell."

"Uteq, you were so brave back there with those stupid wolves. I'm so proud of you. You've grown up, Uteq. You know, you look like your dear father."

Uteq was startled and pleased, and bending down, he rubbed away some snow with his paw. As if in a dim mirror, under the sudden moonlight through a cloud break, Uteq saw his own face. It had filled out indeed, his form large now and he seemed to see something of Toleg there, yes, but of Anarga too, and yet something that was neither of them. Uteq was suddenly proud.

"Oh dearest, Uteq," whispered Sepharga suddenly, "I love you so."

Uteq looked up in astonishment, and Sepharga almost blushed, but she began to stutter. "C-c-couldn't we run away? Together. And live, wild and free. Not exiled, but side by side."

There was something suddenly confused in Uteq's eyes and he felt a strange conflict of emotions.

"Free, Sepharga? But, my black paw, and what we've set out to discover. And we're friends, and I made a—"

"I know, Uteq, a promise to Matta, and I'm sorry, I shouldn't have said it."

Sepharga dropped her lovely eyes, but as she looked down she growled furiously. It was as if the intensity of all that had happened, the very feelings between them had taken on physical life and were changing into colours now flowing into Uteq's paw print, coalescing in the snowy ice, just as they had in the mark of Sorgan, glittering and glowing, as they spread out before their eyes. Then magical pictures began to form between the two polar bears.

At first it was like the Gurgai images they had seen together, melting ice, and then trees being cut down, but then they saw a trail of what looked like Barg, from all they had heard of them. There were old cubs there, and weak Bergo and Bergeera too, traipsing wearily down into a wide ice depression. Some looked hopeful, but others seemed filled with terror.

"Where are they going?" said Uteq, wondering if murderous Qilaq was among the Glawneye that they could see too. As they watched though, fascinated, and the emaciated Barg reached their destination, their mouths opened in absolute horror. Uteq seemed to hear a voice telling him it would show him evil's real face.

"Glawnaq's secret," he hissed. "Not the human prison, or Snow Raiders either. Not the Col, Sepharga, but the Cull."

"Cull?"

"Yes, Sepharga. That's what the dogs really overheard. And why the Glawneye ate a human cub too, to turn Man against us and all of nature. Glawnaq's not just making slaves then, and calling them blessed, he's culling them, killing them all steadily. That's his real plan. His solution. And now his Glawneye are cannibals indeed."

The word came with the hiss of Kassima, Evil, as Sepharga saw those gullies of blood in the ice running red. Cannibalism is known in nature and yet, this systematic 'solution', this vicious selection, had

united the darkest, wildest instincts of animals, with some ghastly rationale of Man.

"I know nature and the world can be hard, Uteq. But this. It's so horrible. Are they demons?"

"Not only Man's evil then, but Glawnaq too. He *is* a monster."

"But why, Uteq, why?" asked Sepharga bitterly.

"Space, Sepharga. That's Glawnaq's Pheline logic, learnt from Man. If the ice is dying, by steadily culling the weaker Bellarg, there'll be more room, and more seal too."

Sepharga was shaking her beautiful head, trying to resist the truth of what they were seeing.

"And yet...Glawnaq," said Uteq gravely. "No bear could do this alone. He calls to something inside *us*, Sepharga."

As Uteq's black paw pressed down now, his ears were filled with a terrible sound, the sound of screaming. Now it wasn't the ice, or Pollooq either, but the Bellarg. Sepharga looked up, and she found it hard to breathe but she had snapped out of her trance, only to look newly horrified as she peered about.

"Oh Uteq, but we're not on land at all."

It was true, for the dripping bears had really climbed out onto a long strip of ice that was floating in open water still. Uteq seemed hardly able to move though, or to think clearly.

"Uteq, please. The land. The Ever Frozen Sea. Teela and the Paw Print. Our quest."

Uteq's senses seemed to return and a semblance of some will and motion.

"Yes, Sepharga. We'll have to swim again. It's not far. Come on."

Sepharga went first and the clean sea woke them, as they began to swim toward the land. It advanced toward them too, for the chasm that had opened was closing once more. Sepharga was just behind, as Uteq started to pull himself out again. But as he did so, the thought of what he had just learnt of the Cull, and what he had said of Glawnaq calling to something inside *us*, froze him, as he felt an awful resentment about his special mark and all this incredible story expected of some Saviour. Why had he been marked out so?

361

So Uteq did not see that, as Sepharga's paws clawed at the ice, they slipped and she lurched back. The splash stirred him, and he turned and reached out with his paw, but just too late. Uteq missed his friend.

"No, Sepharga," he cried, "No."

The far side of the break was moving at a furious speed toward him, and in the gap, he saw Sepharga beneath the dark water, air bubbles trailing desperately from her lips, her huge, terrified eyes gazing up pleadingly. There was still a look of horror on her beautiful face from what she had seen of the Cull herself, and with it a strange resignation too, as if she no longer wanted this painful life at all. Below her, the open maws of the bowhead whale seemed to be sucking her downward too into the endless depths.

"Sepharga," bellowed Uteq desperately, as he flailed toward her, and now that weed of mist was back, but attached to Sepharga this time and it was tearing something out of him. Even as he groaned in pain, the Frozen Sea veiled her, with a thunderous crash, and Uteq snatched back his black paw, as the ice slammed shut. The polar bear banged at the ice desperately, like Toleg had, but it was too thick, and he was too young and slight. Uteq stood praying for the whale to break the sea ice open once more, yet not believing it either.

Suddenly though, across the ice, Uteq saw not one but two golden shadows. They looked liked Toleg and Anarga, reaching out for each other with their paws, but they missed too and vanished again into nothingness. They had missed then, just as Uteq had missed Sepharga, and now he heard Mad Mooq wailing at him as a cub: "*Murder. It shall murder the ice lore.*" Uteq was to blame and as he looked down, at where the sea had shut, the ghastly images began to come again in the moonlight. Uteq was all alone now. No protective parents, no wise Council, no great Ice Lore lived in the world to stop this, and he thought of the real Pollooq, so bitter that Teela had told the Fellagorn life is unfair, and that the demi-god himself was evil. Why had she called him that? Uteq felt Pollooq's wounded fury, but confusion at his wanting to show Teela the real nature of evil too, and as he thought of the reality of Sepharga's

death, Uteq hated the Mythic Bergo then, hated the hero of his own cubhood.

Heroes were gone, cubhood was gone, Sepharga was gone too and Uteq suddenly wanted to die, and saw the black hairs on his paw, as he touched the ice, his whole belief system torn away, and nowhere in the world was there firm ground to stand on now. Yet the agony was so great, Pollooq's mythic wound so deep, he wanted to know the truth of all, of good but of evil too. To look it all in the face, defiant.

A warning began to sound in his being not to look, not now, not in his own agony and grief, and old Narnooq was telling him to guard his spirit, and from long ago, Narnooq was talking to Qilaq of tearing down the ice lores and having to face the Evil One then, and of the terrible winds that would blow. Had Uteq cut down the lores himself, and was the Evil One waiting to make him his slave in the Underworld, a place of fiery lava, or freezing cold like these arctic winds? Uteq's thoughts and feelings were so slow it was like the sea congealing and he felt he was being dragged downwards, or deep inside himself. As he thought of Mitherakk's warning of looking too long into the dark, and the lemming's of an abyss, he was vaguely aware of the presence of the pole star above, and he felt a fury at a mythic Bergeera too for betraying his god. It seemed to wake a burning will inside him to make everything look hard at the real world, at all its injustice and suffering and pain, its curse, so that they might at least share his own pain.

"Fools," he snarled "can't you see the terrible truth? That the gods are lies? That the Ice Lore's a lie, and what monstrous god would make a world like this anyway? That's reality. And she's gone too. Sepharga. The only lore is to survive."

It was as if his agony had stripped Uteq of any defence, and he could not help but look down and see even deeper now. Dimly he saw the Barg again, tiny creatures, cubs or insects, herded by their Serberan Ice Lords, then he heard Glawnaq's voice, yet it seemed his own, telling him it would hunt him to Hell itself. Again Uteq felt Pollooq's wounded fury, but his being was empty now, scooped out like a snow den, and he realised he no longer even cared. Uteq had

reached the end of himself, had come to a point of total negation, had despaired, and in his pain now he cursed life.

It happened in that moment, as the arctic winds screeched at him. Uteq was suddenly inside the terrible images themselves, like walking into a memory, looking between the Barg and Glawneye, their teeth dripping with blood as they stood among those blood gullies, the Barg's faces filled with a terror as great as his own. Glawnaq was there too, his angry eye boring into him, like a monstrous flame, swirling on some rock tower of the will, and its fire seemed to puncture Uteq. As if we all have some gauzy snow den around us, that protects us from the violence of the world, or of ourselves, and his was gone now. Uteq thought of the Gorg and his own feelings were so violent, he felt he was splitting in two, and presented with a terrible choice now, an invitation, 'join them or us', be victim or killer. In that primitive question it seemed as if words were being created too, good and evil – opposites.

In his fear and anger, Uteq saw everything through that dark tunnel again, like the human telescopic sight, like looking with a single eye. For a moment he wanted to walk to the Barg, but a disgust awoke in him too, then an awful clarity, as he turned on them instead. That force he had felt turning his anger on Sepharga grew, a furious will, an animal hunger, fed by pain and fear, yet mixed with something even more chilling, an ice cold rationale, that he somehow knew Glawnaq had touched near Man in his bear prison, the logic of reason and power in the face of all, and something seemed to whisper to him of Man's *Scientia* too.

Glawnaq had been right. There was no longer enough room for all the stupid Bellarg, in a failing ice world, and Man and the animals did nothing but fight and kill. Uteq knew the cold clarity of pure logic then, of pure will too, like some ancient father scorning weakness and failure, in the endless battle of life.

"Kill them, Glawnaq," he snarled. "Kill the filthy weaklings. Fulfil the terrible, beautiful lore."

It seemed the sea was shaking, and Uteq knew the monstrous strength of pure mind and the unconnected will, Glawnaq's very soul. Then the visions were gone. Uteq expected the pain to stop, to feel

some glorious triumph. He felt none though, no completion of a brave hero's quest, but only shame, the very mark of defeat. Time and the wind wailed around him, but the bear was left all alone on the vast expanses of empty, frozen white, as he slumped onto the ground, curled in a tiny ball, like a cub in a snow den, as the agony of loss rocked through Uteq's very Soul.

Mad Mooq's terrible vision had come as true as the Cull. Sepharga too was dead.

17

THE TWO LANGUAGES

"Oh let me not be mad, not mad."
—*King Lear*

U teq woke, aware only of hard ice and dark clouds. The memory of Sepharga's death and the vision of the Cull returned like some terrible dream though and it was like Pollooq himself crying out, far worse than the cry of the spectre that he had tried to grasp, or like a thousand seal pups, their tongues torn from the ice, screaming.

Uteq felt a monstrous mixture of guilt and pain, horror and self-disgust, yet in that vision of horror evil Glawneye had not looked mad or lost at all, but fit and healthy, and Uteq thought of all his visions of the fighting animals. It was life itself then, and all The Sight and reality had seemed to show him in his journey, life itself was evil. Uteq began to cough and spit, as if trying to spit out a bad Beeg, or some dark poison deep inside. He felt as if he had swallowed the world's darkness and cruelty, had swallowed death, and as he thought of killing Sepharga too, and what he himself had chosen at the Cull, he thought himself a monster indeed.

"I am the Evil One," he wailed, "so I must slay the monster, the monster of myself."

Uteq heard Marg Leantongue too calling on him to redeem us all, but nothing could redeem this, nor stop the pain and Uteq looked up and saw not the beautiful Beqorn, but a vast slick of pure black again,

like a winged demon, swirling down out of the stars, down towards the earth and him.

"The Ice Lord of the Flies is here," he moaned. The bear thought of Glawnaq's mercenaries too and of man, of how the humans paid each other somehow in this black blood, wanting to drown indeed in the blood of their terrible world. Of Glawnaq's world now too.

He dropped his head and the frightening darkness worsened. Uteq felt he was literally going blind, inside and out, for though he could see with his eyes, the things outside him had no meaning, for something terrible had happened, feared in the whispering voices of so many ancient dens. Uteq had the Ice Madness.

"No return," he groaned, his mind unanchored like a ship on some enormous sea, "no return from Hell. No way out."

The wind blasted him, yet Uteq was so inside himself he could hardly feel it, and his very guts were freezing like Pollooq's, and as he stared down, it was as if his eyes held no light, and the reflection of his own face, of his two bear eyes, was becoming misshapen, as he tried to understand, or to keep it all out. As his thoughts tried to interpret his terrible feelings, it was literally as if his left eye had grown huge and bulging, and his right eye was receding. He dimly saw too that he himself was glowing like that strange spectre, but not with light, but a terrible blackness, and he thought he heard the assassin Garq laughing at him out of the winds. *"Don't you know when you're beaten, bear? Don't you know when to give in?"*

Uteq scratched at his reflection pitifully, almost bleating, as Qilaq had done in jest once, but now there was no laughter in thoughts of a Blaarq, and Uteq wanted to be a victim, like the feeble Barg. He thought of all the fears he had seen, consumed by the most terrible fear, in that icy wilderness, as if he had become fear itself. In that, Uteq felt a monstrous weight of darkness, of loneliness and of something he only understood now, of Sin. As if there was nothing between him and the gods, or the merciless judgement of Heaven, or Hell. Although suddenly Uteq seemed to hear a feminine voice on the wind, from inside him too, or Uteq no longer knew the difference between outside and in, as he struggled up again.

"*The light,*" said the voice, "*stay close to the light, Dear Uteq, There's a paw trail back. Always. Even from Hell itself.*"

"Light?" he spat though, as if trying to spit out the pain. "There's no light anymore. Life is nothing but darkness. Blindness. The everlasting Long Night has come."

Uteq's Garn was so faint he felt he was dead, wished he was, a suicide, wished to see nothing anymore, least of all himself. Uteq wanted the sins of the world on his back then, yet there was something else driving him, some memory that the universe itself might fail if he did not go on, some commandment from cubhood telling him that Bergo never back down. With a will as furious as Glawnaq's, he turned and began to move in the direction that he felt was Pollooq's Paw Print, like a shark that must not drown, though that is a myth.

As he went, Uteq heard wailing voices, tempting him aside. "*Fail with us, Uteq,*" the very air seemed to cry. "*There's nothing to believe in anymore, she's gone, so give in and find peace.*" Then Marg's cry came again for a hero to redeem us all, but Uteq did not care, and as ghostly black shapes swooped at him on the wind, which had no substance, he felt as if ten thousand demons were attacking his mind and heart, like evil bats.

Dark. It was so terribly dark. Like Tuq in his fear, Uteq turned back to see his own shadow, but it seemed to turn into Toleg, but then Eagaq, and Glawnaq. The Dark Father was hunting him indeed, like some ancient, vengeful god, demanding sacrifice on the altar of its own savagery. Uteq screamed and tried to run, but he could never get away from his own dark shadow.

On the ice, he saw little pools of moonlight through the swirling clouds, and he would rush at them, and press his snout close, like one needing desperately to drink. Though real things were out there in the North too, a travelling wolverine, the size of a bear cub, with a face like a weasel, that stopped to look at the Bellarg, quivered, spat and ran away. Uteq remembered Egigingwah telling him animals knew when humans were bad, and he knew he was evil indeed.

At last though the Bellarg collapsed and slept. When Uteq opened

his eyes, three nights later, he was so cold he could hardly move, but he felt the Beqorn almost stroking the glassy film of his eyeballs. Somehow Uteq had reached the very northern point of the world, for Teela was directly above him, as if she was drawing him against his will, to face his own damnation. He thought of how dear, gentle Sepharga's name meant Bright Star, as the colours moved in the sky, and on the ice too, like changing shadows of reality, or the pictures thrown on that human screen.

As he looked up, he felt so tiny beneath the might of the universe, but no voices really came to sing to him, or tell him stories. No righteous teeth either, from those that bite with their teeth, to punish him. He heard Mitherakk in his mind too. "*If the hero cannot find the entrance none have, then the journey must fail, everything fail.*"

"The entrance," he groaned, caught between fury and mad laughter, "I must find it. And since I'm the Evil One, perhaps the dead will show me willingly, and speak of the terrible truth at last."

An entrance might shield him from the storm too, thought Uteq, and give somewhere warm to hide, while even the dead would be better company than this. Uteq longed to hide from himself, from the truths he had learnt, except he heard Mitherakk saying that there is nowhere to hide and he struggled up again.

"Those that the gods want to destroy they first send mad," he laughed. "So go on then, destroy me. I murdered her, Sepharga, by bringing her here, and broke your non-existent lores. Punish me then, in the Court of the Ice Lore. I dare you."

The wind scoured him, but there were no gods now, no judging Ice Blocks, no place where mythic Pollooq had stepped from the sky, no entrance to Heaven or Hell, and no merciful destruction came. As the wind screeched, the place was like the silence of Teela herself, in the story, the silence of despair, of failed love, and Uteq wanted Atar to freeze him solid, perhaps to save his soul.

Uteq looked down, but his heart jolted, for he did see a paw print there, until the bear realized that it was not Pollooq's but his own, and a lonely trail threaded back into the endless distances. He had stepped far indeed from the Paw Trailing of cubhood, but remem-

bered Mitherakk's fabled blue black flowers too. They might grow out here, to heal his heart and mind and even in the thought he felt he was giving himself some blessing. The bear began turning in circles, searching desperately, looking for the flowers and some entrance too, but there was nothing but ice and yet more ice, everywhere. At last Uteq reared up and bellowed, then pounded down, digging, as if trying to dig an entrance to the Underworld. Uteq hardly scratched the hard surface, but then he gasped as he saw a speck of blue and black. The flowers?

Uteq's heart beat faster, yet to his horror, out in the snow flopped a Gurgai hand, a real human hand in a blue sleeve, part of the body of a dead polar explorer, its clawed fingers blackened with frostbite. It was so strange out here at the North Pole, and as he touched it Uteq knew that this Gurgai had died a hundred years before, though far from here, but that the shifting ice sea had brought his body to a place he had never even reached in life, although he had sought it like a hunter. The bear sensed the failure of it, a failure he shared in his own impossible quest. Uteq lay down right next to the dead man and closed his weary eyes. Uteq Blackpaw was utterly beyond hope.

As he lay there Uteq moaned too at all the stupid, empty cubhood legends, the lies, and thought of Mooq, and yet some distant voice reminded him now that even Mooq had indeed had the power of a visionary. Had Uteq, especially now that he had the ice madness too? Suddenly, as Uteq rolled on his left, a thought struck him that carried him outside himself again, and he opened his eyes. Of course. There it was, flowing in the enormous skies above him. The astral lights in the skies themselves, the Northern Lights, the Beqorn, they themselves were Mitherakk's sacred Garn River.

Uteq felt as if he was half asleep, more than half dead, yet he could not dispel the feeling, no, the certainty. Yet a thought came like a prophet of doom, for beyond the Garn River above then lay the Realms of Death, where the hero had to go to know the truth, and to see the true journey of Lera and Man. Was Sepharga out there, in some other world, and Egg too, and his father, and all he had loved and lost? Was the mythical Pirik, none had ever seen, and could the

dead tell the bear the truth? Uteq was no hero at all though, and had touched the evil of life, just like Glawnaq, but he remembered Mitherakk saying that the Garn River itself could restore, and cleanse a bear of sin.

Uteq closed his eyes, hating himself and all life all the more, and now his Garn was so faint in him it was as if nothing was moving in his body, and he felt desperately cold. In the real world, exposure was coming on fast, and Uteq was close to death indeed. Yet as Uteq lay there, he seemed to hear a Bergo's voice.

"*Open your eyes then, Pollooq Blackpaw, and quickly too.*"

Vaguely Uteq thought it was Toleg, but as the night wind screeched, he muttered pitifully.

"Go away. father. There's nothing here, liar. No entrance to anywhere. Only your lost souls, tricking me."

"*Let go of the ice raft then, little paws, and look at the whole. Die to the world of the white bear, fabled Uteq. But look out again and grow – by seeing into the centre too. Remember Garn and what it really is. Matter, yet spirit too.*"

"Die, father? Yes, I'm not fit to live. I'm the evil Blaarq. Condemn me. Take my Garn."

Uteq thought of the Saviour destined to sacrifice himself, yet somewhere heard Mitherakk telling him that he must never let life make him a scapegoat, a victim, and Uteq felt resistance and confusion. As his thoughts sought to understand what this stupid centre was, Uteq remembered what he had seen below the submarine, of black blood and a hellish fire down there. Down there? Uteq jolted, as he thought of the vanishing horizon on the arctic ocean too, that they had seen from the ice raft.

"The centre," he gasped. "Then the earth, it's not flat at all, like the stupid stories tell us. It's really a ball, like a giant snowball, in the dark. That's reality. The Pheline sensed it too, then knew."

In his mind, Uteq saw the little lemming, in a ball, falling like a fury apple, and he remembered the husky talking of stars and light and ghosts. If he was really on some vast snowball, if all life was, then why did Uteq not just fall off into the sea of space and drown? It

was as if the bear was approaching some impossible thought, that would change reality itself. Then Uteq was a cub slipping on the ice slide again, the skies spinning, wanting to cling to the ice, but remembered the story of Pollooq, hurling himself into the whale's belly, to find himself inside some far bigger secret. It was as if Uteq was letting go of everything suddenly, even pain, flinging his thoughts and spirit out into the skies, far beyond stories or legends and their lies.

Uteq heard an echoing laughter and he felt completely different. Below him was no longer ice, not water either. Instead the bear was on hard ground and sensed there was no air at all, yet like some fabled Lerop, he could breathe. Very slowly he opened an eye to an immense blackness, far deeper than fear or sleep. Beneath his paw was a dry, grey snow, and as Uteq looked out in the dark, he saw a huge ball hanging there in the dark sky, blue and green, with dots of white at the top and bottom. With an astonishment that seemed to clear the pain, Uteq knew where he was now. The polar bear was on the moon, with holy Atar herself, and he knew what was before him.

"The Earth," the polar bear gasped, in wonder, yet with a deep anguish too, as he looked back at the little planet. "The dying earth, where we all live or lived."

As Uteq looked out through space at our earth, at our little ice ark, he saw that black slick flowing towards it again, and remembered Man and all the harm the Gurgai were doing, and expected some promised calamity. In his anguished separation, words came about Pollooq trying to stop time itself, with his Fellagorn power, for his desperate love of Teela the shining pole star, and yet Uteq had some new power in his mind and knew it was Man's reason and Scientia.

"Time, Sepharga," he groaned, wanting with all his soul to be in a time before she had fallen. Suddenly the earth itself began to spin backwards before his eyes. His vision was going back in time, as his grief for his father had pulled his thoughts back into the past, or touching the black blood had shown him some ancient past, yet now it was millions of years, six hundred million years back in time. There was snow around the earth's girdle, the equator, that as the earth

stopped and turned forwards again, spread out in a giant freeze, a white catastrophe, not only terrible for Man, but for Lera too.

"The Sight," he cried, as the planet changed. "Is this The Sight and what Man really sees?"

Uteq knew he was touching Man's new way of seeing, the reason of the ancient Pheline too, who had wanted to cast down the gods and show Pollooq reality. Suddenly then the earth span faster and trees and plants grew, as monstrous Lera roamed the planet, giants crowding the living seas. Then a shape was hurtling into the planet, sending up smoke and dust as it struck that killed the giant animals.

"The end," the bear wailed in horror. "The Last Judgement is here. For our sins."

Yet this was no end at all, for other creatures were climbing down from the trees and losing their hair, standing taller, apes standing as Man and Woman, and as they used tools, they began to tell stories of demons and gods, of Heaven and Hell, and good and evil too, and of themselves and how they were made. Uteq wanted to know more, to know everything, and now as he looked out he saw that Teela, from their myth, was in reality Polaris, a star 430 light years away from the earth, in the constellation that the words of Scientia named Ursa Major.

He knew that the earth was spinning around the fiery sun god, and kept there by the attraction of all objects, gravity. That the heat Man was putting into the air was an invisible gas, that he and his machines breathed out, and which the trees and very rocks somehow absorbed. Uteq knew a blinding secret then. That everything there is, animals, Lera, black blood, ice, is somehow just Garn, energy, that could neither be created nor destroyed, but that only turned from one form into another, like the changing shape of the gods themselves.

Uteq knew too that the Universe itself is somehow infinite, but that there is no space without time, and no Garn without time either. What the husky had said of light itself then, the purest Garn energy there is, was true, and that there is not one world either, that we can see with our eyes alone, but a tiny world inside that, like Pollooq inside the whale's belly. One made up of things that got smaller and

smaller, spinning like moons orbiting the planets. Was this reality, a reality even far beyond the reality that the Pheline had spoken of? Uteq's struggling thoughts went inside himself again, then out, and he knew that if you could go light years away from our earth, and look back, the light that would reach your eyes would show you just this truth of the past, for you would literally be looking back in time.

Yet did it show the truth, or was it like the human's pictures in that hall, that somehow were not there either, but only magic projections on a screen? Then Uteq saw another freeze come to the earth and black shapes moving over his home, black bears, and over time as the cold came, their coats changed and only those with lighter coats like the snow survived. Uteq realised then that polar bears themselves had evolved from black bears, as all Lera are changing over time.

He shivered, and in the darkness all about, he sensed something he could not even see, then knew the universe is made up of dark matter too, and things that can only be imagined because they give out no light – black holes. That even in the void of supposedly empty space, Scientia now spoke of Dark Garn, dark energy, that made everything move and expand, for the universe itself was expanding outwards, even beyond the force of gravity that bound it back again.

It was impossible, but true, and in struggling to understand it, and where it had all come from, how it had started, Uteq remembered words of a sight that might strike him dead, and there was an explosion in his mind – Bang! – and Uteq felt as if he was everywhere at once.

The Ice Saviour had become Garn itself, matter and light, moving at impossible speeds, not in one direction, but in every direction. Uteq had died, was being torn apart, was food for the universe itself, and in his flying mind he saw stars and planets at their birth and inception, and everything was expanding, so violently that it made the stories and the Ice Lore, talk of good or evil, even Glawnaq's terrible crimes, utterly puny and insignificant.

Uteq had stepped beyond all the Paw Prints, and all the ice lores too. It was far more extraordinary than any story of gods, or heavens or Underworlds. This vision came from the Gurgai's power to reason

and see with their eyes, to gather knowledge like food, yet Uteq knew something was wrong too. Did the Gurgai really know all this, see all this, just by looking out, over time? Somewhere it was true, like proof in some Court of the Ice Lore, yet not enough, and Uteq realised that this way of seeing and reasoning was about looking at the real world, yet did not come about just in plodding paw prints, or adding discovery to discovery, proof to proof, but with something else far more powerful, something buried inside the Gurgai's minds themselves, like a seed inside the tundra; it was looking within, insight, and looking without too, imagination. This way of seeing happened inside their minds then, as well as with their physical eyes.

Uteq thought of The Sight, of his own power to imagine realities, like telling a story, or even dreaming, and of Marg saying that all is connected, but what was the real connection? The gods were overthrown now by this Pheline Scientia, the ancient stories too, even the ice lores and commandments. Yet out here in the fiery dust storm of space and time, Uteq felt utterly alone and a new terror gripped him, and this terror, this utterly abstracted loneliness, was metaphysical.

Existence seemed to have no meaning at all, in this terrible material logic. It seemed purely mechanical, a reality as dark as the black blood, or the blackness flowing out of the skies towards the earth, or that Dark Garn he had seen inside nothing, with a logic quite as pitiless as Glawnaq's. In his loneliness Uteq felt the presence of some terrible evil then, felt the Evil One was here indeed and it was simply darkness.

Then Uteq saw it, buried in the intense night, a tiny animal, no bigger than a claw tip. It was like an ermine, with huge eyes in its minute body, curled up, shivering with fear and horror, as if being tortured by all the world's pain, as the hungry mouth of the universe, Man and the Bellarg consumed everything.

"The Pirik," he gasped, "the fabled Pirik taking on the shape of the world's agony."

Uteq thought of all he had seen, and of Teela calling Pollooq evil, then of saviours and scapegoats too, the opposites of each other, as though bears at a Council were passing on all their responsibility and

blame, and as they did the Pirik suffered even more. Then he thought of what Mitherakk had said of throwing our own shadows on others, our own fear and guilt and hate, like projecting images on a screen. He remembered that isolated cub at the bluffs, feeling a terrible pity for her and the little Pirik too and suddenly wanted to protect everything that suffered in the cruel world. Uteq Blackpaw wondered if in every den then, in every nursery, in every Sound, there is not some poor cub who is somehow made to bear the blame for our own dark natures, and so made a scapegoat, and made to pay the price for life.

Had mythic Pollooq too seen such a cruel reality, such injustice, and had the demi-god wanted to change it in his love, to change this vicious, universal ice lore? Uteq wanted to smite Teela then for blinding the demi-god, for denying his love, with her supposed reason and reality, a reason so much smaller than this astonishing vision of the real, fiery universe. For the Pirik was wounded indeed, and Uteq knew that the universe itself was failing, but he felt himself the Pirik, and he sensed the arctic colds and knew he was almost dead now, but could not wake out of this terrible nightmare – life's terrible nightmare. The bear longed to go back then, even to his own dark story, but all he had seen had made him an exile and he was utterly lost. The hero had failed in his dark quest at last.

"Oh, Matta and Qilaq. Oh, dearest Sepharga," he sobbed, "I'm so terribly alone. There is no return. It's over."

Uteq felt a terrible shame too, like a Bergo that has backed down, but heard that voice again and he was back on the ice at the pole. The bear moaned, and turned and looked up. The black slick was gone and the beautiful lights were flowing even more brightly, but the stars seemed to form into a shape now, like some guardian angel. A kindly Bergo was looking down from the immense, starry night sky above him, and in the heavens Uteq saw that real frozen face from the Field of the Fellagorn Dead. Sorgan.

"Great Master," Uteq gasped, as he noticed an icicle hanging from his nose.

Sorgan's bright eyes opened in the sky, but perfectly clear, as if cleansed with the brilliance of the Gurgai's Scientia, and glittering as

though he had succeeded in a sacred quest to help the One, like some kindly father. And all little heroes need helpers.

"*You're never really alone, brave Uteq,*" whispered the winds, "*so what do you seek?*"

"Seek?" stammered Uteq, feeling terrified to be really talking to the dead. "I seek the entrance, to ask of my story and The Sight. To know the truth, but to be free of this pain. Reason is so cold and terrible sometimes, Sorgan, just like the Pheline's cruelty to Pollooq, and even the Pirik is failing. Am I mad, then, or just dreaming, Great Master?"

"*Truth, brave Uteq? Just remember the two languages then, that come from the two worlds, and see again, but with better, gentler eyes, and be whole, for you are Garn too. Which is both matter and spirit.*"

"No," whispered Uteq, wondering what these two worlds were, "you're not real, Sorgan. You're just a story, or a dream. I'm dying, Great Master. Dead."

As he said the word the Great Master was gone, had not even been born, and there was total darkness, darker even than that invisible Dark Garn. Uteq felt a sense of containment now so tight it was as if the universe had been squeezed into a ball and he was right in the centre, inside darkness itself. Was he somehow lost in some Underworld that he had not even found the entrance to?

It no longer mattered though, for like Pollooq in the Ice Labyrinth, there was no way back for Uteq Blackpaw. He was beaten. Some part of the bear wanted to rage, to throw off the weight of this dark prison, of his own story, his own limitation, to fight on still and live again and be free. But in thoughts of Glawnaq and his struggle, the struggle of all life, will and rage seemed nothing but evil. Yet why had the Great Master talked of two worlds and two languages, and what did the starry Fellagorn mean by being whole, and that he, Uteq, was Garn – at once matter, but also spirit? How could there be any spirit with no bear gods anymore, no god at all, and nothing to believe in now either? Uteq had never shared the secrets of the Fellagorn, like Matta and Qilaq had, but now he thought of how they were masters of words of power, and a

phrase was echoing in his mind from his cubhood: "*In the beginning was the word.*"

Uteq felt as if he was at the beginning of time itself, somewhere he heard Mitherakk talking of finding his faith again, and through the terrible tunnel, he could see the imprint of a paw in the snow, blown by the wind, then thought of those light pictures in the human den. Suddenly Uteq saw that spectral Bergeera again, glowing in black space, a brilliant beacon in the darkness, as pure as the Pureem, and around her was the black blood, no, the Dark Garn flowing everywhere, and yet it could not touch her. She was so brilliant and radiant that it seemed to drive back all darkness and Uteq knew that she had somehow been here since the beginning of everything. What was she though? A dream of Garn, in the Pheline language of Scientia, but yet Garn somehow in the shape of Sepharga, or Matta or his mother, in the Bellarg stories of spirit and meaning and love.

Yet it was not them either, made of flesh and blood, and Uteq had a blinding revelation. This spectre was no dream shape or fantasy at all, it was something female that really lived inside himself, and literally animated him too, something that he recognised in the shape of other Bergeera. That is why he had felt and seen that tearing mist from Matta, Anarga and Sepharga. That is why he had so gone into the dark of himself, without their light. It was as if the light spectre was rushing towards him, melding with him, and Uteq felt a furious Garn, fighting back the darkness and merciless cold, the terrible stillness inside, and he felt he was changing again, somehow being joined, inside and out.

Uteq felt that he could breathe again, felt a glow that also opened his eyes, and mind too, his whole being, and knew that we must not just think into the universe, but feel into it too, with all our senses, as Bergeera feel their way through the world more than Bergo. He knew too why Glawnaq had gone into the dark, why his monstrous will had turned him into a tyrant and a Dark Father. He knew too why Pollooq's soul had been torn. Because they had both lost the female Garn spectres inside themselves, as he had.

Darkness. Dreams. Uteq sensed writhing things then, like dream

shapes too, yet living dark things, struggling for life, out of the shadows, up towards the sun, like plants rise from the earth, but they weren't demons or evil at all, no more than those strange creatures that he had seen on the spinning earth. Evil itself was a word that created opposites and animals need a force to live, like hate and love, like teeth to bite, and like heaven too, like the earth, or the Underworld of the dark that was part of it all too. For life itself came from those dark primal Garn energies, and all creatures needed their own shadows inside too. Suddenly, the black tunnel of his vision changed and Uteq could see a soft light down a Snow Passage, glowing with light.

Uteq heard Mitherakk talking of the power to decide, in the mind, and saw tiny cells with no shape at all turning miraculously into many things, into hair and claws and eyes, and Uteq felt that he was expanding too. Uteq held the seeing and language of Scientia now, part seeing with the eyes, part insight and imagination. But there was some other voice willing him on, like a story, as if he himself was some little god, almost creating himself with words, beginning to tell his story again, as individual as a snowflake. Why had the Fellagorn said that 'In the Beginning Was the Word' and what was the word? That was it, Uteq realised, because you could not truly think about the world unless you named it, especially with words of power, although you had to feel your way through the darkness too, towards understanding. Then a word came to his Uteq's mind like a blinding light – God.

With it Uteq felt brilliantly aware and could feel soft snow beneath his paws and step by step he took, out of the dark tunnel. He had no other words for what he was sensing, but he simply felt their beauty summoning him up out of the Underworld, of himself. He sensed some sacred, eternal light beyond this den of night, he could only really approach if he gave it such words, such concepts as sacred. Yet not from some pitiless, judging god, or from the stories of the ancient past, but from Helios the sun god.

Uteq heard the ancient whispers of the Fellagorn too, and felt as though there was some eye, some way of seeing, some intelligence

right in the middle of his own forehead, yet somehow in his belly too. Uteq pushed his head through a snow wall, and breathed and gasped, but he came up not into a flaring day, but into the mysterious Long Night. Little Uteq saw the boundless heavens again, the stars, and the soft moon goddess, Atar, glowing with Gog's reflected light, and the brilliant, ghostly constellations above him.

Somehow Uteq understood then that man's journey had always been out of the darkness of ignorance and fear, of unknowing, like a journey out of dreams and sleep. Above him, in this brilliant waking at the pole, there was no slick of black blood, but the astral lights again, the Beqorn, all the colours of the rainbow, that shone through that Dark Garn all about and which some cubhood story told him meant a marvellous hope. Suddenly Uteq was not alone too, for a spectral she-cub was at his side now and they both growled as they looked around at the universe together.

Next to her Uteq was at once inside himself, but looking out too, a cub and yet an adult, knowing now that they too speak different languages as well, two languages, the one always talking to the other from different points of the compass, that could no longer share quite the same vision. As adults lose the fear and deep meaning of words, their wondrous, mysterious exploration and power. As Bergo and Bergeera too can speak different languages, hearing the truth of their own needs and fears, through the ears of their own natures, although now Uteq's female spectre turned and growled warmly at him.

The silken snows below were suddenly like a coat of pure beauty and magic, filled with secret gods and goddesses still, that changed shape always, like the changing shape of stories which could never be lost. Yet the world had an intense physical reality too now, a precise clarity, and with the weight of old vengeful stories gone, it was as if Uteq Blackpaw could see the extraordinary crystalline structures of the falling snowflakes themselves.

Yet in that other language, from another way of looking at another world, Uteq knew those wonderful stories of the world and the Lera too, and loved them for it. In that perception Uteq felt something

fighting, but it was in their calm balancing that he seemed to place a brave paw trail ahead him.

"*The real way is never force, Uteq Blackpaw, in thought or feeling, for life and truth live in-between. You must use your reason, yet believe the mystery. Feel it. Trust it all, and yourself too. It makes you.*"

Further Uteq stepped and felt a new Garn in him. He realised what awareness was in him now, spoken of in his cubhood and the stories, the power that Ice Lords alone carry among Lera, brought to earth by legendary Pollooq, bestowed in the love of Atar, yet given meaning in the fight of Pheline. It was the Great Gift to understand all the animals. It itself contained the power of the two languages and the vision of the two worlds.

In that brilliant understanding of reality, of matter too, and of Garn, dark and light, there was no room for ancient gods of vengeance and sacrifice. Yet Uteq knew that Scientia, pure reason, sometimes stole away the words of magic and feeling, words of deep meaning and belief, even ideals like the Pureem, or the immortal Garn Spectres. Yet even Man's amazing Scientia did not understand the mystery yet, because even in their own Scientia there were two languages, of the tiny, minute; and of the vast, and universal.

Uteq realised then that the gods, or those eternal Garn spectres, spoken of in the bears' great myths, were only ways of naming a deeper reality and were always vanishing beyond the borders of new knowledge, and for Man the world had grown small indeed, just as Tuq had said.

Yet the strange Gurgai had journeyed far beyond the Lera too, from whom they had come. Had that turned the Gurgai's will to nothing but a hunt for the black blood, for material existence, consuming their thoughts and dreams, like Glawnaq slaying the Barg? Because they had finally slain their own gods, but in doing so had also slain their greater beliefs too?

Uteq longed now for old gods again, but thought of little Mithril suddenly and the power of The Sight and the harm he or this story had somehow done elsewhere made him jolt again. If something deep in this story had indeed harmed the calf, then the simple reality

of Scientia was far stranger than mere fact and observation. Uteq thought again of Marg saying everything is connected.

That was it. Could The Sight then, imagination and thought itself, even dreams, literally do more than just see, past, present or future, but actually affect physical reality itself? It was, after all, their thoughts that first made the Gurgai's great machines real, and terrible killing sticks too, their drugs and tools, to plunder the black blood and unleash its Garn. The ice lores of the universe were very strange indeed then, as Mitherakk had said, but why could even Man not see the whole yet? Because Man like the animals was still evolving too.

Uteq felt a terrible dizziness, as if two worlds were at always war, until he heard Flep's voice in his memory telling him the wave and the sea are really one. Uteq looked down and saw that the lights of Beqorn flowing around his paws, and he suddenly felt the real world far more wonderful and mysterious than even stories.

Yet Uteq needed stories, or some pattern to give his thoughts shape, like Paw Prints in the snows. Then Uteq noticed something real lying at the bottom of this Garn River. It was Mitherakk's seashell, and it woke some burning light in his mind. He looked up again at a fiery galaxy, light years away, spinning in the dust storms of terrifying space and his mind was gasping in awe. The shape of that physical shell, and the fiery, swirling galaxy echoed each other, were the same.

"There is a pattern then, inside everything there is. A greater meaning and connection."

Uteq knew then that although our minds and eyes are like looking out of the snow dens of ourselves, from whole universes within, we are also somehow connected to something far greater, but by what? There it was then, the very end of Pollooq's terrible challenge. Pollooq's proof of magic and a power beyond the Pheline's simple reasoning, of something that connected us all. The proof was poor little Mithril herself, but in even thinking of her, and of Uteq's own angry words about taking out eyes, a truly terrible anguish woke, and the wastes of the white arctic turned black as night. Had he proved a bad miracle? If so, Uteq knew that he had breached some ice lore of the universe that must never be chal-

lenged – shattered some cosmic balance and thrown down the Pureem forever.

Uteq felt utterly lost, evil, yet again something came to redeem him. First his deep feeling for the calf was its own redemption, and that Garn spectre glowed brighter inside him again. He ached for Pollooq too and knew suddenly that in Teela's Pheline ice mirror, the demi-god, with his own eyes and Bergeera spectre torn out, had thought himself incapable of love, and in looking at evil too, hated his own nature, but that it was a lie. Pollooq had had an extraordinary, immortal love and a deep courage too, to even tell his story before Teela and the Pheline and defy them all.

Uteq understood then too that the demi-god had wanted to cub with Teela, but not only cub but to unite the language of the Fellagorn and Pheline and make a new world, and so renew the wonderful, terrifying universe.

Then thought came to dying Uteq's aid, lost in the dark: If The Sight, or Pollooq in his pain, had somehow dived so deep into the pattern of things, of dreams and of language, and really caused harm elsewhere, then there were real and very deep ice lores in the universe, however strange and mysterious, that we most hold to, yet which can guide us also, even only by sensing them.

The Sight connected us, but if like the seashell, we are really made in the shape of the Universe, or have the power of insight to look into ourselves to see the shape of what lies out there too, then we ourselves must be whole to even see the truth. That is what maturity both bestows and demands, true judgement and true responsibility to all. Yet if we are somehow responsible for things we cannot even see, was that not a truly terrible burden too? Uteq felt an awful guilt now, yet with The Sight, he wanted to use his powers to reach out again, or deep within, and heal little Mithril himself, to turn Anarga's bad dream and all that had happened back on itself, and now he cried out to the gods that no longer existed. "Help me!"

Uteq was near death now, beyond hope, with no return, beaten indeed, with no guide to help him. But somewhere in the black snow den of the universal night, as he lay shivering under the real star, he

heard Sepharga's voice inside himself. *"I love you, Uteq."* Uteq felt an extraordinary, impossible longing, then saw a great ice cliff, a slab of frozen matter, and a crack went scoring straight down its middle, like a lightning bolt, and Uteq let out a shattering sigh. He could suddenly breathe again and the terrible darkness was gone, and he was back at the pole, grown, breathing, filling with energy, swimming now in the Garn River.

Love. That was the Garn that really animated those immortal spectres. Then he realised something that gave him a new force and meaning in his journey. This fabled hero's journey was not just outside in the real world; enemies you wrestled with, courage you showed, what you did in life, it was inside you, in the dark of oneself and in your dreams too. He heard Sepharga asking where dreams come from and Mitherakk saying creatures could share dreams, and in the skies once again, he saw that black slick swirling towards the planet again.

If the Lera could share dreams though, that meant that all things went on a similar journey, but also that dreams were not just like those visions thrown on a wall, of what had been, they were real things that connected everything, on another, deeper level of reality. He knew then that the animals could somewhere reach into the mind of all and share a universal dream, trying to awake together. If that was so then one little life, like his own, challenging the well-worn Paw Prints, was not useless at all, but could have meaning for all life. Then there could be One to save the real world, and not just in a story, and if the dark side of The Sight could do physical harm, the light side could do good.

"We must let our dreams come," he whispered, "but let light flood into them too."

In his mind's eye Uteq saw thousands of cubs now, Bergo and Bergeera, bursting from the snow dens of the world, and all of them carried a mastery of the Great Gift, the two languages reunited. With it Uteq heard a sound then like a beating heart, then the crashing sea, then the strangest and most beautiful sound Uteq had ever heard, like the longing of a Great Master. *"Aaaaaaaarooohhhmmmm!"*

It seemed to come from a primal fear, but defy fear too. It was beyond words, beyond language, before and after them, sounding with the eternal Garn imprints of the universe, that flow down from the skies and the swirling stars, like the darkest and most mysterious secrets of space time, flowing like a Garn River into the real dreams of living creatures, asleep and waking.

As Uteq looked at the sacred river's separated colours, and thought of Flep again, he realised too with the language of Scientia that the spectrum of the rainbow is really only a prism of one light, and if Garn was also spirit, of one Soul too, in the language of the Fellagorn at least and so, if you were whole yourself, there was always a source of light and of enormous, shattering power. A power you must use, as you must trust your dreams to help you see the truth. Suddenly the Garn River was coalescing into a pure white light that shone all around, driving away the demons of doubt and mind and the dark, of separation, filling him with courage. Uteq knew then why Mitherakk had said we must not hide our light, that we must always be responsible to how we look and see, think and feel, and even dream.

The light shot straight up, like a brilliant beacon, and simultaneously Uteq was on the dark moon again, looking down at those humans, looking up in mystery and awe at him, a strange bear in the moon, as the sun rose on the edge of the spinning earth and blazed in his real eyes, before Uteq was carried up and out into the stars. He could see them all, and the earth, swathed in the colours of the North, turning, spinning, a king of bears, redeemed of the dark that was everywhere too, yet with a new power and responsibility, filled with a guiltless, shining life force.

"Atonement, that's what the word means. Not a terrible Last Judgment for our darkness and sin, some evil separation, but at-one-ment. Just being whole."

Uteq thought of a story of Goom and a flower blooming in his forehead, heard words about death itself dying, thought of those immortal Garn spectres, and flowers were opening their petals to the mighty sun, itself one day doomed to burn out, as Uteq saw Lera,

millions, moving through eternity like a million constellations, a million wonderful stories.

In blackest space Uteq saw an igloo too, that throbbed like some mind flashing with the colours of the Beqorn, or billions of synapses trying to connect in a little brain, and see out into what existence is. It glowed for a moment with the sinister colour of war, the red of the warrior, yet inside he saw a beautiful shape, a sleeping human baby, swaddled in flowers, unmarked by the Cub Clawer.

Uteq saw then man was like a god above Lera, yet only worthy of that power if he respected himself and all life. That his true journey was always between opposites; piercing with reason, like a claw pressing through the snow walls of the universe, but growing with feeling, into value, true insight and maturity; a journey between the poles, as he span on the earth. Uteq felt as if he could play with the stars themselves now like a snowball, with the Great Gift, with his spirit and soul, as a new thought woke and he realised the greatest secret is always being part of something bigger than oneself, yet from one's greater self too, one's soul, and it brought him another vision, or a dream worth having.

"The earth, the earth itself can be the ice ark again, Great Master," cried Uteq, "for Man and Lera, travelling through the darkness of space time, together, speaking the two languages once more."

His was a voice that humans cannot ever live without, like food and Garn. For true explorers like Uteq Blackpaw do not journey simply for black blood, or gold, or the mastery of matter, like mercenaries, they journey to explore value, truth, and to make meaning, and to know their own spirits too, their real beings and souls, that they can only know when they are whole.

Uteq Blackpaw had died to his own story, to his ego, and he realised the dead did not return to speak at all of the past, and if ghosts exist they are solely Garn imprints in time. So the answer to Mitherakk's final question was that there are no individual souls, destined for some monstrous hell, or some disconnected heaven either, but only one energy. That meant life is what really matters, always, not the past, only the present and future. Now Uteq seemed to

hear Sorgan's voice asking the most important question in his life though. "*And who do you serve, with your true self, that all are part of, if they return from the Underworld like heroes?*"

"I must help the Barg," he cried. "then serve life. And the Gurgai have forgotten the true connections, and their own real power and burning light. Yet I've died to the world of the white bear."

As he spoke though a gentle female voice filled the universe again. "*Died, Uteq? Garn's eternal and you're an Ice Lord, Blackpaw, a guardian like Pollooq.*"

Uteq was falling, and knew he had decided, and his dream was over.

"*So hear my true commandment. Give out your light, and live and fight well, Twice Born.*"

"Twice Born!" cried the bear, realising too what the greatest Blessing was, sleep itself, and waking in the freezing snows, feeling a little king born in the North indeed. "That's what it means."

18

RETURN

"Recognise that the boundless light of this true reality is your own true Self, and you shall be saved."
—*Tibetan Book of the Dead*

U teq woke on the icy, wind wracked North Pole, all alone, remembering what Mitherakk had said of being remade only by water and the sea, with an ice sea all around him. He heard that fading voice once more too *"The Eight Paw Prints, Uteq. Follow them now, not some fearful commandments, and not like a cub, but as a free wild bear. But keep your own Council. They may not understand. May tear you apart still."*

Uteq's heart ached for Sepharga, but his body felt as if it was burning with Garn and he knew he had a new strength. In his eyes, light was dancing too, glittering with health, and Uteq's pupils looked like galaxies, spiralling with immortal fire. Though desperately hungry, his being was flowing again, alive and free and his female Garn Spectre was inside him once more.

Now Uteq knew why he had to guard his spirit, keep out the real dark, the abyss, and rose, no longer weary and close to frostbite. He felt Sepharga standing next to him, or somehow inside him, yet even as he turned and looked out through the wind and dark, in the distance Uteq saw moving shapes, hundreds of male polar bears lumbering towards him, glowing a brilliant, pure white, like a dawn.

"The White Army," he gasped, and as his black paw touched the

snows, he could hear a whispering, telling him of water, air, trees and plants and animals. Yet as he stared that army turned to a blizzard, and Uteq saw a shape, a lone white wolf, watching him lovingly, protectively, and he seemed to hear a name spoken on the wind too, *Larka*. The she-wolf vanished and the wind blew cold and real in his face, like a slap.

Yet though the storm was bad, the elements hard, the place savage, Uteq set his paws strong on the ground, like a proud Pheline, and almost felt a Garn bubbling up through them now, like a true Fellagorn. He had survived everything and now he knew that beyond loss and fear, despair and meaninglessness, if you hold hard, was something else, gentle and beautiful and mysterious, that you must accept, and he felt like Toleg had that day in the Sound, waiting for his cub, perfectly invulnerable, in his soul at least.

Uteq knew too that beyond enemies and even friends, like a secret promise or whale song, lay an invisible place where you could truly let Garn flow through you, but not with the grief of uncontrolled feeling, the suffering of love or hate, but because you are a part of its secret. Fear blocks it, anger blocks it, so too can reason and mind, but it is there, like a holy secret. Then he knew the answer to one of the most secret Fellagorn questions – how do we know if even stories carry truth, and not some mad fantasy? Because we recognise them only when it is as if we are telling them ourselves, telling our own story.

"Alone," he almost smiled. "Still all alone though."

"Alone, big bear?" said a voice and Uteq nearly jumped out of his bear skin. "Nonsense, silly Bellarg. You're only alone if choose and cut true Self off."

Uteq knew it was true and he swung around in astonishment, for he thought that a Fellagorn spirit was talking to him out there. The bear could see no one at all though.

"Am beink down here, big Bellarg."

Uteq recognised that voice now, and looked down. The pretty little arctic fox was shivering in her pure white fur coat before him. She looked like she'd been bathed in white foam, and her huge tail was

wrapped around her, as she tried to keep warm, and smile too in the freezing winds.

"Ruskova," cried Uteq delightedly, his heart bursting with joy, "but you were black and white."

"Winter coat, Bellarg. And are you likink, big bear? But you are seemink changed too, Blackpaw, in these long two years. Though all is change."

"I've been swimming in the sacred Garn River, dear Ruskova," said Uteq with a smile. "Trying not to drown too, or in the Gurgai's black blood. I died, Ruskova, but I'm much better now."

"Am not understandink," said the poet fox, with a pretty frown.

"No, Ruskova." Uteq smiled, "and no time to explain, except that we are both matter and spirit and you must never block our Garn, little fox, or be split. But what on earth are you doing here?"

"Might be askink same. You ravink mad with Bear Rage. Ruskova has been trailink poor Uteq since before filthy wolves. After year searchink for bear."

"Then it was you following us," said Uteq, and his face grew sad, thinking of Sepharga again. "Or me, Ruskova. But why didn't you just approach?"

Ruskova looked suddenly embarrassed in front of the handsome Bellarg. "I...I...Well...was..."

"Spying," growled Uteq suspiciously. "Are you now one of Glawnaq's..."

"Pah, Blackpaw," hissed Ruskova, spitting inelegantly in the snow. "How could you be sayink so, stupid Bergo? Are havink no faith in common Lera? Am comink farther across ice than any fox, ever, and cubs will never be believink. Though grown now, and two lost to eagles too. You left nothink though, for scavenger to be even eatink. Selfish Bergo."

"I'm sorry, Ruskova. Really I am."

"But was wantink to see why are comink north, and then am losink many times. But here am. A promise deep in mystic heart."

"Thank you, dear Ruskova," said Uteq, remembering the whale and Mitherakk telling him the journey was not really about him at all.

"It was a Great Master, but a dear friend too, that led me out of hell, to the light, and a female as well. Or the memory of her."

"Bergeera?" said the fox almost jealously. "Where is she? Sepharga."

"Gone," said Uteq sadly and the bear's heart ached. "She drowned out there."

"Are sure? Story speaks of growlers comink back to life."

Uteq looked up at the skies but both of the languages had shown him the truth of Sepharga's death.

"I'm sure, Ruskova. I was there, and mad, visionary Mooq saw it in the North too."

"Am sorry. I was likink her, though lost."

"Aren't we all a little lost, Ruskova? But why are you here now, my pretty fox?"

"To be fightink, of course. Is terrible what Glawnaq is doink to Barg, and to nature. Even when lived communally in east, was not so cruel. Tis crime on mystic heart, treatink Barg as slave."

"Glawnaq does something far worse, Ruskova. All must see it now, and it's time to slay the real monster too."

"Monster?" said the fox, "Like gods. Not real, Uteq."

"Oh Ruskova," growled Uteq, as the wind rose, "The gods are very real. Which the Garn energy inside us makes, and we recognise in dreams and name in stories. Stories of gods and goddesses and heroes and monsters, that gather together like currents, to become a great myth, beyond individual lives, holding the kernel of a greater truth, that help us all understand our true Selves. Like souls waking up, and seeing the real paw trails through the stars."

"You have seen gods?" asked Ruskova in amazement.

Uteq saw the fineness of her coat and wondered if there was some link to the colours of emotion and the astral lights too, or those strange sea squid that had changed colour. Was that why bears spoke of the gold of love, the red of war, the purple of magic, and the calm pure white of the king?

"Yes," he said, "and know their power, and danger too. For they can be fierce, and make us project shapes and shadows on each other,

and out of our own dark depths too, that are not wholly real. Of fear and hate and the darkness inside. Yet we are not those gods either, that so often visit us in sleep, and the greatest thing is to see and love another living creature. Mortal and fragile too."

The fox looked almost embarrassed as she stood there in the biting winds.

"Love Bergeera?" said the arctic fox almost sadly.

"Yes, Ruskova. For me at least."

"Serberana?"

"Serberana," spat Uteq though, "kept down by the brute strength of fools, who do not see that love, like Garn spectres, must be free, or which of us is really the greater secret. Like mother nature. You cannot own life, or stop it moving. Yet perhaps forgetful grown-ups can help little Bergo to see and love little Bergeera, truly, and little Bergeera fight for little Bergo. As really equal, but very different."

Ruskova wasn't really listening though.

"Slayers were killink Ruskova's mate, Uteq, and eatink in Sound, though Ruskova got another with tail, and all Lera are talkink of Great Story now, puffins to plankton. Leantongue began it."

"Marg?" said Uteq in astonishment.

"Yes. When began talkink to animals. Asked us to protect you, Uteq and true lore. Said if strike must never strike down, like nasty Cub Clawer, but only up, even at stars. Many Lera know of story."

Uteq suddenly felt a great guilt and gratitude towards Marg. The Leantongue had been trying to escape his dark past, his own darkness, and had kept his promise at the Council. Uteq realised too that he might have trusted Marg, because those little animals had come to him so readily in the Sound.

"And even the Gurgai wake slowly," said Uteq, "to how they harm the world. And how the heat they pump into the air, and the trees they kill, stops the earth from breathing. How too their love of the black blood, of their paper and metal, of matter alone, is making them all mercenaries. They are becoming slaves to it themselves, for it is almost bigger than they are now."

"The Gurgai are beink Kassima then. Evil."

"That's what Glawnaq thought he had learnt, Ruskova, a wounded, maimed bear, most dangerous of all, for he sees only with half their sight. But Man, how can we blame any for what they could not see and Man is amazing too? Strange and beautiful. So terribly beautiful sometimes."

"But what you are sayink are doink to world, Uteq. The end of all."

"No," said Uteq, thinking of time and billions of stars and the violence and mystery of existence. "That fear must never seize their souls, or kill their hearts and minds, for it will drive them into the dark. The earth is very strong, as is the sun. I think it has a power to remove what harms it, if necessary."

Ruskova unfurled her tail to listen closely. She felt like a Pheline.

"And the Gurgai have so much courage, in the dark. They really seek not just survival, the first lore, or the black blood, not just power or victory, but meaning and real morality – out of the darkness of instinctive nature. The best of them anyway. The truth of everything, and the truth of themselves too. And I think their eyes, only they can truly see the whole. When united."

"See truth?"

"Yes, little fox. Though they come from us, and go blind if they forget it, and pretend the journey of animals is not inside them. A force of nature. You cannot be whole by ignoring the dark and its power, or pretending it is just something 'out there', for that can make real evil in the world."

"Some of animals, Uteq, seem to grow guilty at what are beink now. Bad dreams too."

Uteq frowned and nodded gravely.

"Glawnaq's hateful shadow, Ruskova, learnt from the bad reflection of man that makes a prison of the wonderful universe. They need to see again, through eyes that love, and truly understand. That welcome, not banish. For what makes cubs and fox cubs grow but love, and what makes eyes but something waking in life and mind trying to understand itself? And we must be careful how we look, and judge, and let others judge us too. Must never be made victims of fear or hate. So we need our ice lores"

The pretty fox beamed and nodded.

"But humans are like plants too, that need love and meaning from each other, like rain and sun. Like flowing Garn, moving in the flow of Pollooq's fur sleeves. Like light."

Ruskova looked rather jealously at Uteq and seemed to see a light shining out of him.

"Perhaps are becomink famous poet too, big Bergo. And Ruskova, Bellarg's muse."

Uteq thought of the two languages, of Pheline and Fellagorn. A muse, a goddess of inspiration, in-breathing, is usually female, and he was glad to have her here.

"Yet it brings them a terrible burden, little fox, almost as painful as the Pirik, because they can see what the Lera cannot, though we sense it: They have consciousness of their own deaths, Ruskova, in time."

Ruskova felt as if they had both stepped off the end of everything.

"Unless there's beink heaven, or great ice sheets in sky, where fox and Bellarg roam forever, in beautiful stories."

Uteq smiled a little sadly and again thought of Sepharga.

"Yes, Ruskova, but there's something far more beautiful than even stories. Real life, for real Bergo use their power and strength to serve every new day, and be connected. If the Gurgai wake up too, and use the Great Gift again, then Teela may understand Pollooq, and the Fellagorn and Pheline not forever think one must conquer the other. The lion may lie down with the lamb, Ruskova, until it's hungry again. The kingdom is both without and within, in balance."

Uteq's eyes sparkled mischievously.

"Then the earth may become the ice ark indeed," he said, "in the darkest space, as we all grow and go on."

"But what are doink here, Bellarg? Nothink here for hungry bear."

"Seeking the fabled entrance to the Underworld, Ruskova. To talk with the dead and know the truth of the past, and Pollooq's tragic sin."

Ruskova suddenly looked deeply nervous.

"Underworld? Are finding entrance then?"

"Entrances. In our world the entrance is sleep and dreams, for they take us down into the underworld of our darker selves and

natures, made of all the past, but also let us touch immortal Garn shapes, from the beginning of time itself. Especially the Gurgai."

"Where dead are? Like spirit lights."

"The lights?" said Uteq looking up, "the Beqorn aren't the dead, Ruskova. But they do talk, fox, for they're like thoughts and dreams too, flowing out of the universe itself into the world, even into our sleep. Thoughts we can share too, if we all wake up."

Even as he said it, among a flowing wave of blue, he saw a column of white cloud, rising from the pole, but that black slick seemed to be pouring along its edges, down to the earth.

"We must hurry though, Ruskova. For too much darkness is flowing into the world's dream now, or out of the dark dreams that Glawnaq has shown the Lera of the worst of Man."

"Said entrance in our world," whispered the fox though, "what are meaning?"

"There's another, for another language. The entrance in stories and that's a real doorway to Hell."

"Story entrance that none have ever found? Where, Uteq?"

"Pollooq's cave, Ruskova. For though the Pheline did not know it, where they bound the demi-god really stood right above the entrance to Hell. Pollooq was standing above the Ice Labyrinth all along, and the terrible monster all must fight within themselves."

Ruskova was shaking slightly.

"There too, Pollooq committed his sin, Ruskova, and so was truly crucified, even in his pain and love."

"Sin? Crucified? Poetess not likink such talk. What sin? Showing Teela evil?"

"No, Ruskova. It was Pollooq's grief and pain that made him look so deep with the dark side of The Sight and his sin was that in his longing he tried to do what is impossible. Pollooq tried to speak from the two worlds at the same time. Of gods and the Heavens and Under-world, of the mystery of sleep, in his Fellagorn tongue, but of his mortal, fragile love of Teela, as a Pheline. So the demi-god was tortured by dreams and outer reality at once and torn apart."

In his mind Uteq saw Pollooq, standing between the pillars in the

cave, and it seemed as if the wounded demi-god was trying to hold the two worlds together, to join them again with pure will.

"But Fellagorn and Pheline only talk the same language at certain times, Ruskova. The one of gods and immortal, undying ideals, or what fights for life in the dark; the other of harsh, beautiful reality, and seeing with the judging mind. Teela could not hear Pollooq, out of fear, though she had touched Atar's moon dream, but she was more Pheline, though all return to that language when they separate, and are cut off again."

Ruskova thought of what she had heard of the Barg's Separation and shivered.

"In the pain of it the Fellagorn reached so deep into language and mind, with his rage and Fellagorn word power, it shook the cosmic balance, and struck at the very roots of the universe. It terrified the Pirik, and harmed the eye of The Sight too. That caused the curse, Ruskova, and the wound that all living things feel in real nature."

"Curse of speaking unlucky story and it coming true?"

"Unless we turn darkness to light," growled Uteq, "and make the story lucky again. Turn nightmares of Man and Lera to wonderful dreams again. Lead others back from hell, for there is a paw trail out, even when alone. It is always inside you, to light the way. But by reaching into an ancient past, now the languages can be spoken clearly, and we must show them somehow, and free Pollooq forever."

"Free Pollooq! Impossible, he's just a..."

"Story?" said Uteq with a smile. "What is impossible with the strength of the Pureem?"

"The Pureem, bear? Freedom, Beauty, and Truth I know, but what ideal Lera was fourth?"

"Pollooq himself. The spirit without which all fail too. Love. We must free the spirit of love. But not with the anguish of suffering, but with the fiery power and strength of real love and responsibility."

Reality seemed to strike Uteq though.

"But what's happening to the world seems to be happening every-where now, Ruskova, as dark dreams flood out of the stars. Perhaps the borders have grown too small for the Gurgai's dreams and they

forget their spirits. When I put my paw down, almost as Mitherakk spoke of an Ice Whisperer who could heal the ice, I hear it all."

Ruskova looked at Uteq in astonishment.

"Are you beink Ice Whisperer then, big bear?"

"I don't know, little fox."

"Perhaps paw is bringink cold back. Touch Ruskova."

Uteq looked surprised, but very slowly he reached out and gently touched the fox's pretty little shoulder and wondered if he could freeze her like the Fellagorn dead.

"Nothing," shrugged Ruskova, who only felt a slight warmth and looked rather coy. "Snow, then, Uteq, be touching snow. Be whispering to snow with mighty power. Perhaps..."

Uteq lowered his black paw, and pressed it deep into the white, yet all it did was leave a clear paw print, quickly blown away in the arctic winds, like Sorgan's memory or the past itself. Uteq sighed.

"No, I'm still only a real bear...But maybe I am different."

"Different?"

"I've grown up, Ruskova," answered Uteq proudly. "Into a Bergo and my real Self. A bear that must never hide his light. For to blame oneself like a Blaarq is not to take real responsibility at all, Ruskova, it is really to hide. Showing and using one's true power makes others free."

"Are believink though in mystic heart, Uteq, beyond these Garn gods inside?"

Uteq thought of Mitherakk and his poor calf. Pollooq's Proof. He growled.

"I don't believe, fox. I know. Everything's made of Garn, all is connected, and The Sight has real power, but there's something out there, more, I mean. Pollooq proved it, though that's Pheline language, for God, love, faith are not things of Scientia, but like feelings, inklings, belief itself, that nothing can live without. Though we must try to look and see with the light side of The Sight."

"And I can be leadink back much faster and be scoutink ahead too."

"Like a good and clever Pheline, ready to fight in the real world. And for it too."

The arctic fox was nodding.

"Help King Uteq cross Glawnaq's border, safe, sound and secret. Am knowink safest way across Haunted Island, and down through great pressure ridges edgink kingdom, if get past Varg."

"And I'll use my instincts, and wild strength too, though we travel in secret, for I'm no mad Lemming anymore. While I feel something calling me south. The region of the warrior. Perhaps it's Matta, after all."

"Bergeera who liked you?" said Ruskova, remembering that distant summer. Even as she said it something quickened fear in Uteq's heart, and he remembered that terrible vision of Qilaq, or his half dream of the murdering Glawneye, wielding an ice dagger in the dark.

"Yes, Ruskova, for immortal Garn imprints of Bergo and Bergeera can act on each other like the moon on the earth, like gravity, or a Gurgai needle, pointing north, and the Self is as deep as the sea. That Garn force inside us can tear us apart, as it did poor Pollooq."

Ruskova blinked and Uteq looked sad.

"That's why I know Pollooq's terrible suffering. But we need to bring the two languages again, fox, and show them they are all heroes, or can be again. Even gods, though gods of reality."

"Your hero," said the Furguran proudly.

"All are heroes inside, trying to fulfil a journey, not just Bergo. The journey always goes on."

"Met Bergo when followed bears from Sound asked to find Uteq, though has taken while," said Ruskova now. "Secret heart of resistance and mystic too, am thinking. Freedom fighter and wanderer, for he moves among Serberan as if one. Is not freedom true birthright of wild bear?"

Uteq looked down at Ruskova sharply, and in his mind's eye, he saw Sepharga drifting away from him again.

"Freedom? A Bellarg's wildness, or a Bergo's rage? Yes, yet I know too there's no real freedom without love, connection, and others to

serve, or one's greater Self. There's another way of fighting in the world than the killers though. We must turn a warrior's killing power to light and love."

Ruskova felt a pain deep in her heart for the bear. She was a little in love herself.

"Someone else wantink to help too, born again Bellarg, spyink seal holes and food from air."

The sudden cry in the arctic night was the most marvellous thing that had happened yet, and a shape swooped down out of the Beqorn like a feathery spirit. "*Sqark-Grrrrr!*"

"Egg!" roared Uteq happily. It was impossible. Except it wasn't, because in a frantic flapping, the emperor goose descended in the Long Night and landed at the North Pole, dropping a large fish. It was becoming a strange menagerie indeed – a bear, a fox, an emperor goose, and a dead human explorer who had never even made it in his quest.

"But you're dead, Egg. We saw you get eaten by the seawolves."

"Feathers," squawked Egg, slapping his webbed feet against the ice, and Uteq remembered not seeing any spirit light. "Grow back. Poor Egg lost in fog, and spent age looking for Murth—"

Egg stopped and looked suddenly embarrassed, straightening proudly again.

"*Father*," said the goose instead and lifted his beak. "Time to find mate too."

Egg looked lost, for in his absurd squawks and growls lady geese had never understood him at all.

"You've changed too, Egg, and grown," said Uteq, thinking of Mooq's growlers restored, but wishing he could resurrect Sepharga. Could love or any Fellagorn Word Power ever do that?

"Found funny poetess fox," said the goose, "*Geeeek. Grrrrr.*"

Ruskova laughed, as Uteq reached down for the fish, while the goose tried to control his strange noises. "Mad bird findink near Sound. Poetess not understandink, until bird pecking paw."

Ruskova raised her tail as Uteq ate, looking as if she wanted to eat the creature denied her that strange summer, but she lowered it

again, for she had been thinking of trying to help Egg find a mate instead.

"After Marg, is how arctic foxes, lemminks and wolverines, knew you were beink still alive. They feel your Garn, Uteq. We've many on look out. Resistance, like Scouts. Honour and vigilance."

"This mysterious Bergo?" said Uteq suddenly, licking his lips. "Who is he, Ruskova?"

"Wanderer, but resistance among Lera. You're thinkink all Lera faithless or servink simple killers? Not arctic foxes, or mystic heart of east, and many can bite with teeth."

The polar bear smiled and growled approvingly.

"Is beink high time things are back to normal, and if aren't normal up there," said the fox, looking up at her huge friend, "what can be beink normal down here? But resistance weak, Uteq, because Lera not understandink each other. Need translatink with Great Gift of Bellarg tongue."

"The two languages," nodded Uteq, "so we fight for the Gift and knowledge of the two worlds and this time strike only upwards. That's what Glawnaq can't see. The lore that the strong must protect the weak. Only then will the Pirik's suffering end."

"And both are helpink Uteq south. Me by paw, Egg by wing, you by claw. Three. It'll be gettink us quick around black sticks, too."

"Black sticks?" said Uteq sharply.

"Strange poles Gurgai bringink north for year. Wasn't blind Bellarg seeing? Hundreds, like tundra field of tall black sticks in snow. Is strangest thing Ruskova was seeink. In even stranger life."

PART IV

AWAKENINGS

19

A MURDEROUS LEGEND

*"I was angry with my friend, I told my hate, my hate did end.
I was angry with my foe, I told it not, my hate did grow."*
—*William Blake*

og shone hot, bright and angry now in Glawnaq's Sound, where the arctic spring was almost done again. But where, with fear of Eagaq's Knowing and all that was happening, wary mothers had birthed very late, if at all, and remained hidden far longer in their dens. The Serberan patrolled as ever, their eyes with a vicious, hungry look, though all seemed deeply well fed. There were few Varg around, and many of them exhibited a feral air, for Treeg's super pack were stationed to the north, guarding Glawnaq's borders.

Across the arctic snows the ceaseless activity of the Ice Slayers was greater than ever, as regular patrols came in with new and hopeful Barg, and others left, taking the weakest Barg out on regular Leaves. Above the bay sat a pitiful group of Barg; badly fed adult bears, seated in two circles and whispering together. In the centre of a group of Bergeera sat Anarga Calmpaw, and around her, like a little court from the Sound, were Innoo, Matta, and Antiqa. Rornaq, Seegloo, Forloq, and Brorq sat together too, not far away, dozing fitfully, as some Serberan watched at a discreet distance. None of their charges had been marked in the bay with those terrible numbers.

Now a work party of scrawny Barg females came traipsing past them and looked resentful that Bergo and Bergeera should be allowed to mingle so closely – with Glawnaq's permission and protection, for

in the bay they themselves could only mingle at full moon now, and for the briefest of periods. Anarga's wound had healed, and she looked healthier and stronger, although there was an awful sadness in her eyes.

"You resisted that Serberan Furgaq last season, Antiqa?" she growled suddenly, swinging her head. "Even though he showed such an interest in you, my dear? It might have found you a way out of here."

Antiqa had grown very beautiful indeed and she glanced across fondly at Rornaq, although he and the others were out of earshot. She liked the Bergo very much indeed and he seemed to like her too.

"I'd never join them, Anarga," Antiqa growled. "I hate the Serberana. They come down to watch us working sometimes and laugh, and who would give birth to anything now, even if we did have a free choice? No cub of mine will ever be a poor little Tapper."

Anarga frowned gravely. "I know, Antiqa. Last season I noticed how the Tappers hardly seem to grow at all"

"Poor Pooq," whispered Matta, with sudden tears in her eyes. "They took him on a Leave, Anarga. He's gone."

"Yet we must live, Antiqa," said Anarga softly, nodding at Matta, "and nature is strong. Even here."

"As strong as your instinct to resist Glawnaq, Anarga Calmpaw?"

"Hush, Antiqa," growled Anarga immediately. "He believes I heal for him, so it protects us all in this hell. At least Nuuq's safely denned now and I'm glad Soonaq proved so loving, even for a Serberan, and let her den here, near her real friends. He respects her wishes and they'll have fine cubs."

The friends looked toward a line of vaguely regimented dens beyond, and a great boulder beside one snow den.

"Nuuq's cubs will never be Tappers, either," added Anarga with a smile, "Soonaq will protect them, when they Come Out. He talks of escape too. Brorq says he even heard Keegarq speaking of it, after his cub Scarq died in that Moon Duel."

"Nuuq told me through the snow that they're twins," said Matta, "called Olooq and Olooqa."

"Straight and narrow?" smiled Antiqa. "She should bring them out soon for the Wander."

"The Wander-to-the-Sea," said Matta with a wistful sigh, looking out longingly across the terrible bay, as though the memory itself healed something in her. "That'll never happen here though, Antiqa, except for Serberana cubs. What little ice we have is far too weak, with so many work holes. What seal are left anyway, with all the hunting for the Serberan?"

"And that black blood in the ice gullies too," grunted Antiqa. "It drives the seal out. The ice stretches much farther in the Serberan's Sound, though. Nuuq's little cubs will like that."

Matta looked compassionately at Seegloo, who was asleep next to Rornaq.

"Poor Seegloo," she whispered. "It hurt him badly again, losing Nuuq. Like Pollooq and Teela."

"But Nuuq must be so happy," said Anarga fondly, "though vain Bergo never know it, there's no more beautiful sight in the whole world for a Bergeera, and no love deeper, than the first sight of her own new born. We can't help it. But she loves Soonaq too."

The females smiled but even then, a chill breath seemed to come from the north and it had a terrible word on it, hissed out of some nightmare, "*Murder.*"

"Teela," said Innoo, looking around sharply, as if the mythical bear was there with them. "What happened to Teela, Anarga? I always wanted to know."

"Perhaps Tutsitala should tell us, Innoo."

They all looked at Matta. How she had disguised herself as Bergo to help her brother Qilaq, had deeply impressed them all. It was Matta who had often told them stories too, to keep up their spirits and defy the Serberan, just as the strange Janqar had done, though he did not come to Matta anymore and she wondered why.

"But you know that story, Mother," said Matta a little irritably. "Atar punished Teela for wounding the very soul of the white bear, which brought the ancient curse. So she sent her alone into the heavens forever. As the Pole Star."

"That's one version of the story, Matta," said Anarga softly.

"One version?" Matta said in surprise.

"Yes. The Fellagorn made up different versions and endings, as they tried to master life. Another story says that Teela found her own mate and lived a long and happy life, and had many fine cubs too, whom Teela taught to tell stories of power, even though they were Pheline. For at last she realized what she had done to Pollooq, and knew his terrible pain. But when she grew old and began to fade, Teela remembered the demi-God, and knew he was in her soul too, as we are all in one another's souls. And so she asked Atar to be near him in the heavens, shining down on the Lera and guiding them in the dark, forever."

"I prefer her sister's story," said Antiqa though, looking at Matta again. "How Athela loved Pollooq too, but with real love, so listened to him in the cave, as well, and gave him food, then left the Pheline to become Fellagorn herself, disguised as a Bergo. A wise Storyteller and a true heroine."

Matta thought of Janqar again. She missed his cheerfulness and stories, even though she knew he had just been trying to give her hope and courage, though there was something strange and hidden about him. Matta still wondered how he had moved around so freely, and there were always rumours among the frightened Barg of spies to quash dissent. Yet Matta felt a sudden fear that Janqar may have been sent on one of the Leaves too, for he was not protected by Anarga Calmpaw, as they were.

"The Ice Labyrinth, Matta," said Antiqa now, "only you've heard the story of Pollooq's terrible trials there. Will you tell us how he defeated the Gorg then and if he ever escaped? What he saw when he looked on the Gorg's face, down in Hell and the lair of the Evil One."

Matta looked rather warily at the others. The story almost frightened her, but she nodded.

"Yes Antiqa. Very well," she said softly. "Pollooq saw his own features in the Gorg's face imprisoned in the terrible Ice Labyrinth, below the Pheline's cave itself, although the Pheline could not see it. He was horrified that such a creature could even exist, as the Gorg

roared, trying to speak like us – *Gorrr, Gorg, Graaa* – and alone the hero fought the vicious monster. For forty Long Days and forty Long Nights, Pollooq and the terrible Gorg battled, and the whole ice world shuddered beneath the moon. Then Pollooq looked down and saw the Gorg lying there on the ground, quivering, his red eyes extinguished, and felt himself a hero. As the Gorg died, at last that word formed on its bleeding lips. 'God,' it gasped with a sigh."

"In the beginning was the word," said Antiqa, nodding. "The Fellagorn always said that."

The females looked pleased, although they gazed rather mournfully at the Bergo nearby.

"The Pheline in their cave were listening to Pollooq's story intently," Matta went on, "for remember it was just a story he was telling, as they heard their own names, but now the Storyteller spoke again. 'Yet in the hellish Labyrinth Pollooq's eyes were gone,' said blind Pollooq, 'and his bleeding brow crowned with sea urchins, and his fur sleeves cut, so he could not feel the universe anymore.'

"The Pheline, hearing Pollooq speak of himself so clearly now, grew confused and thought he had lost his mind, and his way too, forever. They laughed at Pollooq for telling a tale of heroes at all, especially of himself. The Pheline alone were heroes to themselves now, and the Gods were dead.'

"'See blind Pollooq,' they cried. 'You have even killed your own god, and there are only two real stories in the world, victory or defeat, triumph or failure, and you are already broken, mad, and lost in your tale forever. Let us tell you how your tale ends then. Let us change it for you.'

"'No,' groaned Pollooq in horror, 'you must not. It is a terrible sacrilege to a wild Fellagorn and the end of freedom and the Great Gift too. Do you not know a true story is like a child that must be born and grow into the world?'

"They seemed to hear some truth in his words, and so the Pheline listened again and Pollooq spoke once more of himself in the Ice Labyrinth and now anger set in his voice. 'Yet the hero was still filled with rage in hell, Pheline,' he said coldly, 'so the world nearly lost the

greatest Storyteller, for he thought of replacing the terrible monster himself and becoming the Gorg. Besides, the hero could not make the journey back up to the light, without a guide. He was forever in the dark, mad and alone, a Bellarg imprisoned in the belly of the world, and a spirit lost in hell. For Pollooq there could be no salvation.'"

"Poor Pollooq," growled Antiqa and Matta nodded.

"Now eyeless Pollooq groaned, as he hung there like a Gurgai," said Matta, "wretched and ashamed before the Pheline, for what they had said of no escape was true indeed. He was hoping against hope that even now Teela might call to him to restore him with her love, for he knew now that real love does heal and make us whole."

The she-bears sitting around Matta look almost wounded, and guilty too that they could not have done more in all that had happened.

"Nothing came though, but Teela's fear of the wounded Bergo," whispered Matta angrily, who had grown as good as Athela at story-telling herself, "and the chattering of the watching Pheline too. Pollooq's ragged body seemed to wither even more, and none believed that with his tale he could heal himself, let alone all creation, as he had vowed. Especially since the god of which he spoke was dead."

"Poor Pollooq," said Antiqa softly. "There was no way out for him at all then, Matta. Did he tell them he stayed in the Labyrinth to become the evil monster?"

"No, Antiqa," answered Matta quickly. "For as Pollooq stood before the Pheline, chained in his own story, he suddenly realized something. That he had committed a terrible sin."

"Pollooq?" said Antiqa in surprise. "What did poor Pollooq ever do wrong, except for backing down with Teela, and getting so angry at his friend?"

"Just that." Matta sighed. "A sin against his own soul perhaps, for Pollooq had lost belief not only in Teela and the world, but in himself and the gods and goddesses too. Above all though, he had lost belief in the power and truth of stories, and that power was not his power anyway, only the great universe's, flowing in his fur sleeves and filling

his dreams. Eyeless Pollooq had tried to speak from the two worlds at the same time, and realized then that in the darkness of his despair, he had become mad indeed, and hateful as the Gorg in his story, and that he had become a Pheline too."

"Pollooq become a Pheline?" snorted Innoo, though she was looking about in confusion. "Never."

"Oh yes, Mother," said Matta, glad at least that Innoo was paying attention, "for he had lost belief in the Great Gift and so saw only the terrible battle of everything – not the real living world, and its love and deeper connection too."

"What did Pollooq do, though?"

"He nearly died there, before them," said Matta gravely, for she was suddenly thinking of Qilaq and it hurt her, "for like his wounded body, his wounded soul was literally split in two."

"Dear Pollooq," said Antiqa, feeling a desperate love for Bergo. "Poor, wounded Pollooq."

"Yes. Yet Pollooq was strong, Antiqa," growled Matta softly, as if she was holding onto the story itself, and making it true, "who knew real spirits can't be broken, and being a Storyteller, was half-god. So he whispered faintly for some food and when they brought it, Pollooq ate gratefully, and thought and then, as the Pheline began to laugh at him once more, Pollooq remembered his father, Gog, and his mother, Atar, and he wound the strangling seaweed around his paws between the pillars, tighter and tighter, to remind him that he was still alive."

Matta thought of Qilaq clutching that rock and her heart hurt her desperately, but she remembered his words too. *'There are no happy endings for the Barg.'*

"He felt the real shape of the pillars in the cave – a stalactite that drips from heaven and a stalagmite that rises from the ground – and planted his paws firm on the floor to feel the earth's power, and straightened his back proudly, and went on, and as he spoke, and with true Fellagorn power once again, storm clouds began to gather around the very mouth of the cave.

"'The blind hero was completely alone in the Ice Labyrinth now,' Pollooq told the Pheline, yet he suddenly heard a gentle voice whis-

pering to him, calling him up out of the darkness, into the wonderful light again, a guide telling him that he would heal with the sun and moon, and that they would give him eyes once more. The voice told Pollooq that as a warrior though, and for one time alone, he should bring the fire and fury of the Gorg with him now, out into the light and air, and the fighting power of the wounded white bear.'

"'So the hero turned at that whispering song,' cried bound Pollooq, scorning the Pheline before him now, but paused as the voice came again, *'never look back, for you shall turn to ice yourself'*. So he rose up, never looking back at the endless past, or the deep darkness of bad dreams, and followed that Bergeera voice out through the winding ice passages, which now showed him his own reflection – as a proud living Bergo again, the greatest of the ice heroes. Whole once more."

"Mighty Pollooq came out into the clear blue day, and turned to the right outside the Labyrinth, and scratched three warnings there with his claws, to guide any that ventured too deep within: *Know thyself, Nothing in Excess, and Make a pledge and mischief is nigh.* Then the orbs of the sun and moon healed him, and restored his blinded sight, and Pollooq looked out onto the beauty of the living world again and saw."

In the real world, in the warm spring day, it did not feel as if any mighty spirit had been released in reality at all though, and they heard growling now, and Matta looked around and saw Serberan shaking their heads angrily, for they could not believe that their Dark Father would allow such sacrilege as this silly story.

"But who led Pollooq out, Matta?" asked Antiqa softly. "He may have been strong, but he wasn't really alone. Who sang to him to guide him back, if not faithless Teela?"

"I don't know," answered Matta, as they felt an icy wind suddenly whip up a breath of cold off the cruel sea. "Janqar never told me that part. But I bet I can guess."

Just then they heard a great roaring from the direction of the Serberan's Sound and Matta turned to look and her lovely eyes darkened. She was clearly in great pain suddenly.

"I'm sorry, Matta," whispered Anarga, seeing the young Bergeera's anguish, for they all guessed who she was thinking about.

"And even after what you did for Qilaq, Matta," said Antiqa, "to become a Glawneye."

Matta winced and felt a guilt in her heart for what she had not told her brother.

"Yet you mustn't judge Qilaq too harshly for finding a way out of the Barg," said Anarga kindly. "Your brother's a strong Bergo now, Matta, and has a right to survive, and like Soonaq or Keegarq, they're not all bad. It's hard enough for any bear to survive here."

"And I felt a Bergo's struggle, when I roughed my coat," growled Matta, nodding. "But he's with Glawnaq all the time, Anarga, following him around like a Sqeet. Qilaq even leads the Instructions. I think Qilaq really admires Glawnaq, ever since our own father..."

Matta looked guiltily at her mother for even mentioning Gorteq. She had tried to give Qilaq her love that bright moon in the Sound of the Serberan, but now his was a bitter betrayal to them all.

Even as the Bergeera talked, Qilaq himself stood in the Sound, with five other large Glawneye. The four-year-old had grown into a handsome and very powerful Bergo, as fine as Soonaq, and now he had a generous collar of fur at his throat. Qilaq was watching Glawnaq, who stood next to Eagaq Breakheart, looking down at row upon row of polar bears, massed in ranks before them. Glawnaq One-eye had summoned part of his army of Ice Slayers to inspect them once more.

They were mostly Serberan, maybe three hundred Ice Slayers, but at their front stood ranks of much larger Glawneye, with thick fur collars at their throats and eyes that glittered with a strange expectation. Glawnaq had turned his bodyguard into an elite force now and swelled their numbers too, for it was they who did the darkest work on the Leaves, that so fed their fighting strength – cannibals.

"It's fine, no, Eagaq?" said Glawnaq, as the ranks growled again. "They're all keen to go on the Leaves, but the Glawneye have a special taste for it, especially now that I create my new cult."

Qilaq swung his head and Eagaq noticed that Qilaq was rolling a sharp stone in his right paw.

"A cult, for the pure and strong," whispered Glawnaq, "to teach true Bergo the greatest power of the Gurgai – pure reason. A cult I reveal to the Serberan this very sun."

Eagaq nodded eagerly and his Seeking Claw sprang out, as if he wanted to mark them all.

"Qilaq," Glawnaq growled though, and Matta's twin stepped forward too.

"Yes, Dark Father," whispered Qilaq respectfully. His eyes looked almost mesmerized, as if Glawnaq himself had replaced his longing for his own dead father Gorteq.

"You'll join the cult, Qilaq?" grunted Glawnaq. "And go to work on the Leaves yourself? We must exercise those fine teeth, and famous hug too. You'll like Festlar meat. You know the ancient Bellarg believed they could take spirits of their enemies inside themselves? Foolish, I warrant, but an interesting idea."

"I'm honoured, mighty Glawnaq," growled Qilaq, in a deep, ringing voice, "but I would rather serve at your side, Dark Father. I hate to be away from the true shadows."

Glawnaq One-eye smiled and nodded with satisfaction. He had picked out Qilaq himself, when he had seen him fighting so well during another terrible Moon Duel.

"But I'd lead your cult, Dark Father," said Eagaq suddenly, feeling competitive with young Qilaq. "Your new Glawneye. Perhaps all may grow Seeking Claws now."

There was something both suspicious and competitive in Eagaq's look, for he remembered what his leader had said of his having other eyes among the Five Thousand, and wondered if the spy was Qilaq.

"I know your ambitions, Cub Clawer," growled Glawnaq, "but have patience, Eagaq. There's much to achieve still. A solution to the real problem of the white bears. The problem of the filthy Pirik Barg."

"The Leaves, Glawnaq," Eagaq began. "Rumours are spreading that..."

"Crush them then!" growled Glawnaq. "And I've seen some Barg

hugging one another, of late – in their pathetic fear. That must be stopped too. The Barg must not think of themselves as Bellarg at all, or even Lera, but more worthless than the lowest rubbish. Nor are the Serberan and Varg to think of them as real bears either. Do you understand me?"

Eagaq had raised his Claw and was picking his teeth with it and he nodded.

"While we all look to our future now," growled Glawnaq. "Fearless and proud."

"And Anarga Calmpaw?" said Eagaq, looking toward the ranks of the Serberana who had not denned. "Does she look to the future too, lord? Your cubs, I mean, Dark Father."

"Only the past," grunted Glawnaq angrily, stung by Eagaq's question. "That lying Teela believes she can wait forever, so it's time to tell her the truth at last, Eagaq, and finally break her spirit."

"Truth, lord?" whispered Qilaq, surprised that Glawnaq had spoken of a legend.

"About her little cub. Your friend once, I think. She should know that Uteq and Sepharga are really dead – that both died under the Ever Frozen Sea. Drowned. Treeg brought me the news."

Glawnaq looked at Qilaq, wondering if he would be touched by the words, for Eagaq had told him of their cubhood friendship. If Qilaq was touched by it though, he hid it well. Qilaq seemed as impenetrable as a block of ice, armoured against everything. Glawnaq decided then Qilaq was indeed ready to join his new cult, perhaps to even lead it himself one sun. He knew how fond Qilaq had grown of the sight of blood.

"Spread the word of Uteq's death among the Barg too, Eagaq," ordered Glawnaq, "for some cleave still to foolish stories, and think of him as a Saviour, not the Blaarq he really was."

Eagaq straightened and nodded, with a gleaming smile.

"When Anarga hears of it, and if she refuses me still, I'll place all her little friends under special Glawneye guard," said Glawnaq. "Send them one by one on the Leaves, until she changes her lovely mind. The Glawneye may even tell them what awaits them there, as a

special treat. For there's nothing more terrible than not knowing the truth. I'll go this sun, after the Initiation, for my children must have their Dark Mother too."

Even Eagaq shivered, as Glawnaq turned and bellowed: "Serberan. Loyal Ice Slayers. Your normal salute, to honour Glawnaq One-eye. The Dark Father."

The massed ranks of polar bears lifted their heads and rose on their hindquarters – Tulqulqa.

"Purity and Power," the Ice Slayers roared like an evil wind. "Hail to the Dark Father."

In their birthing dens, the Serberan mothers and their cubs heard it, and shivered, as did the little Tappers nearby in the Bay of the Blessed. As the Bellarg roared, the Glawneye in the front rows swung their arms too, left and right, and in their paws were sharpened ice daggers. There was a sudden growl from Glawnaq's right though. Another Bergo was approaching fast and Glawnaq grimaced at being interrupted in the Initiation of his new cult. It was Sqalloog who came up, swaying a pair of very long fur sleeves. The little bully had grown into a powerful but brutal-faced Bergo, with cruel, devious eyes and Sqalloog looked rather jealously at Qilaq, standing so near to Eagaq and the Dark Father. He had watched Qilaq's rise with both fury and hatred.

"What is it, Sqalloog?" snorted Glawnaq. "Can't you see the Leader's busy?"

"Forgive me, great Lord. But something's happened," said Sqalloog. "A murder."

Above them a soaring gull screeched, and Qilaq seemed to straighten and his eyes clear.

"Murder?" Glawnaq almost laughed, for it was common enough among the Serberan. "What petty troubles are those compared to my great struggle, Sqalloog? Death is a part of life, is it not? Tell me though, who died?"

Glawnaq opened his mouth as if to bite, but he yawned and Sqalloog looked crestfallen.

"Soonaq," he answered, looking sharply at Eagaq now. "The Serberan who followed that filthy Barg Bergeera and then…"

"Soonaq?" growled Glawnaq. "Perhaps it's no matter, then. That Serberan sounded soft."

Glawnaq's eye glittered suddenly. "But Eagaq," he said, turning to his lieutenant, and Sqalloog's eyes lit up, "didn't Soonaq den that Bergeera you had your eye on? Nuuq, wasn't it? The one I protected with the others, while Anarga pondered my choice."

"I think so, Dark Father," said Eagaq with a shrug. His eyes remained focused on Sqalloog, who he knew was angry with him, for since he had made him a boss among the Barg, the Cub Clawer had almost completely ignored him and seemed to admire Qilaq far more. The anger and jealousy had begun to fester in secret.

"And how was Soonaq murdered, Sqalloog?" grunted Glawnaq lightly.

"A mystery, lord," lied Sqalloog, staring straight at Eagaq again, trying to ignore Qilaq. "I found Soonaq last night, Father, on the snows inland – a hole close to his heart, matted with blood."

"A hole?" said Glawnaq, glancing back at his Cub Clawer. "Like a blow from a Seeking Claw, you mean, Sqalloog? Sudden and swift, secret and deadly. Almost invisible."

There was something very strange in Sqalloog's eyes, yet the bear had learnt to love lying. It came easily to the ambitious young Bergo.

"No, great Glawnaq," Sqalloog answered quickly, as Eagaq's eyes bored into him. "It was too large, and there were no traces of fur, as you'd find from a paw blow with a Seeking Claw."

"There, Cub Clawer." Glawnaq smiled at Eagaq. "You are off the claw at least, Breakheart."

Glawnaq chuckled at his own joke.

"But lord," said Eagaq indignantly. "How could you think that I…"

"But you Qilaq," said Glawnaq, ignoring Eagaq. "I saw you arguing with Soonaq last winter, furiously. Dear, oh dear, perhaps there are killers everywhere, with blood on their paws."

Glawnaq laughed again and Qilaq's face seemed to change but the Glawneye answered him calmly.

"That quarrel was nothing," Qilaq grunted, although now Qilaq seemed to be lying, "Yet I'm not sad he's dead. Soonaq won't be missed."

"Go on though, Sqalloog," said Glawnaq. "Tell us all the details."

"It's like nothing I've ever seen, Glawnaq," said Sqalloog, who suddenly looked at the Glawneye with their ice daggers. "No teeth marks either, just a perfect hole. Almost the perfect crime."

A crime inspired by an ancient legend, thought Sqalloog, and a story of cut fur sleeves and melting faith.

"Well," Glawnaq growled, "you've done well to report this, Sqalloog. And so I'll set you to investigate. There'll be some reward."

Eagaq stepped forward slightly. "And I'm sure it was a filthy Barg, aren't you, Sqalloog?" he said, looking threateningly at the four-year-old. "You'll find him out, Sqalloog, all right, with those cunning eyes of yours."

Sqalloog looked coldly back at the Cub Clawer and smiled.

"And I've my eye on you for advancement, little Sqalloog," added Eagaq quickly. "Perhaps if I lead the Dark Father's new cult then, you'll be the Cub Clawer yourself one sun. Think of that."

Sqalloog beamed, suddenly hugely proud of himself, for he had learnt much since he had come to Glawnaq's kingdom, yet Sqalloog wanted something else now. He wanted Qilaq removed from the Glawneye altogether, and broken back down the ranks.

"Yes, Eagaq, of course," he said. "A sneaking Barg must be the culprit."

"Start searching then," ordered Eagaq, "but go and bring Nuuq to me too, Sqalloog, and as Cub Clawer I'll question her myself. My Knowing gives me an ear for the truth. She may reveal something that will lead us to the heart of this terrible crime. Bring her from the snow den and their cubs too."

Glawnaq yawned again but he had suddenly decided to set his own secret eyes and ears abroad to find this murderer out too. Even as he did, far away a figure was moving toward the bay, through high pressure ridges of snow and ice. Sqalloog turned away from Glawnaq and the others, but he growled at a little black-and-white creature, he

suddenly noticed listening in the snows nearby, a filthy, common Lera among Ice Lords. As Sqalloog showed his teeth to it, it flicked its tail at him and scurried off, with a spitting hiss.

Glawnaq looked back at his army for a while, then spoke again.

"Now, Serberan," roared the mighty Bergo, "behold and marvel too. For I've brought you together for a little ceremony. The Initiation of your Father's great new cult, to show you the might of my Glawneye, and the true power to which you must all aspire."

As one, the assassins in the front of the ranked Serberan rose and bellowed, but the Glawneye started slashing at their own left paws with their ice daggers. Garq was missing from their ranks, for he was still in bear prison far to the south, but red blood dripped from soft black pads into the white snows, and then the Glawneye held their paws up to show the marks they'd made to the Ice Slayers, like inverted crosses, or the moving metal cross in that telescopic sight in Churchill.

"Tulqulqa," they roared proudly. "Hail to the Gurgai Cult of Death."

As he watched Glawnaq's spirit swelled and along the line of dens on the edge of the sound, back in the Bay of the Blessed, a Bellarg mother, deep underground, nestled a single cub more tightly to her, trembling at the terrible roars coming from outside, like cries of murder. But with that she heard a very unusual noise.

"*Hopink,*" a female voice whispered, inside the den itself, "*be hopink, little paws, and good mother courage. Be followink dreams, wherever they take. Dark or light, but light better.*"

The mother, who had been suckling too, looked around in disbelief, but no one was there.

Later that same evening though, Sqalloog came wandering lazily up from the Bay of the Blessed, after having pretended to seek out Soonaq's murderer among the Barg. For of course he knew it was no Barg, at all, for none could get into the Sound, unless somehow disguised, and he knew too that an ice dagger had done the deed and melted away. As to the culprit, he had his suspicions all right and they seemed to be helping his plan too. Yet he had picked out a few Barg

Bergo nonetheless, to pin the clever crime on. Now he was thinking how to punish one publicly, ferociously, before he was killed, when Sqalloog heard a sound across the snows, making the mothers and newborn Tappers stir nervously in their snow dens.

It was a roar of pure anguish, and Sqalloog knew that voice well too; it was Anarga Calmpaw's, bellowing in pain, mourning over the news that Glawnaq had just brought her, of her little Uteq's death, and dearest Sepharga too, and of the second bargain that he had imposed if she still resisted him – to kill her friends, one by one, if she did not love him and give him cubs. Cruel Sqalloog smiled sadistically and remembered his own mother, how he had taken her eye, as he wandered on toward the Bergeera's snow dens, in search of Nuuq.

Sqalloog's scheming brain was filled with plans and dreams of raw ambition now, and he could hardly contain his excitement that soon he might be the Cub Clawer himself. After all, he had long been growing his own seeking claw and when it came, Sqalloog suddenly thought how quickly he would use it on Qilaq.

It had started to snow heavily, as Sqalloog wandered on, trying to find the right den. The last in the rows in the Bay, Nuuq's snow mound was not quite in a line with the others, but set back near a great boulder. At last, there it lay, well rounded in the snows, and perfectly crafted, with a care not common to the broken Barg. As Sqalloog lumbered lazily over to it, he noticed what he thought was a snow swan flapping through the cloudy air above him.

The polar bear was surprised to see it at this time of year and he wondered how long he would have to wait for the mother and cubs to come out, so that he could take Eagaq his longed-for prize. Sqalloog was distracted though by another little bird perching on a prong of ice on the ground near the den, ruffling its grey feathers and lifting its little black red-beaked head. A second feathered creature appeared in the air in front of the tern, a tiny flying belly, with open white wings, a minute sprat in its beak.

The male tern, already in full courtship, with the gorgeous spring, and quite unaware of the bears' monstrous world, landed precisely on the cold ice prong, to present his proud prize to his tiny mate. Sqal-

loog scowled, wondering if he should kill them both, but his scowl turned to a roar of rage, when he looked up again and saw Nuuq's birthing den was open already.

"Gone?" he snarled, and the bear rushed straight toward the ice passage.

Sqalloog thought Nuuq and her cubs might still be inside, and now the Bergo jumped at the snow wall angrily, to make the stupid opening bigger. He called out Nuuq's name too, but his paws and shoulders went straight through the snow wall and, with a furious growl, the Bergo found himself tumbling head over paws, straight down the ice passage, and into the birthing den itself. Sqalloog lay there on his back in a painful heap, gripped suddenly by his cubhood fear of small and enclosed places, for to Sqalloog the place felt like a tomb. The Bergo struggled up though, to claw his way back to the lovely air, when he froze, as he heard a whispering voice all around him.

"*So, little bully,*" it hissed scornfully. "*Still fearink tiny place, and fearsome dark? Be afraid though, beastly Bergo, for very soul, for darkness and death await now.*"

Suddenly a silent terror enfolded Sqalloog in the empty snow den.

"Nuuq?" he whispered, looking all around helplessly.

"*Why are persecutink me, Bergo?*" said the voice though. "*Why persecutink all?*"

"All?" said Sqalloog, as he stood there and growled impotently at the voice.

"*But know now that all Bellarg, Bergo and Bergeera, must be hearink new voice, Sqalloog HateSoul, and Barg be risink again, like Twice Born.*"

"Twice Born?" grunted Sqalloog, looking around the glittering walls of the empty cavern. "But Uteq's dead. I heard it this very sun."

"*And are not believink in spirits, faithless fool – or livink souls? Because are believink in nothing, Sqalloog WeakPaw, but power and darkness and death. Not light and love and mystic heart. So legend is comink true, even as all hope fades, for is part of Great Story too. Always.*"

"The Great Story?" whispered Sqalloog fearfully. "But they're all dead. The Fellagorn."

Sqalloog was shivering bitterly, wondering where Nuuq and her cubs had vanished to, and where the disembodied voice was coming from.

"*Perhaps story tells self, but speaks of resurrections too. Growlers come alive. So be goink and speakink of true Knowink, when we are comink again.*"

"But who are we?" said Sqalloog bitterly.

"*Spirits of murdered Fellagorn, fool,*" said the voice. "*Warrior Story-tellers return at last, to brink true justice of Ice Lore.*"

20

THE UNBELIEVEN

*"A man must stand in fear of just those things
That truly have power to do us harm
Of nothing else, for nothing else is fearsome."*
—Dante, The Divine Comedy

"But it's so dark here," whispered Uteq Blackpaw, as he gazed out to sea in Glawnaq's kingdom and took in all that lay before him. "So dark and black. The Bellarg must see the light again. Must wake up and open their eyes."

It was deep into the arctic night, as Uteq looked out to the sea, but the skies were strangely bright. The sea was half-covered in ice, but a long fissure had opened to the east and against a rock climbing out of the arctic waters, a small ship had foundered, its rusting hull protruding viciously. All around it, and reaching back to shore, lay a thick sludge of black blood, choking the seas. The water was as polluted as Glawnaq's heart, slopping against the rocks and up over the edges of the ice shelf. Here and there, among the terrible gloop, where living Puffin that had flown in to hunt for fish, they were floundering still, their feathers thick with the muck, squawking pitifully as they died.

The little cove was edged by walls of wet ice, underlaid by ancient rock that made it harder for them to melt in the summer months. It was part of a chain of gullies, this the southernmost gully, that edged the Barg Bay, and shielded it from any open view. Uteq had arrived that very sun and was hiding still.

"Yet what can I really do to help?" he said almost sadly now. "I

can't clear the blood, or bring the ice cliffs back with a sweep of a magic paw, legend or no legend. It's hopeless."

Uteq felt bitterly discouraged yet he noticed a gaggle of young puffins nearby, who seemed to want to approach the bear, and smiled sadly at the little creatures.

"Hopeless, Blackpaw?" said a deep voice. "Never say it, friend."

Uteq jumped and swung around to see a large Bergo standing there. There was a fluttering too, and Egg flew down, as Ruskova poked her snout out from behind the Bergo's strong legs.

"The Fellagorn believed that in stories lie the greatest patterns, Blackpaw," said Janqar softly. "If the words of seeing, out and in, are truly respected. You must know that now, Uteq Blackpaw. They always said, too, that if something's impossible then it *can* be done."

"Patterns," Uteq whispered to the stranger, remembering his extraordinary visions. "Yes, Bergo, it's true. Stories can dive so deep sometimes that they really touch the real world, though I am not a true Fellagorn. But who are—"

"Janqar," said Ruskova, stepping up smartly. "This is beink Janqar, Uteq. Brave Bergo, Ruskova was tellink of. Heart of resistance here. Strange traveller too."

Uteq fancied Janqar's eyes flickered and, as Matta had done, he felt strange and his paw tingled. There was something almost false in Janqar's clever face.

"I was coming south to find you myself, Uteq Blackpaw," said Janqar, "when the Serberan caught me. And I'm honoured to meet you at last. The very fulfilment of centuries of Fellagorn Storytelling."

Uteq felt that he had almost been invented.

"And I've heard much about you from your friends, Uteq Blackpaw."

"Friends?" said Uteq, thinking of the pact of four. Sepharga's death and his friend's loss had begun to haunt him, especially as he had drawn nearer to Glawnaq's kingdom, like an old wound that had never healed, and perhaps never could. Yet Uteq had told himself that if he could get to see them both, perhaps he could help Matta and Qilaq fight their fears.

"They're everywhere if you look, Ice Whisperer. Your friends. The Lera awake again."

Uteq held his gaze, and his Bergo eyes were strong and clear, but with danger in them too, and something deep and mysterious, like love. It stirred Uteq's heart and he suddenly missed Toleg bitterly.

"And we must turn their dreams back to light," he said firmly. "But it's good to meet you."

"And we've brought another friend, Uteq," said Janqar with a smile. "We had to get her away from the foul Breakheart. Eagaq planned to question poor Nuuq about her mate Soonaq's murder."

Uteq's head rocked up and he gave a groan, and heard a terrible voice on the air, out of his own dreams and his journey to the North. His mind was reeling, half inside a dream and half outside.

"Murder?"

Ruskova was nodding, for of course it was she who had been spying in the Sound, so gone to Janqar to tell him to warn Nuuq and get her and her cubs out of their den. Then she who had scared the living daylights out of Sqalloog, digging a little recess, and lying to him about the return of the Warrior Storytellers. It was all the fox could think of.

"You know of it already, don't you, Uteq," said Janqar gravely, and his eyes were filled with a strange, searching light. A question. "Just as they said you would be able to see things. But who killed Soonaq?"

"Hush, Bergo brute," whispered Ruskova, "not in front of cubs."

Uteq noticed three bears coming toward them now; a mother and her two cubs, looking desperately excited, for it had been the strangest Coming Out that cubs had ever known, if the only one.

"Nuuq," growled Uteq, but although overjoyed to see her again, alive and well, with her new cubs too, his thoughts were filled with shadows again. "And your little ones? I'm so proud for you, Nuuq."

Uteq could see the pain in Nuuq's huge eyes too, she had been hiding from her cubs on learning of Soonaq's murder, and it was in that moment that Uteq swore to himself to keep secret what he knew about Qilaq. The crime was terrible enough, done with a vanishing

ice dagger, but if he told Nuuq who had really done it, it might really break her heart, just as it wounded his.

"Hello," piped the little female cub, who looked very much like Matta. "I'm Olooqa."

"And I'm Olooq," growled her twin, frowning at his sister. "Have you really come to save everything then? Just like the legend says."

Uteq tried to smile, but as he remembered his vision of the ice ark, he realised again that this was the real world, and a very dangerous one indeed. There was much work to be done.

"Please," said Olooqa, holding up her left paw, "I hurt myself. Can you..."

As Uteq looked down he felt a deep humility towards this extraordinary little creature.

"Heal it? No need, little paws. It'll grow better. Lick it with love then, and keep it clean."

"You can't heal then, like a king?" said Olooq rather rudely. "I knew it."

"Hush, Olooq," said Nuuq sharply and Uteq thought of the two languages again, as he looked down rather warily and wondered too.

"King? A king knows how to rule himself first, little Olooq, before he can hope to guide others."

The Bergo cub looked bitterly disappointed.

"But I think perhaps we can somehow send each other Garn, little bear. If we don't block things. Like love on the wind. But we do the work ourselves too, inside our bodies, and there's something else. We must be careful and respectful, of ourselves and others."

The cub scowled and thought the silly adult utterly stupid.

"Oh, dear Uteq," said Nuuq softly. "When Janqar dug us out, then told me the news, your news, I could hardly believe it. How you've grown into a fine, strong Bellarg."

Uteq saw the anguish in her clouded eyes still and wondered what this Soonaq had been like, but he was desperately pleased to see her alive and a mother now, if with all the pain it brings too.

"But tell me, Nuuq, does my mother still live?"

"Anarga lives," answered Janqar, "along with several others from

your cubhood, Uteq. Among the Scouts, Tortog and Sarq, Seegloo, and Brorq, Forloq and Rornaq."

Uteq felt a strange thrill to know that these bears had all survived, as if a little pocket of resistance from the days of the Scouts existed in them still.

"There's Antiqa too," said Janqar, "Innoo, the Serberan Sqalloog, and of course the twins, Qilaq and Matta."

Janqar seemed to put a heavy weight into Matta's name and shot Uteq the deepest of looks. The twins' names had an immediate effect on Uteq, especially Qilaq's, and he winced inwardly, though he kept his poise and said nothing. Uteq thought of Matta and her own betrayal, but, with all he had seen, he knew that had been done as a blameless cub, who might not yet have known true responsibility. Yet what could justify Qilaq's crime – murder – and what had eaten at his heart so, to make him break the Ice Lore? Warriors may fight and kill in the real world, but they do not murder in secret.

"Although Calmpaw thinks you dead, Uteq," Janqar went on, "for Glawnaq told her this very sun that you were lost to the Ever Frozen Sea. The Glawneye have your friends under guard, to force Anarga to the Dark Father's will. Glawnaq threatens to kill them, one by one, if she resists him still."

"Scum," growled Uteq, though furious with Qilaq suddenly, "Then I must get to her quickly somehow, and tell her the truth."

"But they are held in the open, Uteq, so it's too dangerous."

"But you come to tell us stories again too, Uteq?" asked Nuuq now. "Just like the Fellagorn? I could hardly remember any in the den, for my little ones."

Uteq looked almost helplessly down at Olooq and Olooqa.

"Stories? Yes, Nuuq, though the Fellagorn are all gone, so I come to speak of realities first. Even in the language of the Pheline. I've no real power to bring ice back, or build an ark, yet there's great light too, and so I must address the Barg. Tell them all that I know and all I've seen."

"All you know?" said Janqar, looking sharply at Ruskova and Egg.

"Glawnaq's terrible secret. A secret so horrible that it seems to rob

the world of light. But you'll hear of it together, my friends: the truth of Glawnaq One-eye, at last."

Janqar was very thoughtful, his eyes bright and strangely alert.

"Then I'll lead you. Both Bergo and Bergeera gather each evening to discuss the work parties, and choose candidates for the Leaves."

"Among Bergeera bosses," said Nuuq, "Farsarla's sympathetic, Uteq. She may listen."

Uteq smiled, though his being ached with thoughts of Sepharga, and of Matta too. "Good," he whispered. "And I'd talk to Bergeera now. Perhaps they will really listen and really hear."

Not long after, in the terrible Bay of the Blessed, many Bergo were slumped on the edge of the meagre ice, exhausted, ragged, and half-starved. The Bergeera were stirring for another meeting, and it was here that Janqar had led Uteq now. Not all the females were gathered, for many were too exhausted to even move, but those who did attend had formed a loose circle together. Farsarla stood at the top, with squat Gerla, addressing them all as Nuuq approached them with her cubs, but Janqar and Uteq following close behind, watching for Serberan all the while. They came up on the edge of the group, so as not to attract attention to themselves, although Ruskova and Egg had stayed in the ice gullies, chatting and arguing as ever.

"So we must ration the food even more, Bergeera," Farsarla was saying gravely. "Keep what we can for the young ones. It will be worse when the summer comes, and they say they're stepping up the Leaves. Too many of us seem not to make it back, though they talk of a new resting place."

Farsarla looked at Gerla, a grave doubt in her heart, but she did not want to frighten the others.

"We'll give some of the Tapping to the older Bergeera, too, since it's not too strenuous, and we must help each other carry. Too many of us are falling on the ice, to be pushed into the sea for those filthy orcas. Too many of us plunge through ice holes too, on purpose."

"I overheard the Serberan, Farsarla," said a scrawny Bergeera named Meeqa, whose face looked like a skull, "saying more Barg being brought from the west. But how will there ever be enough

room? Even Bergeera fight, and when the cubs come, how will mothers give any milk?"

Nuuq's twins looked at each other in horror, starting to suckle at Nuuq's belly.

"I know it's hard, Meeqa," said Farsarla, as bravely as she could, "but we've just got to make the best of it. What else can we do but bear our sufferings patiently, and go on as bravely as we can?"

"Fight," growled Uteq suddenly, stepping into the circle. "Escape this horror, Bergeera, and this terrible darkness forever. Leave this past behind us, once and for all."

All the Bergeera froze, utterly shocked to see such a powerful male there, for they thought it was a Serberan, even a Glawneye, yet the handsome stranger had no great fur collar at his throat.

"A Bergo here?" grunted Gerla. "You're not allowed to fraternize, right? I'll report you to—"

"I said escape," snapped Uteq. "You must listen to me now, Bergeera."

"Impertinent Bergo," spat Gerla, looking as if she wanted to roll up the fur on her arms and box him. "Are you a Barg boss, yourself, to talk to me like this? I am Gerla and when I—"

"Hush, Gerla," snapped Farsarla though, seeing something grave in Uteq's eyes, and hearing a deep truth in his voice too, as Janqar stepped up beside him.

"Who are you, strangers?" Farsarla asked softly, half recognising Janqar. "If you're new Barg here, we've rules. They're hard, but they help us all survive. But you, I know—"

"Forgive me, Farsarla," said Uteq, pressing his black paw into the snow to hide it, remembering the Bergo Council. In her talk of rules Uteq thought of the Ice Lore and how Glawnaq had cut it down, but how some far deeper law, some cosmic balance had been challenged as well.

"I'm one who has seen much and travelled far. So I come to tell you all that you must be slaves no longer. That you must find your freedom, or win it back again yourselves."

"Slaves?" winced Gerla. "We serve the Serberan, Bergo fool, who'll

427

preserve the true lineage of the great white Ice Lords. And what Bergeera does not suffer for the future, like the Pirik?"

Many of the Bergeera looked resentful or guilty and dropped their eyes.

"And where would we go anyway?" said Meeka mournfully. "Out there, where the ice is even sparser, and the Gurgai hunt us now too? Where the vicious Snow Raiders—"

"Snow Raiders are not real," growled Uteq furiously and both Janqar and Nuuq looked at Uteq in astonishment.

"Not real?" growled Farsarla. "What are you talking about, bear? We all know they cleave to the ancient gods and that their attacks—"

"They are really Glawneye, using ice storms for cover. That's all. Phony enemies, created to spread nightmares and terror, so to bring the Barg to him, as your Dark Father casts his terrible shadow over all. Just as the Gurgai cast a shadow on him. Do you not all have bad dreams now?"

The Bergeera were murmuring, and at the mention of the Dark Father, they all seemed to cower back, for Glawnaq's shadow had got inside them. Yet Uteq thought of that black slick flowing from the heavens too, like the black blood.

"Glawnaq tries to turn the humans against us too," he growled, "though he needs little help from some. He had his Glawneye eat a human cub, and attack others, to raise their fear and hate. But what he does to you, that is his true evil."

There was a gasp among the Bergeera, for there was not one of them who could not feel the anguish of a mother for young, even a human.

"The Cull, Glawnaq calls it. That's his real secret."

"Cull?" said Farsarla, suddenly trembling.

"That's why Glawnaq really brings the Barg to him. To serve the strength of the Serberan, yes, but really to cull the Barg. To kill you all, and make space for his terrible, ruthless future. His Solution."

Nuuq was nestling her cubs under her belly in horror.

"What are you saying?" growled Gerla furiously. "We know that

some Barg die doing their work details. We know we are not free, but death is a part of life. We all fall in the great struggle."

"And it's so dark out there," wailed another Bergeera. "Life's a very curse, but at least here we're alive. Perhaps it's our Karmara. Such dreams I have."

Now Uteq saw something extraordinary. Beside the Bergeera, in the circle, suddenly stood Bergo, just shadowy shapes, but glowing with a similar light he had seen in the North, like the female's twins. But unlike the vision Sorgan had seen in the ice mirror, or Uteq himself when he had tried to hold onto that brilliant shape, their light was dim and their forms seemed starved and feeble. Only Gerla's Bergo shone brighter than her coat and Uteq growled and the Garn shadows vanished.

"No, Bergeera," he cried. "Not so dark out there. For I myself have cursed life, so cursed myself. If you look again with better eyes though, it's wonderful. The shadows are inside you, and now they're outside, only because Glawnaq has brought them out. Shadows of fear, and monsters that weaken you, and turn you on each other in hate. You mustn't be victims, as I became. Ever."

"Victims?" mumbled Meeka guiltily, who saw no light in at all.

"Or Blaarq. Scapegoats. You must look out with meaning again, and live or die by what you believe. For there's no more terrible death than to believe in nothing, each living day, like a coward. You must see the whole, of which you are all a part. The wonderful light, everywhere."

"Wonderful?" snorted Meeka and something strange came into Uteq's eyes, for he needed to tell them what he had seen and learnt in the North, yet was frightened to.

"I've despaired too, and gone deep into the dark, like Pollooq. Yet the things I've seen too. The earth like a snowball. Great galaxies burning in the firmament of infinite space. Yet something beyond, that nothing can comprehend yet, flowing down the Beqorn into dreams. Among it too, Man, like a guardian, seeking meaning and love. The connection of all. We must tell a new story then, together."

Uteq was thinking of Mithril once more, but he stopped, and real-

ized the terrified Bergeera were looking at him as if he was quite mad. He remembered wailing Mooq and how terrifying he had seemed as a cub.

"And it's not all misery here," whispered Meeqa. "We survive."

"And is survival enough, Bergeera?" said Uteq. "Not for me."

"We Blessed still have the Leaves," insisted Meeqa. "They make another Selection soon."

"The Leaves," snarled Uteq, "from which no Barg ever returns."

"Some don't come back, Bergo," Gerla said coldly. "But many do, rested and restored, although they say the reason most are not returning now, is that they're making another place—"

"There's no other place. Only one place – a great recess of ice and fear, of horror and death, where ice gullies run with blood. A true hell on earth. I've seen it myself. Glawnaq's Solution."

Uteq remembered the voice in his vision, warning him not to speak easily of his powers, or what he had seen but he had to tell the truth somehow. To bear witness.

"I stumbled on it in my travels and it's true darkness, Bergeera. A real Hell."

"Hell?" said Meeqa. "There is no Hell, Bergo. No Heaven. Just survival. Animals know that now. That's reality."

Uteq thought of animals and man and the two languages he had sworn inside to reunite.

"Animals survive, and fight. But not like the madder Gurgai can. And if Man looks at nature he can see anything, but it is his worst shadow that has been thrown on the animals now by Glawnaq. For there the Varg feed, Bergeera, but there Festlar has a new meaning, because in the ice, the Barg simply go to die, young and old, mad and sane, Offlar and crippled, and there the Glawneye wear Barg skins to warm them and have become cannibals."

As Uteq spoke of the scene and trap, and the horrified Bergeera listened, even Janqar and Nuuq seemed doubtful. It was too terrible, too much to even contemplate, especially since it was for them that the fate awaited.

"Barg skins warm them?" hissed Meeqa. "Ice gullies run with blood. It's impossible."

"It's true. Glawnaq takes his madness from mad Gurgai."

The Bergeera were shaking their heads, but somewhere in their souls many felt it true indeed.

"And there no light breaks, and not even an arctic tern flies. It is a place of death, of bones and flesh and blood. A place of skulls, for the Ice Lords of the Flies."

"No," groaned a Bergeera in terror.

"It is simply the truth," said Uteq. "And I predict this. Soon Glawnaq shall try to destroy you all. Even those strong enough here, to work and cub. For that's the logic of his terrible plan. His Cull. I know it. I've seen his heart. His broken, maimed soul, that cannot see itself."

There was a ghastly silence around the circle of females.

"They do that to little cubs, too?" whispered a mother bitterly.

"They do," answered Uteq, feeling a rage rising inside him and now he rose up on his haunches and bellowed. "The Glawneye's jaws are steeped in Barg blood."

"There," cried Gerla immediately. "Look at the liar's paw. Black. It's the Kassima cub that some liars call the Ice Whisperer."

Uteq lifted his paw higher, for it hardly meant anything to him now.

"A ghost," wailed a voice. "He comes from Hell then, to drag us there himself. The Evil One."

"No," grunted Gerla. "The stranger's just mad and lying. He has the Ice Madness. Not even the Glawneye would commit such sacrilege. They're ruthless, in ruthless times, yes, but not evil. There is no evil, only wild nature. Great Glawnaq himself..."

"Yes," said another. "We all long for the Leaves. For hope."

"There is evil," cried Uteq furiously, pounding down again, "without love and truth and balance, and in the end it's anything that attacks innocence, and the wisdom of experience too, and beautiful life itself. That destroys ideals, and tries to make it like itself. Empty and savage and dark. Perhaps we really let it in when we deny it all

together, for then we use only one language. But we must shine light into the darkness of ourselves."

Another Bergeera spoke up now. "Keep away from us, Kassima bear. Spreading your fear and hate. Only Glawnaq's strength and purpose can protect us. The Dark Father."

The hiss went up through the crowd of females, "Kassima!"

"No," growled Uteq bitterly. "No more scapegoats. Please. We must all wake up."

It was useless and now Uteq and the others had spotted Serberan turning towards the frantic circle and they started to back away quickly, as the females crowded together, whispering nervously.

"The Unbelieven," Uteq growled to Janqar, as they turned in the snows. "So it's true too."

"True, Uteq?" said Janqar, as Uteq thought he recognised Tortog and Sarq in the distance.

"Something Mitherakk told me. He said the Ice Whisperer would not be believed, even now. Maybe it's just too horrible for any to believe – such a crime against life, and a shadow so great that nothing can escape its darkness. Like a black slick in the heavens, filling their dreams."

Uteq remembered his vision of the stars, and a black hole, swallowing light, bending time itself, a terrible singularity, yet one around which galaxies themselves form, in a fiery blaze of life.

"Like a human story, Uteq," said Janqar thoughtfully. "Illooq saw in Sorgan's Paw Print. Of a questing human and a terrible ten-year war. There was one there so desperate to talk with the gods, and know their secrets that she touched the gift of prophecy, yet was cursed never to be believed."

Uteq thought of the curse once again and shivered.

"They gave her the language of the Fellagorn," said Janqar, "only to be heard by Pheline and not believed. But you really saw this terrible place of death? It's impossible."

"Even you," growled Uteq, striding off. "Even you don't believe, with your mystic heart."

"Uteq, wait. I—"

"No, I must think and be alone again, as I've been alone for so long. Like Pollooq in his trials. The Barg, perhaps I can get into their dreams. Or I must talk to my true brothers and sisters again."

"True brothers and sisters?" said Janqar, looking hurt and Uteq looked up at the skies.

"My brother sun and sister moon," he whispered sadly, "and the free Lera too. I'd stand in no shadow but the sun's now. The gold of love."

Uteq strode away across the snows, back toward the gullies, to hide himself again and his black paw, as Janqar turned to Nuuq. "Go back to Farsarla, Nuuq. You must persuade her somehow to keep the Blackpaw's coming a secret among the Barg. We must keep him safe while we plan."

"But how, Janqar?" asked Nuuq nervously, not wanting to leave her cubs.

"I don't know," Janqar growled, almost angrily. "Think of something, Nuuq. Anything. Use your intuition and appeal to your own. I'll guard little Olooq and Olooqa."

In the gullies beyond, Uteq was walking slowly back towards the polluted, blackened sea. The bear had been hit hard by these doubting Bellarg, perhaps as hard as the truth of a murder, for he had hoped for more from Bergeera, and he was thinking of trust and of his mother now. Uteq wondered how he would ever get to see Anarga, if she was surrounded by Glawnaq's Ice Slayers, yet she would surely believe him, and hear the two languages in him too. Perhaps no one else could.

Uteq remembered Mitherakk saying we are linked to one parent more than the other, and then Anarga herself, calling to him on the ice raft and that tearing pain between them – *"Come back to me, Uteq, if I ever survive this terrible wound. For I've two wounds now, my cub, in body and in soul."*

Uteq had come back to Glawnaq's kingdom to find his mother too, although he had no magic healing berries, and no power to stop the ice melting either. He only had the power of what he saw and felt, only had his voice and courage.

433

Although it had never been dark, a true dawn was coming properly, breaking out of the arctic horizon, as he walked, as the sun blazed on the edge of the earth, painting the distant icebergs with a shattering pink and making the icy sea burn. Suddenly Uteq stopped in amazement and wondered if he was dreaming. Before him he saw Anarga Calmpaw standing there herself, a great, white silhouette bending her powerful neck by the lapping waters.

"Mother?" he whispered, as he padded up behind her, hardly believing she was real, or here at all. "It's me, Mother. I've come back. Is it really you? I thought you a prisoner."

Anarga didn't seem to hear him at first, and Uteq drew closer still. "What are you doing here in the Ice gullies, Anarga? All alone..."

As she heard Uteq's voice, Anarga went rigid, but she didn't turn her head.

"Uteq? Is it really my Uteq?" she whispered faintly. "I didn't expect you so soon. That filth who killed your father let me wander, to consider his terrible bargain. After he told me the truth."

"So soon, Mother?" said Uteq in surprise. "It's been a long, hard journey. Three whole Long Days and Nights, since I left you. I might have come quicker. I'm sorry. I was searching so hard."

"You came as quickly as the true dawn, Uteq," said Anarga, "and after all, your spirit could do no more. Yet I'm afraid to look on such a face, Uteq, like the spirits of the Fellagorn themselves."

"Spirits?" whispered Uteq, and a sudden fear crept across his soul. "What do you mean, mother? It's all right now. Things will be different now. I promise."

"I thought it would all be different," said Anarga softly. "Ice sheets in the sky. And I'd like to see my Toleg again, and know how he's changed. My little Sepharga too. And you, Uteq, because I only remember you as a cub, and you died as a grown bear, out on the Ever Frozen Sea."

Uteq's whole body froze.

"Died, Mother?"

Of course, thought Uteq. Like Glawnaq himself, Anarga still believed Uteq was dead. But if she had come to see him, had

somehow expected him, then that could only mean that now Anarga believed that she too was...

"I must be as brave as I tried to be in life," said Anarga resolutely. "Although I was often frightened inside, true Bergeera never back down. We must not show children our fear, or fill them with it either. We must let them grow and be whole. They always sense it."

Uteq looked into his mother's eyes. She seemed much older, and sadder too. Then Uteq saw the little dribble of black trickling from Anarga's lips.

"The black blood," he gasped. "That's why you're here? You've been drinking it. Human poison."

"Drinking my fill," whispered Anarga proudly, as her son looked at her in horror and agony. "Drinking in a sea of black blood, to clean the beautiful oceans, and drown thoughts of that monster Glawnaq. That's no sin, for the sin would be to harm myself by taking his bargain, and living in a world with no Ice Lores. But there's no sweeter poison, no greater freedom, now you're here too."

"Oh, Mother..." cried Uteq and he felt as if he were drowning in a sea of black blood.

Anarga's moist eyes were shining happily though, as the sun flashed across the brilliant horizon and she sighed. "I thought there would be more pain, like there was when I birthed you in the den, Uteq, and the ice screamed and I saw the Fellagorn fall. But life must include pain. Perhaps only in Heaven we'll really heal the wound of the White Bear. For it's always the wonder of love."

"Oh, Mother, but I'm not..."

Uteq stopped himself. He could not do that to her heart or mind, as he could not reveal to Nuuq who had killed her mate. Uteq had to bear this alone and speak like a Fellagorn too.

"Not, Uteq?" said Anarga, with a look of sweetest confusion, her eyes bright. Too bright.

"Not . . ." Uteq watched the hateful, poisonous blood lapping around the edges of the ice sheet behind his mother, and almost hated Man. For their carelessness and greed. For their stupidity. For forgetting that they are connected to it all, as is all they do. "I'm not

sure where Father is, Anarga," he said. "We must look for him together."

Anarga nodded, as she started to sway. "Yes. The other part of my Soul. My Self. That will make me whole again. To see Toleg Break-back again."

Uteq was in agony and needed to use the Great Gift more than ever, to somehow heal her spirit.

"I think Father may be far out, across the spectral ice sheets, hunting the spirit seal in freedom, Mother. You know how wild he is. Like a true Bergo. We must take the great Wander-to-the-Sea together then, to find Toleg Breakback."

Anarga's eyes lit up, as Uteq saw her almost totter in the snow and stepped closer.

"Have no fear, Mother. A great ice raft is waiting too," Uteq growled kindly, his heart tearing inside, "and a thousand golden narwhals, to keep you safe from the evil orca of the deep."

Anarga smiled warmly. "You know, Uteq, I'm almost glad to be away from it all. Back there, in the world, there seemed so many impossible problems. Too much to..."

"But here there's peace," said Uteq cheerfully, although sobs were choking his throat. "And look – the dawn has come fully, mother. A brave new Long Day. It'll last for months on end, and keep the cubs awake to listen to our stories, forever."

"And then, by Atar, I'm glad," said Anarga happily. "That I did not have to drive you out, brave bear. That there's no more pain, Uteq, and we are dead."

Anarga Calmpaw let out a soft moan. She felt the human poison seize her stomach, and gazed back at what she thought was the spectre of her son, wondering why it suddenly hurt so much to be dead. Then the great Bergeera crashed down onto the snow. Anarga Calmpaw was gone.

Uteq stepped forward and lifted his black paw and touched her still warm nose. Anarga's body shuddered with a shaking rattle of death, and out of her mouth rose a purple light, that shimmered, a fighting spirit that swirled once around Uteq, then swept north and

was gone, though Uteq heard her voice. *"Be free, Uteq. And find the one that makes you whole."*

"Farewell, Mother. Good hunting. I shall make your name a legend."

Anarga's great body lay there motionless by the arctic sea, its Garn spirit gone, and Uteq felt a rage begin. Yet when he remembered what he had seen in the North, a calm touched his heart too, and brought him peace again. At least Anarga was free now, as free as Garn, or light itself. Half in a dream he saw Janqar wandering toward him, with the little twins and Ruskova, as Egg sailed down as well. They all looked horrified.

"Murth—" Egg began, but the goose shut his beak respectfully.

"Uteq," said Janqar. "What's happ…"

Janqar saw the polluted waters, and understood immediately. They stood mourning her, silently, together, for what seemed an age but then Janqar saw a she-bear approaching and Nuuq was the next to arrive and she growled bitterly. "Oh, Uteq. I'm so sorry."

Uteq was gazing down at his mother still.

"Nuuq," said Janqar softly. "What of Farsarla?"

"The Bergeera will not speak of it, I think."

"Good, Nuuq. But why?

"I told them his journeying had indeed touched him with the Ice Madness. Besides, the Barg fear what he said. They do not want to believe in this Cull, but there's certainly doubt in Farsarla's soul."

Janqar nodded and Uteq turned to the others. There was something clear and resolute in his eyes, a brilliant light, like some fire contained in the walls of a strong snow den.

"Your mother, Uteq," said Janqar kindly, "can we help drag her with our teeth, and hide her in the deeper snows? If the Serberan find her here and see that she harmed herself, it might not go well with your friends. They're still prisoners."

"No, Janqar. Thank you for your respect, but Anarga's immortal spirit goes north to freedom and what Garn energy remains is for the world and Lera, so let the dead bury their dead. Now is not the time

for selfish grief, or the past either. We all have work to do though, my friends."

"Work?" said Janqar, tilting his scarred forehead.

"For life," growled Uteq. "If the Bergeera will not listen, we must turn to the Barg Bergo instead and then I may kill Glawnaq myself. That will be my mourning call to Anarga Calmpaw and to Toleg Breakback."

The little party of friends nodded resolutely, wondering if they could possibly keep themselves safe and secret here, but Ruskova lifted her little head next to Olooq and Olooqa.

"Uteq," said the furry poetess softly, unfurling her bushy tail in amazement. "Be looking, Uteq."

Uteq followed the arctic fox's gaze, his vision still clouded with grief, trying to hide it too, but as he saw what Ruskova was staring at in in the late spring snows, Uteq felt the strangest feeling he had in his whole life. For there, right by Anarga's proud muzzle, was a bank of little blue snow flowers he had not noticed before, thick with black spring berries, blooming across the brilliant ice.

REUNIONS

*"We cannot live only for ourselves. A
thousand fibres connect us with our
fellow men."*
—*Herman Melville*

Dark dreams gripped Glawnaq's kingdom now, and looming shadows, of murder and snow ghosts breaking out of the dens with emerging cubs. There were rumours everywhere, like hope, or a legend suckled deep in the earth's belly, that the Fellagorn would somehow return miraculously, and once again tell the Great Story. Yet across these brighter dreams fell Glawnaq's shadow, stealing away hope again and turning them to nightmares, nightmares dreamt by the fearful Barg of what really waited at the end of the Leaves.

Yet Glawnaq's solution was too horrible for most to accept, the very mind revolted. The weary Barg woke to each new day then, making survival and acceptance even more imperative, or the Barg were too browbeaten to resist the Serberan anyway. Although several tried to escape that season, all were clubbed to death by the Ice Slayers, or driven into the sea to feed the lashing Orca. Meanwhile Farsarla had told the Bergeera not to speak of this Blackpaw at all, lest the Serberan hear of it and seek vengeance.

Now the Barg's dreams and nightmares were so strong though that they could little distinguish sleep from reality, and wondered if they had dreamt Uteq Blackpaw too. Some murmured fearfully of the ghost of a Blackpaw instead, an evil Kassima spirit, although a few

spoke hopefully of the Ice Whisperer, a king sent by Atar to save them all, and to heal the very world with his touch and drive out wickedness forever.

Other voices were there too, carried on the wings of a strange emperor goose that had made the bay his home, and underground by the scrabbling paws of an arctic fox, burrowing deep, or travelling out into the world to speak with the Lera. Often Ruskova would vanish from the friends' midst, it seemed on some secret mission, although she and Egg had begun to quarrel about what they should do next. Egg seemed impatient, for the natural rhythms of life were swelling in his feathers and he longed for freedom. There was another reason for their quarrel though, Soonaq's murderer, for from the air and ground they both began to keep an eye on the Serberan and argued together about who the killer might be. Eagaq was the obvious culprit, but Qilaq's name came up too, and it seemed to divide the loyal pair, although they never spoke of it in front of Nuuq.

Yet there were other animals there two, for in the ice gullies strangers came to see Uteq Blackpaw now, cormorants and puffins, gulls and arctic terns, and he would whisper to them softly to calm their fears, as if talking to the Pirik. Uteq was sometimes seen staring out to sea with a little robin sitting on his shoulder like Marg and it spread the secret rumours of returning resistance among the animals, in the world beyond.

Eagaq Breakheart had bad dreams too, after Sqalloog reported Nuuq's strange disappearance. Sqalloog had said he had heard a voice there speaking of the Fellagorn, and a Twice Born. After reporting Soonaq's murder so openly in front of Glawnaq, the Cub Clawer had told Sqalloog to keep the disappearance quiet, although he had gone down to the den to investigate himself, but a snowfall had covered any tracks, and Eagaq had quickly let it go.

It had troubled Eagaq though, the mate of dead Soonaq turning into a voice in an empty snow den and Eagaq wanted the matter kept quiet. Yet there was something else in Eagaq's watchful mind though. He wanted to discover how much Glawnaq had learnt abroad, and if

the incident itself could help him uncover the identity of the Dark Father's spy.

Among the dreams, nightmares and rumours, there was also real news. Five days after Anarga had drunk the fatal poison, two Glawneye had gone roaming down to the southern ice gully to duel in private. Although they had not discovered Uteq and the others hiding in the north gully nearby, they had found Anarga's great body by the sea. A snow eagle had been perched on top, filling herself with good, fresh meat, to give her hungry young some wonderful Garn for the future.

It had raised Glawnaq's fury, and as a kind of punishment against all Bergeera – not just Barg – he had ordered the Serberan's Wander-to-the-Sea cancelled. Rather than releasing Uteq's friends, who had heard of Nuuq's tragedy too, yet strange escape, he had also doubled their guard, and halved their rations. It was as if his control of the bears closest to her heart could somehow compensate for Anarga's escaping spirit.

Late that spring then, it was strangely cold, and the ice actually lasted into early summer. All there was of life across the ice sheets in the Bay of the Blessed though revolved around the regimented work holes, weary Bergo Still Hunting for a catch that wasn't even theirs, and the ghastly sound of nervous tapping, as the tiny, ragged cubs from new Barg dens were set to work immediately, without even being weaned off their mothers' desperately thin milk, wondering what terrible world they had been born into.

Meanwhile Uteq had walked among the weary Bergo, although he had hidden his paw in the late snow. Many times, he had to make excuses to passing Serberan about why he was standing so still. Sometimes though he would touch a Bergo and listen and know their very deepest fears. Uteq had learnt a new love inside, a love for the struggle of all Bergo, and would try to tell them of the wonder and mystery in the world, and the great unity of life, that was only possible to even see away from Glawnaq's shadow.

Uteq learnt a terrible thing too though: Apart from their own dark dreams, above all, the Bergo feared what Uteq himself saw about their

own fate, so closed their ears and beings to his words. Uteq had become the Unbelieven indeed, and he saw in some of their eyes the Pheline hate too that would have returned if Pollooq himself had somehow come back down to earth. Though some of the Barg mothers did break away with their young to find Uteq in the ice gullies.

There they all lived on what little they could find, including dead birds they scraped clean of black blood. Two Bergo also joined them, for Uteq had indeed seen Tortog and Sarq together, and they were overjoyed to see him again, although much diminished themselves. They began to speak of honour and vigilance again though, like free Scouts, yet each sun Uteq was increasingly demoralized as he returned, and they all wondered what he would do next.

The summer arrived, making the polar bears slow and listless again, and Uteq found it harder to conceal his paw. Uteq had wanted to see his friends, of course, especially Innoo and Rornaq, but they were still kept under strict watch, as if to punish them for telling stories, and he could not risk being discovered. Besides, there was one there that made him strangely desperate – Matta. It was not alone that cubhood resentment, it was because he knew what her twin had become.

The rumours on the arctic wind grew so loud though, as the relentless Leaves continued, that Eagaq began to realize that Sqalloog, itchy for advancement, might speak once more of Nuuq and that strange voice in the den, and it made him strangely wary. So one day, Eagaq Breakheart went to Glawnaq and spoke to the leader of it for the first time himself, though wondering if the Dark Father knew of it already with his secret eyes abroad.

"A snow ghost, Eagaq?" snorted Glawnaq with amusement in his cave. "The ghost of the Blackpaw, or the Storytellers themselves perhaps? Why didn't you tell me this nonsense sooner, Cub Clawer?"

"I didn't want to trouble you with something so foolish, Dark Father," answered Eagaq softly, and his eyes flickered, though it was hidden by his twitching face. "Besides, you've other eyes."

Glawnaq looked at Eagaq sharply.

"Only in the greatest of emergencies," he growled, "for to reveal their identity would end their work here for good. If there's some real resistance still, is it not better to bring them all in together, suddenly, like bleating Blaarq?"

Glawnaq grunted as he lifted something he was eating now. It was Bellarg meat.

"But I believe this no more than a stupid legend," snorted Glawnaq, munching on the flesh of a weakened Barg, who had displeased him that very sun. "Sqalloog must have been dreaming that day and anyway Treeg saw Uteq die, Eagaq, and that Varg's as loyal and honest as the sun. The stupid wolf's weak enough."

"Yes, great Glawnaq," muttered Eagaq, wanting to taste the Bellarg himself, but wanting even more furiously to lead Glawnaq's death cult. "I delayed too, as we sought Nuuq, and Soonaq's murderer too."

"And?" said Glawnaq coldly.

"No sign of her. Maybe Nuuq threw herself down an ice hole, with her filthy cubs, but the scum that killed Soonaq has been fed to the orca," added Eagaq, not seeming to care about Nuuq at all, and remembering how Sqalloog had picked out some poor, helpless scapegoat from among the Barg to pin the crime on. Glawnaq's single eye flickered suddenly and he smiled. "Eagaq, Eagaq. Does my own Cub Clawer not trust his Dark Father then?"

"Trust, Glawnaq?" whispered Eagaq, feeling strangely nervous.

"Can a true father not see into his own children's very souls, Eagaq?" said Glawnaq. "As he can into his own heart. I already know you killed Soonaq, Eagaq, with a vanishing ice dagger."

Eagaq looked at him in horror and wondered how much Glawnaq could really see.

"No, Glawnaq, I swear it on my soul."

"Why should you not kill though, for love of a Bergeera, and hate of a rival?" said Glawnaq indulgently. "You must love your deeper instincts Eagaq. Trust your Dark Father to be lenient with his favourite cubs, my little Eagaq."

"But Glawnaq—"

"Well, if I'm wrong, it matters little," said Glawnaq, with a shrug.

443

"We are so far beyond the morality of the common herd, far beyond good and evil, if such foolish things exist."

Eagaq nodded and felt a strange tenderness for Glawnaq. A gratitude.

"And besides, I've more than one murder for you to work, soon enough. It's all coming to a head, Cub Clawer. My glorious Solution's logic is its very power, so we step up the Leaves, to dispose of Barg detritus, as you go among them, and use that claw to quash these Twice Born lies, or rumours of Fellagorn filth."

"Yes. I'll use the Seeking Claw, Father," growled Eagaq. "We'll have another Knowing."

"And then you'll take on a new role."

Eagaq looked up and wondered if he had won leadership of the cult indeed.

"As Cub Clawer with a new title too. The Dark Son himself."

"Dark Son, Father?" Eagaq gasped delightedly. Eagaq felt his heart swell and rose up to his full height, but Glawnaq's shadow fell on him still, and Eagaq felt he could never escape.

"Then, Dark Father," said Eagaq, "I lead the Glawneye too?"

Glawnaq's eye flickered though.

"Not too greedy, Dark Son. We must share. I have given that roll to Qilaq already."

As Glawnaq said it, Eagaq felt hate pierce him indeed, but now, as the Long Day tipped toward the Long Night, a new terror settled over the Barg, despite the promise of returning cold in the rising west wind. Great parties of Glawneye set out for the Leaves, almost every day now, as food was rationed ruthlessly, and Eagaq suppressed rumours with an iron claw.

It caused real fear in Uteq's little party, especially the news of Qilaq's new role, and Egg and Ruskova were arguing all the time, for the poetess would look at Uteq disapprovingly sometimes, and curl her tail round her for warmth, telling Egg that Uteq had lost his way again, and should not spend so much time thinking or talking, when all the Lera were in such terrible danger.

At this Egg would flap his wings furiously at the little fox, loyal to

the last, much as he wanted to live and start a family himself, and tell her that the Leaves may be increasing, but they were safe, while, like Fellagorn had, Uteq Blackpaw saw and understood things they simply could not.

One evening though Tortog and Sarq were standing together, watching the polluted sea ice and Tortog seemed deeply troubled and shivered in the coming shadows.

"What is it, Tortog?" whispered Sarq. "You look as if you've seen a snow ghost."

"Perhaps I have, Tortog," growled the former Scout, small and thinner now, "but it's Uteq…"

"What of him, Tortog?"

"All these rumours. Something's bound to creep out. And I heard Eagaq talking to that Sqalloog, when I went among them last sun. Sqalloog spoke of a spy among the Barg themselves."

"A spy? Have we ever escaped such filth? But not among us, you mean, not again?"

"Perhaps. And when I heard the story as a cub, it always spoke of betrayal."

"Like Eagaq betrayed us," said Sarq angrily, "but hasn't that already happened?"

"So much has happened, Sarq, since everything went wrong. So much can happen still. But I've been watching Janqar, and I don't really trust him. He's grown strangely quiet of late too."

"Janqar," said Sarq, in astonishment, "but ever since he's been here he's been moving among us, trying to keep our spirits up, Tortog. The resistance. Honour and vigilance. The fight for freedom."

"And moves about far too easily, if you ask me," said Tortog suspiciously. "It's as if there was no Separation for him at all. What better way to capture Uteq though, Sarq, than to send out that fox to find him in the North and bring him here, even if she's loyal, into the devil's lair itself."

"No, you mustn't let the Barg's fears infect you too. Besides, Uteq's been here so long already. If Janqar had wanted to go to Glawnaq, or to Eagaq, he could have done so already, many times."

Tortog was thinking deeply, struggling to fathom it all and his own dark dreams too.

"But remember how long it took them to scoop us up in the Sound?" he whispered. "To break the Scouts. And what Glawnaq said on the ice? The first rule of war, Sarq. *Never engage the enemy until you've already won.*"

Something darkened in Sarq's hopeful features and he shivered.

"I'm not saying I know that it's true, Sarq, but we Scouts must keep a keener eye this time and redeem ourselves."

It was that same evening that Eagaq returned to his father in his ice cave as fresh flecking snow started to strike their faces from the high North.

"The Barg?" Glawnaq inquired, with a lazy yawn, staring at his own shadow in the wall.

"Broken, Dark Father. None dare speak of the Blackpaw now, nor Warrior Storytellers either. The Barg have no spirit left to fight us at all. We hardly need to move without them flinching."

"Good, Eagaq," growled Glawnaq, unshakeable in his swelling plans. "Good. Yet the Cull's not going quick enough, so we'll have to do it here. A day of judgement, at last. Did not the Blessed, with their stories of their special father, bring judgement on themselves and set themselves apart?"

"Kill the Barg here?" said Eagaq. "But how?"

"How?" repeated Glawnaq, with a smile. "Anarga gave me the way, as her final gift. Poison, Eagaq, from the clever Gurgai. The black blood. The ice gullies will become your Dark Father's Last Solution. His real killing ground for the Barg. So begin to gather the Serberan tonight for the attack."

Eagaq shivered as he imagined the terrible plan in action and the hateful Barg herded together like tame musk oxen to drink the poison together at the sea shore. Mass murder.

"We'll teach all the stupid Lera the true lesson of history, Cub Clawer," hissed Glawnaq. "Lead, follow, or get out of the way. Now release those friends of Anarga's, to be poisoned too, except one of them, of course."

"One, Glawnaq?"

"The sister of the leader of my Death Cult. Matta. I must have cubs, and now I have chosen a fine new mate to replace Anarga. You'll soon have little brothers, Dark Son. Send Qilaq to bring Matta to my cave now, although tonight I shall Still Hunt myself and build my strength."

Outside Glawnaq's cave, Qilaq looked up sharply, among a little troupe of Glawneye, and hearing the terrible command, in his sister's name, the Glawneye's right paw closed even tighter on a jagged stone, as Qilaq's eyes glittered and he watched the blood bead into the snow.

Within half a sun, as the equinox passed and the twilight before the Long Night began, Matta herself was standing in front of Glawnaq in his ice cave, unable to believe what she was hearing from the most powerful Bellarg the Five Thousand had ever known. Glawnaq had sent Qilaq and his guards away for a while, after they had brought her to him, as he spoke with her in private, to tell Matta the glorious news: That he wanted Matta to become the Dark Mother. He even told Matta she could tell him her stories.

"Your heart must be free to choose though, my dear," Glawnaq said softly. "As Anarga's could never be, since I was forced to slay her foolish mate. My victory's already legend."

The word murder came to Matta's lips instead, but she held her tongue. She missed Janqar bitterly, and wondered why she had not seen him at all. Her heart was crying out for Qilaq too, until she thought of what he had become, and what he had said to her as well, as Qilaq had brought her here.

"I'll give you time, Matta," said Glawnaq. "Although the winter's already here, and so perhaps you'll den late?"

"Then I'll go back among my friends, Glawnaq," said Matta quickly. "Especially Antiqa and Innoo, and think about all you've said, and do your noble offer the greatest of justice in deciding."

"Friends?" said Glawnaq and he smiled, as he heard lies in Matta's voice. "Oh, no, my pretty Matta. For I've released them into the bay this sun, to work once more. For you, the world has changed already, and now you'll stay in my ice cave, alone, all the Long Day through."

447

Matta looked at Glawnaq blankly and felt a dark poison spreading everywhere. She felt hope and her very will draining into the ice. Her mind was reeling as she thought she imagined a little white shape by the entrance to the cave, or was it just a breeze that had stirred the bitter arctic snows?

It started snowing thickly that evening, as Uteq stood listening to Ruskova speaking to him almost angrily. What she said seemed almost to wake Uteq again from some dark dream, as Antiqa, Rornaq, Forloq and Brorq looked at him, as if in a dream themselves. The Scouts were glancing at Tortog and Sarq, and the gaggle of Bergeera and cubs who had become his followers, while Janqar was standing to the side as he listened too, and the Bergo seemed almost confused. Just beyond another Bergo stood trembling in the hardening ice gullies and dropped his head guiltily. Seegloo had aged, his eyes hollower, as he looked back at a beautiful Bergeera, and her two lively new cubs, and Seegloo suddenly felt desperately ashamed.

"Seegloo," said Nuuq softly, turning to him now. "I'm sorry for what happened between us. That we fought."

"Sorry, Nuuq?" The Bergo dropped his eyes. "And I'm sorry I hadn't more real fight in me. Now that I've seen what these filths really do. That I became so angry and resentful, in the Sound."

"Perhaps we understand each other better then," whispered Nuuq gratefully. "The pain and need that all creatures feel. But I hope we can be friends still."

Seegloo looked up almost sadly at this talk of being just friends.

"And it troubles the Ice Lore to fight twice," he said sadly. "But Soonaq was—" Seegloo stopped, looking down at her smiling cubs, "Soonaq is so strong. You've good taste, Bergeera. I was a fool and weakling, and look nothing like your cub's fine father."

At the voices Uteq turned his head vaguely, but he went on listening to Ruskova.

"Come then, Seegloo," said Nuuq. "Embrace an old friend again."

Seegloo looked unsure. "Embrace you, Nuuq? We...we don't do that anymore."

"We do here," said the beautiful Bergeera, "now Uteq's back. We

hug deep too."

Nuuq growled and reared and swung her arms around Seegloo in a tender bear hug, and both of them felt almost whole again, as they clasped one another.

"But come, Seegloo," growled Nuuq, as they dropped down again. "There'll be time to talk together of the past. Now we must listen though, carefully, and fight for the future."

The friends turned and walked over to the gathering of bears around Uteq. They were in a small circle, thin-looking cubs pushing between the smattering of nervous adults.

"His Last Solution," said Uteq, in the middle of the crowd, as Seegloo and Nuuq wandered over. "And so soon, Ruskova? Then I've delayed too long. I've tried to see a way for all of them."

Ruskova nodded and glanced at Egg and the others, especially Janqar. As soon as word had come that Anarga's friends had been released, Janqar had sent Sarq to bring Seegloo and the others to the ice gullies, although Innoo was missing from their party, as was Matta.

"Mad Mooq foresaw it too," said Uteq. "Poison. We must plan though, as we hide here still."

"We're in more danger here if it starts, Uteq," said Brorq gravely. "If the Serberan begin to drive the Barg toward the poison, we'll be discovered here for sure. We can't fight fate though."

Uteq's eyes filled with a sudden guilt. "Yes, Brorq, you're right. There's nowhere to hide. And I must stop it," he added bitterly. "Glawnaq's terrible plan – his disgusting lie. His darkness."

"But the Barg fools," growled Forloq, "they will still not believe you, Uteq Blackpaw?"

"No," said Uteq sadly, shaking his head. "The Unbelieven. The two languages fail."

"Lost, Father," squawked Egg and Ruskova looked sharply at the Emperor Goose. Yet as Uteq stood there, he seemed to realise something and a new light was sparkling in his eyes.

"Oh, what a fool I've been," he cried. "So many words, when it's not about words, but how we act. So we must escape. It's so good to

see you all, and we can get away at least, live in the High Arctic and be free. If you can't make the world see your vision, take it somewhere else instead."

The other bears were nodding around him, for they had given up any hope of challenging the Dark Father's power here, or over-throwing his shadow. They simply wanted to escape.

"I'll go to the Barg one more time," said Uteq, "and plead with Farsarla, and warn them. We must at least try to get the females and cubs away. I couldn't live with myself if we didn't try."

Janqar nodded but his eyes were full of a strange cunning now.

"If they won't listen, we must take word of the truth out into the living world again," said Uteq. "Tomorrow morning, we go north, back the way I came through the pressure ridges, and out across the ice sheets, to the Haunted Island and beyond."

"But they say the ghosts of Varg live up there, Uteq," said Antiqa nervously. "Thousands, Uteq, that help the Dark Father protect his borders."

Olooq, Olooqa and the other cubs were suddenly trembling.

"There are no ghosts," Uteq growled softly. "Only Garn shadows of our own fears. Shadows inside us, we sometimes see without. We go via the ridges then. Glawnaq has Varg everywhere else, with the Serberan ever on the prowl."

"North, Uteq?" said Seegloo nervously.

"North first, then west. Into the deepest night. The region of magic and of change. But for now, we think and act as fast as Pheline, and speak their powerful language too. We must."

"And if we're caught in the pressure ridges?" said Tortog, as Ruskova looked up. She had hated the place when she led Uteq back towards Glawnaq's world, then gone on ahead.

"We must take our chances. Yet it will take some miracle still to convince the Barg, and even if I can, it makes it harder to escape. With so many of them, and so weak and ill."

"But the Barg?" said Tortog, glancing at Sarq and Janqar. "What if they betray the plan instead. Betray you, Uteq. I've seen it in many of their eyes."

"I won't let them betray me. I won't let them betray themselves, ever again."

"Yet we must go quickly, Uteq," agreed Janqar, as something again flickered in his face, and he seemed to snap out of a kind of reverie. Tortog saw it. "And I leave you, now."

"Leave, Janqar," said Uteq in astonishment, "but where are you going?"

"Only for a while," said Janqar, dropping his eyes strangely, "I...I go to find Matta."

Tortog was looking between Sarq and Janqar suddenly, but Uteq felt a heavy weight inside himself and an awful sadness at her name.

"Matta. Such a friend of my youth, Janqar. So very long ago."

"And I've wondered why you have not spoken of her," said Janqar softly. "But Uteq, Glawnaq has taken Matta to his—"

"Ice cave," said Uteq softly, gazing at the sea. "Yes, Janqar, I know."

Janqar blinked and the others looked at each other, but since Uteq had known mysteriously about the murderous ice dagger, Janqar didn't question it. The others were horrified, for they had not known where the Glawneye were taking Matta when they had been released, although Rornaq had thought it a good sign, because Qilaq had wanted to see his sister at last. They had heard much of Qilaq.

"They say Gurgai can read thoughts," said Uteq almost bitterly, as he peered around.

"He keeps her there now, under guard," growled Janqar, "though they say the Dark Father has gone Still Hunting, and his guards grow slack on seal blubber and Festlar meat, like Pheline."

"Perhaps she welcomes it," said Uteq. "They say twins are much alike, Janqar, and..." Uteq paused as he looked at Nuuq and her little ones and he could not speak of the murder, "is not Qilaq a lord of death, and a Glawneye now, who eats Festlar meat too?"

Rornaq raised his head slowly and looked straight into Uteq's eyes.

"Qilaq may have gone bad, Uteq, but Matta's heart is pure. She often spoke of you."

Uteq looked back at him with clear eyes and there was no anger in his answer.

"And as fondly as a Bellarg kiss, perhaps, Rornaq? Since it was poor Matta who let them all into the Sound that terrible day"

Uteq stopped himself, stopped the feelings welling up inside him like a sea, and remembered Mitherakk's words about there being no worse poison than bitterness. Besides, it was all so long ago and she had only been a cub. Janqar looked at him in as much astonishment as the others though.

"Matta betrayed you, Uteq? But why didn't you tell us this sooner?"

Uteq blinked and looked confused.

"There are more problems now than just one bad heart, Janqar," he whispered. "But I know she did, Janqar, just as poor, mad visionary Mooq foresaw. Maybe she was just scared though, Janqar, and I wish I'd been there for her. The day the Serberan struck though, Qilaq's sister knew the passing word. *Alive*. The Glawneye that attacked talked of a she-cub too, and Tortog told us they were trying to work through cubs. She was the only Bergeera that could—"

"No, Uteq," growled a voice full of anguish suddenly. It was Antiqa who had spoken and the pretty Bergeera's eyes were filled with guilt and the others even more astonished. "It was me, Uteq, not Matta. Sqalloog made me. I was near Matta and she told me that morning what she'd heard, no one else. Sqalloog had met a Glawneye, coming across land from the south."

Antiqa paused and looked shamefully around the old Scouts. "They were looking for you, Uteq, but couldn't get onto the ice – with so many Scouts out. Sqalloog said it was only for the bears' good we tell, and get rid of that paw, to find a new Ice Lore. Though I don't think he suspected Glawnaq's full attack. I'm sorry, but Sqalloog bullied me badly, and I almost loved him then."

Antiqa dropped her eyes miserably. She had grown into a very beautiful Bergeera, even though her face was filled with shame and darkness now and Uteq felt something extraordinary in him.

"You were just a cub, Antiqa," he said kindly. "And so brave to tell

us. But then Matta..."

"Dear Matta has always been true, Uteq," said Antiqa warmly, "even when Qilaq joined the Glawneye. She disguised herself as a Bergo to help him fight for a place in the Serberan. For love. She told me Qilaq had asked her if it was her, and was always guilty she didn't deny it, but when she saw how ambitious he had become, she hated her own brother, I think, and it hurt her terribly. Poor Matta. On the Long March I begged her not to tell anyone it was me. I was so frightened."

Uteq felt an awful sickness in his gut that he had doubted his own friend for so long and made so much of a betrayal that had never even happened. The revelation filled Uteq with a sudden power though, like hope. As if another layer of darkness was lifting from him and his mind was clear again, yet with this new clarity came more shadows too, and some distant voice in the back of his mind, a voice he had just heard somewhere nearby.

"Yet it's so strange," he said. "You're a single cub Antiqa, and what Mooq prophesied about a sister. Everything else came true, for Mad Mooq had The Sight too. He saw betrayal."

This news seemed to have the strangest effect on Janqar, who looked up.

"I must hurry to Glawnaq's cave, Uteq, I'll never leave here without Matta."

The two Bergo's eyes locked though and there was almost a jealousy in them, but Tortog was glancing at Sarq again and frowning, as Uteq growled. "No, Janqar. I'll go."

"But the Sound," insisted Janqar, "I'm good at getting through. They know my bribes."

"I see you feel for her, Bergo," said Uteq softly, "but I must do this now. She's my friend and I've a sacred promise to keep before the sea. Perhaps it's I that have broken the Ice Lore all along."

Janqar held Uteq's gaze too, and there seemed a male aggression in him, a deep resistance and frustration, but he dropped his eyes. "Very well then, Uteq Blackpaw. But be careful."

"And Janqar, take our Bergo and go to the Barg again. Gather their

Bergeera, and as many Bergo as will listen too, and tell them I come to address them for one final time. When I've Matta at my side. Half of the old pact, at least. A pact we swore before the very sea."

Janqar nodded but it was as if the Bergo was calculating and Janqar was suddenly sweating.

"And Bergeera," said Uteq. "Rest with your cubs here tonight and sleep deeply, for we've a long journey when the day dawns again. A terrible journey, yet one out of shadows forever."

Uteq realized that someone was missing though.

"Innoo," he whispered. "Wasn't Innoo with you, Rornaq, with mother?"

"Yes, Uteq," answered Rornaq. "But she went wandering when they released us. They let her be because she can't really work, and the Slayers don't like that collar. I don't know where she is now."

"Poor Innoo's mind's wandering too though, Uteq," said Antiqa, "But I'm sure she'll be fine."

"Bergeera with collar?" said Ruskova suddenly.

"Yes, Ruskova," said Uteq, looking down sharply. "Our friend Innoo. The twins' mother. Now Matta's coming with us, dear Innoo will surely come too."

"But beink gone to Leave, Uteq," said the fox, "and seemink happy."

"Leave, Ruskova?" gasped Uteq, looking in horror at the little arctic fox.

"Mad Bergeera's beink goink to Selection tonight. Sending to Bergeera in bay first for mark."

Uteq's eyes blazed and he snarled at Ruskova.

"Stupid fox, why didn't you tell me this sooner?"

Ruskova looked bitterly offended, and deeply hurt too, and she curled in her tail.

"Does fox know all? No time for arctic fox in all these months, big Bellarg."

"Then we must hurry," cried Uteq in anguish, "before they set out. Go, Janqar, with the Scouts. Hurry to the Selection. There's much to do this night, for all our sake's."

BETRAYAL

"The roaring of lions, the howling of wolves,
the raging of the stormy sea,
and the destructive sword, are portions of
eternity too great for the eye of man."
—*William Blake*

I t had started to snow heavily as they watched Uteq set out alone from the north ice gully to try and get into the Sound, and see his cub hood friend at last. Uteq's heart beat strangely as he did, and his very soul was anxious now at seeing Matta again, not least because of the terrible secret he knew himself, of Qilaq's crime. The boars in the gully turned toward the Bay of the Barg, and Forloq and Brorq were walking with Janqar now, ahead of Tortog and Sarq, proud to have found a strength and purpose once more, but behind them Tortog's eyes were filled with doubt and fear.

"What is it Tortog? said Sarq. "What's wrong now?"

"Janqar," he answered quietly, "he's acting so strangely, and now we know that Uteq must be betrayed, Sarq. Since it wasn't Matta at all, and Mad Mooq prophesied betrayal, remember."

"No, Tortog. I was at the Council too. Mooq did speak of a sister, as Uteq said and perhaps it was one of the other cubs then, or Antiqa never knew she had a—"

"No," insisted Tortog gravely, "I've been Scouting and was talking to a Bergeera last night in the gullies about the legends, when she said something extraordinary. About old Fellagorn words. Two words she knew in particular. Qaar, meaning *a secret*, and Janna."

Sarq blinked in confusion.

"So what, Tortog? Just words."

"Janna was the Fellagorn word for a sister. Don't you see? Janqar. Janna-Qaar – Sister's Secret."

Sarq looked at Tortog in horror and Mooq's voice was wailing in his head once more.

"Then it's Janqar. Another brilliant master spy."

"I think he really hates Uteq," said Tortog. "You saw the jealousy in his eyes when Uteq spoke of Matta. He always liked her, and was always looking out for her. Strange the Serberan were so soft on her. Or I bet there's another reason he so wanted to go to Glawnaq's cave. To betray us, just like Eagaq."

"And Janqar knows everything now," gasped Sarq. "Of Uteq's existence. Matta's escape. About gathering the Bergeera tonight, and where Uteq plans to lead us too, through the pressure ridges."

"Yes, Sarq, Janna-Qaar knows everything all right."

Even as he said it the Scouts saw Janqar had stopped in the snow, between Forloq and Brorq, and was turning back towards them. There was a strange look in his face.

"You two," he grunted, "I forget to tell Nuuq something. So go on ahead, will you, and half of you gather the Bergeera, and half the Bergo. I won't be long, I promise."

Tortog flashed a warning glance at Sarq.

"Yes, Janqar," he whispered with a false smile. "Of course."

Janqar nodded and now he set off at a great galloping run, as the snows came down and Tortog virtually hissed at Sarq, as the others stopped to listen. "Follow him, Sarq, for Atar's sake, follow him, and don't let Janqar out of your sight for a single moment. I want to know everything he does."

"What is it?" said Rornaq, feeling the old Scout's instinct rising in his blood.

"I'll tell you as we go, Rornaq," grunted Tortog. "Grave news, I fear. But Sarq, if that liar tries to get to the Serberan's Sound, kill him."

Sarq nodded and slipped after Janqar in the snows. Back in the ice gullies the ragged Bergeera were settling in a circle in the semi-darkness, their breaths steaming in the rising cold. Olooqa, Nuuq's daugh-

ter, couldn't understand why all the grown-ups looked so miserable. "Will you tell us a story, mother?" she asked, grinning encouragingly at the other cubs.

Nuuq looked sad and thoughtful. She had been thinking of dear Soonaq again and all she wanted to know now was who had killed him. What point in justice though, in a place like this?

"Please, mother."

"All right, my darling," said Nuuq, looking up, "I'll tell you a story of a Lera...of a Herla."

"Herla?" said Olooq, next to his twin, thinking the name funny. "What's a Herla?"

"A deer, Olooq," growled Nuuq, in the snowy twilight. "Sort of like the great caribou that roam the arctic ice world, but different too. They called him the Fire Bringer."

"May I listen too, please?" said a voice. The twins, Bergeera and their ragged cubs turned, and there in the snowy half-light was a terrified, scarred face, peering back and shivering furiously.

"And who are you, stupid?" growled a scrawny cub angrily. "This is our ice gully."

"Hush," said his mother. "Don't be so unkind. But what's your name cub?"

"Pooq," answered the strange little Bergo, his right leg starting to tremble. "And I'm two years old, not a silly cub. I went on a Leave, but escaped along an ice gully of blood. I don't have a home, or parents, so I came back here. I've been hiding, but I was afraid. Where's Matta? I like Matta. She's like a beautiful goddess."

Nuuq's big heart ached. "Oh, my little darling, come and sit by me then and listen too."

Scrawny, terrified Pooq walked over and sat next to Nuuq, and suddenly it was as if his face was filling with light, although the cubs looked at him in astonishment to think he was really two years old and had escaped down gullies of blood.

"Well," Nuuq went on softly, "this strange Herla was born among his herd at a time called Larn, the time of the evening star, but also at

457

a time of great sorrow and wickedness and fear. When his whole herd was in danger and murder whispered on the wind."

"Just like now?" said Olooqa, with a happy shiver.

"Yes, darling, just like now. But listen quietly."

So Nuuq told the little gathering a tale of the Lera from long ago, and of the Gurgai too, and of a great journey through a land to the southeast called Scotia, filled with wild Varg, and many rare and magical creatures too, like a wise seal called Rurl.

"So the Herla had brought fire and courage to the world again," said Nuuq, as she finished, "and purified life once more, and saved the deer forever. Born a healer, and a king."

"Like Uteq," cried Olooq as Nuuq nodded and nuzzled Pooq. "Is that what it means then?"

"Yes dear. And that you must never, ever wound the spirit of love," she whispered, her heart breaking for Soonaq and all her dead friends.

"Fire, mother?" said Olooqa. "And heat. It sounds like such a terrible world though."

"Just different, my darling. Perhaps there are many. Not just worlds for bears."

"But it's not different at all. From the Great Story, I mean," insisted Olooq with a growl.

"Well, Fellagorn Great Masters taught the same Garn lives in everything, Olooq, and so important patterns too. A journey that all living things make, again and again. A journey for two brave, little Bellarg heroes like you, to show you what's really important in life."

The twins looked delighted, but Nuuq wondered what horrors the morning would bring.

"And you'll need to be brave tomorrow," she said firmly but softly to all the cubs. "So we must all get some sleep now, just like Uteq said."

The Bergeera and cubs settled in the snows together, and soon rest fell over them, a deep and calming sleep. Nuuq had tired herself out with her tale, and drifted off quickly, yet with the fear and excite-

ment, his bad dreams too, Olooq couldn't sleep at all. The cub started nudging his sister roughly instead.

"What is it, Olooq? Stop that."

"We've got to help," growled little Olooq nervously.

"What do you mean help? We're only cubs, stupid."

"Yes, but we've got to be heroes, like that Herla. Bergo never back down. It's the Ice Lore."

As the cubs spoke of helping, Uteq was approaching the Sound of the Serberan, grateful the snows were getting deeper again, and that he was cloaked in heavily falling white. Uteq did not notice a pair of Bellarg eyes following him through the half-light. Eyes he knew very well.

As Uteq padded on and was able to avoid the guards around the bay, the Barg were so subdued by Eagaq's visitations, the ever confident Serberan were hardly alert, even to a bear with such a paw. They had relaxed their grip too, preparing for the great poisoning tomorrow, so Uteq reached the Sound safely. There he saw four Serberan outside the entrance to Glawnaq's huge ice cave.

It was twilight, so Uteq couldn't rely on the cover of true darkness, but the snowfall was getting heavier and turning into a blizzard and as the wind moaned, the Bergo crept closer and heard the guards talking and eating loudly. They were munching on great slabs of seal blubber, white whale meat, and the haunch of a Barg too. Janqar had been right then, and Uteq suddenly wondered how he knew so much. Two of them were asleep and snoring, and the other two so busily engaged in their feast, they did not notice Uteq slipping past them quickly, straight into Glawnaq's cave.

Uteq felt some terrible fear as he did so, some presage of doom, and hated the secret he carried about Qilaq and The Sight too, but his heart was thrumming as he stopped and almost gasped, as if looking on some sacred thing. There was Matta, sleeping by the side of the glittering ice wall and Uteq remembered her as a carefree cub, but now she had grown into a lovely Bergeera, with a rich, soft coat. Although there was care in her face, he had not known before, and a terrible sadness too.

"Matta," he said, half lifting his black paw. "It's me, Matta. Wake up now, pretty Tutsitala."

The she-bear blinked and opened her eyes, as his voice echoed around her. "Such terrible dreams in here," she moaned, "and Uteq's gone forever. Everyone's gone."

"No, Matta, it's not a dream," said Uteq tenderly. "Or not wholly. Wake up now and let go of the past. We've got to get away. The others are waiting, with Nuuq and her twins, and other Bergeera, and all their cubs. We're all gathered again, but we must escape this nightmare together."

Matta opened her eyes fully, and felt a shock to her very soul.

"Uteq," she whispered in astonishment. "But it can't be, you're..."

"Alive, Matta. I never drowned on the ice. The Varg saw us fall, but a whale saved us, or me, maybe because my Garn drew it, and a seal and a goose helped. And I've come to tell you that I..."

Uteq stopped, and looked into Matta's pretty, brave eyes and seemed tongue-tied.

"Yes, Uteq," she said softly.

Uteq blinked back at her and remembered their promise, spinning on the ice, like the world in the skies, and on the Wander too, but now he felt strangely lost and the darkness of dreams and The Sight were in him too, like a snow cloud.

"To tell you that I'm sorry I didn't come sooner," Uteq whispered in confusion. "I've been here since the spring, Matta. Can you ever forgive me?"

"For going away on your Odyssey? Friends don't need to forgive, and it wasn't your..."

"For my own doubting heart, dearest Matta," said Uteq angrily. "I thought that you gave the Serberan or Sqalloog the passing word that day, but it was Antiqa. She told us herself. Although she was only a cub, and she did it for Sqalloog. It wasn't her true heart then. Her true Self."

"You thought I betrayed you?" gasped Matta. "Never, Uteq. How could I ever..."

"Perhaps it was the stories, Matta," answered Uteq sadly. "I know we must be careful of stories. It was because of visions and prophecies, and what Mooq said at the Council about a sister. And it hurt me for so long, like Pollooq's wound. But I was wrong. Sepharga never doubted you."

"Sepharga," said Matta, her eyes filling with light, for she had often berated herself for being so jealous and cruel to Sepharga. "Is she—"

Uteq shook his head sadly. "She's gone too, Matta. Maybe it was meant to be, since her ship foundered in the storm. Her Karmara. Maybe everything happens for a reason. I've seen strange patterns under the surface, terrible patterns sometimes. Icebergs, in the sea of the world."

"It's so sad, Uteq. But you've no reason to blame yourself for doubting. Even my twin..."

Matta stopped and lowered her head in shame, yet with it there was guilt and Uteq felt a terrible sickness, the sickness of knowledge, but tried to veil it with something else.

"I heard what you did for Qilaq, Athela. How you disguised yourself as a Bergo to help him."

"Become a killer you mean?" said Matta bitterly. "And as for Athela, I don't think Qilaq ever knew it was me. But there are no real gods, Uteq. Only stories of them. And I could not stop his heart turning black. I think I helped that darkness by not telling him the truth about Antiqa. To protect her."

Something had caught in Uteq's face that really frightened Matta, as she spoke this truth of Qilaq and yet she denied the truth of some greater power and faith.

"Uteq, what is it?" she growled.

"I..."

"Please, you're frightening me. There've been so many strange rumours. After dear Nuuq vanished so strangely, and we heard the terrible news of Soonaq's mur..."

As she stared into Uteq's eyes and saw the truth there now, the word froze on her lips.

"No. It can't be. Not my brother. Not Qilaq. He killed Nuuq's mate? He murdered Soonaq."

Uteq felt a terrible pain.

"I'm sorry, Matta. I saw it with The Sight, in a dream in the North. It was Qilaq, yes, with a vanishing ice dagger. Perhaps Mooq saw it too."

A wind moaned into the cave, and though Qilaq's role as head of the Glawneye was bad enough, at least they were soldiers with their own code, one the Ice Lore too must keep away from normal life. Matta almost sobbed, and blamed herself for not telling Qilaq the truth about Antiqa, for the right reasons, but the wrong, terrible effect. It was Matta who had really broken her brother's spirit.

"But, Matta, don't think of it now. It's not for us to judge him. The Ice Lore does that. Come. We must get you far away, and first the Barg must believe what Glawnaq plans soon, for his Last Solution – while your mother's in terrible danger too. She goes on a Leave."

"It's foul," growled Matta, her heart pounding for Innoo and with thoughts of Qilaq's crime too. "Glawnaq told me, and simply laughed. Cannibals. His *Unnatural Selection*. I'd kill him, if I had Athela's strength. A true warrior."

Matta's eyes were flashing, bold and bright and her spirit was glowing inside her again, and it helped her rise to her feet and push back the shadows.

"Then come, Matta. Hurry. We have to go before the guards realize, or Glawnaq returns."

"Janqar," said Matta though. "Have you met a Bergo called..."

Uteq looked up and there was something strangely competitive in his eyes and, deep inside, he heard some warning voice too, like some presentiment of doom.

"Oh, yes, Matta. Janqar's down in the bay already. Come then."

"But Uteq, can we—" Matta paused as she thought of what she had just learnt. A knowledge she would rather live without.

"What, dear Matta?"

"Give this story a happy ending, Uteq. Unlike the rest. Please."

"Perhaps we can together, Matta, but it's not finished yet."

Uteq led Matta out of the ice cave, back through the swirling snows, and soon there were two trails of paw prints in the white. They prayed they had gone unnoticed, as the snowfall swallowed them up, unaware of other Bellarg watching, looking down at them from a slope nearby. Eagaq Breakheart stood with his Seeking Claw out, like some paw of final judgement, as the head of Glawnaq's Death Cult stood behind him, watching his sister coldly. Next to them both was Glawnaq's spying Barg too, revealed to Eagaq at last.

BACK DOWN IN THE ICE GULLIES, NUUQ MOANED IN HER SLEEP, FEELING A guilty worry from nowhere she understood, and snapped awake. The air was wrapped in a mist after the long snowfall, and though it had stopped snowing so heavily, the twilight hadn't brightened, and Nuuq sensed that it was still night. She yawned and glanced around at the Bergeera and cubs in the circle, but her heart started pounding as she saw a trail of little paw prints, snaking out of the north gully towards the bay from where Olooq and Olooqa had been laying.

"My cubs," she groaned. "Where are my cubs? The twins."

Pooq looked up nervously. He never slept.

"Little paws?" gulped the stunted two-year-old. "They've gone to be heroes, Nuuq. They said mothers follow cubs, so they went to talk to theirs."

Nuuq thought of the story she had told them about the brave and fearless Herla.

"Heroes," she growled in horror. "Oh, you foolish Bergeera, what ever have you done?"

Far off in the Bay of the Blessed, the twins were nowhere to be seen, but Egg was ruffling his feathers near the ragged Bergo Scouts, shaking their heads, as the snow began to get heavier again. The bears had visited Farsarla first, as Uteq had ordered, then the Bergo, to try and raise some support. But all were desperately worried about what Janqar and the night were bringing, and how they could protect Uteq and the others. They heard a growl and there was Sarq running back to them.

"Well, Sarq?" said Tortog, as he reached them. "Janqar?"

"It's him alright," hissed Sarq, "that filthy little Ineq. I followed and though Janqar didn't go towards the Sound, he did go towards the southern ice gully and met a Serberan there. The snow was heavy, but I'm sure of it, Tortog. They were whispering together for ages. Planning something."

"Then soon Eagaq will know he's alive," said Rornaq, "and that Uteq's coming here with Matta."

"Betrayed," growled Forloq, looking sharply at Brorq. "Then it *is* Janqar. I can't believe it."

"If they start a search, they're bound to see his black paw," said Sarq. "And if Uteq feels he's endangering anyone else, I know that he'll sacrifice himself for us."

"Like Great Story?" squarked Egg, snapping his beak and wondering where Ruskova was. "Marked out bear. Ice Saviour."

"Yes, Egg. But it's not Uteq's sacrifice we want now, like the stupid Blaarq," said Rornaq gravely. "It's his strength and hope and courage. The light he sees. His vision."

"Then we have to help him," said Tortog, and Sarq lifted his head and growled. "Help him fight off the Serberan, when they come for Uteq. Get back the honour Eagaq stole too."

"We?" said Seegloo. "Darq and these other fools couldn't fight a mouse. They spend their last scraps of Garn fighting each other, Tortog. We must stop Uteq coming to the bay altogether."

"In this weather we could miss him easily," said Sarq, as the snows swirled, "and he won't leave without talking to Farsarla one more time. He must come."

With that the group of Scouts spotted Janqar though, walking steadily towards them and there seemed a new confidence in the polar bear's tread, as Rornaq started growling furiously.

"Hush," whispered Tortog, "now we'll test him, all right."

"What's wrong?" said Janqar as he reached them, his eyes darting round the group, "have you gathered the Bergeera for Uteq's return, or talked to the Bergo too? Nuuq's fine."

The old Scouts were all looking at him strangely and Janqar's eyes flashed.

"They know, don't they?" he growled, "That Uteq's here, coming to the bay?"

"Yes, Janqar," answered Forloq coldly, look straight into his eyes, "They know, somehow."

Waring emotions seemed to be moving in Janqar, but he growled suddenly.

"Then all of you," he grunted, "come quickly. In secret. It's time I acted."

"Secret?" said Sarq, thinking of the sister's secret, and Janqar's name.

"You're proud Scouts, aren't you, and still believe in stories? Well I've a secret to show you now, my friends, back in the southern gully. But first you must trust me and believe."

Tortog could see Forloq wanted to spring at Janqar, but he stepped across him.

"Yes, Janqar, of course, so lead and we follow. The heart of the resistance, eh. And the spirit of the Scouts too. Honour and vigilance."

Janqar turned quickly and hurried away, and Forloq hissed at Tortog, as the others looked lost.

"What are you doing, Tortog? He said the southern gullies, where he met that Serberan. Perhaps other Slayers are waiting there, in secret, or preparing the poisoning already. Another filthy trap."

"Exactly," said Tortog, showing his teeth, "and if they are, at least we can do some good. At least they'll be less Slayers alive to search for Uteq. Egg, you must try and warn Uteq somehow. Go."

It must have been a good hour later when Matta and Uteq stood in front of Farsarla and her Bergeera, swollen with ranks of mothers who had come out from the dens with their new Tappers. Nearby, a very ragged group of Bergeera were waiting to join a Leave, including Innoo, who kept staring at Uteq, as if trying to remember, though there was no evidence of any Serberan yet.

"You must follow us, Farsarla," growled Uteq. "They'll be coming for you soon. This very sun, I think. Glawnaq's Last Solution. Poison."

"Liar," said Meeqa resentfully. "Kassima bear. We thought you'd gone away."

"It's true," said Matta, standing at Uteq's side again. "Glawnaq told me himself. They plan to poison you all, and clear the bay forever. With seal so scarce, they've no need of you at all."

"You," said another female, glaring at Matta. "You're the twin of that hated Glawneye. Why should we trust you either? Like brother, like sister, they say."

Matta looked back indignantly, and felt a deep wound in her heart.

"I can understand why you say that," she growled furiously. "And not only a Glawneye killer, Bergeera, but a filthy murderer too, who killed Nuuq's mate, out of jealousy. My own brother."

Uteq looked at her in surprise, as did the Bergeera, but they respected the truth in Matta's voice.

"But I'm not like him, Bergeera, and we must tell the truth now, if no one else will."

Suddenly they heard it, the great Summoning call of the Serberan, echoing loudly across the Bay of the Blessed, through the lightly falling snows.

"The poisoning," cried Uteq desperately, completely unaware that Eagaq's henchmen really sought him now. "Is it too late then? Have they come for you all already?"

Uteq saw that many Bergo were already moving up the slopes, as if they had no will of their own. The Bergeera too were starting to answer the mesmerizing summons and turning away from the group, and at least he was glad Gerla was absent.

"Stop them," Uteq growled. "For Atar's sake, stop them. You must believe me, Farsarla. We can get you Bergeera and cubs away, at least. We must save the little ones. The future itself."

Farsarla looked bitterly torn.

"I...I don't know, Blackpaw. There don't seem to be that many Serberan," she grunted. "So they can't force us easily into the ice gullies. There's some fight in us still."

This was true, and Uteq wondered if the Serberan had come for

some other purpose. A shadow crossed his mind, although he little knew he was in such danger. Yet the same knowledge he had sensed long ago, and suppressed about Eagaq, was wrestling inside him and Uteq suddenly realised, just as the loyal Scouts had, that if Mad Mooq was right, his betrayal was yet to come.

"I'll hear what the Summons is about, Uteq," said Farsarla, "and talk to the Bergo, especially Darq. Come later. Maybe they'll believe you then. I'll hold up the Leave for now."

The boss frowned and looked back at Innoo, then hurried away. Uteq and Matta stood in silence, but after a while saw Nuuq and Antiqa rushing in their direction from the gullies. Poor Nuuq looked desperate, and her eyes seemed to be scanning the Bergeera and cubs making their way with Farsarla towards the summons. Nuuq slowed as she saw Uteq and Matta, and Matta dropped her eyes guiltily, thinking of Qilaq and Soonaq, but Nuuq blinked and rushed on.

"Olooq and Olooqa," panted Antiqa, as she reached Uteq, embarrassed by Matta. "The twins went to help, Uteq. To be little heroes. We followed their tracks, then lost them in the new snow."

"Then we must search too," said Uteq, as a wind rose. "And if the Serberan see Nuuq here and alive and well, they'll take her, for sure. We've got to stop her."

"But Uteq," growled Matta. "Your black paw. They'll..."

Uteq felt a horrible sickness but remembered Pollooq had known he would be betrayed, yet had still gone on.

"The snow's deep, Matta, to hide it," he said firmly, wondering where the ice dagger in his own heart might really come from. "We have to find Janqar too and the Scouts. They must be among the Barg Bergo now."

"I don't think so," growled Antiqa. "When I first started searching for the cubs, I thought I saw Janqar leading Rornaq and the other towards the southern ice gully. It was so strange, the way they followed him, as if they all distrusted each other, or were reluctant somehow."

"Perhaps Janqar's abandoned us too then," said Uteq, and

wondered again why Janqar had known all about Glawnaq's movements that night. "He seemed so jealous of you, Matta."

"No," said Matta hotly, "not Janqar too. Oh Uteq, that I refuse to believe, The Sight or not. That would truly break my heart."

Uteq stared back at her and nodded, and Matta and Antiqa looked sharply at each other and they turned and followed, as Uteq made for the Summons. Another doubt awoke in him though as he walked and tried to stop them.

"No. Stay here, Matta. Maybe they've discovered your escape. It's not safe for you either. Go and wait in the gullies with the others then. We'll come and find you later."

"If you think I'm going to leave you again, Uteq," growled Mata, "you're mad as Mooq. It's safe for no one. I'll take my chances, Uteq. Maybe I'll rough my fur and be a warrior once more."

The friends' eyes locked and something brilliant shone between them.

"It's warriors we'll need, Athela, if they learn we are trying to escape. But the Storytellers are overthrown and cannot come again. Not even Athela, so we work in secret and must just believe."

Uteq turned again and as they approached the Summons through the now thickly falling snow, they saw the Serberan, bright in the twilight, and what appeared to be thirty huge Glawneye, including Keegarq and Qilaq. Matta felt a furious anger as she saw her murderous twin, yet even now could not bring herself to really hate her brother. How can we hate what we really love?

Sqalloog was there too, giving orders loudly, and right in the middle stood Eagaq Breakheart. It was a shock to Uteq's soul to see the three of them together. Eagaq swayed his fur sleeves, as the weary Barg Bergo and Bergeera came up to listen, mingling together to hear their cruel master's orders. Uteq saw how Eagaq's face had changed, marked by Marg's strike, and remembered that terrible day his father had died.

The friends edged to the back of the group and slipped among the Barg themselves, peering around the many Bellarg. Uteq recognized few of them though, and certainly none from the party of Scouts, but

it had started to snow more heavily again and gusts of icy wind were stirring the air. The three of them were but a hundred yards from Eagaq now, as they wondered what the Summons was for. If the poisoning was at hand, they might just make a stand against this group, if the Barg could be roused, although that would take some real miracle.

"That's close enough," whispered Uteq, pulling up dead. "Look around for the Scouts and for Janqar, Nuuq and her cubs. Let's pray Nuuq doesn't show herself though, or the game's up."

Nearly two hundred browbeaten Barg, male and female, had drawn up in front of Eagaq and his band of thugs. They all looked nervous and confused, and as Uteq watched them once more, he saw silvery shadows as their sides, Bergeera by Bergo, Bergo by Bergeera. But all the shadows looked pale and transparent and the snow was falling through them, as they vanished. Then Uteq saw a little face moving between their legs, looking back wide-eyed, as Olooqa spotted Uteq, but hurried on. Matta and Antiqa were aware of nothing of the spectres, but suddenly heard Eagaq's voice ring out, as he rose in the snow like a Tulqulqa.

"Blackpaw," Eagaq bellowed to their amazement. "Where are you then, Uteq Blackpaw? We know you live and that you have returned, like the spirit of evil itself."

"No," gasped Matta, trembling furiously. "Then they know everything, Uteq. We're lost."

23

WARRIORS

"Save one life and you save all the world."
—Talmudic Proverb

"Y ou've been seen already, Blackpaw," snarled Eagaq. "So show yourself and that filthy smudge of yours too, little cub."

Uteq pushed his paw down into the deep snows and growled angrily under his breath.

"Yes, Barg," hissed Eagaq, extending his Claw and staring at his bewildered slaves. "A spy among your own brought me the news, before I saw Blackpaw myself, just last night. He never died, did he, slaves? You can't hide from your Cub Clawer. You never could. It is the Ice Lore."

The Barg were looking round, some guiltily, some in astonishment, as they muttered.

"Betrayed," said Matta bitterly. "Pollooq betrayed once more. But who?"

"Twice Born and Twice Betrayed," laughed Eagaq, as if reading Matta's thoughts. "So show yourself immediately, and even now great Glawnaq may be merciful to you, and to these fools. Otherwise, Blackpaw, both you and these Barg filth shall surely suffer."

A terrible stillness had descended across the Bay of The Blessed, as the snows heaped down on the mesmerised polar bears.

"You think you can hide, scum? The snows may be deep and the

twilight growing, but it's only a matter of time before we root you out. And if you force us to search, Uteq, it will only be the worse for you, and all the Barg too, I promise you that. I never liked you as a cub."

The Barg's frightened eyes searched around the gathered Bellarg, and Uteq began to stir, but Matta stepped across him.

"No, Uteq, don't. Eagaq will kill you."

"But, Matta..."

"You're our only hope, Uteq," said Antiqa desperately, "*their* only hope, although the Barg don't even know it. We've got to think of another way."

Uteq sunk his black paw even deeper, and stood stock-still. His will was beginning to freeze inside him and he felt ashamed for it and somewhere could see the Pirik again, in terrible pain.

"Ever the coward, I see, Blackpaw?" cried a bear at Eagaq's side. "Very well, then."

It was Sqalloog, and he who gave the order now, as the Serberan began to advance into the ranks of frightened Barg, pushing and barging and searching for Uteq Blackpaw.

"Your paws," cried one furiously. "Show us your damned paws, fools. Which is this Evil One?"

Some of the Barg looked confused, and a Serberan reared and slashed a Barg Bergo across the face, cutting open his cheek, as the others cowered back and lifted their white paws meekly.

"It may take us all moon to find you, Uteq," cried Eagaq, huge snowflakes drifting over his angry face, "but I promise you, Ice Whisperer, we'll have you soon enough, and then all will pay."

As the search among the Barg commenced in earnest it was only a matter of time and Uteq heard Narnooq's voice on the wind again, speaking of cutting down the pressure ridges themselves to get to the lair of the Evil One.

"You see the price of a legend, Tutsitala?" whispered Uteq sadly. "Oh, Matta, how I wish—"

"Hush, Uteq. We've got to get you away."

Suddenly there was a cry though, and they saw that some of the

Serberan had surrounded a Bergeera and were marching her straight back toward Eagaq and the others. With her were two little cubs.

"What's this?" said Eagaq scornfully, when he saw it was a female obscured in the rising blizzard and noticed the two little bears. "Idiots. A she-bear with her two cubs. Did I not say *he*—"

Eagaq stopped in mid-sentence though as he recognised her and his eyes glittered.

"Nuuq," growled Matta by Uteq's side. "They've found Nuuq, and Olooq and Olooqa. Oh no."

"Well, my dear," Eagaq was already hissing, his eyes shining. "This *is* a surprise."

"And her cubs too," grunted Sqalloog, behind Nuuq, pushing the twins out of the frightened throng. Nuuq was trying to turn back to her cubs through the five Serberan surrounding her. She had found them only moments before, among the Barg, trying to persuade the little Tappers to get their mothers to leave with Uteq Blackpaw.

"So, my beautiful Nuuq," said Eagaq bitterly. "You never killed yourself at all and are helping the Blackpaw too. Well it proves one thing, that there are no magic spirits, haunting the Barg and Sqalloog heard nothing in your snow den. Just lies and tricks."

"Like the lie of your filthy murdering heart?" snarled Nuuq proudly, as her cubs wondered what their mother was talking about. "It was you, wasn't it, who murdered my Soonaq? Or the lie of the Leave, where Barg are murdered and fed to the Glawneye. Where bears have become feral wolves. And now even helpless cubs will be poisoned to feed your Cult of Death. You're an insult to life, Cub Clawer."

Eagaq was shocked himself to hear the truth spoken so openly, and by a Bergeera he had wanted so long.

"Is this the lie that Uteq has been spreading among you then, Barg?" he said calmly though. "Can you believe that such a thing is ever possible, among proud and fearless warriors like the Serberan?"

Many of the Barg were growling and shaking their heads.

"Of course not. The Dark Father's our only Saviour, proud Bellarg, which is why Uteq's evil must be rooted out forever. Reason and

strength shall prevail, and the new Ice Lore too, for a thousand Long Nights."

Eagaq cast a look at one of the Serberan, who reached down and snatched up Olooqa by the scruff of her little neck and swung her toward him, dropping her in the snow. Nuuq bellowed and reared in fury, as the cub landed right at Cub Clawer's paws. The wind had dropped and the snow fall was less and the air sang with the vicious threat.

"My dear," hissed Eagaq, peering into Olooqa's terrified face. "You're going to help us find the Evil One, aren't you, like a good, loyal grown-up? And although your mother and sister may have to be punished, we'll give you a nice fat fish, all of your own, if you do. Wouldn't you like that?"

Uteq's heart pounded, as he realised Olooq's sister had spotted him in the gathering and Mooq's prophecy came sounding through his mind too. *A Sister betrays.* Olooqa stared back at the horrible Cub Clawer, and as she remembered what Olooq had said of heroes, she stuck out her little pink tongue. Eagaq flung up his head.

"See, Blackpaw, just what your so-called courage does to innocents? And what price a mere cub shall have to pay, unless you reveal yourself? A terrible mark indeed you carry, Uteq Blackpaw."

Nuuq chuffed, but the Serberan held her back, as Uteq felt a sharp guilt. He was thinking not only of Olooqa but of Mithril. How many had suffered or died in his strange journey?

"He'd never dare, Uteq," gasped Matta, "not even the Cub Clawer. Poor Nuuq's wrong about Eagaq killing Soonaq, but not even he could harm her, not in front of everyone."

Eagaq's Seeking Claw flashed just above Olooqa's head though, like some sacrifice to Heaven itself.

"Five sways of my claw, Blackpaw," Eagaq growled, peering around at the obedient Barg. Eagaq's claw was about to fall when Uteq bellowed, with a deep and wounded groan.

"No, Breakheart. Stop. Stop it now. I'm here."

"Uteq," said Matta. "Please...don't. You mustn't."

The Cub Clawer swung towards them, but Uteq was looking at

Matta. "Don't, Matta?" he hissed. "I may be no Ice Whisperer, but I must, for Olooqa. I'm not important, Matta, and can do nothing else but sacrifice myself to serve a cub. In the dark, when there's nothing left to believe in, we must just give and trust and become what we're sometimes frightened to believe in most."

Uteq reared high in the snows and there was a humility in his voice now.

"Enough, Eagaq. I'm here. Let the cub go. Your shadow's grown longer than Glawnaq's."

Eagaq's cold eyes glittered triumphantly and twitched too, as he saw the polar bear, fully grown, but certainly about the right age to be Uteq, and glanced back at Qilaq, who in the snow fall could not see Uteq clearly himself.

"Show it then, Marked One. Show us your paw. Prove it."

Uteq remembered those wonderful visions – the love and the light he had seen – and although he knew he would die, he held up his black paw proudly. He felt the Bellarg's eyes lock on him, as if all knew him now and Uteq was revealed at last. Lost as well. Some strange Ice Lore had brought him to this place at last, brought him like a story, a legend, but suddenly another strong Bergo voice rang out across the bay.

"No, Breakheart, the mad Bergo's lying, or he has the madness. Look."

Matta and Antiqa turned and gasped at what they saw, and Uteq blinked in astonishment too. A second Bergo was standing on his hind legs among the Barg, holding up a paw. In the glittering twilight, beneath the myriad stars, Janqar was showing Eagaq and the Barg a perfectly black paw too.

"Two?" grunted Eagaq in confusion, suddenly feeling split apart, as Uteq was astonished to see Janqar there, like this, with his own black paw. "But it's impossible."

"Yes, Eagaq," said Sqalloog at his side, glaring hatefully at Janqar. "And that's not Uteq Blackpaw at all. I'd know Janqar's scar anywhere."

Sqalloog turned back to face Uteq, and Qilaq's eyes had locked on

Uteq too, but a third Bergo suddenly roared, rising up in the snow and holding up a black paw as well.

"No," cried Seegloo, "I'm the Blackpaw. See my mark. So take me and do your damndest."

The Serberan were utterly bewildered, feeling bewitched, and they all began turning right and left, and back again, almost frightened by the strange magic of it.

"And I," bellowed Tortog now, lifting a fourth paw to reveal the very same magic. Then Sarq was rising beside him too, and Brorq and Forloq and all were looking back proudly at Janqar holding up their black paws. Poor lost Uteq felt something choking in his throat, as an ordinary Barg rose and then none other than Darq, the Barg boss here. One after another, Bergo began to rise on their haunches in the snow to protect the Ice Whisperer, holding up their black paws too.

"Quickly, Uteq," growled a voice, and Uteq swung his head to see Rornaq suddenly standing beside him. "We'll blend in with the others, and get you three safely away. They can't murder us all."

"But how, Rornaq? Have the gods returned? It's real magic."

"Magic?" grunted Rornaq with a smile, lifting his own black paw. "Of course not, Uteq," as Uteq looked down and smelt a sharp scent on the air.

"The black blood," he almost hissed. "From the ice gullies. Pheline magic."

"From the gullies yes," answered Rornaq, "but you think Scouts use the Gurgai's poison?"

"Soot then, Gurgai soot," said Uteq, remembering himself and dear Sepharga in Churchill.

"It's the berries, Uteq. The healing berries, in the Southern Gully."

"Where Mother died. The blue snow flowers I sought in vain in the North?"

"Yes. We thought Janqar was betraying you, but he'd formed a plan in case they discovered you, and took us down to the flowers to stain our paws. Then, Bergo among Bergo, he told us a very great secret. But Egg, who couldn't find you, back came to us and then

475

brought others, who came of their own accord, to anoint their paws too. For you, Uteq Blackpaw. To share your terrible burden."

Uteq's heart was suddenly thundering. He realized that not all had betrayed him then, and some of them really believed. Uteq remembered the glorious Garn River, where dreams flow into the world itself.

"Anoint?" said Uteq suddenly. "What do you mean anoint?"

"Janqar says we must go now," growled Rornaq though, cutting through him. "Hurry."

Uteq held his ground.

"No, Rornaq. What of Janqar – and the other Scouts, and the Barg? We can't just leave them to the mercy of these murderers. I must do something. Fight."

"But we're here to defend you, Uteq, and a legend."

"But we must wait, fight and die if we must. Must stand together and defend the real Ice Lore."

"It can't be," gasped Eagaq on the slope above them now, as the Serberan and Glawneye looked back at the rising Barg in astonishment. In normal circumstances, such a group would easily have subdued the exhausted Barg at a summons, but the Ice Slayers' courage began to waver in front of the thirty or forty Bergo, calling out around Uteq, and holding up their stained paws angrily in the snowy air.

The Bergo and Bergeera, not part of this strange miracle, were looking around in bewilderment, including Farsarla, although she had just seen Darq and felt her heart melting at his sudden courage. Indeed, many of the Bergeera felt their hearts stirring in defiance of Glawnaq's tyranny, as they saw the courage that the Bergo were willing to display once again, in defence of the mysterious stranger, and life and freedom.

"Fools," cried Eagaq, noticing several Scouts in their midst, "I don't know how you've worked this lie, but the Clawer can never be tricked. I alone see into your hearts and know. I alone see weakness and fear and punish them mercilessly. Would you put your trust in a

non-existent Saviour, or believe in some holy Bellarg, long dead and gone, like those cowardly Storytellers?"

"Warrior Storytellers," bellowed Janqar, baring his teeth and roaring.

"Cowards," hissed Eagaq, with a laugh. "They were liars, who we destroyed long ago – murdered on the Never Frozen Sea...frozen like growlers by your unholy Atar's breath."

"Perhaps to save their souls, until they rise again, traitor," roared Janqar, "to avenge their own legends. Like the Great Story, Eagaq Breakheart for that may never be stopped."

"Oh, dear Janqar," whispered Matta, trembling strangely next to Uteq. "I think he really believes it. As he always believed in you, Uteq. And I wish that Athela really..."

Eagaq was looking back scornfully at Janqar still.

"Bravely spoken, Bergo," he said now, almost sincerely, "but words are nothing, Janqar, and the Fellagorn gone, while none but a Great Master may anoint another. That's your own Ice Lore, fool."

"Ice Lore, Eagaq?" hissed Janqar, glancing warmly at Matta in the throng. "What do you know of the sacred Lore, Breakheart, or the cosmic balance that connects all? Or of a master's soul, travelling into a snow den to be reborn? Sorgan had another journey, to help the One, but chose me before he died, out there on the Ever Frozen Sea and anointed me too. So I've anointed many others this fateful day, Eagaq Hateheart, as Fellagorn once more."

"Anointed?" said Eagaq. "We know you, bribing, sneaking Janqar, and you're nothing but—"

"Here my name's Janqar, fool," bellowed the proud, scarred Bergo, "in a world gone mad. For it really means the Faith of Athela. But know this, Breakheart, sometimes in danger and the dark, it's courage and wisdom to hide your truth, and go around to work. So I cut my own fur sleeves to hide myself, when I escaped the Field of the Fellagorn, but was known once as Illooq Longsleeves, when I set out to tell the Great Story myself, summoned by my master, and shall do so again."

"Illooq," Matta gasped, swinging her head in astonishment. "It

can't be, Uteq. The Great Master's first disciple and bravest fighter. It was Janqar all along. He won the Story Joust out there on the ice then, and Sorgan touched him. Made him the new Great Master."

The Serberan stepped back in horror, and Eagaq felt the ring of truth sing in Illooq's shattering voice, as if the Ice Lore had come down to judge them all.

"Quickly, Sqalloog," Eagaq shouted though, as he saw the spirit of rebellion growing around him. "Take your Serberan, and go straight to Glawnaq's ice cave. Tell him everything – and bring the army down, as fast as you can. All of them, waiting for the day's great work. Serberan and Glawneye too. A revolt's begun among the Barg, but we'll drive them into the poisoned waters to die."

Sqalloog nodded willingly, terrified by the strange events that had brought back fear as tight as a Snow den, and eager to get out of this place fast. He fled with his Serberan, as Eagaq rounded on the hated Barg, still confident his loyal Glawneye could contain them for a while.

"You cut your fur sleeves, fool," Eagaq snarled at Janqar, "so have you not drained away your very fighting power? If the Storytellers ever had any, as they mumbled of peace and Pollooq."

Janqar was smiling coldly, though his fur sleeves he had cut to hide himself indeed.

"So, you believe in Pollooq now?" he growled defiantly. "But Pollooq's just a legend, Eagaq Breakheart, and a language to warn of the harm that others may do in fear and betrayal, and one may do to oneself in rage and isolation. A legend of the agony of love too. But I'm a real Fellagorn, Cub Clawer, and since I cut them myself to hide myself from lies, I broke no pact with the gods at all."

Eagaq blinked and felt a cold fear deep down in his own soul.

"So it begins, Eagaq," cried Illooq Shortsleeves, turning to the others. "The end of the Dark Father, forever, for all darkness has its end, and that is the Lore too. Hold your courage and freedom deep within then, this sun, like proud, fighting Bergo, and nothing that these killers can do will ever prevail. Hold hard this day, my brothers."

As Uteq watched, he saw among both Bergo and Bergeera their

Garn shadows reappearing, their gods and goddesses, and glowing brighter and brighter, beside each other. He saw Tortog and Sarq standing almost side by side too, and between them were the shapes of two golden Bergeera, and as they stood there, they smiled at each other with glittering eyes, one by Tortog, gentle and feminine, one by Sarq, strong and fiery, and their heads came together as they touched snouts.

Eagaq stepped forward and seemed to draw the Glawneye in around him.

"Barg or Fellagorn," the Cub Clawer hissed. "It does not matter. You're all weak with lies, and rotten seal blubber. What is it that keeps you here now, Barg, but shame at your own fear, and jealousy that you had not the courage to act like Serberan? The courage to stand taller than your own lurking, filthy, cowardly shadows."

Illooq's eyes flashed and he remembered Beloq and Teleq, his brothers, dead, as the Scouts remembered their fallen, but the Barg were cowering back, for the Clawer seemed like an evil god.

"True, Breakheart, true," cried the Great Master, "but now we would be heroes once more, and so from this day we shall carry our own shadows before us, our own shame, so be whole once again."

Suddenly the old Scouts, now the newly anointed Fellagorn, roared as one and with those stained paws they were swiping at their own cheeks. Rather than a gash though, each boar left a black streak instead, left and right, on his proud face and in the twilight the strange new Fellagorn seemed even more ferocious, and some of the Serberan began to shake and back away. Yet the Cub Clawer cried out defiantly once again.

"Stop, fools. For I've a little offering, and a promise to keep to my dearest beloved."

Eagaq flashed his Seeking Claw and swung it straight toward Olooq's terrified face, but even as Eagaq's vicious strike was about to fall, another paw suddenly knocked it away and a Bergo thrust Eagaq violently sideways.

"Qilaq?" cried Eagaq in astonishment, staring in disbelief at the growling Glawneye who had just blocked his strike.

"Brother," gasped Matta, "But he saved Olooqa. Why, when he's a Glawneye murderer?"

There was a terrible confusion in Matta, and Uteq too, yet something was stirring in Uteq as well, some further attempt to understand his own strange gift.

"You'll not touch a hair on her head, filth," bellowed the Death Cult leader as Qilaq glared.

"Yes, Qilaq, yes," cried Matta, her heart flying into her mouth and wanting to cry and forgive her brother for everything, even if he had killed Soonaq as Uteq glanced sharply at Seegloo.

"Qilaq?" hissed Eagaq furiously. "But you've been taken to Glawnaq's heart, Qilaq. I saw how you killed even Ogguq, fed on Festlar meat and marked in the Cult of Death. Its very leader."

"Never," growled Qilaq, and there seemed a terrible pain in his strangled voice. "I've never touched Festlar meat, scum, although I know that what Nuuq says of the Leaves is true. I bear no mark either, and shall never bow to a Cult of Death, or lead truly it either. Nor bow to the voice of a murderer, who stabbed Nuuq's mate with an ice dagger that melted in the sun, to hide the crime."

The Bergo and Bergeera among the Fellagorn and Barg were beginning to mutter and look across to one another, for this was the first time that the Leaves had been spoken out of the mouth of a Serberan – to confirm the terrible truth that they all knew deep in their frightened hearts. This word of a murder revealed as well, only added to the very power of it. Nuuq was staring hatefully at Eagaq, who suddenly seemed to cringe back before them all.

"Murder?" he hissed, "and what of it? You hated Soonaq yourself, Qilaq."

"No. I admired Soonaq with all my heart," growled Qilaq, "and there was only one thing that we ever fought about, to let Nuuq den near her friends. He wanted to protect her in the Sound."

Olooq and Olooqa had heard this but they little understood what was happening, as Nuuq began chuffing furiously at Eagaq.

"But Uteq," whispered Matta.

"Of course," growled Uteq, "dreams, Matta. They are not the truth

either, but the shadows of connections only. And The Sight, the power of The Sight itself was wounded. Oh, you stupid Bergo. Mad Mooq's vision was wounded too, so he only half saw, just as I did."

"And Glawnaq may have taken me to his filthy heart," snarled Qilaq, his coat bristling, "but my heart has never betrayed a promise to Uteq I swore long ago. I've doubted, yes, but I only truly knew myself when Janqar sent word to me through Keegarq, a friend he had cultivated in secret, of who it really was who came to help me that night at my Moon Duel, or how the word of passing really came out too."

"But Qilaq..." growled Eagaq desperately. "I know you. I know your soul."

"I cut my paw with stones too," cried Qilaq bitterly, "only to stop my mind and spirit being mesmerised, and how else could I get as close as I did to Glawnaq, you fool, and to you too – to know all your hateful plans, many of which I relayed to Janqar through Keegarq. But it was you I swore that I'd kill even before Glawnaq, Eagaq Breakheart, for what you did to us and your Scouts in the Sound, and for killing my father. For murdering Nuuq's mate in your hate and lust."

"Strike Glawneye," cried Eagaq, appealing for help to the huge Bergo around Qilaq, but all the twenty Glawneye, including Keegarq, had stood down too and were watching Eagaq coldly, like a pack of free hunting wolves.

"See, Eagaq. I've been telling them stories too since I've led this filthy cult," said Qilaq proudly, "but only stories they wish to hear. And none here have touched Festlar meat, or taken the mark of death. Instead they would be real Warriors again, real bears too. Brave and free and proud."

Qilaq lifted his paw now, where he had so long held that stone and it had a mark like the Glawneye's, a cross, although it was not inverted at all. The Glawneye were looking admiringly at the Fellagorn, and as their eyes met, with pride and love for what it meant to be a real Bergo again, and it was as if the Cub Clawer was completely encircled.

"Betraying them with lies," muttered Eagaq helplessly.

"Telling them the truth. You know why in stories sleepers, lovers and warriors, are freed from nightmares and fairy tales with a prick of blood, weak Eagaq? Because beyond ideals and legends, life is real, and the Ice Lore too, so fight in the light of the day, Eagaq Breakheart, and die."

Qilaq leapt at the quivering Cub Clawer, but Eagaq swung with his Seeking Claw, and Qilaq caught it straight between his claws and snapped it clean off. Eagaq bellowed, as if a limb had been torn from him, but he was a young bear too, and pushed Qilaq back, who went tumbling back in the snow. Now Eagaq extended all his claws and rushed forward on his hind legs, aiming to plunge them into Qilaq's back, just as Ogguq had done at the Moon Duel. But Nuuq dipped and threw something to Qilaq which had dropped from a Glawneye's paw, and he grabbed it and rolled, bellowing furiously.

As Eagaq lunged, Qilaq swung upward with the ice dagger and Eagaq stopped in mid air, as if frozen, right in the middle of the circle, a look of amazement in his twitching eyes. As the Bergo gazed down at his own chest, murdered by his own crime now, he saw the stream of blood pouring down as Qilaq let go, and Eagaq tottered back, clawing at the thing, looking helplessly at Nuuq too.

Some of the Barg gasped at the enormity of that strike, for the Cub Clawer had cast such a terrible shadow over them all, it seemed impossible it could be over so quickly. Yet now they saw Eagaq Break-heart crash heavily to the ground, the Cub Clawer's body twitch, and the Scout they had all so loved and trusted in the Sound so long was dead. A terrible stillness descended on all the Bellarg, but as Eagaq went limp, a black shape rose from his mouth and swirled in a futile circle, then disappeared like a puff of smoke.

Uteq walked slowly toward Janqar, through the crowd of stunned polar bears, followed by Matta, Antiqa and Rornaq.

"Uteq," cried Qilaq, his eyes filling with passion, "It's so good to see you again, my friend."

"And you, dear Qilaq, and you. Thank you."

"Oh, Qilaq," cried Matta. "Dearest, darling brother. It's so wonderful."

"And I'm sorry what I said, Athela," said Qilaq softly. "When Glawnaq sent for you. And sorry I doubted. I had to survive, and hide my heart. It was the only paw trail I could see in this terrible place. Yet Janqar got me word of a plan and when I heard that it was you that sun, the Tok, I mean, I finally woke up."

"Yes, Brother," growled Matta, her heart bursting with happiness. "It was me."

"We must act quickly though, Uteq," said Illooq. "And Qilaq too."

"Yes, Janqar," growled Uteq, looking at the twins, and thinking with wonder how the promise they had sworn before the sea had come almost true, but wishing with all his heart that Sepharga could he here to see this. "Or is it Great Master, Illooq Longsleeves? A Fellagorn reborn..."

Uteq dipped his head respectfully, but Janqar smiled and shook his own.

"A Fellagorn that never died, or that nearly died, inside my true self, only to be reborn."

"Yes, Illooq, our deaths have not been real, and yet more real than perhaps we will ever know. Egg. Me. You too. More real than any physical end, for a true life is what counts, and now there have been resurrections also. The two languages join."

"Lead us then, Uteq Blackpaw. It is time, Ice Whisperer."

"But Janqar," said Matta, hers eyes glittering, as she looked at those black streaks on his paw, "Or Illooq Longsleeves. It's all true then. That scar, you got it when the Seeing Caves collapsed?"

As Matta and Janqar's eyes met, Uteq felt an awful loneliness and longing, as Janqar nodded.

"And your voice, Illooq," said Matta tenderly. "Is that what enchanted so many, to help you move around at will? And enchanted me too."

The new Great Master nodded again.

"Our Fellagorn secret was to master the power of words, Matta," he said softly, "that become things and realities, so talk to them now, Ice Whisperer. Give them your true voice."

Uteq was suddenly a cub outside the snow den once again,

remembering his father telling him that a little bear must find his true voice. In his mind he heard a voice whispering to him now too, and a warm, female voice like Sepharga's. *"You are cub no more, Uteq. It is time."*

"Barg," Uteq cried, lifting himself high in the snows. "Bergo and Bergeera. Will you believe us now? Follow us from this dark, unnatural place, so find freedom again out on the Frozen Sea?"

Many were whispering and nodding, yet still others seemed to have doubts.

"Qilaq's a Glawneye still," growled one. "And how do we know this isn't another trap? That they don't just lie in wait out there to kill us all? The Dark Father is cunning, and his reach is long."

"But can't you believe even now?" growled Uteq. "They're killing you all already. We must escape, before it's all too late."

"Then we don't fight, Uteq?" said Qilaq with a growl. "Revenge ourselves."

Frustration glittered in his brave eyes, and in the eyes of the young Glawneye around him too, who wished they bore marks like the Fellagorn.

"An eye for an eye?" said Uteq sadly. "Tooth for tooth? If that lore ruled how long before we all went blind, and couldn't eat. Besides, with so many mothers and their new cubs to protect? No, Qilaq. We get as many as we can to safety first."

Uteq rose once again.

"Bergo, Bergeera, little paws, my heart burns, and now I'll return your faith by leading you, if I can. Try to trust. We go through the gullies, safely past the poison of the black blood, then north to the great pressure ridges that curve round the ice mountains to the sea ice, and so to the Haunted Island. Then out into the High Arctic. Freedom for a wild polar bear. We'll found a better world."

"No, Uteq," growled Darq, looking fondly at Farsarla. "They say the ice packs there have not frozen solid. I heard Serberan saying the sea's still nearly at the shores of the Island."

"*Nearly,*" Uteq growled, "so ice is there. And that's the route beyond Glawnaq's borders."

"And straight toward patrolling Varg," said another Barg and a nervous murmuring went up.

"Have the white bears forgotten our birthright?" growled Uteq. "Wild nature. We face life together, death, if necessary. We'll make it the greatest Wander-to-the-Sea cubs have ever known."

"Herald the Ice Whisperer, Fellagorn," growled Illooq. "Herald Uteq Blackpaw."

Illooq's anointed reared up again.

"The Ice Whisperer," bellowed the Storytellers.

Uteq's heart thundered and Illooq glanced at him sharply.

"You *will* trust the legend then?"

"Not alone, Longsleeves," answered Uteq with a smile, "but I'll trust my true Self and the Great Gift, at last. And tell only of life. We're all part of the Great Story, Illooq, large and small, Lera and Man too. There's one thing though I still cannot see. Mooq's warning of a betraying sister."

Egg fluttered down, flapping his wings frantically and looking miserable and lost.

"What's wrong, Egg?"

"Egg wonder where Ruskova is," answered the bewildered bird, "Promised to help find mate and always teasing Egg. But gone. Frighted. Betrayed Egg. *Swurk. Grrrrr.* Mystic heart fails."

Uteq could hardly believe his mystic muse would disappoint so, but he felt guilty at how he had snarled at her and lifted his head and they began to move away together. The Bergo and Bergeera and cubs followed Uteq, like a people escaping to some promised land, whispering excitedly, but fearfully too. Yet many stayed in the bay too, hunched and broken and filled with shadows.

"Look, Uteq," said Matta though, as they went, and all the escaping Bellarg gasped. There in the twilight, far to the north, blue green lights were flowing and glowing right across the distant arctic horizon.

"The Beqorn," cried Uteq. "The dreams summon us friends, out of the Realms of Death."

POLLOOQ'S RETURN

"Even after all this time, the sun never
says to the earth 'You owe me'. Look what
happens with love like that. It lights the
whole sky."
—Hafez

Away in the Sound of the Serberan, the Dark Father's paw swung viciously and struck Sqalloog so hard that he was thrown backward against Glawnaq's ice cave, hunched like a frightened child.

"Eagaq dead?" snarled the Leader. "My Dark Son dead? And Uteq Blackpaw alive and escaping with my Matta, and all my slaves? The Cult of Death thrown down too? Is this a dream? A nightmare. How can this happen?"

"We, er, stood on the edge of the bay and watched, Father," stuttered Sqalloog, trembling furiously. "But it's all true. After your spy brought Eagaq the news of Uteq's return."

"Gerla," snorted Glawnaq, as Sqalloog mentioned his spy, "And where's my Dark Sister now?"

"Sister?" said Sqalloog in amazement, but some rumour of a mad prophecy sung in his ears.

"My half sister, at least," said Glawnaq. "We shared a mother, but she was always difficult and jealous. I let her work with me inside the Barg though as my secret eyes. Where is she?"

Sqalloog looked suddenly terrified.

"Dead, lord. She was impertinent when she tried to get to see you,

and...and Eagaq lost control. He was not used to being addressed by a Barg like that, even if she'd watched Uteq so long."

Sqalloog wondered if Glawnaq was controlling his emotions as he spoke of Gerla's death but the look in his eye was cold and unmoving.

"Very well, she became a Barg after all, and Eagaq's paid himself. What other news?"

"The Fellagorn are reborn," said Sqalloog, almost wincing, "and anointed with berries by Illooq Longsleeves – the last of the Warrior Storytellers. The new Great Master comes."

"Then we must follow this damned Whisperer and strike them down," snarled Glawnaq, feeling an uncontrollable rage rising inside him. "Where are they headed?"

"To the Haunted Island, I think, and then north to the Ever Frozen Sea, if they can ever reach it, cloaking themselves in the coming Long Night."

Glawnaq paused thoughtfully, and seemed to be measuring the snowy distances in his lonely ice cave. "Then they will have to go by the pressure ridges."

"Yes, Dark Father. And may I lead the Serberan now?" growled Sqalloog, desperate to regain favour with his leader. He was filled with ambition to be the Cub Clawer too, now that Eagaq was gone. "I'll try to cut them off there, in your service, Dark Father. I never disappoint."

Sqalloog extended the Claw he had been nurturing himself, but it was stunted and misshapen.

"No, idiot," snapped Glawnaq, "it'll take time to rouse the full might of my army. Go down into the sound instead and summon the others – and take half the Serberan with you, as fast as you can. Delay Uteq and his followers however you can. They must not reach their promised land. If you fail me, you'll pay with your life, fool."

As Sqalloog turned and hurried out of the ice cave, a Varg appeared in the entrance. Glawnaq saw it with his single eye, and thought the only truth what he saw in his own dark mind.

"You heard?"

The wolf nodded sleekly and licked his lips.

"Then go, Treeg, and raise all your mercenaries. The plan we discussed for just such an eventuality must be enacted now. But first go down and howl to the sea."

The Varg smiled and growled, and Treeg was running as fast as he could through the snows, away from the ice cave, his tail raised like a banner.

A GREAT TRAIL OF BELLARG, LED BY UTEQ, QILAQ AND SEVERAL OTHER Bergo, their eyes clear and strong again, was snaking away from the polluted ice gullies now. Behind them came a column of growling Bergeera, flanking their cubs. Behind these, looking back constantly, came the new Great Master and his anointed Fellagorn, stained with healing berries, their cheeks marked as Warriors. Above all the fleeing Bellarg circled Egg, like a feathered helicopter, wondering where Ruskova was, while in the far distances the great Northern Lights flashed in the mighty heavens still. As they watched them though, Uteq saw that terrible slick of black curling down out of the skies towards the earth once more.

"You've really been up there, Uteq," asked Qilaq, "without falling off the edge of everything? Is it as scary as they say?"

"Just ice, Qilaq," lied Uteq. "And the dream lights, too, from out there in the Universe."

"You found out what the Beqorn are then? They're not the spirits of the dead Bellarg?"

"They're Garn, Qilaq, but flow between the heavens and the Underworld. There's only really one light though, Qilaq, everywhere, though sometimes hidden indeed."

"Garn? That's how Illooq described the blood pouring from the Ice Mirror, before it cracked and split in two. The black blood."

"He did what?" said Uteq, swinging his head sharply.

"Saw the black blood, Uteq, in the Seeing Caves. That's what the spirits showed Sorgan, when they sought the real reason that the ice world dies. Because of Man. Though for a good while, I wasn't sure I believed the story. Wasn't sure what I believed."

Uteq nodded. "I saw that, too. Man warms the earth and the air grows full..."

"The Gurgai," grunted Qilaq angrily. "Kassima."

"No, Qilaq. They suffer and fight to survive too, just like the Lera, and why shouldn't they? But when they see well, and unite their souls, they are the measure of all things. For how will they love and protect us all, if they do not love themselves, and tell the truth again, with the Great Gift?"

"In the beginning was the word?" whispered Qilaq.

"No Qilaq. Remember the Sight, and where Man came from. In the beginning was fire and flame, then water, plankton, and egg, then the howl, and the hiss and the growl. But then came Primate Man and made the Word, and the Word made Man too. Language."

The two suddenly heard Barg whispering behind them.

"We're free," one said. "And when we're out of here, I'll take revenge for the past, all right."

"Hush," said another, "we must look to the future now. Don't speak of all that darkness."

There was something terrible in the anguished voice and it was as if the Barg, struggling with all that had happened in those horrible years, were padding across a frozen sea of tears.

"Moons back, Uteq," Qilaq growled, "Glawnaq's Varg brought news of a strange floating den, five times the size of the metal belly. They've seen it before, waiting beyond the Haunted Island – until the ice melts. Then it'll enter the Ever Frozen Sea to plunder the back blood."

"Then the Ice World shall truly never be the same again for Bellarg," growled Uteq sadly. "And the wilderness will be gone for good. I've seen the borders of the world grow so small."

Even as he said it though Uteq realised the borders of mind were monumentally large and spirit too.

"What does matter if we all die today then, Uteq? And die we shall, if the Serberan catch us."

"Then keep them marching hard, Qilaq. I'm dropping back to check on the Bergeera."

"My sister? Send Matta my love, Uteq. How I've missed Athela these moons, without her good reflection, to remind me who I really am."

"Yes, Qilaq. But Matta gave you that true reflection, and you gave it to her."

Uteq turned but even as he did saw he saw Janqar, Matta, Pooq, and the others hurrying towards them and Uteq realised that they had already reached the entrance to the pressure ridges, their most vulnerable point. He lifted his head and Egg came sailing straight down towards him.

"Egg here, Uteq," said the emperor goose smartly, coming to attention as he landed, and they were astonished to see that his little cheeks were streaked with black too.

"Egg, we need your eyes more than ever now, my friend. So, fly ahead and scout the ridges carefully. See if they are safe to travel through. Go, Egg, quickly."

"Yes, Light Father."

The emperor goose opened his great wings again and took to the sky. The Barg were gathering now, crowding forward and Uteq noticed how close Matta and Illooq were standing, as Pooq looked fondly at them both. His heart suddenly ached and yet he smiled sadly.

"Matta," said Illooq nearby, as the she-bear stood beside him, "I'm sorry I deceived you."

"Deceived me? You told us the deepest truths. And kept faith inside. The Faith of Athela."

"I was the Fellagorn's only hope, Matta, and I had to try to stir the Bargs' souls, before I revealed myself. But I used my voice on them all, and they turned and believed in Uteq too."

"And I wish I could do more, like you – both a Storyteller and a Warrior, Illooq Shortsleeves. But I'm just a weak and feeble Bergeera, and none of *them* was ever a Fellagorn."

"Except Athela."

"All I did was sneak into the Sound," said Matta, with a smile,

"touched for a moment with the pain and courage of Bergo. Athela may have been a fighter, but didn't do anything much really."

"Didn't do anything much?" said Illooq in astonishment. "Apart from keep my own heart alive, dear Matta, and don't you know the real story of Athela Pollooq told himself?"

"Told what?"

"The Fellagorn voice Pollooq heard in the darkness of the Ice Labyrinth, when he had slain the Gorg in Hell. He wondered it if came from deep within him, but it was really Athela's voice. The goddess of wisdom – Tutsitala. A beautiful, kind female voice, strong as the wind and a fighter."

Matta shivered, but she felt a new courage in her heart. She felt like a warrior indeed.

"Poor Athela," said Matta though, looking fondly at Janqar. "Even after that, she lost him again, then Atar hurled Pollooq's claws into the heavens to join Teela forever, like some Pureem."

"Stories can be cruel," said Illooq, nodding, "like life. But Atar put Athela there, too. For when she died the moon goddess took Tutsitala's delicate claws, and placed her right next to her sister, to be with Pollooq in the heavens too, and to guard us all, especially cubs. The Little Bear."

They could see both the constellations in the giant heavens, among the Beqorn.

"Oh, how beautiful, Janqar," cried Matta, tenderly, looking down at Pooq.

"Then come," said the Great Master, as the Barg began to huddle at the entrance to the pressure ridges. "As we wait for Egg, let's keep their minds busy, and tell them the end."

"End?" said Matta in surprise, as if her own desire for happy endings was coming true too.

"What blind Pollooq told the Pheline to meet their challenge," cried Illooq, turning to the others, "and heal the whole world – not just the wounded white bear. You'd like that, wouldn't you?"

The Barg Bergeera and their cubs nodded excitedly.

"The story the Pheline knew was impossible to tell, and especially

Teela's mate, the leader of the Pheline, as they kept watch over their slaves in the real world."

"After poor Pollooq told them of his escape from the Labyrinth?" said Matta, stepping up grandly beside Janqar. "And pretended the Storytellers had made him new eyes."

"Yes, Athela," said Illooq warmly, "then asked for food from a Bergo, that Athela brought him in disguise, and which Pollooq ate before he went on. So then he told how Pollooq went wandering in search of love and meaning."

"Told them of the twelve labours of Pollooq," said Matta, and their voices seemed to blend together, "before he was reviled and dived into the blue whale's mouth to save his soul."

The Tappers were staring at Matta and Illooq in wonder, especially Pooq, and Uteq sighed. He suddenly felt bitterly alone, but the story cheered him too, spoken with the two languages.

"And how inside the whale's belly, Pollooq counted the dripping bones of the creature's ribs," said the Great Master, his eyes glittering. "And measured the waters in its vast stomach, and knew he could still not know the world without stories and feeling, without love and meaning. So he spoke the words of passing, that made the great whale open its jaws to release him onto the earth."

"Alive," said Matta with a laugh, and she smiled at Antiqa nearby.

"So eyeless Pollooq stood there, still in chains, before Teela and the Pheline. The Pheline who had said that he and the past, and the world in its pain was so separate from themselves, and had nothing to do with them at all. Then Pollooq finished his story and their challenge, which had been a living agony to him, but the ancient Pheline just looked back, and again they started to laugh.

"'You can tell wild stories still, blind one,' cried the half-sighted leader of the Pheline. 'You can spin your pointless, ancient yarns, but this you think will heal dying creation? You cannot even heal yourself, mad Pollooq. The power's broken, of Storyteller and warrior too. Your own are dead, or slaves in the paws of mighty Pheline, and the cruel, real world. For we alone are the future now.'"

The listeners thought of all they had to face, and Glawnaq's

terrible shadow coming down on them, and began to mutter, trying in vain to complete the story themselves, for Pollooq was still a prisoner in the story begun so long ago, lost and without any hope of escape.

"But Pollooq stood there, snarled in seaweed and crowned with urchins," cried Illooq Longsleeves. "His head still bowed, yet now he was no longer in the Labyrinth of himself, and he believed in stories again. He knew too that although he had loved Teela, she was truly a Pheline too.

"'You're here with us still, Pollooq, last of the ancient Fellagorn,' cried the leader of the Pheline. 'You're broken, bowed and shamed, and now shall die indeed, King of Bears. Killed with the strength of real Bergo, and the will that sets in them like ice.'

"With that some of the Pheline in the cave heard a great crack run through the ice that seemed to split Pollooq's broken body apart. They were amazed, for he had vanished. But there in his stead stood what they thought was a skeleton – but then they saw it was really a tree, its roots reaching down into the snowball of the world, and its branches climbing to a starry heaven.

"For when Pollooq had asked Athela for food," said Matta, "the Goddess had brought a magic seed, contained in a nutshell he swallowed entire, and so it had grown, and flowered through his entire being, and bound him together to make him whole again. But the vision disappeared, and there was Pollooq again, yet now he was a huge, smiling Bergo, with the most enormous belly, and in the centre of his forehead a beautiful flower bloomed, and on his lips was laughter. Goom."

"But Goom too vanished, and for a moment the Pheline thought they beheld a human, a beautiful man broken on a cross, telling only of love and faith, and yet he vanished too and there was bowed Pollooq once more. Now Pollooq began to speak softly. 'Pheline,' he growled. 'You've brought me here, and shorn my fur sleeves. You've plucked out my eyes and spat at me. Yet you have made me tell a story you could never believe, my very soul feared to tell, without the light and love I needed to see in the true darkness of despair, and so you heard the Scream of the White Bear.'

493

"The Pheline began to murmur and stir, as did the Bergeera and cubs, for they felt a new presence in the ice cave. 'But that's not how wild Bellarg really are, Pheline. It was the voice of a human that really took me into the Labyrinth, and the darkness of Man, which is the darkness of animals to the Gurgai. And it was the song of a Bergeera that led me up again into the wonderful light, of Athela, the faithful Storyteller. But I'm not Gurgai, Pheline, the measure of all, sacrificed to the blind world, to show love is all that truly matters. Although that is the purest truth, from father to son, mother to daughter, for the kingdom is within, united. A Gurgai sacrificed to show that by dying to the body, the spirit is always reborn into the true Self, so may see the wonder and unity of all things, with real love and real meaning once again. The light.'

"The Pheline began to back away, for it seemed as if light was glowing from Pollooq now.

"'No, Pheline,' growled mighty Pollooq. 'You who are ripe with laws and rights, yet cut off from nature, and each other. The journey all take, and the pain and wonder and pity too of both Man and beast, the triumph and tragedy. Know then that I am Pollooq, a wild Bellarg, first of the Storytellers, a living Bergo, and would live in what you call the real world too, and have eyes and teeth again and breathe.

"'I've been into the Labyrinth, been inside the whale's mouth, seen the nature and connection of the stars. I've slain the Gorg, but brought forth his spirit, once, for if we must see with reason, we must also see with love, and know the world outside is inside us too. And both must be protected.'

"Pollooq began to stretch his great bear arms as he spoke as if binding together the two worlds of heaven and earth, reason and feeling.

"'So while ancient Pheline tell a simple story only, of victory or failure, of reason or madness, of the rights of their individual wills, and the *I* that harms, Pollooq and the Fellagorn will speak the story that contains *all* the others, the Great Story. Which is also the story of rebirth, that always remakes the world. This is why Pheline who make slaves of warriors must be shaken and thrown down, and where

once you heard a scream from a dying Bergo, now you will hear his roar.'"

The cubs and the Bergeera was gasping and trembling, filled with hope and courage.

"So the great bear, like pure spirit, lifted his blind and wounded eyes, and they were healed. He stretched out his mighty arms, and among his chains of seaweed they saw his fur sleeves growing once again. And with a gigantic bellow, the mighty Bergo pushed at the stalactite and stalagmite, and rocked them with his huge paws, and the roof of the cave began to shake and crack in the bitter cold. The terrible cave of the Pheline, the entrance to Hell, was brought crashing down around them all.

"Pheline Bergo and Bergeera fell there, and Pollooq snapped the chains of weeds, and roared with all his soul. He turned right and left to smite the Pheline, and free his Fellagorn, although three Pheline alone the mighty bear left alive – Athela, Teela, and the Bergo she had taken to her frozen heart. But Teela was cowering in the cave before Pollooq's might and wrath.

"'Kill me then,' said Teela proudly, for she had great pride, 'and have your hateful revenge.'

"Pollooq looked into her eyes and his own were filled with tears. 'Revenge?' he whispered. 'Could you not hear how I loved you? How I love you still. Yet none can force another to see what they will not see, Teela, to feel what they cannot feel. So, go and be free.'

"'So I owe you my life?' said Teela scornfully. 'It's *my* life, Pollooq.'

"'Owe me?' growled Pollooq and his tears turned to ice. 'You said you owed me nothing when I bellowed, even as you walked with Ineq, then bound me for all to see. But you, not I, broke the bonds both of love and friendship, and used words like a Pheline alone.'

"'You hate me because I betrayed you, oh so mighty Pollooq?'

"'Hate you? No, Teela. But I know you're blind and love only your-self, though not your real Self, because that I'm a part of too. Evil is not some mythical beast, some terrible devil, but it does live in broken chains of being, and in cruelty too. So it's not me you betrayed, Teela, it's your own moon dream, and the Great Story. You owe me nothing.

But be careful, Teela, for there is a Hell out there indeed, yet something far, far greater. Real love. And a word too that, though there must be lores, you shall never really understand, in its beauty and connection and courage – tolerance.'

"Teela turned away, as the ghosts of murdered Fellagorn rose up too, resurrected, and went out into the snows – a White Army."

A great wonder had filled the Barg as they listened, for in their minds they suddenly saw Glawnaq fall. But the light was beginning to fail, and it had started to snow heavily again and it seemed to make one of the mothers doubt, as Uteq looked sadly at Illooq and Matta. He remembered someone telling him there were only two types of Bergo in the world, and Uteq knew which he was.

"There's no army of light in there," said a Barg, looking at the ridges, "just dark. Perhaps we're wrong, should turn back. Perhaps Uteq saw something horrid, yes, but the Leaves were really—"

"Believe," growled Uteq, "please. To turn back would have turned Pollooq to ice."

"Believe in the story?" said the Barg sceptically. "Simply made to bring hope to slaves."

"Believe in the words of a free Bergeera," cried a real female voice suddenly. "Who's seen the Leave herself, and knows it is evil. An evil that justifies even war."

Uteq's heart could have stopped as he heard that voice, like the song of the whale in a youthful sea, or music whispering through reeds of half-frozen grass. Out of the ridges a she-bear was coming and in the moonlight her coat seemed to be glowing like Pollooq. Uteq wondered if he was dreaming of that spirit he knew had been inside him. It was more extraordinary than any Fellagorn or Pheline tale and Uteq's whole body trembled as he saw her limping on her right paw.

"Sepharga!"

Sepharga looked straight at him, with glittering, certain eyes, that seemed to have been on a very long and strange journey indeed and now Uteq doubted the Pheline power of his own eyes.

"Yes, Uteq. Dear Uteq, it's really me. I've found you again. I've

come so far."

Qilaq and Matta were looking at each other in astonishment too, for this was a resurrection indeed. Sepharga had died.

"I'm sorry it's taken so long, after I escaped the Ever Frozen Sea."

"But how?" Uteq said and he felt as if some shard of ice was melting in his heart.

"It's like a dream. The whale that saved us drew me in its wake and broke through again. I was half-dead, and slept long, but tried to follow north, then was captured in the wake of returning Glawneye. So I've seen the Leave with my own eyes," she cried, turning to the gathered Barg. "A hell I escaped."

"As great as the hell without you," whispered Uteq. "That's a real place too. Inside. If we get out of this alive I swear that I'll always leave something for the gods."

Uteq was amazed. It was as if everything was coming back to life. As if life itself was just a circle, held inside eternity. The Barg could sense the wonder of it, and the hope the friends felt at the restoration of the four, who came together now, as loving words spilled out of them all.

Illooq suddenly cried out too, to his marked Fellagorn.

"Bears," he roared. "What heals the wounded Bergo? And what is the secret of his real strength, the white bear's fighting power?"

"Knowing the good Bergeera within," answered Rornaq, looking lovingly at Antiqa. "Feeling her love and compassion. Then the white bear roars again, but with justice and meaning."

"And what protects the wounded Bergeera?" cried Illooq. "Saves her from her pain and longing and fear, and preserves her gentleness too, the mother of the world?"

"The reason and order of the true Bergo within," answered Seegloo.

"And how may the white bears flourish?"

"By joining as one," they all cried, "growing like the tree of the world, for Life we serve."

As they finished, Egg sailed back again and landed by Uteq and Sepharga, wondering why everyone looked so strange.

497

THE MIRACLE

"And learns at last that it is self-delighting,
self-appeasing, self-afrighting, And that its
own sweet will is Heaven's will."
—W.B. Yeats, "A Prayer for My Daughter"

"Ridge edges clear, Uteq," said the emperor goose, and Sepharga nodded. "Egg flew all along and saw nothing. But Sqalloog and Serberan behind, Uteq. Coming fast."

Uteq wasted no time.

"Friends," he cried, rousing them from the strange story. "Don't look back now. Follow and run with all you are. Hurry."

Uteq turned and faced the looming ice ravine, where the banks had been made even higher with the snowfall of the last few days, rising steeply around the polar bears, as the forward party led the mothers and their cubs in first. As the shadows of the ice walls fell on them, the Fellagorn brought up the rear, with Illooq hanging back all the while, shepherding any stragglers.

"Up there in the North, Uteq," said Sepharga, as they went, "you did cross the Garn River and become the Ice Whisperer? You've new powers?"

"Not to heal the ice, Sepharga," growled Uteq softly. "But stories may serve us now, and not we them. For whatever life throws at us, we must try and be in control of our own story. Or perhaps only by telling real stories, from deep within, can we find our true way back to the light."

The night had deepened, and the wind moaned, and at last all the

fleeing Barg had entered the pressure ridges, and they felt a strange fear gathering around them, as if they were not alone at all.

"Can you feel it, Sepharga?" whispered Uteq, as they hurried along. "As if we're being watched."

"Stop Uteq, you're..."

Sepharga stopped herself and showed her teeth bravely and set her eyes ahead.

"What's that, Uteq?" growled Qilaq behind them. "I thought I saw something move."

"Just the wind, Qilaq," answered Uteq. "There are no snow ghosts. Not even on the Haunted Island. I've been there before."

"Stay close to me Pooq," whispered Matta behind them.

"The Ice Whisperer will guard us all though, Uteq," said Sepharga. "Whatever comes, you're making your true destiny. Telling your real story. Oh, Uteq, I'm so proud of you."

"I've done nothing, Sepharga. Fought no one. Except perhaps myself. Like Pollooq."

"Betrayed by Teela," said Sepharga sadly.

"Perhaps she was just too innocent, too Pheline, in seeking the future so fast."

"While Pollooq looked so much to the past, as he tried to stop time and grieved."

"Yes, and isn't the most dangerous place in all the world when the past seems so much better than the future, and life itself freezes?"

"Not this past though. Not Glawnaq's."

"No, and now I know there's something more important than both. The present. And of course young Teela was fighting for something else too, fighting for her own freedom."

Sepharga smiled. "Fought no one, though Uteq? Except all the demons that came to assault great Goom himself. By the twin's account it took more strength to reveal yourself today, for the sake of one little cub, than to battle all the Bergo in the world, or to have the strongest grip."

"We'll need more strength for what is to come, Sepharga. And more courage too. A Faith."

"Dear Matta," said Sepharga. "She's looks so well. Go to her, Uteq. Now."

"No," said Uteq softly, feeling a strange pain deep inside, but a happiness too.

"But your cubhood promise..."

"We must not just be true to some Fellagorn promise beyond what is real, Sepharga, for that's a prison too, and life must be free. I talked with Matta when I rescued her from Glawnaq, although I knew already how we've both grown and changed. I love Matta as a friend, but she loves Janqar."

"Oh, Uteq, I'm—"

"Sorry? Don't be. I knew in my heart Matta wasn't for me, yet she's inside me too. My friend. There's only one Bergeera that I truly love," said Uteq, looking into Sepharga's tender, dark eyes. "Closest to the Bergeera inside myself, perhaps. Who I saw in my Ice Madness, and why I thought I recognized you, when I first saw you on the Wander. My little goddess."

"Recognised me? Stop. You're teasing me," said Sepharga, with a wounded growl.

"But we cannot love gods and goddesses, Sepharga, or Pureem either, though they guide. For we must live as Pheline too. Strange, that one should travel the ice world in search of something you think you want, only to find that very thing under your paws. Did we not see the world when we touched, Sepharga, and hurt each other pulling apart?"

"Just as quick, harsh Teela tore away from Pollooq?"

"Isn't that the meaning of the Great Gift? I know nothing can love either, unless they truly love their real Self. But we must be careful of each other. Animals are fragile. But you said you loved me once, Sepharga, before I missed your paw. Do I dare hope you feel it somewhere still?"

Sepharga turned her head and raised her huge eyes, rich and deep and open.

"With all my heart, Uteq. I was wounded and lost without you too. I called to you."

"Then I know the most beautiful feeling in all the world."

"Oh, Uteq, do you really..."

"Of course I love you, Sepharga. A cub needs and seeks love like its mother's milk to grow and know itself, but isn't it an adult's joy to give love instead?"

The fleeing mothers and their cubs thought for a moment they were being attacked, as they heard Uteq's mighty cry, but the Bergeera, long split from their Bergo, soon recognised a sound they had all known themselves, and it brought a thrill to their hearts and filled them with joy and courage.

"You know, dearest Uteq," said Sepharga, as the bears came back down to earth, "all along I felt as if something has been marching at our backs. Like a great spirit. Can it be true?"

Uteq smiled at Sepharga, but they were looking down again as they had on the ice. In both their paw marks they saw that light and Human Gurgai Sorgan had seen voyaging, and now his beautiful wife was taking his hand and leading him into a chamber, where they saw a magnificent tree.

"They're home," said Qilaq, coming up beside them. "Their Odyssey's done, though ours has just begun. This story unfolds indeed, lovebirds."

"Dear Qilaq," said Sepharga, but she dropped her eyes. "I've thought of you too. Often."

"Don't say it, Sepharga. No need. Uteq always loved you, Sepharga and now Matta has found her Fellagorn. But don't worry, I'll find my One, all right. Maybe a Pheline."

At that they heard a cry that chilled the cubs to their very souls. "*Aoooooooow.*"

To the right of Uteq, the snow was moving, and from the ground they heard a snarling voice.

"We can play tricks too, Ice Whisperer, just as you tricked my eyes on the Ever Frozen Sea. And Varg do not feel the cold, as we lie waiting with our trap."

A huge grey-white shape burst from the snow, at the top of the ridge.

"Treeg," growled Uteq, and on either side of the Bellarg snow wolves were appearing everywhere, bursting out of their hiding places. Glawnaq's mercenaries were snarling, hungry for the Festlar meat they had been denied by the Glawneye, and the air was filled with a ghastly anguish.

"If some of you escape," howled Treeg, "we've summoned help to the edges of the Haunted Island, where the Serberan shall drive you into the sea. But now we'll worry you, bears, until your cubs curl up in terror, and the Dark Father falls on you all."

A growling Varg leaped from the ridge on the left at a Bellarg mother, who swung with a paw and dashed him sideways. Suddenly, ten or fifteen packs, sixty wolves in all, were advancing down the sides of the pressure ridges, as the Bellarg began to roar and growl. It certainly checked the wolves, and yet Uteq was desperate.

"Sepharga, we must get away, or..."

The she-bears were going nowhere though, not with their little cubs to defend and Qilaq cried out defiantly. "All my life I've lived in fear of your filthy cries, Varg, but now I face you unafraid."

It was as if Qilaq had thrown off a great shadow, and his eyes flashed proudly at Sepharga as he rushed into the fray, but suddenly they were amazed to see little brown balls flying off the edge of the pressure ridges, hundreds of them, bouncing down the slopes and hitting the legs of the wolves.

"The Lemmings," cried a Barg cub, as they knocked some over. "The lemmings are coming."

"Mind their teeth, *piff, piff*", squeaked one of the unfurling balls, "we're not here for suicide."

Uteq grinned in astonishment but to his horror they heard more distant howls on the wind, and straight down the ice ravine, hurtling toward them, came yet more Varg.

"Stand, Sepharga," growled Uteq, feeling it would kill him to lose her now. "Stand."

"Oh Uteq, I love you. If this is the end, it's enough to say that."

Uteq and Sepharga stood side by side, setting their great haunches square against the wolves' attack and Uteq knew he could face

anything now, as the tide crashed over them. He had never felt less alone in all his life. But even as the running wolves hit they didn't break on the bears, but broke right and left, sweeping straight toward the Varg mercenaries, attacking their own.

All around the fleeing Bellarg, as if some god had held them safe inside the eye of a terrible arctic storm, wolves clashed in midair, snarling and fighting, with a sea of lemmings biting and fighting below. Then Uteq and Sepharga saw a single Dragga running towards them, with a little white bundle of fur following hard.

"Be slowing, silly Varg," piped a familiar voice on the wind and as Ruskova and the proud wolf reached them and came to a halt, Uteq cried out in delight.

"Karn."

"Well met, Uteq Blackpaw," said Karn, as Sepharga noticed there was earth on Ruskova's snout. "We've come to pay a blood debt, Bergo. For saving me from the drift."

"Oh, bless you, dear Karn," cried Sepharga. "Bless you."

Karn curled up his snout coyly in front of the big she-bear, but he seemed delighted too.

"And I'd never have done such a thing if this blasted fox hadn't found me wandering to the north," said Karn. "She kept nipping at my tail. She seems to speak a bit of Varg somehow, and kept saying you'd told her some story, Uteq, of saving my life. But Varg do not normally fight Varg, Bellarg. We're loyal, strong creatures, who care for our own kind."

"Yes, Karn," said Uteq. "Nature does not behave like this normally. All fight to survive and change, but things are made in their environment, not alone. Only Man changes that Lore. And Glawnaq. Yet some Man think life nothing but a fight, when it is anything but."

"And I'll not have the name of proud, free wolves smeared with the shame of filthy mercenaries," said Karn. "Besides, Mitherakk sends a message. Another secret about the One."

"Tell me, Karn."

The Varg looked doubtful. "He said until this is done, Uteq, only you will understand."

"Then give it to my ears alone," growled the bear and Karn came forward and whispered in Uteq's ear. A strange understanding seemed to light in Uteq's eyes and he smiled.

"We're in your debt then, Karn."

"Enough of debts," said Karn. "When this strange legend's done, we'll respect each other, and hunt each other too, perhaps, but not at this cost. But there's something else, about Mitherakk."

"Something else?"

"A rumour about little Mithril's sight, that it's healed."

"Healed?" whispered Uteq as Sepharga remembered the adorable little she calf, peering back at her from the circle of musk oxen. Then it was all true, and in that discovery Uteq realised something else. That the very mind and perception of Man contained an astonishing power, and was evolving too, and if that was so then there was always hope for the world.

"But they say it annoys her sometimes, just being ordinary," said Karn. "But go, Bellarg. We'll hold them back long enough for you to get to the sea, and longer too, if we can."

"Thank you, dear Karn, thank you."

"Uteq. Did you find them though? The magic flowers growing in the north?"

"Yes, Karn," answered Uteq with a smile. "But not up there. They flower by the shores of the strongest, most powerful Garn of all, but it grows in real ground too, always. As do we all, Karn."

The wolf looked confused, but Uteq was distracted by something in the distance. At first, he thought it was another wolf, but then he saw that although very similar, it was really a dog – a husky.

"Egigingwah," Uteq gasped delightedly.

"I heard, bear," panted the dog as he reached them, looking scornfully at Karn, "Mustn't be too domestic, eh."

Uteq beamed but he didn't answer, and Sepharga was already calling to the mothers to get moving again, fast, as Uteq turned to Ruskova. "We thought you'd abandoned us, little fox."

"Faithless Bergo," smiled Ruskova. "Abandon mystic heart, or good Mother Courage?" she added, recognizing Sepharga. "Not so

lost now then. In travelinks to find lady goose, Ruskova was hearink of Karn, and when talkink of ridges, was makink own plan. And be lookink too, bears."

Suddenly in the air, they saw a beautiful lady emperor goose swooping toward them.

"Be flyink fast, Feelar," cried Ruskova. "Egg is beink that way. Handsome, brave goose."

"*Squaaaaawk,*" cried the she-bird delightedly, looking down with a beautiful goose beak.

"Oh, lovely Ruskova," growled Uteq. "You may have saved us all, my little poetess."

"Not yet, Bergo. Perhaps we must be hidink in mystic heart still."

Uteq noticed Ruskova surveying the fight and beginning to pad toward it too.

"You can't help, little fox, and I won't lose you now."

"No, Uteq, but can be sayink sorry. Sometimes hardest think of all, it seems."

"Sorry?"

"Qilaq," said the fox guiltily, dashing away. "Not bad Bergo at all. Ruskova was wrong and hurt his dear heart. How to undo what have put in world?"

"Perhaps with a kind of magic," growled Sepharga, "a sacred lore the Fellagorn taught. By taking all Pollooq's pain and feeling in a story and turning it to love, and simply unsaying things, Ruskova. Perhaps that makes miracles and heals, and then we can change time itself."

Uteq thought of what he had seen of eons of time, that somehow light and matter were related to time, and thought of the ball of the world. Then he thought of little Mithril and, in his mind, saw a beautiful water droplet, glittering with sunlight and splashing on a little ox face, on an eyelid, like a gentle, beautiful blessing, that contained all the magic of the world, as an eye opened, bright with wonderful tears. Ruskova beamed and hurried on.

"Can you smell it though, children?" cried Sepharga behind her. "The first breath of the sea ice?"

Uteq had scented it too and forward they raced, as Egigingwah

and the wolves dropped behind, and it was close to dawn, as they came out of the pressure ridges and saw the sea ice. The cubs were desperately excited, and the mothers kept growling, for the blue-green Beqorn seemed brighter than ever in the twilight.

Now Sepharga noticed Ruskova had vanished again, but Uteq was staring out across to the distant so-called Haunted Island. It reared up like a small iceberg, twenty times the size of the growler where they had first spotted the Glawneye taking their terrible prize to the orca.

"But look, Uteq," whispered Sepharga. To the east, they could see open water lapping at the ice edges and among its watery shoulders, great black shapes were rising, shrugging off the waves.

"Drang," growled Uteq bitterly. "Drang and his seawolves. Orca."

"And the ice seems so thin to me," said Sepharga, looking across the sheets that ran to the Island, scanning it with her careful eyes. Uteq turned to the Barg though and addressed the cubs first.

"Children. We're going for a little walk now. But I need your help, cubs."

They looked desperately pleased, especially Pooq, who had come up with Matta.

"I need to listen to the ice," said Uteq. "So I want you to make it sing for me, Tappers."

Pooq and twenty ragged little expert Tappers started banging, as Uteq placed his paw down.

"It's grumbling and groaning, all right," he said, "but I can't hear that many cracks. It's strongest in the centre. I can hear the orca talking and planning, but I think it will hold. The orca may have teeth like sharks, but they haven't the strength of true whales to break it open. Beyond the island will be the real sea ice too. The Ever Frozen Sea."

"I can see the sea already, Uteq," said Olooq, who was at the front of the group with his sister and Nuuq, and the Tappers stopped. "Over there, Uteq. There are funny shapes in it."

The bear cubs were marvelling at the great bergs floating in the distance to the east, but some of them had seen the orca, too, and started chattering nervously.

"You can see that sea, Olooq," said Sepharga softly, throwing her lovely shadow protectively over the little bear. "But we're going to walk to a different sea now, where those strange lights are."

Olooq nodded uncertainly.

"And I want you all to be as sensible as you possibly can. Mothers, keep your cubs with you, but a distance between each too, to spread the weight."

Olooqa spoke up now though.

"Uteq, is it really called the Haunted Island because dead wolverines live there, killed by a Gurgai plague, who return to wreak vengeance on the living Lera?"

"That's only a dark story," said Uteq, looking at Nuuq. "Not the Great Story, Olooqa. While Ruskova, Egg and I came here across that island, and saw nothing but lovely fresh snow."

The growing cubs seemed reassured, especially the ragged little Tappers, who felt little bigger than wolverines themselves, in their hearts at least.

"And Bergeera," said Uteq gravely, his eyes trying to communicate the importance of what he was saying, "keep your young ones far away from the water. Understand me?"

"They've come for us, haven't they, Uteq?" said Nuuq. "The seawolves."

"Yes, Nuuq, I can't lie to you now."

Uteq lead them out onto the sea ice first, as Sepharga and Matta hung back with strange Pooq, to guide them all to where the ice seemed thickest. So the Bergeera started to cross, Innoo and Farsarla and Antiqa too, eighty mothers and their hurrying little cubs, as Uteq put himself between the orca-infested sea and his kin. He kept touching the frozen water with his paw, testing its strength. It must have been a good half mile to the Island, but soon all the females and cubs were on the ice, walking in a steady line towards it.

"Look, Mother," cried one, as Sepharga joined Uteq again. The bear cub was staring in horror at the sea now, for in the water the orcas were rising, showing their white underbellies and glistening teeth.

"It's all right, little one," cried Farsarla nearby. "They can't get to us up here."

With that three orcas dipped below the sea again, and the bears held their breath. There was a ghastly pounding below though, as the killer whales began striking at the ice, trying to break through.

"Mother," trembled another cub. "I'm frightened."

The Bergeera were no less frightened, for bears could not fight the orca in the sea, in their own element, and feared nothing more than death by water.

"What can we do, Uteq?" cried Sepharga. "If they split the ice and it breaks, we're finished."

"Scare them off, Tappers!" ordered Uteq.

So the cubs tapped and thumped on the ice, but the terrible pounding beneath wouldn't stop.

"Try to keep them moving, Sepharga," cried Uteq.

"Uteq," said Matta, coming up with Pooq, "will it never end?"

Just as she said it Pooq cried out.

"Look, Matta. What's that?"

In the sea, a grey shape had risen, well beyond the black orca – and then dozens of them began appearing at its side in the great waters, like floating rocks hurled into the waves by Pollooq.

"Seal," growled Matta. "I think they're seal, Pooq. But whatever do they want?"

In the sea, some of orca had noticed them too and began to turn hungrily, for instinct is strong, and hunger stronger. The pounding stopped, and the three seawolves re-emerged beyond the ice as Uteq saw more and more seal rise in the waters, and to his astonishment realised they were actually waiting, as the school of killer whales turned on them.

"The seal, Uteq," cried Sepharga. "They're drawing the seawolves away."

"The Ice Whisperer," cried a Bergeera. "The Saviour commands the very sea. We're saved."

"I don't command anyone," muttered Uteq, "but I bet I know who does."

Right in the middle of the waiting seal, a white figure rose, slapping a flipper on the water.

"Flep," cried Sepharga. "Flep's come too. You think..." Sepharga paused though.

"What my love?"

"What Mitherakk said about the helpers, Uteq. I mean Karn spoke of Wind Talking and do you think Flep could really be the great Sea Summoner?"

"I...I don't know," said Uteq doubtfully. "Let's hope so."

The seawolves were almost on the poor seals now, powering through the waves, but suddenly Flep was rising and falling through the freezing ocean, and turned and led his seal away. The orca came on fast in their wake, but as their opening jaws nearly reached them, the seals began to spin and turn, and break left and right, led by Flep, moving faster toward the great floating bergs, as the hungry orca pursued them instead of the fleeing bears. Uteq shook his head.

"Oh bless you, Flep. Bless you." Uteq knew they had to hurry, though. "Get them moving again, Sepharga. There's no time to lose. This ice won't hold much longer."

Just then, Uteq caught sight of Illooq and his Fellagorn rushing out of the pressure ridges to the shore themselves, and from the wounds on many of them, it was clear that they had been fighting hard. Rornaq was there with Seegloo, Tortog, and Sarq. Then came Forloq, Brorq, Qilaq, Keegarq and Darq. Matta's heart stirred to see Illooq and her brother were both safe.

"I think it'll hold, Sepharga," cried Uteq, "but don't let them stray. I must—"

"Yes, Uteq. Go to them, Bergo."

Uteq raced back across the ice, and Illooq was looking back nervously towards the ridges as he reached him.

"Sqalloog and the Serberan," the Great Master panted wearily, "close behind the Varg, and armed with ice daggers. We fought them off, and Karn and his wolves are holding them back still with that brave husky, but they're bound to get through soon. A huge group of Serberan were coming up behind."

"And Glawnaq?"

"It's strange, but there's been no sight of the Dark Father at all."

"I wish we'd had time to lay some trap, but we'll have to make a stand here, Illooq," said Uteq gravely now. "If the females can get to the Island safely with the cubs, they may have a chance at least. But the weight of so many Bergo will surely collapse the ice. We can't follow them now."

"Then the Serberan must never reach the ice," growled the Great Master resolutely. "And here we must turn the snow blood red. Warriors again, but speaking a brave Pheline tongue this day."

His words were a harbinger to the event, for through the pressure ridges came the Serberan now, led by Sqalloog, with a few of Karn's Varg worrying them and risking their lives snapping at their heels, as Egigagwah barked some rather lofty orders.

"If there were time, I'd embrace you all, Fellagorn Scouts," cried Uteq, "but come, my friends, we'll die together, if necessary – for the Bergeera and the children, and for the future."

"No, Ice Whisperer," said the Great Master. "They need you. You must lead them north still."

"In a while, Illooq. I am Uteq, and I'll fight with you now. We'll make your names a legend."

"And I," growled Qilaq, stepping up and showing his fine collar of fur.

"And I," cried the other Bergo, including Seegloo, who was looking back across the ice longingly at Nuuq. "For the Fellagorn, and the honour of the Scouts."

"Hold then, Fellagorn," said Illooq, staring back toward the Serberan. "It's the Garn Path to make peace and tell the ancient stories, and shall be again when this is done, but now the times need the warriors in you, and we carry our shadows into battle. Wild and true."

With that they raced into the fray, and soon Bellarg were rearing up, slashing at each other, swinging and cuffing with their paws and roaring terribly, and a hundred pairs of full-grown polar bears were at war – the Serberan against the Warrior Storytellers. Many began to

fall in that ghastly fight, and red lights, the colour of the warrior, were soon shooting north, as their hot blood melted the snow and ice, seeping into the earth beneath, to feed the frozen tundra and give life perhaps to healing blue flowers. At least the Garn in their blood would bring new life one sun, and help to nurture the earth, yet it was not an easy fight, for the Fellagorn had been as starved as the Barg, and although their courage was strong, their bodies were weak.

As they fought on, Uteq noticed Ruskova and twenty artic foxes appearing from nowhere. They were snapping at the Serberan too, and seemed to be drawing them towards them. Several followed, and as they did so suddenly they disappeared into the ground with a great roaring, just like Karn in the snow drift, and the Fellagorn fell on them furiously. Ruskova and her friends had burrowed into a series of old warrens, laying their clever trap and it made Uteq's heart thunder.

Something even more extraordinary happened though. As the Fellagorn fought on Illooq could not reach one of his brothers in time to beat off a blow, but the Great Master suddenly sank in the snow, his mind so concentrated that he looked like a statue, then, from his belly, he punched out a single word: "BACK."

To Uteq's astonishment the attacker was blown off his paws.

"DOWN," growled another Fellagorn, seeing the strike and his opponent crashed to his forepaws. "NEVER," hissed a third as a Serberan swung at his face and the Ice Slayer's paw seemed to lock in midair. Five Warriors Storytellers Tellers turned to face ten Slayers and as one they growled out a word that swept four in the middle back in the snow, and sent the others tumbling over them – "BERGO!"

"The Word Power," cried Uteq. "The Fellagorn Word power has become physical."

The battle was with claws too though and as the bears fought still, Qilaq found himself battling beside Seegloo, who had already distinguished himself by killing two large Serberan.

"I was wrong, Seegloo," said Qilaq, as he roared to keep back two Bergo, "I thought you were just a coward."

"Perhaps I was, Qilaq," growled Seegloo, "for this fighting is nothing."

"Nothing?" growled Qilaq, slashing at a Serberan, as he saw poor Brorq fall and noticed Tortog and Sarq battling furiously nearby, as if defending the Great Sound itself.

"Or not how I would live, at least. This isn't real strength, Qilaq. That isn't anger or rage, but strength to hold a Bergeera calmly, and love her, and sire cubs, is it not – in peace and happiness? And that was the most terrifying thing, when I touched Nuuq and she seemed to me like a goddess."

"Why, Seegloo?" said Qilaq softly, surprised a Bergo would admit such a thing.

"Because that true stand holds all the fear and the care of the future too, and the world perhaps, and of anything that can come. But now that I know how to give, I'll be frightened of nothing. Except a life without a future, without love. Alone and angry, or haunted by the Bear Rage."

Qilaq nodded gravely. He had often had to control it, especially when he was most frightened.

"Yet I know something else, Qilaq. I was really frightened of Bergeera, because I was so ashamed of Bergo, sometimes, and the dark, harsh world. But I am proud once more, of Bergo, of you and of myself, and free."

Seegloo roared and hurled himself at a Serberan, and they struck, as Qilaq turned to fight again. Nearby, Forloq had fallen, but Rornaq was excelling, slashing right and left with his paws, soaked in blood, as if he had never missed fighting on the Field of the Fellagorn.

Uteq and Illooq were battling side by side too, guarding each other's backs, although a Serberan had taken a gouge from Uteq's arm, and it was bleeding badly. As they fought and many polar bears died, more spirit shapes broke from their mouths, spinning in the air and rushing north. They could all see them but Illooq swung his head in amazement. "Look, Uteq."

Back on the sea ice, some of the Serberan had broken through, but a group of Bergeera had turned to face them and protect the line, chuffing, and swinging their paws out, as the huge Serberan tried to advance. At their head were five Bergeera – Farsarla, Nuuq, Antiqa,

and Sepharga, Matta in the middle, rising up and roaring and chuffing furiously. She looked like Athela indeed.

It was a noble sight, and yet the males saw that the column of mothers and cubs behind had frozen. It was led by one Bergeera who had been quite lost in the melee, and seemed to have woken from a nightmare – Innoo. They were all looking back at the terrible battle, wondering about their Bergo, and Innoo had sat down and started to paw nervously at her collar.

"Go, Uteq, you must get them across," cried Illooq. "Walk them to the future."

Uteq was wrestling with something inside himself, but someone had to take them across and protect the five Bergeera, not least because Sepharga was in danger.

"I'll see you on the other side then," he said firmly, and turned and began to run to help the mothers when a hateful voice cried out.

"It's you, scum, that stopped me being the Cub Clawer. Stand and fight, Blaarq coward."

To Uteq's right, a group of Fellagorn had parted, like a sea, and there stood Sqalloog. How far away the world seemed from that first summer, for his huge body was scarred and torn, and he was glaring at Uteq with loathing.

"Coward, Blackpaw," growled the bully, but with fear in his eyes. "Run then, still."

"No," said Uteq softly, feeling all along it was as if a bad Beeg from Sqalloog had gotten inside him. "I run from nothing, and now I'll teach you the name of fear, and of courage too."

Uteq roared and lumbered toward him, but another voice cried out.

"Go, Uteq. The Marked One must survive, and lead us. Now the Fellagorn have returned."

It was Rornaq who had called and he came thundering toward Sqalloog, with his streaked cheeks, and although Sqalloog reared up, struck him and tore open his face, Rornaq struck back hard, knocking Sqalloog back into the snow. Rornaq lunged and bit down at his throat and as Uteq heard the cry and knew Sqalloog was dead, he

charged back toward the five Bergeera, with Darq and a group of Fellagorn behind him.

"Run," cried Uteq, as the Fellagorn engaged, "The others are frozen with fear."

"Uteq," growled Sepharga. "You're wounded."

Matta was staring in horror at the battle though, and as Uteq turned, he wasn't sure if it was Illooq or her brother she was more concerned for, until she saw Qilaq rise up with a wounded roar, then crash down in the snow himself. Illooq, Keegarq and Qilaq's little group of Glawneye all circled to protect Matta's brother, as Sarq, Tortog and Seegloo fought towards them too to try and help.

"No, Qilaq," cried Matta on the ice. "Dearest brother…"

"And Seegloo," gasped Nuuq beside her, as Olooq and Olooqa looked up at her.

"I must go to him, Uteq," gasped Matta, "and Illooq."

"Then I'm coming," cried Nuuq. "Seegloo's suffered so much. Stay here twins."

"No," said Uteq sadly, "you can't help them now. But you can help the cubs. All of them."

It was an impossible distance for the Bergeera to cross in time, and they knew in their hearts they couldn't be of much help either, so reluctantly they turned away, back toward the ice and the Haunted Island, as Uteq and Sepharga raced up to Innoo, at the head of the stationary column.

"The island, Bergeera," cried Uteq, "we must all get off the ice. Now."

Back in the fray on land, Tortog roared bitterly, for Sarq had fallen too, but Illooq Longsleeves was looking down at poor Qilaq, bleeding in the snow, as the others held the ring, their paws lashing back the threat.

"Qilaq," Illooq whispered. "I'm sorry, Qilaq. We didn't watch your back."

"Don't, Illooq," grunted Qilaq, in terrible pain. "It's too late now and we all fought well. But Illooq, will you tell me something – truly?"

"Anything, my friend."

"All you told Matta and me, about the Seeing Caves," whispered Qilaq faintly. "It wasn't really true, was it? You mesmerised us with your voice, a story, and it was as if we were really there. That's all, Illooq?"

Illooq frowned over Qilaq's bleeding fur collar.

"Why do you think—"

"Because I feel it," groaned Qilaq, trying to raise his head. "My instinct. And because I wish to die knowing only the Truth, not lies or myths. The truth of bears, and of life."

"Lies, Qilaq? I—"

"Please, Great Master. Only the truth, I beg of you."

"Believe, Qilaq, just believe," said the Great Master softly. "But remember the two worlds, and the two languages."

"Like Pollooq believed, in the end?" said Qilaq sadly. "I didn't prove a fighter like him."

"Ah Qilaq. They say the humans have a greater story than even Pollooq," whispered the Great Master. "One that truly makes miracles, and heals. A story that simply opens to the sunlight, like a great flower, and grows, like a swelling water drop, or the ball of the earth. Of one bound and reviled, just like Pollooq, but who healed not with rage, but love alone, and spread his light."

"Believe?" whispered Qilaq faintly again, staring at the swirling skies.

"But Pollooq's is a story for the living animals, and now you go north, Qilaq, my friend, like the wind. A Warrior Storyteller indeed. A legend."

"Will I make it though? I didn't even win my lifename."

"You're there already, Qilaq Trueheart," said the Great Master, with tears in his eyes, "for you above all never wavered, but kept a promise deep in your soul. So you've won more than a lifename, Qilaq, you've seen your true Self, and known the beautiful shape of your own soul."

They heard Illooq's Mourning Call, and Matta knew her brother was gone. She felt a deep pain and love for him and Illooq too, as a

glittering shape, yellow and red, black and white, rushed past Uteq's head toward her, then swept away.

"Oh, Uteq," cried Sepharga. "Dearest Qilaq. He's gone"

"Yes," growled Uteq, "life is never perfect in a Pheline world. Not like in stories."

"Then the pact of four is broken."

"No Sepharga, for now we have Janqar with us."

Innoo and the mothers had been somehow unseized by Uteq's return, too focused on getting safely to the island, to stop and mourn, but as Uteq and Sepharga turned, they heard a terrible crack.

"The ice," gasped Sepharga. "It's going, Uteq. We'll all drown."

"Keep moving then," bellowed Uteq, seeing a fissure running across the ice toward the sea, straight through the column's middle. The bears heard another crack ahead, and Sepharga growled.

"A break," she cried. "A water flow. Look out, Uteq."

Uteq stepped back. It wasn't wide, but it had opened up from the sea to the east, right across their path ahead, running due west, cutting the bears off from the Haunted Island. It was no more than two hundred yards away, and they watched helplessly as the water grew wider and wider.

"Can we jump it, Uteq?"

"We might, but the smallest cubs? Never. We can't let the Tappers down. Is this the end?"

"End?" said a voice and a whiskered white head appeared in the water right in front of them, slapping it scornfully with a flipper. "Do you give up so easily, bears? My great, great, great..."

"Flappy," cried Uteq. "Flep."

"Did Flep lead the orca away with the Selaq he's brought to freedom, just to hear this?"

"Flep, you risked yourself and the seal for us."

"Not just for you, silly bear. For everything. But I don't think it such a risk. I've taught them plenty of clever tricks, since I got them away from our Sound. Only half of them would follow anything so strange as a white seal, but their Garn's strong – especially in these waters."

"Why *these* waters, Flep?" asked Sepharga.

"So many yummy plankton and delicious fish here," answered Flep happily, slapping the water approvingly again. "I think Gurgai have been stocking the sea with Lerop."

The polar bears looked at him in astonishment.

"You see," cried Flep, "there's plenty of hope. Don't be so defeatist."

"No, Uteq. Look"

A mask of horror covered Sepharga's face as she said it, and Uteq turned back to look at the Haunted Island. Through the white mist, figures were emerging like ghosts, not ghostly little black wolverine shapes, but huge white Serberan shapes. Glawneye. The Slayers came prowling across the snow, a hundred of them, like a pride of savage lions, their mouths stained blood red and at their head was Glawnaq One-eye. The Dark Father had come.

"Whoops," said Flep, ducking below the sea again. "Didn't see that one coming."

"Glawnaq," cried Uteq, facing his enemy for the first time since he had murdered Toleg.

"So you're trapped on your sainted ice, Ice Whisperer," cried Glawnaq scornfully, as he reached the edges of the shore. "It's finished."

"How, Glawnaq? You come like magic spirits. Are you Fellagorn too?"

"There is no magic, fool. No spirits. Just reason and necessity. Just as my Glawneye came glissading around the pressure ridges, this isle has never been haunted – except by us, this long twilit morning. The snowfall covered our paw marks and we've been on the other side, making ghosts of wolverines, to build our Garn, although we miss the taste of white bears. Show him, Glawneye."

The terrible Glawneye strained forward and roared, then reared to show their paws and markings. Those inverted crosses.

"The Cult of Death," they snarled. "Hail to the Dark Father."

The mothers and cubs froze again in horror beyond the water flow

and the Fellagorn and the Serberan, weary with battle, stopped fighting as they heard it, and turned to listen and watch.

"No, Glawnaq" hissed Uteq, "The true glory is life, and you serve only darkness."

"See what the 'Saviour' has done for you though, foolish Barg," cried Glawnaq, his voice bouncing across the cracking ice. "Led you with his black paw out here, like bleating Blaarq to be killed. Unless you surrender, slaves, and agree to come back with me, and then only some of you shall be punished. Glawnaq swears it. Even now, we need workers still."

The Barg were all looking at each other in terror.

"No," cried Farsarla, "we'll never betray the Ice Whisperer again."

"Ice Whisperer," snorted Glawnaq, stepping off the shore onto the ice on the other side of the lead. "Have you learnt nothing? Look at you, dying on the ice. And how can *he* stop it? He can't. A Saviour come to save the whole ice world, like Pollooq with his ice ark, that's what your Story says."

Glawnaq's hard eye glittered. "Very well, Blackpaw. I'll make you a bargain. Use your magic powers now, touch the ice with your paw and heal it, as if it were alive, and then I'll let you all go without a fight. The Barg shall be free. Slaves no longer."

As Glawnaq spoke, there was a crack to the right, and a Bergeera and her two cubs who had strayed wide of the column crashed through the ice into the sea, scrabbling desperately in the water. It was Matta who, conquering her fear of the water, dived to help them back and Pooq too.

"Do it, Blackpaw," snarled Glawnaq, "Fulfil your promise. To creation. Like false Pollooq."

A whispering had gone back through the white bears, as they relayed Glawnaq's challenge – just as impossible as the challenge given to Pollooq by the Pheline. Now a great hush descended, and all the Bellarg were watching Uteq, who felt as tiny as a cub, helpless and still trying to believe.

"What do we do, Uteq?" whispered Sepharga, as if in a dream, as Uteq lifted his black paw.

"I don't know. But they mustn't lose faith, nor see me fail, Sepharga. Not now. Maybe the ice gap will close normally, and they'll think I . . ."

Uteq was bitterly torn. He wanted to believe the legend, and had to try to think of a reasoned way out of their terrible plight, but there seemed no way, even with his mastery of the two languages.

"Well, fraud," snarled Glawnaq, "show us Atar's blessed powers, and the truth of some ancient legend, or why any of us should believe in anything but power and strength and ruthlessness. In Nature's and Man's terrible struggle. So what are you going to do, Ice Whisperer, freeze us in our paw marks, like the blessed Fellagorn on the Field of the Dead?"

Uteq glared at Glawnaq, but he could think of nothing. He reached out his black paw nonetheless, praying to some nameless power, giving himself a blessing, then paused in fear.

"The ice," snarled the Dark Father. "Touch it, Ice Whisperer. Talk to it and heal it, fool."

Glawnaq started to laugh as Uteq opened his mouth.

"I..."

On the air though, they heard a sound, full of longing and complexity, the song of free wolves. Karn was Wind Talking with Egigingwah, and Sepharga looked up, for it seemed to give Uteq strength and hope.

"Fool and liar," snarled Glawnaq. "There are no miracles. No sacred Ice Lore."

"But don't you see yet," said Uteq, "everything that lives is a miracle. Though Pheline words blind the Fellagorn, and Fellagorn words blind the Pheline, life itself is sacred."

Very gently, Uteq reached down to touch the ice, and three hundred Bellarg eyes locked on him and his black paw, Fellagorn and Serberan, Bergeera and cub, as the Ice Lords held their breath. Sepharga noticed Ruskova padding up and saw that the fox's mouth was full of dirt, as Karn's cries came once again, wild and free and full of longing.

"The Wind Talker and Earth Eater," she gasped. "It's Karn and Ruskova. I know it is, Uteq."

Uteq thought of Flep but doubted the funny seal could be the Sea Summoner, as he laid his black paw down on the ice now. So gripped were the watchers, that just for a moment they thought something was happening. There was a sudden, expectant stillness in the arctic air, but Glawnaq reared on his haunches and opened his arms triumphantly.

"See, fools," the tyrant bellowed, as the gap actually seemed to widen. "Your Whisperer lies, of course, and so shall die this very sun. As shall you all, culled by your Dark Father. There is no magic. No gods. No heroes. No hope for the worthless Barg. The story has no happy—"

Flash.

Sepharga saw it first, beginning at the arctic horizon, like a glow of white light, below the Beqorn in the twilight, then suddenly bursting up through the Beqorn themselves.

"The White Army," whispered a voice in awe. "Have they come to fight ten thousand demons?"

Another bear was sure he saw a white ermine in the sky, as big as a Bellarg, it's eyes flashing with fearless fire, and Uteq felt that slurry of black blood and dreams sucked back into the heavens. The lights of the north, the great aurora borealis, were flashing and glowing and sparkling more furiously than ever. It looked as if a thousand light-ning bolts were moving slowly between heaven and earth, and a great moan went up among the frightened polar bears, as they felt their coats themselves tingling furiously. The very air seemed alive now.

"The Fire Bringer too," cried Sepharga. "In the heavens, Uteq."

Suddenly Flep jumped in the seas, but if they thought he was the Sea Summoner, in the next moment something even more extraordinary happened. Beside Flep they saw a narwhal raise, its proud living tusk pushing into the air, then a gigantic shape came breaching out of the arctic ocean, a huge humpback whale, spinning in the air and crashing back again, sending up a funnel of water.

"Life comes again," roared Uteq, "and the day is here indeed."

"What's happening?" wailed a Bergo, fearing his shadow. "Atar herself. The Last Judgement."

Glawnaq was peering at Uteq in amazement, and terror too. Uteq's black paw pressed more firmly down onto the ice, and suddenly, and shooting right down into the water, the polar bears all gasped in awe, as a great sheet of ice ran straight along it and sealed the sea completely.

"The Ice Whisperer," cried Innoo, waking to the world again as if she just had been bitten. The polar bears could all feel it beneath them, the ice hardening, shoring up, growing strong and thick again, and spreading out into the sea to the east as well. They all felt colder, too, a delicious iciness coming through the bears' paws, and they could see that more ice was forming – a foot, ten, twenty feet of ice, reaching into the sea and back into the water. Even Sepharga was looking at Uteq in awe and fear, as above them Teela blinked in the heavens, beside Athela and Pollooq.

"Uteq. What did you—"

"Nothing, Sepharga, I swear it."

"But Uteq, the ice..."

"The Gurgai," said Uteq, the confusion in his eyes clearing. "What they were doing up there in the North, under the lights, Sepharga. And over there. Look."

Sepharga looked in the direction Uteq was pointing his snout, and farther along the shore, buried deep in the ground, the she-bear saw a line of black metal poles sunk deep into the ice.

"The black sticks. But it's still impossible. The power to change the weather itself?"

"No. The Two Languages. What did I see about the universe and their arts of Scientia?"

"See, Uteq?"

"The Sight. That in the days when they first fought to get to the Pole, the humans might have thought what they do now impossible. And what of thousands of years before that, when they still believed in magicians? Perhaps Scientia itself is a bit like belief, Sepharga, or magic. Perhaps nothing is impossible, within the Ice Lore of the

universe, if their power is turned to good, and to life. For the universe holds a mighty power and a mighty secret, when the Great Gift returns."

"Yes, Uteq."

"And Man, I think they can do anything, if they believe in the miracle and unlock their power. Just believe and let go. But now what matters, is that to the Bellarg, I am the Ice Whisperer indeed, and the Great Story is fulfilled. The ancient curse is lifted forever."

Uteq roared triumphantly and across the hardening ice charged straight at the Dark Father, but to Glawnaq's surprise, the Bergo stopped, and sat down on his haunches, breathing deeply and calmly and simply waiting. Uteq looked like Goom, so peaceful was his face, as Glawnaq reared up, and opened his arms furiously.

"What's this? A challenge to an Ice Duel, like stupid Toleg Breakback?"

"Of course," whispered Uteq. "You said you would chase me to Hell and back, and have truly made a hell on earth. You, whose reason denied life itself, and love, Pheline. Who saw only with the madness of the Gurgai, not their beauty and real language."

"Very well, Blackpaw, and just as I slew your father, I'll kill you, arrogant cub."

Glawnaq crashed down again and began to advance, but still Uteq did nothing, and the One-eye was amazed to see Uteq's eyes were closed, as if he had fallen fast asleep, like Mitherakk and the musk oxen. Glawnaq prowled toward him, seeing how large he had grown, at almost five, and began to circle Uteq dangerously, sniffing at him.

"Fight me, Uteq, or has the hot blood frozen in you, and turned your heart to seal blubber?"

Uteq was silent still, his calm breaths steaming in the air.

"Hate and fight me," snarled Glawnaq, "the bear that murdered your father, and caused your mother's death. A bear that will take Matta and Sepharga and Nuuq too, and destroy the Blessed."

They were all watching Uteq, wondering if his courage had failed him.

"You're weak and evil, Blackpaw, and even if you can somehow

summon Atar's power, it makes you nothing but Kassima...What are you doing, Blaarq?"

"Still Hunting," whispered Uteq, opening his eyes, as he roared and rose again. "And I will not miss my mark again, I promise."

Uteq, who had been calming his mind like a Great Master, storing his Garn strength deep inside, now exploded into action. He sprang up, swung with his black paw and caught Glawnaq straight in the chest. Glawnaq bellowed and staggered back, but Uteq was too quick, and struck him in the stomach with his head and knocked him over. As Glawnaq clambered to his paws again, Uteq let the Rage flow freely, filling him, yet not turning him mad, for this was a righteous anger.

"For Father," he cried. "And Mother. For Qilaq and Narnooq of the North, and for all my friends and helpers."

Uteq swung again and struck Glawnaq straight in the face and Glawnaq spun, the blood flowing down his snout, as Uteq grabbed him from behind and began to squeeze.

"But above all, Glawnaq One-eye, for life and light and the Great Gift."

The Barg gasped, like a final sigh of returning hope and Glawnaq moaned impotently.

"I—" he gasped. "I'm the Bellarg's one true god."

"God," cried Uteq, "you dare to speak of God, in your hate and fear? Speak the first Fellagorn word, as the Lera struggled out of the dark, into mind and language itself. Perhaps you think you know the mind of the universe, when it always contains doubt and love and growth? The mystery. For truth lies in between, and nothing can speak of God like some ancient Ice Lore. For that is only power, and religion. I have gone to the left, into the dark, but shall swing to the right and fight for the good."

"Truth," hissed Glawnaq, "there is no truth. That's the lore."

"We need laws to respect, but ones that understand the Ice Lore too and the laws of nature also. Yet you would make some ancient lore, like a prophet of vengeance, like some vengeful father, who does not know that the stories changed, or why. Who thinks themselves a

Bergo, a hero, as he worships Man, because they send metal birds to kill, and maim real lives in their evil, to murder brilliant Scientia, and all our faiths, which hold the stories of the world's very waking. To make fear and attack anything that challenges their frightened need to be certain and righteous and powerful. But the truly righteous know, Glawnaq, that although wild nature is hard, real Bergo love peace, with honour and justice, and above all freedom."

"Kill me then, Uteq Blackheart, and join me in Hell, and become like me. Like the Gurgai."

"Liar," snarled Uteq. "You know nothing of them, or of the real Hell. And I am not Gurgai. I am Lera, wild and free."

"Wild? I thought that to you Fellagorn the jaw is mightier than the claw."

"Far mightier, fool, except when we have to fight, and so sometimes must be summoned by those that bite with their teeth!"

Uteq squeezed, then bit down into Glawnaq's neck, as they all heard a snap and saw the Dark Father go limp in Uteq's arms. Uteq let go, as if releasing a bad Beeg in disgust, and spat out the blood, as Glawnaq crashed to the ground, with a single bitter word on his lips: "Anarga."

Glawnaq One-eye was dead.

Behind him the Glawneye were motionless, pressing their marked paws in the snow shamefully, and the Beqorn flickered, now a perfect rainbow of coloured lights. A grey shape rose from Glawnaq's mouth, and seemed to turn north, but with a terrible, defeated moan, it rushed back and plunged into the sea. Drang rose and swallowed it whole, before letting out an agonised belch, and the sea bubbled. Yet even as Drang basked there, a fin shot towards him and the sea went red. It was Sguguq the shark, who had come too.

Uteq turned slowly, and walked wearily back toward his beloved Sepharga.

"Uteq. Dear Uteq. We've won."

"Yes, my love, we've won."

Uteq stepped towards the others.

"Barg," he cried, as he stood proudly by Sepharga's side. "Bellarg

and Fellagorn. Serberan too. The stories return like the lore, and you are free. The shadows gone. You're bears once again."

A great roaring went up, but Sepharga noticed something out of the corner of her eye. In the distance, near a large berg, a metal ship had just appeared on the arctic ocean – an icebreaker and on the side was written *The Divine Comedy*.

"The Gurgai. They're here, Uteq. You think they come to plunder the black blood?"

Uteq shook his head.

"Qilaq said their machine was waiting beyond the Haunted Island, but that they're going away from our ice world. Perhaps they were seeding the sea."

As he spoke, a little cub appeared at Uteq's side, a plucky little Tapper and was staring in fascination at Glawnaq.

"Is the monster dead?" he whispered, as Uteq noticed Glawnaq had fallen on the good side of his face, and with his dying breath, something seemed restored, although his eye was closed forever on the beautiful, painful world. Uteq sighed.

"Perhaps by believing in monsters, we throw out our own fearful shadows and blind ourselves to how and why things really happen."

Uteq smiled too. "But yes, little paws. The monster's dead."

"And what do you fear King Uteq? Nothing I bet."

"Oh, several things, little bear, but most I fear lies, and bears hiding their light. Never do that, or do nothing, as others are suffering, for nothing can live in isolation of its fellow creatures, unless all they ever want of life is war, not peace at all. One world is the only true fortress."

"And have you truly saved the whole world forever then, Ice Whisperer?"

"Hush, Terto," said his mother. "Don't trouble such a great Bergo with childish questions."

"No," said Uteq, "Let him ask, and I'll try to tell the truth. We must believe in ourselves and life, cub. In the whole, extraordinary world. And something has happened, and there must always be hope, and

Bergo don't back down, nor do Bergeera. Unless they're wrong, like Glawnaq."

Uteq smiled at Sepharga.

"I want to be Pollooq," said another cub, "and save the world. Immortal."

Uteq swung his head and growled softly.

"No, stay in the Paw Trails, cub. Yet don't just Paw Trail your mother, or father, but watch both. And if they walk well together, knowing themselves and each other, walk proudly in the path between the two, and grow. But one day you will die," added Uteq softly, "although that's not a frightening thing, because you're part of that Garn that's truly immortal. Pollooq was a Pureem in the end. Don't you know the Eighth Commandment though, little cub? It commands us to live and love."

The cub's face shone.

"Anyway, some say Pollooq wasn't God, but the son of God and the story was to help take away the weight, cub. And though you may have a Pollooq nature, you've a Lera nature too, both Fellagorn and Pheline. But remember always, you don't have to be perfect, and you're very special."

The cub looked uncertain.

"But remember this with all you are, little bear, when one day a great Summoning Call comes, you must answer it, with all your courage and all you are. For if you do not, you may fall in between the worlds and that is a terrible place, where no bear wants to be."

The cub gulped and nodded, not really understanding.

"So, don't try to save the whole world alone, little bear. For we must all do that, and nature is strong. Give all you can to joy and life. It is wonderful, little paws, if you do not lose your way. Never, ever let another tell you you're worthless, or steal your light."

"What does your paw mean though, Uteq?"

"I don't quite know, but if there was a symbol that could strike, like brilliant lightning from the heavens, it must be one alone that destroys the real darkness that kills ideals. In you cub."

"Is this the happy ending then?" said Matta, thinking of her brother seeming doubtful.

"The Great Story has no end, Matta, that's the whole point. And there are as many tears in it, as there are in the sea. But many happy endings on the way, and many new beginnings too."

Uteq turned to the other bears again. "And I tell you all this," he cried. "In the endless sweep of time, all is change, and none must be afraid or give up, except afraid of what does harm. Yet there's other hope. I saw things in the North, and know the earth is far stronger than anyone thinks, and has survived far more than this. As will we all. No shadow must haunt you then, for lives are short and beautiful. Stand in the snows and love the sun, proud Bellarg, and roar in freedom too."

The polar bears were nodding delightedly and felt freedom flowing in them again.

"Yet if life turns on itself, with the blindness of split being and is abused, if language is abused, then it will remove the enemy in itself. Just as the darkness hides the real light everywhere."

"And the Gurgai?" growled a Bergo.

"They evolve, and will grow too, if they free what's inside them. But they see at different times and what some do to the ice and trees, will come to hurt them all, unless they stop it. Change. Indeed they change now, and I believe rebel against the forces that destroy the world and make them slaves too. Even their young rebel, for the future."

"Rebel?" said the cub, "against everything dying? Though we die."

"Against dying senselessly, and being destroyed. Perhaps they want to be Guardians again."

The polar bears were growling and nodding.

"So let's send them a message, Bellarg, now, before it's too late. Arm the best with the love and power and pride of the wild white bears. A cry for the ice world, then, and the ice ark too, the planet itself, for everything that lives, and all our futures. From the Five Thousand."

Uteq turned to the sea, and Sepharga with him and Uteq rose and

lifted his paw, and let out a great bellow. Then all the Ice Lords had turned, roaring or chuffing or swaying, as if the very bear world was dancing and as their brave breaths rose, their voices seemed to turn to ice on the air.

"Damnedest thing I ever saw," said a very different voice, a human voice, as he heard them, "More polar bears than I've ever seen together. It's like some great migration."

"And a strange one," said another, on the deck of the moving icebreaker, "that old female we've been tracking for years with the radio collar. She's still alive. I'm glad she's made it."

"Seems as if they're growling at us. Though they're fading in the snows."

"Growling at us? Yeah, right. We're trained to avoid that one, Bill."

"It's not so bad thinking like that," said a lovely female scientist with red hair, who joined them at the rail. "I don't think we can help it. Thinking of nature like us, I mean. And it may not be exactly scientific, but anything that makes us feel closer, but respect it, that's fine by me."

"Maybe they're all trekking north," said the first. "I bet they all got the shock of their lives."

"Shock, Bill?"

"With the ionization, Christina. The flares in the aurora were electric and the readings extraordinary. Around the static poles we achieved a drop in temperature by at least half a degree. To use the thin atmosphere up there, and exposure in the borealis for a fridge effect was brilliant. It's your triumph, Dr. Sculcuvent."

The scientist smiled. "Warriors of light, eh, Bill, and a shift in consciousness? But just a tiny step, and it'll be expensive, but at least the new administration's behind it. New technologies. But we all need to change the system, perhaps with borders around the wild and forests, if we wake up. Not bad for three seasons work, though. I was holding my breath."

"Hey," said one of the others, "didn't you leave some early experimental poles near here?"

On the sea ice, the growling polar bears watched the ship

continue on, as the snows came down, and there seemed to be fewer and fewer, like paw prints blown away by the wind, as they blended against the white, and the troubling human voices dissolved too. Uteq could see seal riding in the boat's wake, and Flep at their head with the narwhal, its tusk gleaming in the twilit waters.

"The legend," growled Sepharga softly.

"Of the Ice Cry, Sepharga?" said Uteq, feeling as if they were fading into the storm together.

"No, Uteq. The descendants of a human coming to save the whole world with The Sight."

"Have they saved it? As Pollooq smote the Pheline?"

"Teela," said Sepharga, looking up, "so much seems about Teela, and how she wounded the white bear."

"For Pollooq fell in love with an impossible ideal, Sepharga, the perfect Bergeera in him, and it acted on his soul like the pole on a metal needle. Yet it saved him too, for it kept the light of love shining bright. Cold, but bright. So the story made her the Pole Star, above the Paw Print, to remind every Bergo what they really seek. What the living soul really is, that always brings light and goodness. To be whole."

Sepharga nodded. It was a wonderful idea.

"But he knew no creature can truly heal another's pain, Sepharga, if they cannot heal themselves, and Bergo and Bergeera must know how to stand apart, and honour the changing nature of the cubs, nestling beneath their shadows, as they grow happily into themselves. After he regained the warrior power though, Pollooq walked with bright-eyed Athela, wisdom itself, and he loved her, for she told him wonderful and wise stories, and was a real Bergeera too. They spoke the two languages together."

"Uteq, I'm so tired," Sepharga said, wanting to rest her snout on his, "yet glad that you've brought us here. You are the Marked One."

"I? Didn't you fall from heaven, my love, when a unicorn's—"

"Stop teasing, Uteq. You've proved the power of the One."

"Oh, no. What's really one is light and connection and truth, though not as many understand it. But Karn told me of something far

stronger. Mitherakk's final message. The strength and wonder of two, that becomes the future and the many."

"Tell me," said Sepharga softly, nuzzling Uteq and growling happily. "What is the wound?"

Again Uteq thought of the taste of that fish and his vision that sun by the sea.

"Perhaps for the Gurgai, consciousness itself, Sepharga, which is why some thoughtless Lera are so blessed, even in the dark."

"And can I know what all life fears above all?"

"Yes," whispered Uteq of the Blackpaw, with a warm and loving growl. "being alone, Sepharga. Though we never are, if we truly see."

EPILOGUE

I n the Great Sound there was a squawk in the skies, and a bird landed next to his beautiful empress goose in the fresh snows.

"Egg?" he whispered nervously. *"Grrrrr."*

"Yes, dear," said Feelar proudly. "Ruskova's guarding it. And do stop growling, it's silly."

Egg and his mate saw the pretty fox peering around, her tail curled round their egg for Ruskova had had little time for her poetic heart of late, with all the caring she had to do for others.

Nearby, Olooq and Olooqa were sitting together next to a large snow den, beneath a flourishing snow pine. The twins had grown considerably, and they seemed bored. Olooqa was watching two polar bears strolling toward the sea. Nuuq and Seegloo.

"You think that Mother will ever..." Olooqa couldn't finish the question.

"Beats me, Olooqa, but Seegloo's not bad. Knows a lot. Though he keeps hugging trees."

"And Illooq and Matta," said Olooqa, "they're always wandering, telling stories all the Long Day and Night. Farsarla says Illooq will take her north, now the Fellagorn and Fellagorna gather again. She said they can't have cubs, but I'm glad they've Pooq. He's started to

grow again. Matta says it was that evil, that 'Solution' that locked him in the past and made him scared to live."

"That's all adults seem to think about though," growled Olooq irritably. "Darq and Farsarla. Even Rornaq and Antiqa now. I want to go Still Hunting instead and kill a seal. One day I'm going to have a hug as famous as Toleg Breakback's or Uteq Blackpaw's. Then I'll win my real life name."

"Well, I'm going to be a Fellagorna, just like Matta, and I'll guard the true Lore."

Olooq scowled at his twin but they heard a roar and saw Sarq, whose wounds had healed, rising up and hugging Tortog warmly. They were always together now, scouting for them all.

"And Sepharga," said Olooqa, looking toward the snow den, "I wonder when she..."

As if on cue, the wall of the den quivered, and with a muffled growling from deep within, Sepharga's lovely head broke through the snow wall. She bellowed softly, happy to be back in the light again, breathing in the glorious clean arctic air.

A way beyond, a lone Bergo turned immediately, hearing, scenting and sensing his mate's eagerly awaited return to the sunlight. Uteq had been gazing out to sea, as he often did, guarding for any threat, and pretending not to be interested in the den at all. But he ran to Sepharga now, and as he did so, the twins saw that the fur on his paw had almost faded to a gentle grey.

"My Uteq," cried Sepharga delightedly, as she pulled her whole body out of the den and Brave One and Bright Star touched noses, their warm breathes mingling lovingly in the icy air.

"How many, Sepharga?" asked Uteq softly, his heart pounding.

"Two, Uteq."

"Good, Sepharga. One for sadness, two to be, three for a she-bear, four a He. Bergo or..."

As if in answer, the most ravishing little Bergeera poked her face out of the den mouth and peered around nervously, as the three of them looked at each other and laughed like Goom.

"Hopi's still sleeping in the den," said Sepharga. "She dreams a lot."

"Hopi? It means peaceful one in Fellagorn. How lovely, darling. And what's—"

"Mother?" said the other eagerly, gazing back with eyes as beautiful as galaxies. "Father?"

"I've been telling them stories in the den, my darling, so they know all about you," said Sepharga and Uteq looked as if he could have burst open with pride and joy.

"And what's her name?" Uteq almost whispered.

"Gaia," answered Sepharga gently. "Come on, little Gaia. Come up into the wonderful air, and let your parents tell you a story in the lovely sunlight."

ON GLOBAL WARMING

2008 Global Warming - Ice Melt Estimates To President Obama's Office

Over the past 25 years, the average annual arctic sea ice area has decreased by about five percent, and summer sea ice area decreased by roughly 15. The collapse of the Larsen Ice Shelf off the Antarctic Peninsula appears to have no precedent in the last 11,000 years. There may be doubts about global warming, and always the need for reason and clarity, but how can we doubt the harm we can do to the environment? What happens when the human population doubles, then doubles again? Alarmism may be unattractive, nor do we want our children to grow up in fear, but if we don't act, globally, and at a political level too, perhaps fight for world government, to confront both global warming and the depletion of the rainforests, most especially use of fossil fuels, logging, and palm oil plantation, a catastrophe awaits mankind, and of course nature too, on which we all depend. Six degrees of global warming by the end of the century, may cause mass extinctions. But perhaps there's another biosphere where we can find a solution, the biospheres of our connected beings and 'souls'.

WWF TOP TEN ENDANGERED SPECIES

- **Black Rhino.** Since 1970, has declined by ninety percent to less than three thousand.
- **Giant Panda.** China. Fewer than a thousand remain in their native habitat.
- **Tiger** Less than six thousand tigers remain in the wild from poaching for body parts and bones.
- **Beluga Sturgeon.** Caspian Sea. Poaching is out of control.
- **Goldenseal.** Herb favoured for its perceived ability to heal numerous ailments.
- **Alligator Snapping Turtle.** The largest freshwater turtle in North America.
- **Hawksbill Turtle.** Tropical reefs.
- **Big Leaf Mahogany.** Mexico to the Amazon Basin. Demand as great as ever.
- **Green-Cheeked Parrot.** Mexico. Illegally traded across the Mexico/U.S. border.
- **Mako Shark.** Highly sought for its tender meat, and especially in Asian markets, for its shark fins.

There are now over 8,000 species on the endangered list. Animals, insects and habitats vanish by the second. Japanese, Norwegian and Icelandic commercial whaling still butchers 2,000 whales a year. Whales are thought to have evolved 60 million years ago, after the extinction of the Dinosaurs, and may have evolved out of a wolf-like creature with hooves that returned to the sea. Is it worth it, just for a delicacy, though life indeed must eat and evolve?

Press Release - Polar bear listed as threatened species.

The animal, whose habitat has been shrinking with the melting of arctic sea ice, is the first to be designated as threatened with extinction mainly because of global warming.

In 2019, Donald Trump confirmed America's 2017 withdrawal from the Paris Accord on Pollution and Climate Change

ABOUT THE AUTHOR

David Clement-Davies is the author of such highly regarded novels as *The Sight*, *Fell*, and *The Telling Pool*, which contain many of these characters and legends, and *Fire Bringer*, which *Booklist* called "a masterpiece of animal fantasy" in a starred review and which Richard Adams, author of *Watership Down*, hailed as "one of the best anthropomorphic fantasies known to me." His books have been named *Booklist* Books of the Year and Book Sense 76 selections. As House Manager of Regent's Park Open Air Theatre in London, he once appeared, for one night only, on the stage, as the bear in Shakespeare's Winter's Tale, when he borrowed an actor's costume, on a whim, and growled at the audience.

David is also a travel writer, who has specialised in environmental pieces, studying whales in the Azores, dolphins in Costa Rica, wolves in Romania, and has dived with sharks, human and animal. His wide-ranging journeys are often inspiration for his vividly set stories. He is a graduate of the University of Edinburgh, where he studied history and English literature. He lives in Italy and has become a Sculptor as well.